new dictionary of

modern sculpture

new dictionary of

modern sculpture

General Editor
Robert Maillard

TUDOR PUBLISHING COMPANY

NEW YORK

Originally published in 1970
as Nouveau dictionnaire de la sculpture moderne
© Fernand Hazan Editeur, Paris 1970

Translated from the French
by Bettina Wadia

Standard Book Number: 8148-0479-9
Library of Congress Catalog Number: 70-153118
TUDOR PUBLISHING COMPANY
572 Fifth Avenue, New York 10036
All rights reserved. Published 1971
Printed in the United States of America

Preface to the second edition

Not so long ago, sculpture occupied a limited place in the life of the arts and was treated as a poor relation. No one, apart from the specialists and a few art lovers, seem to have noticed the profound changes that had disrupted the course of its development over half a century. In fact, painting alone and its history absorbed the interests and enthralled the general public.

The reception that welcomed the first edition of this dictionary in 1960 showed that a fresh awareness had been awakened in the public and its former indifference had been replaced by curiosity and a need for information, which was met by its compilation.

Ten years have gone by and the situation seems to have changed radically. They have witnessed a sort of acceleration, which suddenly made sculpture front-page news among avant-garde activities. Countless exhibitions, open-air shows, Biennials and Symposiums are an indication of this change and have integrated sculpture into our daily life, as never before. Even the number of sculptors has increased.

The new climate of opinion and the new horizons, opening before the sculptor, are paralleled by a ferment of experimentation, a multiplication of the means at his disposal and an increasing diversification of disciplines, which have ended by dislocating our perennial notions of the sculptor. His materials are no longer confined to wood, stone plaster and clay; he has turned blacksmith and begun to work directly on metals, he uses plastics and synthetic resins, he has been transformed into a mechanic, aspires to be an engineer or programmer, and resorts to modern industrial technology and science. Concurrently, the traditional distinctions between painting and sculpture, sculpture and architecture have been abolished. No single definition can any longer cover an art that ranges from the verist images of Pop Art to the immaterial creations of Kineticism, from object-sculpture to environments.

It was impossible to give an account of this headlong development without a complete revision of the dictionary. The second edition includes nearly two hundred additional artists, with an equal number of fresh illustrations. The schools of a number of countries, such as Czechoslovakia, Rumania and Canada, which were omitted before, now come within its scope, while the representatives from the others have been increased, often by an appreciable amount. The reader can in consequence be sure of finding as objective a survey as possible of the main tendencies in sculpture today.

The same plan has been retained for each article and, besides the indispensable biographical details, it contains all the technical and stylistic information necessary for a sound understanding of the artist's work. The dictionary does not claim to be either a thorough, critical study, or a comprehensive, historical account: it should be considered as an impartial, but sympathetic reflection of contemporary art.

List of contributors

Giovanni Carandente	G.C.	Ionel Jianou	I.J.
Denys Chevalier	D.C.	Jorg Lampe	J.L.
Juan-Eduardo Cirlot	J.-E. C.	Francine-Claire Legrand	F.-C. L.
Raymond Cogniat	R.C.	Giuseppe Marchiori	G.M.
Petru Comarnesco	P.C.	Jerome Mellquist	J.M.
Michel Conil-Lacoste	M. C.-L.	Franz Meyer	F.M.
Jean-Luc Daval	J.-L. D.	Michael Middleton	M.M.
Frank Elgar	F.E.	Raoul-Jean Moulin	R.-J. M.
Dino Formaggio	D.F.	Joseph-Émile Muller	J.-E. M.
David Fuller	DA. F.	Nello Ponente	N.P.
J.A. García Martínez	J.A.G.M.	Frank Popper	F.P.
Gérald Gassiot-Talabot	G. G.-T.	Juliana Roh	J.R.
Carola Giedion-Welcker	C. G.-W.	Gualtieri di San Lazzaro	S.L.
Robert Goldwater	R.G.	Guy Viau	G.V.
Maria-Rosa Gonzalez	M.-R. G.	Pierre Volboudt	P.V.
W. Jos. de Gruyter	W.J. de G.	Dolf Welling	D.W.
Radu Ionesco	R.I.	Herta Wescher	H.W.

The Publishers
wish to express their gratitude
to the many Artists,
Collectors and Art Galleries
whose kindness and cooperation
have made it possible to assemble
the material for this book.

a

ACHIAM. Born 1916, Bet Gan, Israel. He began his career as a sculptor, when he was twenty-four years old. He was attracted by the stone found near Jerusalem, a kind of greyish-black basalt, and learnt the art of direct carving. The hardness of the material taught him restraint and simplicity. The Bible and its stories provided him with his most important subjects. In October 1947, Achiam went to live in Paris and the following year gave his first one-man exhibition at the Galerie Drouin, Place Vendôme. Since then, he has contributed regularly to the Salons. He won the First Prize of the State of Israel (1955) and the Grand Prix des Beaux-Arts of the City of Paris ten years later.

Since he has lived in France, he has used a far greater variety of stone and his style shows greater freedom. The admiration he always felt for Canaanite and Phoenician art is certainly as strong as ever, but instead of imitating them, he now takes them as a starting point for fresh exploration. He is careful to leave his stone unpolished, so that its surface texture is like a sensitive skin. Deeply rooted in an ancient tradition, which he has successfully revived and made flower again, his art is both figurative and primitive in its technique and significant distortions. D. C.

ADAM Henri-Georges (Paris, 1904 – Perros-Guirec, 1967). Adam's father was a goldsmith, who taught him his craft and instilled a life-long love of well-made work and fine materials, but Adam soon gave up craftwork to learn drawing and engraving. He decided to become a sculptor in 1943, when Jean-Paul Sartre commissioned him to design the setting and costumes for his first play, *Les Mouches* (produced by Charles Dullin the next year), which entailed making two statues, 13ft high, for the stage. His famous *Reclining Figure* dates from the same year, 1943, which caused a scandal at the Salon de la Libération, but earned him the watchful friendship of Picasso, who encouraged and helped him by lending him his studio in the Rue des Grands-Augustins, Paris, then his house at Boisgeloup. It was at Boisgeloup, in fact, that Adam prepared an exhibition of his work for the Galerie Maeght, Paris, in 1949, which included such notable works as *The Point* (1947), *Standing Woman* (1948) and *Large Nude* (1949), which was acquired by the Musée National d'Art Moderne. After this, it was impossible to ignore an artist who was gifted with such creative power and who had so quickly mastered his art. The most striking thing about him was an obvious and courageous effort to restrain an inclination to glibness

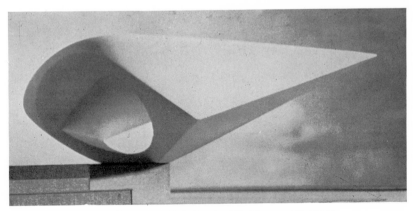

Adam. Signal. 1955-1961. Esplanade of the Museum at Le Havre.

Adam

and to control the wealth of his ideas, which was very noticeable in his very first works. With *The Point* and *Large Nude*, a fundamental change is discernable. Henceforward, Adam sought in the severity of his conception, in the purity of his lines and in the relationship of geometrically carved planes, a style independent of time, of contingency and personal associations. And yet a classicism as strict as this escaped from insensitiveness and frigidity. The simple bend of a line, a curve meeting a straight line, a slight salience here, or there a receding contour, a solid mass contrasting with a tapered end were enough to preserve, if not to accentuate, the human element without which the work would be nothing but the dry interpretation of an idea. Adam always considered sculpture an art that was essentially monumental. So it is not surprising he imparts grandeur to the least important of his works, however small they may be, like *The Doll* of 1946, the wonderful *Horned Beast* of the same year or again the *Black Head* of 1955. He looked back over the centuries to an ancient, undying tradition and turned towards a synthesis of sculpture and architecture. The *Monument to an Unknown Political Prisoner* (1952) is one of the best examples of this. Unfortunately,

Adam. Engraved woman. 1949. Plaster.

Adam. Marine mutation. 1959. Engraved bronze.

this work, like the Auschwitz memorial called the *Beacon of the Dead* (1957–1958), remained as a maquette. On the other hand, the work commissioned from him by the town of Le Havre for the esplanade in front of the museum was successfully completed. This white, concrete *Signal*, like a lookout, facing the sea, is unique of its kind and a masterpiece of refinement and strength, elegance and solidity. Far from wanting to specialise in monumental sculpture, Adam always let his inventive powers range freely beyond any preconceived ideas. And it was by ceaseless experiment that he was able to enrich his vocabulary and discover fresh forms and unexpected rhythms. With a wisdom that accompanied his artistic daring, he realised that impassibility could become frigidity, bareness could become impoverishment, so he went back to a process he had already used for his *Engraved Woman* and, after 1955, livened his surfaces with a slight relief of chasing and grooves of varying depth. In a group of bronzes of 1959, not a square centimetre remains that is not grooved or embossed with strokes, signs or geometric motives: little squares and interwoven patterns in relief, strongly marked ribs in links, chequers and cross-braces. Although the forms in his last works cannot really be identified and could be described as abstract, they were imbued with a very strong feeling for nature and all its surging,

multifarious forms of life. The sea and the plant world inspired some of Adam's finest works: *Nautilus* (1959), *Pointe Saint-Mathieu* (1960), *Plant Mutation* (1960), *Flower* (1961), *Venus Sea-foam* (1964) and *Dying Sea Bird* (1967). Most of these works, with other, singularly powerful sculptures, like the *Resurrection of Lazarus* (1964) and the *Sarcophagus-woman* (1966), were exhibited in the brilliant retrospective show organised in 1966 by the Musée National d'Art Moderne in his honour just before he died.

An intense and exhausting activity filled the last years of his life. He not only directed a studio at the École des Beaux-Arts, which he had taken on in 1959, he continued to produce engravings, cartoons and large-scale sculptures: *Leaf* and *Engraved Wall* for the lycée at Chantilly, the *Swan* (1964) for the boys' lycée at Vincennes, *Three Tapering Points* (1965) for the school complex at La Flèche, *Oblique Obelisk* (1967) for the French pavilion at the World Exhibition at Montreal and the *Conference Table* (1967) for the technical lycée at Saint-Brieuc. This does not cover all his work. He designed about thirty medallions after 1961, which were cast in bronze by the Hôtel des Monnaies and exhibited there during the winter of 1968–1969, with the whole of his engraved work and a selection of his sculptures. These various activities are all stamped with the same clarity and wholesomeness, the same grandeur and urge to go further. After Laurens and Brancusi, Henri-Georges Adam has taken modern sculpture to the point of incandescence, where it has no more questions to ask and so its very justification is challenged by itself. F. E.

ADAMS Robert. Born 1917, Northampton. He trained at the Northampton School of Art. After his first exhibition in 1947, he was represented at several international exhibitions, notably at the São Paulo Biennial (1951 and 1957) and the Venice Biennale (1952). He was an instructor at the Central School of Art from 1949 to 1960. Within his generation, Adams remains one of the purest sculptors in Britain. Totally unaffected by the romanticism, the expressionism and the anti-rationalism that have attracted so many younger artists since the war, he has evolved a calm, non-figurative idiom that has strong architectural qualities. He had done a good deal of wood carving but latterly has worked more frequently, and with equal feeling for the medium, in stone, concrete and metal. His metal sculptures are characterised by their lightness, by the upward thrust of metal rods, by the curves of sheet-metal; his stone and concrete sculptures by their massive weight, geometric lines and play of simple relief forms. The same qualities are to be observed in his drawings and prints, which are most often executed in cool, calm colours. M. M.

ADAM-TESSIER Maxime. Born 1920, Rouen. He joined the Académie Julian in 1939 and met Despiau in 1942, who influenced his work for a time. At the end of 1945, he made friends with Laurens and he and Lobo became his favourite pupils. At that time his art was greatly influenced by Cubist technique and it showed a constant exploration of the interrelation and superimposition of planes. He exhibited for the first time in 1947. The poetry of mechanical and industrial inventions, like jet planes, took the place in his work of trees and plant forms, which had inspired him till then. This development finally completed the transition from an art that was still figurative to the idiom of uncompromising abstraction. Gradually he moved towards compact, full volumes, unrelieved by any saliences; only slight, hardly perceptible accidents caught the light, which suffused them with mysterious life. Adam-Tessier has regularly taken part in the Salon de la Jeune Sculpture and has done several large sculptures for civic and religious buildings. D. C.

AESCHBACHER Hans. Born 1906, Zürich. He was thirty when he began to sculpt. After modelling a few heads in clay and plaster, which were cast in bronze, he began carving directly in stone and produced portraits

Adams. Architectural screen. 1956. Bronze.

Aeschbacher

Aeschbacher. Figure II. 1960. Marble.

Agam. Transformable spatial relief. 1958.

of women and torsos in pink marble, porphyry, granite and limestone. With the *Abstract Faces* of 1945, all details were eliminated and absorbed into unified volumes. At the same time, he made his *Feminine Idols*, mysterious stone statues, shrouding biological forms, with vague, imprecise outlines, like the *Venus of Six-Four* (a little Provençal village, where Aeschbacher spent the summer from 1947 to 1965), which were not unlike Arp's sculptures. From 1953, Aeschbacher turned finally to abstraction; the *Stelae* were withdrawn, columnlike forms, composed of geometric elements, scored with vertical and oblique lines. Lava rock became his favourite material and its porous texture did something to soften the austerity that was typical of his works carved in granite. These sculptures, flushed with the reddish tints of the rock, are rather like milestones, or, as some writers have said, like prehistoric menhirs. In 1959, his sculptures became more lively; the angles intersected more acutely, the intervals between the different, constituent elements narrowed, and sharp edges separated the surfaces

exposed to the light from those sunk in shadow. But this was a brief phase and he soon returned to the simplest geometric forms for severe, monumental sculptures, between 13ft and 15ft high, which were landmarks, symbols of stability in the midst of a feverish city environment; for instance, *Explorer I* at the Zürich-Kloten airport and the *Three-part Figure* in granite for the courtyard of a school at Bregenz, Austria. Sometimes he also used concrete for building structures, based on concave lines, which were more supple in character (*Figure III* for the Wülflingen swimming-pool at Winterthur, 1968). Besides countless one-man shows in Switzerland, notably at the Kunsthalle of Berne in 1961, and in Germany, Aeschbacher has been regularly represented at the Bienne Quadriennale since 1954, as well as the international exhibitions at Arnhem, Holland, in 1955, 1958 and 1966, the Kassel Documenta in 1959 and the Venice Biennale in 1956 and 1968, where he shared the Swiss pavilion with the painter Fritz Glarner.

H. W.

AGAM Yaacov. Born 1928, Rishon le Zion, Israel. He trained at the Bezalel Art School in Jerusalem, then went to Paris in 1951 and has lived there ever since. His conceptions of a new visual idiom were materialised in the works at a one-man show at the Galerie Craven, Paris, in 1953, which consisted entirely of polymorphic, transformable and tactile constructions in movement. In 1955, he contributed to the exhibition, 'Mouvement', at the Galerie Denise René, Paris, and in 1963 he won the Prize for Experimental Art at the São Paulo Biennial. Several one-man exhibitions of his work have been held, notably at the Tel Aviv Museum in 1955, the Palais des Beaux-Arts, Brussels, in 1958 and at the Marlborough-Gerson Gallery, New York, in 1966. His public commissions include the ceiling for the National Convention Centre in Jerusalem and a 'metamorphic' wall for the Israelian liner 'Shalom'. Agam was a pioneer of kinetic art and one of the first artists to realise as early as 1953 the importance of time as a constituent element in a work of art and to set the problem of the obsolescence of form and image. His experiments with transformable and moving images were followed by others that invited the participation of the observer by manipulating the work himself and this manipulation was integrated in the surrounding space. After an initial series of works incorporating light, this assumed a capital importance in the artist's theories. Agam's experiments depended on elaborate, technical preparation. Observer participation could be a factor in the sound modulation of light as in *Rhythmic Space* (1967), or an illusion of appearing and disappearing images in juxtaposition or superimposition, like *Painting rhythmised by Light* (1956–1967), which rotated at great speed and was played on by strobo-scopic rays. The public had an opportunity to see these experiments for the first time in the exhibition of 'Lumière et Mouvement' at the Musée d'Art Moderne de la Ville de Paris in 1967. F. P.

AGOSTINI Peter. Born 1913, New York. He studied at the Leonardo da Vinci Art School, New York. Since 1960, he has had eight one-man shows at the Stephen Radich Gallery, New York; two at the Richard Gray Gallery, Chicago. He contributed to the São Paulo Biennial in 1963. Agostini taught at Columbia University (1961–1966) and, since 1966, at the University of North Carolina, Greensboro. His medium is plaster; he has a mastery of its casting techniques, including some personal methods, and he employs it not as a stage towards another final product, but as an end in itself, one that enables him to create surprising, individual effects. By means of slush-casting within cloth, rubber or plastic containers (pillow-cases, balls, balloons, etc.), which are then removed, he creates hollow, airy forms, which he can combine and pile upon each other at will. The plaster takes on the folds and gatherings with absolute fidelity. In their apparent softness but actual hardness, in their deceptive brittleness, in their translation of varied, accidental colour into a uniform, bright white, these sculptures have the shock of the unexpected. They translate the accidents of trompe l'œil, with all that this suggests of both change and imitation, into a neo-classical purity that is real rather than ideal. R. G.

ALALOU-JONQUIÈRES Tatiana (Russia, 1902–Paris, 1969). After training at the Academy of Fine Arts in Moscow, she went to Paris in 1920, where she first attended classes under Bourdelle and then joined his studio as an assistant. There is no doubt that the attraction that a massive style in sculpture has for her today dates from this period. She was working then at a whole series of portraits: *Stravinsky, Derain, Rouault*, etc., the human face providing her with an endless source of sculptural experiment. From the beginning, Alalou-Jonquières was represented in various Salons in Paris. She found the mediums of clay, stone and metal equally congenial. Her art is realistic, but more intimate then Bourdelle's and it often shows affinities with Despiau. Her first experiments in the significant distortion of naturalistic volumes date from the war. After the Liberation, she exhibited at the Galerie de Beaune (1946), then took part in various group exhibitions, while her sculpture moved more and more towards abstraction.

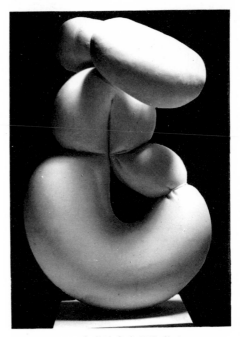

Agostini. Baby Doll. 1967. Plaster.

Alfaro

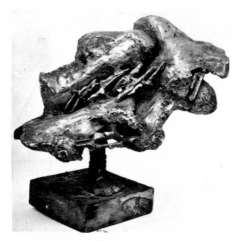

Alalou-Jonquières. Sculpture. Bronze.

She has generally modelled in clay, which was fired or cast in bronze. Now she often uses lead and her forms, which were static and strongly rhythmic, but always simple and pure, have become fragmented and highly emotive, with the result that her sculpture has been drawn into the expressionist current of abstract art. D. C.

ALFARO Andrès. Born 1929, Valencia, Spain. He was self-taught and began exhibiting in Valencia in 1955. Two years later, he became a foundation member of the Parpalló Group. He was invited to send work to the São Paulo Biennial in 1961 and was twice represented at the Salon de la Jeune Sculpture in Paris (1967 and 1968). A huge retrospective exhibition of his work was organised in 1965 in Barcelona at the famous Sala Gaspar. Alfaro's sculpture belongs, at least in the early work, to the Constructivist tradition and has shown a remarkable consistency of inspiration and idiom. Although the subject has never been used as an expression of personal problems, it is, nevertheless, a preponderant factor in his work and reflects his interest in the world around him, which he distils as the spirit of technological progress in sculptures, which are almost symbolic. As the choice of materials depends on the final meaning of the work, their range is extremely varied and includes metals (stainless steel, aluminium, copper, etc.), wood, painted or coloured plastic. His style has an unrelieved austerity; uninterrupted extension into space is characteristic of Alfaro's sculpture and he has given up any kind of soldering or joins that would break the continuity of the forms. Alfaro is justly considered one of the most disciplined and original of contemporary Spanish sculptors. G. C.

ALVIANI Getulio. Born 1939, Udine, Italy. He is a member of the Nouvelle Tendance group and has been attracted since 1959 to contemporary problems in visual art. He has held one-man exhibitions since 1961 in Italy, Yugoslavia, Belgium, Germany and the Städtisches Museum at Leverkusen (1963). Alviani is a kinetic artist, who is fascinated by the incidence of light on a surface, and he made reflecting objects, then chromatic structures. Besides this, he has been interested in the programming of dynamic, optical objects. His most original works, *Luminous Lines*, consist of aluminium surfaces in the shape of curved signs, based on the same module, but arranged in different heights and positions. The light, reflecting on these surfaces, creates optical lines on them that vary according to the observer's angle of vision. Recently, Alviani has widened his field of action and produced works that are constructed on the alternation of convex and concave, plane and relief, light and dark. The purpose of the artist is not to create an effect of shock, or simply of romantic contrasts, but an interpenetration of these elements. Alviani's art is fundamentally constructive in all its various expressions, whether he is concerned with the integration of sculpture with architecture, the definition of optical phenomena in terms of time and dynamism, or the rarefaction of air and the effects of heat. F. P.

ANDOLFATTO Natalino. Born 1933, Pove del Grappa, Italy. He trained at the École des Beaux-Arts, Paris, and also worked as an assistant in Zadkine's studio. He had two one-man shows at the Galerie Lucien Durand, Paris (1966 and 1967) and was represented at

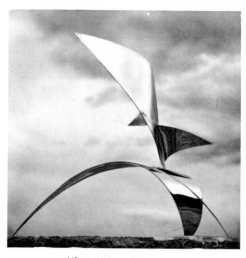

Alfaro. Malaga. 1963. Copper.

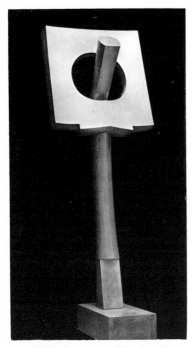

Andolfatto. Assemblage. 1968. Aluminium.

to the principal Parisian Salons, the Biennials at Venice and Ljubljana and held several one-man exhibitions in Paris, São Paulo, Brussels and Athens. At each of these exhibitions, it was evident that he is one of the rare contemporary sculptors who knows how to capture, without diminishing or taming it, the instinctive and savage poetry of the animal world. Robert Lapoujade made a film about his work in 1962. For some years, Andréou has been interested in polychrome sculpture, which is a synthesis of formal and coloured elements, each treated separately but conceived in terms of each other. D. C.

ANTHOONS Willy. Born 1911, Belgium. He trained at the Brussels Academy and the Institute of Decorative Arts, then worked both as painter and sculptor. His experimental work brought him his first one-man show in 1944 at the Galerie Manteau, Brussels, but his artistic personality did not develop until he went to live in Paris in 1948. The first part of his work is typified by the compositions in wood and stone called *Cathedrals*, which were like slender columns in which forest images

the Paris Biennale and the Symposiums of Grenoble (1967) and Kosice in Czechoslovakia. He used iron for the first time in the large-scale sculpture exhibited there. He had been trained in stone cutting and marble carving and it was only in 1962 that he began working in bronze. Five years later, he learnt how to cast aluminium and the closed, static character of his earlier work disappeared in the slender shapes that were often poised in overhanging, unstable equilibrium. His abstract art of interpenetrating forms depends for its effect on the classical means of light and space. D. C.

ANDRÉOU Constantin. Born 1917 at São Paulo, of Greek parents, who had emigrated and then returned to Athens in 1924, where Andréou did his training. He went to live in Paris in 1945. Three years later, he discovered the material that suited him, sheet-brass, which he hammered and soldered together. His experiments led him from a kind of neo-classicism to a sculpture of synthesis in which naturalism found a harmonious plastic expression. Indeed, if Andréou's first sculptures gave the impression that they tended towards a rather academic perfection, the most recent have strong affinities with archaic Greek and primitive art. He contributed regularly

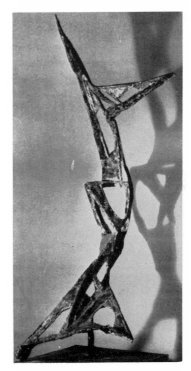

Andréou. Icarus. 1958. Metal sculpture.

were mixed with architectural constructions. A similar change came over his figurative subjects as he tried to give plastic expression to their inner meaning; for example, human relationships, *Love, The Embrace, Couple* are expressed in an abstract idiom of volumes and planes, linked and enfolded. In the desire for simplification and purity, he carved his works in massive, compact blocks on which the particular subjects are unobtrusively indicated. Straight and curved lines were lightly incised on the surface, suggesting the correlations between the *Ephemeral and the Eternal, Being and Becoming*. Working for preference in white stone, Anthoons hammers it carefully, as if to open the pores and allow them to breathe, but he never polishes it. On the other hand, when he uses wood, oak, ebony, etc., he accepts its peculiar qualities, its mottling, striations and flaws, which preserve the natural character of the medium in works that are in themselves aesthetically satisfying, like *North Sea*. In 1953, he also began using more malleable materials and created mobiles, in sheets of aluminium, and stabiles, made with a single sheet of copper, which was cut out, incurved and folded. About 1962, narrow slits let in the light between the masses and, for a moment, his sculptures seemed to be on the point of opening out and growing less weighty. Similarly,

Apergis. Palace of dreams. 1968. Bronze.

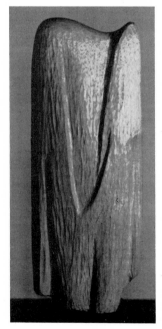

Anthoons. Ascetic. 1957.
Gilded wood.

interwoven bands, forming an airy trelliswork, appeared on his reliefs. But it was not long before Anthoons returned to the unity of the original block in which the attached elements coalesced as if in the process of growth. Anthoons makes countless preparatory drawings for his sculptures, which help him to clarify his ideas. Besides several one-man shows in Brussels at the Palais des Beaux-Arts (1945, 1951 and 1957), in Paris at the galleries Les Deux Iles (1950), Colette Allendy (1954) and Ariel (1959 and 1962), and at the Musée Communal of Verviers, Belgium (1967), Anthoons has sent work regularly to the principal Parisian Salons since 1949. He was also represented at the Biennials of São Paulo (1953), Middelheim (since 1957) and Yverdon (1958). H. W.

APERGIS Achilles. Born 1909, Corfu. He trained at the Athens School of Art. One-man exhibitions of his work were held in Greece, England and Italy and he was represented at the Venice Biennale as well as the Biennials of São Paulo and Padua. A period of realism, which ended in 1950, was followed by an abstraction that still took nature as its point of departure. Then he gave up soldering sheets of iron and copper and, for a time, used iron bars, which gave his work a more aggressive appearance. He was still using these bars in 1962, but they

were now in bronze and arranged in vertical rhythms, which he soon drew together into broad planes, which were also vertical. Apergis's sculpture is now extremely simplified; it is based on precise, mathematical calculations and the countless metallic wires that constitute it are absorbed and merged by the forms into a pure, strictly unified cohesion.　　　　　　　　　　　　　　D. C.

APOSTU George. Born 1934, Stanisesti, Romania. He trained at the Nicolae Grigoresco Institute of Plastic Arts, Bucharest, and was awarded the prizes of the Union of Artists and the Academy of the Republic. His work was exhibited in Bucharest and, in 1967, in Paris at the Galerie Cazenave. A number of his public monuments are to be seen in Romania, at Blaj and Bucharest, and also in Grenoble. After an archaising period, influenced by the folk art of his country, Apostu turned to abstraction. His sculptures are either modelled in terracotta, or carved directly in wood or stone, depending on the subject and the style it requires. For some years, his work has been produced for two cycles of abstract sculpture, *Father and Son* and *Butterflies*, in which there is a personal flavour in the variations of very simple, compact and disciplined forms. A monograph on Apostu

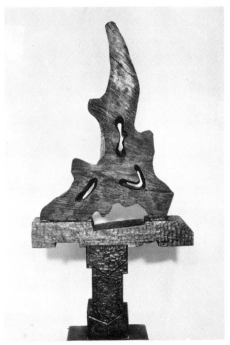

Aramesco. The steps. 1965. Wood.

by O. Barbosa has recently been published by Meridiane of Bucharest.　　　　　　　　　　　　　　　D. C.

ARAMESCO Constantin Emile Tico (Galatz, Romania, 1914 — Miami, United States, 1966). After study visits to France, Italy, Spain and England, he emigrated to the United States in 1948. For a long time, he had to earn his living by other means than art and he could not devote all his time to sculpture until 1957. A large retrospective of his work was held in Romania in 1968. Aramesco gradually distilled his images by drawing off every accessory element from them and reducing them to the essentials of abstraction. It was the same path that Brancusi had trod, with the difference that Brancusi had sought for perfection in the closed volume, while Aramesco's sculptures were open and space was integrated into them, which created a dramatic tension that expressed the artist's personal tragedy in being separated from his spiritual home by the vicissitudes of history. His methods changed from direct carving to assembling bits of mechanism. His 'electronic sculptures', for instance, were made from the components of radio and television sets, while his carved sculptures were made from pieces of wood salvaged from old wrecks that had been worn

Apostu. Studio of the artist.

17

with time. They possess a plastic tension and inner signif-
icance, while he respected the structure of the original
block. Wood was a witness for Aramesco of the past,
while the mechanical components were a sign of the
future. This dual attraction of memory and the technical
accessories of a new world gave his sculptures a bold
originality, which was dominated by the powerful
rhythms of his plastic style. I. J.

ARBUS André. (Toulouse, 1903 - Paris, 1969). He came
late to sculpture; he first made a name for himself as
a furniture designer and decorator, then as an architect.
Although his art has an intense and disturbing realism,
it is also derived from the dreams and anguish of an
inner life. His portraits, for instance, are not only a life-
like presentation of a person; they resemble the model
less by faithful representation than by an intimate
rhythm, a painful tenseness that betrays their unhappiness.
This mastery over his medium is the same in the torsos
and the large nudes of women and youths, which have
the purity of an ancient statue, but they belong to an
antiquity of quivering flesh, empty eye sockets, mouths
opened by a silent cry. R. C.

ARCHIPENKO Alexander (Kiev, 1887 – New York,
1964). Although Cubism proved less stimulating to
sculptors than painters, it is impossible to discuss it
without mentioning Archipenko. Admittedly, he was not
tempted to analyse the mechanism of form, as Duchamp-
Villon did, and his works have neither the strength nor
the breadth of Lipchitz or Laurens, but he showed that
he had a sense of the imponderable, which was alien to
them, and his special contribution was to replace the
solid volumes of classical sculpture by forms that were
reduced to essentials in which saliences receded into
hollows and the alternation of convex and concave made
space the primordial element in the sculpture. In doing
this, Archipenko laid down some of the analytical prin-
ciples that were to transform modern art. He trained at
the Art School of Kiev from 1902 to 1905.

In 1906, he left for Moscow, where he was soon show-
ing his work in various exhibitions. He went to Paris in
1908 and joined the École des Beaux-Arts, but he was
stiffled by the academic teaching and only stayed for a
few weeks. He completed his own training by visiting
the museums assiduously. By 1910, he was exhibiting
at the Salon des Indépendants and, the following year,
at the Salon d'Automne, where his *Woman with a Cat*
was the sport of the caricaturists. His first one-man show
took place in 1912 at the Folkwang Museum of Hagen.
His first carved and painted plaster reliefs, which he
called 'sculpto-paintings', date from this year. He
belonged to the Section d'Or group and contributed to
their various exhibitions. In 1912 again, he opened his art
school in Paris, where he put into practice some of the
experimental aspects of his sculpture. He lay particular

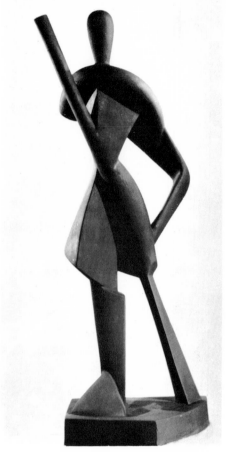

Archipenko. Gondolier.
1914. Bronze.

stress on the modelling of space, unsuspected possibilities
in the concave and novel uses of transparency.

A resourceful workman, he sometimes modelled his
forms as if turning them upon the potter's wheel: they
were scooped and rounded, though a somewhat more
emphatic note was lent by the stress of the rhythm.
Introducing into such productions the more jagged
potentialities of Cubism, he syncopated his rhythm by
juxtaposing an oblique against a sinuous vertical. Still
more essential, he utilised voids so as to replace solids.
This indeed became the hallmark of his sculpture:
Gondolier (1914), *Marching Soldier* (1917) and *Standing
Figure* (1920). Ivan Goll remarked in 1921 that 'void
seems as visible to us as substance'. Archipenko moved

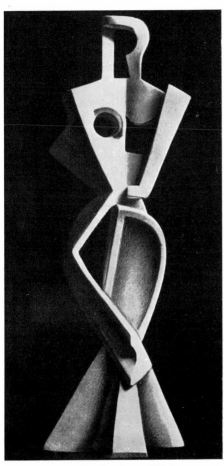

Archipenko. Standing figure. 1920. Stone.
Darmstadt Museum.

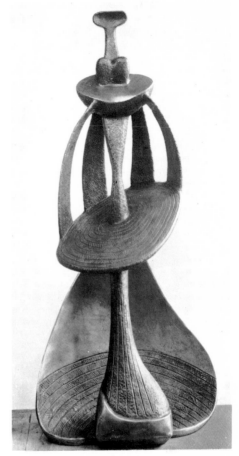

Archipenko. The Queen of Sheba. 1961.
Polychrome bronze.

to Berlin in 1921 and opened a school there, which he directed till he left for United States in 1923. He obtained American nationality in 1928 and taught in a number of establishments, notably the University of Washington, Seattle (1935–1936), the Institute of Design, Chicago (1946), and the University of Kansas City (1950). In 1939, he opened a School of Sculpture in New York, which he directed till his death. He was also associated with the New Bauhaus founded by Moholy-Nagy in 1937. Although his activity never slackened, he produced the best of his work in the experimental years from 1910 to 1920, which were particularly fruitful. After this, a fondness for anything symbolic prevented him from continuing with a fundamental reconstitution of form,

but it should not be forgotten that Archipenko was one of the innovators who made modern art what it is. J. M.

ARMAN (Armand Fernandez, *called*). Born 1928, Nice. After a few attempts at abstract painting, Arman found his real vocation in 1960, when the Parisian art critic Pierre Restany took the initial steps to found the Nouveaux Réalistes group, whose purpose was to present reality as it appeared in everyday life and reduce the artist's interference to a minimum. Arman began by discovering this reality in dustbins, which he emptied into transparent containers without sorting the contents. In the same way, he made 'portraits' of his friends by

19

Armitage

taking possession of their waste-paper baskets, which, according to him, contained all the necessary information about their owners. He soon gave up this fortuitous scavenging for piling identical objects in countless numbers into boxes. He used any sort of rubbish for this: old pistols, spectacles, sets of false teeth, dolls' hands, electric light bulbs, etc. The unexpected effect made by these *Accumulations* resulted from the fact that the objects lost their material identity, because of their numbers, and to a certain extent became unreal entities. Subsequently, Arman started to put order into the chaos: he arranged manometers or cameras in a row, groups of hand-shaped door-knockers in an irregular line, gathered clothes-irons to form a sculpture or piled gas-rings into an airy stele.

The pleasures gained from arranging objects went with a strange need for destruction as another aspect of the artist's taking possession of the real, which has a touch of mania about it. Arman was not content to break ordinary things like a coffee-grinder, but also attacked plaster statues, which he sliced into pieces so that their dismantled outlines became simple arabesques. Musical instruments were the main victims of Arman's *Angers*; old pianos were burnt and dismembered so that he could display them with a malicious joy; violins were sawn up and hammered and the bits inserted into a bed of polyester. He used the same process to pour all the equipment of his studio into a mass of plexiglas: brushes, palette knives, crayons and tubes of paint oozing out streams of colour. The *Accumulations*, made from industrial materials from the Renault car factory with which Arman was connected from 1967 to 1969, were a contrast to these arbitrary works. They were subjected to a complete artistic transformation; the selected colours

were applied to the elements themselves and also to the foundation on which they were sometimes arranged, or he displayed pieces in planned compositions and enclosed in transparent blocks of plexiglas. The large panels of brightly coloured bodywork were piled into spiralling sculptures, while the small components, like rear lights, starter-buttons and electric wires, were used for object-paintings, which were based on a strict order or a subjective structure. The various tendencies of art today provide an ironic commentary on this kind of work, which makes such cavalier use of the triumphs of industry. Since this first exhibitions at the Galerie du Haut Pavé, Paris, in 1956, Arman has already about forty shows to his credit in France and abroad. He has been represented at over three hundred group exhibitions and Salons, at the Paris Biennial in 1961 and the Venice Biennale in 1968. He was awarded the second prize at the Tokyo Biennial (1964) and won the Marzotto Prize in 1966. H. W.

ARMITAGE Kenneth. Born 1916, Leeds. He studied at the Leeds College of Art (1934–1937) and at the Slade School, London (1937–1939). He served in the British Army during the war. From 1946 to 1956, he was head of the sculpture department of the Bath Academy of Art. Since his first one-man exhibition in 1952, he has contributed to the Biennials of Venice (1952 and 1958) and São Paulo (1957), besides a number of international open-air exhibitions (London, Middelheim, etc.). In 1956, Armitage was awarded first prize in an international competition for a war memorial in Krefeld Bronze is Armitage's chosen medium. Though he shares with his near contemporaries, Butler and Chadwick, an

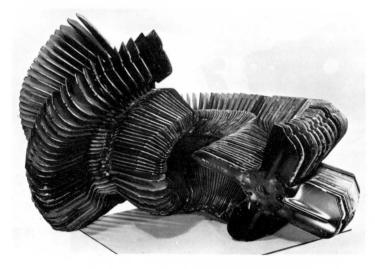

A 19

Arman.
Renault Accumulation
N° 143. 1968.
Soldered
fan blades.

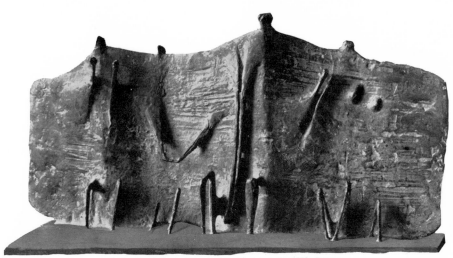

Armitage. Seated group listening to music. 1952. Bronze.

interest in structure that places him in the current British reaction away from direct carving, technical innovation as such has never attracted him. For Armitage, the human figure about its unheroic, everyday activities remains the proper study of sculpture. Humanity he regards with affection and detachment, at times with a whimsical observation. More particularly, he has made his subject the group, seen as a common unit, a single silhouette so simplified and formalised that the individuals comprising it have all but merged their separate identities.

His first essays of this kind, *People in a Wind* and *Family Going for a Walk*, both 1951, expressed their movement through diagonals and metallic curves; in the observation there was a hint of caricature. Since then the idiom has grown more static, more monumental. The group has become a single flattened slab, sometimes resembling a folding screen, each panel of which represents one individual. From this screen, emerge attenuated limbs, breasts, impersonalised knob-like heads. 'I desire,' Armitage wrote some years ago, 'to express a large volume with a minimum of material . . . Pleasure from wondering what is on the other side . . . ' To this recurring conception of a frontal viewpoint, Armitage joins a preoccupation with verticality and horizontality which increasingly lends his works strength, gravity and monumentality of a sometimes hieratic kind.

Bronze is Armitage's chosen medium, but in recent years he has also cast in aluminium, iron and has worked in wood and polyester. He has frequently produced series, as for example the seven versions of *Pandarus* (1963). These prophetic sculptures with pillow-box mouths and the poignantly exposed breasts of *The Legend*

of Skadar (1965) indicate a preoccupation with literary or descriptive sources used as a foil to abstracted quasi-anatomical themes. M. M.

ARP Jean, or Hans (Strasbourg, 1887 – Basel, 1966). Arp's love of poetry was awakened at a very early age by his reading of the German Romantics; he joined a group of Alsacian poets, when he was eighteen, and published his first poems in 1904. A year later, after a visit to Paris, he went to the Academy of Weimar to study painting. In 1908, he returned to Paris to join the Académie Julian. He spent the following years at Weggis in Switzerland where, while painting his first abstract works, he began to do some simple modelling. His first meeting with Klee took place here. When in 1912 he took part in the second exhibition of the Blaue Reiter group in Munich, he made the acquaintance of Kandinsky, who supported and encouraged him. But his real personality did not develop until his activities at Zürich in 1916 as one of the originators of Dadaism. Of all those who gathered at the Cabaret Voltaire (Hugo Ball, Tzara, Janco, Hülsenbeck, Sophie Taeuber), Arp probably possessed the most varied talent. He wrote burlesque poems, produced reliefs in coloured wood, made collages, illustrated the poems of his friends and saw to the production of their plays when the need arose. One should remember what relief was like at that time to assess the originality of Jean Arp's work (*Forest* 1916, *Hammer-Flower* 1917). Admittedly, they bear a certain resemblance to the constructions that Picasso created by putting together bits of wood, cardboard or metal,

21

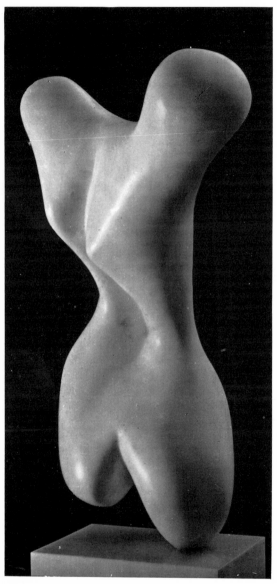

Arp. Torso. 1931. White marble.
Müller-Widmann collection, Basel.

which were a development of his work in collage. But what was new in Arp was that he introduced space and proportion as significant elements into more than one form that is normally recognisable by its organic character. Unusual groupings of forms appeared in a pattern of unconventional relations, with sharply defined contours, which sometimes undulated like leaves and sometimes were broken off like torsos or piled mud. Arp aimed at a new symbolism of form; he wanted an art that would be so dynamic that it would be like a natural world, never ceasing to grow and transform itself. Although his work is always imbued with a profound humanity, it is impossible to find the slightest naturalistic detail in it. Natural objects find in it an elemental language that is fundamentally their own. And if the figures that the artist invented are wholly independent of all prototypes, it is because the individual form is merged in the universal form and is subjected in consequence to the laws of a secret order. In Arp's sculpture, man expresses himself through nature and objects, and these through man. As Max Ernst so justly felt, 'Arp's hypnotic language leads us back to the lost paradise and to the mystery of the universe. He has taught us to understand once more the language spoken by this universe.'

While Arp was doing his Reliefs at this time, he was also making collages, in collaboration with Sophie Taeuber, which were abstract from the strictly architectonic point of view. These 'neutral forms', as Mondrian appreciatively called them, expressed a whole set of relationships that Arp used again later on with more flexibility in his Constellations, which were created 'according to the laws of chance'. Mondrian admired these when he became a friend of Arp's in Paris about 1926. Meanwhile, Arp contributed to the review *De Stijl* as well as *Mecano*, a publication started by Van Doesburg and the Dutch Dadaists. At the same time, he was a member of the Dadaist and Surrealist group in Paris (1922–1928), which is a good indication of the two aspects of his character. Actually, however inclined he might be to fantasy, Arp never allowed himself to be beguiled by the literary and descriptive aspect of Surrealist painting—in this he was like Miró—but always expressed himself by purely plastic means.

In 1926, Arp, who had married Sophie Taeuber four years earlier, finally settled at Meudon, near Paris. After 1930, he turned more and more to sculpture in the round. Although at first he composed groups of objects similar to those he had introduced into his reliefs and engravings (bottles, bells, nombrils, etc.), he afterwards offered organic configurations of increasing effectiveness, which revealed a new conception of life: what was evoked now was no longer, as in the Dada period, the estrangement between man and nature, but their complete union. There again, a humorous, grotesque element no longer predominated as it once had done; instead there was an overriding desire to weld the forces and laws of life into a universal synthesis. From then on, the title, Human Concretion, frequently appears. As Arp said in his

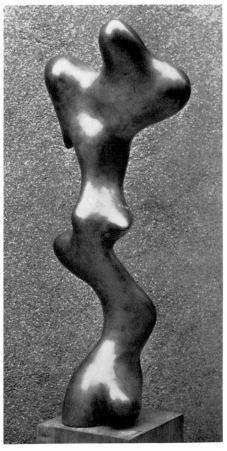

Arp. Growth. 1938. Bronze.

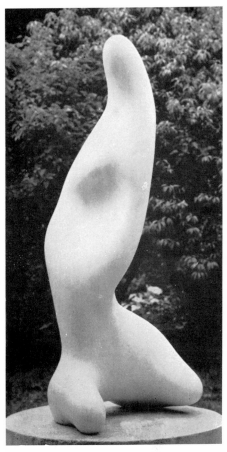

Arp. Cobra-Centaur. 1952. White marble.

memoirs, *Unsern täglichen Traum* (Our Daily Dream, 1955) he was destined 'to invoke the forces of concretion that make a concreted whole of the earth and the stars, of rock, plant, animal and man. Concretion is the product of growth...'

Arp left the fantasy that appears in the strange, prodigious combinations of volumes *(Bust of a Goblin, Head on Claws)* and moved towards an increasing refinement, creating forms that reflected a balanced, peaceful, withdrawn existence. Besides romantic works that seemed plunged in a dream world (*Sculpture of a Being Lost in a Forest* 1930, *Human Lunar Spectral* 1950) bright, radiant creations in marble appear, born of a nostalgia for the Mediterranean. Arp always felt at home in the south of France and, fleeing with Sophie

Taeuber from the miseries of the war, Grasse seemed another Arcadia to him. Later on, Greece attracted him and there it was pre-Socratic philosophy and archaic sculpture that fascinated him. If we look at his works, especially his 'Mediterranean' groups (*Orphic Song* 1941, *Idol* 1950, *Cypriana* 1951), from this point of view, we can feel a sunny serenity and profound dignity emanating from the extreme simplification of their masses. In a number of his later works, Arp abandoned solid form for an open form in which mass and space define and balance each other (*The Star* 1939, *Ptolemy* 1953). The metal reliefs commissioned for the University of Caracas (*Configurations* 1956), which hang before the walls like oriental figures, are treated in this manner, while those, which decorate the Graduate Center at Harvard Uni-

Arp

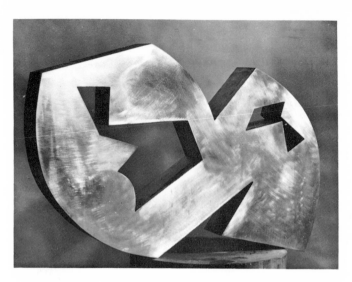

Arp. Moustache of machines.
1965. Bronze.

versity (1950), are made up of compact, horizontally deployed elements, which give a dynamic life to the wall.

With a rare originality, Arp created a world and an artistic language peculiar to our own day. At the same time, he made new forces rise from the depths of human memory and was always discovering new affinities in them with the primordial reign of nature. All the works he created in the last ten years of his life, while he was living at Ronco dei Fiori in Ticino (Torso-fruits, Winged Entities, Daphne), are marked with the dynamism that is inherent in the metamorphoses of life. Born from a daring imagination, his forms embody the conception of an irrational world; however, they are nonetheless subjected to a severe discipline and are always obviously fashioned in the first place according to plastic laws. So true is this that the characteristics of organic growth are mysteriously united with architectural severity. Arp spoke of his 'vegetative constructions'. He also called his

Auricoste.
The Beast of Gévaudan. 1958.
Iron. Marvejols, Lozère.

works 'structures made with the help of lines, planes, forms and colours.' An avowed enemy of everything suggestive of adroitness, vanity or imitation, art for him could only be a 'spiritual and mystic reality.' C. G.-W.

AURICOSTE Emmanuel. Born 1908, Paris. He studied first under Bourdelle then under Despiau. From the first he learnt the meaning of plastic composition and from the second he learnt the need for the psychological interpretation of a model. His first works were mainly figures and busts. Plaster, clay and bronze were then his favourite materials. In 1935, the Galerie Jeanne Castel put on his first one-man exhibition. Meanwhile, he was engaged on monumental works, which suited his temperament: a bas-relief for the Palais de Chaillot (1936), a statue of Chateaubriand presented by France to the Ambrosian Library in Milan and a bronze door for the League of Nations Palace in Geneva. Later on, discussing the nature of his art, he said, 'Sculpture is closely related to architecture, it might even be called an interpretation of architecture. It is the truest symbol of the continuity of life, and epitomises the absolute meaning of a building, since it is inspired by its conception and its place is decided in the preliminary plans.'

Although Auricoste's art is representational, the need for self-expression is more important to him than truth to appearances. He now finds hammered lead and iron are congenial mediums, but he does not use them exclusively; the requirements of his subject are his only guide. In 1949, the Galerie Dina Vierny held a retrospective exhibition of his work. In 1954, the Galerie Galanis did the same. In the last few years, Auricoste's composition and modelling have gained freedom and breadth, while his form and movement show greater economy and concentration. He is as much an impressionist by the delicacy of his use of light as an expressionist by the vitality of masses. The sources of his inspiration are often popular and rustic. He is so completely concerned with plastic problems that he does not differentiate between major and minor subjects. His most recent sculptures since the war are a statue of *Henry IV* and the *Beast of Gévaudan* at Marvejols. D. C.

AVRAMIDIS Joannis. Born 1922, Batumi, U.S.S.R., of Greek parents. Avramidis is now living in Vienna. From 1937 to 1939, he studied at the Batumi Art School. From 1939 to 1943 he lived in Athens. In 1943 he arrived in Vienna where he studied painting from 1945 to 1953. Then from 1953 to 1956 he learnt sculpture in Wotruba's studio. Since 1956 he has exhibited in Austria and abroad: Venice Biennale (1956 and 1964), Middelheim Biennial (1957 and 1959). In 1958, the Wurthle

Gallery in Vienna presented a one-man exhibition of his work. Avramidis has acquired a thorough knowledge of the human body by studying systematically the functional harmony of each limb and its movements. His masses and linear composition are determined by original

Avramidis. Figure. 1958. Plaster.

conception, based on this study. The figures and heads of Avramidis (the same can be said of his drawings and paintings) achieve a bareness, an equilibrium and serenity that remind one of Schlemmer, but their real affinities are even more with icons: forms evolve, which express simultaneously ideal properties and the essence of man in which order and growth are united. J. L.

b

BADII Libero. Born 1916 in Italy. Badii has been living in Argentina since 1927 and has become a naturalised citizen of the country. After studying at the Buenos Aires Art School, he won a scholarship in 1944 which enabled him to travel in Bolivia, Peru and Ecuador. He visited Europe in 1948 and 1949. On his return to Buenos Aires, he began to exhibit his work, which showed, even then, a strongly marked individuality. His one-man exhibitions in 1954 and 1955 confirmed the generally favourable opinion. At the end of 1958, he returned to Europe, spending several months in Paris. He won the Palanza prize in 1959 and lived on the fringe of coteries and groups. The Museum of Fine Arts in Buenos Aires organised a large retrospective of his work in 1962. Like all the Latin American countries, Argentina receives its intellectual and artistic stimulus from Europe, but more enthusiastically even than the others because it has no roots in the past Indian civilisation and has always depended entirely on European culture. Badii, because of his background could be no exception. So freeing himself from academic conventions, he soon turned towards Constructivism,

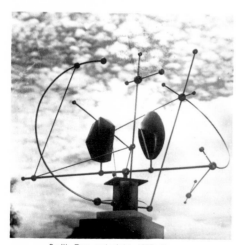

Badii. Day and night. 1957. Bronze.

transforming the reality before him according to its strict aesthetic principles. He was fascinated by the powerful images of the *Dance*, *Desire*, the *Mother* and for some years these were his favourite subjects. Sometimes he composed a sort of plastic music, an etherial, winged geometry through which the air flowed freely; sometimes he embodied in a static, heavy form, jagged with angular masses, the exuberant and eternal fertility that symbolises the Mother. About 1955 he became less figurative. Yet even where his sculpture became more abstract, it was entirely governed by the laws of nature. The final impression left by his work is of a delicate, constantly alert imagination fused with great austerity in the construction.

M.-R. G.

BAENNINGER Otto-Charles. Born 1897, Zürich. He learnt the rudiments of his craft in the city of his birth during the years 1914–1918. At the end of the war he went to Paris where at first he attended the Académie de la Grande-Chaumière (1920–1921), before working in Bourdelle's studio. He became friendly with him and was to become to a certain extent his partner. From 1931 to 1939, Baenninger divided his time between Paris and Zürich. He was awarded the international sculpture prize at the Venice Biennale in 1941 and the First Prize of the city of Zürich in 1956. His art is in the classical tradition as it was revived by Rodin and Maillol. He resembles the second with his voluptuous masses, and the vigour and power of his technique. Although he has been praised for several large groups, there is no doubt that the best of his work is to be found among his portraits.

BAIZERMAN Saul (Vitebsk, 1889 – New York, 1957). He emigrated to the United States in 1910 and earned his living with a variety of jobs while attending evening classes at the National Academy of Design and the Institute of Fine Arts in New York. After his marriage with a painter, he spent two years in France and Italy at the beginning of the twenties. His first exhibition of sculptures in copper and hammered bronze was held in 1938 at the Artist Gallery, New York. Since then he has exhibited several times, notably at the same gallery in 1948, then at the Philadelphia Art Alliance in 1949 and the

Baizerman.
Vestal.
Copper.

man shows outside his own country at the Galerie Denise René, Paris (1959), and the Corcoran Gallery, Washington (1966). As all this early sculptures were destroyed by the Germans in 1941, his work only became known after he began work again at the end of the war. His first portraits were in the Rodin tradition, but after a visit to Paris in 1953, his forms became more compact and geometric in the Cubist manner. There is something of Brancusi's influence in his marble and stone Torsos and Heads, with their pure, simple masses, where Bakić has not emphasised any of the physical features, but only suggested them with subtle modelling. On the other hand, some animal sculptures, *Bull*, *Head of a Horse* and *Birds*, already showed signs of the eventual integration of space as an element in his sculpture, a problem that he tried to solve in the bronzes of 1958, composed of metallic surfaces, which curve and bend to enclose imaginary volumes. Although they are called *Unfolded Forms*, the vitality of their movements suggest seated or standing figures. Since 1964, Bakić's work has become completely abstract. His *Forms*, *Vessels of Light* are metal constructions, with aligned and regularly spaced elements, supporting shimmering discs. As they can be arranged vertically and transversally, they lend themselves marvellously to the play of light, which etherealises all opacity and makes them vibrate in space. H. W.

Walker Art Center of Minneapolis in 1953. During the last years of his life, Saul Baizerman's reputation was associated with the very unusual effects he achieved through a personal technique, which he invented and was later adopted by some abstract sculptors. This consisted in the direct hammering of a sheet of copper hung from the ceiling of his studio. He created in it his most characteristic works, monumental nudes (really bas-reliefs), whose somewhat traditional character was enlivened by unevennesses and indentations that produced a vibrant luminosity on the surface of the metal. In this way form, material and atmospheric light became one. Baizerman evolved this technique after ten years spent in making small bronzes. Although Baizerman's technique confined him to the human figure, he revived through it the harmonies of a classical ideal. R. G.

BAKIĆ Vojin. Born 1915, Bjelovar, Yugoslavia. He studied sculpture at the Zagreb Academy from 1934 to 1938. After the liberation, various prizes were awarded him by the People's Republic of Yugoslavia and he was represented at several international exhibitions, including the Biennials of Venice (1950 and 1956), Middelheim, Antwerp (1963) and the open-air sculpture exhibition at the Musée Rodin, Paris (1961). He has had one-

Bakic.
Sculpture IV.
Bronze.

Barlach

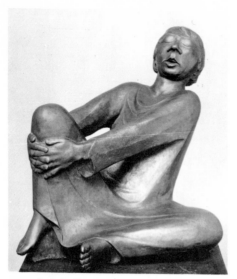

Barlach. Man singing. 1928-1930. Bronze.

BARLACH Ernst (Wedel, Holstein, 1870 – Rostock, 1938). He trained at the Hamburg School of Arts and Crafts (1888–1891), then at the Dresden Academy (1891–1895), before he went to Paris for a year and attended the Académie Julian. From 1898 to 1902, he worked as a draughtsman for the review *Jugend*, then from 1907 to 1908 for *Simplizissimus*. In 1919, he was elected a member of the Berlin Academy, but the Nazis considered him a supporter of 'degenerate art' and, in 1938, 381 of his works were confiscated and banned from public collections. He died the same year. Barlach can be more justly described as an Expressionist than even the painters of the Brücke group. The cube is the characteristic shape of his style, which hardly changed once he had formed it. A single, vitalising movement sweeps over each sculpture and integrates it. The statues of the *Avenger* (1914) and the *Fugitive* (1920), their heavy masses uplifted, as it were, by a superhuman force, are examples of this. Another characteristic of his art was the interest he always had for groups in which the figures merge as a whole to express the same unifying idea (*Women Singing* 1911, *Abandoned* 1913, *Death* 1925). His Monument to the Dead at Güstrow (now destroyed) was a daring conception, the main feature of which was an outstretched figure hovering, like the spirit of the dead, over the tombs. A variant of this figure, caste by Barlach himself, can be seen in a chapel of the Gothic church of St. Anthony in Cologne. In 1934 the collector, Reemtsma, encouraged Barlach to finish the *Frieze of Listeners*, a screen of nine oak figures set in a semi-circle against a wall, originally intended as a commemorative monument to Beethoven. Barlach owed his popularity to his sculpture and graphic works, although his importance as a dramatist of Expressionist theatre is considerable.

J. R.

BASALDELLA Dino. Born 1909, Udine, Italy. He is the eldest brother of the painter Afro and the sculptor Mirko, both of whom are known by their first names. Basaldella did his training at Venice and Florence and his early works, which were bold and touched with a sort of romanticism, already showed quite clearly his desire to break away from the current academicism; in the *Portrait of Sandro Filipponi*, for example, after a provocative rejection of form, he tried to create chromatic effects. He very soon went on from here to extraordinary experimental work like the *Squale* in wood, exhibited at the Venice Biennale in 1936. He was invited to send work to the international exhibition for the Bronzetto prize at Padua in 1959 and 1963 and in between showed his work in Rome at the Galleria La Tartaruga (1960) and in New York at the Catherine Viviano Gallery (1961). In 1964, at the Venice Biennale, a large room was reserved for his work. His rather late conversion to abstraction about 1950 indicates that his work only changed after mature consideration. His most recent sculptures, the *Omega Dial*, the *Ear of Dionysos* (1963) and *El Partidor* (1964), are notable examples of how he has explored all the possibilities of wear and alteration in material: rust and inlay, polishing, burnishing and colours applied directly to surfaces, which were remarkably effective in making forms, which were already eminently esoteric and emblematic, even more powerfully expressive. G. C.

BASALDELLA Mirko. *See* Mirko.

BAUM Otto. Born 1900, Leonberg, Wurtemberg. His father was a farmer. From 1924 to 1927 and from 1930 to 1933, he trained at the Stuttgart Academy. During the Nazi régime, he worked on his own at Stuttgart. He was appointed to a teaching post at the Academy in 1946 and took part in several German and international exhibitions. A retrospective exhibition of his work was organised by Günther Francke at Munich in 1947. Otto Baum developed independently. Without ever having studied abroad, he knew the work of Brancusi and Arp, whom he admired. His sculpture was distinguished from the beginning by its weight and massiveness, which was relieved by flexible modelling. For instance, he has done reliefs in wood in which the subjects are hardly raised from the surface or merge into it. Otto Baum is always searching for simplification and concentration, whether he is modelling the figure of a woman or an animal. He tries above all to maintain the continuity of the mass. In his animal sculpture, after 1945, like Mataré, the German sculptor who was his contemporary, he aimed at an extreme

attenuation of form with hardly any perforation of the compact mass. In recent years, Baum has evolved towards an increasing freedom of representation. There are the same heavy, sturdy, thick-set forms, but their contours are rounded. Several of them are like the tools of an extinct race of giants, like clubs, hammers or axes, which, even in their formalised rhythms, belong to the archetypal forms invented by man. J. R.

BEAUDIN André. Born 1895, Mennecy, Seine-et-Oise. Between 1911 and 1915, he studied painting at the École des Arts Décoratifs in Paris. He was to remain, in fact, all his life more a painter than a sculptor and it was only in 1930 that he took up modelling in plaster or clay for casting in bronze. His style remained profoundly affected by the aesthetic principles of Cubism. Beaudin took part regularly in the most important art exhibitions in France and abroad. In 1962, he was awarded the Grand Prix National des Arts. The most striking characteristic, perhaps, of his sculpture is that its development has always followed his painting so closely that Jacques Lassaigne could say of his work that it was 'with its superposed planes like the concrete images of the compositions in his painting'. In fact, the strict interdependence of volumes in simple, bare patterns, in his sculpture, correspond to the logical and transparent superimposi-

Beaudin. Wedding bird. 1953. Bronze.

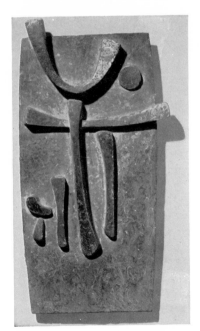

Baum. Greeting. 1956. Bronze.

tion of coloured planes in his painting. In the one as in the other, the art is restrained, a little severe, and, in short, very classic. Notable among his works is a fine portrait of *Paul Éluard*, completed in 1947. The artist exhibits regularly at the Galerie Louise Leiris, in Paris. D. C.

BELLING Rudolf. Born 1886, Berlin. Belling belonged to the Sturm circle before the First World War and, in 1918, was one of the founders of the Novembergruppe. In 1924, the Nationalgalerie of Berlin held a large retrospective exhibition of his work. When Hitler came to power in 1933, he emigrated to Turkey, where he taught at the Istanbul Academy. Rudolf Belling, with Hermann Obrist and Archipenko (when he moved to Berlin), was one of the pioneers of abstract sculpture in Germany. The problem of empty spaces, which were termed 'dead form' in academic circles, led him early to search for a non-figurative sculpture in which he could express more clearly the relation between volume and space. In the group called *Combat* (1916), which represented two, struggling, human bodies already drew the forms into a self-contained sculptural composition in which the voids were an integral part of the work. In an even more radical way, in 1919, he made *Threefold Harmony* a completely

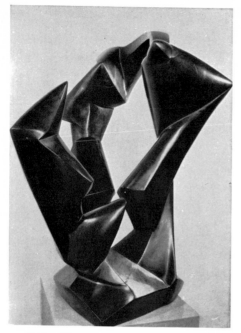

Belling. Triple harmony. 1919. Polished wood.

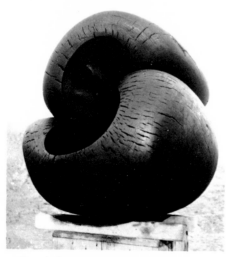

Benazzi. Composition N° 1414. 1966. Eucalyptus.

non-figurative sculpture, a pure expression of force. There is the same boldness in *Erotic* of 1920, the *Organic Forms* of 1921 and *Brass Head* of 1923. Unfortunately, Belling subsequently reverted to a more conventional art. It should not be forgotten, however, that in his time he had anticipated the problem of solid and hollow forms long before Henry Moore, at the second stage of the general development of modern art, made it a commonplace of sculpture. J. R.

BENAZZI Raffael. Born 1933, Rapperswil, Switzerland. He did his training in the studios of various Swiss artists, but there is no doubt that his friendship with the painter Julius Bissier from 1954 to 1965 made the deepest impression on him. He began using metal in 1955, without giving up stone and wood, which he preferred as mediums. Benazzi, in fact, felt a need for a living material, which resisted him and whose texture had been marked by life. Since 1957, he has held several exhibitions of his work in Switzerland and contributed to the great shows of European sculpture. He was awarded the Jean Arp Prize in 1966. Benazzi practises direct carving of marble and alabaster; eucalyptus trunks are a particularly congenial material, which he carves into free and powerfully sensuous forms, which are true to the character and spontaneous life of the original wood and, in their moving conciseness, are a triumphant homage to the soaring spirit that informs everything fashioned by nature. The smooth, delicate sheath enveloping his volumes, imposes a final order that the accidents of growth have only suggested. His sculptures have no history; they have the certitude of primitive idols. They are often split or hollowed out and invite the eye to penetrate the mystery created by the shadow within; and the touch of the hand follows the eye. Like Étienne-Martin, but in his own idiom, Benazzi offers us 'dwellings' as attractive and satisfying to the mind as to the senses. J.-L. D.

BÉOTHY Étienne (Heves, Hungary, 1897 — Paris, 1961). When Béothy was twenty-one, he went to the School of Architecture in Budapest, where he became friendly with Moholy-Nagy. Then, in 1920, he joined the School of Fine Arts to study sculpture and stayed there for four years. In 1925, he went to live in Paris. His first one-man exhibition was held in 1928 at the 'Sacre du Printemps'. His first works, produced about 1919, were inspired by architectural themes and based on Constructivist principles. As a result of the strictly calculated proportions, they did not escape a certain rigidity. As soon as he settled in Paris, his style became more flexible, his forms, incurved and hollowed, acquired a more human appearance. A new theme appeared, the couple, but this development did not mean that the artist had been converted to a narrow, representational art. As a matter of fact, the human form only interested him in so far as it

lends itself to certain significant distortions through which Béothy could express his emotion as well as assert the necessity for an exclusively plastic idiom. At the same time, his artistic vocabulary grew richer; the appearance of hollow forms naturally created a whole pattern of contrasting convexes and reliefs. About 1929, a new tendency showed in his work; he undertook a series of sculptures called *Parables,* which were remarkable for the extreme refinement of their upthrusting volumes and elegant curves. Wood then became his favourite material. It was in this material that he carved his sculpto-paintings of 1931–1932.

Béothy was a prominent personality in avant-garde movements; he was a founder member of the Abstraction-Création group, its vice-president for four years and organised the first exhibition of abstract art to be held in Budapest (1938), when he delivered an important lecture on the 'Problem of Creation'. The following year he published in Paris his book, *The Golden Series,* a successful attempt to investigate and throw light on the mathematical basis of every work of art. He also tried to elucidate in it the relations of music and the plastic arts. A profounder appreciation of this relationship and a thorough understanding of them became the foundation of Béothy's future work. The choice of titles alone emphasised his intentions *Solfeggio, Cross Rhythms, Notes,* etc.

In 1946, Béothy and a few friends founded the Salon des Réalités Nouvelles. Following a one-man exhibition at the Galerie Denise René in 1947, an important retrospective exhibition of his work took place the following year at the Galerie Maeght. In 1951, he edited with Fernand Léger and Le Corbusier the first number of *Formes et Vie* and then, shortly after, he founded, with André Bloc and Del Marie, the group, Espace. Among his other activities, he was keenly interested in the problem of a synthesis of the plastic arts, painting, architecture, sculpture, through functional forms. His last works from which every suggestion of the human form has disappeared are compelling in their serenity and a severity that is tempered by a sort of tenderness. Indeed, however great and varied may appear the qualities of this art, the most important of them all is that technical perfection is never valued for itself, but as a means of pursuing to the utmost a very human desire for expression. D.C.

BERROCAL Miguel. Born 1933, Algaidas, Spain. He trained at the Academy of San Fernando in Madrid and the School of Arts and Crafts. In 1952, he went to live in Italy. A French government scholarship enabled him to visit Paris for the first time in 1955. His first sculptures of wrought and hammered iron were an agglomeration of rivetted and soldered components. In 1958, this kind of sculpture developed into compositions with mobile elements, which were simply juxtaposed at first, then gradually interpenetrated and fitted enigmatically into

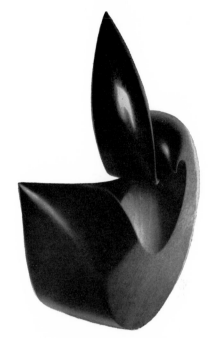

Béothy. The sea : opus 67. Mobile. 1934.
Brazilian rosewood. Adler collection, Geneva.

each other. His first sculpture that could be dismantled was produced in 1960, the *Jewel,* a construction formed of six detachable pieces, which could be assembled in such a way that, once the last was set in place, the whole was immovably locked. Since then, Berrocal has increased the constructive complexity of each of his works; *Caryatid* of 1966 has twenty-two components and *Adamo II* (1966) has forty-one. Most of these elements are invisible from the outside, which has a smooth surface. The rods, stems and other technical pieces are fitted with such complexity and tightness that they are only reassembled with the greatest difficulty once they are dismantled. This is why some of his statues, like *Torso of a General II* are provided with a book of instructions and an account of their composition. The male torsos, like *David* (1966), have rather summary, abstract forms, but the female figures are gracious and elegant, with subtle modulations of forms and line. *Cleopatra,* however, is rather disconcerting, because there is a casket, hidden beneath her legs, which is full of chains for adorning her face. The polished bronze figure has all the appearance of a precious object, which raises doubts about its essentially plastic qualities. This is only one of the contradictions of Berrocal's sculpture in which the distortions help to stress the original beauty of the body

Bertoia

and in which the clock mechanism can set off some disturbing metamorphoses. 'Multiples' (copies) have often been made in forged and soldered steel from the original; the original of *Romeo and Juliet*, constructed of sixteen removable components, was reproduced, for instance, in an edition of 2000 in polished brass. Since his first exhibition at the Galleria La Medusa, Rome, in 1958, Berrocal has held several others in Paris (Galerie Kriegel), New York (Albert Loeb Gallery), London (Gimpel Fils), Germany and Switzerland. He was represented at the Kassel Documenta, the Venice Biennale of 1964, and the Biennials of Middelheim (1965) and Paris, where he was awarded the sculpture prize in 1966.
H. W.

BERTOIA Harry. Born 1915, San Lorenzo, Udine, Italy. He emigrated to the United States in 1930. He won a scholarship to the Cranbrook Academy of Art, Michigan, in 1937, where he later taught metal-working techniques. Since 1959, he has held several one-man shows at the Staempfli Gallery, New York. A number of commissions include a mural for Dulles International Airport, Washington (1963), a mural for North-western National Life Insurance Building, Minneapolis (1964), and a fountain for the Philadelphia Civic Center. Bertoia started doing sculpture while on the designing staff of

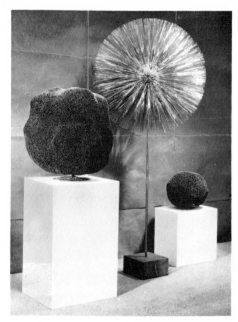

Bertoia. Sculptures: project for a fountain. 1965. Stainless steel.

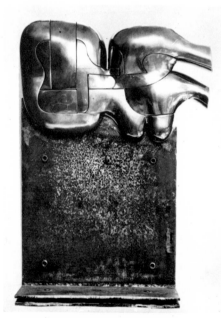

Berrocal. Carmen. 1966-1967. Iron.

Knoll Associates. For the last fifteen years he has concentrated on his own sculpture. He works with brass, bronze, stainless steel and nickel rods, sometimes short and stiff, with a porcupine-like quality, sometimes long and spreading from a tight base in fountain-like forms. Many of them are so anchored that they swing in the wind, or under the touch of the hand, and create rustling sounds that seem to rise and fall, approach and recede into the distance. These are sculptures that deliberately invite the spectator to disturb them. Colour, produced in the casting of the metal and so integral with the material, also plays an important part.
R. G.

BERTONI Wander. Born 1925, Codisotto, Italy. He is living now in Vienna, where he was deported as a foreign worker. There he was associated with the artistic circles that were in revolt against the official culture of the day. In 1945, he was able to begin studying sculpture at the Viennese Art Academy in Wotruba's studio. He was a foundation member of the Art Club and took part in the exhibitions it organised in Austria and abroad, then at the II Biennial of São Paulo (1953), the Venice Biennale (1954, 1956, 1966), the Brussels International Exhibition (1958) and the Biennial of Middelheim (1957 and 1959). In his first sandstone and limestone sculptures, there is a characteristic equilibrium in the composition of the

human figures, but from 1948 the modelling was of primary importance and gradually all details became, as it were, absorbed into the form until about 1951–1952, when his sculpture became completely abstract. His works were generally in polished metal. During the period, 1954–1955, the artist worked at an *Imaginary Alphabet* in monochrome and polychrome wood, marble and bronze, which was a sort of transposition into space of the letters of the alphabet and their sounds. After *Totems* of 1956, the following year saw the creation of seventeen variations on the theme *Ecclesia*, which, far from being exclusively Christian, included symbols of other religions as well. In spite of certain deviations, the direction of Bertoni's development for the moment, at least, is towards forms that are free, but close to nature, so that a certain affinity is evident between the feminine figures of 1946–1947 and the *Plant Compositions* of 1958–1959 and his recent works. J. L.

BESNER J. Jacques. Born 1919, Vaudreuil, Quebec. He obtained a teaching diploma before he began his artistic training at the International School of Architecture. From 1963 to 1964, he lived in Europe. While

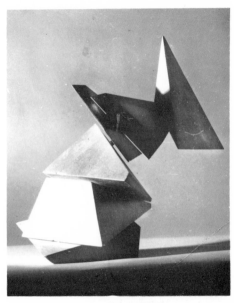

Besner. Pivotal. Wood.

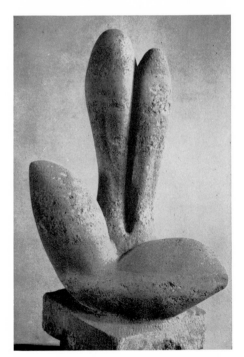

Bertoni. Plant composition II. 1958. Sandstone.

practising as an architect, he also did some work in designing and advertising. Since 1968, he has been director of the 'La Sauvegarde', an art centre in Montreal. Besner is a Constructivist; his 'machine-sculptures' have no utilitarian functions, but they retain what he considers are the positive and beneficial aspects of real machines, and the characteristics that stimulate the intelligence and rouse emotion. He makes use of various physical phenomena: magnetism, hydraulics, optics, electronics, mechanics, expanding gases, condensing steam, and chemical reactions in transparent retorts. With his *Pivotals*, notably, he invites the observer to take part in the creation of the work of art. G. V.

BILL Max. Born 1908, Winterthur, Switzerland. After studying at the School of Arts and Crafts in Zürich, Max Bill worked as a pupil at the Dessau Bauhaus (1927 to 1929). All his subsequent activities were influenced by the training he received there; besides a sound knowledge of materials, its influence made him a life-long advocate of the idea of a synthesis of the arts centred on architecture, which would determine, not only the style of painting and sculpture, but also of all the objects of daily life as well. With this training behind him, Bill settled in Zürich, in 1930, as an architect and from then on extended his activity also to painting, sculpture, typography and publicity. As a theorist, he is responsible for

Bill

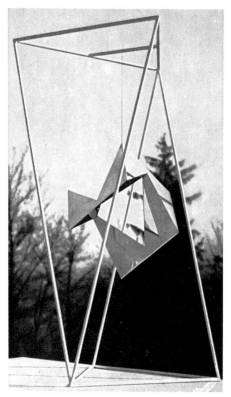

Bill. Construction with suspended cube. 1935-1936.
Iron and brass.

a number of essays on architecture as well as on painting, notably on Kandinsky and Mondrian. He also drew up plans for the improvement of industrial design. But, although he adhered to the strictest rules of measurement and proportion in applied art, he gave free play to his gifts of invention, when he was concerned with original creation. From the beginning his experiments aimed at placing plastic works in space, so that, by freeing them from their frontal, static quality, they gained visual mobility. In a construction of 1934, he used a light scaffolding of iron rods to arrange two elements, one a sphere, the other a plane, in such a way that light and space could freely circulate around the open-work sculpture. The following year, he worked at a *Construction with Suspended Cube*, where he interrelated and contrasted the exterior and interior contours. Later, triangles and squares were built into aerial sculpture, sometimes piled up into a broken column, sometimes hung in bold equilibrium,

as in *Construction with Thirty Identical Elements* (1938 to 1939). Meanwhile, he produced a preliminary model for *Unending Band*, which, after several changes, acquired its final form in 1953. Here, Max Bill grappled with the problem of perpetual movement in sculpture, which was to remain his main preoccupation. It is this theme that is found again in *Rhythms in Space* (1947–1948), which, seen from the front, contains a symmetrical pattern, but from either side merges into an endless maze. Most of his constructions, intended for final execution in bronze or marble, are on a large scale and are seen to great advantage in the open air. However, the peculiar qualities of his sculpture, which depend on the extreme precision of its components, can be appreciated in a more concentrated way in the small models in bronze or copper. Bill harmonises them with such sensitiveness that we can almost catch the timbre of the metal and the vibration of the incisive contours. Their names, which are simply mathematical statements *(Double Surface with Eight Short Edges and Eight Long Edges, Double Surface, Based on a Circular Plane)*, are sufficient indication of the importance he places on exact measurement in his conceptions. As a matter of fact, the mathematical formulas only serve to give a soundly constructed basis to works in which the inherent movement is prolonged beyond the limits of the forms; for example, *Infinite Surface in the Form of a Column*, a slender, brass strip, rising up like a revolving axis; or, even better, *Transition*, in which the surfaces slope from the outside and cross in the aperture of a metal square.

Max Bill set himself the same problems in painting as in sculpture and his attention was absorbed by each in turn. In 1965, he invented a series of variations on the theme of the sphere. Among these was the *Pyramid in the Form of an Eighth of a Sphere*, in black granite from Sweden, and the *Family of Five Semi-spheres* for the Institute of Mathematics of Karlsruhe University, each of which had the same volume but a different form determined by its particular, intersecting lines. The *Column of the Wind*, which he erected in front of the Swiss Pavilion at the World Exhibition at Montreal (1967), was in aluminium, 46 ft high, and consisted of cylindrical elements superimposed in a most vigorous rhythm. A sculpture of 1968, in which double bars of chrome aluminium intersected in a diagonal to form the *Nucleus*, the geometric locus of structural forces, is a good example of the skilful complexity that Max Bill could produce from the simplest elements.

He was awarded the first prize for sculpture at the São Paulo Biennial in 1951 and the art prize of the City of Zürich in 1968. From 1951 to 1956, he was director of the Hochschule für Gestaltung at Ulm, whose buildings were constructed from his designs. He has organised several exhibitions, including Art Concret at Basel (1944) and at Zürich (1960). At the Exposition Nationale Suisse of 1964, at Lausanne, he supervised the Bilden und Gestalten section and inaugurated the art course. Several exhibitions of his work have been organised by museums

Bloc

(São Paulo, 1950; Ulm, 1956; Munich, Duisburg, Leverkusen, 1959; Stuttgart, Winterthur, 1960; Berne, The Hague, Düsseldorf, Zürich, 1968). He has been represented at the major international exhibitions. Nearly the whole of the Swiss Pavilion at the Venice Biennale of 1968 was devoted to his work. H.W.

BLASZKO Martin. Born 1920, Berlin. After his training in drawing and painting under Henry Barcynsky in Poland and Jankel Adler in Danzig, Blaszko went to Paris, where he received advice from Chagall, then went on to Buenos Aires in 1939, where he finally settled. In 1946, he joined Arden-Quin and Kosice in founding the Madi movement. His works consist mainly of wooden structures, painted white, with a Pythagorean harmony and purity. He also uses plaster. Blaszko has stated his aims in the following words: 'Pure rhythm is the starting point of my sculptures. I set antagonistic forces in movement between two opposite poles. The resulting forms conform strictly to the golden number. In this way, the work retains its character of continuous movement. When I introduce space within a structure, the golden number prevents arbitrary relationships from being set up between rhythm, form and space.' J.A.G.M.

Bloc. Sculpture in brass. 1959.

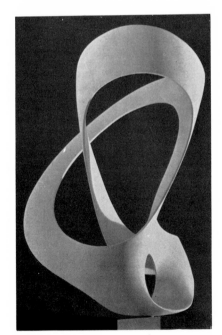

Bill. Tripartite unity. 1947-1948. Stainless steel. Museum of Modern Art, São Paulo.

BLOC André (Algiers, 1896 — New Delhi, 1966). Bloc began his career as an enterprising editor of a number of technical reviews and, in 1930, founded his own avantgarde periodical, *Architecture d'aujourd'hui.* In 1940, he took refuge at Biot in the south of France and, in this country of pottery makers, he began his first sculptures in clay. When he returned to Paris in 1945, he gave up using terracotta for cement. Two years later, he visited Brancusi and produced his first abstract sculpture, a *Signal,* in 1949. After this, he contributed regularly to the principal Parisian Salons. After starting the review, *Art d'Aujourd'hui,* in 1951, he founded the group, Espace, and became its leader. An ardent theorist and tireless innovator, André Bloc endeavoured to create a sort of synthesis between the different plastic arts, the fundamental problem being their integration in architecture. His love of experiment led him to use new materials like brass and iron, then about 1953, he returned to concrete. Afterwards he worked in plexiglas, metallised plastic, bent and folded sheet-metal and, finally, marble, which he combined in different coloured blocks. His inexhaustible curiosity made him try his hand at painting,

Boccioni

stained glass, tapestry and mosaic. In spite of the variety of his ventures, his work maintains a remarkable unity. Although the sculptures of his first abstract period were sometimes rather rigidly conceived, his last works have a freer expression and a refined sensuality like an intimate emotion breaking through the surface. His 'sculpture dwellings' and the monumental *Brasilia*, commissioned for the new capital of Brazil, are notable among his major works. D. C.

BOCCIONI Umberto (Reggio di Calabria, 1882 – Sorte, near Verona, 1916). Painter and sculptor. After meeting Marinetti in Milan in 1908, he signed with Balla, Severini, Russolo and Carrà the Manifesto of Futurist Painters (February 1910). He was the real theorist of the group in everything to do with the plastic arts and, in April 1912, he published his own *Technical Manifesto of Futurist Sculpture* and, in March 1914, a work called *Futurist Sculpto-Painting*. His first sculptures, which date from 1911, were reflective and, at the same time, spontaneous. His purpose was to create forms in space, on the principle of 'interpenetrating planes' and, in this way, confer on them the freedom of objects in move-

Boccioni. Unique forms of continuity in space.
1913. Bronze.

ments, bare shapes without any Impressionistic sensitiveness of modelling. At Paris, where he made frequent visits, he was acquainted with the Cubists and was particularly friendly with the sculptors, Archipenko, Brancusi, Agero and Duchamp-Villon. His first exhibition of sculpture took place in 1913 in a gallery of the Rue La Boétie. The evening of the opening day, the public created a disturbance and reacted so violently that one of the works in plaster was broken. The same exhibition was later transferred to Rome to the Sprovieri Gallery, Via del Tritone, which was to become the permanent gallery of Futurism. Each of these exhibitions was followed by lectures and discussions given by Marinetti, Boccioni and other artists of the group. He was called up in July 1916 and died soon afterwards from injuries received, when he fell off his horse during manœuvres.

His output as a sculptor was less considerable than as a painter, but it was in the former that his imagination was most daring. In fact, unlike his painting in which neo-Impressionist influences lingered, his sculpture appeared from the first compelling and dynamic. His manifesto on sculpture reveals a deeper critical acumen than his writings on painting. Although he was indebted to Medardo Rosso, he went further and felt the need to emphasise that 'sculpture should make objects vital by expressing their extension in space systematically in tangible, plastic terms'. His first sculptures had an obvious connection with his painting and were often preceded by a series of detailed drawings and studies; *Portrait of his Mother* (1911), for example, preceded by the series called *Antigrazioso*. Realistic truth is observed in them, but the form already showed that he was as much concerned with the problems of space and lines of force as with the model herself. It was by further experiments that Boccioni came to establish in his last works an entirely fresh relation between matter and space, a relation that he described himself by the notion of 'form-force'. These principles gave his works an absolute artistic value; *Unique Forms of Continuity in Space* (1913) and *Development of a Bottle in Space* (1913) are excellent examples. The history of Boccioni's sculptures is rather dramatic. They were exhibited at the large posthumous exhibition, 1916–1917, in the Central Art Gallery of the Cova Palace in Milan, and then left in an open courtyard, where most of the plaster works were ruined. Apart from the unique version of *Horse-House* in wood and cardboard (Peggy Guggenheim collection, Venice) only a few examples are known, but several bronze casts had been made of them. G. C.

BODMER Walter. Born 1903, Basel. Painting, sculpture and relief are inseparable in Bodmer's work, but on leaving the Basel School of Arts and Crafts, he began his career as a painter. His canvases were filled with strange stag-beetles, half bird, half machine, or displayed 'architectural visions', with transparent frames, but with staircases rising into a void. Then in 1936, Bodmer removed

Bodmer. Sculpture
in iron. 1968-1969.

Bodmer. Sculpture
in iron. 1968-1969.

his drawings from their background of painted canvas and modelled them in iron wire, so creating his first pictures in relief. During the same period, he did three-dimensional sculptures of wire welded roughly together. Some years later, Bodmer turned towards more geometric forms. A few years later, his compositions became more restrained, more calculated, more geometric especially and the interest lay entirely in the clear arrangement of the various elements and the precision of their spatial relationships. The mounting of the reliefs, which till then, had been deliberately casual, was now faultlessly finished. Pieces of sheet-metal were inserted in the restless lines that intercrossed, knotted and then separated. Bodmer also tried his hand at suspended sculptures from which iron arms stretched out in all directions. In other works, placed on the ground, the dynamism seemed to be concentrated at the intersection of the moving forces. In 1965, a fresh development was noticeable, particularly in his reliefs; the graphic elements became rarer, even disappeared altogether and were replaced by coloured, metal sheets, in the shape of branches, which seemed blown by every breath of wind, or clung to the wall, as they swung rhythmically on ball-bearings. One sculpture of the same period was like a bare tree that had been changed into a distress signal. Bodmer is not only a skilful and delicate technician, he is also eager to surprise the visible behind the invisible and give every freedom in his work to the incalculable and the unexpected. Besides one-man shows in Germany and Switzerland, notably at the Kunsthalle of Basel (1952 and 1964), he has been represented at several international exhibitions: the Biennials of Venice in 1956 and Middelheim in 1957; the Kassel Documenta in 1959; the exhibition of Swiss artists at the Musée Rodin, Paris, in 1963. In 1968, he was awarded the art prize of the City of Basel. H.W.

BOILEAU Martine. Born 1923, Neuilly-sur-Seine. She trained in the United States at the Art Students' League of New York under William Zorach, then in Paris at the Académie de la Grande-Chaumière, where Zadkine taught her, but it was her meeting with Germaine Richier in 1952 that was the decisive event of her development. In 1957, she gave up using traditional materials: clay, plaster or stone for industrial wax, which is worked while it is hot. The responsive, exact, instantaneous and malleable, qualities of wax are ideally suited to her temperament. Talking about her experiments, she said, 'I have always been interested in the representation of movement, the dynamic of crowds and human relations. I began with an almost realistic interpretation, but my idiom has become more abstract. Throughout this evolution, however, one overriding consideration has remained, to find what it is that makes an object mysteriously human, let us say, more completely itself.' After contributing to several group shows, she exhibited alone in Paris in 1960 at the Galerie Jeanne Castel, and again in 1962. About this time, she was drawn through the object to the expressive potentialities of non-representational forms. Her source of inspiration changed from human beings to the world of plants and minerals. She explored simultaneously the problems created by the use of colour and invented a new technique for working plaster (1964–1967) and then adopted the processes proper to coloured polyester, direct assembly and moulding. D.C.

Bontecou. Untitled. 1959-1960. Metal and canvas.

national shows: Kunst-Licht-Kunst (1966) at the Stedelijk van Abbemuseum at Eindhoven, Directions in Kinetic Sculpture (1966) at Berkeley University in California and Cinetisme, Spectacle, Environnement (1968) at the Maison de la Culture in Grenoble for which he made programmed environments. Boriani is a kinetic sculptor. In 1961, he made revolving plates on which metallic dust formed into patterns, or more precisely, evanescent organisms, as it was alternately attracted and repelled by magnets. Then he constructed three-dimensional modulators, consisting of concentric cubes revolving at different speeds, and environments, which depended almost entirely on the play of light. The aim of these works was to produce a dynamic, irregular entity, depending, on the one hand, on the developments and variations inherent in the works themselves and, on the other, on the conscious or unconscious perception of the observer. According to Boriani, kinetic art leads to programming and the control of aesthetic phenomena and opens perspectives onto cybernetics, electronics and modern science in general. F.P.

BONTECOU Lee. Born 1931, Providence, Rhode Island, United States. She trained at the Art Students' League in New York and made her début with bronze sculptures in the shape of birds, which were exhibited at Gallery G, New York, in 1959. The same year, she began making constructions with bits of canvas stretched and sewn over an armature of wires. The same process was used for her reliefs with convex forms, planned in circular movements around elliptical or round craters. Then the framework became more architectural, an order could be detected in which the voids looked like sinister eyes and the zip-fasteners suggested mouths with clenched teeth. These ordinary, but carefully worked materials were blended with a mixture of eroticism and exorcism to produce works of a demoniac character. In recent years, Lee Bontecou has varied her materials with plain and black textiles, printed cottons and pack-cloths with their inscriptions, which give her works a more colourful appearance. Sometimes she includes materials with hard stripes. Her drawings (pencil on paper, or carbon on muslin) are detailed studies for her strange sculptures: shapes of eyes or wings, mechanical components like cogs and threads of screws, insects and lobsters. Besides several one-man shows in New York (Leo Castelli Gallery, 1960, 1962 and 1966) and in Paris (Galerie Ileana Sonnabend, 1965), she was represented notably at the Spoleto Festival (1958) and the São Paulo Biennial (1960). H.W.

BORIANI Davide. Born 1936, Milan. He trained at the Brera Academy, Milan. He was one of the foundation members of the T Group in Milan in 1959. Besides one-man exhibitions in Milan, he was represented at inter-

BOTO Martha. Born 1925, Buenos Aires. She trained at the Buenos Aires Academy and, in 1956, became one of the foundation members of the group of non-figurative

Boriani. Stroboscopic space. 1966-1967.
Steel, wood, mirrors and projected light.

Boto. Chromatic dilatations. 1967. Detail.

BOURDELLE Antoine (Montauban, 1861 – Le Vési-
net, 1929). Bourdelle is an outstanding example of the
humble craftsman who rose to become a great artist. His
father, who was a cabinet-maker, taught him a respect
for fine workmanship. In 1876, he was awarded a grant,
which enabled him to attend classes at the École des
Beaux-Arts in Toulouse. In 1884, he won a competitive
place at the École des Beaux-Arts in Paris, where he
worked in Falguière's studio. There he learnt how neces-
sary it was to acquire technical knowledge before trying
to develop an individual style. An even stronger influence
on him was Rodin, who took him on as his assistant in
1893. However severe a limitation this may have been, it
probably strengthened his personality in the end. Bour-
delle had the patience and pertinacity of a craftsman, who
can only express himself through his work and can see
his own thoughts, after the long period of gestation,
reflected in it. This attitude was more than a rational
conception, it was a way of life. Yet, in spite of the
obvious certainties it implies, Bourdelle's art was marked
by an unending conflict between the spirit and matter in
which the spirit was always victorious, mainly because
he refused to see in techniques any more than a means of
achieving a unique expression, of creating poetry, that
half-divine presence in man of which the gods are only
a magnified image.

Argentinian artists. In 1959, she went to live in Paris with
her husband, the sculptor Gregorio Vardanega, with
whom she exhibited at the Maison des Beaux-Arts in
1964 and the Galerie Denise René in 1969. She also took
part in the exhibition 'Lumière et Mouvement' (1967) at
the Musée d'Art Moderne de la Ville de Paris. Martha
Boto passed through a phase of strict constructivism
before the 'chromokineticism' of her present sculpture.
This is the term that she herself applies to her luminous,
coloured works in movement. As early as 1957, when she
was still in Argentina, she was interested in the effects of
transparency and luminosity, which she investigated in
plexiglas works vitalised from within with units of liquid
colour. The tendency of her later work is to arrange
coloured elements in multipliable structures, which can
be juxtaposed or superimposed in static or mobile reliefs.
Infinite variations of light and colour are produced by
luminous, coloured projections and reflections acting at
different speeds on transparent materials (plastic sub-
stances), which are coated with luminous paint them-
selves. The movement is sometimes extremely rapid and
the effects intense. As the source of the light is rotating
constantly, and the light alternately appears and dis-
appears, the observer has a continuous impression of
contraction and expansion, diffusion and intensification
of the optical rays. F. P.

Bourdelle. Liberty. Study for the Monument
to General Alvear. Musée Bourdelle, Paris.

Bourgeois

Because he lived his whole life in the service of his art, every work became an essential act for Bourdelle; an open hand or a contracted foot expressed as much as the whole sculpture. More than any other artist, Bourdelle felt the need, after Rodin's explosive art, to rediscover a monumental style, rigorously controlled by the organisation of masses, by the denseness of its volumes and by an almost linear geometry which, without being as strict as that of Cubism, forced movement to be contained within preconceived limits. Nothing illustrates his aims better than the famous statue of *Hercules*, which he sent to the Salon in 1910. It is an undoubted masterpiece with the emotive power of its violence, the severity of its style and its inventiveness, which dismisses any ideas of slavish realism. Bourdelle had found his idiom in this work and, from that moment, he never failed to create sculpture of a very high order. His bas-reliefs for the Théâtre des Champs-Élysées (1912–1913) were another landmark in his career, because of the way the sculpture is integrated with the architecture and enhances it. These qualities are again harmoniously embodied in the impressive *Memorial to General Alvear* (1912–1923, Buenos Aires), an equestrian statue of Argentina's liberator, surrounded by four, large symbolic figures: Liberty, Strength, Victory and Eloquence.

It is impossible to class Bourdelle either with the realists on the grounds that he made several lifelike portraits, or with the traditionalists on the grounds that he often made use of allegory. Allegory was not simply a form of narrative art for him: it measured the breadth of his thought and was the indispensable element that inspired gestures and expressions. Although all this seems to have become rather alien from sculpture today, Bourdelle remains nonetheless one of the greatest forerunners of modern art.　　　　R. C.

BOURGEOIS Louise. Born 1911, Paris. After attending the Lycée Fénelon and the Sorbonne, she studied at the École des Beaux-Arts and then at the Académie Ranson under Bissière (1935–1936). Subsequently she worked with Robert Wlerick and Fernand Léger. She has lived in New York since 1938. The first exhibition devoted entirely to her works was held in 1945 at the Berta Schaefer Gallery, New York. Since then she has exhibited at the Norlyst Gallery (1947), the Peridot Gallery (1949, 1950 and 1953), the Allan Frumkin Gallery, Chicago (1953), the Egan Gallery, New York (1955), the White Art Museum of Cornell University (1959), and the Stable Gallery (1964). Her work is represented in the Museum of Modern Art, New York, the Whitney Museum of American Art, and the Rhode Island School of Design, Providence.

Louise Bourgeois's sculpture unites repose and tension: repose and containment in the individual forms, tension and magnetic pull in relation to their ambience and to each other. The elongated, painted wood forms, reduced to a deceptive simplicity, sometimes angular,

more usually fluid in shape, are isolated, self-aware Neither abstract nor symbolic in the usual sense, but human in scale and rising upright from the ground without bases, they suggest the human figure. Alone, or in movable pairs and groups, they contain and concentrate a vision of individual isolation within a network of relationships. Technically apparently modest, psychologically apparently solipsistic, they are presences that demand and hold the attention, creating a mysterious relation among each other and with the beholder: an ambiguity of attraction and alienation. Neutral and unified in colour (most often black or white), and entirely mat in surface, they disdain gesture and absorb the gaze. They deny, or rather ignore, the romance of materials and refuse the histrionics of technique. Their appearance in 1950 was an influential counter-statement to the methodology of welded metal. The rigidity and withdrawal of the earlier sculptures, foreshadowed by a book of engravings, *He Disappeared into Complete Silence*, evolved into gentler and softer shapes, gathered together or created as close-huddling groups, where warmth and intimacy have conquered separation. They are both abstract constructions and variations on a theme: the drama of one among many.

The work of the early sixties represented an interlude of hollow forms, continuously related interior-exterior surfaces with generalised cave-womb references, worked in cement and then cast in bronze. Since 1966, she has returned to the earlier assemblages of upright, rounded forms of extreme simplicity and purity of surface, executed on a larger scale in black or white marble. R. G.

BRANCUSI Constantin (Pestisani, Romania, 1876 – Paris, 1957). After seven years of wandering and odd jobs, this son of a peasant found his bearings again and joined the Craiova Art School in 1894, then trained at the Bucharest Art School from 1898 to 1902. He left for Munich in 1903, arrived in Paris the following year and decided to settle there permanently. Although he worked at the École des Beaux-Arts under the iron rod of the extremely academic Antonin Mercié, Brancusi felt the influence of Rodin, who was then at the height of his fame. In 1906, he exhibited for the first time at the Société Nationale des Beaux-Arts and the Salon d'Automne. His works impressed Rodin, who invited him to work with him at Meudon, but Brancusi was too jealous of his independence to accept the offer; besides, he was already instinctively turning away from Rodin's ideas and methods. From this point, he continued alone along the path of his own discoveries. He rejected classical naturalism, as completely as Rodin's Impressionist fragmentation, Maillol's sensuousness and the Cubists' intellectuality. No one was more ruthless in eliminating irrelevant and superfluous detail in order to achieve, by severe concentration, an impersonal, primordial, essential form. He went to the embryo, the nucleus, the primordial egg and the oval, which is both an idea and its realisation, to define the numerous versions of his *Sleeping Muse*, the *Prometheus* of 1911, the *New-born* of 1915, the *Beginning of the World* and the *White Negress* of 1924, besides the innumerable variations of the bust of *Mademoiselle Pogany* done between 1912 and 1931. His urge towards simplification drove him to polish and repolish

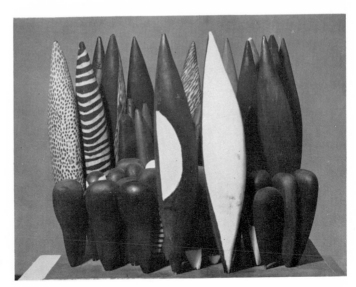

Bourgeois. The one and the others. 1955. Painted wood. Whitney Museum, New York.

Brancusi

Brancusi. Mademoiselle Pogany. 1913. Bronze.

Brancusi. Torso of a young man.
1922. Maple wood.
Museum of Art, Philadelphia.

his marbles and bronzes, refine the contours and surfaces slowly and lovingly, as if he were imparting transparency of soul to the material itself. These ovoid heads, with their features barely indicated, their eyes closed, their gently parted lips, seem to prolong the meditative trance of the Buddha, just as the two entwined figures of *The Kiss* – that moving stele, which he placed over a tomb in the cemetery of Montparnasse in 1910 – have the severe grandeur of the Toltec gods. In the curve as well as in a straight line, in the graceful, elongated oval as well as in the geometric solidity of the block there is always the same conciseness, the same intensity of feeling invested in the material, the grain of the marble and the mollecule of metal.

In 1907, Brancusi gave up his studio in the Place Dauphine, which he had occupied since his arrival in Paris, and went to 54, Rue de Montparnasse. He became friendly with some other artists of the district, particularly Modigliani. It was on his advice that the Italian painter took up sculpture. He loved to spend hours with the Douanier Rousseau, whom he admired and for whose tomb he carved a memorial cippus and engraved Apollinaire's famous poem on it. His reputation was growing and he began to receive invitations from abroad. In 1913, he sent five works to the Amory Show in New York and three others to the Allied Artists Exhibition in London. Then his first one-man exhibition took place in New York at Alfred Stieglitz's Gallery 291 (1914).

Brancusi. The beginning of the world.
1924. Marble.
Museum of Art, Philadelphia.

From 1914 to 1918, he created a series of sculptures in wood: the *Prodigal Son*, the *Sorceress, Caryatid*, the *Chimera*, which he hewed in oak, with the strength and vigour of the peasant he had always been. We must be cautious of making hasty comparisons between African art and these fantastic effigies, these roughly squared elemental masses in which the primitive character seems so close to African fetishes, particularly as he always denied ever having been influenced by Negro art or the other exotic arts. There is, above all, humour and malice in his alleged 'primitivism' and an innate sense of the permanent and universal in his search for absolute form. After the war, his wood carvings became more abstract; for example, *Adam and Eve* (1921), *The Chieftain* (1925), *Socrates* (1923), *Endless Column*. He spent a considerable time deciding the final proportions of this last work. It was ninety-eight feet high, consisting of units of the same size, placed one on top of the other in a symmetrical pattern. It was eventually cast in gilded steel and set up at Targu Jiu in 1937, at the foot of the Carpathians, the region where the artist was born.

His struggle with his materials was accompanied by a mysterious complicity. He subjected stone or metal to his will, by a combination of determination and guile. A close affinity united the artist with the hidden forces of nature, so that he found instinctively among the profusion of forms, the one that was the epitome of them all. Look, for example, at the *Torso of a Girl* (1922), *Leda* (1924), *Cock* (1941), *The Flying Tortoise* (1943), *Seal* (1943), and *Bird in Space* for which he made, between 1924 and 1949, a series of variations that were increasingly more summary, concentrated, reduced to essentials as his ideas became clearer and his creative power quickened. In doing this, Brancusi found the themes and forms of ageless humanity, the eternal archetypes that constitute the indestructible repository of millenniums and have never ceased to inspire great sculpture. His *Golden Bird* can be associated with ancient Egypt, his *Portrait of Mademoiselle Pogany* with some Cycladic idol, *Sophisticated Girl* can be compared with the Venus of Lespugue, his *Gate of the Kiss* seen as a transposition of the Sun Gate of Tiahuanaco.

He moved in 1925 to 11, Impasse Ronsin, where he worked till his death in proud solitude, indifferent to honours and rewards, discouraging prospective buyers and refusing to take part in the Biennials of Venice and São Paulo. The United States, where he found his first purchasers, was practically the only place in which he consented to exhibit a few collections of his works (Brummer Gallery, New York, in 1926 and 1933; the Solomon Guggenheim Museum in 1955). He even visited the United States three times in 1926, 1928 and 1939. In 1937, he went to India to direct the building of the *Temple of Deliverance*, commissioned by the Maharaja of Indore. A serious illness of the prince prevented its completion, but the maquette still remains (1933, Paris, Musée National d'Art Moderne). With the *Caryatid*, the *Gate of the Kiss*. the *Endless Column* and the *Spirit*

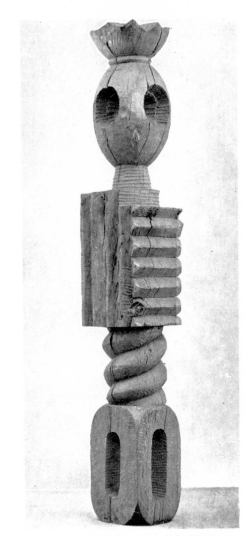

Brancusi. Spirit of the Buddha. 1937. Wood. Solomon R. Guggenheim Museum, New York.

of the Buddha, it was one of Brancusi's most successful exercises in architectural sculpture. He showed the delicacy of a goldsmith in his work with marble and bronze, but he was equally capable of creating monumental works. This is hardly surprising when one remembers his conciseness and sense of proportion, which never left him. Beyond fashions and accidents, successes

Braque

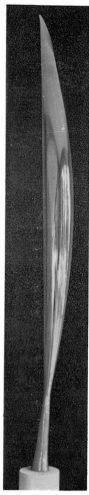

Brancusi. Bird
in space. 1940.
Polished bronze.

Brancusi The cock. 1941.
Polished bronze. Musée d'Art
Moderne, Paris.

mattered to him. 'To create like a god, to command like a king, to work like a slave.' He died a few days after obtaining French nationality and was buried in the cemetery of Montparnasse. His studio and the works it contained were left in his will to the national museums.　　　F. E.

BRAQUE Georges (Argenteuil, 1882 – Paris, 1963). Like most painters of his generation, Braque wanted to apply to sculpture, which was a new technique for him, the principles that had guided his ventures as a painter with such brilliant results. It was inevitable that the man who wrote, 'It is not enough to make people see what one paints, they should be able to touch it', should try his hand at a form of art calculated to satisfy his need for a 'tangible space' or in his own phrase, 'manual space'. By following this conviction, he was only fulfilling a need to increase and strengthen his bonds with reality; it was a need he had already felt as far back as 1911 in the middle of his phase of Cubist abstraction. His first attempts at sculpture really date from 1930, when he worked out a personal technique of engraving plaster. This consisted of coating a layer of plaster with black and then incising lines so that the white of the chalk was left bare. Braque naturally made innumerable and subtle variations in this process; sometimes large areas were uncovered by scraping; at others he used a combination of several colours. The subjects of his first plasters were all borrowed from mythology: *Saon, Themis and Hera, Helios* and *Heracles*. They began as simple drawings, but they gradually developed into bas-reliefs, notably *Io* (1935) and the *Bird* (1958). Animal figures succeeded gods and heroes; some of them were real, like the *Hen*, white on a blue ground (1942), and the *Duck* (1957), others were imaginary, but they were all depicted with a gentle humour and sometimes with a childlike comicality.

Braque worked actively at his sculpture during the war, probably because it was difficult to get painting materials. Whatever the reason, he modelled during this period the largest number and the most characteristic of his works, which were cast in bronze after 1944. Among these is his *Ibis* in which the consummate skill of the technique and the restrained and graceful style show an astonishing mastery. He also did a series of human profiles and free-standing horses, which however Hellenic they were in spirit, they reflected a universal archetype rather than a particular model. They were, in fact, millennial themes that the genius of the artist metamorphosed into works that were specifically modern. What is so striking, particularly in his plasters and bronzes, is the concern he shows to develop the planes rather than the mass, to make the surfaces vital with lines, incised and in relief, by nodules and carefully calculated roughening of surfaces. With the exception of the *Horse* of 1939, *Vase* of 1940 and *Vase* in bone and plaster of 1949, which have well-developed volumes, Braque's sculptures only seem to have two dimensions, but this is a hasty impression. Volume, weight and density are not insignificant because

and set-backs, certainties and doubts, he always maintained a fine ambition to attain the archetypal form, the eternal, primordial form, the beginning and end of the world. A robust old man with a patriarchal beard, Brancusi worked till he died with a joy and eagerness that age did not diminish. He distrusted theories and disliked formulas; his one concern was to communicate his love of essential things. Creating a masterpiece and leaving a work completed mattered little to him: 'It's a memorial to the dead,' he used to say. Living, acting, working – that was what

they are merely suggested, here by a simple structure, there by an incised stroke. The eye can see round them, the hand can touch them, feel and weigh them. In spite of their small size and absence of any desire for monumentality, they were strongly expressive and showed an undeniable power of synthesis. It was enough for him to elongate the muzzle and spread out the mane of his *Head of a Horse* (1943) to create the illusion of a wild gallop. Three triangles crossed by a horizontal line is a migratory bird flying swiftly away. A little bronze fish, dated 1942, consists simply of two unequal losanges, streaked with parallel lines; all the vertebrate, aquatic species, however, are epitomised in it. Such is the power of great artists, who are able to enclose in an elemental form, in a single sign, all that is most lasting and yet most ephemeral, on the earth, in the skies and in the waters, and endow them with an eternal reality. F. E.

BRECHERET Victor (São Paulo, 1894 – São Paulo, 1955). After training in São Paulo, he settled in Paris. He was only thirty years old then. He dreamed of creating a peerless art and he had an unqualified admiration for Meštrovic, who had been his master in Europe. He helped to found the Salon des Tuileries and exhibited in various places, notably at the International Exhibition in Rome in 1925. On his return to his native city, he became the leader of a group of avant-garde poets and artists. He carried out important commissions in which his imagination and peculiar qualities could have free play. He won the First Prize for sculpture at the São Paulo Biennial in 1951 and was represented in two of the Venice Biennales (1950 and 1952) and the Salon de Mai in Paris (1952). After his death, the IV Biennial of São Paulo in 1957 honoured his memory with a large retrospective exhibition.

 All Brecheret's work bears the stamp of Meštrovic. It was in vain that he tried to escape from it, smoothed his forms, stripped them and brought them to the limit of

Braque. Ibis.
1940-1945.
Bronze.

abstraction; the stamp was recognisable, refined by the talent and experience of the artist. He worked unremittingly to create a sculpture that was vigorous and, at the same time, had breadth and clear lines. His series of incised *Stones* display a real talent for animal carving. They show, not only his artistic integrity, but how he always returned to a lyricism, that was each time more difficult, more personal and more profound. Brecheret attempted many things. He at least knew how to take advantage of the rich folklore of his country and he bequeathed us a picture of his native culture, far different from the one left by his precursors. M.-R. G.

BRIGNONI Serge. Born 1903, Chiasso, Switzerland. He attended the School of Arts and Crafts at Berne before going to the Berlin Academy. But the decisive years of his development were spent in Paris where he lived, except for brief intervals, from 1924 to 1940. He was friendly with the Surrealists and took part in several of their exhibitions in France and abroad. Although he was primarily a painter, he took up sculpture at various times. His experiments in sculpture date from 1932 and include work in wood as well as metal and stone. Surrealist influence is particularly evident in his sculpture in wood, which can be compared with his paintings on

Braque. Bird. 1958. Ceramic.

Brown. Heads, looks. Bronze.

the same subject. He took his subjects from the world of biology, but they were imaginary hybrids of the vegetable and animal species. The resulting figures were strangely contorted shapes. On the other hand, his human sculptures in stone or lead are composed of massive volumes, elemental forms, reminiscent of the primitive sculptures of Oceanic art. The graphic qualities of two reliefs, dated 1941, one in copper and brass, the other in aluminium, are strongly marked by the interplay of lines on the chased, incised surfaces. About 1956, Brignoni attempted large figures in iron and copper, restless compositions whose appearance changes with the viewpoint. With their perforated bodies and jagged limbs, these statues are like hideous spectres, tattered Don Quixotes. They are most characteristic of Brignoni's art. He now lives at Berne and has exhibited his works since the war at various times: Düsseldorf (1951), Helsinki (1952), Paris (1953) and Antwerp (1957). In 1956, he was represented in the Venice and São Paulo Biennials. H. W.

BROWN James. Born 1918, Paris. Brown began sculpting in 1945. He was entirely self-taught and had never received the slightest artistic training. Even his first works attracted the attention of artists like Étienne-Martin, who gave him unfailing encouragement. Although it is figurative, Brown's art is not realistic. Nor is it expressionist or baroque, naïve or primitive. It is all this and more too, something that is like the celebration of a rite; each one of his works stands in the attitude of an idol, like an object connected with incantation or exorcism. In the avant-garde of contemporary sculpture, he enjoys a very special position. Apparently impervious to all influences, his favourite subjects are people and animals, cats and owls. The liturgical and dramatic char-

acter of some of his works has increased with time. About 1955, he began to use new materials such as plastic. His sculpture became light and polychrome, but the large models he made in the new manner have a characteristically supernatural quality. He has been contributing since 1952 to the Salons de Mai and de la Jeune Sculpture. After an interruption of nearly three years (1957–1959), when he devoted his time to painting and drawing, Brown produced some sumptuous, abstract hangings in velvet and then returned to sculpture, but this time his figures had a breadth and size that endowed them with an unmistakably theatrical character. His most important work in this style is the *Chariot*, a sort of dramatic, polychrome set piece, which was the central attraction of the large exhibition of his work organised by the C.N.A.C. (Centre National d'Art Contemporain) in Paris in 1968. D. C.

BRUSSE Mark. Born 1937, Alkmaar, Holland. He trained at the Arnhem Academy (1956–1960) and went to Paris on a French government grant in 1961, where he was associated with the Nouveaux Réalistes. In 1963, he contributed to a room called the *Slaughterhouse*, a team effort that caused a scandal at the III Biennale of Paris. His share consisted of 'soft machines' and 'screens' in the shape of instruments of torture, made of bits of old wood and tarred cables. From 1965 to 1968, he lived in New York on a Harkness Foundation scholarship. He contributed to the Forms of Colour exhibition at the Stedelijk Museum in Amsterdam in 1968. Brusse has now turned from romantic assemblages to producing brand new objects, such as a plain wood box set in a lacquered frame. Apart from their hooks and screws, the purity and clarity of these forms are reminiscent of the severe formalism of the De Stijl movement. More

recently, Brusse has been attracted to Minimal Art and his experiments have expanded to a giant scale; he placed in a museum room an enormous box of white wood, which occupied nearly the whole space, so that the walls and ceiling acted as a framework. D. W.

BURCKHARDT Carl (Lindau, near Zürich, 1878 – Ligornetto, Ticino, 1923). He began as a painter in the wake of Hans von Marées and it was not till 1910, during a visit to Rome, that he finally decided to become a sculptor. The following year, with the encouragement of the architect, Karl Moser, he began a series of bas-reliefs to decorate the Kunsthaus of Zürich, but these were not finished till 1914.

His art was characterised by elemental forms and a restrained and compact composition. No embellishments, no details, even of a picturesque kind, were allowed to break the severity of his works. Although it is obvious that he was inspired by archaic Greek sculpture, its influence was absorbed into the contemporary style of his art. It needed the recent retrospective exhibition in the Kunsthalle at Berne, in 1952, to show how much of a real pioneer he had been in his mature works, and how unjustly neglected. One of the most important of his productions was the collection of statues he did for the Baden station fountains in Basel (1914–1921), the *Saint George* (1923) in the town square and the *Amazon,*

Bury. Twenty-one balls reflected on eighteen planes in depth. 1969. Brass.

also of 1923, the last work he did, which still guards one of the Rhine bridges. Unfortunately, he died prematurely when he was forty-five years old.

BURY Pol. Born 1922, Haine-Saint-Pierre, Belgium. He was training as a painter at the Mons Academy, when he met Magritte in 1939, who encouraged him to join the Surrealist group. In 1948, he turned to abstraction and joined the Cobra movement. In the end, he gave up painting and, in 1953, exhibited his *Mobile Planes* in Brussels, which consisted of plaques of masonite, either coloured or painted black and white, and fixed on axes, which the observer could adjust himself. In 1957, the *Multiplanes* appeared, which were still rectangular, but pivoted on themselves and were driven by little electric motors. Subtler and more complex constructions followed these in 1959; *Punctuations*, made of little, round-headed stems, set up a constantly changing pattern in relief by striking against the back of a rubber sheet. The *Erectile Punctuations* (1961) were in the same style; their slender metal blades, spurting out of a wooden base, were like sheaves of scintillating flowers with golden buttons that

Brusse. Assemblages. 1968. Wood.

Butler

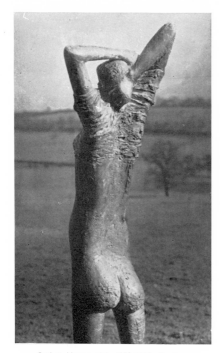

Butler. Young girl. 1952-1953. Bronze.
British Council collection, London.

the major exhibitions of kinetic art: Museum of Arts and Crafts at Zürich (1960), Stedelijk Museum, Amsterdam (1961), Musée d'Art Moderne de la Ville de Paris (1967). He was represented in 1964 at the Venice Biennale and the Kassel Documenta. H. W.

BUTLER Reg. Born 1913, Buntingford, Herts. He became an Associate of the Royal Institute of British Architects in 1937. Except for the period of the war, he practised as an architect and did not begin to work seriously as a sculptor till 1944. He held his first exhibition in London (1949) and his work has since been seen fairly widely in western Europe and the United States. He was represented at the most important international exhibitions: the Venice Biennale (1952, 1954), the Biennial of Middelheim, Antwerp (1953, 1959, 1961) and the sculpture exhibition at the Musée Rodin, Paris (1956, 1961). In 1953, he won the Grand Prize in the International Sculpture Competition on the theme of *The Unknown Political Prisoner,* organised by the Institute of Contemporary Arts, London. Butler's technological interests and the spatial considerations of his architectural training coincided completely in the open figures of wrought iron that were his first mature work. The iron structures of an earlier generation he refined to linear arabesques in three dimensions and his technical control over his material (he once worked for some time in a village blacksmith's shop) resulted in complex yet infinitely graceful constructions of great sophistication. The springing vitality of these figures led naturally into the animistic tradition of Paul Nash and Graham Sutherland. Then Butler began to experiment with bronze, which enabled him to produce continuous surfaces and consequently to think more in terms of volume than hitherto. Though for some time the linear aspects of his work remained, these tended increasingly to establish a space-frame in which solid forms could exist. The prize-winning maquette for *The Unknown Political Prisoner* — now being erected to a height of 60ft in West Berlin — fell within this period. Latterly the space frame has totally disappeared, the treatment has become more naturalistic and, save for certain modish accents, traditional. The simplifications of form and preoccupation with surface, combined with a dramatic straining in the pose, which are evident in Butler's nudes — notably *Girl 5253* — might be thought to derive in part from post-war Italian sculpture. In the early 1960s, Butler made a series of bronze box-towers, or *Tcheekles,* whose totemistic forms are re-echoed in the solitary, standing male figures of the same period. M. M.

shook in the wind. In a rather more austere spirit, he carved simple cubes, cylinders and balls of polished wood, which he connected by invisible threads of nylon. After they had been set up, the forms had to carry out the most delicate manoeuvres by sliding along a slope and returning to their places at the critical moment. In his most recent works, the same elements are made of polished brass or steel. Small balls and cylinders are arranged on cubes and platforms, or more daringly, on spheres or inside hollowed forms, which revolving magnets, hidden in the supports, set in motion or hold back. The faultless mechanism and the reflections of the metal increase the play of forms, which are fascinating to watch because of the extreme slowness of the motions. Besides one-man shows in the United States, London and Paris (Galerie Iris Clert, 1962 and 1963; Galerie Maeght, 1969), Bury has sent his work to

C

CABRERA German. Born 1903, Las Piedras, Uruguay. After he had trained as a sculptor in the Fine Arts Circle of Montevideo (1918–1926), he lived for two years in Paris, where he was a pupil of Despiau and then Bourdelle. He returned there a few years on a government grant and exhibited at the Salon d'Automne and the Salon des Tuileries and contributed to the Exposition Universelle of 1937. In 1938, he was appointed by the Venezuelan government to teach in the schools of Caracas. In 1958, he won the sculpture prize at the National Salon of Uruguay and, the following year, the scholarship of the Montevideo Biennial.

After 1937 Cabrera was encouraged by the example of Laurens, Lipchitz, Arp and some others to adopt a less traditional manner. Then, about 1946, he realised that non-figurative sculpture was the logical outcome of the unadorned style he had chosen. He searched nature for rhythms that would suggest new forms and he found them among the plants and crustaceans. After 1955, his art developed more quickly. His work steadily became more formalised, more refined and more intense. A pronounced tendency towards the monumental appeared, with simple lines and broad surfaces. Cabrera's craftsmanship was sound in his use of marble, cement, clay, plaster, sandstone from Tacuarembo and metal as well as materials like tempered glass and enamelled iron. Cabrera's extensive decorative work helped to bring a fresh approach to religious art in Uruguay. The tower of the Mormon church in Montevideo is by far the best example of his work in this line. **M.-R. G.**

CAILLE Pierre. Born 1912, Tournai, Belgium. After studying at the Abbaye de la Cambre in Brussels, Caille began his career as a painter. The architect Henri van de Velde turned his attention to pottery during the Exhibition of Arts and Techniques at Paris in 1937. Caille became absorbed in the problems of this medium and he set out to master them completely. He modelled his forms with the hands of a sculptor and then coloured them with the instinct of a painter. The distinction between decorative art and sculpture does not exist for him; he will turn from making personal knick-knacks to working on a large piece of sculpture, which sometimes stands on its own and is sometimes intended for a building (the casino at Ostend; the Town Hall at Mons).

Pierre Caille began the revival of pottery in Belgium. He won numerous international prizes including the International Prize for Ceramics awarded at Monza in 1963. For some years, he did sculpture in hammered copper, but he is now working in wood and is interested in sculpted groups. The humour and vitality of his art give it a profound originality; it seems to have escaped from the country familiar to James Ensor, who called it the 'land of mockery'. **F.-C. L.**

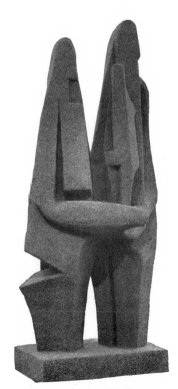

Cabrera. Family. 1959. Cement.
National Museum, Montevideo.

Calder

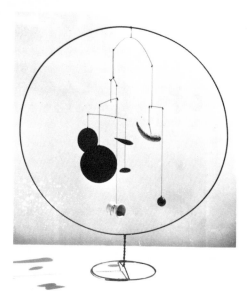

Calder. Mobile. About 1934-1935.
Wire and various objects.

CALDER Alexander. Born 1898, Philadelphia. Calder trained as an engineer and did all kinds of work until he decided to become a painter and, in 1923, joined the Art Students' League in New York. When he went to Paris in 1926, he made articulated toys in wood and wire, a complete troupe of acrobats, clowns and tiny dancers, which he set in motion in a small ring. This was his miniature *Circus*, which he took all over Paris in suitcases, then all over the world. He also made his first wire sculptures, which he exhibited in 1928 in New York, then the following year, in Paris at the Galerie Billet. Calder had an attractive personality and he very soon made friends with Mondrian, Léger, Miró, and Jean Arp. In 1932, thirty years before the first kinetic sculpture, he exhibited at the Galerie Vignon, Paris, a group of abstract forms, which were either set in motion by hand, or by electric motors. Marcel Duchamp immediately suggested that they should be called 'Mobiles'. When he gave up using motors the next year, the name remained to describe all his sculptures that moved in a current of air only. His first large mobile, *Steel Fish* (1934), was nearly 10ft high. It was followed by other airy metal flowers that spread their waving fronds in all the museums and great galleries of the world. He varied their size, rhythms and shapes. He added colour. Sometimes he hung them from the ceiling like oscillating leaves, sometimes he poised them in a fragile equilibrium on a single foot, or nailed them to the wall like an enormous spider.

But, after all this light-heartedness and technical

Calder. Red construction. 1945. Mobile in metal.

Calder. Red pyramid. 1945. Mobile in metal.

agility, a temperament as sturdy as Calder's had to go on to sculpture that was more monumental in character. In 1937, in his workshop at Roxbury, Connecticut, he began to forge the sculptures, solidly planted on the ground, that Jean Arp called 'Stabiles'. They grew in size and weight, especially after 1944. Their opaque bodies and powerful arching forms were a complete contrast to the exquisite lightness of the mobiles. As the size of the stabiles grew, so the mobiles naturally grew larger too. Then Calder grafted one onto the other and produced the 'Stabile-mobiles', which encroached more and more on the surrounding space, until in their turn, they became 'Arrow-mobiles', exhibited by the Galerie Maeght in Paris in 1968. Calder has made large mobiles, notably for the UNESCO building in Paris (1958). Gigantic stabiles, crouching like dinosaurs on their clawed feet, are now to be found at Spoleto, Rotterdam, Grenoble, Sidney, Montreal, Berlin, at the Fondation Maeght, St-Paul-de-Vence, at Fresno, California, and at Cambridge, Mass. In 1968, a stabile, 90ft hight, was erected in front of the Olympic stadium in Mexico City. In April 1969, another mastodon, 30ft high this time, was placed at the entrance of the Fondation Maeght, Saint-Paul-Vence, and all the visitors to the largest retrospective

ever held in honour of Calder had to pass under it. Countless exhibitions preceded this one and probably succeed it, because the activity of this man, who looks like an nonchalent clown, defies description.

Calder belongs to that vigorous and adventurous generation of Americans who, instead of trying to find a place for themselves in the intellectual interests and preoccupations of Europe, have preferred to venture on their own. Having escaped from the constraints of classical tradition, he was able to create an art of unusual originality which, while it challenged the fundamental principles and methods of sculpture, nevertheless, made an immediate appeal through its plastic values and rhythms. As a poet, he has given speech to beasts and plants and, as he played, created a world in which imagination and mechanical precision combined to produce the undeniable beauty of his sculpture. For some years, his works have tended to become larger and larger. One by one, they all issued from the Roxbury studio where this modern Vulcan shears, hammers, twists, lengthens and welds metallic sheets, which, by their shapes, their thickness, their movements, by the subtle interplay of straight and sinuous lines, of acute angles and curves, of appendages escaping from the

Calò

framework, communicate an epic quality through the language of wrought iron: movement, fluidity, elegance, at one moment; stability, weight and hardness, at another; but always the same unfailing technique and the same ebullient invention. And what a heap of prejudices and musty ideas were swept away by this proud mechanic! F. E.

CALÒ Aldo. Born 1910, San Cesario di Lecce, Italy. He studied at the Lecce Art School, then at the Institute of Art at Florence. His first important exhibition took place in 1947 at the Cavallino Gallery in Venice. He was director of the Institute of Art at Volterra for several years and is now in charge of the Institute of Rome. His first works showed a mixture of archaism, in the style of Martini, and a strain of pathos that was in keeping with the Baroque traditions of his own region. It was only after the 1948 Biennale that he became interested in international art movements. During a visit to Paris in 1950 he met Arp, Brancusi and Zadkine. His travels ended in England where Calò worked for some time with Henry Moore. With these invaluable experiences behind him, he was now able to develop his own style. Although Calò's early works preserved a bond with natural objects, even though it might have been strained by the incongruities of Surrealism, during the

fifties he produced completely abstract sculptures free from all influences. This creation has a dual aspect: in his use of two kinds of material, wood and iron, and in the subject matter, where the duality is made explicit by the frequent title *Biform*. Since then, his works have resolved this dualism by carrying the contrast between different sculptural values to the point of fantasy. He was awarded the National Prize for Sculpture at the Venice Biennale of 1962 and the following year won the competition for a Memorial to the Resistance at Cuneo.
 G. C.

CAMARGO Sergio de. Born 1930, Rio de Janeiro, Brazil. He was studying philosophy at the Sorbonne, when he met Brancusi and Arp and decided to devote his life to sculpture. On his return to Brazil, he held some successful one-man shows. He went to live in Paris permanently in 1961. He was awarded the national prize for sculpture at the VIII Biennial of São Paulo and the international prize for sculpture at the Paris Biennial in 1963. Most of his early works were mural reliefs, which is still his usual means of expression. Apart from a few sculptures in marble, his subsequent works were all made of innumerable wooden units, based on the same module, but not necessarily with the same proportions, meticulously cut out, arranged and glued.

Camargo's art is based on the principle of serial organisation and depends for its appeal on the harmonious combination of numbers. The strictness of his method is tempered by an extreme sensitiveness, which is reflected in the subtle variations and vibrations of his forms. Their stark, unvaried whiteness is an effective safeguard against any tendency towards romantic expression, but it is also a powerful contribution to the luminous aura that covers them. D. C.

CAMESI Gianfredo. Born 1940, Mensonio, Ticino. He has lived and worked in Geneva since 1958. Camesi was self-taught and a painter at first, but an interest in relief gradually grew out of his systematic enquiries into the potentialities of composition, movement, colour and space. He used wood and cardboard for his attempts in this direction (1965–1966), but very soon changed to the more lasting materials of metal and plexiglas. He exhibited his work in one-man and group shows in the main Swiss towns and Amsterdam. As a member of the Italian group, Set di Numero, he was represented in several shows in Italy. Camesi was fascinated by the

Camargo. Relief N° 5/5. Painted wood.

Calò. Biform. 1959. Wood and iron.

appearance of raw materials and made use of their expressive value in direct contrast to the formal beauty of the work. The forms of his sculpture have great purity and the problems of the spatial development of a single element are implicit in its geometric order and the multiplication of shapes. Knowledge and technique combine to create a dimension that is the measure of contemporary man, in other words, sculpture that is in harmony with the space without and the space within.
 J.-L. D.

CANNILLA Franco. Born 1911, Caltagirone, Sicily. He did his training at the art school of his home town, then at the Palermo School of Sculpture. In 1940, he went to live in Rome. His first one-man show took place in 1943 and immediately after the war Cannilla stood out as one of the most promising of the Italian sculptors. He did not become well known, however, until his exhibition at the Galleria Selecta at Rome in 1959, where he showed his first uncompromisingly abstract works. The development to abstraction had been gradual and coherent. It had begun with Manzù's influence and the

53

Cantré

maturation of this first stay in Rome had led Cannilla consciously to a more international experience, which was directly derived from the major movements of modern sculpture. He assimilated the work of Zadkine and Moore, Picasso and Uhlmann when, between 1947 and 1950, Italian art was undergoing a real crisis. His sculpture of the early sixties, on the other hand, in which the resemblance to the human form is remote and the graceful, heraldic shapes seem part of a mobile space, swept by a perpetual wind, was the creation of a mature artist. Since then, Cannilla has turned towards a sort of constructivism and seems to have found a suitable medium for this new idiom in plastic and synthetic materials. A link still remains with the previous forms, which infuse his latest work with their essentially dynamic and mechanistic character. 　　　　　　　　G. C.

CANTRÉ Joseph (Ghent, 1890 – Ghent, 1957). As well as being a sculptor and one of the leading figures in the Belgian Expressionist movement, Cantré had a considerable reputation as a wood-engraver, illustrator and book designer. He was trained at the Ghent Academy. His career as a sculptor began in 1909 under the influence of Constantin Meunier and George Minne. He took

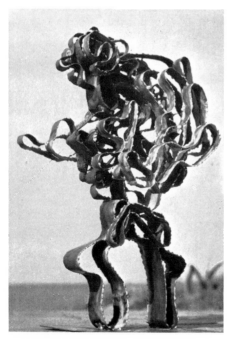

Cannilla. Anatomical parabola. 1959. Brass.

refuge in Holland during the First World War and settled at Blaricum, where Gustave de Smet and Frits van den Berghe were already living, and did not return to his own country till 1930. His work as an engraver encouraged him to give up modelling completely for direct carving in wood or stone. His style was rather rough and very expressive at first, but it became more concise and gradually developed into geometric structures with sharp edges, which are sometimes reminiscent of Zadkine and not unlike the style of Oscar Jespers. In spite of its greater suppleness, Cantré's art remained faithful to this manner and was always distinguished by its purity and the extreme clarity of its forms. Among his most important productions were the figure on the tomb of the poet, René de Clercq, at Lage Vuurse, Holland, and the monument to the memory of the Socialist leader, Édouard Anseele, at Ghent. 　　　　　　　　F.-C. L.

CAPPELLO Carmelo. Born 1912, Ragusa, Sicily. After preliminary training in his own country, he went to Rome, then to Milan to complete his studies. With the help of a grant, he was able to attend the Institute of Monza. His career as a sculptor began in 1937. In 1958, the Venice Biennale and, in 1965, the São Paulo Biennial reserved a whole room for his work. It was exhibited in Paris at the Galerie Hervé in 1957. Cappello is still living in Milan, where the Galleria Blu organised a large exhibition of his sculpture in 1963. It was the genius of Sicily that enabled him to understand the real, profound significance of sculpture, because the creation of each work leads him back to fundamental sources and meanings. After a period of wavering and hesitation between Impressionism and Expressionism, Cappello has been able to carry his work beyond the false antinomy of naturalism and abstraction, an antinomy, anyway, that should be transcended, not ignored. From this experience, he created a sculpture that had brilliant, soaring rhythms, which swung out with fluent curves. Having refused all compromise with 'technical' and 'mechanistic' art, Cappello was equally opposed to the devitalisation inherent in various theories of pure art. Instead of giving himself up to demonstrations of the principles of hollows and volumes, he models space in a sculpture that is made pregnant with instinct and feeling. And so, whether we consider a *Nest*, gaping wide for food, or the livid and lacerated *Tempest*, he succeeds in maintaining his objectivity by using a pure association of images in a clear, sculptural idiom. In such works, without any intellectual acrobatics, the idea is completely unified with the image, stands in all its original purity, and grows like a fruit, fed from deep springs. Between 1958 and 1960, cosmic themes appeared in his work *(Icarus, Stratospheric Flight)* and afterwards the tension of the curves, the structural rhythms and the airy quality of both became more emphatic and were the culmination of Cappello's supremely elegant sculpture with its discipline and continuity. 　　　　　　　　D. F.

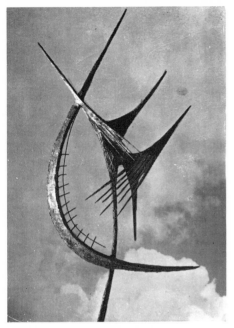

Cappello. Eclipse. 1959. Bronze.

CAPRALOS Christos. Born Panaetolikon, Aetolia, Greece. He trained as a painter at the Athens Art School, then went to work in Paris as a sculptor in Marcel Gimond's studio. He has exhibited in Greece, Italy, Germany and the United States. One of his best-known works is the memorial to the liberation of the Dodecanese on the Island of Rhodes. The very free, personal interpretation of the human form in his sculpture achieves a harmonious synthesis of plastic values, architectural requirements and decorative elements. He has been carving stone since 1951 and casting bronze since 1958. His stone sculptures are the transpositions of the impression of light and landscape in Greece, while his bronzes are the medium for expressing human emotions. In the wood carvings, which he has been doing since 1965, he has rediscovered the charm of the old domestic utensils and agricultural tools of former times. D. C.

CARDENAS Agustin. Born 1927, Matanzas, Cuba. He trained at the Havana Academy from 1943 to 1949 under the sculptor Sicré, who was one of Bourdelle's pupils. Although his inspiration was still entirely realistic, Cardenas soon felt impelled towards some degree of plastic distortion. He revolted against his official teaching and from 1953 to 1956 belonged to the famous

Group of the Eleven, which brought together painters and sculptors of the Cuban avant-garde. He took part in several group exhibitions and held a one-man show at the Havana Museum. In 1954, he was awarded the National Prize for Sculpture of Cuba. At the end of 1955, he went to Paris where the experimental nature of his work drew him immediately into the militant wing of young sculptors. He exhibited at the Galerie de l'Étoile Scellée (1956) and since 1957 his work has been seen regularly at the Salons de la Jeune Sculpture and des Réalités Nouvelles. His work, which has now crossed the border of non-figurative art, is less concerned with the world of poetry than with restoring an aura of magic to sculpture. At first he generally worked in plaster for casting in bronze, then wood became his favourite medium before he turned to marble. His sculptures, which are either slender totems or ample masses given vitality by the space within them, show an inexhaustible power of invention. Their emotional and, at the same time, abstract aspect has been characteristically described by André Breton in his preface to the exhibition that took place in the Galerie de la Cour d'Ingres in 1959: 'Here, springing from his fingers, is the great flowering totem, which, far better than any saxophone, sets the women dancing.' Cardenas won First Prize at the Paris Biennial (1962) and was invited to send work to the

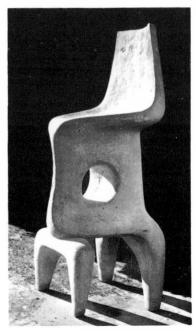

Capralos. Knossos. 1964. Stone.

Cardenas. Plaster. 1955.

Biennials of Middelheim, Tokyo and Carrara. He has also contributed to the Symposiums in Austria (1961), Israel (1962) and Canada (1964). D. C.

CARLISKY. Born 1914, Buenos Aires. He did not begin to sculpt until he was thirty-five years old. He taught himself and began with figurative works, generally faces, which he modelled in a sort of papier-mâché that he had used a few years before to make a puppet theatre. He went to Paris in 1952 and attended the Académie de la Grande-Chaumière, in Zadkine's studio. There he learnt that sculpture is not necessarily carved from a solid block: it can also be an aerial labyrinth of hollow volumes, which was a revelation to him. He held two one-man exhibitions in rapid succession, one in Paris at the Galerie La Roue (1954), the other in Buenos Aires at the Bonino Gallery (1955). He was represented at the Venice Biennale in 1956 and the São Paulo Biennial in 1957. In 1959, he finally settled in France. In the course of his experiments, Carlisky invented a new material to suit himself, which he called plâtron. After leaving the subject of *Faces*, he turned to compositions, consisting of groups of thread-like

figures, and then went on to completely abstract works, which he called *Sculptures without a Face*. Since 1967, Carlisky has been illustrating the work of great contemporary writers in highly symbolic sculpture. He no longer created object-sculpture and his style became monumental. Although its form was arborescent, his work never failed to suggest human feelings through the theme of the moment. D. C.

CARO Anthony. Born 1924, London. He read engineering at Cambridge, then trained at the Regent Street Polytechnic and the Royal Academy Art Schools, London (1947–1952). He held his first one-man exhibition at the Galleria del Naviglio, Milan, in 1956 and since then has exhibited regularly in London, New York and in Europe. A major Arts Council retrospective exhibition of his work was held at the Hayward Gallery, London, in 1969. He has been very frequently represented at the main international exhibitions in Europe and the United States. In his work of the late 1950s, most frequently in bronze, Caro, with other British sculptors of his generation, set out to obtain the utmost expressiveness in the handling of the medium itself. The human figure was his main concern but its treatment, though traditional in essence, was so free as to form part of the general trend towards art brut and antirationalism. When Caro first worked in welded steel at the beginning of the sixties, he used heavy, ready-made materials, in part deriving his technique from the sculptures of David Smith, whose tradition he has continued. The sculptures of these years are essentially massive and analogies are to be found with the chunkiness and weight of the earlier bronze figure sculptures. Despite such possible comparisons, it was with Caro's painted metal sculptures of the early sixties that the 'disassociated' quality of present-day sculpture made its first appearance in Britain. By 1963, as in a piece like *Early one Morning*, Caro began using varied lengths of tubing and steel sheets in place of the heavy girders of his first welded pieces and the 'minimal' qualities of his recent work began to emerge. M. M.

CASCELLA Andrea. Born 1920, Pescara, Italy. He came from a family of craftsmen and served his apprenticeship with his father, Tommaso, then worked for a few years with his brother, Pietro, in Rome, where he specialised in sculpture and ceramic reliefs for architecture. Finally, he settled in Milan and concentrated on his own independent work, which in 1950 began to produce some convincing results. He has been exhibiting his work since 1949 in various galleries in Italy and abroad. The Venice Biennale, which had invited him in 1950 for the first time, reserved a room for his work in 1964 and awarded him the National Prize for sculpture on that occasion. Meanwhile, he had contributed in 1960 to the Rome Quadriennale. Cascella has done

several large-scale sculptures and was associated with the architect Ignazio Gardella in designing the façade of the Olivetti building in Düsseldorf. His work has been exhibited several times at the Galleria Ariete in Milan and, in 1962, at the Grosvenor Gallery in London.

Cascella's stone and marble sculptures have a monumental quality and tend to be inscribed within a compact block. They are the reflection of a serene attitude, an Olympian view of life that tries to restore a harmonious order and the clarity of ideal forms in a civilisation of destruction and anguish. The solemnity of their masses and a closed, architectural conception, circumscribed with uninterrupted outlines, which curve, proliferate and emphasise their symbolic character, are a direct contrast to involution. In spite of their cerebral inspiration, they possess an unambiguous sensuality and a clarity without coldness, which makes them particularly evocative.

G. C.

CASCELLA Pietro. Born 1921, Pescara, Italy. After his father had taught him the techniques of painting, he went to Rome to attend the sculpture classes at the Art School. In the post-war years, Pietro and his brother, Andrea, worked as potters and were both leading craftsmen in reviving the art of ceramic. Then Pietro returned to sculpting full time and joined the abstract movement that was developing in Italy. He won the Copley Foundation prize in 1950 and had several one-man exhibitions in Rome, Milan, Venice, Brussels, New York and Paris. He was contributing at the same time to the Biennials of Venice, Tokyo and Carrara, which awarded him its prize in 1967. Stone and marble carving was his usual medium, but he also cast his work in bronze and aluminium. His works, often built up with assemblages or imbrications of volumes, show a mythical conceptual-

Pietro Cascella. Head. 1968. Black marble.

isation of the most banal and realistic forms through the almost magical way he defines them. They have an affinity with the ritual objects of primitive civilisations, but without any suggestion of facile archaism. The evocative power of such sculpture is modern in spite of this. It is deeply rooted in Cascella's attentive, direct observation of the profound mechanisms of nature and

Caro. Hopscotch. 1962. Metal.

has no connection with literary or ethnographical culture. From this point of view, each one of his sculptures is a plastic metaphor, whose complex ambiguities are measured by the variety and powerfulness of their constantly changing forms, which go beyond a strongly unified and homogeneous organisation. D. C.

CASTELLI Alfio. Born 1917, Senigallia, Italy. He studied at the Florence Academy and then at the Academy at Rome, where he has lived since 1941. His first one-man exhibition took place at Rome in 1940. His early experiments showed an obvious talent, but he still relied then on traditional ideas of naturalistic sculpture. Towards 1950, he achieved a style of his own after an intense search for the values of light and corresponding retraction of surfaces. The swift, bright light that passes over the figures he sculptured at that time, most of them nudes, made the volumes seem less heavy. Since 1960, Castelli has been teaching at the Naples Academy. He won several awards, in particular the International Prize for Sculpture at the 1950 exhibition in Celle Ligure for his work *Adam and Eve*. Finally, he carried out some important commissions, sometimes on religious subjects, like the great *Crucifixion* in terracotta, finished in 1956 for a church in Rome. A restrained expressionism is the outstanding characteristic of his work in which the figures have a consistent sadness while the unevenness

Ceroli. "Il Mister". 1964. Wood.

Cavaliere. Large flower. 1965. Bronze.

of the surfaces are emphasised by the light playing over the points of greatest tension. His recent sculptures, little bronzes or wood carvings, or metal coated plaster figures of acrobats, bishops, shepherds or nudes, are rather like bas-reliefs because of the sudden flattening of the form, a characteristic development from Cubism, planes abruptly cut short and a thread-like calligraphy, which increases the potential expressiveness of the image. G. C.

CAVALIERE Alik. Born 1926, Rome. His first one-man show was held in Milan, where he has been living since 1937, at the Galleria della Colonna in 1952. This was followed by others in Rome at the Galleria Il Pincio in 1953; in Milan at the Galleria Bergamini in 1959, the Galleria Cadario in 1961 and at the Galleria Schwarz in 1964. The Venice Biennale reserved a room for his work the same year. He has been an assistant to Marino Marini at the Brera Academy in Milan since 1956. Cavaliere has shown from the beginning a marked leaning towards expressionism and a fantasy tinged with folklore. From 1959, a Surrealist tendency gave his works an even more hallucinatory character, which was accent-

uated by his use of a great variety of materials: glass, mirrors, objects lighted from inside, moving panels and china combined with metals, wood and cement in polyhedric compositions with an inexhaustible verve. Automatism, a taste for Pop Art, a love of the object for its own sake, especially after 1961, indicated a distinctly more realistic but still profoundly oneiric leaning. Cavaliere's work, which is at once bitter and lucid, caustic, capricious and bizarre, is the perfect symbol of the restlessness that drives the endless search of this most original of artists, whose creations are free from any cultural influence and assert themselves by their sheer novelty. G. C.

CEROLI Mario. Born 1938, Castel Frentano, Chieti, Italy. He was a student of Ettore Colla and Fazzini at the Institute of Art in Rome, and eventually chose to work as a ceramist under Leoncillo. But in 1958, he gave this up too and began making a series of works with pieces wood assembled with large nails, which were to some extent influenced by Nino Franchina. However purely formal this experimenting might have been, it was not completely lacking in figurative allusions. Then in 1961, instead of wood, he used sheet-aluminium, which was smooth and undulating and always assembled by the same process. Military service interrupted his artistic activities for two years and, in 1963, he made a clean sweep of his previous experiments and, in the frankly aggressive spirit, which was more in keeping with the ebullient younger generation, he began carving objects from huge blocks of rough wood. The first of these 'objects' was a simple letter, the letter A, like an affirmation of the elementary starting point of his new experiments. When they were exhibited at the Galleria La Tartaruga, Rome, in 1964, these works roused the keenest interest. Since 1966, Ceroli has taken his experiments still further and has tackled the problem of the human figure, which he reintroduced in the form of silhouettes roughly cut out in white wood. When they are regrouped in large compositions they are a means of 'describing' events as different as the Last Supper and the Chinese Revolution. In spite of their provocative and sometimes facetious aspect, these figures, which seem to play on the antinomies of reverse-obverse, truth-falsehood, positive-negative, show a visual and plastic sense that will undoubtedly lead to remarkable developments. G. C.

CÉSAR (César Baldaccini) called. Born 1921, Marseilles. He began his training at the Marseilles Art School, then continued it in Paris in 1943. As wood and stone carving had constituted the major part of his training, he particularly admired, at that time, the great classical sculptors. In 1947, he discovered the potentialities of metal, hammered sheet-lead and especially iron. He created images of perfectly identifiable reality from pieces of scrap iron, soldered together with a rare

quality of creative imagination. Then began the period that he himself called his 'amalgam phase'. The amalgam consisted of welding together material of the most heteroclite forms (worn springs, crank-arms, bolts, preserving cans) into a homogeneous entity with an independent plastic existence of its own. Soon, there grew out of this chaos of metamorphosed, mechanical components, a swarm of disquieting insects, birds,

César. The Grand Duchess. 1955. Iron and steel.

fantastic beasts, and sometimes anthropomorphic figures that were hardly less fabulous although they were always plausible. In 1956, there was a fresh development towards a more structured sculpture, with a stricter, more controlled rhythm. This was the period when he set up large screens of iron, with a majestic frontality. Their surfaces were modelled with tiny, regularly shaped units, which were often square. César continued to produce them until 1959 and their clarity and breadth still seem to possess a sort of Mediterranean classicism. It is characteristic of the man that he should refuse to exploit systematically any process or formula and he soon sought for new means of expression. This was the famous series of *Compressions* of car bodies, which he exhibited at the Salon de Mai in 1960. They were the logical culmination of this search for a direct grasp of reality. However, his innate feeling for craftsmanship and the aesthetic considerations inherent in it, and his love of form experienced in the making of his sculptures led him to begin a whole group of busts and figures in 1963, which included the *Victory of Villetaneuse* (1965), a powerful fertility image, which was recognised as one of the great pieces of contemporary sculpture in its objective truth to plastic values. César's work is full of

César. Thumb. 1966. Bronze.

César. Controlled compression A. 1960. Metal.

surprises and a new impetus came in 1966 when he began using the new material of polyester for monumental enlargements of anatomical imprints, like his *Thumb*. The possibility of being able to execute a form instantaneously fascinated him and he went on to use polyurethane foam, a synthetic resin, which swells in size as its pasty consistency solidifies. The *Expansions*, either controlled or free, were the product of this process. A view, unprejudiced by the scandals they caused, would admit that this limited artistic act has opened new perspectives of creativeness. Since his first one-man show at the Galerie Rive Droite, Paris, in 1955, César has exhibited several times in France and abroad. He has exhibited regularly at the major international shows, the Biennials of Venice, where a whole room was reserved for him in 1956, Carrara, where he was awarded the sculpture prize in 1957, Middelheim, São Paulo and the Kassel Documenta. D. C.

CHADWICK Lynn. Born 1914, London. He trained as an architect. He began experimenting with mobiles in 1945 and first exhibited in 1950. Since then his work has been seen widely throughout Europe and North and South America, notably at the Venice Biennale (1952 and 1956) at the later of which he was awarded the international sculpture prize; in the International Open Air Sculpture Exhibitions in London, Middelheim,

Paris; the 4th São Paulo Biennial (1957); and the Brussels International Exhibition (1958). The elegant angularity of Chadwick's metal sculpture reflects with peculiar precision, as it has helped to create, the most characteristic formal language of the immediate post-war period. His early constructions, suspended systems of mobile buoys that moved with a somewhat convulsive pulse, paid homage to Calder. These were soon followed by the much more personal, balanced sculptures of 1951–1952, the ribbed skeletons of which already hinted at anthropomorphic life. Within them, eccentrically pivoted, sharp-toothed inner elements swung and revolved within each other, creating the sense of a creature snapping and biting and baring its fangs. The mobile became stabile and the stabile took flesh. As the welded frameworks stood upright upon their feet, as their character became more unmistakably insect-like, animal-like, and finally man-like, so it seemed that Chadwick was using the techniques of metal construction to create 'object personages' in that tradition of English roman-ticism followed by Paul Nash and Graham Sutherland and, among his contemporaries, Reg Butler. As has the latter, however, Chadwick has moved steadily towards less ambiguous conceptions, great solidity, and more monumental effects.

His more recent groups are constructed of mild steel armatures, or cages, filled with a compound of gypsum and iron filings, which is then modelled, chiselled and filed down to the 'bone', like the *Watchers* of the sixties, resembling menacing, silent robots. The geometric nature of their framework lends these figures a bold simplicity of modelling, the large planes of which are relieved by the fanning ribs of the armature and the rich surface texture of the infilling. In them, as in all Chad-wick's work, one senses a creative ambition that is perfectly attuned to the technical ability available for its execution. M. M.

CHAGALL Marc. Born 1887, Vitebsk, Russia. After studying painting at the Imperial School for the Encour-agement of the Arts in St. Petersburg, he went to Paris in 1910, settled in La Ruche and made friends with Max Jacob, Apollinaire, Blaise Cendrars, Fernand Léger and Robert Delaunay. Until 1914, he only painted. On return-ing to his own country, where he was caught by the war, he painted stage scenery and taught with the encourage-ment of the new régime. In 1923, he left Russia for the last time and settled in Paris where, at Ambroise Vollard's suggestion, he took up engraving. He illustrated Gogol's *Dead Souls* and La Fontaine's *Fables*. He had already made an international reputation for himself. During the Second World War, Chagall took refuge in the United States and came back to France in 1947. He went to live at Vence, in the south of France, and in 1950 became passionately interested in ceramics. He felt stirred by the climate and a Mediterranean land to express himself in sculpture. He was then over sixty. He amused himself

by modelling and carving stone, without any pre-conceived ideas, as if it were a pastime; his sculptures are secret songs, personal pleasures. They were inspired by a combination of Biblical reminiscences and influences from the south of France. He twice held an exhibition of his work, bas-reliefs and sculpture in the round, the first time in 1956 at Yverdon in Switzerland and, the following year, in Paris at the Galerie Maeght. His art, at least his sculpture, is intuitive and sensuous. It is remarkable for an idiom that is paradoxically naïve and erudite. He loves the solidity of sculptural volumes and to give them vitality he resorts to a delicate and restrained graphic decoration in which his former skill as an engraver· is easily recognisable. He said himself, 'I sculpt as I feel, without thinking of anything. It gives me pleasure just to say it.' D. C.

CHAISSAC Gaston (Avallon, 1910 – Vix, Vendée, 1964). He was a primitive artist of humble origins, who taught himself to sculpt. Otto Freundlich, who encour-aged him to paint about 1931, said of him, 'A master is born among us.' Chaissac was primarily a painter, but he did a number of sculptures in folded sheet-metal and

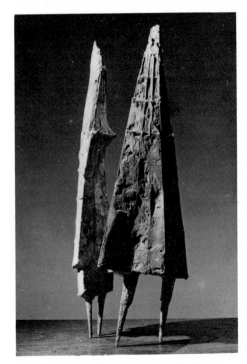

Chadwick. Teddy boy and girl. 1959. Metal.

Chamberlain

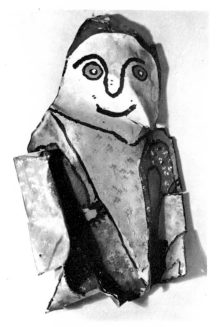

Chaissac. Folded and painted sheet-metal.
About 1955-1958. Private collection.

1960 appropriated the compressed blocks of cars, as they were turned out of the scrap iron works, Chamberlain selected his pieces for their shapes and colours. He has been justly compared with abstract painters, because he treated these pieces of scrap metal as abstract elements before scattering them along walls. These agglomerations of twisted sheet-metal from car bodies, pipes, iron bars, mud-guards and other mechanical detritus differ from abstract painting, however, in the way he works them into hallucinatory outlines, like helmeted heads, ragged beggars, luxuriant plants or aggressive animals. In the final work, the meanness of the material is belied by the rich and vivid colours, blues, greens, yellows and orange, which offer a joyous vision of our industrial age. There is a different spirit in his work, when he breaks polyurethane statues, a plastic material that looks like a whitish stone, and builds them into monuments to the glory of degredation. H. W.

CHAPDELAINE Jacques. Born 1932, Montreal. He was self-taught and has been sculpting since 1953. After several visits to India, where the culture left a profound impression on him, then to Europe, he is now living by the sea at Grande Vallée, in the Gaspé Peninsula. He is a foundation member of the Society of Quebec Sculptors and also a member of the Society of Canadian Sculptors. He has contributed to several group exhibitions, including the Salon de la Jeune Sculpture, at the Musée Rodin, Paris (1965), and the International Salon of

a whole series of *Totems*, which were assemblages of untrimmed wood painted so that the colour was an integral part of the form. The resulting figures were primitive and powerfully evocative. His artistic employment of waste materials anticipated the New Realism and, from the Vendean village of Vix, where he used to live, he exercised an influence on two generations of artists from Dubuffet to Appel, which was nonetheless effective for being so remote. Chaissac was as sort of rural Pop Artist and the purest example of *art brut*. His imagination and constant renewal of forms made him one of the most profoundly individual and genuine artists of our times. He published a collection of poetry and prose in 1951, called *Hippobosque au bocage*. D. C.

CHAMBERLAIN John. Born 1927, Rochester, Indiana, United States. He trained at the Art Institute of Chicago from 1950 to 1952. After his first one-man show at the Wells Street Gallery, Chicago, in 1957, others followed in New York, at the Martha Jackson Gallery in 1960 and the Leo Castelli Gallery from 1962 to 1969, and in Paris in 1964 at the Galerie Ileana Sonnabend. For years, Chamberlain used pieces of scrap iron from cars for making reliefs and free-standing sculptures. Unlike César, who shared the same passion and from

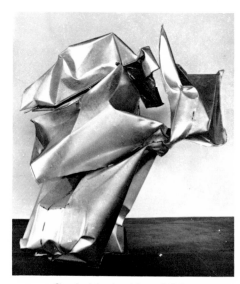

Chamberlain. Angel beyond Opio.
1967. Galvanised steel.

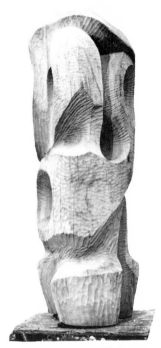

Chapdelaine. Man. 1962. Wood.

Sculpture at the Galleria d'Arte Moderna, Milan (1967). He is thoroughly Canadian in his approach. His wooden totem-like sculptures are non-figurative, but the composition, rhythm and sinuous lines of the forms, enclosing hollows and solids, suggest organic life and are like the secret, ritual aspect of primitive arts. G. V.

CHAUVIN Louis. Born 1889, Rochefort-sur-Mer. Very little is known of this quiet artist, who has pursued a solitary way in unfrequented places, except that he worked until 1914 in the Paris studio of Joseph Bernard as his pupil and assistant. Under the influence of this master, his sculpture was figurative at first. But Chauvin was soon attracted towards a kind of art in which the inner motivations assume greater importance than anything else. At the end of the First World War, his search led him to the threshold of the unexplored realm of abstraction, where he became one of the pioneers. He went beyond Cubism from which he retained its fundamentally classical spirit and rejection of accidental effects. His technique and craftsmanship are incomparable and he uses the most varied materials with equal skill, which are always chosen to suit the subject: clay, wood, marble

or bronze. He handles them all with the same concern for perfection and gives an extraordinary precision and purity to the finish of the surfaces. He likes using rare woods, thuya or maidou, for instance, from his love of a fine craft. He has exhibited very rarely and between the wars only took part in a few group exhibitions and Salons. The public had to wait till 1949 before it could get an idea of his work, as a whole, at an exhibition held by the Galerie Maeght in Paris. Through the years, his art developed more and more severely geometric forms. The perfect symmetry of a good many of his creations puzzled and sometimes surprised some art lovers, but the reason for it is better understood today. Far from being contrary to the spirit of sculpture, as Stanislas Fumet declared, the conception of two similar forms, developing in strict parallels, 'has nothing to do with decoration, but comes from architecture' and, as such, is a necessity. A further characteristic should be mentioned: the use of a sort of sexual symbolism, drawn from the couple and the figure 2, a symbolism that is even found in his titles, *Lover's Sleep, Narcissus, Chrysalid* and that seems to have influenced the development of these spatial compositions. Although Chauvin continues to live in a proud and hard-working retirement,

Chauvin. Sculpture.

Chavignier

it would nevertheless be easy to show how present-day art is indebted to him. His last exhibition was held in 1958 at the Galerie Verneuil. Christian Zervos wrote the standard monograph on him, published in the Éditions des Cahiers d'Art in 1960. D. C.

CHAVIGNIER Louis. Born 1922, Montboudif, Cantal. When he had completed his training at the École des Beaux-Arts, Paris, he worked as a restorer in the Egyptian and Chaldaean departments of the Louvre. He was awarded the Prix Fénéon in 1952 and the Prix d'Auvers-sur-Oise in 1957. His first one-man exhibition was held at the Galerie Le Gendre in Paris (1958) and was followed by several others, notably at the Kunstkring in Rotterdam (1962) and the Galerie Beno d'Incelli in Paris (1965). He was represented at the Biennials of Venice (1960) and São Paulo (1965) as well as the Symposiums of Yugoslavia (1964) and Montreal (1964). His work has been exhibited regularly at the Salon de la Jeune Sculpture in Paris. A severe and exact manner replaced the gracefulness that was typical of his first works. At the same time, although he was still as much inspired by nature as before, he abandoned all direct representation; his interpretation of the animal or plant world became allusive. During this period Chavignier worked directly on plaster for casting in bronze, without passing through a preliminary stage with clay. He used great economy of means, was disdainful of obvious effects and possessed a keen sense of the equilibrium of masses. A restrained delicacy, a kind of reserve and modesty in his expression indicate a scrupulous and demanding temperament, while the monumental characteristics of his art have attracted the attention of several

architects, notably Maurice Novarina. In recent years, while a slightly expressionist flavour in his manner disappeared before a colder and more tense plastic vision, Chavignier was learning new techniques: assembling cold, stainless steel, the use of synthetic resins (polyester and polyurethene foam), moulding white concrete and anodised aluminium. In spite of the tension of his forms, they still vibrate with an inner feverishness; for, although there is a fundamental reflectiveness in his development, mood and pantheistic expression have been more compelling factors in it than strictly rational motives. D. C.

CHEWETT Jocelyn. Born 1906, Weston, Ontario. She trained at the Slade School in London (1927–1931), where she learnt modelling, then she went to Paris where she worked for two years with Zadkine, who taught her direct carving and initiated her into the Cubist principles of the analysis of forms. When she returned to England, she married the painter and sculptor, Stephen Gilbert. Among other commissions, she carved two stone groups, six and a half feet high, for a park entrance at Kettering. She returned to Paris in 1946 and decided to settle definitely in France. She was strongly influenced by Brancusi and she gradually turned to abstraction, a geometric abstraction that reduced forms to their essentials. But the change was not completed until about 1950 and was partly brought about under the influence of the Constructivists, Malevitch and Vantongerloo. She used hard stone, like granite and marble, which are suitable for delicate carving and incising and could give her work the severity she wanted. She has contributed to the principal Parisian Salons since 1951

Chillida. Abesti Gogora. 1962-1964. Wood. Museum of Fine Arts, Houston.

and, in 1965, the Institute of Contemporary Art in London held an exhibition of her work. At the moment, she seems to be turning finally towards an architectural form of expression with elementary structures, which are often built up of painted, plywood panels. D. C.

CHILLIDA Eduardo. Born 1924, San Sebastian, Spain. After he had studied architecture at the Madrid School of Fine Arts from 1943 to 1947, he turned to sculpture and worked at first in clay and plaster before he grappled with stone and granite. It was at Paris, where he lived from 1948 to 1951, that he discovered iron, a material perfectly suited to his temperament and artistic aims. After 1959, he hardly used anything else. This metal, which he forged himself and only left the final tooling to assistants, freed his sculpture from the opaque mass and allowed him to make bare, austere constructions that cut unhindered into space. When he returned to the Basque country, he worked at monumental sculptures, notably the gates of the Franciscan basilica at Aranzazu (1954), which he made of old, worn metal with considerable effect. The same year, he held his first one-man exhibition at the Clan Gallery in Madrid. In 1955, he executed a monument to Alexander Fleming for the town of San Sebastian. The influence now of his own country, its landscape, customs and life replaced French influence. Asceticism, or austerity led him to value appearances, not for their own sake, but as the effects of profound and hidden causes. His style became completely abstract; every superfluous detail was eliminated as Chillida gradually laid greater importance on the relationship of forms and rhythms evolving from his sculpture. A large exhibition of his work was

Chillida. Distant murmur. 1958. Iron.

Chlupac

Chlupac. Limestone. 1963.

held at the Galerie Maeght, Paris, in 1955, followed by three others at the same gallery in 1961, 1964 and 1968. His career has been starred with prizes: the Kandinsky Prize (1960), the Carnegie Prize (1964) and the Lehmbruck Prize (1966). Chillida's art is one of the finest examples today of a monumental sculpture that is uncompromisingly modern in its spirit and sensibility. Even his small-scale works have breadth and power.

There is not a trace of extravagance in a style where lanconicism is the predominant characteristic. The enormous iron bars of Chillida's sculptures seem folded, twisted and bent by the hand of a Titan and their plastic symbolism is a restitution, not of life but of its principal, distilled into its quintessence and confined within an irreducible nucleus. D. C.

CHLUPAČ Miloslav. Born 1920, Benesov, Czechoslovakia. He studied sculpture at the School of Decorative Arts in Prague from 1943 to 1948 and has been a member of the May group since 1957. He has contributed to several exhibitions in his own country and abroad (Carrara, Warsaw, Paris). In 1963 and 1964, he took part in the Symposium at Santa Margarethen, Austria, and in 1965 at the Symposium at Vysné Ruzbachy, Czechoslovakia. Chlupač's sculpture is firmly based on the human form; at first it embodied a gesture (*Woman combing her Hair*, 1959), or its relationships (*Mother and Child*, 1961). Then about 1964, he produced his *Faces*, either whole or fragmented, which seem the result of a slow abstraction of appearances. This appreciable refinement of his material and patient wearing away of its hard grain led to the search for a purely elementary, plastic idiom. The three blocks he carved for the Grenoble Symposium in 1967 give the measure of his feeling for space. Their monumental compactness, massive curves and natural lines accentuate their individuality and, at the same time, differentiate their response to light and shade and give a tangible shape to a network of time-space relationships, which are constantly changing.
R.-J. M.

CIMIOTTI Emil. Born 1927, Göttingen, Germany From 1949 to 1953, he trained under Otto Baum at Stuttgart, Karl Hartung at Berlin and Zadkine at Paris.

Clatworthy. Bull. 1956-1957. Plaster for bronze casting.

He soon made a name for himself by winning a number of prizes; among these were the Junger Westen of Recklinghausen and, in 1959, the scholarship of the Villa Massimo in Rome. Besides exhibitions at Munich and Düsseldorf, he took part in the Venice Biennale (1958), the Biennial for young artists in Paris (1959) and the Documenta II at Kassel (1959). Cimiotti began as a figurative artist. Even his works of the years 1958–1960, which look like trembling, ghostly bushes, still derive from groups of people in movement, but they are made unrecognisable by the fusion of the individuals. Since then, his links with reality have weakened. He is trying to achieve, so to speak, a primitive state of the material, as if it had suddenly been solidified in an irregular casting. The products of this have a genuinely plastic form. The movement pours over them, not by sliding continuously or flowing back on itself, but by a combination of large masses and little eddies, alternating with each other. Most of Cimiotti's works have a disturbing side to them; in the onlooker's imagination they become spectres that are whirled into a storm. In them shapelessness is given shape and elevated to the violence of a natural phenomenon. J. R.

CLATWORTHY Robert. Born 1928, Bridgwater, Somerset. He studied at the West of England College of Art and the Chelsea School of Art, London (1944–1950). He held his first exhibition in 1955. Clatworthy's energetic handling of his material has at times almost reached the limit to which expressionistic modelling may be pushed without altogether losing contact with the objective image. The substance of his more rococo figures appears to boil like molten lava. Cloaked figures on horse-back and a man leading a dog are recurrent motifs: Clatworthy has indeed a particular ability to render the nature and movement of animals. The great *Bull*, seen in the Holland Park exhibition, London, 1957, was an impressive 'attempt to discover in plaster an equivalent for the sheer physical power' of its subject. M. M.

COLLA Ettore (Parma, 1899 – Rome, 1968). He was called up during the First World War and had to break off his training at the Academy of Parma. After peace had returned, he went to Paris in 1923, where for some time he attended the studios of Despiau, Laurens and Brancusi. Then during a visit to Munich the following year, he made the acquaintance of Lehmbruch. He did a variety of jobs to earn his living, which included working as a miner in Belgium, a street photographer in Paris and an assistant elephant keeper in Vienna. He returned to Italy in 1926 and contributed to a number of exhibitions at Naples, Rome, Florence and Turin and the Venice Biennale of 1930. In 1935, he carried out his first large commission, a stone sculpture in high relief for the Palace of Agriculture in Rome. His sculpture changed imperceptibly after 1941 from a figurative style

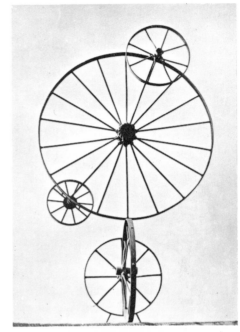

Colla. Continuity. 1961-1963. Iron.
Museum of Modern Art, New York.

to a subtly abstract idiom. After the Second World War, his reputation steadily increased; he was invited to various group exhibitions and in 1953 was appointed to teach at the Institute of Art in Rome. In 1962, he executed for the Spoleto exhibition of 'Sculpture in the City' a *Large Spiral*, an iron sculpture 40ft high, which was placed at the entrance to the town. Two years later, a room was reserved for his work at the Venice Biennale. During the intervening period, from 1959 to 1963, he held several one-man shows in Italy and abroad, notably at the Institute of Contemporary Art, London, in 1959, and at the Stedelijk Museum, Amsterdam, in 1961. Like Julio Gonzalez and David Smith, iron was Colla's characteristic medium, but it was always in the form of industrial waste and pieces of scrap iron, worn beyond recognition, which he fashioned into extraordinary, humorous figures, less like totems than spatial emblems or industrial automatons. Similarly in his reliefs the human figure was replaced by a freer, objective structure, which was unmistakably architectonic and endowed the found object with a new aesthetic value. But, unlike the fortuitous assemblages dear to the Dadaists, Colla's works rose out of a consideration of the relations between form and space and between the elements constituting them. As Calvesi pointed out in the cata-

Colombo

Colombo. Elastic space (Environment). 1966-1968. Ultra-violet light.

the visitor an enjoyment equal to his skill, as he passes through them. He made his first 'situation' at the Venice Biennale in 1968 with objects perceived as luminous structures in space. Other 'situations' consisted of an ambiguous space created by mural projections and flashes of light *(After structures)*, and an 'expanding space', which was the first experiment of the kind in which the light had a chromatic effect owing to the orthogonal and diagonal play of lines. F. P.

logue to the 1964 Biennale, Colla's sculptures do not aim at any kind of 'representation', but exist in their own right, like figures without past or future, that are subtly and maliciously 'present'. G. C.

COLOMBO Gianni. Born 1937, Milan. In 1959, he was associated with Giovanni Anceschi, Davide Boriani and Gabriele de Vecchi in founding Group T. In 1963, he took part in organising the international movement Nouvelle Tendance. Besides several one-man shows in Italy, Germany and Switzerland, he has built environments for the exhibition 'Kunst-Licht-Kunst' at the Stedelijk van Abbemuseum, Eindhoven, in 1966, the Venice Biennale in 1968, where he was awarded the prize for Italian sculpture, and the Kassel Documenta the same year. Colombo is a kinetic artist. In 1960, he experimented with surfaces electronically animated with rhythmic movements *(Pulsating Wall)*. Then he turned his attention to three-dimensional structures and programmed graphic works, before going on to producing 'multiples' (mass-production of a single sculpture) with industrial techniques. In 1962–1964, he studied the effects of artificial lighting, especially when it is projected onto vibrating mirrors. At the same time, he worked on rapidly moving, eccentric structures and was interested in the luminous effects of the rhythmic flashes produced by perforated, rotating screens. His environments are based on the use of light and permutable structures, which require the participation of the observer. They are 'places to be lived in psychically'; Colombo describes an environment as a plastic realisation, constituted by a succession of several 'situations', which should offer

COLVIN Marta. Born 1917, Chillan, Chile. She trained at the Santiago Academy. When she went to Paris in 1948 she had already taken part in a number of exhibitions at Lima, Rio de Janeiro and Bogota. She very soon freed herself from traditional formulas and searched for new forms that would be in harmony with the spirit of South America. Her works mix human and plant forms, in an embryonic stage of their development, until they merge in a dream-like synthesis. In Paris, Marta Colvin joined the Académie de la Grande-Chaumière under Zadkine and then made the acquaintance of Laurens and Brancusi. The revelation of French sculpture turned her art for the moment from its natural evolution. Her first exhibition in Paris took place at the Galerie de Verneuil. When she returned to Chile, she was appointed to teach sculpture at the Santiago Academy. A number of visits to Bolivia and Peru in 1957 encouraged her to widen her knowledge of pre-Columbian art. This return to cultural sources confirmed a manner that was naturally her own. These influences are now imperceptible, but if her work has now definitely become non-figurative, its themes are still taken from the art of primitive America. Since 1958, she has been living in France. Wood was for a long time her favourite material before she began using stone. She has described her attitude to it herself: 'Setting up a stone is a repetition of the millennial gesture, which on the first occasion placed man's defiance of space against the sky. It gives a shape to that space and challenges it by building an invisible architecture of its energies and power. It is the incarnation in a thought of conjugated forces (wood, stone, polyester) of the aspirations of man today, who is destined to master, conquer and penetrate a field of unknown dimensions where he is prospecting.' Marta Colvin held her second exhibition in 1967 at the Galerie de France in Paris and has also contributed, among others, to the Biennial of São Paulo, where she received the Prize for Sculpture in 1965. Her most recent sculptures are assemblages of pieces of wood, dyed with natural pigments and striated with countless fissures, which can be manipulated into different shapes. D. C.

COMBY Henri. Born 1928, Puy-en-Velay. He trained at the École des Beaux-Arts, then at the Académie Ranson in Paris, where he learnt the technique of fresco painting. He was awarded the Prix de la Jeune Sculpture

Colvin. Solar sign. 1962. Bronze.

Giacometti, brought a change over his sculpture that eventually led to abstraction about 1954. He preferred carving to modelling, so throughout this period he used materials like stone, marble and wood. In an attempt to harmonise more completely the form with its surrounding space, he chose an art in which hollows predominated over volumes. After 1955, the terms of the problem were suddenly inverted and he began to create massive constructions, generally carved in wood, which he conceived as a synthesis of general impressions and the natural form. In fact, in spite of their obviously abstract character, his works always derive from some organic, living form, generally the human body. Condé's work has had several one-man exhibitions: in France at the Galerie Breteau (1959) and the Galerie Maywald, Paris (1963); in Germany at Darmstadt (1958); in Switzerland at Berne (1964) and Zürich (1967). He was also represented at the Symposium in Quebec (1966). A few years ago, the techniques of soldering metals drew his art towards a synthesis of sculpture, architecture and landscape. Today, his use of synthetic resins, either directly or by moulding, has produced works with hollows that can be opened or closed, which encourages the observer to come into physical contact with them. His style has in this way become a form of dialectical exchange between outer and inner, seen and unseen, man and his work. D. C.

in 1964 and held his first one-man show at the Galerie Chave, in Vence, in 1967. The technique he used mainly for ten years was direct carving, but, about 1960, he began modelling in plaster as a more suitable medium for experimenting with forms. His style developed remarkably in 1963, when he began using brass and copper, often in the form of the ready-made objects of industrial waste. The malleability of these metals gave his works a precious and unusual quality. Embossing, construction and assemblage were his principal methods of working. His sculptures are generally vertical and look like small triumphal arches, tabernacles or splendidly barbaric chests, which he uses as a means of glorifying the simple, universal themes of sex and death, as well as the fantasy of modern life expressed through objects of our industrial civilisation. Since 1968, aluminium has been Comby's favourite medium; its lack of romantic associations and even its banality are an appropriate expression for the world of today. D. C.

CONDÉ (André Affolter) called. Born 1920, La Chaux-de-Fonds. When he had finished his training at the art school of his home town, he worked for some time as a drawing teacher. Then in 1946, he went to Paris and worked for two years with Germaine Richier. He generally used terracotta at that stage. His first exhibition took place in the museum at La Chaux-de-Fonds in 1949. The profound attraction exercised by the work of

Comby. "Raralias". 1968. Brass.

Condoy

CONDOY (Honorio Garcia) called (Saragossa, 1900 –
Madrid, 1953). When he was fourteen, he began work-
ing in the studio of a sculptor in Barcelona. At eighteen,
he held his first one-man exhibition in Saragossa. He
went for a year, in 1929, to Paris and saw the works of
Laurens, Zadkine, Brancusi and Arp. The use of wood,
which was then his favourite material, explains the
vertical shape of his works. He went in for the Prix de
Rome in 1933 and, having succeeded, went to the Italian
capital where he stayed until 1936. When the Spanish
Civil War prevented him from returning to his country,
he returned to France. It was then that he gave up Cubism,
which he had always accepted and, after 1937, turned to
a sort of psychological realism; it was the period when
he did several busts. At the end of the war, his art
underwent a rather unexpected development; his works
became mannered and acquired an emaciated, precious
style. It was his period of Expressionism in which he
resorted to sculptural features such as holes and sharp
edges while, at the same time, he tried to simplify his
forms. After 1949, his art became increasingly restrained
and evolved its own plastic unity without ever suffering
from stylisation or an arbitrary geometrisation. Condoy
was very ill for a long time and died in Spain, where he
had returned for medical treatment. A retrospective
exhibition of his work was held in 1954, a year after his
death, at the Galerie Galanis, Paris. D. C.

CONSAGRA Pietro. Born 1920, Mazzara del Vallo,
Sicily. He trained as a sculptor at the Palermo Art School.
In Rome, where he settled in 1944, he joined in the

Condoy.
Sculpture.
1950. Wood.

Consagra. Colloquy with time. 1957. Iron.

artistic controversies that followed the end of the war
and, in 1947, founded with some friends, who were
painters, the Forma group, which held his first non-
figurative art exhibition at the Art Club. At that time,
Consagra had already abandoned the expressionism of
his early works. He rejected representational art and
pure aestheticism and committed himself to abstraction,
which, in his own words, 'tries to express the realities of
our age in an objective manner.' He defended this attitude
in *The Necessity for Sculpture*, published in 1952, in
reply to A. Martini's book, *The Dead Language of
Sculpture*. Since his first show at the Galleria Mola,
Rome (1947), several other exhibitions of his work have
been held in Italy and abroad, notably at the Palais des
Beaux-Arts, Brussels, in 1958 and at the Galerie de
France, Paris, in 1959. In 1960, he was awarded the
first prize for sculpture at the Venice Biennale. The works
produced in the fifties that marked a new style, like the
Manifesto for the Future, designed for a public square,
rose vertically in airy frameworks. But soon most of them
spread out horizontally, with flat, superimposed surfaces
in a two-dimensional order. The human figure reappeared
in the form of symbolical persons, either in isolation like
the Greek hero and the model for *The Unknown Political
Prisoner* (1953), or in two groups, connected by gestures
of desire or aggression. When Consagra declared that
'abstraction offers a hope of solving the conflict in life
today between the human and the inhuman', it was
because for him abstract forms were in themselves a
revelation of absolute truths.

So, Consagra chose to express human relationships
in the *Colloquys*, which have almost become his unique
subject since the first version in 1952, endlessly devel-

Constant.
Concert hall for
electronic music.
1960. Plexiglas.

oped and varied in iron, bronze or wood. From the pattern of interpenetrating and separating planes and of lines, which circumscribe and intersect, are born his imaginary figures, in silent communion or restless meeting, in deadly encounter or loquacious gossiping. Their bodies have no substance; they are silhouettes given weight by means that are peculiar to the sculptor and painter. As they inscribe themselves in the space flowing across and through them, these reliefs sometimes seem like open doors and sometimes like huddling, impenetrable walls. After the first, rather stark forms, straight lines and acute angles, the contours became curved and broken, and the concavities predominated over the convexities. The carefully applied patinas covered these compositions with a mysterious overlay. In the bronzes, the lustre of the polished metal merged into the dull parts and the tints of the verdigris were intensified by the glint of the metal beneath. They are often marked with scorches like scars. The lucid, restrained spirit of the earlier works has given place to tragic emotion. H. W.

CONSTANT (Constant A. Nieuwenhuys) called. Born 1920, Amsterdam. In July 1948, he wrote a Manifesto of Experimental Art and, the same year, joined Corneille, Appel and the painter Asger Jorn to found the Cobra group in Brussels. Although he was primarily a painter, he turned his interests to sculpture and architecture at an early stage. In 1958, he elaborated the idea of 'unitary town-planning' in association with G. E. Debord. Painting and sculpture were primarily for Constant a means of sharing in the creation of this global city, the New Babylon, where the man of the future would find his self-expression in purely leisure activities.

He is the only member of Cobra who has contributed to all the arts in some way and he constructed large models of buildings in which spatial ideas, partly derived from Van Doesburg, were embodied and elaborated. He represented Holland at the Venice Biennale of 1966. D. W.

CORBERÓ Xavier. Born 1935, Barcelona. His career began in the years 1955–1960, which coincided with the peak of abstract expressionism. His first works reflect this. They consist of bronze reliefs with uneven surfaces, inlaid with nails and small sticks, which bear a certain resemblance to details of the human anatomy. This romantic period was soon followed by three-dimensional works in a severer, more disciplined style. The break with the earlier manner was complete. His montages and geometric forms were made with an unusual precision in the way he combined transparent materials with elements like metal balls, driven by electromagnetic currents, which traced a variety of figures in space. Their liberty and inventiveness surround these works with an aura of playfulness, which is all the more captivating for the beauty of the materials and the flawless finish of the execution. The idea of play, in fact, dominates all Corberó's sculpture. J. E. C.

CORNELL Joseph. Born 1903, Nyack, New York. Although he attended the Phillips Academy at Andover, Massachusetts, he always refused to bend his natural talents to any traditional mould. He was associated with the Julien Levy Galleries and exhibited there from 1932 to 1943. Since the end of the war, he has held several exhibitions of his works, particularly at New York: Peggy

Coulentianos

Cornell. Construction. Wood, wire and paper.

with infinite nuance both in execution and intention. Thirty years' concentration has created an art as retiring and single-minded as the artist, a distillation of light-hearted, but sometimes melancholy Dada and unsinister Surrealism. R. G.

COULENTIANOS Costas. Born 1918, Athens. He trained at the National School of Fine Arts in Athens and left, when he had qualified, in 1940. In 1945, he went to live in Paris after winning a French government scholarship. The following year, he made friends with Henri Laurens, whose advice helped him to evolve a style that was more taut and disciplined. He adopted the impersonal and unemotional principles of Cubism. From 1948, Coulentianos exhibited regularly at the Salon de la Jeune Sculpture in Paris, but his first one-man show took place at Athens in 1955, followed the same year by another at the Obelisk Gallery in London. For some time now, Coulentianos had been working in iron, combined with elements of lead. His style was now mature and, although his idiom was derived from an interpretation of the natural world, the essence of that world meant so much to him that the form of his works, which became purer and more concentrated, was wholly self-contained. It requires no subject interest or literary appeal, it commands immediately like a fact that,

Guggenheim's 'Art of this Century' Gallery (1944–1945), the Egan Galleries (from 1947 to 1953), the Stable Gallery (after 1953) and the Schoelkopf Gallery (1966). There have been retrospective exhibitions of his work at the Walker Art Center, Minneapolis (1953), the Pasadena Art Museum (1966), the Guggenheim Museum (1967) and the Rose Art Museum, Brandeis University (1968).

Joseph Cornell is an altogether singular artist: by divorcing himself from the changing currents of his time he has attached himself to its main stream. Self-taught, he has learnt the essence rather than the manner, and given his work a timeless quality. His art belongs both to Constructivism and to Surrealism, incompatible traditions, which he has not only succeeded in reconciling, but even uniting. Like members of an aristocratic family his caracteristic offspring always resemble each other, but never anyone else, and always remain entirely themselves. Cornell's sculptures are abstract constructions, arrangements of volume, colour and line, put together with objectivity and dignity, and employing a minimum of means (the curve is rare) and a maximum of restraint. They are also evocative presentations of the trivia of our lives, brought together with poetic freedom, and a subtlety, wit and humour that combine to arrest the attention and compel the imagination. Innocence of vision. both interior and exterior, is mysteriously fused

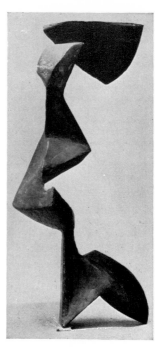

Coulentianos.
Sculpture. 1958.
Iron and bronze.

through the harmony of its proportions and its inmost relations, belongs to the silent world of plastic music. His sculptures, which are so light and airy that they seem weightless, are not only a vehicle for transposing the morphology of the bird, one of the artist's favourite themes, they also express the idea of soaring, momentum and flight. The most remarkable of Coulentianos's recent works is the huge steel sculpture that he made for the Symposium of Grenoble in 1967. D. C.

COUSINS Harold. Born 1916, Washington. Harold Cousins was one of the most satisfying of the group of metal sculptors that was working in Paris during the fifties. The originality of his works lay in the fact that they were always invested with a sense of poetry. One could almost say that Cousins was born to work with metal. As a child, he loved using his hands and already took pleasure in making little mechanical engines. After two years' service in the army (1943–1945), he decided to become a sculptor and, in 1948, joined William Zorach's studio in the Art Students' League at New York. He went to Paris in 1949 and worked for a time as Zadkine's assistant. Cousins gradually gave up working in stone and, in 1950, began using metal as a medium. His works were largely figurative. They often contained a streak of humour and showed a taste for animals, forest and mythological subjects. However, fresh experiments soon led him to use metal rods exclusively, which he welded together as if he were making so many vertebral joints. His skill was such that even the lumps of solder became decorative elements. In the same manner, Cousins produced his famous linear sculptures, rod-like inventions, which, when they are vertical, are like stems shivering in the wind and, when horizontal, like staves of music. If they are fixed to a wall, these compositions acquire depth from the subtle pattern of shadows produced by their complex ramifications. Since 1958–1960, he has tried to combine this linear style with some experiments with compact sculpture in iron, bronze or nickel. This has resulted in perforated masses, shooting out antennae, here and there, that vibrated at the slightest breath. In all his work, whatever it is, there seems to be a memory of the forest. This is the poetic strain mentioned earlier and it is this, too, that sets Cousins apart from other sculptors like Gonzalez, Gargallo or Lardera, who were sculptors in metal before him. J. M.

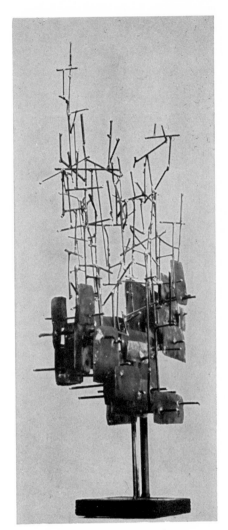

Cousins. Oberon. 1958. Wrought iron.
Dr Werner Haftmann collection.

COUTURIER Robert. Born 1905, Angoulême. None of the artistic training he received before 1928 left any impression on him. On the other hand, his meeting with Maillol took place in this year and their friendship was a lasting one. He was one of his favourite pupils and worked for him in his studio for some little time. In 1937, Couturier received important commissions for bas-reliefs for the International Exhibition. His favourite material at that time was stone. Gradually his full, ample forms changed and he discarded the canons of neo-Classicism. There were already signs of his fondness for attenuated, angular volumes as a means of expression. It was not, however, until 1944 that his art freed itself from the hampering restrictions of traditional realism. The memorable works of this period are a *Leda* (1944) and especially the *Monument to Étienne Dolet* (1947), which the City of Paris has not yet had the courage to put in its place. The daring, plastic conception of this

Couzijn

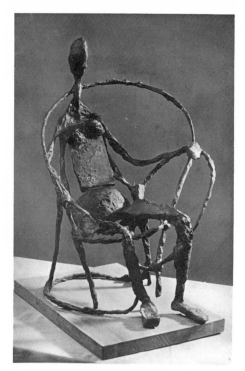

Couturier. Woman in an armchair. Bronze.

COUZIJN Wessel. Born 1912, Amsterdam. When he had completed his training at the Amsterdam Academy, he travelled in Europe. He spent the war years in New York and, on his return to Amsterdam afterwards, his work caused a considerable stir. While the older generation remained faithful to the tradition of Maillol and Despiau, Couzijn had broken away from it after his wide experience with the new tendencies in sculpture, notably the innovations of Lipchitz and Wotruba. Instead of solid volumes, which had been generally accepted till then, he hollowed the mass and made every sculpture into a vigorous and imaginative creation in which the bronze seems to defy the limitations of its weight. In spite of their violent expression, his forms retain a sound armature and are endowed with a powerful and independent organic life. Couzijn has done several relief decorations for public buildings, notably the provincial administrative building of Gelderland at Arnhem. His major work of this kind is a monumental sculpture, 26ft high, 54ft wide and 29ft deep, which has been placed in front of the Unilever Company building (1962) in Rotterdam. Since 1964, he has been making bizarre assemblages combining objects, like wooden furniture or an iron bedstead, with pieces of bronze. He has also constructed sculptures with stainless steel, which have all the vehe-

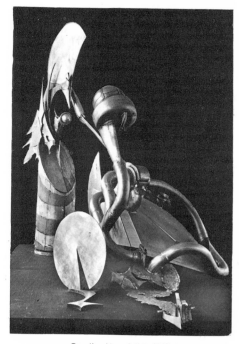

Couzijn. Imperialist. 1968.
Stainless steel and painted wood.

last work caused a scandal, but the artist showed that he was not only capable of achieving monumentality, but had succeeded in escaping the temptation to be decorative as well. After that, it was usual to include Couturier in the French Expressionist school, but this came from a failure to see anything but the elements of a purely emotional language in his plastic distortions. His eventual development belied this judgement. As he felt himself irresistibly attracted towards a sculpture in which space would be inextricably involved, he abandoned stone for plaster, whose malleable qualities were better suited to his imagination and the virtuosity of his execution. His forms tended to become elongated, while they freed themselves from any remaining heaviness of expression (the series of *Fauns*, 1959). A new, surprisingly original style emerged which was tense and graceful, etherial, imaginative and critical.

Couturier was one of the founders of the Salon de Mai. He took part in all the major international exhibitions: the Venice and São Paulo Biennials, the open-air exhibitions of sculpture at Antwerp, Arnhem, etc. He has been teaching at the École Nationale des Beaux-Arts, Paris, since 1964.　　　　　　　　　　　　　　　　　D. C.

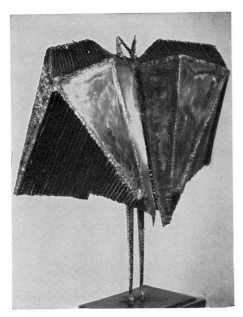

Crippa. Victory. 1958. Brass and bronze.

mence of his bronzes. In 1967, he was awarded the National Prize for the Plastic Arts of Holland.　　D. W.

CRIPPA Roberto. Born 1921, Milan. Crippa was at first a painter and it was not till 1956 that he began to sculpt. Since then, his sculpture has become a natural complement to his painting. The use of iron, specially, enabled him to develop further the conceptions to which he had given two dimensional form some time before in his pictures. From this point of view, his sculpture was, from the very first, an illustration of the aims of the Spatial Movement group which he had belonged to since 1948, with Fontana, the critic Giampiero Giani, and the picture dealer Carlo Cardazzo. A great number of his works, with their inhuman, surreal motifs, are like ancestral fetishes or enigmatic trophies, imbued with some anguished spirit. The virulence of his expressionism seems to have grown gentler in its most recent sculptures and given place to calmer images. His forms have found new life in a fantastic mythology in which the mysterious *Victories* have taken the place of the former *Electric Totems*. A large retrospective exhibition of his sculpture, organised by Victor Brauner, was held in Milan in 1962 at the Galleria Toninelli. Since 1964, Crippa's most important productions have been large mural reliefs and collages in which his use of a variety of thick, often voluminous materials lessens the distinction between painting and sculpture.　　G. C.

CRUZ-DIEZ Carlos. Born 1923, Caracas, Venezuela. He trained at the Caracas Art School (1940–1945), then occupied the post of artistic director of publicity to the firm of McCann-Erikson in Venezuela from 1946 to 1951. From 1958 to 1960, he was assistant director and professor at the Caracas Art School. He has been living in Paris since 1960. Since his first exhibitions at the Signals Gallery, London, and the Galerie Kerchache, Paris, in 1965, his works have been exhibited at the Mendoza Foundation at Caracas (1966) and the Galerie Denise René, Paris (1969). Cruz-Diez is a kinetic artist, who is particularly interested in colour; he directed his attention to the study of changing structures, produced on a plane surface by continuous movement, before he experimented with colour radiation in three dimensions. Having discovered that the addition or subtraction of two colours, red and green, could reproduce the whole chromatic spectrum, he constructed his first *Physichromies* in 1959. These were reliefs composed of strips of cardboard, pointing towards the observer and regularly spaced, which created an interplay of colours between very intense reflections, on the one hand, and, on the other, the impression of expansion on the receptive surfaces adjacent to the pigments. These two sources of colour react on the retina and combine into the colour seen by the eye. More recently, he has been engaged on chromatic environments. In the settings designed by Cruz-Diez, notably at the Maison de la Culture at Grenoble in 1968, the visitor is conditioned by one colour after another as he walks through them, with short rest periods in between. In fact, the artist is less interested in these experiments in conditioning than in the chromatic event and its effectiveness.　　F. P.

Cruz-Diez. Chromo-interference N° 2. 1968.
Plastic, metal, wood and an engine.

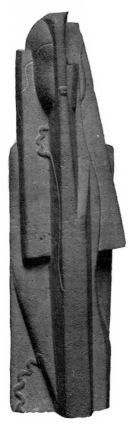

Csaky. Stele.
1929. Stone.

CSAKY Joseph. Born 1888, Szeged, Hungary. He was dissatisfied with the academic teaching of the School of Decorative Arts at Budapest and did not stay long (1904–1905), but soon began to work on his own. His art at that time was influenced by Rodin, whose lyricism, and rejection of all plastic conventions he admired. He went to Paris in 1908 and frequented the free academies more for the sake of the models than the teaching. His style was already developing. He preferred the fullness of Maillol's volumes to Rodin's surfaces with the light scattering over them. However, his admiration for Maillol was not lasting either. He was attracted to avant-garde painters and interested in their experiments. In 1911, he joined the Cubists and took part in the riotous Salon d'Automne and the Salon des Indépendants in the following years. In 1919, he returned from his war service with the French army and settled again in Paris. The following year, he signed a three years' contract with the Galerie de l'Effort Moderne run by Léonce Rosenberg. In 1922, he obtained French nationality. His art had been becoming less representational for some time, but he now returned to the observation and study of nature. His sculpture always retained a thoughtful, intellectual character and traces of a genuinely Cubist spirit remained in it permanently. He was one of the first sculptors to be won over to its principles and he never disowned or abandoned them. In the period between the wars, he took part in the major exhibitions of plastic art in France and abroad, particularly in Germany (1932) and Holland (1933). The strongest influences on his art were from his frequent visits to museums and a visit to Greece (1935). Csaky now considers Cubism the real classical art of modern times. His outstanding qualities are a restrained style, simplicity and clarity in his communication. After using every kind of material, he began to show an increasing preference for extremely hard stone: marble, onyx and crystal. This is why he thinks of himself as a 'carver of images' like the anonymous medieval sculptors. After 1945, bronze seemed to become his favourite medium. In 1956, he completed two large bas-reliefs for an educational institution in Amiens. Since the Liberation, he has been living in seclusion and exhibits very little. D. C.

Csaky. Purity.
1958. Bronze.

d

DALWOOD Hubert. Born 1924, Bristol. He was for a time an apprentice at the Bristol Aeroplane Company. He trained under Kenneth Armitage at the Bath Academy (1946–1949). He went to Italy in 1951 on an Italian government scholarship and stayed for two years. His first one-man show was held at Gimpel Fils, London, in 1954. He has had four other exhibitions since at the same gallery and has been represented at several group exhibitions in the United States and Europe. He represented Britain at the Venice Biennale in 1962. Working in concrete, skin bronze and lead, Dalwood first treated the human figure with unidealised sympathy. The massive women he most frequently depicted in his early work, notwithstanding the grossness of their forms and a certain brutality of treatment, retain dignity, a sense of scale and an undeniable presence as images. Dalwood then began employing aluminium with notable success and came to embrace a certain degree of abstraction in which only the vestiges of symbol or idiogram remain. These works, of which *Icon*, completed in 1958, is an excellent example develop, within a very simple silhouette, a counterpoint of freely executed relief forms that is both rich and subtle. From the late fifties, Dalwood's sculptures became increasingly abstract and hieratic in their forms with such titles as *Throne* (1960) and *High Judge* (1962). Dalwood's work has since become wholly abstract. The *Towers* and *Columns* in aluminium of 1966–1967 are strictly geometric, rectangular shapes, with regularly grooved surfaces, which are sometimes broken and varied with sheets of glass. Their architectural monumentality is surprising rather than convincing, although the perfect finish commands admiration. M. M.

DEGAS Edgar (Paris, 1834 – Paris, 1917). Degas's sculpture is almost entirely overshadowed by his painting for most people. In fact, the artist himself did not try to make it better known. Once only, he sent one of his sculptures to an exhibition. Was this because he did not value them much or that modelling was only a game, an insignificant pastime for him? It is hardly likely when one remembers that he was engaged on it for almost half a century, from 1865 to about 1912, when his eyesight prevented him from doing any more work. On the contrary, it is conceivable that he did not exhibit his

sculptures more, because he realised how daring were his experiments and he wanted to continue them in complete freedom. Whatever the reason, his freedom was so dear to him that he never allowed the exacting conditions of his profession to cramp it. He was self-taught and, although he may have received some advice from his sculptor friends, Bartholomé and Cuvelier, he was determined to be independent, while he naturally used his training and experience as a painter; in fact, his sculpture, painting and drawing show the same preoccupations and the same subjects.

And what were these subjects? Horses, racing generally, dancers, women at their toilet. The horses are trotting, galloping, prancing and rearing. The dancers show off the times of the grand arabesque, fasten their

Dalwood. High judge. 1962.
Bronze for Battersea Park, London.

Degas. Little dancer, aged fourteen years.
About 1880. Bronze and tissue.

tights and examine the soles of their feet. A naked woman gets out of her bath, washes a leg or is seated on a chair, drying her neck or armpit. It is obvious that Degas was seeking for what is unusual and fresh for his sculpture as he did for his paintings. He does not belong to the great family of sculptors who have suggested permanence: it is the momentary attitude, the fugitive gesture that he catches. Nothing could be less rigid than the contours of his works. The curve of a profile, the pattern of a movement made in space matter more to him than mass and the equilibrium of volumes. From all sides, their bodies are thrust and embedded in space so they can control the overbalancing that always seems to threaten them.

The transitory attitudes are paralleled by the apparent spontaneity of the technique. But it is a deceptive appearance, because the uneven, slightly furrowed surface, which the artist deliberately preserved in his works, is a studied stylistic effect and not the result of haste. In this, too, Degas shows himself an Impressionist and has an affinity with Rodin, but the attitudes of the two artists was quite different. Compared to him, Rodin is a romantic for whom the expression of ideas and emotions meant more than the representation of reality. On the other hand, there is no symbolism in Degas's sculpture, not the slightest trace of literary allusion, only a will to show the truth. This realism led him, about 1880, to make the wax model of the *Little Dancer, Aged 14 Years*, then to put a real bodice on it, a ballet dancer's skirt, real shoes and hair, tied round with a silk ribbon. As wax has the colour of fired clay, he even went as far as painting the face. He could hardly have made a more challenging attack on the conventions. And the interesting thing is that, of all his statues, it was this, exhibited in the 1881 Salon, that J.-K. Huysmans hailed as 'the one really modern sculpture', but it obviously made little appeal to the public. Degas himself never followed up this experiment, but it is remarkable that in the twentieth century there is a considerable amount of work that is treated in a quite different spirit, but is constituted of various materials like Degas's statue. As Degas hardly took any trouble to preserve his sculptures, which were executed in the fragile materials of clay and wax, only about a hundred and fifty pieces were found in his rooms of which only about seventy were comparatively intact. These were cast in bronze after 1919. J.-E. M.

DE GIORGI Giorgio (Fassio Giorgio) called. Born 1918, Genoa, where he lived and went to school. His career as an artist began very quietly and remained almost unnoticed for ten years. His name appeared for the first time in 1956 at a national exhibition of religious art. His first one-man exhibition was held in Paris at the Galerie Craven in 1956. After an initial period of expressionism, influenced by the archaism in Negro art, the young artist found a point of equilibrium between Martini

De Giorgi. Relief-composition. 1960. Bronze.

DELFINO Leonardo. Born 1928, Turin. He trained in Argentina, where his family had emigrated. He is now living in France and exhibits regularly in the principal Parisian Salons. He has also taken part in the Symposium of Montreal. His first sculptures in soldered metal were abstract and like emotive arrangements of planes in space. Later on, from 1962 to 1967, the planes closed in on themselves and formed rounded volumes, which often ended in a point, leaving an impression of strangeness and monumentality. The vertical and oblique rhythms of the sculpture always moved in an ascension. Recently he has used synthetic resins. Organic forms have appeared in his sculptures and their previous sensuousness now sometimes appears as a sort of eroticism interpreted in plastic terms. D. C.

DEL PEZZO Lucio. Born 1933, Naples. He studied at the Naples Academy, then joined the Documento Sud group and contributed to the Nuclear Movement before going to live first in Milan, then in Paris. His work lies on the borderline between painting and sculpture in the uncertain zone of objects that he made into assemblages at the beginning of the sixties. His experiments with materials and collages, made of bits of

and the main currents of international art, converging on Zadkine, Reg Butler and Giacometti. With Giacometti in particular, De Giorgio seemed to have a slight affinity. 1957 was an important year. His work was exhibited in Messina at the Exhibition of Twentieth Century Italian Sculpture, then in Rome at the National Gallery of Modern Art and finally in Bologna, where one of the two works presented, *Sculpture 1957*, showed the first signs of a development from figurative art to abstraction. The slow, progressive detachment from the natural object was logical and inevitable. His abstract works not only maintained the dramatic tension already noticeable in his figurative sculptures, they emphasised it by making it more apparent. The abrupt rents in the surface of the material were in keeping with the rough, jagged forms in bronze. De Giorgio was now known and appreciated. The Museum of Rio de Janeiro bought two of his bronze reliefs. His bronze reliefs were an important aspect of his work and include some of his best pieces. Each one of these was a concentrated effort to analyse an emotion, translate it into movement and structure and discipline its disorderly intensity. The reliefs and sculptures of 1959 further emphasised the artist's fluid manner, which was apparent in the works he exhibited in Paris in December of the same year, then in 1961, at the Galerie XXᵉ Siècle. They express a new lyricism: forms escaped from the ocean depths, geological concretions, delirium, visions of stone changed into bronze, a world of plant forms, age old and yet never seen before. G. C.

Delfino. Blazon. 1966. Soldered steel.

Demarco

detritus and waste, only occupied a short phase and was followed by the clear, meticulous style that is associated with his name. He constructed triangles, rectangles, cones and a whole series of elements in the tradition of Metaphysical Painting and gave them a personal meaning. These literary notions never had more than a passing attraction for him and his instincts led him more naturally to the symbols of a world that was half real, half dream, where the signs of menace are as common as the symbols of friendship. The phrase 'inhuman humanism' has been used of Del Pezzo. It was coined in connection with his reliefs, which sometimes achieve an impassive, cold perfection and communicate an almost neurotic anguish, which is crystallised in his work. There is something tense and static about his panoplies of arrows, targets, bright objects and playthings. They would be like the corpses of objects, if they were really objects, but they are more like ideas which Del Pezzo has given the sober shapes of toys, surviving from a childhood that is rather too persistent to be innocent. His reliefs are not dry, conceptual compositions, but special equations, which force us to relearn a language of objects and question ourselves on the difficulties of existence. G. G.-T.

Demarco. Virtual volumes. 1965.

Del Pezzo. Stele N° 2. Assemblage. 1968. Varnished wood.

DEMARCO Hugo. Born 1932, Buenos Aires. He taught painting and drawing at Buenos Aires. His first visit to Paris took place in 1959, then he went to live there permanently in 1962 after the award of a French government scholarship. He exhibited his work at the Galerie Denise René, Paris, in 1961 and 1968. Demarco's kinetic works are concrete illustrations of his notions of space, but an equally keen interest in colour is evident. He first created a group of works in virtual movement, called *Dynamisations*, *Spatial Superimpositions* and *Changing Reflections*, which tried to seize the quintessence of vibrating colour and display its values on different planes. The colours acquired a perceptible movement when they were juxtaposed. But Demarco was soon using real movement and artificial light, especially 'black' or ultraviolet light, as in his section of the 1967 exhibition 'Lumière et Mouvement' at the Musée d'Art Moderne de la Ville de Paris. His various experiments made form appear and disappear, sometimes even modifying the element itself. The appreciation of light and shadow depended on the different speeds of the elements and also the angle of vision. The play of ultraviolet light on spheres, walls, cylinders, vibrating rods and mobile balls creates virtual volumes in space and makes the onlooker 'see the invisible'. F. P.

DEMARTINI Hugo. Born 1931, Prague. He trained at the Prague Academy from 1949 to 1954. He joined the Crossroads movement in 1963 and contributed to its first exhibitions of concrete art held at Prague. Demartini began his career with portraits, but he very soon broke away from tradition and from any attempt to stylise reality, so that by the end of the fifties, his work became more and more abstract. His monumental sculpture in discs of copper for the new station at Cheb and a number of reliefs and objects soldered into the shape of a box belong to this period. The function of art for Demartini was no longer to interpret man and nature, but to contribute to their reciprocal transformation so that society should contain the factors that would activate and quicken the changes in our sensibility. About 1965, he produced plaster reliefs, moulded by semi-spherical units, which were coloured differently and regularly distributed in a quadrilateral pattern, either real or virtual, over the surface. Then the quadrilateral was transformed into shapes like sets of pigeon-holes. These were the ground for a confrontation or juxtaposition, either inside, or distributed over a register, of spherical or semi-spherical volumes, whose perfectly smooth surfaces in chrome metal acted like mirrors. Their reflections of our world in which we are the dynamic motifs, decrease the real space of our familiar gestures and return a fragmented image of our life, leaving us free to imagine the synthesis and anticipate what we shall become. Demartini experimented with mass-produced objects as units and used them a basis for an impersonal, anonymous art, which is directly dependent on industrial technology and associated with architecture and town-planning. This aspect of his activity has produced spherical houses and giant mirrors to reflect the landscape and clouds in the sky. The aim of all his creative 'interventions' is to act effectively on human space and the conditions of our life.

R.-J. M.

DEMOU Dimitrios. Born 1920, Kumaria, Greece. His parents went to live in Romania in 1928, so he trained at the Bucharest Academy. He was awarded the Paciurea Prize in 1948 and won various competitions, notably for a Memorial to Pushkin in 1949. He left Romania in 1963 and, after a study tour of Europe, settled in Venezuela. He has made several fountains in Venezuela, notable among these is the Fountain of Pearls on the Island of Margarita. Since he settled in Venezuela, his art has developed unhindered. He gave up figurative sculpture and made mobile structures, pivotting on themselves so that at every movement, new relations of planes, forms and volumes, opening on imaginary spaces, came into view. They invite the participation of the onlooker; a slight push from his hand can alter their arrangement and give him the glimpse of a work in constant evolution. They have an airy lightness and seem ready to vibrate at the smallest breath of air. The hollows are harmoniously integrated into the whole and the flexibility of their metal ribbons are like writing in space. Demou's sculpture embodies the aspiration to conquer the weight of matter and a nostalgia for the sky; the dream of Icarus returns as a leitmotiv at each stage of his development.

I. J.

DERAIN André (Chatou, 1880 – Chambourcy, 1954). About 1905–1906, when he was painting pictures remarkable for their aggressive Fauvism, Derain began to carve column-like statues or severely geometric caryatids. Then, apart from a few masks he forged during the war from shell cases to amuse himself, he does not seem to have given any serious thought to sculpture until after 1939, when he started modelling again and completed a few works that were cast after his death. These were heads of men and women, rather like the Roman patriarchs of Chartres, Coptic angels or Celtic gods; statuettes, deriving from Aegean art; little high-reliefs influenced by Mesopotamian seals or Benin bronzes and several masks that bear the strongest resemblance to those from Mycenae and the Ivory Coast.

Demartini. Sculpture. 1966.
Chrome metal and lacquered wood.

Descombin

Derain. Man. 1939-1953.
Bronze bas-relief.

various representational subjects (busts, nudes, groups). It was not till 1946 that it turned abstract. The sound technical training he had received as a craftsman served him well and his works emerged immediately from the experimental stage. He admired Mondrian, whom he considered the greatest painter of his time and tried to introduce the Dutchman's ideas into the sphere of sculpture. Descombin belonged to the Espace group and exhibited in the principal Parisian Salons. He stopped using stone, which had been his favourite material for a long time and uses wood, iron, stainless steel, reinforced concrete, aluminium and plexiglas. In 1956, at the École de Dessin in Mâcon, he was put in charge of an experimental class where he taught furniture making and coloured photography. His works and his brilliant personality make him the moving spirit of a real centre of modern art in the district. Descombin became enthusiastic about a process using glass with clear colours, which he invented and called 'dynamystic relief'. It consists of arranging plates of glass against a wall in such a way that the patterns of colour, thrown against it, will change with the light. He executed several monuments, designed sets for a variety of plays and contributed to the Symposium at Grenoble in 1967. He has recently begun using the most modern industrial materials for an individual type of sculpture, which he produced in serial form

All this obviously indicates a deliberate archaism, even primitivism. Sometimes, however, he transcended this refined barbarism and gave a very personal character to his sculpture, as in the large head of a woman, with globular, dilated eyes, thoughtful forehead and lips trembling with sensuality. When André Derain's painting was growing insipid and stereotyped with the unwavering devotion he gave to Raphael, Caravaggio and the Bolognese painters, he despised the sculpture of Donatello, Ghiberti and Bernini, and turned instead to the art of ancient civilisations and exotic races. It is impossible not to feel such a contradiction disconcerting. Derain's sculptures, with their vitality, their freedom of inspiration and technique, their sensitive form and the warmth and intensity that make them live give us the true measure of his powers better than his pictures, where it is painful to see the promises of a genius unfulfilled because of the tyranny of preconceived ideas. F. E.

DESCOMBIN Maxime. Born 1909, Le Puley, Saône-et-Loire. Descombin was self-taught; he learnt the craft of stone-cutting, when he was twelve, then trained his hand with ornamental work. His sculpture developed gradually and, between the wars, he exercised it on

Descombin. Small shell sculpture in steel, 1957, with Dynamystic monofacial relief, 1958.

according to principles he had elaborated in 1949. These works differ fundamentally from 'multiples' in that they require the active and close integration of the sculpture in the life of the community. Descombin's example has opened an original path for the monumental sculpture of the future by solving some of the social problems it raises. D. C.

DESPIAU Charles (Mont-de-Marsan, 1874 — Paris, 1946). Despiau went to Paris in 1891 to train at the École des Arts Décoratifs, then at the École des Beaux-Arts. Rodin with whom he worked in 1907 was the major influence that helped him to develop his personal manner. In spite of this close relationship with Rodin, Despiau's sculpture was so different from the older artist's that it drew attention at first by its restraint, calm and avoidance of emotional gestures. Even a work like the *Seated Man* (1929), which immediately invites comparison with Rodin's *Thinker*, is, in fact, psychologically and stylistically very different. The attitude of the figure suggests determination and not disquiet, the surface is hardly roughened and there is nothing dramatic in the contrast of light and shadow. Despiau's male nudes, as a matter of fact, have a closer affinity than Rodin's with classical Greek statues. Like these, their outlines are slender and lithe and the articulations of the body are only slightly indicated (*Athlete Resting*, 1923; *Apollo*, 1936–1946). His female nudes appropriately have rounded volumes, smooth surfaces and gently curving contours (*Eve*, 1925). They are fairly individualised as well, which distinguishes them from Maillol's especially. Their faces reflect their feelings and states of mind; in short, they are affected to some extent by the most characteristic aspect of Despiau's art, the portrait.

Most of them are statues of young women, not because he was particularly attracted to prettiness, but to the freshness and generosity of faces that time has only lightly marked. All his sitters have a withdrawn air. Among his portraits most richly endowed with an inner life of their own are those of *Line Aman-Jean* (1925), *Mlle Bianchini* (1929), *Princesse Murat* (1934), and *Maria Lani* (1929). It is almost as if these women were absorbed in their own thoughts, listening to their own heart-beats, waiting to catch the tremor of their most intimate feelings. Some of them show a quiet wonder, almost surprise to feel life pulsing within them. The gentlest light surrounds their heads, penetrates their skin, dreams on their cheeks and trembles on their lips. If Despiau reveals the truth about a human being, it is the most delicate and lovable side of that truth. He is unaware of the depths of the soul and refuses to remember the storms that can disturb these looks and destroy the serene purity of these foreheads. He knew how to give his sitters a wonderful dignity and seriousness without making them cold. At a time when avant-garde art had turned away from portraiture and academic art could only appreciate its superficial aspect, Despiau was able

Despiau. Nude, young girl standing. 1925. Musée National d'Art Moderne, Paris.

D'Haese

ous expression of a natural mystery. He made beetle-like creatures out of bronze and sheet-metal. His bronzes are assembled from units, cast by the lost-wax process. They possess an extravagant exuberance, beyond the control of reason, but firmly rooted in life. His major work up to date is the monumental *Song of Evil* (1964, Musée Royal, Antwerp), which has given fresh life and significance to equestrian sculpture. Although D'Haese's art is extremely individual, it belongs to the fringe of a modern movement derived from Surrealism, which must express one aspect of the world today, since young artists from every country have joined it of their own accord without any encouragement from the art schools. But D'Haese's work also belongs to one of the main streams of Flemish art, which flows from Jérôme Bosch to James Ensor and Fritz van den Berghe, a fantastic art in which terror is tempered with humour. F.-C. L.

DIETMANN Erik. Born 1937, Jönköping, Sweden. He trained as a painter at the Malmö Art School. But the limitations of plastic expression in two dimensions left him unsatisfied and in 1963 he began to explore the problems of volume in real space. He then produced a group of constructions that he called 'literary objects', which were simple assemblages or juxtapositions of objects and ready-made utensils, whose ambiguous complexity was calculated to define a complex of associated ideas. Before this, about 1960, he had wrapped his forms in bands of gauze, then strips of sticking-plaster, which hid them mysteriously. Since then, Dietmann has continued to execute what F.T. Bidlake called his 'intellectual, double somersaults' with other

D'Haese. To Lumumba. 1961. Bronze.

to give it a new life and a strength and emotional force that it used to have with the Quattrocento masters.
J.-E. M.

D'HAESE Roël. Born 1921, Grammont, Belgium. He attended evening classes at the Aalst Academy and then joined the École Nationale Supérieure de la Cambre, Brussels, from 1938 to 1942 as a pupil of Oscar Jespers. After this, he worked independently and evolved on his own an individual manner that would express his inner world. He used in turn stone, rivetted and welded iron, sheet-metal and the lost-wax method. In 1954, he won the Young Belgian Sculpture Prize of the René Lust Foundation. He exhibited regularly in Paris at the Galerie Claude Bernard and sent work to several of the important international exhibitions: the Biennials of São Paulo (1953), Venice (1958), Rotterdam (1960) and Paris (Musée des Arts Décoratifs, 1965). D'Haese is astonishingly close to nature, not because he copies her, but because he is in harmony with her and all he creates is alive. His work grows from a fusion of instinct and what could be called chance, but it is even more the spontane-

Dietmann. Still life. 1963.
Objects wrapped in sticking-plaster.

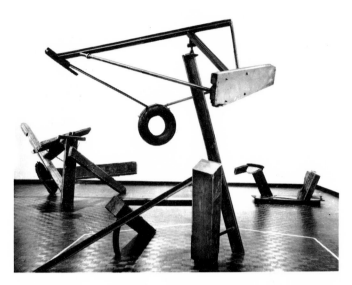

Di Suvero. Zero. 1964.
Wood and steel.
Left: Champion Hank.
1960. Wood and chain.

materials (plexiglas, rubber, etc.), but always with the same imaginative elaboration and construction. He has settled in France and has taken part in various Salons and twice exhibited at the Galerie Mathias Fels (1966 and 1969). D. C.

DISKA Patricia. Born 1924, New York. After studying economics in her own country, she went to Paris in 1947. She was attracted by the plastic arts and at first studied drawing with an engraver and then joined the Académie Julian. Later on she learnt direct carving from the sculptor, Marek-Szwarc. She was invited to send work to the Salon de la Jeune Sculpture in 1955 and afterwards took part in several group exhibitions in Paris and London. She is fond of very hard stone, particularly granite, which she gradually chips and wears away, so that the final effect is of slow erosion. Her art is uncompromisingly abstract. It achieves monumentality by the economy of her planes and volumes, which are simple and at the same time suggestive. Diska's recent development indicates that she is more interested in the form evolved from an inner necessity than in the surface, which she now deliberately leaves rough. She has not given up stone, but also uses expanded polystyrene, for casting in bronze and aluminium, and wood, which she carves with a very free technique. Since her first one-man exhibition at the Galerie Colette Allendy, Paris, in 1961, she has had two further exhibitions in 1965 (Galerie de Coninck) and in 1966 (Galerie Jacques Casanova), also in Paris. Patricia Diska has contributed as well to the Symposiums of Yugoslavia (1961), Israel (1962) and Austria (1966). D. C.

DI SUVERO Mark. Born 1933, Shanghai, China. He emigrated to San Francisco in 1941 and attended the University of California, Berkeley, where he later taught in 1968. He has had one-man shows at the Green Gallery (1960), Dwan Gallery (1965), the Park Place Gallery (1966 and 1967), all in New York. Although Di Suvero belongs to the younger generation, his sculpture is in both concept and manner of execution essentially a development out of the Abstract Expressionism of the New York painters of the early fifties. He works with junk-yard material: old wooden beams, metal rods, tyres, and machine parts. But, unlike the neo-Dadaists, and in consonance with the large-size canvases, the sweep and gesture of the Abstract Expressionist painters, Di Suvero composes on a monumental scale. Typical also, is the deliberately raw and brutal character of his surfaces and the apparent 'injuries' sustained by the limbs of his constructions. These are assemblages, with strong intersecting lines and overlapping planes, which in their thrust, energy, and sense of interlocking directions moving through and controlling space, as well as their apparent savage improvisation, at their best capture in sculptural form the spirit of the New York School of painting of the previous decade. R. G.

DODEIGNE Eugène. Born 1923, Rouvreux, near Liège. French sculptor. He trained at the École des Beaux-Arts of Tourcoing, then the same in Paris. He has been living at Bondues, Nord, since 1949. His first one-man show took place at the Galerie Evrard in Lille (1953). He has exhibited several time since then in Paris at the Galerie Claude Bernard (1958), Galerie Pierre

85

Domela

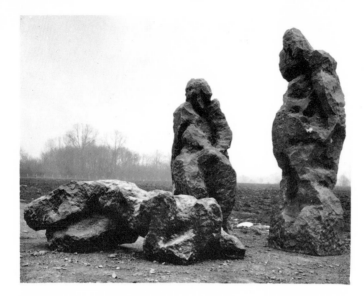

Dodeigne. Man and women. 1963. Soignies stone.

(1961), Galerie Jeanne Bucher (1964); in Brussels at the Palais des Beaux-Arts (1957); in Basel at the Kunsthalle (1964); and in Charleroi at the Palais des Beaux-Arts (1966). He sends work regularly to the Salon de Mai and was represented at the Tokyo Biennial in 1967. Dodeigne learnt the stone cutter's craft in his father's workshop and it was this work in stone that has influenced his present monumental style. Before this, he had done wood carvings of angular figures with fragile joints. They were spectral in appearance and were transfixed in a gesture or action. The natural blemishes in the wood, knots, splits and worm holes, were left conspicuous because of their expressiveness. His stone figures, which he was carving from 1955, on the other hand, are immobile and hidden as if they were swathed in heavy draperies that still give them freedom of movement. They soon became abstract and their massive volumes rose up vertically, twisted by inner contortions or folded back on themselves in horizontal assemblages. The surface of the blue, Soignies stone, which is Dodeigne's favourite medium, is finely polished in sculptures of an intimate nature, but roughly hammered if they are intended for the open air. Since 1962, the human figure has reappeared in his work, treated in an emotive style eventually derived from Rodin. Dodeigne's Men and Women seem whipped by a tempest and siezed in the attitudes of the solitary, when fate weighs heavily upon them. They stand side by side, or in groups of three, absorbed in some common ritual and, in their tragic grandeur, they achieve monumentality. The small, bronze heads and busts have the same disturbing fixity and the same anguish. H. W.

DOMELA (César Domela Nieuwenhuis) called. Born 1900, Amsterdam. He began his career as a painter and, in 1923, his style went abstract; the works sent the same year to the exhibition of the Novembergruppe in Berlin are non-figurative. He made the acquaintance of Mondrian and joined the Stijl movement. His first reliefs were produced in 1929. Their effect depends on contrasts of different materials, such as copper, wood, glass and plexiglas. They were basically linear constructions in round, oval, elliptical or sinuous shapes, which were strengthened or softened by the painted bases. Domela's style, which has remained unchanged, is very individual and is a harmonious combination of the potentialities of both painting and sculpture. Since 1950, Domela has been interested in strictly spatial sculptures. Some are made of metal frames, enclosing rounded elements of wood; others combine copper bars, with sinuous lines, and discs of plexiglas; the filiform sculptures consist of narrow, metal ribbons, of varying thickness, which inscribe their great curves in space and project the play of light and shadow with infinite variations. The quality of Domela's works derives from the way his materials are subjected to the strictest, manual processes to adapt them to his artistic conceptions, which demand a precision and clarity, beyond any pedestrian calculation or reasoning. Since his first one-man show at The Hague in 1924, others have taken place, notably in Paris at the Galerie Pierre (1934), then at the Galerie Denise René and the Galerie Colette Allendy (1949 and 1951). In 1937, he was co-publisher with Arp and Sophie Taeuber of the review *Plastique*. Domela is regularly represented at the Salon des Réalités Nouvelles. Large

retrospective exhibitions of his work have been held at the museums of Rio de Janeiro (1954), São Paulo (1955) and the Stedelijk Museum of Amsterdam (1955).

DONEGÀ Jetta. Born Robbio Lomellina, Italy. She was a pupil of Marini and Manzù at the Albertina Academy in Turin, from 1941 to 1942, and finished her training in 1943 at the Rome Academy. In 1957, she shared an exhibition with the painter, Spazzapan, at the Bussola Gallery in Rome. The same year, she took part in the exhibition of 'Italian Twentieth Century Sculpture' in Messina, Rome and Bologna. There was an important exhibition devoted entirely to her work at the Blu Gallery in Milan. A retrospective exhibition of her work was held in 1962 at the Museum of Contemporary Art, Barcelona, and in October of the same year by the Association of Polish Artists in Warsaw. When she had left Marini and Manzù, Jetta Donega was influenced by the work of some of the leading European artists. Brancusi, Arp and Moore taught her a love of well finished work and beautiful materials, wood, marble or bronze and the forms of her sculpture show her respect for the essential qualities of each material. Each one of her

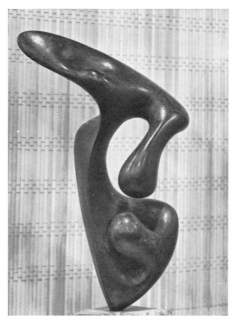

Donegà. Form Nº I. 1954. Bronze.

works is complete and satisfying and possesses an inner rhythm. By 1957, she had established her reputation by sculptures such as *Surviving Goddess, River in Spate, Leviathan.* The deepening significance of some of her plastic subjects led her in the space of two years to the complete abstraction of *Form 1* and *2,* which were shown at the Bronzetto exhibition in Padua. Her sculptures are distinguished by an exquisite grace and an extraordinary nobility; they are the expressions of a culture that she has lived, experienced and shared with others. G. M.

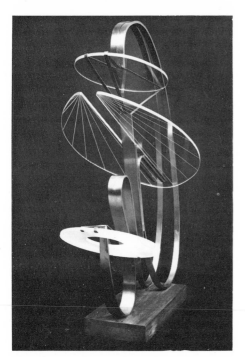

Domela. Sculpture. 1965. Copper and plexiglas.

DUARTE Angel. Born 1930, Aldeanueva del Camino, Caceres, Spain. He trained from 1945 to 1948 at the School of Arts and Crafts in Madrid. He went to live in Paris in 1954. Three years later, he founded Equipo 57 with Agustín Ibarrola, Juan Serrano and Jose Duarte, and joined all the activities of the group until its dissolution in 1965. He has exhibited in Paris, Madrid, Copenhagen, Zürich, Geneva, New York, Baltimore, Brussels and Rome. The purity of their forms and high technical finish drew considerable attention to his works at all the 'Lumière et Mouvement' exhibitions in Paris. Since 1961, he has been living at Sion, Switzerland. Angel Duarte's aim has been to reconcile science and the arts and to make mathematics a creative factor in his sculpture by

Dubuffet

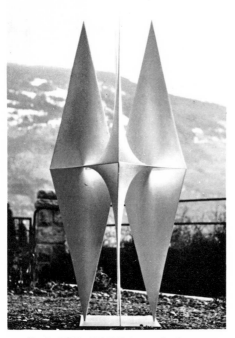

Duarte. E.2AP. 1961-1966. Iron and polyester.

organising space and defining it according to a system of laws that excludes all caprices and chances. His concave-convex forms are the result of experiments that he conducted within the Equipo 57 group on hyperbolic paraboloids. The sculptures grow from a single line, which is displaced according to an exact principle. With their perfect discipline, there is a sort of ambiguity about them; while their volumes are formed by a continuous surface, the symmetry of their equilibrium suggests movement derived from their dynamic constructive element. Duarte went on from the hyperbolic paraboloid, as the structural unit, to a module, composed of several paraboloids, and is now creating non-Euclidean forms, whose clarity of spirit has become a fitting adjunct to contemporary architecture. The most varied materials are used in his sculptures, including wire, steel and glass polyester fibre. Duarte is one of the most important of the optical artists and he has done much to increase the potentialities of sculpture. J.-L. D.

DUBUFFET Jean. Born 1901, Le Havre. It is not surprising that this triturator of *Hautes Pâtes*, the sculptor of *Sols et Terrains* and the *Texturologies*, who of all painters today is the most obsessed with his materials

should have been attracted for a time by sculpture. In 1954, while he continued with his painting, Dubuffet produced about forty statuettes, made of the most unusual materials, which he exhibited at the Galerie de la Rive Gauche with the title 'Little Statues of Precarious Life'. The precariousness was doubtless that of the works themselves, whose days were already numbered. But it would be more correct to say that it applied to the domestic and industrial refuse of vegetables and minerals of which the statuettes consisted, or rather it applied to their purpose and ephemeral existence before they became refuse. *Grouloulou*, the largest of these 'little statues', was three and a half feet high and was made of newspaper, *France-Soir*, as Vialatte pointed out in the preface to the catalogue, *Gigotan* out of Gex scouring pads, the *Spirit of Morvan* out of a vine stock. Dubuffet rummaged in the cinder heaps of an engine depot and carried back clinkers by the basinful from the Montrouge marshalling yard, which he then built up into amusing little figures with Portland cement. Charcoal and soapstone, broken glass and Volvic lava, tattered sponges and bits of string, tow and rusty bolts, even the debris of a burnt-out car, all go to the making of these poetic, gallows-haunting gnomes, which are given titles like *Commander Savonarola*, the *Giddy Thing*, the *Tatterdemalion*. They are, in short, the embodiment of *Figures without Bodies* of 1952. M. C.-L.

At the time, this irruption into the plastic arts seemed an isolated incident, but it had an unexpected and sensational rebound in 1968. Since the *Hourloupe* cycle began (its appearance at the 1964 Venice Biennale caused something of a scandal), a sort of escalation has made Dubuffet progress from painting to sculpture and from sculpture to architecture. After he had created a fauna of disturbing characters against a black background, with the trappings of their occupation (scales, liqueur cabinets, bottles and coffee-pots), Dubuffet seems to have been so fascinated by their vitality that he suddenly saw them escaping from their two-dimensional frame and inhabiting our world, dedicated to machinery and functionalism, with a sort of ironic, ferocious counterpoint.

This was the beginning of his 'Monumentalised paintings', with black outlines and cross-hatchings of white, red and blue, which are really three-dimensional objects, requiring an architecture to their measure. Sculpted in polystyrene, *Fiston la Filoche, Papa Loustic* and *Béniquet Trompette* were soon equipped with all the indispensable accessories for their life on earth: chairs, a kitchen, telephone, chest-of-drawers and a *Table furnished with instances, objects and projects*. But all this implied an appropriate dwelling, whence the large-scale *Buildings*, like the *Castelet de l'Hourloupe*, the *Enamel Garden* and the *Tower of Chantourne*, 85ft high, which he is soon going to erect at Los Angeles for the exhibition of 'Art and Technique', planned by the town museum. These constructions 'of a strictly mental nature', were exhibited in 1969 at the Galerie Jeanne

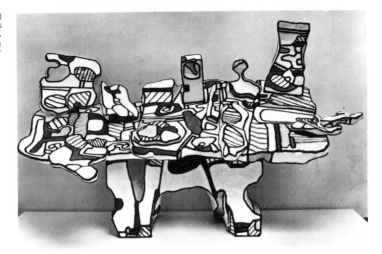

Dubuffet. Table covered with instances, objects and projects. 1968. Monumented painting in polyester

Bucher and the Musée des Arts Décoratifs. They are the product of an odd, wry humour and a rebellious spirit, at times with ambiguous overtones, which Dubuffet has further vented in his pamphlet against the Asphyxiating Culture (1968). R. M.

DUCHAMP Marcel (Blainville, near Rouen, 1887 – Paris, 1968). Marcel Duchamp gave a new dimension to sculpture without ever having made a real sculpture himself, when he introduced the notion of the 'object' into it. With the paintings of the years 1911–1912 *(Nude descending a Staircase, The Bride, The King and Queen surrounded by Swift Nudes)*, he won an important place in twentieth-century painting, lying on the confines of Cubism and Futurism, before he introduced the ready-made in 1913, which made him the authentic precursor of the Dada movement and its revival in Pop Art today. The first object he invented, 'untouched by the artist's hand,' was the *Bicycle Wheel*, fixed by its bracket into a stool, so that it could turn freely. In 1914, he brought a *Bottle-rack* in galvanised iron from a shop in Paris and elevated it to the level of a work of art by simply signing it. In selecting this kind of object, he was not

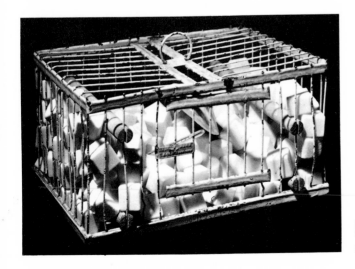

Duchamp. ''Why not sneeze, Rose Sélavy?''. Ready-made. 1921. Marble and wood. Museum of Art, Philadelphia.

Duchamp

Duchamp. Rotating semi-sphere. 1925.

bone. The work was signed 'Rose Sélavy', a phonetic transcription of the common phrase, 'C'est la vie' (It's life).

Marcel Duchamp produced other optical inventions. Besides the mobile object he made in 1920 with Man Ray *(Revolving Glass)*, he produced *Rotating Semi-sphere* in 1925, which was driven by a machine, and the *Roto-reliefs* (1934), which were ordinary gramaphone records decorated with various spirals, which an optical illusion turned into unexpected patterns, as the record turned round. These experiments were not followed up at the time, but they anticipated some of the Optical Art of the sixties. Among the variety of objects invented by Duchamp's fertile brain and insidious imagination were some little erotic sculptures, like the *Female Vine Leaf* of 1950 and the *'Objet-dard'* of 1951, in galvanised plaster, and the *Corner of Chastity* of 1954, in bronze and plastic material. H. W.

guided, as he said himself, by good or bad taste: he simply followed the intuition of the moment. He subsequently gave them titles that were calculated to surprise or disconcert the observer. In New York, where he took refuge in 1915, he exhibited a snow shovel, labelled 'In advance of the broken arm'. The first exhibit he sent to the exhibition of the Society of Independent Artists of New York in 1917 was a china urinal, entitled *Fountain* and signed by the name of a manufacturer of porcelain sanitary equipment, 'R. Mutt'. When the work was rejected, he resigned from the committee organising the exhibition. Besides these ready-made objects, there were also 'corrected ready-mades', like the advertising plaque of the Sapolin company of enamel-makers that he altered to *Apolinère enamelled* (1916–1917). One of the most curious is a knick-knack, placed inside a ball of string, which was itself inserted with four long screws between two plaques of brass, so that the knick-knack made a sound when it struck the metal plaques (*With Hidden Noise*, 1916). All these ideas came to him while he was working on the *Large Glass*, which occupied him for nearly ten years (1915–1923). It indicated his growing interest in machines and his final abandonment of painting in the strict sense of the term. Other ready-mades that should be mentioned are the *Hat-rack*, hanging from the ceiling, the coat-stand nailed to the floor-boards and called *Trébuchet* and a real Dada object, *Why not sneeze?*, which was a bird-cage containing cubes of white marble in the form of ice cubes, a thermometre plunged into the middle of them and a cuttle-

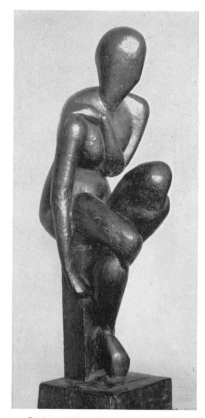

Duchamp-Villon. Seated woman. 1914.
Bronze. Musée d'Art Moderne, Paris.

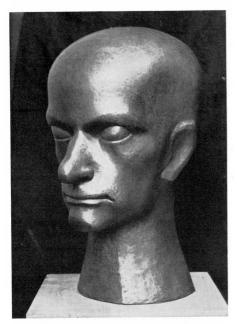

Duchamp-Villon. Portrait of Baudelaire. 1911.
Bronze. Musée d'Art Moderne, Paris.

DUCHAMP-VILLON Raymond (Damville, Eure, 1876 — Cannes, 1918). He was the brother of Jacques Villon and Marcel Duchamp. He began by studying medicine, but left it about 1900 to take up sculpture. Although he trained himself, he developed so quickly that in 1901 he was admitted to the Salon of the Société Nationale des Beaux-Arts. Like many young artists of the period, he was a follower of Rodin, whose influence can be seen even so late as 1907 in the large and sturdy *Torso of a Woman*. Three years later, however, his *Torso of a Young Man*, which is thrown forward with such an impetuous movement, seems to be a challenge, not only to Rodin's *Walking Man*, but to Maillol's *Chained Action* too. Far from creating dynamic movement from a more or less complex analysis of muscular tension, Duchamp-Villon concentrates the different parts of the body into large masses in a subtle counterpoise from which movement springs. After this, he was sure of his way; he continued to liberate his form and make it more and more a synthesis of various elements. His head of *Baudelaire* (1911) is circumscribed by an oval and, although the hollows of the eyes, the nose and the modelling of the cheeks and mouth are clearly delineated, the purity of the line remains unspoiled. Although the sculpture is so simplified, it is nonetheless a vital and unmistakable portrait of the poet with his distinctive features and the complex-

ities of his personality. The next year, Duchamp-Villon modelled the head of a woman, *Maggy*, in which the independence of the form was even further stressed. From the front, the head is like a sphere on a cylinder. Whatever respect and tact he felt for his sitter in the *Baudelaire* has disappeared. The nose, eyes and mouth look as if they have been hewn out. The contrast between convex and concave is sharply accentuated, the edges are hard, the volumes firm and spare and deliberately deprived of any delicacy. It is less like the head of a woman than an idol, confident of herself and her sinister power; in fact, one of the first idols of modern art which was soon followed by many others. Obviously Duchamp-Villon was consciously influenced by Negro sculpture which as we know was admired by the avant-garde artists of the period and especially by the Cubists. At that time, he was an exponent of Cubism himself. He had been a member of the Puteaux group since 1911, which included his two brothers, La Fresnaye, Léger, Gleizes, Metzinger and, in 1912, he held an exhibition with these artists at the Salon de la Section d'Or in the Galerie La Boétie. But his most daring and most important sculpture is the famous *Horse* of 1914, half animal and half machine; some rigid, mechanical parts seem to have come from an engine: others, which are curved, flexible and taut, are like the muscular tension of

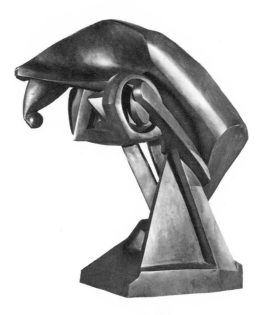

Duchamp-Villon. Horse. 1914. Bronze.
Musée d'Art Moderne, Paris.

Dzamonja

a leaping horse. The disparate elements are unified into an organic, self-contained creation of exceptional originality, which quivers with a powerful dynamism. Nothing could be a truer realisation of the new dominant principle of modern technology, which subjects the resources of nature, only to replace her by greater, harsher and more formidable forces. The war unfortunately interrupted this brilliant career. Duchamp-Villon was called up and, in 1916, caught an infectious disease from which he died two years later. The work, which had come to such a sudden end, included in its small output some of the most significant creations of the beginning of this century. J.-E. M.

DŽAMONJA Dušan. Born 1928, Strumica, Yugoslavia. He trained at the Zagreb Academy from 1945 to 1951. Since his first exhibitions at Zagreb and Belgrade in 1954, he has taken part in several international exhibitions: Venice Biennale (1954 and 1960), Middelheim,

Antwerp (1959 and 1961) and the II Biennial of Paris in 1961. His early works were torsos, which were distinguished by their purity of line, and the calm spirit of their closed forms. His experiments in a more denuded style led him, after 1957, to begin using different materials, which enabled him to open up his sculpture and penetrate to the interior of the form. His use of nails to create a metallic texture in which a lump of uncut glass often glinted was completely original. It did much to help Džamonja towards a new means of expression and gave a fresh stimulus to his invention of abstract forms. Since 1959, Džamonja no longer represents the human figure in his sculpture, but its presence remains. His nails are inserted into a wooden foundation, which is afterwards burnt and reduced to a charred mass, leaving only a spiky shell that suggests in purely plastic terms the presence of torture. His sculptures, with their jagged, tormented symbolism and the unusual rhythm of his austerely beautiful forms, have a monumental character, which always possesses a genuine poetry.

Dzamonja. Sculpture. 1960. Metal and glass.

e

EPSTEIN Sir Jacob (New York, 1880 – London, 1959). He studied in New York and at the École des Beaux-Arts and the Académie Julian in Paris. He moved to London in 1905 and worked there for the rest of his life. In 1907 he was commissioned to carve eighteen figures for the British Medical Association's building in London. The acute controversy which these aroused, was a fore-taste of the abuse and sensationalism that Epstein was to attract throughout his life and are so difficult to appreciate today. It was his misfortune to have had to work in England at a time when sculpture there was almost entirely academic and derivative. In 1911 he was commissioned to carve the tomb of Oscar Wilde for the Père-Lachaise cemetery and while in Paris met Picasso, Brancusi, Modigliani and Paul Guillaume by whom he was introduced to African and primitive carving. In England, he moved for a time in Vorticist circles (*Rock Drill* of 1913 is highly typical of its period) and became a founder member of the London Group in 1913. After that, Epstein always went his own way, essentially un-influenced by and uninfluencing the great contemporary movements. He was indifferent to technical innovation and remained faithful, in one direction, to direct carving on a large scale, and, in another, to modelling with an Expressionist freedom of touch.

The dichotomy between these two branches of his work – there is little formal relationship between them – has always troubled his public. It is the former (*Genesis* 1931, *Ecce Homo* 1935, *Adam* 1939, *Lazarus* 1949 and a memorial to the war-dead of the working classes, 1958, in London are among the best known) which has so often outraged the general public by what has been taken for wilful brutality. These are massive, even un-gainly, works, whose exaggerations and deformations are in part Expressionist.

Unlike his carvings, Epstein's portraiture and modelled groups have found favour by their brilliance and a florid vigour of execution, an almost painterly concern with light and shade and texture: Einstein, Shaw, Conrad, Nehru, Paul Robeson, Yehudi Menuhin and many others. An aristocracy of intellect and of character was, it would seem, that which moved him to the closest sympathy with his sitters when they were men: exoticism of feature and a certain flamboyance of personality when they were women.

He produced at intervals bronzes of a more monumental kind; for example, *Lucifer* (1945), *The Visitation*

Epstein. Madonna and Child. 1952.
Convent of the Holy Child
Jesus, Cavendish Square, London.

(1926), *Christ in Majesty* (1957) and his *Madonna and Child* (1952), commissioned for the Convent of the Holy Child Jesus in Cavendish Square, London, which is accounted by many among his finest works. M. M.

Ernst

Ernst. King playing chess with his queen. 1944.
Bronze. Jean de Menil collection, Houston.

ERNST Max. Born 1891, Brühl, near Cologne. Painting has never been more than one among many means of giving visible expression to his own world, where dreams and visions have the same justification for their existence as real objects and where everyday things wear the most mysterious disguises. Just as he discovered new processes in painting and collage when he felt the need for them, sculpture similarly played a dominant part during certain periods of his development. When in 1919, with Arp and Baargeld, he founded the Dada group in Cologne, he considered that the underlying principle of art was to unite incongruous elements for a blasphemous and deliberately nonsensical effect. In the same spirit as he did his collages, he created three dimensional 'objects', consisting of odd bits of wood and scrap iron, bound together with rope and iron wire. Unfortunately, all these objects, produced in a burst of high spirits, have been lost, except for two reliefs, both called *Fruits of Long Experience,* both made of bits of painted wood, combined in one with fragments of electric bells, and in the other with collages and printed texts. When Max Ernst settled in Paris in 1922, he became known as one of the founders and leaders of the Surrealist movement. It was the period of 'objets trouvés' and, on one occasion in 1927, a single, round pebble,

placed on a velvet footstool, was displayed as an exhibit. But his real interest in sculpture was awakened with his discovery in 1934 of the granite near Giacometti's house in Maloja, in Graubünden. He chose oval stones and incised on them the outlines of fabulous beings, bird-men and frog-nymphs, which peopled the virgin forests of his paintings at the same time. In the same year, he produced extraordinary sculptures, heads and huge symbolical figures with human bodies, like *Oedipus,* his double face symbolising the soothsayer, and *Lunar Asparagus,* tall figures rearing up like signals.

When he was living in the country in Ardèche, he started to decorate his house with sculptures and reliefs on the walls. Later on, he did the same with his house in Arizona where he settled in 1946. There he set up a group of giant figures in cement *(Capricorn),* facing the desert mountains like the totems of ancient races. In between producing these, he worked at a series of bronzes, amongst which were *A Worried Friend,* all covered with geometric plates like shields, and *The King Playing Chess with his Queen,* a proud chief, with horns on his head and his thin arms resting on the table. The willowy figure and polished surfaces of the *Parisienne* of 1950 give it a certain prettiness.

Since his return to France in 1953, Ernst's inventive mind has been as active as ever, producing bronzes that reincarnate the spirit of Dada *(Are you Niniche?,* an assemblage of found objects, two oxen yokes and an engraved plaque), a series of statuettes of gnomes and goblins with wooden heads and webbed feet, and the *Spirit of the Bastille* (1960), which consists of a legendary being enthroned on a high column, covered with dents as if the inscriptions had been effaced by rioters. A stone carver from Huismes, Indre-et-Loire, made some monumental sculptures from Max Ernst's maquettes, notably *Teaching Staff of a School for Killers* (1967), a group of fabulous figures, with cunning expressions on their faces, who are seated or standing in pretentious poses. H. W.

ESTOPIÑAN Roberto. Born 1920, Havana, Cuba. He attended Juan José Sicre's classes at the San Alejandro Academy. After his training, he visited Mexico, Portugal, the United States, France and Italy. On his return, he held regular exhibitions of his work. In 1956, he was awarded the National Prize for Sculpture of his own country. His visit to Europe had a salutary effect on the young artist and after 1954 he was able to free himself from academic rules and traditional notions of composition. His own conceptions led him to give up the more usual materials for welded iron, which he shaped into open forms, rough with angles and sharp ends. Estopiñan's determination to shake off the restraints of figurative art produced figures carved like totems, which were a reflection of the attraction he felt for primitive cultures. The bronze and copper statue of the *Prisoner* (1958) also suggests this. M.-R. G.

Étienne-Martin

Estopinan. Project for a fountain. 1955. Soldered iron.

ÉTIENNE-MARTIN Martin Étienne, called. Born 1913, Loriol, Drôme. He joined the École des Beaux-Arts in Lyons, when he was sixteen, and stayed until 1933, when he went to Paris. There he attended the Académie Ranson under the guidance of Malfray, who was the first to open his eyes to the real nature of his art. He formed a group with a few painter friends, Le Moal, Bertholle, Manessier and the sculptor, Stahly, who all shared his own interests. Marcel Duchamp, whom he met in 1935, made a strong impression on him. There is in him an odd combination of obstinacy and a keen desire for new ideas and his receptive mind is never closed to any fresh influence. His experiments with materials produced wood and string sculptures on the theme of Night, which was to preoccupy him for a long time. He was called up in 1939, captured during the 'phoney war' and released in 1942. He settled at Dieuléfit in the Drôme, where he made friends with the writer and collector, Henri-Pierre Roché. His art has developed considerably since the war. It was distinguished until then by a sort of belligerent modernity; now it tends to show an attachment to the past, not in external appearance, but in its emotional overtones.

From 1944 to 1947, he lived at Mortagne, Orne, with the painter Manessier. Wood was his favourite material, which he used in the form of massive, knotted roots and trunks and carved into contorted or ecstatic forms (*Large Couple*, 1946). Two years after his return to Paris, he was awarded the Prix de la Jeune Sculpture in 1949. He contributed to the principal Parisian Salons and exhibited regularly at the Galerie Denise Breteau. Since 1966, the Galerie Michel Couturier has made bronze casts for the first time of several of his works that were originally in plaster or wood. The same year, he shared the Sculpture Prize of the Venice Biennale with Robert Jacobsen and was awarded the following year the Grand Prix National des Arts. Large retrospective exhibitions of his work have taken place at the Kunsthalle of Berne (1962), the Stedelijk Museum in Amsterdam (1963) and the Palais des Beaux-Arts in Brussels (1965).

Étienne-Martin refuses to accept the alleged divorce between figurative and abstract art. He considers that

Étienne-Martin. Of them. 1956. Wood. Speyer coll., Paris.

Étienne-Martin

abstract art only exists in so far as sculpture is the means of revealing and expressing the unseen and intangible. So every work is its own justification, since it is a unity of subject, invisible and yet present, and its own form. After experiments in cloth sculpture about 1948, which were like tents or curtained beds, these ideas gave birth to the series called *Habitations*, a natural development from the esoteric theme of Night. After this, Étienne-Martin's art was concerned with creating a fundamental unity where contrary concepts, spirit and matter, void and fullness, male and female, might meet. This rather moving search for a unity that has been lost today, far from encouraging him to be satisfied with a facile symbolism, led him to invent subtle, sculptural networks, like labyrinths of organic proliferations, conceived in the image of life itself. These works can be criticised for a certain lack of finish in the less prominent planes and

volumes; the latter, for example, are never polished. This would be a misunderstanding of its significance; in so far as it is an indication of a work's freedom of conception, it gives the artist reassurance of his own liberty and vital independence. Étienne-Martin exercises an important influence on the young generation of sculptors by the severity and originality of his style.

He has been teaching at the American School at Fontainebleau since 1958 and also teaches now at the École Nationale des Beaux-Arts. The year of his appointment to this post (1967), the Éditions Claude Givaudan published a sort of catalogue of his work with his backing, *Abécédaire et autres lieux*. The C.N.A.C. (Centre National d'Art Contemporain) chose Étienne-Martin to inaugurate its premises in 1968 by exhibiting the largest of his *Habitations* ('House no. 10'), real sculpture-architecture, which the visitor can walk through. D. C.

Étienne-Martin. Homage to Lovecraft. 1956. Plaster.

f

FABBRI Agenore. Born 1911, Barba, Italy. He was a student at the Pistoia Art School in 1935, then went to Albisola in Liguria, famous for its ceramics, where he worked as a designer in a factory. He was serving in the army for a long time and did not go back to his sculpture until the war was over. In 1952, he was invited to send work to the Venice Biennale where a room was given over to him. Since then, he has taken part in the most important international exhibitions and held various one-man exhibitions in Europe and America. His training as a ceramist has had a profound effect on his work, even though his recent sculptures have all been cast in bronze. At first, his sculpture was composed of severe, compact masses, clearly influenced by Marino Marini's busts, but when he began working in terracotta (1950–1955), Fabbri turned towards a kind of expressionism, which was already noticeable in his early work, but which left a lasting impression on his later development. His most unusual subject matter consisted of struggling animals, witches, giant insects metamorphosed into terrifying monsters, swarming masses of antennae and hairy legs and Fabbri's peculiar position in contemporary Italian sculpture depends as much on the contents of these involved fantasies as on their plastic qualities. In his recent work, however, he has become concerned with an entirely new and evocative subject, the man of the future, conceived as a fantastic and terrifying being, with countless figurative features, and galvanised by the addition of metallic spikes and antennae, in short, a kind of fanciful robot, born of the human imagination, instead of technical progress. G. C.

FACHARD Robert. Born 1921, Paris. After attending the École des Beaux-Arts in Toulouse, he went to Paris to continue his training and worked in Henri Laurens's studio, which helped to free him from academic conventions. At that period, Fachard used all the traditional materials: wood, clay, marble, stone. He was attracted to monumental sculpture and did various bas-reliefs and large-scale sculptures in the Toulouse region, where, with a few friends, he founded an abstract art group in 1950 and collaborated with Jean Arp. Since 1953, he has taken part in the principal Salons and group shows. His means of expression gradually became more varied and he drew his inspiration from the world of sculptural rhythms instead of from natural appearances. In 1955, he

exhibited his work at the Galerie Simone Badinier and three years later at the Galerie Colette Allendy. At one period, Fachard tried extending the range of his mediums by working on sculptures that he called 'bivalent'. He aimed at combining different textures, volumes and surfaces: marble and bronze, lava rock and cut-out sheet metal. The most usual combinations in his bas-reliefs were slate and bronze. Freed from every element of figur-

Fabbri. Spatial figure.
1959. Bronze.

Fazzini

Fachard. Sculpture. Red sandstone and soldered iron.

ative art, his work then seems to have achieved complete liberty of expression.

Fachard was fascinated by experiments and inventions and, about 1958, he explored the problems of polychromy and its adaptation to carved stone. But it was not till he had examined the technical, structural and expressive potentialities of brass, then aluminium and stainless steel that he discovered his own idiom. It was architectural in spirit, based on planes rather than volumes, and created space within the work itself. D. C.

FAZZINI Pericle. Born 1913, Grottamare, Italy. He began to sculpt in Rome in 1929, while attending drawing classes at an independent academy. After a group of vital portraits, he made an impression with a major sculpture, *Leaving the Ark*. Two large compositions, *The Storm*, in stone, and *The Dance*, in wood, both done in 1934, confirmed his exceptional gifts. A fiery imagination, a rich inventiveness in the composition of his masses and powerful modelling were his outstanding qualities. The same year, 1934, he held an exhibition for the first time in Paris, which was well received. His reputation has grown ever since. The sculpture prize was awarded to him at the Venice Biennale in 1954 and, in 1958, he won the competition for a memorial to the victims of Auschwitz.

His works are a lyrical interpretation of reality, but their objectivity is transcended by a poetical inventiveness and the dynamic thrust and equilibrium of the form in space. Fazzini always achieves a new synthesis between form and subject, whether he is modelling arresting portraits, like those of *Valeria* (1933) and *Ungaretti* (1936), or is creating enigmatic, inscrutable figures like the *Sibyl* of 1947, or nudes in the harmonious attitudes of dance. Since the war, his style has become more sensitive and eclectic and the *Acrobats* (1950), the *Small Horse out of Control*, repeated in *Mounted Herdsman* (1953–1954) and the series of *Cats* (1958) illustrate his characteristically dynamic manner. Notable among his recent works is the sculpted porch (1965) of the

Fazzini. Acrobats. 1952. Bronze.

Fenosa. Storm driven away
by fine weather. 1958.

accepted him on their list of artists and organised several exhibitions for him (1946, 1952, 1956, 1961, 1965). Fenosa is as fluent with large-scale works as he is with small sculptures. They have an imaginative quality now without having lost any of their plastic value and are impregnated with emotional, even sensual feelings, as, for instance, the Nudes which, beneath their elegant but unaffected exterior, are moulded into the rhythms of the plant world. At the same time, he has continued to enlarge his gallery of portraits and, while he was modelling busts of Henri Michaux, Francis Poulenc and Tristan Tzara, he executed a large figure of Christ for Fribourg and a monument at Guingamp. His contributions to the various biennials of sculpture received honourable mention: at Antwerp in 1954, at Carrara, where he was awarded a prize, in 1957, 1959 and 1965, at Yverdon in Switzerland in 1958 and at the Musée Rodin, Paris, in 1966 and 1968. D. C.

FÉRAUD Albert. Born 1921, Paris. He trained at the École Nationale des Beaux-Arts and was awarded the Prix de Rome in 1951. Besides several one-man exhibitions at Paris, Cannes, Lucerne and Bochum, he was represented at the principal Parisian Salons and the large international shows. He has sculpted monuments at Paris, Carcassonne, Toulouse, Marseilles and Arles. Féraud's sculpture became abstract at an early stage. The

church built by the architect Michelucci by the crossroads of the motorway of the Sun and the Florence—Sea motorway. Besides one-man exhibitions in Rome (1943 and 1951) and New York (1952), Fazzini has also been represented in the Biennials of Venice, Antwerp and São Paulo. G. C.

FENOSA Apel'les. Born 1899, Barcelona. After training as a sculptor in Casanovas's studio in Barcelona, he went to Paris in 1921 and stayed for eight years. During this period, he made friends with Max Jacob, Picasso, Cocteau and Supervielle. In 1925, he held his first one-man exhibition at the Galerie Percier and the second at Zborowski's three years later. His favourite materials were then stone and marble. He returned to Barcelona, stayed there from 1929 to 1939 and held three exhibitions at the Galerie Maragall in 1931, 1933 and 1936. He went back to France just before the war and settled permanently in Paris. From that time, he nearly always worked in bronze. His volumes became lighter and were integrated into the general composition with remarkable facility. About 1945, he worked on portraits: *Paul Éluard, Dora Maar, Jean Marais, Cocteau,* etc. and a series of little, graceful, delicate figures. He also did a memorial for Oradour-sur-Glane. The Galerie Jacques Dubourg

Féraud. Sculpture. 1968. Steel.

stone and bronze of his first work were replaced by stainless steel, which was treated in a style appropriate to the nature and potentialities of the material. Féraud's sculpture is composed of a number of elements soldered together and reflects a fertile imagination and a generous spirit. The proliferating forms are well suited to his large-scale sculpture; they give it compactness and exceptional richness and, at the same time, an appearance of light-ness, largely owing to the ambiguous quality of the space within and without. D. C.

FERBER Herbert. Born 1906, New York. When he finished training as a dentist at the City College of New York, he studied sculpture at the Fine Arts Institute of Design. His first exhibition was held at the National Academy of Design at New York in 1930. He held one-man exhibitions at the Midtown Gallery in 1937 and 1943; the Betty Parsons Gallery in 1947, 1950 and 1953; the Kootz Gallery in 1955 and 1957; at Bennington College in 1958; at the Emmerich Gallery in 1960 and 1965. In 1962, the Walker Art Center organised a retro-spective show. He was also represented at the Musée du Jeu de Paume in Paris, in 1938, and the World Fair at New York in 1940. In 1952, he was commissioned to do a large composition for the synagogue in Millburn, New Jersey. For over fifteen years, Ferber has been a very

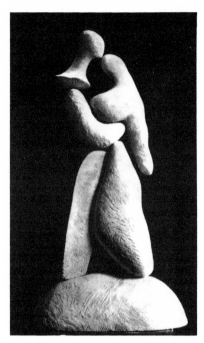

Ferrant. The lovers. 1948. Plaster.

Ferber. Calligraphy on a wall. 1957.

active member of the New York school of abstract Expressionism. He fashioned forms from lead and bronze that were completely abstract and yet were not entirely lacking in psychological or symbolical meaning. It was the use of metal that made him create a sculpture of open forms in which surfaces were reduced to a minimum and space became an essential element. His early works were a sort of stylisation of reality, in a Surrealist manner. About 1950, a marked change came over his work; he freed his art from its last links with reality and his com-position became more rational and airy. His sculptures were built up of slender, elongated forms and inter-penetrating planes of light and space, bound together by curved and vertical surfaces, which suggested fields at harvest time. From his love of spaces, torn by sharp, hard edges, there came a sculpture, so weightless that it seemed inscribed in the sky like a constellation. In 1954, Ferber began to evolve compositions in which the shapes were contained by rigid planes acting in static opposition to interior tension. By 1958, these 'roofed sculptures' had developed into full-scale 'environments' or rooms to be entered, one of which was erected at Rutgers University, New Jersey. In 1961–1962, Ferber created a series of calligraphs in open-work cages; in his most recent work these vertical structures have been replaced by more horizontal forms. R. G.

FERRANT Angel (Madrid, 1891 – Madrid, 1959). He was the son and grandson of painters and taught himself to sculpt. He completed his artistic education by travels in Germany and Italy, with several visits to Paris in between. He spent long periods in Barcelona between 1925 and 1935 and joined two avant-garde groups there, Els Evolucionistes and the Amics de l'Art Nou. Ferrant's style was figurative in the beginning and gradually turned abstract, as in the *Cyclopean Groups* (1940–1950), which have the power of prehistoric, megalithic monuments. His most original work is the articulated reliefs, which he began in 1950. The constituent pieces of wood can be shifted by the observer and Ferrant showed wit in planning their countless variations. In the very last years of his life, he produced a series of more complex works in iron, which were similarly made of several, movable parts that can be arranged in different patterns. Although Ferrant had to fight all his life against misunderstanding, his single-mindedness has been rewarded, like Gonzalez, by the admiration of young Spanish sculptors.

J. E. C.

FILKO Stano. Born 1937, Velké Hradné, Czechoslovakia. He trained at the Bratislava Art School and then took part in various exhibitions in Czechoslovakia and abroad, particularly in Italy and France. After a period of lyrical abstraction, he drew attention to himself with his composite reliefs, made of boxes and screens, bristling outside with points and crucifixes and piled inside with broken mirrors, religious images and erotic photographs. These *Contemporary Altars* (1963–1966) were exhibited as strange and barbaric spectacles, devoted to the violent desecration of sacred and profane fetishes. Filko suggested that anyone could impersonate the celebrant by putting on one of the tunics he had painted with signs and inscriptions, which would make him the 'Living Statue'. Besides these blasphemous and absurd rituals, Filko and his fellow-countryman, Alex Mlynarčik, organised group activities called *happsoc*. These took place twice at Bratislava in 1965 and, in contrast to 'happenings', they were based on a carefully selected, sociological reality. Then in 1967, he expressed his unfailing desire to 'communicate with the outer world' by erecting a three-dimensional arrangement of mirrors, placed on the ground, and transparent veils, hung up on vertical frames. This was his *Universal Environment*, which housed a shadow-play projected by cut-out female figures and the reduced reflections of objects (atlases, chess-games) and real people. The environment was exhibited at the Maison de la Culture at Grenoble in 1968.

R.-J. M.

FLANNAGAN John B. (Fargo, North Dakota, U.S.A., 1895 – d. 1942). Flannagan began as a painter and developed an unusual technique with wax. The painter Arthur Davies encouraged him to sculpt in 1922 and he spent all his time on it after 1927. He gradually produced his humorous, touching, but impressive sculptures of elephants, goats, dragons, cats, lizards, monkeys, frogs and chickens in the following years. Writing one of his irresistible letters, later published by the New York dealer, Curt Valentin, Flannagan said that he sought a sculpture of such 'ease, freedom and simplicity' that it would scarcely seem carved 'but had endured so always.' It might even have been said that the weather had intervened to obtain some of his effects. At the same time, it could be objected that before the year of his suicide (1942), he tended to abuse symbolism in his interpretations of the Rebirth theme. Such work did not show him at his best as a stone-fashioner whose originality, waywardness and unbroken fancy left him an inimitable American of his generation, if not a world figure. J. M.

FONTANA Lucio (Rosario de Santa Fé, Argentina, 1899 – Varzi, Italy, 1968). His parents returned to Italy when Fontana was six years old and he trained at the Brera Academy, Milan. However, this academic teaching did not leave a lasting impression on him. His technical skill and assurance did not depend on any formula or canon; they were adapted unfailingly to the spirit and requirements of the work in hand. In 1930, Fontana broke with all tradition and worked in the same direction as the

Filko. Universal environment. 1966-1967.

Franchina

Fontana. Spatial concepts. 1957. Bronze.

'all physical elements: colour, sound, movement and space in a unity that was at the same time ideal and material.' From the very fact that it 'would contain the four dimensions of existence', this synthesis would abolish not only the barriers between the arts, but also between art and nature; in other words, there was no matter or concrete organisation of space, of any kind whatever, that could not be united in it. Fontana was one of the leaders of a movement that set out to decide on ways and means suitable for overcoming the crisis of rationalism. It aimed at the reinstating the irrational provided that it did not trick itself out with a metaphysic and was capable of conceiving form and giving it a concrete existence, according to its own impulses, and not as happened in Surrealism, according to external stimuli. There would then no longer be any barrier or division between the conception and its realisation, as there is no longer a qualitative difference between play and involvement, terms which constitute the fundamental ideas of plastic problems today.

As time brings his career into perspective and a number of his works and experiments that once caused a scandal are now valued as examples, it is easier to measure Fontana's position as an innovator. Two instances illustrate this: the exhibition of 'spatial surroundings', organised by Fontana in February 1949 at the Galleria del Naviglio, Milan, which showed the first example of what has since been called 'environments'; and the famous white hall at the Venice Biennale of 1966. They indicate that art today is indebted to him for some of its leading principles. N. P.

most important of the avant-garde circles. He was led towards it by the same profound urge that guided all his endeavours till his death. It was this that made him join the Abstraction-Création movement in 1934. However, he never subscribed to the dogmas of 'geometrical' art, the golden number, or the reasoned and rational control of Expressionism. His fundamental principle was liberty. The plastic use of metal, stone, ceramic, precious or common materials, or the simple rent in a canvas always attracted him for their experimental value and, too, as a means of reaffirming all the more insistantly, at the end of every venture, the unfailing validity of a work of art.

From 1939 to 1946, Fontana went on working in Argentina, where he published in 1946 the *White Manifesto*, which was a vague document, but the desire to explore beyond outworn formulas anticipated his later development. On his return to Italy, this development led him to condemn the traditional frontiers between painting and sculpture. He clarified and defined his ideas on spatial problems in various writings, particularly in his *Technical Manifesto on Spatialism* (1947). Fontana declared in it that the moment had come for a synthesis of

FRANCHINA Nino. Born 1912, Palmanova, near Udine, Italy, from Sicilian parents. He spent his childhood and youth in Palermo and then lived in Milan during 1936–1937. Since then, he has lived in Rome. He married the daughter of the painter, Gino Severini. In 1947, he joined the Fronte Nuovo delle Arte and exhibited with it at the first Venice Biennale (1948), after the war. From 1947 to 1950, he lived in Paris in the midst of the avant-garde movements. An exhibition of his work was held at the Galerie Pierre in 1949. Since then, he has taken part in a number of international exhibitions and stands out as one of the leading sculptors in Italy today. His early work was entirely figurative and reflected to a certain extent the influence of Arturo Martini, which was widespread in Italy at the time. Franchina's discovery of the main international currents after the war, as, for instance, during his visit to Paris, must have affected the direction in which his work developed. It was not till 1950 that his experiments culminated in a completely personal manner. He then adopted an uncompromisingly modern, non-figurative' style, distinguished by his use of industrial materials and techniques. At this time, the components of his works were made at a carriage-builder's in Bolzano and these mass-produced industrial products were given a new existence and a unique

Fontana. Spatial
decoration for a
cinema ceiling. 1953.
Detail. Plaster.

character by the sculptor. Works such as *Metallurgy*, in iron and sheet-metal, and *Aerodynamic*, in polychrome sheet-metal, both done in 1953, show how successful was this unusual experiment and demonstrated how stimulating the process had been for the whole work of the artist, even when he gave up these new materials for the traditional use of bronze as in *The Farmer* of the same year. Then the influence of abstract English sculpture infused a new imaginative feeling into his art and added a flavour of his own to the creation of metal sculptures in space, with their fragile forms quivering in the light. Graceful leaves, stirred by the slightest breath of wind, and trembling wings, opened in flight, gave these works the grace and brilliance of mysterious and ephemeral things (*Trinacria*, 1955). It is in this concern for rhythms and their mysterious inflorescence that the great appeal of his art lies, an art that tends more and more to free its materials, gold or silver, iron or other metals, from its own weight so that it is only subject to the caprices of the imagination. The room that was reserved for his work at the 1958 Venice Biennale and his impressive contribution to the São Paulo Biennial in 1959 showed how brilliant his sculpture could be. Franchina, who can produce work worthy of a goldsmith, can also produce distinguished, large-scale sculptures, as, for instance, the 50ft high work in sheet-metal and tubes for Italsider at Cornigliano (*Order 60124*, 1960), or the sculpture he designed for the exhibition, 'Sculpture in the City', at Spoleto in 1962. G. C.

FREUNDLICH Otto (Stolp, Pomerania, 1878 – Concentration camp of Maidanek, Poland, 1943). Freundlich did not decide to devote himself to art till he was twenty-

seven years old during a visit to Florence. He began by painting. In Paris, where he went in 1909, he lived for a time in the Bateau-Lavoir and was a neighbour of Picasso. His first sculptures in plaster were produced then and he exhibited them the following year at the New

Franchina. "Trinacria" (Sicily). 1955. Bronze.

Frink

Secession in Berlin. These masks and heads were not individual portraits, but universal types of the human race, conceived as impressive, compact forms with a monumental symmetry. He did not follow the traditional techniques of modelling, but throughout his career covered the surfaces with a granulated texture of thin plaster appropriate to his monumental type of sculpture. Freundlich returned to Germany in 1914 for ten years, when some important commissions led him to experiment with mosaic and stained glass. He continued painting and produced uncompromisingly abstract work. His art was dominated by a single aim from this period: to give visible expression to the moving, governing forces of the cosmos. It was a theme that he pursued untiringly in his paintings and the two large sculptures on which he worked in 1929 and 1933. His entirely abstract works, which rose from the dual expression of accumulation and dissociation of volumes, showed a courageous and independent spirit for that period. The architectural character of

his style was already very marked; it was dominant in two works of 1934, a high-relief and a 'Mountain-sculpture', which he dreamed of producing on a colossal scale and placing in the country, where it would become identified with nature. While he still kept to his solitary path, Freundlich contributed from 1930 to the exhibitions of the Cercle et Carré, then the Abstraction-Création groups. In 1938, the Galerie Jeanne Bucher in Paris held a large retrospective of his work to celebrate his sixtieth birthday. One of the sculptures, the *New Man*, was used as the cover illustration to the catalogue of the exhibition of 'Degenerate Art' in 1939 organised in Germany by the Nazis. He directed until 1940 the academy of painting, drawing, sculpture and engraving, called Le Mur, which he had opened two years earlier in his studio in the Rue Denfert-Rochereau. There he taught the modalities of a synthesis of the arts, which he had warmly defended in writing on several occasions for its ethical and social value. H. W.

FRINK Elizabeth. Born 1930, Thurlow, Suffolk. She studied at the Guildford School of Art (1947–1949) and at the Chelsea School of Art (1949–1953). She held her first exhibition in London in 1952. Her commissions include a large concrete *Wild Boar* for Harlow New Town, a large bronze *Man and Dog* for a housing scheme at Bethnal Green, London.

Elizabeth Frink is the most notable woman sculptor of her generation in Great Britain. Nevertheless, femininity is not an attribute of her or her manner. She is drawn towards the heroic: the unflinching calmness and strength of the helmeted warrior, the physical energy of the boar and stallion. As befits such images in an age of anxiety, however, they are often instinct with a sense of conflict, mutilation and death. Where these things are not to be read explicitly in the cruelty of beak and claw, in the jagged rhythms of unliving and unco-ordinated limbs, they may be sensed implicitly from the very surfaces of her sculptures. The slashed plaster of her earlier pieces recalled nothing so much as splintered bone; she now handles concrete, an intractible material, with equal bravura; her bronzes, though built up rather than corroded away, have a final surface as brutally rough as those of Germaine Richier's. Frink has shown a particular affinity with, and gift for depicting without trace of sentimentality, animals of all kinds: cats arching their backs in fear, horses rearing, birds dead and alive *(Warrior Bird* 1958, *Winged Figure, Bird Man)*. The human figure has had a minor interest for her until more recently, when the brute force of *Judas Figure* (1963) and *Assassins* (1963) have shown how effectively she could use it as a vehicle for earlier themes. M. M.

g

GABO Naum. Born 1890, Briansk, Russia. He took the name, Gabo, when he was quite young to distinguish himself from his brother, Antoine Pevsner. His father sent him to Munich to study medicine, but he took mathematics and physics instead and learned the techniques of engineering too. His interest in art was already keen and it was further encouraged by visits to Italy in 1912 and Paris in 1913 and 1914, where his brother was living as a painter. There he was in touch with the avant-garde movements and made the acquaintance of Archipenko, in particular. When war was declared, he left Munich for Stockholm, where he was soon joined by his brother. It was then that he did his first sculptures in 1915: a *Head*, a *Bust of a Woman* and a *Torso*, constructed in the Cubist manner and made of bent sheets of material that circumscribed space with their clean lines. The materials he used were sheets of metal, wood, cardboard and celluloid, the same in fact, that Archipenko had been using in France and Tatlin in Russia since 1913, with the avowed purpose of replacing the stone and bronze of academic sculpture with means of expression appropriate to the times. When Gabo returned to Russia in 1917, he took some of his constructions with him and joined Malevich, Tatlin and Rodchenko in Moscow. While Pevsner was appointed to teach painting at the School of Arts and Techniques, the Vchutemas studios, Gabo, who had no official position, gathered round him the students interested in sculpture. The problems of art, its future development and its function in society were discussed in public meetings, where the supporters of a free and independent art were attacked by those who wanted to make practical use of it. Gabo's contribution to the controversy and to the autonomy of art was to draft, in 1920, the famous Realist Manifesto, which his brother signed as well. It was distributed and posted up in the streets of Moscow while the brothers were exhibiting their works in the open air, in the gardens and bandstand of Tverskoï Street. The Manifesto contained the fundamental principles of what has been called Constructivism. Since space and time are the only elements of real life, an art that is trying to grasp the essence of things must be founded on them. The following principles derive from this. Line should not be given

Gabo. Head of a woman. 1916. Celluloid and metal. Museum of Modern Art, New York.

any descriptive value; it should only be used as an indication of the forces and rhythms, peculiar to objects. Volume should be abandoned, because it is incapable of suggesting space; depth and transparency should take its place, since space is, by its very nature, impenetrable depth. Artists should free themselves from the age-old misconception that static rhythms are the only basic elements in a work of art, because kinetic rhythms are essential to express the spirit of modern times.

As an illustration of these principles, Gabo made in 1920 his first kinetic sculpture, a simple steel blade, seventeen inches high, which circumscribed a virtual volume in space once it had been set in motion by an electric motor. These moving components are found again in his model, in glass and bronze, for a monument

Gabo

Gabo. Construction. 1924. Metal and glass.
Yale University Art Gallery, New Haven.

1946) that he was one of the editors of *Circle*, a book on Constructivist art. The next development in Gabo's style was in a series of constructions in which he replaced angular planes by curved surfaces, modelled in an unbroken rhythm. They were delicate networks of light, built up of slender tubes and plastic threads, superimposed on each other. The integration of space was even more successfully achieved in these works than formerly, so that each one of them seems to generate its own light and shade. However, this was only a phase and Gabo afterwards abandoned spherical forms for even more mysterious constructions in which clusters of crystal and alabaster seemed to be enclosed in glass cages. He created extraordinary conjunctions of curved and angular forms, while combining materials as different as aluminium, bronze, steel and gold wire. He even went so far as to use colour, brick red, for example, although this violated one of the principles he had enunciated in his manifesto, which stated that the artist should keep the natural colours of his materials.

Since he settled in the United States in 1946, Gabo has created a number of large-scale monuments while continuing to use light materials. In 1949, he did a sculpture in plastic, for the Rockefeller Center in New York, with iron wire wound round a luminous column in

for the Institute of Physics and Mathematics (1925). He made reliefs on the same principles, which were constructed of pieces of plastic, cut out and superimposed. The transparency of the material extended and intermingled the relations between planes and lines. Sometimes he added spiral tubes, filled with liquid, which increased the reflections of light.

In 1922, Gabo left the U.S.S.R. for Germany, where he stayed ten years, helping Lissitzky and Moholy-Nagy make their Constructivist ideas better known. There was an architectural element in his work that gave strength to its technical processes and in the end became predominant. After the drawings and models for the *Towers*, in 1923, he created the astonishing *Column*, a pure geometric construction in glass, metal and plastic, which is now in the New York Museum of Modern Art. The following year, he did *Monument for an Aerodrome*, which had the same lucidity of construction. In 1927, Gabo and Pevsner did the décor and costumes in steel and transparent materials for *La Chatte*, performed by Diaghilev's Russian Ballet. Two important exhibitions of their work took place in this period: one at the Galerie Percier in Paris, in 1924; the other at the Hanover Kestnergesellschaft in 1930.

In 1932, Gabo settled in Paris, where he shared the activities of the Abstraction-Création group. Three years later he went to England, where, with the German emigrant artists, he did a great deal to make non-figurative art better known. It was during his stay in England (1936–

Gabo. Linear construction in space Nº 2. 1949.
Plastic and nylon.

widely sweeping spirals. The same spirit is reflected in the huge monument he constructed for the Bijenkorf shops in Rotterdam in 1957, which suggests a tree with spreading branches, sheltered by a protective framework of light steel. In the small bronzes that he has done since, the surfaces interpenetrate each other in a continuous movement, which the observer can only follow by turning round the works. Their full effectiveness thus depends on a combination of time and space, which for Gabo are the twin bases of modern art. A large retrospective exhibition of his work was held in 1965 at the Kunsthaus, Zürich, and the Tate Gallery, London. H. W.

GARAFULIC Lily. Born 1914, Chile. Her parents were Yugoslav. In 1934, she went to the Santiago Art School and, in 1936, she sent a remarkable piece of sculpture to the Salon, which was the beginning of a brilliant career. A Guggenheim scholarship enabled her to visit the United States in 1944. She has been teaching sculpture at the Santiago Art School since 1951. Three exhibitions of her work in Santiago in 1944, 1947 and 1949 brought her into the public eye. Important commissions followed: sixteen statues of the prophets, a throne in stone, capitals and mosaics for the Chilean Basilica of Lourdes, two reliefs, twenty-six feet high, for Valparaiso, etc. Lily Garafulic was fortunate enough to begin her career when there was a revival of sculpture in Chile with the work of three artists, Julio Antonio Vasquez, Samuel Román and Lorenzo Dominguez, whose pupil she was. So she had the chance to acquire a thorough training. By some mysterious path through the Latin tradition, she drew her inspiration from remote sources, which gives an almost dramatic flavour to her work. With the years, her work has become distinguished by its restraint and a unified style in keeping with the principles of modern art and her own refined sensibility. It is hardly surprising that she should be counted among the foremost of Chilean sculptors. Her sculpture, which was characterised, at least until 1957, by its human appeal, has recently become abstract and a new phase has opened in a work that is already rich. M.-R. G.

GARCIA-ROSSI Horacio. Born 1929, Buenos Aires. Garcia-Rossi, who lives in France, was one of the founders in 1960 of the Groupe de Recherche d'Art Visuel, in Paris, and contributed to all their exhibitions until the dissolution of the group in 1968. He exhibited at the Rubbers Gallery, Buenos Aires, in 1967. The theme of instability linked with the idea of chance runs all through Garcia-Rossi's work. His experiments were concerned at first with surface texture, then with reliefs and volumes, which he called 'structures', and particularly with light: *Structures with Changing Light, Structures with Colours and a Double Screen.* The *Boxes with Unstable Light* illustrate some of the paradoxes dear to Garcia-Rossi: 'antagonistic' forms like the square and the circle oppose

Gabo. Monument for the De Bijenkorf stores, Rotterdam. 1957. Stainless steel.

Garelli

Garcia-Rossi. Relief with changing light. 1965.

each other on the principle of instability; colours clash while the quality of the light is subjected to 'dialectical' changes (sources of coloured and variable light). In all his experimental work, 'real' and 'unreal' space are simultaneously suggested. He maintains that, unlike the scholar or the simple decorator, his function consists in exploring the realm of the paradoxical. He uses the natural forces of light and movement in a way that is both objective and aleatory in order to create mystery and 'immaterial realism'. F. P.

GARELLI Franco. Born 1909, Diano d'Alba, Piedmont. In spite of his medical training, Garelli turned enthusiastically to an artistic life. His first one-man exhibition was held in 1936 at the Stampa Salon in Turin. Since then, he has been represented in several Italian and international exhibitions (the Venice Biennale since 1948, the Rome Quadriennale, the Carnegie Prize in Pittsburgh, 1958, etc.). He exhibited twice in Paris at the Galerie Rive Droite in 1957 and the following year at the Galerie Stadler. The experience of taking part in the Osaka Festival, in Japan in 1958, left a lasting mark on his experiments. One of his works adorns a modern building in Turin. It offers a masterly solution to the problem of integrating sculpture with architecture. The artist himself has described the principles underlying his work: it is not enough just to interpret the external world in sculptural form; the artist should create a dynamic relationship between them of such a kind that form does not merely contain space, but space creates a series of vital exchanges between the planes and intervening voids. The endless possibilities of integration or disintegration of the form depend on the variations of these different elements and their equal share in the unique

world of the work of art they belong to. The products of these ideas are intensely dramatic metal sculptures that derive their power from an astonishing dialectic of masses and voids. However, not all his works have this anguished, Expressionist quality and there are a number in which the dialectic relationship is quieter, as in some of the large, solitary, vertical figures, symbols of an Olympian serenity and detachment. A retrospective exhibition of his sculptures (1953–1963) was held at the Galleria Blu, Milan, in the summer of 1963. G. C.

GARGALLO Pablo (Maella, Aragon, 1881 – Reus, near Tarragona, 1934). He trained at the Barcelona Art School, which he joined in 1898. In 1911, during his second visit to Paris, Gargallo was shocked by Picasso's Cubist paintings into realising that the sculptor today was faced with new problems just like the painter. He had reservations in this approach to modern art and all through his career one part of Gargallo's work remained faithful to the principles of traditional realism. In fact, whenever he modelled clay, or carved stone and marble, his art had an affinity with Maillol's. What distinguished him from Maillol was the greater importance he placed on the sinuous line of his contours than on the full modelling of the volumes. His nudes, too, had a less universal quality. But, as soon as Gargallo began working in iron,

Garelli. Alciel. 1965. Iron.

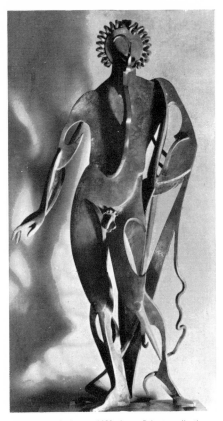

closed form by an open form, the tangible by what is only suggested or understated, and because of this revolutionary attitude, he is counted among the inventors of a modern idiom of sculpture. He was one of the first, twentieth-century sculptors to work successfully in iron, which opened a way to artists, some of whom were more daring than Gargallo but they could not fail to have been stimulated by him. J.-E. M.

GAUDIER-BRZESKA Henri (Saint-Jean-de-Braye, Loiret, 1891 – Neuville-Saint-Vaast, 1915). He was educated at Orléans, studied in England and Germany, then in 1910, decided to devote himself to sculpture. In Paris, he met a Pole, Sophie Brzeska, with whom he left for London in 1911, adding her name to his. In London, he moved in Vorticist circles and exhibited with them and with the London Group. He joined the French army, when war was declared, and was killed in June, 1915, on the Western Front. Such was the rough brilliance of his personality and his promise, coupled with his early death, that there was created about his name a myth that retains its potency to this day. Working with all the incandescent and iconoclastic enthusiasm of youth at an exciting period in the development of western art, Gaudier-Brzeska ran through many influences from a classicism inspired by Rodin *(Dancer)* to Vorticist works

Gargallo. Antinous. 1932. Iron. Private collection.

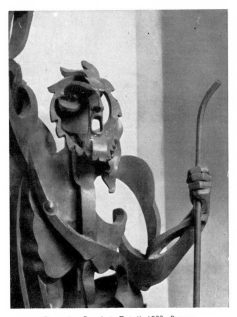

Gargallo. Prophet. Detail. 1933. Bronze. Musée National d'Art Moderne, Paris.

lead or copper, his manner changed. The first metal sculptures he made about 1911–1913 were masks, which had obvious similarities with Negro art. There is something elegant and precious about them and they generally lack any suggestion of terror or numinousness. When, after several years in Spain (1914–1923), Gargallo returned to Paris, his art had matured and he was now able to tackle more complex problems; *Christ on the Cross* (1923), *Dancer* (1924), *Bacchante* (1932), *Harlequin with a Flute* (1927–1932, Musée National d'Art Moderne, Paris) and a *Prophet* (1933, ibid.) are among his finest works. Although his style became increasingly free and expressive, his fundamental conception of sculpture remained naturalistic. Nearly every one of his iron or copper sculptures could have served as the armature for one of his works in clay. But, when he was working in metal, Gargallo would sometimes replace a volume by a hollow or a plane surface, sometimes by a void circumscribed by a line; he would transpose a convex by a concave, a

Gauguin

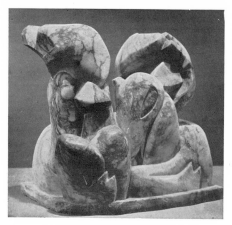

Gaudier-Brzeska. Stags. 1914. Alabaster.
Art Institute, Chicago.

search for something that would resolve the contradictions in him: his refined and yet barbaric taste, and his attraction for a certain elemental ugliness. Once he had settled in Tahiti, Gauguin discovered new means of expression. He had fled from a world, worn out by civilisation, and he found his dream of renewal in the magical and barbaric figures he created. He invented his own popular mythology, not to embody the aspirations of the men around him, but to harmonise the images that obsessed him in that tropical country. He carved wood, either tree trunks or planks, and decorated his hut like a pagan temple. His sculpture was not so much an intellectual invention as a necessary activity for the production of articles used in a familiar cult. He had already carved clogs, walking-sticks and even furniture in Brittany. He used to express his strange personality freely in them. In Tahiti, he became the dedicated workman he had always been, ironical and disturbing, even sarcastic, the creator of authentic pagan divinities. Although whatever he did, his painting remained linked to western art, it is undeniable that his sculpture derived from quite another vision. R. C.

like the portrait of Horace Brodsky. The pioneer quality of his works is still worthy of note today; while a head of *Mademoiselle B* anticipates the qualities of a neo-classical head by Picasso, *Birds Erect* (Museum of Modern Art, New York), *Stags* and the *Red Dancer* are highly abstracted carvings. Gaudier-Brzeska was undoubtedly the most promising sculptor of his generation working in England. M. M.

GAUGUIN Paul (Paris, 1848 — Atuana, Marquesas Islands, 1903). The importance of Gauguin's painting has quite overshadowed the qualities of his sculpture and it is rather unjust to relegate this to a secondary place. In this field as in his painting, it was some time before Gauguin found an individual style that would faithfully reflect the complexities of his temperament and before the skilful amateurism became original invention. He was taught the rudiments of sculpture by a sculptor's assistant, called Bouillot, who lived near him. A respectable bourgeois, a competent clerk and a good father to his family, Gauguin spent his leisure at this time painting, but he also modelled the portraits of his wife and son and one can feel in these faces the scrupulous care he took to make them lifelike. Later on, when he decided to earn his living by painting, he took up pottery, which Chaplet taught him, in the hope that it would offer him opportunities he could not find in painting. This work in ceramics is not without interest and it can be included in a discussion on his sculpture. Even the shapes of his vases have nothing in common with the products turned on the wheel; their volumes are original creations, with the unusual contours of faces, animals and strange objects, while their design is both naïve and complex. They are an expression of his artistic conflict, that restless

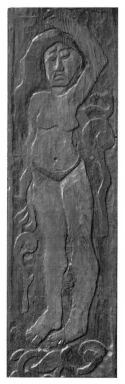

Gauguin. Engraved wood panel. Detail.

of which he is a founder member. He was represented at the Biennials of Tokyo (1963) and Venice (1964). A large exhibition of his work was held at the Palais des Beaux-Arts, Brussels, in 1964. Gentils was strongly influenced by Dada and his first works were simply a means of attacking traditional values in sculpture. His later constructions in wood were generally made from fragments of dismantled objects, particularly pianos, which he reassembled with a genuine artistic sense; the components were completely deprived of their identity in the process. A search for a personal style took the place of his nihilist attitude. Jean Dypréau has described this style very aptly: 'Vic Gentils works like a hypnotist; he plunges objects into an eternal coma to deprive them of their functions.' Assemblage and the production of work in series are his most usual methods. D. C.

GERSTEIN Noemi. Born 1910, Buenos Aires. She trained under the sculptor, Bigatti. She held her first exhibition in 1948 at the Peuser Gallery, Buenos Aires. She stayed in Paris on a French government grant from 1950 to 1951, working under Zadkine's direction at the Académie de la Grande-Chaumière. Since 1955, she has held a number of exhibitions devoted to her works: the Galatea Gallery in Buenos Aires (1955), the Bonino and Héroïque Galleries in Buenos Aires (1957 and 1958). In 1959, the Art Museum of Parana, Argentina, held a retrospective exhibition of her work. In 1960, she exhibited at the Art Institute of Mexico. In 1962, she was awarded the international sculpture prize of the Di Tella Institute. The young sculptor has tried to find a new idiom that would be a better means of expressing the spirit of our

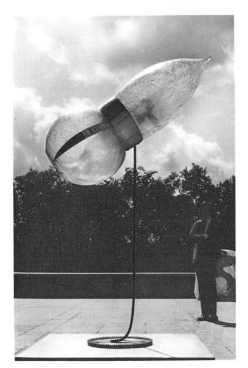

Geissler. The fall. 1968. Polyester and stainless steel.

GEISSLER Klaus. Born 1933, Leipzig. He trained as a painter at the Geneva Art School, then in Karlsruhe and Berlin. There have been several one-man exhibitions of his sculpture particularly in Paris, where he lives, notably at the Galerie Iris Clert, in London and Amsterdam. He is represented at the principal Parisian Salons and exhibited at the Paris Biennial. His sculptures are in metal, shaped into spherical vessels and, through the sidelights let into the outer wall, the observer can see dolls, figurines and other objects, selected for their symbolical value. Subsequently, these sculptures were mounted on springs, so that a gentle push would set them in motion with slow oscillations, like the movement of a pendulum. Geissler now uses polyester laminates instead of metal to model oblong or oval shapes. The aesthetic synthesis of his art is based on the application of optics, kinetics, moulds and sometimes the interior lighting of a mass. D. C.

GENTILS Vic. Born 1919, Ilfracombe, Devon. He is Belgian by nationality and trained at the Antwerp Academy. His first one-man show was held in 1946 at the Antwerp Cercle Artistique. He has sent work to several group exhibitions, notably the Nouvelle École Flamande

Gentils. Relief. 1960. Wood.

Gerstner

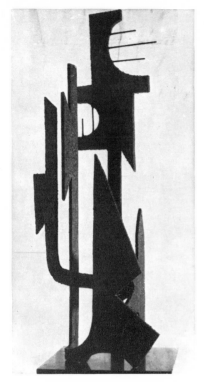

Gerstein. Sentinel. 1957-1959. Iron.

kinetic, but livened with a delicate wit and he was one of the first to realise the importance of programmed art. In practice, he does not perfect anything except the programmes. His first changing paintings (spiral in a right angle) appeared in 1952–1953. In 1962, a friend who worked in industry, helped him to produce an edition of 120 interchangeable paintings. Recently, his luminous and chromatic constructions and environments, which are also programmed, are based on a study of the relations between a given structure and the potential combinations contained in it; for example, his scheme for a permutable lighting, composed of elements that possess varying degrees of brilliance and reflecting power, offers a variety of combinations that are as complex as a game of chess. In fact, for Gerstner, each structure is a unique example among a vast number of possible groupings. There are a thousand different types of realisable order, but on the other hand a hundred thousand types of disorder that we see as a single variation. F. P.

GETTE Paul-Armand. Born 1927, Lyons. He began as a painter and learnt to sculpt about 1959. Before this, he had already held nine one-man shows in France and abroad and had been represented at the Biennials of Tokyo and Middelheim, Antwerp. He has also published

times. As a result, about 1953–1955, she abandoned figurative for abstract art. The art that she had evolved and that had given her a deeper understanding of the things around her and a means of expressing them, was no longer adequate. She replaced traditional materials by new ones; instead of clay and plaster, she preferred iron (wire and sheets), bronze and silver, which enabled her to construct new symbols or a world of plant forms, governed by laws of its own. Noemi Gerstein's style is of her age, but the vibrating undertones of her metal sculptures are peculiarly her own. Her most recent works show a high technical finish in which her experienced craftsmanship and vision are harmonised. M.-R. G.

GERSTNER Karl. Born 1930, Basel. He trained at the School of Arts and Crafts in Basel (1945–1946 and 1949–1950), then at the Zürich School of Decorative Arts (1955), and in 1963 became one of the founder members of the international movement 'Nouvelle Tendance'. He lives in Düsseldorf and has exhibited in Zürich, Paris, Cologne, New York and Tokyo. Gerstner's art is strictly

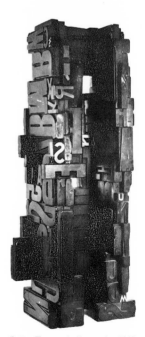

Gette. Tower, hollow ruin. 1962.
Assemblage of wooden type faces.

of Artists in 1963. One of his favourite subjects is the human figure, especially women. He distorts their outlines into forms that are often like peasants' tools. Gheorghita makes innumerable preliminary drawings, so that he can concentrate his attention, during the final execution in stone or wood, on the finish of the work. In spite of its apparent abstraction, the subjects and techniques of his art are deeply rooted in popular tradition. R. I.

GHERMANDI Quinto. Born 1916, Crevalcore, Bologna. He was forty when he began his career as a sculptor, first with pottery, then with iron and bronze. In 1959, he was awarded the international prize of the Bronzetto at Padua and, in 1960, the Venice Biennale reserved a room for his works. His first one-man show took place the same year at the Galleria La Loggia in Bologna. It was soon followed by several others in Naples, Rome, Verona, São Paulo, Copenhagen, Ljubljana and Klagenfurt. Ghermandi teaches at the Academy in Florence. His sculpture is made with the traditional process of cire perdue, but the works themselves, with their antinaturalistic, up-springing line, are most untraditional, yet they preserve a

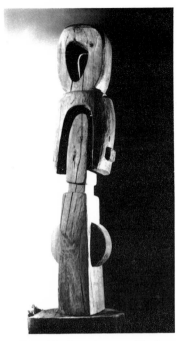

Gheorghita. Peasant woman. Wood.

several collections of poetry. His first sculptures, depending for their effect on the unusual significances created by inverting formal order, were small and consisted of assemblages of lead type-faces. About 1960, he manipulated the wooden type used for posters into larger sculptures. They were based on the same principles as the first, that is, a perversion of the normal purpose of a form and an inversion of optical perception. From 1964, Gette's experiments turned to enlarged, mechanical insects in bronze or polyester; a change in scale took the place of the previous change in function. More recently, he has developed a new formula with his *Crystals*, which consist of crystallised forms that have been cut and engraved by industrial processes and placed on plaques of synthetic resin. One of the peculiarities of these works, which are more like reliefs than free-standing sculptures, is that the verso is the same as the recto reflected in a mirror, so that the observer, who has walked round it, has the impression that he has crossed through it. D. C.

GHEORGHITA Alexandru. Born 1931, Fântânele, Romania. He came from a family of sculptors and craftsmen. He completed his training at the Bucharest Art School in 1956 and was awarded the Prize of the Union

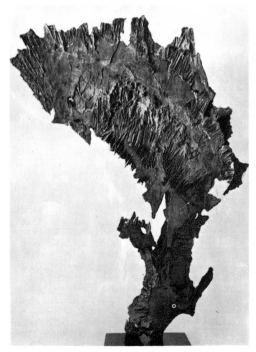

Ghermandi. Last quarter. 1960. Bronze.

Giacometti

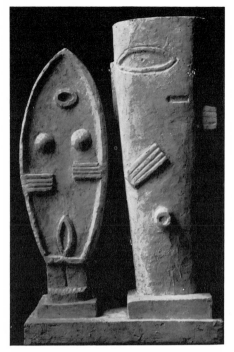

Giacometti. Two figures. 1926. Plaster.

the Tintorettos, before going on to Rome, where he was fired with enthusiasm for Baroque and the ancient Christian mosaics. He went to live in Paris in 1922. Three years of training under Bourdelle convinced him that he would never seize the 'totality of a figure' if he remained too near the model. 'The form disintegrated', he said, 'and was no more significant than particles, stirring on a black, deep void; the distance between one wing and the other of the nose is like the Sahara; there is no limit to it, nothing is firm, everything is in flux . . .' It was then that the strange collection of *objects* and magical constructions were created which the Surrealists were not slow to recognise as the final sculptural expression of the world of dreams and the irrational. As a matter of fact, Giacometti's works between 1925 and 1933 were like elemental symbols or like ideas rising up from the depths of the memory. These sculptures are true fetishes; inscribed in a limited space by a fragile framework, they rise up, solitary figures in an awful void that they seem to create themselves. The titles he gave them (*Hanging Ball* 1930, *Unpleasant Object* 1932, *Hands Holding the Void* 1934) are sufficient indication of what they meant to him. Apart from their enigmatic life, it was above all the spatial relations set up between the objects that interested him. From this point of view, there is nothing more revealing than his *Palace at Four o'Clock in the Morning* (1932–1933). It is a fantastic construction, open on all sides, but filled with delicate, spatial vibrations,

classical, even antique significance and the memory of the outstretched wing of the Victory of Samothrace returns insistently as one looks at them. The surfaces are simple, but they are worked over with meticulous concern for chiaroscuro and vibrating light. The sculptures as a whole are remarkable for their bold extension into space, where they seem inscribed negatively, as the interplay of their outlines and rhythms creates a virtual volume in it, which pulses with a hidden life. G. C.

GIACOMETTI Alberto. (Stampa, Switzerland, 1901 – Chur, 1966). He came from a family of artists – his father, Giovanni, was a well known landscape painter – and he spent his childhood among the forbidding mountains of Graubünden. Northern and southern strains were mingled in the spirit of this Latin Swiss. From the beginning, his interests were varied; he practised sculpture, painting and drawing at the same time. In every sphere there was an outstanding originality about his style. He was only thirteen when he modelled his first portraits. In 1919. he went to the School of Arts and Crafts in Geneva. From 1920 to 1921, he paid a long visit to Italy to study its art during which he spent some time in Venice, examining

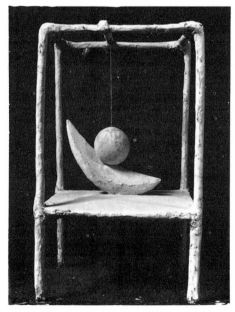

Giacometti. Hanging ball. 1930. Plaster.

which call into play both the relations and the movements of the forms, contrasting immobility with mobility, in the sculptural vision of a building seen in a dream.

It left Giacometti unsatisfied and he decided to study the living model again. 1935 to 1945 was the most critical period of Giacometti's life and, at the same time, one fraught with his deepest experiences. He was searching for an all embracing totality that would reveal the outer significance of the model as well as the inner vision and, with this aim in view, he experimented in all kinds of proportions and distortions. He was appalled as he realised that whatever he saw or felt shrank under the pressure of memory into smaller and smaller shapes. The bust of his brother, Diego, which he had been working on for an interminable length of time, was finally small enough to fit into a match-box with its base. A standing woman became more and more attenuated until, thin as a stick, she was nothing but a fragile, vertical line.

Then again, the problem of movement occupied his thoughts. The image of a walking figure appeared in his work, with gesturing arm or outstretched hand. But he was not interested in the purely physical aspect of movement. This always grew out of an emotional attitude in him and it was always this emotion he communicated to the onlooker. As in Arp's sculpture, a whole world took shape that seemed to come from the furthest depths of human memory. Skeleton hands, their fingers parted, grope in the void like enigmatic signs and, like the red hands painted on prehistoric caves, they gesticulate in magical conjuration. Primitive and modern meet here over the huge tracks of time separating them; the past is united to the present, although this has become a period in which the utilitarian has replaced the sacred.

If the external form of things has little interest for Giacometti, abstraction for its own sake holds equally little appeal. Like Picasso, the emotional reaction to life was always a starting point for him; art and life were continually involved in each other. Breaking his foot in an accident in 1938—a strange coincidence, he thought, among the mysterious incidents of life—necessitated a long spell in hospital. This enforced inaction became an intellectual adventure through which he learnt some remarkable facts about the laws governing balance, walking and upright positions. The wheels and movements of the hospital furniture carrying patients and medicines, the necessity of using crutches for a short time, the plaster which finally encased his foot, were all experiences he later made use of in his works. In trying to find a union between the truth of life and artistic freedom, Giacometti created an entirely new conception of sculpture and its relations with space. Spatial relations were included in the sculpture, an effect that had only been seen before in painting. As Jean-Paul Sartre explained so appositely, it forces the observer to look at it from a distance. Another of its characteristics is that its forms are visually exciting, but never make one want to touch them.

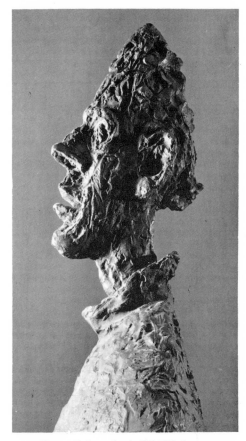

Giacometti. Large head. 1954-1955. Bronze.

Giacometti showed, in a different way from Brancusi, that concave and open forms, enclosing a void, are not the only ones capable of suggesting spatial relations; solid volume can also establish a dynamic relationship with space. What Brancusi achieves by proportion and the light reflecting from his hard, polished forms, Giacometti produces by etherealising the mass and giving it a roughened, porous structure. 'Sculpture rests on void,' he wrote. 'Space is hollowed to build up an object and, in its turn, the object creates space.' To increase the value of this space, he places his statues on heavy, cube-shaped bases that emphasise the fragility of the figure by contrast. These bases are not only used to unify different figures, they increase the feeling of remoteness in the onlooker, in rather the same way as the foreground of a picture acts as foil to the perspective.

If Giacometti had been asked whether he could

Gigon

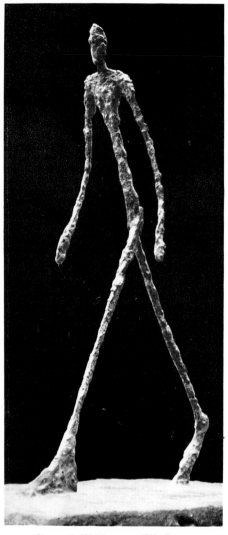

Giacometti. Walking man. 1949. Bronze.

existence. However, the authorities objected when he wanted to do this in Paris.

Giacometti lived a very secluded life. Apart from five years during the Second World War (1940–1945), which he spent in Geneva, he always lived at Paris, with his studio in the Rue Hippolyte-Maindron, in the heart of the XIVᵉ arrondissement, so beloved of sculptors. After the war, he exhibited twice at the Pierre Matisse Gallery in New York (1948 and 1950) and twice at the Galerie Maeght in Paris in 1951 and 1954 and at the Fondation Maeght, Vence, in 1964. He was awarded the first prize for sculpture by the Venice Biennale (1962) and two large retrospective exhibitions of his work were held at the Museum of Modern Art, New York (1965), and the Orangerie, Paris (1969). The success he enjoyed and the fact that he changed the outlook of a whole generation of young artists from every continent made little impression on Giacometti, because he felt that he was always moving on in search of the absolute and each sculpture was only a further attempt to attain it. C. G.-W.

GIGON André. Born 1924, Biel, Switzerland. When he left school, he attended the applied arts department of the Biel Technicum. He began by making pottery and it was not till 1954 that most of his time was given to sculpture. His first works resembled Constructivist art; they consisted of geometric elements, brought together in strict equilibrium and yet they were full of fantasy. They were like the cells of a huge hive, but it was a hive from which some parts could be shaken off by an earth tremor and replaced by others in another position. When they were exhibited at the 1956 Venice Biennale, they excited a good deal of comment and drew attention to the activities of the young artist. Now cement is Gigon's favourite material. It has encouraged him to create simpler, purer forms in which the structure of the composition is more clearly marked. The integrity and strength of these works made the representation of his subjects convincing. The commission for an exterior decoration for the church of Ballaigues, in 1957, gave him the opportunity for an interesting experiment. He was given the *Flood* as a subject. He modelled it in cement and incorporated it directly into the wall by using shuttering. In the space of a few years, Gigon has become one of the finest sculptors in Switzerland today.

GILBERT Stephen. Born 1910, in Fife. He studied architecture at London University, but gave it up for painting. From 1938 until war broke out, he lived in France, and returned there in 1945. After 1948, his painting became abstract and, four years later, the idea behind a series of experiments in form led him to his first three-dimensional polychrome constructions made of duraluminium and steel. After 1953, he gave up painting altogether and devoted his time to sculpture. His former interest in architecture appeared even more clearly in his

imagine his sculptures in an architectural setting, he might have given an evasive answer or even refused to envisage such a possibility. When the opportunity came, he could hardly get used to Father Couturier's proposal, made before 1955, to do ten or fifteen figures for a church. He would have preferred to set up his figures in the streets where the unhallowed comings and goings of everyday life would give reality and dignity to their

sculpture than in his painting. His first works consisted of slender sheets of coloured metal, fixed to a slight framework. In 1957, his manner changed. Sculptures, made of curved elements, which stood erect without an armature and so avoided any impression of weight and opacity, replaced the former straight, perpendicular constructions. As he considered his materials simply a base for polychrome design, they were as thin and slight as possible. He won awards from the Gulbenkian Foundation (1962) and at the Tokyo Biennial (1965) and has had one-man exhibitions in London (Drian Gallery, 1961 and 1963; Hamilton Gallery, 1965) and at the Sheffield Museum (1966). His sculptures today are monumental in conception and made of polyester or metallised board, with simple, smooth volumes and planes, which are both curvilinear and rectangular. He has produced a great deal of monumental sculpture in England, notably in London and for Leicester University.

D. C.

GILI Marcel. Born 1914, Thuir, Pyrénées Orientales. He trained under a Perpignan artist, met Maillol in 1930 and was influenced by him for some time. In 1933, he was represented at the Salon de l'Art Mural in Paris. Later, he was associated with the Abstraction-Création group. In 1935, a crisis in his artistic conscience made him destroy all his previous works. He reversed the usual

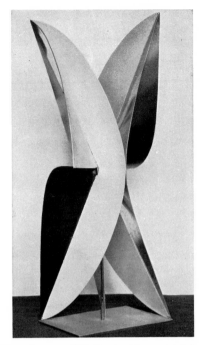

Gilbert. Structure. 1959. Duraluminium, painted steel.

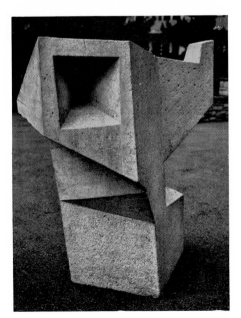

Gigon. Large object. 1958. Concrete.

sequence of artistic development and from then on considered abstraction the first stage towards figurative art. He set out to create sculpture that accepted the laws governing the external world as its starting point. He used terracotta, because it was more malleable than other materials. His main preoccupation in the composition of his volumes, as he modelled their saliences and hollows, was the effect of light and it is easy to detect in this traces of the counter-evolution that led him from abstract to figurative sculpture. In 1943, he became a foundation member of the Salon de Mai. In 1946, he was awarded the Casa Velasquez Prize. His work, which was always austere, has gained a new depth and seriousness. He has done important monuments, among which are a terracotta sculpture, thirty by nine feet high, for Saint-Maur-des-Fossés, and one in wood, nine feet high, for Bourges, called *The Technician*. Gili's medium changed from stone carving to bronze, then to hammering metals (copper and aluminium) and recently he has discovered the sculptural resources of polyester and stainless steel. Since his first exhibition at the Galerie Maurs (1948), he has held two shows at the Galerie Simone Badinier in 1955 and 1965 (series of *Possibilities*). In his ceaseless experiment, his recent works grouped under the title *Gangues* are an endeavour to express the driving forces

117

Gilioli

Gili. Danaid. 1958. Marble.

lines fascinated him. Gilioli belongs to a race born to shape, though in his case an attachment to powerful, if refined, ancient forms is combined with an extremely alert modern sensibility. He works slowly, and patiently leaves his works maturing over the years, abandons them, then returns to them to give the sculpture its final form. His first one-man exhibition took place in 1945 at the Galerie Breteau, Paris. He has been a member of the committee for the Salon de la Jeune Sculpture from its inauguration in 1949 and exhibited his work regularly there until 1966. He has also been represented at the principal Parisian Salons and all the great international exhibitions. The exhibitions he held in the Galerie Louis Carré in 1958 stands out from all these; besides a few gleaming bronzes, there was a series of works in marble, granite, and agate, while the colours varied from turquoise blue to the gleaming white of Carrara and the yellow of Siena. In spite of their flawless surfaces and the care devoted to polishing them, they attracted attention especially by an unexpected quality, the subtlety of an art in which the sculptor was deeply concerned to communicate through the imagination. The shift of a plane would alter the rhythm and counteract any impression of undue smoothness or a too facile appeal that it might otherwise have had. Again the almost geometrical design of certain angles would be abruptly counteracted by an unmistakable return to the asymmetrical. His later works impress the observer through their meditative

within form in a state of permanent fermentation. As Gili follows the process of working from within to without, he practises a sort of natural synthesis in which imagination fashioning material and imagination fashioning form correspond and alternate. D. C.

GILIOLI Émile. Born 1911, Paris. He spent his childhood in Italy and trained at the École des Arts Décoratifs of Nice, then in 1931 at the École des Beaux-Arts of Paris, where he was a student of Jean Boucher. But he very soon discovered the attractions of modern art through the work of Duchamp-Villon and Brancusi, whom he got to know well later on. Demobilised after the collapse of 1940, he settled in Grenoble, where he met André Farcy and the painter, Closon, who had belonged to the Abstraction-Création group. These men enabled him to understand Expressionism and Cubism as a continuation of Cézanne and the so-called Primitives. To a persistent observation of other contemporaries was added, as a counterpoint, a growing admiration for Egyptian, Greek and especially Romanesque art. Still other factors in his development were his meeting with Deyrolle and Dewasne and his subsequent participation in their abstract group, whose work was exhibited at the Galerie Denise René in 1947. As a child, Gilioli recalls that he liked 'the blade of the plough, the curve of a top', which seemed to invite the caress of his hands. He also said: 'When I find a pebble in a stream, it has the same effect on me as the sight of a beautiful woman, a fine tree, mountains or a flower.' In other words, textures, the curve of volumes and the sustained continuity of

Gilioli. Imprisoned bird. 1958.
Baccarat crystal.

Gilioli. Imaginary village.
1966. Marble.

quality, their austere grace and sure sense of the monumental (*Beggar*, 1962; *Appearance of the Virgin to Bernadette transformed into a Bell-tower*, 1964). The last of these characteristics were already a notable feature of the Memorial at Voreppe (1945), the Memorial to the Deported of Grenoble (1950) and the Reclining Figure at Vassieux in the Vercors (1952). *Prayer and Strength*, an impressive sculpture in cement, which he worked on from 1959 to 1963, and the Fountain, which he has just completed for the Hôtel de Ville at Grenoble, are further examples of this monumentality. His varied experience as a cartoon designer for tapestry has recently induced him to colour some of his works, like the *Spanish Woman*, which, in the original plaster, is painted with a strong red and a deep black. The retrospective exhibition at the Palais Galliera, Paris, in 1968, offered an opportunity to assess the recent developments of the artist; its plain-chant lacks neither measure nor rigour. Gilioli has made his profession of faith and described his experiences with complete simplicity in *la Sculpture*, published in 1968. R. M.

GIMOND Marcel (Tournon, 1894 — Nogent-sur-Marne, 1961). When he had finished his training at the École des Beaux-Arts in Lyon, he worked first with Renoir in 1916 at Cagnes, then with Maillol, but he owes his real training to himself, to his patient observation and conscientious workmanship. He gave up large sculptures quite soon (very refined and elongated female nudes) and devoted himself exclusively to the portrait. He was a tireless worker and never stopped drawing and modelling; in the solitude of his studio, he went back again and

again to the same face, in an attempt to find a purer synthesis. Then he would call back the model to compare his own work with the original, before he finished the work without a witness in the human face that had served as a pretext for his own thought. It is understandable that his finest sculptures, produced in these

Gimond. Bust of a woman. Bronze.

Giorgi

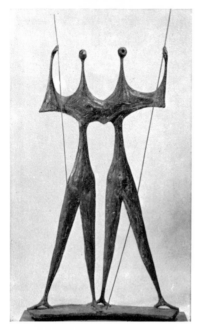

Giorgi. Figures. Bronze.

conditions, have an etherial and timeless gravity and seem, like some Egyptian statues, withdrawn into their own mystery. Of all the sculptors today who belong to the classical tradition, Marcel Gimond was unquestionably one of the most exacting in relation to his art. R. C.

GIORGI Bruno. Born 1908, Mococa, Brazil. He lived for a long time in Europe, mainly in Italy, then in France, where he trained with Maillol and was closely connected with the leading personalities of modern art. He held a one-man exhibition of his works in the City Hall in Rio de Janeiro in 1948 and another in 1950 at the Museum of Modern Art in São Paulo. He was represented at the Venice Biennale (1950 and 1952) and the São Paulo Biennial (1951 and 1953). He worked regularly with modern Brazilian architects and a good deal of his sculpture has helped to decorate their buildings. One of his most striking sculptures is the *Monument to Youth* in the gardens of the Ministry of Education in Rio de Janeiro. The whole of Bruno Giorgi's work can be divided into nudes and portraits. His early works were strongly influenced by Maillol but, about 1947, a change came over them and the voluptuous, imposing curves were replaced by forms, whose extremely simplified outlines were intensely vital. His figures became almost threadlike; they were reduced to a basic shape, which was

stretched out and distorted, with huge shoulders and a minute head. This natural development in his work has connected him with the experimental manner of several other contemporary sculptors. However, Bruno Giorgi cannot be claimed by any particular school; his art is constantly developing and he refuses to be limited by any theories. He is an indefatigable worker and his studio is crowded with his sculptures in plaster, granite, marble and especially bronze, which form the bulk of them. M.-R. G.

GISIGER Hans Jörg. Born 1919, Basel. He studied medicine before learning sculpture from a former studio assistant of Rodin's. He gave up the figurative style of his early heads and figures carved in stone and turned to abstraction in 1954, with simplified, geometric forms. The subjects were symbolic, like *Ulysses' Tomb*, a spectral ship, with a restrained and significant outline. After 1955, he worked in metal only. His sculptures gained in breadth and their lines became more elegant after he had equipped his studio with modern machinery so that he could carry out precision cutting and soldering of very thick sheet-steel. One of his favourite subjects is *The Couple*, purely abstract compositions of forms interlocking with each other of which one of the last versions has fully modelled surfaces with a trelliswork pattern. In

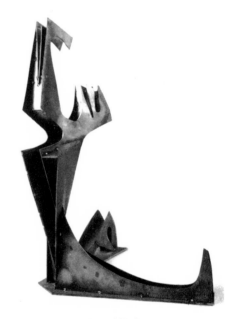

Gisiger. Tree. 1968. Sheet-steel.

120

other works, however, he experiments with contrasting curves and straight lines and smooth planes against coloured or slightly structured surfaces. In the early sixties, the compact blocks disappeared, his sculptures acquired greater breadth and refinement and he gave an astonishing flexibility to the hard, resistant substance of steel. Lanceolate forms and strange flowers, composed of clusters of square rings, rise from the enveloping leaves of *Vegetal* (1966) and *Orchid* (1969); the abstraction of *Tree* (1968), a restrained sheaf of pointed, jagged branches, is the same as in mythological figures like the *Archer Heracles* (1967), who accomplishes his perilous act in a skilfully balanced, acrobatic movement. Gisiger designed huge mural decorations for buildings in Lausanne and Geneva in 1958, which spread their superimposed planes along the walls, like banners or manifestos of today's spirit. Notable among his large-scale works are a fountain in sheet-copper, 20ft high, for the 1964 Exposition Nationale Suisse in Lausanne, and a steel sculpture 32ft high, at Thionville, Lorraine. Besides one-man exhibitions in Paris, notably at the Galerie Creuze in 1961, in Zürich and Lausanne, he was represented at the Venice Biennale (1956) and, several times from 1955, at the Salon des Réalités Nouvelles, Paris.
H. W.

GOERITZ Mathias. Born 1915, Danzig. He was a student in Berlin, where he prepared a doctoral thesis in philosophy before he entered the School of Arts and Technology. He left Germany in 1936 and lived in Paris until 1938. During the war, he lived in Morocco, then went on to Spain. In 1948, he founded the School of Altamira at Santillana del Mar, which exercised a great influence on young Spanish painters, like Tapiès and Cuixart. In 1949, at the invitation of Guadalajara University, he went to Mexico, where he has lived and worked since as a sculptor and architect. His sculptures and mural decorations, which still showed the influence of his association with Dada and the German Expressionists a long time before, roused violent controversies in Mexico, particularly his experimental museum, El Eco, built in Mexico in 1953. Mexican artists, like Diego Rivera and Siqueiros, publicly accused him of wanting to introduce European decadence into their country. Nevertheless, Goeritz was asked to teach there and was director of the School of Plastic Arts in the Hispano-American University of Mexico from 1955 to 1959. At the invitation of the architect, Mario Pani, he designed in 1957–1958 a monumental group for the entrance of the satellite city of Mexico. It formed a harmoniously combined group of five units of unequal size, towering up to heights ranging from 185ft to 120ft. The open space where they were situated was called the Square of the Five Towers, three of which were white, one yellow and one orange. This daring sculptural group created a great stir. Goeritz is still living in Mexico, where he is director of visual education in the National University. Architect, painter,

Goeritz. Square of the Five Towers. Satellite town, Mexico City. 1957-1958. Height: 120-185 ft.

sculptor, poet and writer, Mathias Goeritz has become one of the leading figures of Mexican artistic life. His varied interests have all converged and merged in a single overriding aim: the integration of the arts into the city. About 1950, he worked on clay and wood sculptures with Biblical subjects, which were expressionist in style. Then he built a group of giant, metallic structures, which anticipated Minimal Art by ten years. His work, in all its aspects, must be the touchstone for anyone who wants to understand the experimental art of Mexico. Since 1960, he has turned his back on the cramped world of galleries and has refused to work for what he calls the élite minority. Egocentric and personal art are abhorrent to him and a 'socialisation of art' is the only means of satisfying, in a planned community, the fundamental spiritual needs of contemporary society. M.-R. G.

Gonzalez

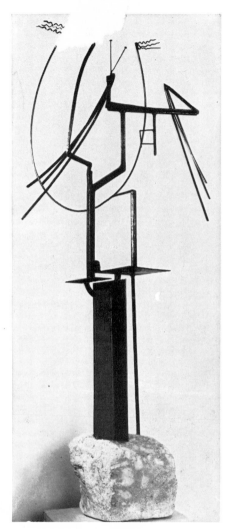

Gonzalez. Woman combing her hair. 1932. Iron.

GONZALEZ Julio (Barcelona, 1876 – Arcueil, 1942). Gonzalez learnt how to work metals at Barcelona in the workshop, where his grandfather, then his father had exercised their craft of art ironworkers. He also studied drawing and painting at the Art School. In 1899, the Gonzalez family settled in Paris. Julio met Picasso again, whom he had known in Barcelona and made friends with Manolo, Maurice Raynal and Max Jacob. He exhibited with his brother, Jean, a painter like him, at the Salon des Indépendants and the Salon d'Automne. Jean died

in 1908. In his grief, Julio lost all interest in his work for several months. At the end of this sombre period, he gave up painting, because his blacksmith's hands were too coarse for so fragile a tool as a brush, and began to sculpt with the techniques he had learnt in his youth. He made his first masks in hammered metal, which included the portraits of his aunts Pilar and Lola. He broke away from his Cubist friends and, for fifteen years, withdrew into himself and lived in almost complete solitude. In spite of unhappiness and extreme poverty, he continued his experiments, encouraged by Brancusi, Gargallo and Despiau. In 1927, he found his real artistic self and devoted himself entirely to sculpture. The series of *Cut-out Masks* and *Still-lifes* were his first works in iron. By this time, he had shed every influence and was creating art in which his knowledge of metal was producing astonishing effects. He used the process of oxy-acetylene welding, which he had learnt at the Renault factory in 1917, and only took a few years to make the greater part of his sculptures in original forms and a new technique.

'To project into space and draw in it, with the help of new mediums; to use this space and build with it, as if it were a newly discovered material – that is my whole endeavour.' In these words, Gonzalez described his contribution to contemporary sculpture. He was skilled in beating out, forging, rivetting, welding and hammering metal. With his imaginative genius and a consummate craftsmanship, he worked ceaselessly and was never satisfied. He discovered the plastic qualities of iron and gave, or gave once again, a noble distinction and high purpose to this metal that had only been used till then for minor, if not coarse work. This hard and intractable

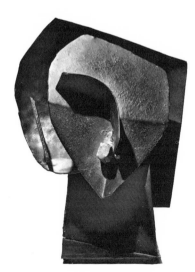

Gonzalez. Head. 1930. Iron.

122

material was used to fashion masses in all their fullness, or more often, to suggest them by lines, perforations, even voids. Instead of freeing a form by carving it out of a block of stone or defining it by modelling it from a lump of clay, Gonzalez assembled pieces of metal and created a work that was completely satisfying as sculpture and simply as sculpture. A familiar phenomenon in the world of art was repeated when the choice of a material, which had hitherto been despised, led the Spanish artist to evolve a suitable technique, and when this, in its turn, gave rise to an appropriate idiom and the idiom to an original style. His return to an ancient craft had not only given back its glamour to iron, it had also made it into a peculiarly modern medium of expression. This is why, though he was unknown in his own time, he is now recognised as a precursor of ours. 'Building with space': it was just this that attracted Gonzalez and that he succeeded in doing. His works, in fact, are constructed with space, are united with it, find their identity in it and by it. Free, supreme within their own laws, their presences are commanding even to the least experienced eyes, whether their forms are immediately intelligible like the *Don Quichotte* of 1929 and the *Montserrat* of 1937, or, on the other hand, daring transpositions like the *Kiss* (1930), *Woman with a Mirror* (1936) and the *Cactus-men* (1939–1940). Whether he turned from a naturalistic form to an abstract form, from a solid, massive form to a linear form, which traced a graceful, fantastic arabesque in space, he always began with nature, the inexhaustible source of his hazardous interpretations. During the winter of 1941, he began a huge figurative, plaster sculpture, but only finished the head. This was *Montserrat No. 2*, inspired by the horrors of war. On the 17th March, 1942, he died suddenly at Arcueil, leaving behind him works that only a few had appreciated, but that are now universally admired and have often been imitated since. They gave birth to a new conception of sculpture and became the justification for using iron in sculpture. The work of Julio Gonzalez is very well represented at the Musée National d'Art Moderne, Paris, because of the large donation made by his daughter, Roberta. F. E.

GONZÁLEZ GOYRI Roberto. Born 1924, Guatemala, Guatemala. After training at the National Academy, he was commissioned with Julio Urruela Vasquez to do the decorative motifs for the National Palace and was also appointed assistant to the chief of the Department of Ceramics in the Museum of Archaeology. He exhibited a collection of his works for the first time in 1948, at the Guatemala Academy. He received a grant from it that enabled him to go to New York, where he joined the Sculpture Center. He was awarded the Central American Prize for Sculpture in New York (1959). González Goyri does not only use clay, but also, when the work requires them, iron, tin and stone. About 1950, after a period on which his academic training had left its mark, his works

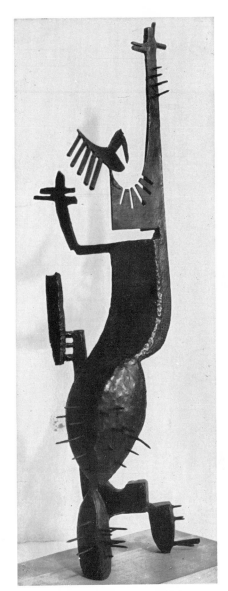

Gonzalez. Cactus-man N°. 2. 1939. Iron.

Gorin

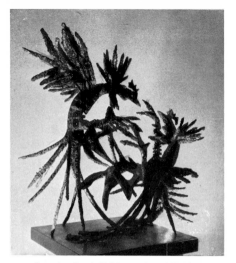

Gonzalez Goyri. Fighting cocks. 1950. Tin.
Merle Armitage collection, California.

his maquettes, but sheets of steel or aluminium for the final work (*Construction no. 9* for the Institut Universitaire de Technologie, Nancy, 1955). Gorin is equally well known as a painter and as a sculptor and several retrospective exhibitions of his work have been held during the last few years, notably at the Musée des Beaux-Arts, Nantes (1965), the Stedelijk Museum, Amsterdam (1967) and at the C.N.A.C. in Paris (1969). His whole work has developed logically, but a powerful individuality and neo-Plastic principles have given it an unusual character.

D. C.

GRECO Emilio. Born 1913, Catania, Sicily. He was self-taught and learnt his elementary technique while working with a monumental mason. With these modest beginnings, his early career was difficult and he did not make a name for himself until after the war, when he moved to Rome and his first one-man exhibition took

showed a decidedly expressionist tendency. He was twenty-six then. His *Fighting Cocks* (1950) in tin are spirited and show a genuine decorative sense. Four years later, his art became non-figurative, but his instinctive love for the sensuous warmth of life saved his sculpture from a frigid inhumanity. M.-R. G.

GORIN Jean. Born in 1899, Saint-Émilien-de-Blain, Loire-Atlantique. His training at the École des Beaux-Arts in Nantes (1919–1922) was hardly over, when Gorin set out to experiment on his own and free his work from academicism. Then in 1927, he met Mondrian and his friendship led to Gorin's conversion to neo-Plasticism. The same year, he exhibited for the first time at Lille with the Vouloir group, Mondrian, Domela and Huszar. His sculpture, consisting of reliefs and polychrome wood, was an activity parallel with his painting. In 1930, he joined the Cercle et Carré exhibitions, then, two years later, after a study visit to Germany and the U.S.S.R., the Abstraction-Création group. After the war, he sent work to the Salon des Réalités Nouvelles (1946) and has exhibited there regularly ever since. From 1947 to 1956, he lived in the south of France and it was during this period that he experimented in spatial constructions, consisting of coloured planes and black lines. Colour has a great importance for him, because he considers that in any plastic composition it contributes towards the spatial, constructive and architectural effects. It is significant that in 1951, he signed the manifesto of the Espace group, whose aim was precisely what he had been striving to attain, integration of all the arts. He uses wood for

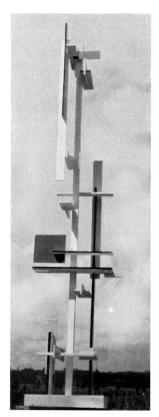

Gorin. Space-time construction No 9. 1955.
Musée d'Art et d'Industrie, Saint-Étienne.

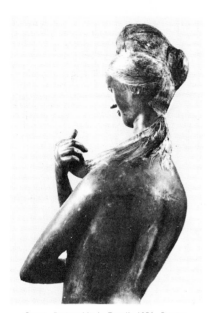

Greco. Bather N° I. Detail. 1956. Bronze.

awarded the Prix de la Confédération Helvétique (1952 and 1955). Several one-man shows of his work have been held at the Museums of Lucerne, Zürich and Basel. He now lives in France and contributes to the principal Parisian Salons. Grossert began by carving wood and stone, then casting bronze; in 1967, he changed them for plastic materials. An extraordinary freedom came over his work, as he explored all the possibilities offered by these new materials, especially with colour and optical imbalance. The unity and physical continuity, which had characterised his work till then, disappeared and he broke down the conventional limitations of space that were inevitably associated with it. He refused, too, to subscribe to the accepted and cramping conceptions of high and low and so arranged the plastic elements of his sculptures that the whole equilibrium of different constituent units was the sum total of innumerable, partial disequilibriums. The violent dynamism and freedom of these constructions were intensified by the skilfully distributed areas of colour. D. C.

GUADAGNUCCI Gigi. Born 1915, Massa, near Carrara, Italy. He began his career as a marble mason and went to live in Grenoble before the Second World War, then moved up to Paris. Monumental sculptures by Guadagnucci can be seen in Marseilles, Grenoble and Cannes. He is an abstract sculptor and has a deep respect

place in 1946 at the Galleria Cometa. Two years later, he was awarded the Saint-Vincent Prize for sculpture. He won another prize at the VI Quadriennale in Rome and, in 1956, the prize awarded by the municipality of Venice for his sculpture in the XXVIII Biennale. He was given other distinctions when he won the competition for a *Monument to Pinocchio*. Invitations to send work to important national and international exhibitions were added to these successes. In 1964, he executed the doors of one of the porches of Orvieto Cathedral. 'A melancholy Hellenism and an Ovidian sensuality, exquisite and, at the same time, sentimental, a refined passion . . .' (Ragghianti): these are the outstanding qualities of his works, which consist for the most part of harmonious figures and portraits of women in the tradition of Italian Mannerist sculpture and archaic classicism. Although his work is on the fringe of avant-garde art, the forms of Emilio Greco's sculpture are simplified and reduced to essential rhythms. A gentle luminosity plays over the modelling of his surfaces, a characteristic that recalls Giacomo Manzù's sculpture. Its light envelops the angular and mannered rhythms of his Bathers and Dancers and emphasises the preciousness of his treatment. G. C.

GROSSERT Michaël. Born 1927, Sursee, Switzerland. He trained at the School of Decorative Arts in Lucerne, then at Basel. Rodin was the sculptor he most admired before he discovered Giacometti. He was twice

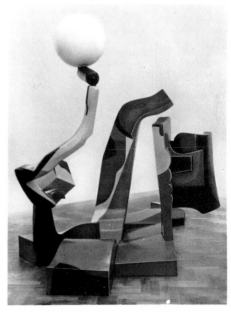

Grossert. Infinite zone. 1968. Polyester.

Guerrini

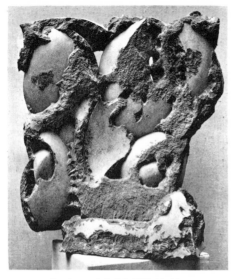

Guadagnucci. Relief. 1962. Marble.

for the nature of his material, marble, which he carves into contrasting smooth, sensuous planes and more dramatic incisions that burst through them. His blocks are often hollowed into large concave spaces and the light, filtering through the thin, marble walls, illuminates the solid stone into a flower-like object. D. C.

GUERRINI Lorenzo. Born 1914, Milan. After 1930, Guerrini lived in Rome and attended classes at the Academy and the Arts Museum. He completed his training in Breslau, at the Hochschule für Bildende Künste in Berlin and then in Paris. His first one-man exhibition took place in 1947 at the Barbaroux Gallery in Milan and was soon followed by another at the Galleria L'Obelisco

in Rome. He was the first to create 'abstract' medallions (1949), which he called 'plastic imprints' and sent to the Venice Biennale in 1952 and 1954. He was reviving an ancient art in a modern idiom and struck several kinds, in various shapes. Among them was one for the International Association of Art Critics, 1957. He won a prize at the first International Exhibition of Sculpture at Carrara in 1957, was invited in 1955 to exhibit his work at the São Paulo museum and at several exhibitions in Italy and abroad, where he was awarded the highest distinctions. In 1957, he exhibited at the XI Triennale in Milan a large sculpture in freestone that showed the final development of his style. Besides bronze and copper, Guerrini has worked in the hard and massive medium of freestone, which has enabled him, better than any other material, to give sculptural expression to his ideas. 'A few blows and a few marks are sufficient to indicate my personality,' he declared, summing up in a sentence the essential characteristics of his stylistic experiments. Although his work can be compared to Wotruba's art, it does not make it any the less unusual or any the less impressive in the wealth of its ideas, which are always extremely simple. His huge blocks of stone and sheets of almost unshaped metal, which are the stuff of his creations, catch the light in subtle variations and are amongst the liveliest examples of contemporary sculpture. G. C.

GUINO Michel. Born 1928, Paris. He was the son of the Catalan sculptor Guino and he trained at the Académie de la Grande-Chaumière, Paris, where he knew Despiau, then at the École Nationale des Beaux-Arts. In 1951, he discovered the work of Gonzalez, which was a revelation to him of the astonishing potentialities of metal sculpture. Two years later, he adopted the medium himself, which enabled him to lighten his masses and break with the traditional methods he had followed until then. Although his art has been fundamentally non-figurative since this period, it still contains traces of a strong continuity with the past. In fact, it has all the

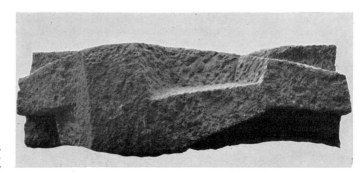

Guerrini.
Metamorphosis.
1957. Stone.

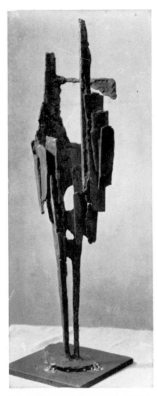

Guino. Sheath of light. 1958. Bronze.

studio at the Académie de la Grande Chaumière. The experimental work of Braque and Picasso interested him and he was one of the first to apply the principles of Cubism to sculpture. While, as the 20th century dawned in Czechoslovakia, the classicism of Myslbek (1848–1922) and his followers lingered on, and symbolism and Art Nouveau inspired the graceful figures of Stursa (1880–1925), Gutfreund's sculpture was a powerful synthesis of contradictory and complementary elements, which combined to form modern Czechoslovakian art. The double tradition of Czech Gothic and Baroque were fused into Gutfreund's work to create an endless dialectic of static and dynamic, which embraced all the problems of form and space. When he returned to Prague in 1911, Gutfreund became one of the founder members of the Group of Artists, which brought together all the artists who used some form of Cubism to express the modernity of their age. Gutfreund's strong personality dominated his generation and his work was the finest product of Cubo-expressionism, which was Czechoslovakia's main contribution to the developing years of modern art. Whether it was analytical, like *Grief* (1911), or synthetic, like the versions of *Embracing Figures* (1912–1913), Gutfreund's work was not exclusively constructive; there is a strain of expressionism in its natural polymorphism (*Viki*, 1912–1913) and its constantly broken rhythms.

The First World War forced Gutfreund to flee from his country and take refuge in France. Several little sculptures, produced during this period, were made from

characteristics of his former works: the same attempts to disintegrate space and the same elevated construction. This verticality gives human feeling to even his most extreme compositions. Guino exhibited at the Galerie Creuze in 1954, then at the Bongers (1966) and Le Grall (1968) galleries, all in Paris. He shared the sculpture prize at the Paris Biennial in 1959 and the First Prize for Sculpture of Marseilles in 1960. He has sculpted various monuments in Paris for the C.S.F., in Nice, Rabat and Agadir. Recently his work has developed from closed forms to volumes folded back on themselves. Stainless steel and a variety of scrap materials, which he uses for assemblages, have led him to an open style that gives every plastic element an independence and a proliferating life like that of cellular organisms. D. C.

GUTFREUND Otto (Dvur Kralové, Czechoslovakia, 1889 – Prague, 1927). When he had completed his training at the Prague School of Decorative Arts, he went to Paris (1909–1910) and worked in Bourdelle's

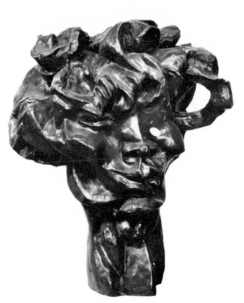

Gutfreund. Viky. 1912-1913. Bronze.
National Gallery, Prague.

Guzman

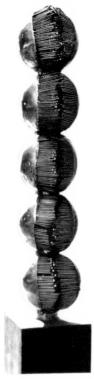

Guzman. Bronze. 1966.

simple pieces of wood and some of them (*Seated Woman*, 1917), unlike the analytical approach or figurative synthesis of previous works, were built of specifically plastic elements, derived from reality, which led Gutfreund to the threshold of his constructivist and abstract experiments. On his return to Prague in 1919, his style changed radically. With his training in pottery, he modelled in clay a whole series of picturesque and extremely realistic figures, which went beyond mere subject interest to sociological allegory. These terracottas reflected his desire to rediscover the basic simplicity of primitive and popular art, and he emphasised it even further by painting them. This development, which was paralleled by the growing influence of the official neo-classicism, did not prevent him from sculpting a *Seated Woman*, in the year he died, which is summarily carved like a stele and incised with the sexual organs. Its modern simplicity and restraint indicate that the processes of abstraction had been permanent for Gutfreund. R.-J. M.

GUZMAN Alberto. Born 1927, Talara, Peru. He trained at the Art School in Lima. He is now living in Paris and has held two one-man exhibitions at the Galerie Davray (1965) and the Galerie Martin Malburet (1969). In 1967, he was awarded the Prix de la Jeune Sculpture. Since 1953, Guzman has been using a medium that is perfectly adapted to his particular kind of spatial sculpture. It consists of very thin metal rods in aluminium, iron or bronze, stretched parallel to each other to form a close trellis, which catches the light and reflects it in a network of vibrating rays. The play of tensions on which every one of his works depends transforms it into a vital presence, reassuring at times, disturbing at others, which is open to all that surrounds it and is sensitive to the modifications affecting it. D. C.

Gutfreund. Seated woman. 1917. Wood. National Gallery, Prague.

h

HABER Shamaï. Born 1922, Lodz, Poland. He emi-
grated with his family to Israel and trained at the Academy
of Fine Arts at Tel Aviv (1943–1947). Two years later,
he went to live in Paris, where for some time he was
influenced by Despiau but also discovered Hittite and
Assyrian art at the Louvre. As his style gained in breadth,
he gradually moved away from all representation and
gave greater importance to the nature of his material,
which became the determining factor in his sculpture.
Granite was his favourite medium then. Since 1953, when
he was represented for the first time at the Salon de la
Jeune Sculpture, Haber has belonged to the Paris School.
He was awarded the Prix Bourdelle in 1959 and exhibited
his work the following year at the Stedelijk Museum in
Amsterdam and the Musée Bourdelle in Paris, then more
recently at the Eindhoven Museum (1965). He aims at a
monumental manner and to attain it he is for ever
searching for the simplest and most austere forms. It
entails a constant struggle with himself to sacrifice every
imaginative, but superfluous detail, in the single-minded
pursuit of the essential. Haber is one of the rare artists
who conceive monumental sculpture as a collection of
distinct and separate masses, rather like a three-dimen-
sional puzzle in which the different parts are unified by
bonds that are slender and yet effective; they alternately
draw together and repulse each other in a dialogue in
the void surrounding them. These sculptured groups,
with their massiveness and simple rhythms, seem one
with the forces of nature and are akin to the architecture
of mountain gorges and geological structures. Recently
new materials like steel and synthetic resins have brought
variety to his idiom. After the sculpture of landscape
(waterfalls of slate and a monument of red granite for the
Atomic Research Centre in Israel), Haber proceeded to
create, not object-sculptures, nor even environment-
sculptures, but complete town plans, which are real city-
sculptures modelled in terms of landscape. D. C.

HADZI Dimitri. Born 1921, New York. He trained at
the Cooper Union and the Brooklyn Museum Art School.
In 1950, he spent a year in Greece on a Fulbright Fellow-
ship grant. Since 1952, he has been living in Rome.

Hadzi has had one-man shows in Rome (1958, 1960),
Munich and New York (1961), Düsseldorf (1962) and a
retrospective exhibition at the Massachusetts Institute of
Technology (1963). Hadzi has had several commissions,
including work for the Lincoln Center, New York (1964)
and the Sun Life Insurance Company, Baltimore (1965).
Bronze is his medium. He casts the easily flowing, formal
vocabulary of the baroque tradition into a modern
abstract, or semi-abstract idiom. The separate forms of
Hadzi's sculpture move and weave together, sometimes
suggesting human, sometimes stalk and leaf stylisations,
sometimes free and intricate calligraphies. The alternately
stretched and bulbous contours, have the flow, both

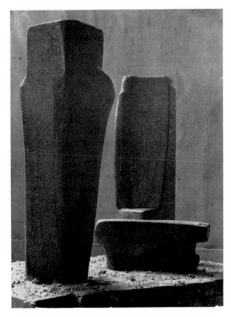

Haber. Sculpture in granite.

Haese

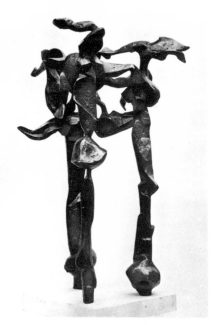

clusters of tiny bells. The sculptures of Haese are graphic intrusions into space; they have neither weight nor volume and the slightest breath can set their delicate equilibrium in motion. Their poetry is tinged with a delightful humour, which he brings out in the choice of his titles. Since his success at the Venice Biennale in 1966, he has received the prize of the Solomon R. Guggenheim Foundation of New York (1967). Exhibitions of his work have been held at the Kunsthalle in Düsseldorf (1967), the Kunstnerns Hus in Oslo (1968) and the São Paulo Biennial (1969). H. W.

HAGUE Raoul. Born 1905, Istanbul, of Armenian parents. He came to the United States in 1921 and trained under William Zorach. In 1943, he moved to Woodstock, New York, where he has lived since. He visited Paris, Rome, Greece and Egypt in 1951. His one-man show at the Egan Gallery, 1962, was followed in 1964 by a retrospective exhibition at the Washington Gallery of Modern Art. Hague's development as an artist was personal and unhurried and entirely outside the quick succession of fashionable styles. His earlier work in stone already showed the strong feeling for material that also characterises his later work in wood, which has been his exclusive medium since 1947. Until about 1950, Hague's

decorative and vital, of a symbolic Art Nouveau, now no longer flat, but made constructive, three-dimensional, space-enclosing and energetic. R. G.

HAESE Günter. Born 1924, Kiel. He trained as a painter at a private school in Holstein, before attending the Düsseldorf Art School. He discovered the materials that suited him when, during the winter of 1960–1961, he began taking an old watch to pieces and decided to make plaster moulds from these components, which he would then use for printing monotypes. His first constructions were built from wire and these prefabricated components. These forms soon became more precise, even mathematical, but there was always something unexpected about them. In the wire network, for instance, that gives coherence to a sphere, there is a small part missing, as if to allow the space without to enter; or a globe is fractured in two and taut antennae strain over the break. Günter Haese's sculpture depends entirely for its effect on the use of his favourite material, very fine, transparent mesh, which he shapes into infinitely variable forms. A subtle rhythm runs through the serried rows in which they are arranged and one can almost hear a thin, high music accompanying it, while his metallic sponges, hanging on a framework, are like

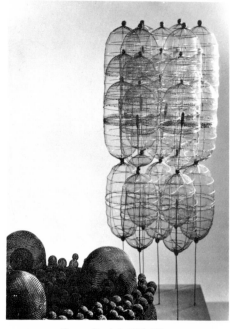

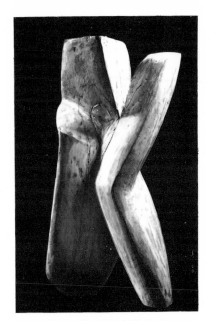

Hague. Phoenicia. 1960. Deal.

Silva and Arpad Szenes. He was mobilised in 1939, released the next year and spent the rest of the occupation in the Pyrenees, earning his living as a marble-mason. In this isolation, his art became simpler and more contemplative. He carved his first bas-reliefs then and made a brief return to figurative art in a series of works, inspired by the insect world. During the whole of this period (1941–1945), marble was his favourite material. Returning to Paris after the war, Hajdu continued his experiments systematically and the significance of his art increased over the six years in which he worked on huge bas-reliefs in plaster. It was not until much later, when he had completely evolved his own idiom, that he interpreted his vision in a new medium, metal. He used lead, copper and aluminium. The material itself had no particular significance for him; it was primarily the medium for transmitting an experience and, if he varied it so much, it was because this very diversity enabled him to achieve a final unity. In short, the material only had a secondary consideration. Admittedly, he loved its beauty, texture and richness, but only because these qualities were a means to the indispensable act of transcending the

sculpture, although strongly stylised and simplified, still bore a recognisable relation to the human figure. The torso was a favourite subject for a long time. About 1950, Hague moved slowly towards abstraction. Increasingly dynamic contrasts of masses and dramatic oppositions of truncated forms fuse a concentrated, inward energy with a basic sense of the unchanging. Although Hague's forms are rigorously abstract, they convey the humanly organic and a pantheistic vitality. R. G.

HAJDU Étienne. Born 1907, Turda, Romania. His family were of Hungarian origin. He went to Paris in 1927, where he entered the École des Arts Décoratifs in Niclausse's studio. Later on, he trained under Bourdelle at the Académie de la Grande-Chaumière, but he found the master too theatrical and bombastic. He obtained French nationality in 1930 and completed his artistic education by visits to Greece and Holland and a bicycle tour of France on which he discovered the beauties of Romanesque art. He had to earn his living by other means than art and could only devote his evenings to it. Although about 1934, his works were composed of abstract volumes in bare, primordial forms, later on they developed, doubtless under the stress of events, towards a more tragic, violent form of expression. In 1939, he was accepted as one of its artists by the Galerie Jeanne Bucher and shared an exhibition with Vieira da

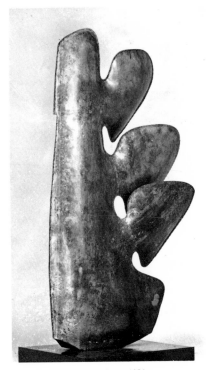

Hajdu. Cock. 1954.
Solomon R. Guggenheim Museum, New York.

Hajek

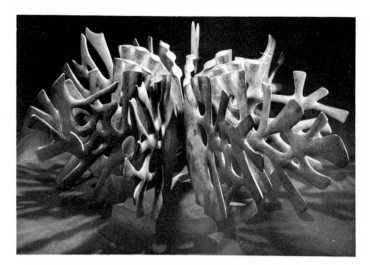

medium. He said himself, 'Art begins when the material ends.'

Hajdu's sculpture developed slowly but convincingly and, over the years, he evolved his own personal style. After the war, his works were a synthesis of dynamic elements, inherited from Romanesque art, and static qualities, characteristic of the archaic Greek statues and Cycladic art he has always admired. Hajdu is now a mature artist; he has used every kind of technique from terracotta to hammered metal and is quite indifferent to bickerings about artistic labels. It is truer to describe his art as having developed beyond both figurative and abstract art than to say it has developed from the first to the second. When his attention seems deliberately focused on the first, it is not because he wants to solve an additional and gratuitous difficulty, but because he has always been essentially concerned to give a new meaning to the human, in other words, to infuse a fresh emotion into the forms he creates. To accomplish this, he uses volume and the endless ways of manipulating it as well as the illusion of volume, the simple suggestion of space that is always in process of being recreated. His sensitive magician's hands excel in reading the jealously guarded forms at the heart of materials, however hard, or however malleable they may be. Flesh and spirit are united in the highly emotive forms of his works. Sharp edges and acute angles make a pattern with graceful arabesques. Although Hajdu's sculptures have weight and solidity, they stimulate the imagination of the observer. They are self-contained and create their own spatial relationships within themselves and their effectiveness depends on their rhythm and architectural composition.

In 1958, a year after the publication of a monograph on him by the poet Robert Ganzo, Hajdu exhibited a collection of 'estampilles'. They were produced by his own process, which consisted in stamping paper with designs from metal shapes he had made himself. More recently, he has seen the possibilities of casting and polishing aluminium as a means of overcoming the opacity of material, not by transparency, but through reflection, as the continuous surface of each work mirrors the reflections of its environment. This also creates a new space, which introduces the most objective reality, that of the surroundings, into the most elaborate plastic context, the work of art. Hajdu's work is known internationally now. He exhibited his work at the Galerie Jeanne Bucher, Paris, from 1946 to 1957, but shows them now at the Galerie Knoedler. He is represented regularly at the principal international shows, the Biennials of Tokyo, Lugano, Middelheim, Antwerp, and São Paulo. The extent of his influence entitles him to be considered as one of the most original of modern sculptors. D. C.

HAJEK Otto Herbert. Born 1927, Kaltenbach, Czechoslovakia. When he left school, he entered the Stuttgart Academy in 1947. In 1952, he visited Paris and then went to England and Italy. Besides his exhibitions in Germany, he was represented at the Venice Biennale (1958). He is living at the moment in Stuttgart. Hajek first made his name by sculpture he did for the Catholic church: altars, sarcophagi, crucifixes, baptismal fonts, a set of Stations of the Cross and a variety of religious articles. Hajek continues his own work, quite independently of the commissions he receives. For some years, he has been interested in a problem that he calls 'spatial nexus' (Raumknoten). His aim was a complete interpenetration of matter and form so that the predominant impression was neither of empty space, nor of mass displacing space. The positive and negative elements are

so blended that the whole arrangement looks like some fantastic grating or an eroded shell in which the structural framework as well as the remains of the superstructure can be seen. There is only one version of each of his sculptures, because he uses the lost-wax method. On the whole, Hajek prefers to keep the unfinished appearance of the metal, immediately after casting, only polishing the bronze in a few places. Consequently he increases the picturesque, romantic effect of his sculpture, which, like a ruined building, has only one façade that can be admired for its apertures and angles. Recently, he has begun to use new materials, like steel and wood, and has added touches of colour (*Paths of Colour*, 1964–1965). These new sculptures are more massive, simpler and there is a purely constructivist side to them. J. R.

HAMM Henri (Bordeaux, 1871 – Paris, 1961). He trained at the École des Beaux-Arts in Bordeaux. He went to Paris in 1902 and, the following year, founded the Salon d'Automne with Frantz Jourdain, Eugène Carrière and Georges Rouault. His art was influenced by Cézanne and Gauguin and anticipated Cubism with its severe, bare forms. A short time after this, he became a frequent visitor at the Bateau-Lavoir and made friends

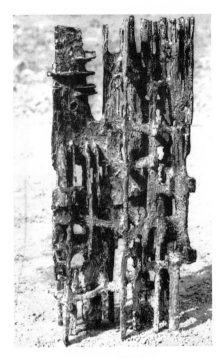

Hajek. Space. 1957. Bronze.

with Apollinaire, Max Jacob and Picasso. After doing some work for the glass-making industry, Henri Hamm did a whole series of small sculptures in silver, ivory and horn. From 1918 to 1936, he taught sculpture in various art schools in Paris and was appointed to the École des Arts Appliqués in 1925. He was an untiring defender of modern art and did his best as a member of the committee for the 1937 International Exhibition to give work to avant-garde artists. His numerous commitments did not prevent him from producing work that was remarkable from every point of view and had affinities with Arp, whom, incidentally, he did not know. After the Liberation, Hamm was represented at the Salon des Réalités Nouvelles and, from 1953, at the Salon de la Jeune Sculpture. The same year, the Galerie Pierre held a one-man exhibition of his work. He nearly always works with plaster, whether as a preliminary to modelling in clay, or directly as sculptural material. The most striking aspect of his strictly abstract work, which is nearly all on a large scale, is its frankly architectural character. More recently, the extremely sharp contours of the masses gave his works variety and a surprising vitality. Just before his death Michel Seuphor said, not without reason, that 'Hamm, who is over eighty, is in step with the most advanced sculpture of the day.' D. C.

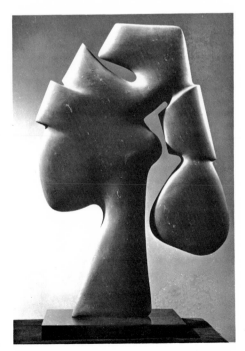

Hajdu. Head in slate. 1965.

Hare

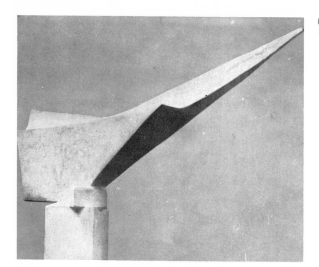

Hamm. Sculpture.
1956. Plaster.

HARE David. Born 1917, New York. He was a qualified chemist and worked from 1938 to 1943 in coloured photography. His artistic vocation was awakened by some work he had undertaken on the American Indians, for the Natural History Museum in New York. Without any previous training, he began to make metal sculptures with the help of a blow-lamp. Sometimes he used the lost-wax method for his works. He has had several one-man shows in New York since 1944, generally at the Kootz Gallery. In France, he exhibited work at the Galerie Maeght (1948) and the American cultural centre in Paris (1958). The connection that he had for a long time with the Surrealists influenced his sculpture. Although his works are abstract, with a touch of eccentricity, there are some naturalistic elements in them and the contrast

they make is an amusing expression of David Hare's sense of humour. F. E.

HARTUNG Karl (Hamburg, 1908 — Berlin, 1967). He joined the School of Arts and Crafts in Hamburg, when he was seventeen, to train as a sculptor. When he was twenty-one, he went to Paris for three years, where he came under the influence of Maillol. In 1936, he moved to Berlin and worked there in retirement throughout the Nazi period. After the war, he was one of the first German sculptors to exhibit abstract works. Since 1951, he has been teaching at the Art School in West Berlin. In 1952, the Haus am Waldsee in Berlin held a large retrospective exhibition of his work, which was followed,

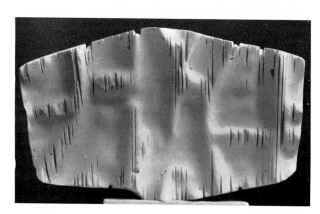

Hartung. Sculpture.
1956. Plaster.

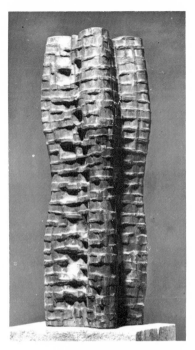

superfluous detail and reduces form to the essential and the permanent. J. R.

HAUSER Erich. Born 1930, Rietheim, Germany. After working as an apprentice engraver, then as a modeller, he attended the free Art School of Stuttgart. As a sculptor he soon turned his back on traditional representational art and evolved his personal style when, in 1960, he began using steel plates as his unique material. At first, he cut them into irregular triangles, which he soldered together into polyhedral forms, with sheer surfaces. Originally, the ridges intersected each other as in Cubist sculpture, but they became more supple and the volumes opened, revealing the space within through the gaps. For some years now, the plane surfaces have disappeared and Hauser bends his sheets of metal into cylindrical columns, whose verticality is only broken by elements attached like grafts onto a branch. When several of these columns are grouped into a single unit, they form walls in which the last pillars seem to be sinking in a succession of suspended rhythms. Hauser's sculptures have been placed in front of a number of public buildings in Fribourg, Stuttgart, Konstanz and Wuppertal. He has also done steel reliefs for the foyer of a theatre in Bonn and the Kubus House in Hanover. He was represented at the Biennials of Paris and Middelheim, Antwerp (1966), and São Paulo (1969) and the Kassel Documenta (1968). H. W.

Hartung. Bronze. 1963.
Nationalgalerie, Berlin.

in 1953, by one at the Kestnergesellschaft of Hanover. He is regularly represented at all the important exhibitions of sculpture in Germany and abroad. Hartung's work is exceptionally varied and side by side with simple, geometric compositions in which the convexes and concaves are violently contrasted, there are other sculptures, which are equally abstract, but exceptionally harmonious, which preserve the formalised and simplified shape of the human body. His art has an indirect affinity, especially in his fondness for fine materials (marble, granite, smooth wood and polished bronze) with the tradition of Arp and Brancusi. Sculpture is essentially, for Hartung, a material that can be modelled and, whether the forms project or recede, they are always firm and strong. The almost dramatic mastery of space, which is accomplished by the curves and voids in a work by Henry Moore, for example, is quite alien to him; he deliberately refuses to attempt the creation of structures that are more dynamic and always returns to simple, monumental forms: *Sign of the Bull* (1952), *Kore* (1953). Although the surfaces of the 1956 plasters are restless, he remains faithful to a massive, block-like contour. His recent works may have become more abstract and gained in dramatic intensity, but they are as subject as ever before to a strict economy of means, which eliminates

Hauser. Column. 1969. Stainless steel.

Heiliger

HEILIGER Bernhard. Born 1915, Stettin, Poland. He attended the Stettin School of Arts and Crafts and then the Berlin Academy. For some time, he worked in Paris, where he met Maillol and Despiau. He began exhibiting soon after 1945 and was represented notably at the Venice Biennale in 1956 and the Kassel Documenta

Heiliger. Three figures. 1957. Bronze.
Robson collection, Hollywood.

in 1955 and 1959. Since 1949, he has been in charge of a sculpture class at the Art School in Charlottenburg. In 1950, he was awarded the Berlin Arts Prize for sculpture. A combination of natural, organic form with traditional sculpture is the distinguishing characteristic of Heiliger's art. A faint resemblance to the human prototype still lingers. This may change into a plant form, tree or fruit, or it may pass imperceptibly into the animal world. Something always remains, growing upwards and developing from the base to the top, and the corporeal creates a movement around a solid nucleus. Besides the upward thrust of his sculptures, he is also concerned with the problem of equilibrium. In a limbless torso of 1953, called *Seraph*, Heiliger created the illusion of a

winged being. *Plant Figure* of 1955 is a modern version of the Daphne myth, except that here the tree is metamorphosed into a human being. In *Metamorphosis* (1957), the human body merges into a form that can be described equally well as plant or animal. The archetypal shapes of Jean Arp find an equilibrium in themselves, but Heiliger's forms try to reach beyond themselves; they are like buds or chrysalids, a mysterious beginning, the first stage of a creative act that is still incomplete. However, even in these ambiguous resemblances to living forms, there is nothing arbitrary; Heiliger is averse to all uncontrolled creativeness. His *Two Related Figures* have been placed in a square in Darmstadt. He produced the *Ferryman* for the bridge over the Necker, near Esslingen, a moving interpretation of floating equilibrium. Heiliger is also an excellent portrait-sculptor; he has modelled the painter, Hofer, the mayor of Berlin, Reuter, and Kurt Martin, the art historian. J. R.

HEPWORTH Barbara. Born 1903, Wakefield, Yorkshire. She studied at the Leeds School of Art and at the Royal College of Art, London. She spent nearly three years in Italy on a travelling scholarship. Since her first show in London in 1928, numerous exhibitions of her work have been held in England, the United States, Holland, Germany and South America. The most notable retrospectives were at the Venice Biennale (1950), the Whitechapel Art Gallery, London (1954), the Biennials of São Paulo (1959) and Middelheim, Antwerp (1961), the Rijksmuseum Kröller-Müller, Otterlo (1965) and the Tate Gallery, London (1968). Her commissions include two large sculptures for the Festival of Britain (1951), *Vertical Forms* for the Technical College at Hatfield, and *Meridian*, fifteen feet high, for State House, London (1959).

It is inevitable that comparisons should be drawn between the work of Barbara Hepworth and Henry Moore. They come from the same district, attended the same art schools, have been subjected to many of the same influences. Until the mid-thirties, and on occasions subsequently, their progress has been parallel. In particular, Barbara Hepworth shared with Moore the move, during the thirties, fully to open up the sculptural mass by piercing it and hollowing it out. Hers, however, is a colder and more enigmatic talent, static rather than dynamic, less rich in allusions, more fastidious and more concerned with physical perfections. As with Moore, her starting point is her response to the natural qualities of stone and wood: she remains pre-eminently a carver. Decisive upon her was the impact of Brancusi and Mondrian and Arp; to a lesser degree, of Gropius and Gabo and Moholy-Nagy, too, during their time in England before the Second World War. The greater part of her work has been non-figurative and since 1934 her references to humanity, at least in her sculpture, have been limited.

The period, 1934–1939, saw her concerned with near

geometrical forms in relationship. In the latter year she moved to St. Ives, in Cornwall, where she has lived and worked ever since. The Cornish landscape released fresh impulses and between 1943, when she was able to start carving again, and 1947, she produced a number of her most lyrical works. These open and hollow forms, mostly carved in wood, were sometimes threaded with strings, sometimes painted with white or a flat colour upon their concave surfaces. Of the period she has written: 'I was the figure in the landscape. The colour in the concavities (of my carvings) plunged me into the depths of water, caves, or shadows deeper than the carved concavities themselves. The strings were the tension I felt between myself and the sea, the wind or the hills.'

A returning interest in the human figure led her during the next few years to somewhat modish series of representational drawings of surgeons and doctors at work in operating theatres—drawings as far removed as possible from the mathematical precision of her crystalline drawings for sculpture. Human allusions crept back intermittently into her sculpture, which often, however,

Hepworth. Orpheus. 1956. Brass.
Mullard House collection, London.

Hepworth. Two figures, Menhirs.
1955. Teak.

revealed unresolved dichotomies. Many of her heads and figures have their features or limbs incised in representational line upon a simplified and formalised mass, a technique which contrives to invalidate both idioms. Some small scale groups of monolithic figures, made in 1951, produce an equally uncomfortable sense of being neither human beings nor dolmens. Latterly, she has turned once more with renewed success to non-figuration of a less compact nature, often on a considerable scale. Technically, Barbara Hepworth's sculpture is characterised by a masterly sense of material, an absolute perfection of surface and a very subtle flow of planes within a simplified conception. Hers is a contemplative sensibility which perhaps liberates the form from without

Heras Velasco

Heras Velasco. Form. 1958. Bronze.

her work in various Salons in Argentina since 1955. In 1957, she was awarded the sculpture prize at the Mar del Plata Salon. The Van Riel Gallery in Buenos Aires held an exhibition devoted to her work in 1959. Gifted, patient and restrained, she has disciplined herself ruthlessly in her anxiety not to be tempted by mere facility or any fashionable formula. She has never wavered in her belief that, although sculpture needs the control of technique, it is a slowly burning fire that will admit neither deception nor carelessness. She rejects ready-made methods and uses a great variety of materials, clay, plaster, concrete, aluminium, which are the mediums for her bold and confident manner. Her most recent work is characterised by geometric structures and broad, clearly designed rhythms. M.-R. G.

HERMANNS Ernst. Born 1914, Munster. He trained at the School of Arts and Crafts in Aix-la-Chapelle and the Düsseldorf Academy and then visited France, Greece and Italy to study the art of these countries. He did his first non-figurative sculpture in 1950. He is a member of the Junger Westen group and, in 1951, was awarded the prize of the town of Gelsenkirchen. His first abstract sculptures evolve from a single, solid mass that seems to turn on its own axis. Strange forms, rather like molluscs, protrude from this. When this style is used for mural relief the result is a heavy salience or deep hollow, with planes projecting at right angles to the support; the ceramic wall of a modern house in Gelsenkirchen is an example of this. Hermann gave up a whole year, 1957–1958, to drawing and painting in an attempt to represent spaces in less solid compositions. When this was transposed into sculpture, it appeared as plant forms, rather like sponges, moss or lichen, in other words, as perforated, natural forms, without any plastic solidity. The contorted stone seemed as if it were trying to achieve organic life, while the sculpture, as a whole, looked like the excrescences from organisms that already existed. This romanticism and poetry of the amorphous links Hermann's sculptures with some kinds of Tachiste painting. J. R.

rather than creates it from within. Her best work has a timeless perfection and she has created, through the years, a vocabulary of shapes which has affected a whole generation of painters and sculptors. M. M.

HERAS VELASCO Maria Juana. Born 1924, Santa Fé, Argentina. She was a science teacher when, in 1945, she decided to become an artist. She attended the independent studio, Altamira, went to Lucio Fontana's classes in sculpture and Emilio Pettoruti's for drawing. From 1947 to 1952, she studied painting and abstract composition in the Pettoruti Studio. She has exhibited

Hermanns. Polyform sculpture. 1959. Bronze.

Hiquily. Seated woman. 1958. Iron.

metal and incorporate scrap iron. He forged, hammered and welded them himself without the help of an assistant. From 1956, Hiquily contributed to the principal Parisian Salons. He was awarded the Prix des Critiques d'Art at the Biennale des Jeunes Artistes in Paris in 1959 and has exhibited his work frequently at the Galerie du Dragon and the Galerie Claude Bernard, also in Paris. The formal aspect of his sculpture is a combination of broad, rather shallow volumes and slender, filiform elements, which are nicely balanced on an axis rather like a ballet dancer poised on her toes. Its inspiration is often erotic, but this is sensitised by Hiquily's plastic stress into a powerfully imaginative whole. Besides iron, he also uses brass, copper, aluminium and stainless steel. Hiquily was invited to the Symposium of Sculpture at Montreal in 1965.

D. C.

HOEYDONCK Paul van. Born 1925, Antwerp. He studied at the Institut d'Histoire de l'Art et Archéologie in Brussels, but as a sculptor he was self-taught. His first one-man show took place in 1952 in Antwerp. In 1963, he was awarded the Belgian Critics' Prize and has been represented at the major international exhibitions (Biennials of Venice, São Paulo and Tokyo, Exhibition of 'Antagonismes' in Paris, the Kassel Documenta). Hoeydonck uses the most varied materials and gathers the pre-existing forms, which he selects for their significance, into a sort of coagulation. As far as possible, he chooses his raw materials from objects that are characteristic of urban culture. He extracts a sort of symbolism from them through the way they are used and arranged, and there is often a keen sense of mockery in his assemblages too.

HIQUILY Philippe. Born 1925, Paris. He spent the first part of his life in Mont-de-Marsan and Orléans, where he used to go to a sculpture class at the Art School. At the Liberation, he joined the army and took part in the fighting in France and Indo-China. He was demobilised in 1947, joined the École des Beaux-Arts in Paris, and was trained in the studio of the sculptor, Jeanniot. He stayed there just over two years. It was only towards 1951 that his art, which had been frankly figurative, began to develop. He had just discovered a new material, iron, and learnt its technique himself. At the same time, the sources of his inspiration changed. Strange forms attracted him and Surrealist ideas seemed to appeal to him. A little later, a fresh development took place in his art under the combined influence of Germaine Richier and Robert Müller. In 1954, he held his first exhibition at the Galerie Palmes in Paris. The unvarying method he now finally adopted was to work directly on

Hoeydonck. Green grass. 1967. Assemblage.

Hoflehner

Hoflehner. Figure VI. 1957. Solid iron.
Ministry of Internal Affairs, Vienna.

HOFLEHNER Rudolf. Born 1916, Linz, Austria. At the School of Mechanical Engineering in Linz, he learnt forging, lathe-work and welding. Later on, he attended the Vienna Academy. In 1945, he was appointed to a teaching post at the Linz School of Art and Crafts and, in 1951, settled in Vienna as an independent artist. In 1954, U.N.E.S.C.O. enabled him to visit the Ionian Islands. Exhibitions of his work were held in Vienna (the Würthle Gallery), Linz and Basel (the Gallery of Modern Art). In 1954, 1956 and 1960 he was represented at the Venice Biennale and at the Kassel Documenta in 1959 and 1964. Hoflehner taught himself sculpture. He began with wood carving and then, in 1951, went on to work with iron and steel. His art was abstract until 1954, but it became figurative after his visit to Greece. Simpler constructions took the place of the extremely broken forms he had preferred before. Cutting out metal, welding and the polishing and assembling of the components created a rhythmic pattern in these constructions. The treatment of the surfaces helped to emphasise the structure. Sometimes his figures were reminiscent of Gonzalez, but they were more primitive than the Spaniard's. In 1958, his art seemed to become less strained. The edges became gentler and the forms became more rounded. This stylistic change has become more marked since 1965 with the appearance of forms that are more plant-like and more erotic. His sound craftsmanship as ironsmith, welder and metal-fitter, combined with a refined sensibility, give each one of his works a most attractive freshness. J. L.

HRDLICKA Alfred. Born 1928, Vienna. He trained as a painter from 1946 to 1953 at the Vienna Academy, then worked under Wotruba until 1957. An almost unique theme runs through his work: flayed man, victim of the violence and constraints inflicted on him, his protests and revolts, which are always repressed. He does not, however, indulge in romantic or Michelangelesque effusions in his treatment of such an image; it dominates with all the power of a primitive, ill-contained force. Besides his sculpture, Hrdlicka has always practised engraving, again on the same theme. He has been represented at the Biennials of Venice (1964) and São Paulo (1967). He has also exhibited at the Marlborough Gallery, London. J. L.

HUET Jacques. Born 1932, Montreal. He is self-taught. He exhibited in 1965 at the Salon de la Jeune Sculpture at the Musée Rodin, Paris, and was represented at the second Symposium in Quebec (1966). His work reflects his peasant origins through the honesty of his materials, his methods of assemblage, which are the same as those used for the framework of Canadian houses and barns, and through his organic forms with their robust and sly humour. G. V.

His fertile inventiveness and the variety of his artistic output has helped to make Hoeydonck one of the leading Flemish artists today. For some time, he has been developing a personal Art-Fiction from science-fiction materials, which are a mixture of the facts and fantasies of spatial exploration. He is also an engraver, poster and jewellery designer. D. C.

i j

ILIESCO-CALINESTI Gheorghu. Born 1932, Calinesti, a small village in Romania. From 1953 to 1959, he trained at the Bucharest Academy. In 1961, he produced vigorous peasant portraits in wood, which were stylised in the spirit of folk art. His first one-man show took place in 1966 at Bucharest. He was represented at the Paris Biennial in 1967. The folklore of his country is the source of his creative imagination; for instance, when he was asked to illustrate the legend of the shepherd Dochia watching over his flocks, he carved a group of rocks in the Herastrau Park, Bucharest, which bear a remote resemblance to human animal forms (1955). The forms that Iliesco-Calinesti carves out of wood and stone, his favourite materials, are obviously inspired by the familiar objects of peasant life, like ladles, balcony pillars and cradles, but, as Brancusi did before him, he transfigures them in his sculptor's imagination and imparts a symbolic value to them. This sensitive and refined stylisation stirs the imagination as much by its simplicity as by its modernity. P. C.

IMOTO Atsushi. Born 1915, Tokyo. He trained at the Tokyo Art School. In 1961, he went to live in France and has since been represented regularly at the principal Parisian Salons and has held several one-man shows in

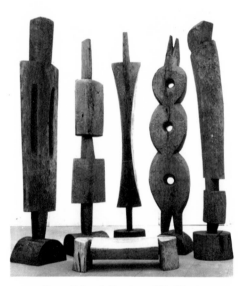

Iliesco-Calinesti. Meanings. 1966. Wood.

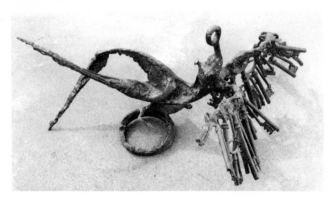

Imoto. Fire-bird.
1966. Soldered assemblage.

141

Ipoustéguy

Ipoustéguy. Helmeted head and head of a falcon. 1959.

France, Belgium, the United States and Japan. He worked in stone for a long time before he began using soldered metal as his medium. His brilliant improvisations are touched with an almost surrealistic fantasy and imagination. His technique consists in assembling and soldering together mass-produced, metal objects; an example is the recent series of Birds, Flowers and Insects, in which the effects of feathers, corollas and elytrons are produced by old keys, which he bought at the Marché

aux Puces (the market for second-hand goods in Paris). In spite of his comparative faithfulness to outward appearances, his sculpture shows a genuine plastic inventiveness and is inspired with a spirit that is more mythological than descriptive. D. C.

IPOUSTÉGUY Jean-Robert. Born 1920, Dun-sur-Meuse. He did not devote himself entirely to sculpture till 1954. Before this, he had made a reputation for himself as a painter and had executed notably the frescoes for the church at Montrouge (1948). He was trained by Henri-Georges Adam and his early work, at least, was influenced by Picasso and Brancusi. He seemed to be moving towards abstraction for a while, when he produced a series of quivering, trembling sculptures, some of them mounted on springs (1958), which already showed his unusual sensitiveness to surface sensations and tactile perception. But fundamentally, Ipoustéguy is not an abstract sculptor; he needs a subject, or to be more exact, a theme. This was the beginning of his reconversion. Except when architectural canons alone could solve the plastic problems facing him, he always followed his natural instinct for representational art. Besides plaster and clay, whose malleability suited his temperament, his most usual materials at this period were wood and metal. Later on, his sculptures were cast in bronze, or metal, after models in expanded polystyrene. The underlying myths of Ipoustéguy's extreme, violently expressionist style are a means of transcending description and lifting them up to the level of history. The conception and arrangement of his works are epic rather than emotive and the powerful, generous imag-

Ipoustéguy.
Death of the Father.
1969. Marble.

ination infusing them absorbs all particularities and accidents into a whole with symbolic significance. A visit to Greece, the death of a friend or street scenes are all used as pretexts for heaping up volumes, like a vast metaphor, into which he often introduces heterogeneous elements, such as figurines or other objects (*Speeches under Mistra*, 1964). Ipoustéguy's demonstrably aggressive, violently perturbed forms, with their shattered articulations and gutted planes, riven like wounds that gape to let in death, or like phalli, pouring out life, seem symbols of both destruction and fertility. Through passages of continuity, which break them, like hinges binding and conferring mobility, his forms invite a deep penetration within his sculptures and an active understanding so that the hand as much as the eye becomes an instrument of comprehension (*Woman Bathing*, 1966). From August 1967 to September 1968, he worked on the marble at Carrara, which was a new material for him. He combined it with polished steel in particular and produced a striking group of sculptures, including the *Death of the Father*, exhibited at the Galerie Claude Bernard, Paris, in November 1968. It possessed all the familiar characteristics of his personal world, but this time it was suffused with a new and surprising light, like an aureole. D. C.

JACOBSEN Robert. Born 1912, Copenhagen. He had never received any previous training, when he first began to sculpt. Rodin and Henri Laurens were the artists he first admired. However, it was an exhibition of German art, containing the work of Nolde, Klee and especially Barlach when he was seventeen, that made a deep impression on him. The following year, Jacobsen produced his first carvings in wood. His art showed Expressionist tendencies at first, but it soon developed a sort of lyrical interpretation of reality. His works had a barbaric, primitive appearance and finally looked like the objects of some sort of magical cult. In 1941, he joined the Danish group, Host, a group of painters and sculptors who were influenced by Surrealist principles. Nevertheless, the same year he produced his first purely abstract sculptures. He already knew the work of Jean Arp, which had opened new vistas to him. After remaining faithful to wood for thirteen years, he changed his material and learned the techniques of stone work, generally hard stone, like granite. While he was still in Denmark after the Liberation, he began to get rid of the rather literary interpretation of reality, which he had adopted up to that point, and turned to strictly plastic experiments. The use of colour interested him, not for its imitative value, but because it could be a means of neutralising the forward or backward movement of certain planes. He succeeded, for example, in using it to give exactly the same value to forms that, in themselves, were very different. In Paris, where he went to live in 1947, the variety of artistic circles and the freedom of individual expression came as a shock to him. Although

Jacobsen. Sculpture Nº 88. 1958. Iron.

he had attempted some metal sculpture in Copenhagen, in 1936, it was only now that it became his favourite material. After negotiations with the Galerie Denise René, two one-man exhibitions of his work were held there, in 1948 and 1953. In 1949, during a visit to Denmark, he produced an experimental film, *Reality A*, on some of his iron sculptures, to an accompaniment of concrete music. From this point, his work was concerned with the problem of space and its organisation. For years Jacobsen worked on cubic shapes, endlessly breaking them up to analyse all possible ways of rearranging them. He sent work regularly to the Salon de Mai, the Salon de la Jeune Sculpture and the Salon des Réalités Nouvelles. In 1952, his own country recognised his talent, when the newspaper, *Politiken*, awarded its prize to him. Three one-man exhibitions made his name known abroad: at the Palais des Beaux-Arts in Brussels (1954); at the

143

Jancic

A.P.I.A.W. in Liège, the same year; at the Stedelijk Museum, in Amsterdam (1956).

While he was continuing his experimental work in pure sculpture, Jacobsen invented a whole new world of little figurines, full of humorous fantasy, made of bits of old iron and scrap metal of all kinds. These 'dolls', which he made for his amusement during periods of relaxation, were exhibited at the Galerie de France, in Paris, in 1957. Gradually a stage, called the period of 'boxes' or of broken cubes, which was characterised by an extremely intellectual theorising, was succeeded by an analysis of movement and vitality in a work of art. It was perhaps not so much movement, properly so called, that interested him as the possible shifting of surfaces and their inner displacement. This was demonstrated later in the *Cosmonauts* series (1962), when he used polychrome relief. It is nonetheless true that Jacobsen would probably never have achieved his present freedom of expression and emotional freshness, if he had not first of all bound himself to a strict intellectual discipline. He does not make any preliminary models or drawings for his sculptures, but works directly on the cold metal. He hammers it out in all its natural hardness or malleability. He respects it too much to want to supple or soften it by forging it while it is hot. There is not a trace of the

processes of creation, except the welding, not a hammer blow marks the integrity of his works, which gives them a sort of inevitability that nothing could change. Their intense vitality reveals an artistic conscience that has always been alert and never stifled by natural sensuousness. Curves, which appear more frequently now, balance the intersecting, perpendicular lines and introduce a sensitive, dynamic element into the composition as a whole. Jacobsen now enjoys an international reputation; he shared the Sculpture Prize with Étienne-Martin at the Venice Biennale in 1966 and several one-man shows have been held of his work all over the world: Stockholm (1960, 1961), Copenhagen (1961, 1963, 1967), New York (1961, 1967), Venice and Oslo (1967) and, of course, in Paris (Galerie de France, 1963, 1965 and 1968). D. C.

JANCIĆ Olga. Born 1929, Bitola, Yugoslavia. When she had completed her training at the Belgrade Academy (1947), she worked for five years with the sculptor Toma Rosandić. She has been represented at several exhibitions in Yugoslavia and abroad, notably in Paris (Galerie Creuze, 1959), Antibes (Musée Grimaldi, 1960) and London (Tate Gallery, 1961). She was awarded the sculpture prize at the Paris Biennial in 1959. She never broke away completely from reality, although her interpretations of nature were very free. The human figure is the major subject of her art: Gravid-Forms, Maternities and Torsos. Her bold manipulation of masses, the absence of purely descriptive detail and the appearance of the material itself made her sculptures look like limestone concretions, which have been released from their gangue by the slow erosion of winds and water. When her forms become more dramatic and tense, like the *Weeper* of 1954, they still remind one of natural processes, like a fragment of lava that fire has distorted and twisted in its terrible embrace.

JANKOVIČ Josef. Born 1937, Bratislava. After he had completed his training at the Bratislava Art School (1956–1962), he was represented at several exhibitions in Czechoslovakia and abroad, notably in Hungary, Poland, Italy and France. Since 1964–1965, Jankovič has been modelling or constructing parts of the human body and making strange objects from them, which are the image of the haunting fears and massacres that have disfigured us. He arranges arms, legs, hands with dislocated bones, which seem to be oozing out their substance, on an armchair, a cupboard, on boards or wheels, or any other familiar object. A body, crushed in a folding bed, two legs, lacerated or hung up like an old pair of trousers; hands, emerging from indescribable parcels, which have been hastily tied up, are like terrible altarpieces on which we can decipher the appalling, unending tortures. These efflorescences, which proliferate in tangled heaps, these atrophied limbs form the

tragic sheaves of a humanity, mutilated in its flesh and organic unity. Jankovič's sculptures are an expression of the anguished martyrology of our times; they possess a wild fantasy and an unnatural reality, which have their source less in the phantasms of metaphysics than in the crimes of history. R.-J. M.

JANOUŠEK Vladimir. Born 1922, Zdirnice, Czechoslovakia. He trained at first at the Brno School of Arts and Technology, then from 1945 to 1950 at the Prague School of Decorative Arts. He is a member of the UB 12 group and has represented his country at the Venice Biennale (1954) and other international exhibitions at Helsinki, Copenhagen, Carrara, Paris, Bochum and Berlin. He has done several sculptures for public places, notably the Ostrava crematorium and the Prague stadium of aquatic sports (1964–1965). After he had finished a series of portraits towards the end of the fifties, Janoušek simplified his style and concentrated on the purity of the mass and its lines. Shortly after 1960, he left the metal armature of his sculptures partly visible, as a way of escaping from representational exactitude and, at the same time, they tended to shed any superfluous descriptive or formal details. About 1965, he wrested the form from the interior and the rods of iron irrupted out of the concrete or plaster; they grew into a tangled outgrowth before they became a frame, which imprisoned or supported filiform figures, often reduced to essentials, within their graphic network. The simplified structures of the human body, considered as

Janousek. Isaac Laquedem. 1966. Iron.

a field of organic and contradictory tensions was the starting point of this change from the uncontrolled to the controlled and its insertion within a tubular scaffolding. These twisted masses of iron, which balance or transfix the figures, are the measure of their mutilated gestures and trammelled flights. The *Large Clock*, in blue metal (1968), gives a new monumental dimension to his sculpture through the breadth and flexibility of its movements and the strange cadences it beats in space.
 R.-J. M.

JANOUŠKOVA Vera. Born 1922, Ubyslavice, Czechoslovakia. When she had finished her training at the School of Decorative Arts in Prague (1945–1950), she joined the UB 12 group and took part in numerous group exhibitions in Czechoslovakia and abroad (Budapest, Genoa, Liège and Paris). Since the late fifties, her sculpture has gradually developed from a Cubist construction of the form to the assembling of detritus. The early sculptures were large stelae, cut out from concrete blocks and livened with countless pieces of metal inlaid on the surface. Then she gave up using concrete for enamelled sheet-metal, which was sheared and soldered with a blow-pipe into reliefs, which were like the devalued reflections of our industrial folklore, with their barbaric

Jancic. Maternity. 1957. Stone.

Janouskova. Figure. 1962. Cement and iron.

expansive, compact shapes, with sensuous, harmonious lines, which seem to grow like flowers or fruit. Partially modelled, identifiable objects decorate her last works like filigree and give them a romantic flavour, while the ease with which they blend into the landscape endows them with monumentality. R.-J. M.

JENDRITZKO Guido. Born 1925, Kirchhain, formerly a part of Germany, now in Poland. He joined the Berlin Art School in 1950 and worked in Karl Hartung's studio, where he stayed till 1956. The same year, he won the Critics' Prize in Berlin. In 1958, he held two one-man exhibitions, one at the Springer Gallery in Berlin, the other at the Frank Gallery in Frankfurt. In 1959, he was represented at the Kassel Documenta II and Middelheim Biennial. Jendritzko's first sculptures in marble were influenced by his master, Hartung, and indirectly by Jean Arp. Then, for some time, he worked in slate and his works were like exotic plant forms. After that, the sculptor, Uhlmann, taught him the technique of cutting out metals, but he soon abandoned this medium for stone and bronze, which became his favourite materials. From 1955 to 1958, he did an important series of reliefs that were a new kind of decorative, architectural sculpture. His works were purely abstract constructions, without a trace of natural inspiration and their combination of rounded forms with pointed, jagged motifs was particularly powerful. Jendritzko has returned to more supple rhythms and his works now consist of plant forms that rise in broken, irregular lines, as if they had been galvanised by some strange kind of energy. J. R.

brilliance and their violent colour, dominated by gaudy reds and blues. A change in her vision about 1967 brought about a radical conversion in her means of expression. After the solid, frontal volumes of concrete sculptures, then the metal reliefs, Janouškova fashioned

JESPERS Oscar. Born in 1887, Antwerp. He received his first training from his father, who was also a sculptor, and then attended the Academy and Institute of Fine

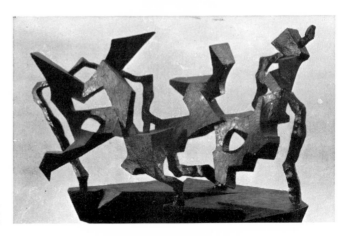

Jendritzko.
Composition III.
1959. Bronze.

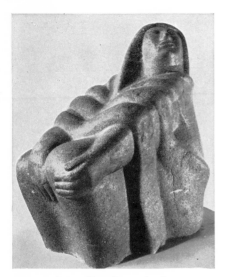

Jespers. The prisoner. Granite.
Musée des Beaux-Arts, Brussels.

JEVRIĆ Olga. Born 1922, Belgrade. She studied at the Academy and the Conservatoire, and has been exhibiting her work since 1948, but she did not have a personal show of her sculpture till 1957 (Ulus Gallery, Belgrade). She has been represented at several exhibitions in Yugoslavia and abroad, notably in Paris (Musée Rodin, 1956; Galerie Creuze, 1959), London (Tate Gallery, 1961) and the Biennials of Venice (1958) and Middelheim, Antwerp (1959). She has also had two personal exhibitions in Italy at the Galleria Ferrari, Milan (1954), and the Galleria Notizie, Turin (1959). After her early portraits, Jevrić suddenly turned in 1954 to abstraction. The wholly original *Plans for a Memorial* in iron and concrete were the result. These harsh, powerful works have an acute sense of space and the requisite qualities for reproduction on a large scale. Her sculptures have the sombre, tragic poetry of the medieval tombstones of her country, but it has been transposed into a modern idiom. Her art tries to convince rather than please and, if it possesses the funereal note of the fratricidal war that men have fought through the ages, it also possesses a magic feeling of strength.

Arts in Antwerp where he was taught by Vinçotte. His works reflected the influence of Rik Wouters, but this soon disappeared and he followed the Cubists in the simplification and geometrisation of forms. He became friendly with the Flemish poet, Paul van Ostayen, and with his younger brother, the painter, Floris Jespers, and Paul Joostens, who later became known as a dadaist and one of the pioneers of abstract art, he took up an uncompromisingly avant-garde position in art. After the First World War, he joined the Sélection group and became an Expressionist without giving up the fundamental principles of his art: restraint and bareness, solid forms that created an impression of heavy monumentality. After 1937, a further change came over his art and he abandoned the geometric principles, which had transformed some of his works into stark monoliths. He tried to give greater suppleness to his sculptures of the feminine body by returning once again to flowing curves, rounded contours and smooth volumes. It was a phase of classical serenity and a gentleness without flabbiness or affectation. Jespers had tried his hand at a variety of techniques and had a thorough knowledge of their possibilities. During his Expressionist period, he had generally practised direct carving on wood and stone, but he had also modelled clay and hammered copper. He did several large-scale works in an architectural setting, which showed his innate sense of monumentality (high-relief in painted wood for the model station in Brussels built for the Exposition Universelle of 1935; two stone high-reliefs for one of the postal buildings in Brussels). In 1941, he was elected to the Flemish Royal Academy. F.-C. L.

JONAS Siegfried. Born in 1909, Geneva. When he had finished his training at the Art School in Geneva, he went to Paris in 1931 for two years. There he found Laurens, Lipchitz and Picasso as exciting as Romanesque and Negro art. He produced nothing, after his return to Switzerland, and did not begin working again till about 1940. He then did innumerable studies from life, but he

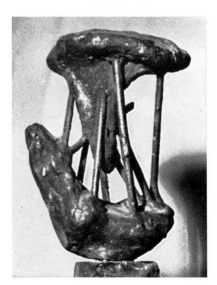

Jevric. Composition I. 1956. Iron.

147

felt ill at ease with a figurative form of expression and gradually turned towards a freer style. His first abstract work appeared in 1945 and, the following year, he went to live permanently in Paris. By 1949, he was exhibiting in the principal Salons and a number of his works were cast in bronze. At the same time, he was working on a series of metal reliefs in sheet-iron, which contained further experiments in new forms. Although he had not been commissioned to do any monumental sculptures at that time, he was concerned with the problems inherent in large-scale work. His first one-man exhibition took place at the Galerie Arnaud in Paris in 1953. Soon a new development was noticeable in his work; he abandoned solid masses and turned towards a more flexible kind of expression in which space became an integral element

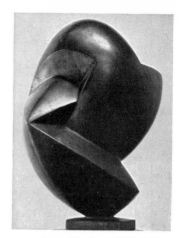

Jonas. Song of the hours. 1953. Bronze.

in his sculpture. He began to use plaster for his new manner and worked on it directly. He liked this awkward, unpleasant material, because it is difficult to handle and shows up the slightest imperfections. In 1958, an exhibition of his work was held at the Galerie Breteau in Paris and, two years later, he designed a Signal, 120ft high, in concrete for the Sacré-Cœur church at Mulhouse. The geometric forms, which were leading to a sort of formalism, have disappeared from Jonas's sculptures today. He is primarily concerned with the contents of his art. The composition of its organic volumes, with their expressionist overtones, is more spontaneous than in the past and implies the least amount of logical interference. D. C.

JONES Arne. Born 1914, Medelpad, Sweden. After working with a stone carver and attending the Technical School for five years, he continued his training until 1947 at the Stockholm Academy. At first Arne Jones treated the human body as a dehumanised, simplified construction of movement and tensions and from there his sculpture developed into pure form. He reduced it to linear shapes, enclosing virtual volumes, poised on an imaginary axis. Eddying, girating lines develop an inner space which sometimes seem like abstract Gothic. Among his most important works, mention should be made of *Fountain* (1948) and *Cathedral* (1948), both in Norrkoping Museum; *Spiral Space* (1953), *Andante* (1959), *Within and Without* (1959). In his most recent work, Jones creates monolithic forms in undulating, ascending rhythms. P. V.

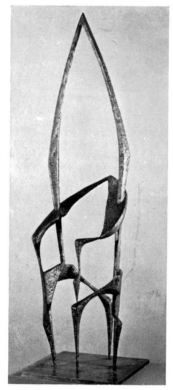

Jones. Cathedral II. 1947-1948.
Bronze and silver.

k

KALINOWSKI Horst Egon. Born 1924, Düsseldorf. He trained at the Academy in Düsseldorf (1945–1948), then went to Italy, before settling in Paris. He began as a painter and attended Jean Dewasne's studio of abstract art. In 1956, he began making collages, or rather object-paintings, of materials chosen at random, such as printed paper, netting and other tissus that were half frayed out. These were succeeded in 1958 by 'Shrine-paintings', made of even more disconcerting detritus, dusters, rope, straw, pipes and imitation jewellery, which suggested obscene, or even blasphemous remains. Then, in 1960, he began the series of 'Chests', a framework of wood covered with leather to which he gave the subtlest variations of tone and texture. He used the same process for making stelae, a few sculptures and particularly mural reliefs, whose ample forms became increasingly more simple. Kalinowski does not begin with any preconceived ideas, but lets the work take shape as he proceeds, so that the final sculpture is a crystallisation of past experiences and the materialisation of fresh ideas. The Chests are disquieting and austere; they belong to a closed world, the realm of magic forces and are steeped in the strange associations of pagan cults, incanted ceremonies, inquisitorial proceedings and sexual obsessions. Suggestive ornaments, ambiguous objects, placed at their openings, or hanging from heavy chains are a striking contrast to broad, strictly geometric surfaces. Beneath their static, calm appearance, these works conceal an almost unbearable tension, which seems on the point of exploding at any moment. Even the careful finish of the works reinforces their disturbing presences. Since 1953, Kalinowski has held more than twenty one-man exhibitions in Germany, Belgium, England and France (Galerie Daniel Cordier, Paris, 1958 and 1963; Centre National d'Art Contemporain, 1969). He was awarded the Carl-Einstein Prize at Essen in 1966 and, the following year, the first prize for sculpture at the Haus der Kunst in Munich. H. W.

KANO Minoru. Born 1930, Tokyo. When he had completed his training at the Tokyo Art School, he went to Paris in 1957, where he attended the École des Beaux-Arts and the Académie de la Grande-Chaumière. He was represented at the Biennials of Paris (1965) and Tokyo (1967), as well as the principal Parisian Salons. He has had two one-man exhibitions in Paris (1965 and 1966) and another at Evreux (1962 and 1966). Kano was influenced at first by classical and Romanesque art, but since 1961 he has turned to abstraction. Instead of plaster, bronze and stone, he now prefers using wood, particularly ply-wood, metals, sometimes powdered, and especially synthetic resins, which lend themselves to a more flexible and more exact modelling. Kano's art is inward-turning and grows out of the study of the latent energies peculiar to each form. His volumes are created

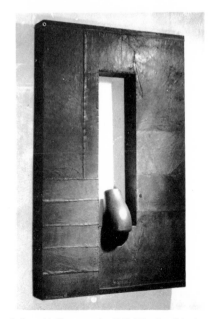

Kalinowski. Torquemada. 1967. Wood and leather.

Kelder

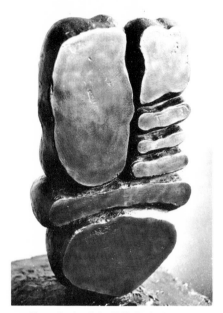

from the compression or flattening of a mass of materials. The exceptional concentration imparted to them by this brutal manipulation leaves an impression that the living forces within are pushing through the surface. D. C.

KELDER Toon. Born 1894, Rotterdam. He trained at the Academies of The Hague and Rotterdam. Although he is domiciled at The Hague, he has lived in Paris since 1945. Kelder's artistic history is extraordinary. Until the Liberation, he had only painted in a romantic, thoroughly fantastic manner. When he was about fifty, he had the strength to set off on a completely new venture. Eventually, the line he had been tracing over paper was projected into the air in the form of a slender, flexible shaft of metal. His first works in iron wire, masks, figures, stylised animals were still in two dimensions, 'drawings in space', as Frank Elgar called them, when they were exhibited in Paris, in 1950. Kelder inevitably went on to solder his wires together and arrange a three-dimensional interplay of planes and lines; in doing this, he created a form that was undeniably sculptural in its conciseness and clarity. Later on, a need for volume made him carve his shapes in wood and then cover them with metal. Indifferent to success and aggressively independent, Kelder continued along his own way as his instinct and temperament led him. Although

his sculptures were essentially derived from natural forms they seem more like the embodiment of patterns, conceived in his mind and vital with a stark unsentimental lyricism. The arrangement of his planes in space, their weight, relationship and contrasts show that he has mastered his idiom. Whether they are defined in harmonious or asymmetrical patterns, they form a whole that is alive with a serene vitality and a virile confidence. Kelder is capable of producing large-scale work, too; as, for example, the large sculpture at the entrance to the radio laboratories at Leidschendam, near The Hague.
W. J. de G.

KEMENY Zoltan (Banica, Transylvania, 1907 – Zürich, 1965). He trained as a cabinet-maker, studied architecture at the professional school in Budapest and designed fashion models before choosing the career of painter and sculptor. He lived at first in Paris (1930–1940) and then at Zürich from 1942. He began to establish a reputation after the war through a number of one-man exhibitions at Zürich, London, Berlin and Paris (Galerie Paul Facchetti 1955, 1957) from ready made materials, scrap metal, wire, nails, and springs. Sometimes he makes the components himself from sheet-iron or metal

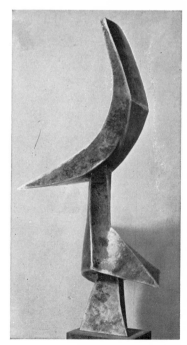

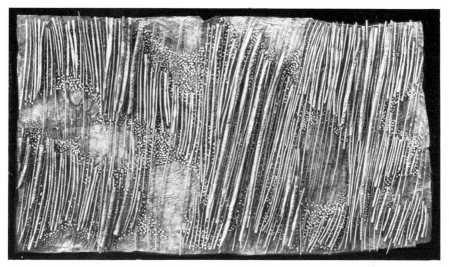

Kemeny. Will Tension Energy Creation.
1958. Copper.

plates, bent, cut and hammered by processes he keeps
secret. He experimented with lead, zinc, iron, tin and
aluminium, but eventually preferred to work in copper
and brass. Once he had chosen the subject, the con-
stituent parts were always the same; they only varied in
shape and size. They create a hallucinatory effect of
proliferation and growth, of matter in process of evolu-
tion, simply in the way they are grouped and massed
together. It needs an imaginative, even a romantic
spirit, to transform the base materials of 'Relief Paintings'
in this way and make lozenges and rings of aluminium
look like lilies, floating on a pool, and ordinary nails look
like clusters of mushrooms in a forest. In his major works
of the years 1961–1963, Kemeny assembled uniform
materials, but he covered the bases of his structures with
the most varied excrescences: copper nails scattered
over the surface to suggest the pieces of a disintegrating
old table; brass bands undulating in horizontal lines,
which stirred in the currents of air; rotating circles
turning at irregular speeds; or misshapen pipes twisted
into an eddying movement. Some of his reliefs, like
Metallo-magic (1963), have an exotic, oriental flavour,
which is accentuated by the iridescent colours from the
soldering heat. His last works, in forms indicated by their
titles, *Wings* and *Clock*, were erected on pedestals to
give them plenty of space to expand. In 1963, he made a
mural relief in brass, for the School of Advanced Eco-
nomic and Social Studies at Saint Gallen and a spatial
sculpture, 390ft long, for the foyer of the municipal
theatre at Frankfurt. Zoltan Kemeny was awarded the
first prize for sculpture at the Venice Biennale of 1964
and a large retrospective exhibition of his works was
held two years later at the Musée National d'Art
Moderne in Paris. H. W.

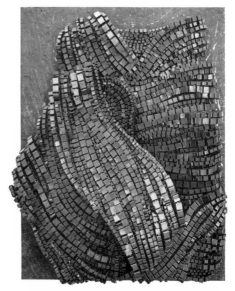

Kemeny. Formations. 1958. Iron. Le Guillou collection.

King

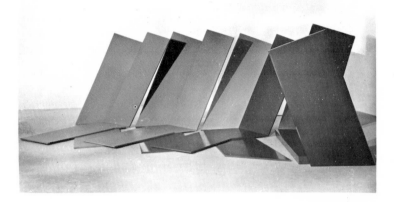

KING Phillip. Born 1934, Tunis. He read languages at Cambridge University (1954–1957) and trained at St. Martin's School of Art, London (1957–1958). From 1958 to 1960, he was assistant to Henry Moore. In 1967, he was appointed a Trustee of the Tate Gallery, London. He teaches both at the St. Martin's School of Art, and the Slade School, London. Since his first one-man exhibition in London in 1964, he has exhibited widely in England and abroad. King has developed very rapidly as a sculptor over the past ten years and from the outset has shown great mastery of both form and colour. The combination of tensions and formal equanimity found in his work seems to result from a striving after the universal and cosmic, allied to a deep awareness of both the beauty and stress of the present day environment. His sculpture has increased considerably in size over the years and he has experimented with a great variety of media including plastic, fibre glass and more recently metal. The sculpture *Through* (1965) represents a high point in his development; the slightly contorted, or even expressionistic air of the works of 1963, such as *Twilight* and *Tra-la-la* has gradually given way to a more geometric and expansive treatment of shape and pattern, already prefigured in the triangular arrangement of *Rosebud* (1962). Since *Through* the space around and between his sculpture has assumed an important role in the presentation and arrangement of King's work (*Span*, 1967). DA. F.

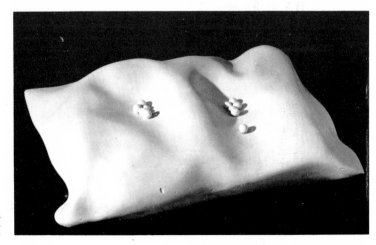

Kmentova. A target-woman. 1968. Plaster.

KMENTOVA Eva. Born 1928, Prague. When she had finished her training at the School of Decorative Arts in Prague, she joined the Journey group and took part in various exhibitions in Czechoslovakia and abroad, notably Paris. After a period that was marked by a Cubist style of expression, shortly after 1960, she began making mural panels and stelae in plaster or concrete, with surfaces enlivened by impressions in hollow or relief made by broken furniture, then stones, pebbles and a variety of other objects. In spite of the mass of motives they covered, three colours already stood out from her concrete idiom as if to lend emphasis to its scansion; blue and green represented natural realities, red was the colour of human reality. Then after 1965, the imprint of hands and lips appeared, like a heraldry of the body, which the artist subsequently elaborated into three dimensions. In 1967, the headless figures of *Mary* and *Eve* in concrete only look human because of the modelled and attached arms and legs. Kmentova took this experiment to its logical conclusions and went on to model the entire body in life-size figures of men and women. The deliberate addition of colour led to a change in the semantics of the forms; a model of a couple was broken horizontally into two distinct parts and turned into a

Landscape (1967), one painted blue to indicate the sky, the other green for the earth. The primary purpose of modelling for Kmentova is to seize the reality of the human body. The choice of her own is not through any sort of introspection, but because she considers her own body a way to a more thorough understanding and sees in it a means to objectify herself into a concrete time and space. This was the source of the 'anthropometric sculpture' in the beginning of 1968 for which Kmentova and her husband were the models. *Target-man* and *Target-woman*, stripped of all emotional or descriptive expression and reduced to the anonymity of a simple outline cut out from a slab of plaster, have a universal dimensions about them. All life and personality have been stripped from these flat, plaster silhouettes; they are cut-outs for a humanity that has been dehumanised by our age. A prophetic vision of life and contemporary history have fashioned them and given them authenticity. R.-J. M.

KNOOP Guitou. Born 1909, Moscow. Her family were Dutch in origin. In 1927, she went to live in Paris, where she became one of Bourdelle's pupils. Her first exhibition took place at the Galerie Cardo, Paris (1932), followed soon afterwards by another at the Galerie Vignon. In 1933, she obtained French nationality. Under Despiau's influence, she spent nearly all her time on the art of the bust. She nearly always worked in clay, which she modelled for bronze casting. When war broke out, she was in New York, where she stayed for the duration of the war, but, since 1945, she has returned to France regularly every year. Soon, her work showed a preoc-

Knoop. « Vayu » II. 1958. Marble.
Baronne A. de Rothschild collection.

Koblasa

fashions from them are monumental in character and strictly classical in their abstraction. D. C.

KOBLASA Jan. Born 1932, Tabor, Czechoslovakia. He is a sculptor, painter and engraver, trained at the Prague Academy (1952–1958). He has fulfilled several public commissions, notably a fresco for the C.S.A. agency in Warsaw (1963) and a relief for the hall of Prague airport (1967). His sculpture is haunted by the human presence. Besides ribbed plaster (1960) and reinforced concrete (1966), his favourite material is wood, which he lacerates into crevasses and gaping caverns. Koblasa invented the players of an imaginary game of chess or the celebrants of some primitive ritual, when he created the cycles of *Kings* and *Queens* (1962), *Madonnas* and *Princesses* (1964), and the procession of grotesque and fantastic *Dwarves*. After he has worked them with an iron tool, modelling or burning them with a patinating scorch, these figures seem to have escaped from some strange, tragic order. Since 1964, the series of *Prophets* has been appearing: blocks of rough wood, in the shape of heads, placed on stakes and then marked with a hot iron or a cold tool. In 1968, he sculpted different types of homage to Kafka and Lautréamont, before he

cupation with fresh plastic problems, as it gradually became abstract in manner. There were two reasons for this; first she was constantly associated with American architects and artists and, secondly, she was deeply impressed with what she saw on a three months' visit to Mexico in 1945. This appeared in the sculptures she exhibited in 1949, at the Pierre Loeb Gallery, which showed the influences of pre-Columbian sculpture. In 1949, the Betty Parsons Gallery in New York held an exhibition of her work, with an introduction to the catalogue by Jean Arp, and since then Guitou Knoop has been regularly represented at the principal Parisian Salons. By this time, her work was entirely abstract. For several years, she worked in brass and lead, but recently she has used stone more and more frequently. In 1958, the Galerie André Schoeller exhibited her sculptures, which were distinguished by a completely bare style which gives free expression to the artist's joy and vitality. In recent years, Guitou Knoop has worked a great deal at Carrara with different kinds of marble. The sculptures she

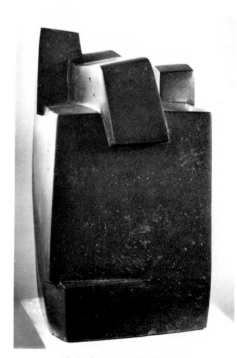

Koch. Sculpture. 1969. Granite.

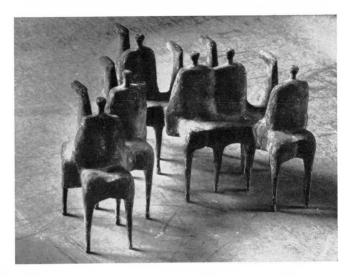

Koenig.
Group of horsemen.
1956. Bronze.

produced a *Triumphal Arch*, which was a sort of gibbet
hung with tortured, menacing forms. R.-J. M.

KOCH Ödön. Born 1906, Zürich. He began by learning
tapestry, before he took up sculpture in 1938. He was self-
taught and never directly acknowledged any master,
although there are reminiscences in his work, rather
remote admittedly, of Henri Laurens and Arp. Stone is
his favourite material, particularly the texture and hard-
ness of granite, which perfectly suited the massive
shapes of his sculpture. These generally consist of in-
genious, geometric patterns in which broad, surface
planes are contrasted with the sweep of voluptuous
curves. But Koch is not a slave to his own formulas and
he has also made strongly rhythmic constructions, with
prominent ridges. In spite of its discipline, the final
impression of his sculpture is made by a prevailing
feeling of sensuousness, the finished execution and the
purity of his means. Everything suggests that, for Koch,
sculpture is a self-sufficient language, which is its own
justification. R. M.

KOENIG Fritz. Born 1924, Würzburg. From 1946 to
1952, he attended the Munich Academy where he was
Anton Hiller's outstanding pupil. In 1951 he stayed for a
while in the south of France and then visited Belgium,
Italy, Greece and Egypt. He was awarded the Böttcher-
strasse Prize of Bremen in 1957 and, in the last few years,
has been represented at the major German and inter-
national exhibitions. In 1959, a retrospective show of his
work was held in Munich. Since his stay in the Camargue,
where he could watch whole herds of wild bulls, he has

been preoccupied with the problem of representing the
crowd. In an attempt to solve it, he did a series of varia-
tions on the subject of *Herds of Bulls* in which the
animals are united in one, unbroken mass with a parallel
structure. When he used this solution to the problem in
the mural relief of *Calvary*, the result was a composition
of ranks of figures, arranged in concentric circles. At the
same time, he attempted to represent the human couple
in a similar manner, which united the man and woman in
a single, abstract figure. In the *Quadriga* of 1957, he
succeeded in merging the horses, the man and the
chariot in one, perfectly coherent image. The same
motif, handled in the round, was even more abstract in
manner. In the last few years, Koenig seems to have
broken all the bonds attaching him to outward appear-
ances. Notable among his works is a series of restrained
sculptures of a geometric nature, which are pure symbols.
Their rigour is softened by the way he has delicately
worked the surfaces, so that they ripple with the palest
gleams of light. J. R.

KOHN Gabriel. Born 1910, Philadelphia. His father
was an engraver and a major influence on his son. In
1929, after leaving school, Kohn enrolled at the Cooper
Union, where he studied sculpture with Gaetano Cecere.
From 1930 to 1934 he studied at the Beaux-Arts Institute
of Design, where he modelled from life. At the same time
he was assistant to various sculptors working in New
York. From 1934 to 1942 he designed for the theatre and
cinema, spending seven years in Hollywood. In 1942 he
enlisted in the camouflage engineers of the United
States Army, and after his discharge in 1946 spent about
ten months in Hollywood. He spent the following year

Kolibal

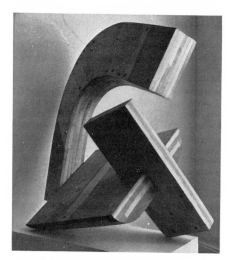

Kohn. Untitled. 1959-1960. Thin board.

made, he puts them together in the spirit of the laboratory chemist, probing balance and imbalance until a stable compound is found, or with the eye of an architect freed from utilitarian constructions, and at liberty to improvise fresh relationships. R. G.

KOLIBAL Stanislav. Born 1925, Orlova, Czechoslovakia. He is an illustrator and theatre designer as well as sculptor. He trained at the Prague School of Decorative Arts (1945–1951) and is a member of the UB 12 group. His first sculptures looked like torsos, but since 1963 they have become abstract, with forms in a pure, sensitive geometry, which have an undeniable monumental quality about them. The whiteness of plaster and polyester, and later on the brilliance of polished bronze seem to stress this constructive aspect of Kolibal's work. After 1965, his manner became more complex. Strange protuberances and sudden, unexpected efflorescences individualised the elementary shapes; others were elongated, twisted and the regularity of their lines broken, while slender, quivering stems of iron projected and suspended flowers of plaster into space. Kolibal's early language of forms, which was deliberately cold and anonymous, has been modified and charged with

ın Paris, working under the direction of Zadkine. Then he went to Nice, generally working in terracotta. After staying in Rome for a year (1948–1949), Kohn lived in France from 1949 to 1954, except for a year at the Cranbrook Academy. In 1953 he was one of the eleven American prize-winners in the competition for the monument to *The Unknown Political Prisoner*, and won an honourable mention in the final international judging. He exhibited his work at the Whitney Museum in 1953 and 1958. He was represented at the Stable Annual in 1956 and 1958; the New Talent Show at the Museum of Modern Art (1957) and at the Recent Sculpture, U.S.A. exhibition at the same museum (1959); the São Paulo Biennial (1959). Kohn had a one-man show at the Leo Castelli Gallery in 1959 and won a Ford Foundation Award in 1960. His work is represented in the collections of the Museum of Modern Art, the Whitney Museum and the Albright Art Gallery, Buffalo.

Although he has previously worked in both terracotta and stone, Kohn has found a characteristic style in his wood constructions of the last few years. These are made of simple geometric, but irregular shapes fashioned from laminated wood. Their surfaces are smooth, polished and machine made, without the traditional carved or modelled irregularities that indicate the hand-made article, since Kohn believes that it is the idea, not the personal touch that is essential. Similarly, he discounts the particular quality of the material in which he happens to work. These constructions are open; they shoot out diagonally or horizontally into space, and often balance on a single point. Kohn's intention is to get away from the restricting human prototype, people erect upon their feet, and instead to 'open things up'. The elements once

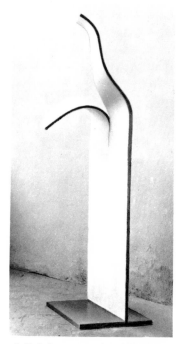

Kolibal. Paper memorial. 1967. Plaster.

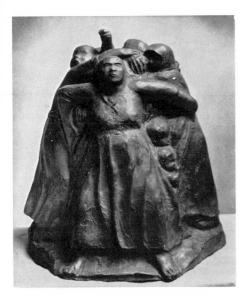

Kollwitz. The circle of mothers. 1937. Bronze.

threatening. Although she was excluded from the Berlin Academy, threatened with arrest and ignored by the Nazi press, Käthe Kollwitz still stayed in Germany. ('I want to stay with the rejected and I must'.) On her seventieth birthday, she received thousands of letters and telegrams: silent Germany was paying homage to her. J. R.

KOSICE Gyula. Born 1924, on the frontier between Czechoslovakia and Hungary. His family emigrated to Argentina in 1928 and he became naturalised there. He studied drawing and sculpture in the independent academies of Buenos Aires (1939–1940). In 1945 he helped to form the group, Concrete-Invention Art, which led to the formation of the Madi group the following year, and a periodical of the same name. The event was marked by a group exhibition. After that, the work of the Madi artists found its way across Latin America as far as Europe, where it was exhibited in the Salon des Réalités Nouvelles in Paris (1948, 1950, 1958) and the Galerie Denise René (1958). Kosice's first one-man exhibition was held at Buenos Aires in 1943. In his sculpture and theoretical writings, Kosice tried to find a solution to the contradictions between man and the world by unifying them in an art of pure invention. His aim was to build a geometric sculpture that would have a dynamic relationship with

expressive, sometimes symbolical tensions. It is the development of a sculpture that has tried to materialise time, not as movement, but as duration, and give permanent form to the attrition and instability of lines, surfaces and shapes invented by man, as, for example, in his *Disappearing Form* (1968) or, better still, in his *Paper Memorial* (1967), which gives lasting form to a piece of paper torn and placed upright. R.-J. M.

KOLLWITZ Käthe (Königsberg, 1867 – Moritzburg, 1945). When she had completed her training in painting and drawing at Berlin (1885) and Munich (1888–1889), she returned to Berlin, where she lived for the rest of her life, except for a visit to Paris in 1904 to learn to sculpt and a year spent in Italy (1907). She first made a name for herself with the series of etchings, the *Weavers' Uprising* and the *Peasants' War*. In 1916, she exhibited her first sculpture, of a loving couple. From 1914 to 1932, she worked on a memorial to the war-dead, which was also to be the tomb of her son, Peter, who was killed in 1914. Her endless sketches and plans for it culminated in the barest conception, untouched by any rhetoric, a humble couple of mourning parents, who have the simplicity and grandeur of medieval Weepers. The two figures were reproduced in granite and eventually erected in the cemetery of Eessen near Dixmude. The *Tower of Mothers* (1937) in which she sculpted her protest against all war, is imbued with the same feeling. The later works, a *Pietà* (1938) and the high-relief, *Lament,* show her resignation towards the events that were

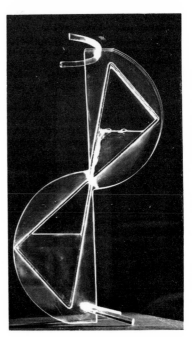

Kosice. Hydraulic sculpture. 1960.
Plexiglas. Galerie Denise René, Paris.

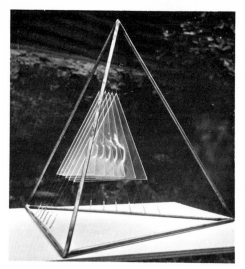

Kowalski. Pyramid. 1967. Coloured plexiglas and lacquered iron.

space. His constructions, in which the planes are gracefully superimposed and interrelated, are made of modern materials, generally plexiglas. His forms show a firm control in which emotion is always restrained by a strong sense of proportion. Towards the end of the fifties, he turned to the problem of movement in a work of art and suggested a new solution in his 'hydraulic sculpture', which he demonstrated in an exhibition at the Galerie Denise René in 1960. The works were made of plastic and the movement was derived from the upward thrust of air bubbles in a mass of water. He elaborated the idea with ingenious variations of an undeniable beauty. In 1968, he published *Arte Hidrocinetico*, a discussion of the basic principles of this new plastic idiom, which combined precision with the most subtle poetry. M.-R. G.

KOWALSKI Piotr. Born 1927, Lvov, Poland. He trained at the Massachusetts Institute of Technology. He has been represented at all the major international exhibitions, notably the Symposium at Los Angeles (1965) and the Venice Biennale (1968). He is now living in Paris. An exhibition of his work was held at the Musée d'Art Moderne de la Ville de Paris in 1969 under the auspices of the A.R.C. Since his decision to devote himself to sculpture, Kowalski has used the non-traditional processes of the most advanced technology. He has rejected the romanticism of manual work, which, according to him leads to imprecision and confusion of forms, and entrusts the works he has conceived to machines and industrial processes. Concrete, synthetic resins, steel and light effects are his usual materials. He

is primarily interested in creating forms through the direct intervention of certain sources of energy; the various elements of his *Sun Trap*, for instance, were sculpted by detonating explosives. He has also treated metals with electrolysis, projected solid bodies against elastic surfaces, and has used inflatable structures and luminous gas activated by an electronic generator. The technical methods are not ends in themselves for him, but simply intermediaries between a strictly scientific conception and the completed work. He demolishes preconceived ideas, which are also the most generally accepted, and hopes to renew the meaning itself of art. This is why original plastic processes have a greater intellectual attraction for him than any other methods. The formalism implied in this approach, however, still belongs to a traditional attitude because of the underlying sensibility that is in direct contact with the technicalities of our civilisation. D. C.

KOZARIĆ Ivan. Born 1921, Petrinja, Yugoslavia. When he had completed his training at the Zagreb Academy, there followed a long and difficult experimental period. About 1953, began what he considers to be his real work as a sculptor. A few months visit to France hastened his development. When he returned to Yugoslavia, he often exhibited his works with one of his friends, the painter, Dulcić, with whom he felt he had a strong affinity. His works were exhibited successively in Zagreb and Dubrovnik in 1956 and Belgrade in 1957. He seldom works in stone, and prefers modelling clay and plaster, welding iron or carving wood. He executed in wood the

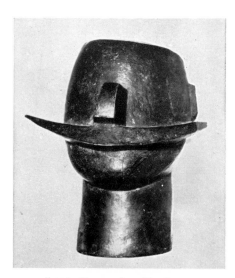

Kozaric. The man from Lika. Bronze.

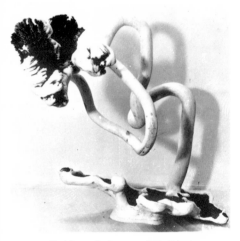

Krajcberg. Exuberance. 1969. Wood

important *Stations of the Cross*, for the church of Senj, and the figure of a sportsman in Zagreb. His art gradually moved away from the representation of reality and soon completely abstract masses, sometimes simple to the point of being rudimentary, took the place of distortion. He became known outside his country through exhibitions abroad: in Germany in 1956, the Carrara Biennial in 1957 and in Paris in 1959. He returned to France for the last exhibition and stayed longer than the first time. Kozarić is using new materials now, notably fibreglass, either coloured or translucent. He was awarded the Prize of the City of Zagreb (1960) and contributed to the Symposium of marble sculpture at Arandjelovac in Yugoslavia, in 1967. D. C.

KRAJCBERG Frans. Born 1921, Kozienice, Poland. He trained as a painter at the Stuttgart Academy (1945–1947) and made a name for himself first as a painter. His career began in Brazil, where he lived for ten years, before he went to Paris in 1958, where he held two one-man exhibitions at the Galerie XXᵉ Siècle (1960 and 1962). He obtained Brazilian nationality. In 1957, he was awarded the first prize at the São Paulo Biennial. Krajcberg came to sculpture through making reliefs painted on paper. The urge to go beyond the limitations of the two-dimensional plane led him to design solid constructions in space. His sculptures, made from wood or parasitical plants of the Brazilian jungle, have a sort of delirious form, which is counterbalanced to a certain extent by their sober colour derived from natural earth pigments or crushed minerals. Krajcberg's works establish a harmony between man and the elements, which is something greater than their baroque exuberance borrowed directly from nature. D. C.

KRAMER Harry. Born 1925, Lingen, Germany. Kramer's various plastic works belong to the theatrical world rather than to sculpture strictly speaking. He is, in fact, a professional dancer and actor himself. He invented a whole series of 'dolls on wheels', which were exhibited at the Springer Gallery, Berlin, in 1955 for a performance in Thirteen Tableaux. He went to live in Paris in 1956, where he began his 'car sculptures', which were made of fragile iron cases in which tiny electric motors and pulleys, holding rubber bands to transmit the movement, were fitted. These constructions were generally built up from elementary forms, spheres, cylinders and pyramids, whose simplicity is belied by a mass of details. The wheels, which are attached to certain parts only, turn in different directions and at different speeds, while their rattling is enhanced by the sound of bells. It is this deliberate lack of perfection that gives these works their special character; as distinct from other artists today, Kramer seems less anxious to protest against an age enthralled with technology than to mock it joyously. His mobile sculptures have been exhibited at the Kunsthalle in Baden-Baden (1960) and the Galerie Kerchache, Paris (1962). Since 1962, Kramer has contributed to various exhibitions of kinetic art. H. W.

KRICKE Norbert. Born 1922, Düsseldorf. He trained at the Berlin Academy. From the beginning, he was concerned, not with the composition of plastic volumes, but with building constructions through which air would flow

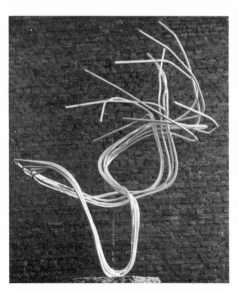

Kricke. Wire. 1957.

159

Kricke

freely. His first works consisted of arrangements of bands or metal tubes in which the zig-zag movements of straight lines and acute angles made geometric patterns, stretching into space with no distinction of upper and lower parts. Soon however, the contours were broken up and the tubes, bound in bundles or sheaves, knotted and unknotted themselves as they traced their restless curves or disappeared into the void. Kricke sometimes used several different kinds of metals for these constructions, tin, copper, steel, nickel and even painted the steel wires in different colours to emphasise the conflict between the forces that had brought them together. However, when they reached a stage of extreme confusion, Kricke reduced them to order by assembling tubes of varying lengths, which he soldered parallel to each other, as, for example, in his first large-scale relief for the annex of the new theatre at Gelsenkirchen. Although his 'Planes in the form of a trajectory', supported by slender, vertical rods, suggest sails or weather cocks torn by the wind, when they are bound into violently dynamic compositions, they are more like spectral birds shearing through the air in their flight. He no longer added colour, but relied on the light alone to shimmer on the polished metal. Kricke has made some very large sculptures, one of which is 22ft high for the grounds of the Baroness Alix de Rothschild at Reux, Normandy, and another, 21ft high for the Mannesmann Company at Düsseldorf, which prove his ability to integrate his works equally well in a landscape and in architectural surroundings. He has tried to conquer weight and achieve complete fluidity by designing several sculptures in which water is used as a primary material. In one of them, made in 1964 for the courtyard of a Düsseldorf bank, the liquid rises within columns of plexiglas and streams down walls, before disappearing into outlets in the ground, and is like a 'forest of water'.

Since his first one-man exhibition in 1953 at the Ophir Gallery in Munich, Kricke has held several shows of his work in Germany and abroad: Kunsthalle of Düsseldorf (1955), Galerie Iris Clert, Paris (1957 and 1959), Karl-Ernst-Osthaus Museum at Hagen (1963), and the Venice Biennale (1964). He has also been represented at several international exhibitions: Biennials of Middelheim, Antwerp, Sonsbeek, Arnhem; Kassel Documenta; exhibitions at the Fondation Maeght, St-Paul-de-Vence, 1967 and 1968. H. W.

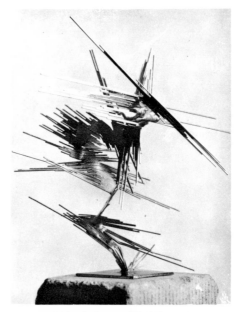

Kricke. Sculpture. 1961-1962. Metal.

160

LACHAISE Gaston (Paris, 1882 — New York, 1935). Although Lachaise is considered the leading American sculptor of his generation, he was born in Paris, where his father was a cabinet-maker. He trained at the École Bernard-Palissy and also attended classes at the École des Beaux-Arts, where Despiau was his fellow-student. He decided to emigrate and landed at Boston in 1906, where he entered the workshop of a sculptor of decorative monuments. In 1912, he left for New York and began his heroic *Standing Woman* in bronze, which he did not finish till 1932. Meanwhile, he fulfilled several commissions for the academic sculptor Paul Manship. His first exhibition at the Bourgeois Gallery in New York (1920) drew attention to him. A retrospective show of his work was held at the Brummer Gallery in 1928. Lachaise is known mainly for his female nudes. His dolphins and peacocks exhibited the skill of a lapidary and he did numerous illustrations for the avant-garde monthly, *The Dial*. He also executed occasional portrait-busts, among which are the portraits of the painter John Marin and the poet E. E. Cummings. He also inscribed bas-reliefs for the New York Telephone Building and tall standing reliefs on the west façade of the International Building at Radio City in the Rockefeller Center. He was a meticulous workman; he carved directly in stone and if he used bronze, the medium he found best suited to his expression, he polished it until it assumed an almost unnatural lustre. He loved rounded masses and feminine shapes. As such, the female figure, whether standing, sitting, or supporting itself on a single hand, like his *Acrobat*, sometimes recalled a Hindu goddess or an Oriental figurine. And yet, while opulence invariably marked them, the peculiarity of Lachaise was not in this slightly overdone luxuriousness, but in the dynamic drive he imparted to his figures. Unfortunately, he degenerated into an inflated exaggerated manner, particularly in his large-scale sculpture. Although Lachaise enjoyed an eminent position among American sculptors during his life-time, he is now considered of minor importance, on the fringe of modern developments, but he is acknowledged to have brought new life to tradition. J. M.

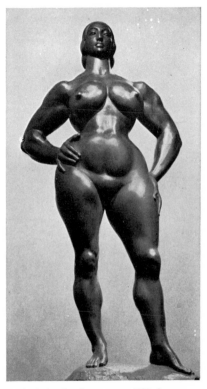

Lachaise. Standing woman. 1932. Bronze. Museum of Modern Art, New York.

LALANNE François. Born 1924, Agen. He has had four one-man exhibitions in Paris, Milan and Chicago. He uses, sometimes simultaneously, the most varied materials (wood, leather, metal, synthetic resins, etc.), and arranges them into forms, which are not only per-

Lamsweerde

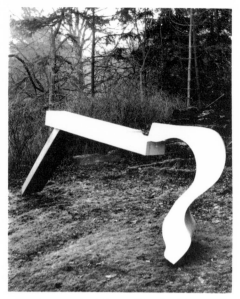

Lamsweerde. Sculpture. 1968. Aluminium.

LARDERA Berto. Born 1911, La Spezia, Italy. When he had completed his education and artistic training at the independent art school in Florence (1939), he went to live in Paris. Besides sending work to the principal Parisian Salons, he was represented at several of the international exhibitions, notably the Venice Biennale (six times, the last in 1964), São Paulo (1951), Middelheim, Antwerp (1953, 1955, 1957), the Kassel Documenta (1959) and the Symposium at Quebec (1965). His first one-man show was held in 1942 at the Galleria II Milione, Milan. Several others have followed in Paris (Galeries Denise René, 1948; Berggruen, 1954; Michel Warren, 1956; Knoedler, 1963), in New York, Brussels, Milan, Krefeld, Munich, Hamburg, Basel, Stockholm and Montreal. He obtained French nationality in 1965.

Apart from a few figurative works, like the memorial to the partisans, killed at Pian Albero, in Tuscany, Lardera's art has been becoming more abstract since 1942. Ridding it of every link with reality, he has endeavoured to create a sculpture which can be seen from two sides only, and, in this way, cancelled two of the four main outlines presented by all traditional sculpture. The result is that the work is flattened until it looks like a sort of plate that has been cut out. The product of these studio experiments was the series of 'two-dimensional sculptures' (1945–1949), which was a turning-point in the artist's development. They consisted of geometric ele-

fectly identifiable, but also functional, at least in appearance. He is an ingenious constructor, with a sense of humour; he will hide a bar in the entrails of a rhinoceros, or suggest that a circle of sheep would do well as a waiting-room bench. His vision and plastic conceptions, like his dual or triple meanings, are only superficially and deceptively simple. Technically and emotionally his formal idiom is constantly being enriched by a controlled imagination and can be equally appreciated as the expression of an arbitrary aesthetic or as an indication of some deliberate purpose. D. C.

LAMSWEERDE Eugène van. Born 1930, Ginneken, Holland. He is self-taught and since 1957 has been teaching at the Breda Art School. He was represented at the Symposium of Grenoble in 1967. The terracotta and bronze of his early sculpture has been replaced since 1963 by materials, especially metals, that are more suitable for an experimental approach. The characteristic of his abstract, monumental sculptures is to extract the maximum plastic expression from the minimum of formal variety. They are conceived in relation to particular environments and are easily integrated into the daily life of the common man. Besides his strictly plastic creations, Lamsweerde also works on maquettes for imaginary cities of the future, which he sees as the product of a close association between architects, sculptors, town-planners, sociologists and engineers. D. C.

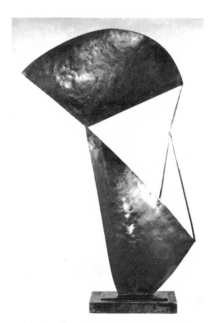

Lardera. Two-dimensional sculpture. 1946.
Copper. Knoedler Gallery, New York.

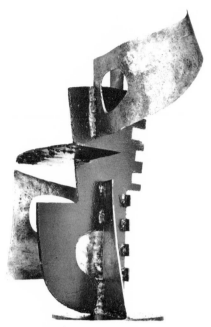

Lardera. Human spiral III. 1960-1961.
Bronze and iron.

Dawns, or quite simply *Sculptures*. The horizontal plane made its appearance, bringing stability and balance with it. At the same time, the vertical or oblique planes were cut away, so that only ringlike shapes remained in which the outer and inner edges were seldom parallel. This produced ovals, inscribed in rectangles, or, inversely, a square shape in a round one. A dynamic movement grew out of the dislocation of the two contours, which affected the whole work. The border of some of the planes was cut out in fringed and crenellated patterns, which made a less stark ending than a continuous edge would have done and also acted as a transition between the sculpture and surrounding space. Lardera did not only work in iron, copper, aluminium and stainless steel, which is so hard to cut out and weld and which is so rigid and has such stern integrity: the void is perhaps his most important material, whether it is formed by a plane, or flows between planes or whether, as space, it surrounds the whole sculpture.

The simplicity of Lardera's constructions does not prevent him from being concerned with problems of technique. Like other contemporary sculptors, he likes to preserve his tool marks just as they are, without smoothing them out or polishing the surface. He never fails to bring out the different qualities of the metal. For two ments, in hammered copper or aluminium, slightly curved like a shield, in which triangular shapes frequently recurred. *Miracle* (1946) is the prototype of this astonishing series. It is a three feet high metal construction, formed of two triangles, which are connected to each other at the apex, with one side extended. The purpose of this kind of art is obvious. The sculptor is reacting against the principles of traditional forms, even when they have reached the perfect elegance and extreme ellipsis of Brancusi's art. He wanted to get away from sculpture with the attribute of mass, which is possessed by any stone or pebble, and in which there is at least the suggestion of an object. At the same time, he rejected some of the characteristics of classical sculpture: tactility (Lardera's works appeal less to the sense of touch than any other artist's: they invite visual enjoyment only); weight of material and the fragmentation of the form in space, which makes the observer walk round it endlessly, in the search of an everchanging contour.

Lardera went on from this plane geometry to a geometry in space, its intellectual severity tempered with a gay vitality. His work became more varied, and he created several series of constructions that remind one of compasses and sextants, rudders and stringed instruments, which he called *Dramatic Occasions, Controlled, Broken*, or *Heroic Rhythms, Archangels, Miracles,*

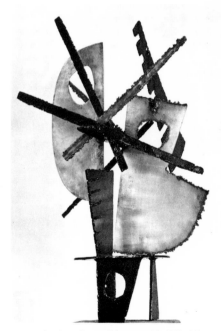

Lardera. Love of the stars III. 1959-1960.
Copper, stainless steel and iron.

Lassaw

years, at one time, he even tried to liven the quiet tones of metal by inscribing into specially prepared recesses, pieces of yellow, blue, and red mosaic, which form an oasis of unexpected colour. The finest flower of Lardera's work would never have come into existence if he had not been offered the opportunity of measuring himself against architecture and setting his daring structures in an urban landscape. Lardera, the welder of metal and space, had long dreamed of 'making a monumental sculpture from four bits of sheet-metal'. He was given a chance and many more, after *Colloquy III* had been erected in the centre of Marl in Germany in 1954–1955, and a feather shaft in iron and copper, 14ft high (1959), had risen in the midst of the Hansaplatz in the new district of Berlin built by Niemeyer and Aalto. In France alone, four towns gave commissions to the sculptor: Le Mans, Paris (Maine-Montparnasse complex), Charleville-Mézières, Grenoble. They finally materialised Lardera's conception of a sculpture for today, set up at the crossroads for all to see and asserting itself against architecture, which, instead of imprisoning it like a museum, is ranged round it. M. C. L.

LASSAW Ibram. Born 1913, Alexandria, Egypt. His parents were Russian. His family lived briefly in Marseilles, Naples, Tunis, the Crimea, Istanbul, before settling in New York in 1921. He obtained U.S. citizenship in 1928. He modelled clay from the age of four and, when he was thirteen, started the serious study

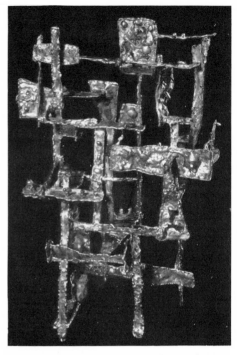

Lassaw. Sculpture. 1958. Bronze. Kootz Gallery, New York.

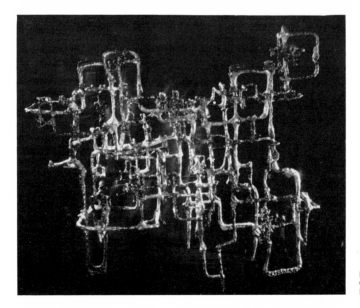

Lassaw. Galactic group Nº I. 1958. Bronze, nickel and silver.

of sculpture with Dorothea Denslow at Brooklyn Children's Museum, then continued his training at the Clay Club (1927–1932), and the City College of New York (1931–1932). He produced his first abstract 'space sculpture' in 1933 and began using welded metal in 1936. He was influenced by Balcolm and Gertrude Greene through his friendship with them. He was given several government commissions in New York. He was a foundation member of the American Abstract Artists in 1936 and was their president from 1946–1949. He studied painting under Amédée Ozenfant (1947–1949). He is a serious student of Zen which he studied under D.T. Suzuki at Columbia University and which influenced him as an artist. He held one-man exhibitions at the Kootz Gallery, New York (1951, 1952, 1954, 1958). He was represented at the Venice Biennale (1954); the '12 Americans' exhibition, Museum of Modern Art, New York (1956); the São Paulo Biennial (1957); the Brussels International Exhibition (1958). He taught at the American University, Washington (1950), and in his own studio. His work is represented in several American museums.

Lassaw's characteristic space sculpture goes back to the middle thirties, and since that time he has sustained his vision and the technique he has employed to express it, with an uncommon singleness of purpose. Trained early in the usual academic methods, it was not until then that Lassaw 'became aware of the modern movement and the responsibility of being an artist'. His first open-work sculpture alternated under the impact of Miró and Mondrian which explains the opposing tendencies between the free and the controlled that he was later to fuse. Lassaw's mature style is based upon a three-dimensional drawing so articulated that the eye can penetrate and 'enter into' the spatial world it establishes without having, as in older styles, to walk around it. There is thus achieved a simultaneous realisation of interpenetrating spaces bounded by implied planes; seeing through and beyond these the eye becomes aware of a multitude of relationships. This space drawing is executed by a continuous line of bent, welded iron wire, varied and enhanced by irregular surfaces of welded bronze, and then finished by the application of other metals (steel, bronze, nickel, copper, etc.) which are than sprayed with or bathed in acids. The result is a three-dimensional, ordered maze at once rigid and fluid, hard and soft, thick and thin, with a surface of variegated texture and a wide range of reflecting colour. In the work of the last few years, the rich surfaces have been further developed and heavy forms interrupt the previously thinner structures. Bulbous shapes on stems, they suggest, and often come close to representing plant and flower forms. In these works, Lassaw has moved away from his earlier purely abstract space-drawing towards something approaching representation, but of a symbolic character still. Lassaw's conceptions are strongly influenced by mystic philosophies (Meister Eckhart and Zen) of identification with the universe. His vision belongs to New York abstract Expressionism in the

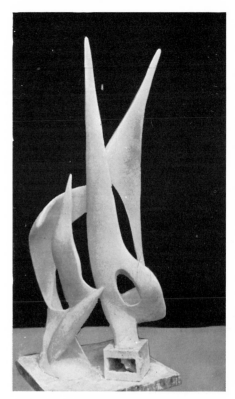

Latorre. Sculpture. 1959. Plaster.

importance it gives to the freeing of the artist's unconscious through the play of apparent accident and immediate inspiration, and in its concern with structure isolated in a portion of infinite space. It is in this sense that the artist speaks of an identification with the flux of the universe. This is malleable space geometry, bent in awareness to the inner and the outer eye. R. G.

LATORRE Jacinto. Born 1905, Irun, Spain. He studied sculpture almost entirely on his own in Spain and, at the end of the Civil War in 1939, went to Paris, where he was taught by Wlérick and Despiau at the Académie de la Grande-Chaumière. Soon the attraction of the experimental work of Laurens and Brancusi replaced the influences of classical sculpture. Although his forms were soon sheered of all representational details, their inner movement moulded them into fantastic shapes. In 1955, his compositions became purely abstract and volume was no more than the sublimation of feeling in material form. Wood remained his favourite medium

Laurens

for a long time, but he has also used iron, bronze and red copper. Since his first one-man show at the Art Vivant gallery, Paris, in 1955, Latorre has contributed to several group exhibitions in France and abroad. In his more recent works, he has tried to draw the play of light to the interior of his sculptural planes by incrusting them with coloured glass and crystal, which increases the emotional quality of their lines and confers an added vitality on them. D. C.

LAURENS Henri (Paris, 1885 — Paris, 1954). He came from a working-class family and went from his primary school to work with a decorator. In the evenings, he regularly attended drawing classes at 'Père Perrin's' in the Rue Turgot. So from fourteen until he was twenty, Henri Laurens learnt in the hard school of life, and tough, manual labour taught him the lessons of humility and integrity, discipline and exactness, which he never forgot in the course of his long, difficult career. No one has ever spoken of his tools with such affection or devoted himself to his work so whole-heartedly or with such patience and determination. In 1911, he met Braque, which was the beginning of a life-long friendship. Cubism was the order of the day and no young artist was impervious to its fascination. Laurens was no exception and he threw himself into the new aesthetic adventure. Besides papiers collés, he made constructions of wood (*Woman with a Mantilla*, 1918), or painted

Laurens. Draped woman. 1927. Bronze.

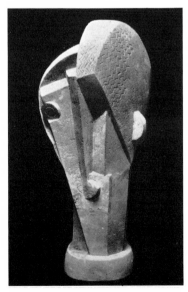

Laurens. Head. 1918. Stone.

sheet-metal, reliefs and sculptures of polychromed stone. He said about these later on, 'When a statue is red, blue or yellow, it remains red, blue or yellow. But a statue that has not been coloured is continually changing under the shifting light and shadows. My own aim, in colouring a statue, is that it should have its own light.' But, although Laurens gravitated in the orbit of Cubism, his integrity and especially his distrust of intellectual speculation saved him from its excesses and preserved his independence. He became friendly with Picasso and was introduced by him soon afterwards to Léonce Rosen-

Laurens. Woman with a mirror. 1931. Wood.

Laurens. Small Amphion. 1937. Bronze.

berg, who bought some sculptures from him and gave him his support until 1921, when Henry Kahnweiler became his agent. He drew, illustrated books with engravings, designed the decor for the *Blue Train* (1924), performed by Diaghilev's Russian Ballet, carved the sculpture on the grave of the airman, Tachart, in Montparnasse cemetery, a porch and a fountain for Jacques Doucet, a column and a fireplace for the Vicomte de Noailles. His geometric phase ended in 1926–1927; his lines curved, the volumes became heavier and the forms took on a sensuous fullness. This was the period of the

series of *Reclining Women* and *Crouching Nudes*, then in 1932 of the *Ondines* and the wonderful *Sirens* of 1937. He began to sculpt large-scale statues with the same serenity and the same whole-heartedness. In 1937, he also did *Amphion* and four high-reliefs, *Earth* and *Sea*, in sandstone, for the Sèvres pavilion at the Exposition Universelle in Paris, *Life* and *Death*, in plaster, for the Palais de la Découverte, also in Paris.

All his subsequent work shows a strong lyrical quality, an increasingly marked endeavour to express the essence of forms and a closer union with the eternal laws and

Laurens. The siren. 1945. Bronze.
Musée National d'Art Moderne, Paris.

as the general public. In 1950, the Venice Biennale did not award him the First Prize, but he had some consolation when Matisse shared his own with him. His turn came, however, three years later when he won the highest award of the São Paulo Biennial. Yet, with Zadkine and Lipchitz, he did more than anyone else to free sculpture from the bondage into which it was sinking. He disliked imitative art early in his career and created his own original rhythms and forms that had a very modern flavour. In spite of the comparisons that can justly be made between Laurens's works and those of the great periods of creation, Maillol is certainly closer to Donatello than Laurens is to Maillol. He had, in a pre-eminent degree, strength and grace, passion and reflectiveness, vitality controlled by logic, a lucidity that checks excessive emotion and an immense love of poetry that impregnated all his work. F. E.

LEE Caroline. Born 1932, Chicago. She trained at the Art Institute of Chicago and, in 1961, was awarded the Copley Foundation Prize. She is now living in Paris and is represented at the major French and international exhibitions. The first show of her work took place in 1965 at the Galerie Lahumière, Paris. After an initial period in which her bronze and metal works drew their inspiration basically from nature, Caroline Lee began creating pure, geometric forms, which had a quasi-mechanical appearance. Her sculptures are executed in polystyrene and, from 1967, they have been cast in aluminium. This eliminates any inclination to preciousness. At the same time, she also adopted stainless steel, which was ideally suited to the tonality she wanted to give her works. These frankly industrial processes, which exclude all possibility of interpretation and demand an unfailing perception, make content and form indissociable in her sculpture. D. C.

rhythms of life. In the *Large Musician* of 1938, *Flora* of 1939, *Crouching Figure* of 1941, *Sleeping Woman* of 1943, four masterpieces, Laurens only uses curves and rounded shapes and aims at an expansion of his forms without, however, losing anything in concentration, massiveness and compactness. With *Farewell* of 1941–1942, which he did on his return to Paris after fleeing at the beginning of the war, *Dawn* (1944), *Large Mermaid* (1945), *Bather* (1947), *Deep Night* (1951), *Woman with a Bunch of Grapes* (1952), a large version of *Amphion*, commissioned by the University City of Caracas, Laurens returned to graceful lines and a free composition that rise boldly into space. But they still have the same vigorous conception, the same virile style and strength, the same taut idiom and vitality and, at the same time, a calm, a restraint, and a controlled audacity and distinction, which were all characteristics of his life. It was the life of a solitary man, humble and disinterested, of a man who endured without complaining the pain of an incurable disease and the neglect of his contemporaries. Official bodies ignored him as much

LÉGER Fernand (Argentan, 1881 – Gif-sur-Yvette, 1955). Although he took up sculpture late in life, Léger had always been passionately interested in it. The sculptor in him is more evident than the painter in the varied techniques he practised with equal success: posters, theatrical décor, stained-glass and mosaic. It was inevitable that there should come a point when this sturdy artist should feel the need to give three-dimensional existence to forms that for a long time had been obviously suited to it. While he was in the United States from 1940 to 1945, he worked with Mary Callery, colouring and combining painted surfaces with the sculptures she had done herself. Léger made sketches for *The Rockefeller Branch* and the high-relief, *The Acrobats*, which he completed in 1950. In that year, he began the well-known series of three-dimensional ceramics, huge, coloured flowers, like the two *Sunflowers* and *Walking Flower*. He also did a number of different bas-reliefs, still lifes, heads of women, acrobats, vast compositions in

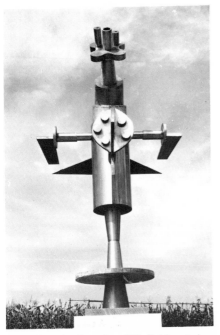

which the outlines were in relief, like the *Black Horse* on a yellow background, or the *Composition with a Parrot* in black and white ceramic. His sculpture, a collection of fifty-four pieces in ceramic and bronze, has all the confidence, discipline and forthrightness that are characteristic of Léger's genius. Its peculiarly plastic qualities of compactness, rhythm and equilibrium of proportion and mass are reinforced by another, colour, which sculptors have often been shy of using. But, while colour is generally no more than a decoration on pottery, Léger made it as much an integral part of his sculpture as weight, line and volume. This innovation brought its own serious technical problems, which were solved by one of his pupils, Roland Brice, who made notably the *Children's Garden*, an astonishing group of plant forms, rising to a height of 26ft in the grounds of the Musée Fernand Léger at Biot, which was executed after a maquette of the artist himself. Léger was not, of course, the only painter who produced sculpture, but he was the only one to have given it such epic strength, such monumental breadth and such gorgeous colour, which has never been seen since the friezes of multicoloured glazed bricks at Susa and Babylon. F. E.

LEHMANN Kurt. Born 1905, Koblenz. He trained under Vocke at the Kassel Academy. A government scholarship enabled him to go to the Villa Massimo in Rome. After a few years in Berlin, he returned to Kassel in 1934. He was in the army from 1940 to 1945. He has

Lee. Reception Perception. 1968. Stainless steel.

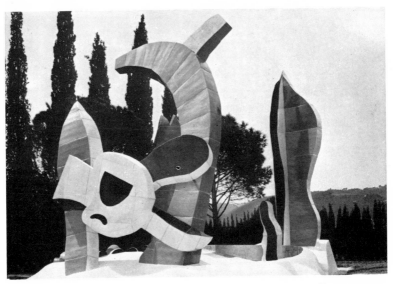

Léger. The children's garden. 1960. Ceramic. Musée Fernand Léger, Biot.

Lehmbruck

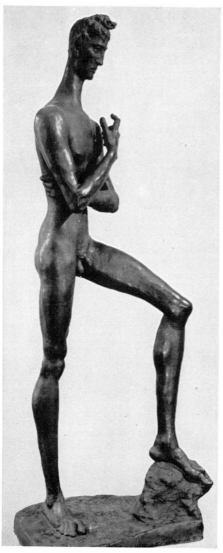

Lehmbruck's legacy while going beyond it. Lehmbruck had shown in works like *Exhausted Man* that the unique problem in sculpture was to enclose each figure in a scaffolding of pillars and counter balances and to achieve, through this impersonal form of expression, the greatest possible vitality. This can be seen particularly clearly in Lehmann's work, although he has been careful until now not to abandon the human figure as a means of expression. Since 1950, he has been concerned with building patterns depending on the tension between rounded shapes, with sweeping curves, and pronounced angles (*Crouching Woman*, 1955). His sculpture became more stylised and he produced works like the *Mother and Child* (1957), which had an exclusively frontal viewpoint. The interplay of curves and straight lines were extremely simplified, but, although far removed from representational art, the form retained an inherent classicism.

<div align="right">J. R.</div>

LEHMBRUCK Wilhelm (Meiderich, near Duisburg, 1881 — Berlin, 1919). He trained at Düsseldorf, first at the School of Decorative Arts (1895–1899), then at the Academy (1901–1907). When he began to grow out of his academic manner he turned to Constantin Meunier. Meunier appealed to him because the world of manual labour was familiar to him; he was a miner's son. In 1905, he expressed his admiration for Rodin and, four years later, his large sculpture, *Man*, showed unmistakably the influence of the French master and even Michelangelo. Meanwhile, he had exhibited his work at Paris, which caused a certain amount of interest and he thought of settling there. He went there in 1910, lived in Montparnasse and met the German painters who were studying under Matisse. He made the acquaintance of Matisse himself, and Brancusi and Archipenko became one of his friends. A year later, he produced the first work of his mature style, a *Kneeling Woman* (Museum of Modern Art, New York), whose elongated forms made it seem less a real human being than a symbol, the concrete expression of intellectual refinement, purity of feeling and a fine and sincere humility. In the following years, the limbs of his masculine nudes lengthened, but, however thin they became, they never lost their inner structure nor their pulsing energy. The eloquence of these slender figures, rising into space, lay in their outlines and the voids were as expressive as the saliences. Then again, while his feminine nudes are thoughtful and rather solemn, the figures of men seem crushed by melancholy and tragically unsuited to life. The *Young Man Seated* (1918) seems hardly less broken by the weight of his solitude than the *Fallen Warrior* (1915–1916), struck down by death in the prime of his life. The *Young Man Standing* (1913–1914), in spite of the determined way in which he flexes his muscles, is vitiated with weariness and doubt and his face is anxious and uneasy. In fact, most of Lehmbruck's faces betray their dejection, even grief, and this is true even of his portrait busts, a kind of

been teaching sculpture, since 1949, at the Hanover Technical School. A retrospective exhibition of his works was held at Kassel, in 1954, and Hanover in 1957. Like his contemporary, Blumenthal, Lehmann was one of the German sculptors who inherited and tried to develop

sculpture that does not generally lead us into the presence of wounded, hypersensitive beings.

The melancholy he had already suffered from at Paris, deepened when the 1914 War forced him to return to Germany. In Berlin, he worked as a nurse in a military hospital and the suffering and misery he saw there increased his despair. A stay in Zürich (1917–1918) did not bring him any lasting relief and he committed suicide in March, 1919, shortly after his return to Berlin. Lehmbruck was the only one among the German sculptors of his generation who could find a solution to the problem of form, as it is directly related to expression. J.-E. M.

LEINFELLNER Heinz. Born 1911, Steinbrück, Austria. He trained at the School of Arts and Technology, then from 1933 to 1939, he continued his training at the Vienna Academy, where Anton Hanak taught him for some time. While he was there, he earned his living as a restorer. From 1947 to 1951 he was studio assistant to Wotruba. Since 1959, he has been teaching ceramics at the School of Decorative Arts in Vienna. He is a foundation member of the International Art Club in Vienna and exhibits work at all their exhibitions held in Austria and abroad. He was represented at the Biennials of Venice (1954) and São Paulo (1956) and at Middelheim (1959), Arnhem and the Kassel Documenta II (1959). Leinfellner began as a Cubist. His sound professional training and adaptability enables him to use a wide variety of techniques and materials, synthetic stone among them. Until a short time ago, his figurative compositions were based on the relations of sharp

Leoncillo. Walls on asphalt. 1957. Ceramic.

saliences and hollows in a static structure, that followed a clear, almost architectural design. This is why decorative sculpture has a particular appeal for Leinfellner and he likes working on large areas. His forms are often entirely southern in character, inspired by his numerous visits to Sicily and Ischia. His natural sense of humour and a bucolic vein save him from a superficial perfection. A fondness for undulating contours and more rounded shapes is apparent in his works in recent years. A similar development in their style is noticeable in the work of other Austrian sculptors. J. L.

LEONCILLO (Leoncillo Leonardi) called. Born 1915, Spoleto, Italy. He attended the Perosa Argentina Institute of Art and then lived at Umbertide, where there is still a flourishing tradition of popular ceramics and where he had his own workshop. He has been living in Rome since 1942 and teaches ceramics at the Institute of Art. Leoncillo has a thorough knowledge of ceramics and all his work has been done in this unusual medium. His art was expressionist and figurative at first, but with more experience of analysing form, it developed into a geometric construction of an object. Picasso was an invaluable guide. At the same time he showed great concern to give a really pictorial effect to the surface of his works. In 1955, he was represented at the VII Quadriennale in Rome by a collection of sculpture that showed an appreciable development in their freer, less analytical manner. After this, Leoncillo no longer expressed his conceptions and feelings about nature in a stylised reality, but through form and material as a

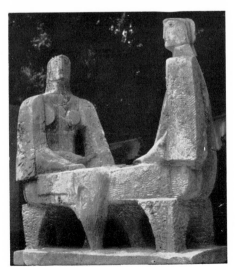

Leinfellner. Seated figures. 1955. Limestone.

Le Parc

means of communication in themselves. He exhibited this new sculpture at the Galleria La Tartaruga in Rome, March 1957. Its final development can be seen in the productions of 1958, which were certainly his most successful. His works were now like concretions. escaped from a world of fantasy. The compact, vigorously modelled forms were like stones and the colour was no longer just a surface decoration, but, like a fermentation from within, it had become an integral element of the mass and conferred a brilliance and unexpectedly powerful expression to it. This period, which could be described as Leoncillo's abstract phase, culminated in his *Passionate Affinities* exhibited in 1962 at Spoleto. Since then, a further change has come over his work and, with the *Pietà* of 1964 and the large pink and white ceramic of *Classical Lovers* (1965), the human figure has once more come into its own. A parti-coloured ceramic by Leoncillo was given the place of honour in the Italian pavilion at the 1967 International Exhibition in Montreal.

G. C.

LE PARC Julio. Born 1928, Mendoza, Argentina. He entered the Buenos Aires Art School when he was fifteen and, from the beginning of his training, was interested in avant-garde movements. In 1958, he went to Paris on a French government grant and has lived there since. In 1960, he joined with a few other like-minded artists, to found the Groupe de Recherche d'Art Visuel. The Venice Biennale of 1966 awarded him the first prize for painting (it should be noted in connection with this prize that kinetic art cannot be limited to the traditional categories separating painting and sculpture). His first one-man show took place at the Galerie Denise René, Paris, in 1966. Le Parc is one of the leading artists and theorists of the new generation and his new aesthetic conceptions, which require the active participation of the observer, have done much to destroy the rarified atmosphere surrounding art. All his ideas and materials have

been strictly analysed and modified before he has finally used them. The logical progress of his work has moved from surface-sequences to reliefs, from the aleatory movement 'mobile-continuals' to that of the 'light-continuals', from reliefs requiring the displacement of the observer to elements that can be manipulated, and from surprise-movements to images of light velocity. Direct light, reflections of the surroundings and travelling beams of light are very characteristic of Le Parc's plastic ideas. The element of play is never absent and the observer discovers as many opportunities of expression in the uneven passages of his environments as in the elements that he is invited to try himself, like mirrors and spectacles to alter the appearance of reality.

F. P.

172

Leygue. Project for a monument to
an unknown political prisoner. 1953. Plaster.

LEYGUE Louis. Born 1905, Bourg-en-Bresse. He trained at the École des Arts Décoratifs, then at the École des Beaux-Arts in Paris. In 1931, he came first in the Grand Prix de Rome competition. Until 1935, he travelled all over Europe, drawing, painting, modelling busts and figures. Despiau and Maillol now replaced his early admiration for Rodin and Romanesque art. In 1928, while he was engaged on some large-scale sculptures in Canada, he began to think of using metal as a medium of expression, but until 1950 his efforts to master this new technique never went beyond the experimental stage. Leygue joined the Resistance in 1941, was arrested and deported to Germany. In 1945, he was put in charge of a studio at the École des Beaux-Arts and was given a teaching appointment a few years later. After 1947, he was engaged on a series of monumental works. Bernini's influence, which began with his visit to Rome in 1935, was beginning to disappear. Although Baroque elements still remained here and there, now they were at least assimilated and integrated into the composition as a whole, which tended to become increasingly restrained. While he was engaged on these commissions, Leygue continued his own private work, which he exhibited at the Galerie Cambon in 1947 and the Galerie Marcel Bernheim in 1959. He also contributed regularly to the large exhibitions of sculpture in France and abroad. He has done countless monuments: in bronze for Caen University and the French school in Lisbon; in stone at Cachan; in wood for the law courts and municipal buildings of Abidjan; in copper at Rheims, Toulouse and Casablanca. His model for a monument to *The Unknown Political Prisoner* is remarkable. He is an accomplished artist, with an admirable technique. His sculptures are clearly influenced by architectural conceptions and, in spite of their emotional elements they are strictly and logically constructed. There is a sort of human pulsation, like breathing, in his sculptures whether they are made of stainless steel or moulded or precast concrete. D. C.

LIAUTAUD Georges. Born 1899, Croix-des-Bouquets, Haiti. Little is known about his early years. He began to earn his living, making mechanical parts in the towns. In 1947, he returned to his village and constructed a primitive forge for making agricultural implements, vessels for cattle and crosses for graves, which he ornamented with little motifs taken from Voodoo mythology. These welded crosses led to his 'discovery' in 1953. His works were soon appreciated in the United States and were acquired by important collections. Then the V São Paulo Biennial honoured him with a one-man show in 1959. This says much for the strangely acquired fame of this humble craftsman. Liautaud's sculpture is inspired and made vital by the religion and popular art of his country. It is bare and dry, sometimes infused with

Liautaud. Maternity. Petrol drum.

Liberaki

tragic feeling and sometimes with a bizarre humour. Doubtless these rudimentary forms, whether they are elaborate or simple, help to free their ingenuous creator from his dreams and myths. He does not seem to select his materials in any way; everything is acceptable: barbed wire, petrol cans, bits of chains, sheet-metal, cast iron and steel. His forge and tools are primitive, like his art, and therein lies its attraction. M.-R. G.

LIBERAKI Aglae. Born 1923, Athens. She trained at the Athens Art School. She has been living in Paris since 1955 and exhibited regularly at the Salon des Réalités Nouvelles. Her first personal show took place in 1957 at the Galerie Iris Clert, Paris. She seems to have been born with a vocation for sculpture. From 1946 to 1960, she was engaged on plaster figures, with painted hair and clothes and eyes made of pebbles, then on figurines and angular reclining nudes and stone reliefs. Animal, plant and sea subjects were later added to these. Horses appeared in the sculptures Liberaki did between her Athenian and Parisian work, but they were soon replaced by ruffled plumaged birds, which she moulded directly in wax. The *Owl* particularly fascinated her, but only a few, specific features of the powerful, geometric volumes could identify her sculpture of it. Some old caiques, the traditional boats of the Greek islands, inspired an attractive series of *Wrecks* in sand and wax. For some time now, Liberaki has also been working in antimony, which she has fashioned into freely imagined abstract sculptures of stems and knotted shapes. The appeal of her work until now has been in its strongly Hellenic character, combined with a dreamlike, hallucinatory feeling, which is almost obsessive. M. C. L.

LIEGME Adrien. Born 1922, La Chaux-de-Fonds, Switzerland. He learnt stone-cutting from a marble-mason in Geneva, then went to Paris in 1946, where he joined the Académie de la Grande-Chaumière in Zadkine's studio. By 1949, he was exhibiting at the principal Salons. In 1951–1952, he visited the United States. On

Liegme. Sculpture. 1959. Plaster.

his return to Paris, he resumed his work with a more objective attitude than before; he did not depend so much on a free interpretation of objects and was more concerned with discovering absolutely valid relationships in his models. His favourite materials were plaster and granite. Underneath this obvious anxiety to give a valid interpretation of an object there really lay a wish for a more complete vision of the function of space in architecture. It was in his search for this that his art changed imperceptibly from a distortion of nature to its

Liberaki. Bas-relief. 1960. Bronze.

174

'reformation' or, to be more precise, to the creation of a new nature, a non-representative one this time. Liegme sculpted granite and marble, not for the beauty of the material but for the weight and tension they gave his work. About 1958, his sculpture was characterised by a sort of outward thrust that gave vitality to the volumes. In some of his recent bas-reliefs, the closed forms in front that protrude, parallel to each other, seem to have no relationship with each other and yet they have a reciprocal appeal and attraction. The only relation existing between them is just this space that separates them, a space they create and reject in the same instant. His first one-man exhibition took place at the Irma Hoenigsberg Gallery in 1960. Since then, Liegme has turned quite unexpectedly towards a figurative form of expression, which mainly depended on the inadequacy of the image to reflect experience. After his long period of abstraction, sculpture has become a technical compulsion as well as an aesthetic adventure. D. C.

LINCK Walter. Born 1903, Berne. After studying in Switzerland he joined the Berlin Academy. He worked in Paris from 1930 to 1939 and then in Berne. From 1956 to 1957, he taught at the Kassel Academy. He sent work

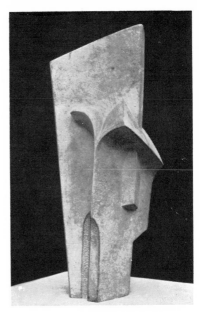

Lipchitz. Head. 1915-1916. Bronze.

Linck. Window open on the sky. 1958. Mobile in iron and steel. Musée d'Art, La Chaux-de-Fonds.

to a number of exhibitions among which was an exhibition of iron sculpture in the Berne Kunsthalle in 1955 and the Venice Biennale in 1956. His primary concern with movement was already beginning to supersede and eliminate the masses in his figurative sculptures. His final rejection of figurative art after 1950, which coincided with his use of metal, instead of plaster, freed his sculpture from all representational elements. The nature of its materials controlled the forms, and, at the same time, its relations with its surroundings became more direct. The water flowing through some sculptures, like the large, metal constructions in the form of fountains (1953–1955) set up regular movements in some parts and unexpected ones in others; in other sculptures, a slight current of air was enough to stir the spirals and delicate trellis designs. The carefully calculated equilibriums of stems, springs, and balls do not give any impression of mechanical contrivances, which explains their free, ethereal character. The unusual poetry of such works depends as much on their extreme simplicity as on the directness of their relations with their surroundings. F. M.

LIPCHITZ Jacques. Born 1891, Druskieniki, Lithuania. When he had studied architecture at Vilno, he decided in 1909 to go to France. When he arrived in Paris, he was disconcerted by the most revolutionary

Lipchitz

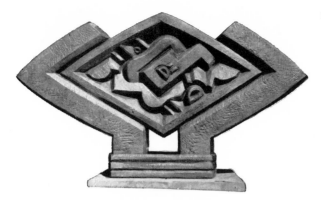

Lipchitz. Musical instruments. 1924. Bronze.

aspect of French art. He began by attending Injalbert's classes at the École des Beaux-Arts, then went on to the Académie Julian, the Académie Colarossi and the municipal college in the boulevard Montparnasse. Consequently, his first years in France were a period of apprenticeship rather than the beginning of his artistic development. He did not take up a definite position until after his return from Russia, where he had to go in 1912–1913 for his military service. In fact, as soon as he went back to Paris, the influence of Cubism appeared in his work, although it was still only superficial and showed in a simplification of planes and volumes and an interpretation of real shapes by geometric constructions. But his new style very soon ceased to be simply an exercise and became an aesthetic, a way of thinking about form and recreating it. His experiments had certain affinities with Cubist painting. He organised his free-standing sculpture like imaginary architecture and reduced figures and objects to their essential structure. Every unnecessary

detail was eliminated from the stiff, austere sculpture he created, as in the *Head* of 1915. In the bas-reliefs of the same period, which were often coloured, objects were transformed by the identical methods that the painters were using at the time (*Still-life with a Guitar*, 1919). Forms interpenetrated each other without merging and, with their precise, linear contours, they traced the most satisfying rhythms. Lipchitz and his Cubist friends gave, in fact, a new look to tradition.

About 1925, Lipchitz began a new experiment. Until then, his works had been effective through weight of volume. Suddenly, he began to look for a lighter, sculptural form; instead of being concerned with mass, he was concerned with the arabesque; instead of weight, he tried to find transparency; movement was no longer created by an outward thrust from within, but by winding contours. He created what we now call 'transparent sculpture' in which the contours and their superimpositions were more important than anything else. A cease-

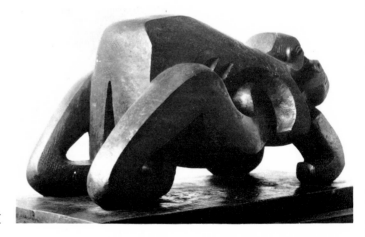

Lipchitz. The couple. 1928-1930. Bronze.

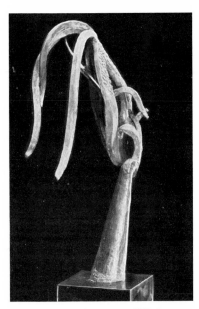

Lipchitz. Head of a woman. 1930. Bronze.

jecting into space with points, ribbons and shrub-like shapes (*Spring*, 1942), or compact masses, rising out of a procreating world (*Prometheus struggling with the Vulture*, 1944). The *Virgin* (1948) of the church at Assy, for example, belongs to this group, with other compositions that were not intended for any particular setting, but nevertheless have a strong religious feeling. Since his studio in New York was burnt down in 1950, Lipchitz has been living in Hastings-on-Hudson. Although Lipchitz has settled permanently in the United States, he belongs, nonetheless, to the School of Paris, where his art began, developed and is deeply rooted and where his influence has been considerable. R. C.

LIPPOLD Richard. Born 1915, Milwaukee, United States. His parents were German. He studied at Chicago University (1933–1937) and at the same time studied industrial design at the School of the Art Institute of Chicago, where he received his B.F.A. degree in 1937. He visited Mexico in 1935 and 1937. He worked as an industrial designer for the Cherry-Burrell Corporation (1937–1938). He lived in Milwaukee from 1938 to 1941 and opened his own industrial design studio there with a partner. He taught industrial design at the Layton School of Art in Milwaukee (1940–1941) and at the University of Michigan, Ann Arbor (1941–1944). Meanwhile he had taught himself sculpture and after 1942

lessly renewed movement displaced, in complete contrast, the impressive stability of his early manner. After his sculpture had been stripped of every link with reality, Lipchitz returned equally unfalteringly, at the peak of his development between 1930 and 1935, to concrete forms and the expression of emotional values; in the *Prodigal Son*, the *Couple* (1928–1929) and the *Song of the Vowels* (1931–1932, Kunsthaus, Zürich), the form is not only the solution of a plastic problem, it is also the issue of an emotion.

Gradually Lipchitz even softened the rigid contours that were still a sign of his attachment to the constructed world of Cubism. The problem that now preoccupied him was how, in the renewed independence of architecture and sculpture, he could conceive sculpture as an autonomous and, consequently, more supple element. The immediate effect was that the surfaces of his forms became mobile and stirred with the life from within. *Prometheus*, which he made for the Exposition Universelle in 1937 at Paris, marks this new development, which he carried still further when he sculptured the same subject in 1942–1944 for the façade of the Ministry of National Education at Rio de Janeiro.

Since 1941, Lipchitz has been living in the United States. His work has developed in an atmosphere that is more strained and frenzied, more romantic too. His smallest works, modelled in clay, show his genius for transforming an object. They are either sculptures pro-

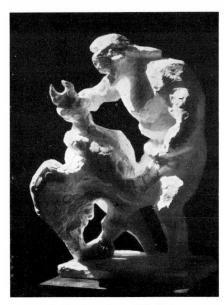

Lipchitz. Prometheus. 1938. Plaster.

Lippold

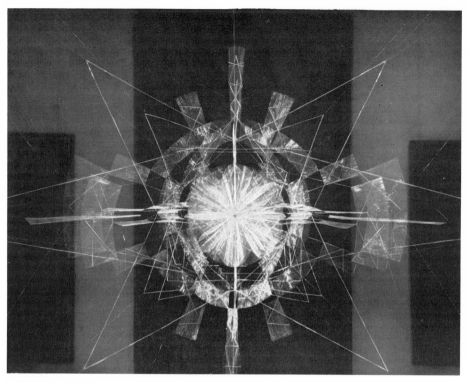

Lippold. Variations in a sphere N° 10: the sun. 1953-1956. Gold wire. Metropolitan Museum of Art, New York.

he spent a considerable amount of time on it. He went to New York in 1944 and taught at Goddard College in Vermont (1945–1947). He was head of the Art Department at Trenton Junior College, New Jersey (1947–1952) and has been instructor at Hunter College, New York. He visited Paris in 1955 for the exhibition 'Fifty Years of Art in the U.S.' at the Musée d'Art Moderne. He held one-man exhibitions at the Willard Gallery (1947, 1948, 1950, 1952). He also exhibited at the Margaret Brown Gallery, Boston (1950), and the '15 Americans' exhibition, Museum of Modern Art, New York (1952). He was commissioned by the architect, Walter Gropius, to execute the *World Tree* at Harvard University Graduate Center (1950) and was one of the prize-winners in the competition for a monument to *The Unknown Political Prisoner*, Tate Gallery (1953). His work is represented in several American museums, notably the Museum of Modern Art in New York and the Metropolitan Museum for which he made a large construction in gold wire, called *The Sun* (1953–1956), which required more than fourteen thousand points of solder.

Since then Lippold has had many important architect-

al commissions. These include *Orpheus and Apollo* for the Philharmonic Hall of Lincoln Center, New York City (1962), consisting of two hanging golden leaf forms; the stretched wire *Flight* for the Pan-American Building, New York City (1963) and commissions for Houston and San Francisco.

Lippold's twenty years of space sculpture has been the result of absolute faithfulness to a single conception. Self-taught as a sculptor, but previously and significantly trained as an industrial designer, he started to execute his abstract wire constructions in 1942 and has since continued in the same style and with the same personal technique. Made of brass, nickel and chromium wire—and on occasions of gold or silver—they stretch in taut lines from poles and axes. They emerge from the Constructivist tradition, and they share its devotion to pure geometry and its philosophical mystique that sees in this geometry an intellectual and an emotional metaphor for the universe, which is the counterpart of nature in its method of operation. With a few exceptions in some smaller pieces, Lippold's space constructions employ only simple geometric curves which outline the edges of

triangles, cubes, pyramids, cones, circles and ellipses. This is three-dimensional mechanical drawing, which in its seemingly weightless transparency suggests feelings of limitless and mysterious space. These webs, which may or may not be given celestial names, depend solely on the principle of tension since all they simply consist of is a thin strand of stretched wire. In turn, their effect is dependent upon the logic of this single principle since, whether or not one analyses their construction, the delicacy of their threading is visually evident; and it underlies their conception since for the artist 'tranquillity resides and can only reside, in the tension of opposites in equilibrium.' They offer a continual contrast between rigidity and charm, and in balancing lightness and geometric law as in some high-wire act seem to pose the constant threat of their own destruction. In this equilibrium lies much of their attraction and their mystery.

R. G.

LIPSI Morice. Born 1898, Lodz, Poland. He is a French sculptor. When he was fourteen, he joined his brother in Paris, who was an ivory carver and his first teacher. He attend the studios of the École des Beaux-Arts for a while. In 1922, the Galerie Hébrard exhibited his ivory carvings; but his interests had already turned towards monumental, open-air sculpture. His art remained figurative and, although there are Cubist features in it, it is impossible to connect Lipsi with any school or particular movement. He was indifferent to the artistic ideas of his time and practised the analysis and disintegration of masses as well as their distortion. After a few visits to Switzerland and Italy, where he went to work every summer, he obtained French nationality in 1933. Two years later, he exhibited at the Galerie Druet a collection of bas-reliefs, portrait busts and a number of garden sculptures which caused considerable comment. After this, his ambition was to create a synthesis of sculpture and architecture or, to be more precise, he tried to give each one of his sculptures an architectural construction that would be logically satisfying in itself. It was this studied development of inner structure that led him to abstraction at the end of a long, quite natural evolution. In 1940, Lipsi took refuge in the south-west of France and stayed there until 1943, when he managed to reach Switzerland, where he remained until 1945. There, he began a series of 'masks' and then worked on the representation of natural structures, like leaves and snails. This group of work, exhibited in 1946 at the Galerie Pierre Maurs, marked Lipsi's abandonment of the technique of modelling. Afterwards, he always practised direct carving. His favourite material was stone, the hardest he could find: marble, stone from Roques, granite or even that difficult, awkward material, lava, which he discovered in 1955 and is still carving today.

There are two distinct phases in his development between 1948 and 1955: the rhythms of plant forms dominated the first phase from 1948 to 1953; he exhibited a

selection of these sculptures at the Galerie de l'Art Vivant in 1953; monumental forms were characteristic of the second phase from 1953 to 1955. Three one-man exhibitions took place abroad: two in Zürich at the Beno and Palette Galleries (1954 and 1958) and one in Ascona at the Citadella Gallery (1956); his sixth exhibition in Paris was held at the Galerie Denise René (1959). For several years, Lipsi has been represented at the principal Parisian Salons. He is a member of the group, Espace. At present, his conceptions seem to develop as he is actually carving the stone and his ideas clarify as the work progresses. As he is unable to express all his ideas in a single work or in the terms he would wish, because the inevitable development of the individual sculpture precludes them, he is forced to leave over some sculptural ideas to the following work; consequently this becomes the offspring of the previous one. This creative process explains clearly the characteristic continuity of his art. The exceptional strength of every one of his sculptures derives as much from the simplicity of the lines and the precision of the edges as the clear design of their structure. Although Lipsi thinks that 'a work is not necessarily new simply because it is made in a new material' and he himself remains faithfully attached to stone, he has recently shown an interest in expanded

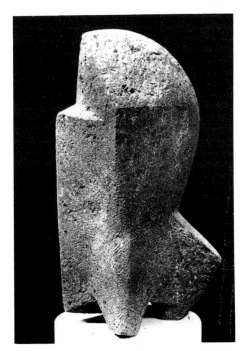

Lipsi. Sculpture. 1959. Red lava.

Lipton

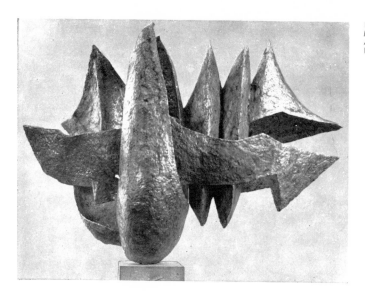

Lipton. Sea king. 1955.
Metal, silverplated nickel.
Albright Art Gallery,
Buffalo.

polystyrene. Now that his recent works make no attempt to integrate their form with architecture, they have gained a new freedom and are independent of all laws except of their own unity. Lipsi was President of the French Symposium of Sculpture and contributed to the Symposiums at Tokyo (1963) and Grenoble (1967). An important retrospective exhibition of his work was held at the Mannheim Museum. D. C.

LIPTON Seymour. Born 1903, New York. He attended the City College of New York (1922–1923) and Columbia University (1923–1927), where he received a degree in dentistry. He began to sculpt in 1932 and is entirely self-taught. The wood carvings he produced from 1935 to 1945 are figurative. Afterwards he worked on metals and his art became abstract. His first one-man exhibition was held at the A.C.A. Gallery (1938) and the second at the Galerie St. Etienne, New York (1943). His abstract sculpture was exhibited several times at the Betty Parsons Gallery, New York (1948, 1950, 1952, 1954); the Watkins Gallery, the American University, Washington (1950); the '12 Americans' exhibition, Museum of Modern Art, New York (1956). He was commissioned to do three ritual figures for Temple Israel, Tulsa, Oklahoma (1954) and five for Temple Beth El, Gary, Indiana (1955). Lipton won a purchase prize at the São Paulo Biennial (1957) and had a one-man show at the Venice Biennale (1958) and at the Phillips Collection, Washington (1964). He has been commissioned to do work for the Philharmonic Hall of the Lincoln Center, New York (1964) and for the Inland Steel Building, Chicago (1967). His work is represented in a number of American museums.

Lipton began his career as a sculptor during the decade 1935–1945 by working in wood, and then for a brief period in sheet-metal. Typical of the times, his work was representational. His characteristic, abstract-symbolic style was first evolved in 1950 when, after three years of using soldered sheet-steel, he began to employ sheet-steel, previously cut with a metal shears and bent, spot-brazed edge to edge. As he has pointed out, it was a method similar to that of a dress designer. The surfaces of his curved forms are given a rough texture, and variations of tone and modulations of colour by melting small rods of nickel-silver over the whole inner and outer surface. Lipton's heavy, roughly textured shapes, which he describes as 'curved and convoluted forms outgrowing but not fully spread,' have vague plant and animal analogies, which his titles confirm. The rhythms of his sculpture are slow, the spaces, even when pierced are held in closed contours, and by their very weight and bulk and uniformity of mass in the parts have something brutal in their presence. These effects stem from the artist's concern 'with internal and external anatomy,' and the expressed desire to use the open-closed relationships of his compositions to convey an organic dynamism embodying what he calls 'the fierceness underneath and within.' R. G.

LOBO Balthazar. Born 1911, Zamora, Spain. When he was very young he was employed in a Castilian workshop of figure carving at Valladolid. In 1927, he went to Madrid and joined the Art School, but he was incapable of adapting himself to the official teaching and left after three months to work on his own. After the Civil War,

he fled to Paris, where Picasso helped him and he met Laurens, who asked him to become his assistant shortly afterwards. His whole life was absorbed in his sculpture; in silence and solitude, he deepened its significance, perfected his technique and would not agree to holding a one-man exhibition till 1957 at the Galerie Villand et Galanis. He did, however, send work regularly to the Salon de Mai and the same gallery supported him until it finally succeeded in building up a public for him. There has rarely been an artist who has felt so strongly bound to the soul of his native country and who has given such striking proof that it is possible to practise an art, drawing on a millennial tradition, in a century that has challenged all accepted ideas and is avid for novelty at any price. The more contemporary sculpture exhausted itself in delirious expèriments and the destruction of form, the more Lobo felt the need to observe the fundamental laws of his art, the discipline of the whole and its autonomy. In the long series of *Maternities* (1945–1954), he progressively simplified the composition, contracted the masses, eliminated details until the work was reduced to a coherent and convincing combination of forms, which were saturated in reality although they

Lobo. Reclining nude. 1958. Bronze.
Maternidad Clinic, Caracas.

Lipton. Sorcerer. 1957. Metal and silverplated nickel.
Whitney Museum, New York.

were abstract. Whether his medium was bronze, or he was carving granite, or more often marble, after 1952, Lobo accentuated the concision and abstraction of his sculpture until his female figures acquired the dignity of an idol and his mammals and birds had all the characteristics of totemic emblems. This laconism is even more pronounced in the torsos, stomachs and hips of the female figures; their salience is so slight that these pieces of anatomy seem to have come to life beneath a tender caress. His human heads were reduced to a pure oval and the nasal ridge is like the very stylised sculpture of Iberian art, which grew up under Aegean, Celtic and native influences and reached its peak about 2500 years ago. In fact, the warm earthiness of Lobo's art comes from the ancient local traditions of Spain. They have enabled him to blend in the same work the harsh flavour of peasant craft and his own relentless drive towards an absolute purity. When the opportunity was offered, Lobo attacked the problems of large-scale sculpture and produced the *Memorial to the Spanish Resistants*, which was unveiled at Annecy in 1952. The following year, he completed a large *Maternity* in bronze for the University City of Caracas. In 1968, he did a polychromed, stone monolith for the technical school at Dijon. The unfailing qualities of his sculpture, in which the material is firmly but gently mastered, are clarity of conception, a disciplined sensuousness, an unobtrusive audacity and a love of restrained, expressive masses. F. E.

LONGUET Karl-Jean. Born 1904, Paris. After he had trained at the École des Beaux-Arts, where he stayed until 1932, he worked on his own and discovered the

181

Lörcher

Longuet. Fountain. 1958. Stone.

ing its unity. Although the size of Longuet's sculpture has prevented him from exhibiting more frequently, he held two one-man shows, one after the other, in 1960 and 1961, at the Galerie Simone Heller, Paris. He has also sent work to the Biennials of Middelheim and São Paulo and most of the Parisian Salons. D. C.

LÖRCHER Alfred (1875–1962). After training at Stuttgart, Karlsruhe and Kaiserslautern in commercial art studios, he attended the Munich Academy as a pupil of Rümann (1898–1902). He spent some time in Italy, before living first in Stuttgart, then in Berlin from 1908 to 1915. After the First World War, he was put in charge of the ceramics department at the Stuttgart Academy, where he stayed until his retirement in 1945. In 1950, the State Gallery in Wurtemberg organised a large retrospective exhibition, and, in 1959, the Kunstverein of Cologne held an exhibition of his most recent works. A serene style of sculpture appealed to him, which was why he never appreciated Rodin. On the other hand, he was influenced by Maillol, who helped him to recognise and use his genius for portraying the feminine body. His female nudes, generally modelled in clay, have the

importance of Maillol and Despiau. Monumental sculpture appealed to him and over the space of a few years, he executed bas-reliefs for the bridge at Champigny, fountains for the 1937 International Exhibition and other works. His art soon became more withdrawn and, until 1944, without rejecting representation completely, his work became increasingly bare and severe, with a greater concentration on essential form. Then in 1948, Longuet visited Brancusi. It was the beginning of a development that led from an increasing bareness of forms to their interpretation and thence to semi-abstraction. Longuet had worked in wood, stone and marble; now he began to use metals, especially hammered lead. One of his works in this medium was placed in the park at Sceaux in 1952. About the same time, he designed several medals for the Hôtel des Monnaies (*Karl Marx, Paul Éluard, Schoelcher*, etc.). In 1957, Longuet was awarded the Marmoro Portoro prize at the International Exhibition in Carrara. He collaborated with architects in decorating several schools. This experience was valuable and may have helped to bring about a noticeable change in his art because, in recent work, he has strengthened the plastic significance of his sculpture by replacing his former solid volumes with saliences and hollows, which are becoming bolder and more assured. They give an added variety and vitality to his sculpture without break-

Lörcher. Horses. Terracotta.

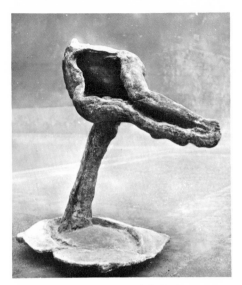

Luboski. Sculpture. 1967. Plastic.

LUGINBÜHL Bernard. Born 1929, Berne, Switzerland. He trained at the School of Arts and Technology in Berne from 1945 to 1948. His first works were figurative, in stone or wood. In 1951, his sculpture became abstract with monumental forms in stone or concrete. Since 1953, iron has been his only medium because it was ideally suited to the requirements of his style and his desire for monumentality. Luginbühl has regularly taken part in the Bienne Quadriennale since 1954 and also been represented at the major international exhibitions: Venice Biennale (1956, 1964), Middelheim Biennial, Antwerp, Kassel Documenta (1964) and sculpture exhibitions held in the garden of the Musée Rodin, Paris. He has had several one-man shows in Europe and America and a number of retrospectives shared with his friend and fellow-countryman, Jean Tinguely, in the principal museums of Europe. Luginbühl and Tinguely are the most original sculptors in iron today, but while Tinguely's characteristic expression is through movement, lightness and irony, Luginbühl tries to give a positive, powerful quality to his work by suggesting movement in stability. His themes are limited in number.

innocence and grace of Renoir. Another aspect of his work is represented by the groups of several figures, a genre which he came to relatively late in his career. It varies from the sculpture of nude figures, engaged in animated conversation around a table, to a solitary couple, facing each other and talking. Their small size encouraged unconventional experiments. However, there is a similar liberty of expression in more important reliefs, which show the artist concerned with the problem of handling a group *(Revolution; Spectators at a Swimming-pool).*
 J. R.

LUBOSKI Richard. Born 1934, Saint Joseph, Missouri, U.S.A. He trained at Kansas and New York, then went to Paris to continue his training and has remained there. Luboski began as a painter, but has devoted himself to sculpture since about 1954. His works look like tangled human bodies and have a slightly surrealistic flavour. The combination of plastic materials with fibre glass has offered him countless possibilities for experiment with forms. These materials, too, enable him to carry through his works to their final state without the help of an assistant. Luboski's working methods make it easier to understand why in recent years he has been absorbed in the creation of an oneiric world, where human and organic forms grow out of the same process and communicate the anonymous vitality of desire as well as the urge to individualisation. Sometimes, during the course of plastic creation, a figure, with no preconceived origins, will evolve, but it is no more than one

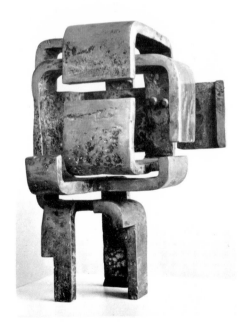

Luginbühl. Construction. 1959. Iron.
Kunstmuseum, Berne.

Lunding

After the soldered, space clawing *Aggressions*, he forged *Spatial Machines* and *C-figures* in 1958, composed of metallic ribbons that imprisoned space in their multi-dimensional convolutions. *North-west* (1964) was the first of the large constructions in his present style. They are made of simple, strong industrial elements, bolted and soldered together, and are as expressive in their forms as they are dynamic in their articulations. They create an impression of grandeur and strength and are fitting monuments to the glory of our machine civilisation. But there is always a touch of humour about them, in so far as it is paradoxical that the artist should freely recreate immobile, useless machines and, at the same time, exalt their indispensable, terrifying power. Since 1965, Luginbühl has forgone the romantic effects of rust and corrosion by painting his assemblages in bright, violent colours, which emphasise the technicality of their construction. J.-L. D.

LUNDING Calle. Born in 1930, he is one of the youngest of the Swedish sculptors today. He uses rods and cut out metal plates to build structures defining virtual volumes. These *Compositions of Floating Spaces* (1953) enclose differently orientated planes in their networks and airy cages. These, with their twisted and inverted surfaces and the equilibrium and transposition of their abstract figures, are like a fantastic geometry of broken volumes and interrupted movements, suspended, as it were, in their potential development. P. V.

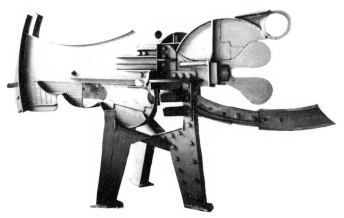

Luginbühl. Punch. 1966. Iron.

m

MACK Heinz. Born 1931, Lollar, Germany. He began his training at the Düsseldorf Academy (1950–1953), then studied philosophy at Cologne in 1956. In 1958, Mack and the painter Otto Piene founded the review *Zero*, but it only lasted for three numbers. They urged artists to break away from the last avatars of abstract painting, which was the work of a generation still deeply affected by the war, and to make a completely fresh start with the vital relations that the young had forged both with nature and the technology of their time. The title of an exhibition 'Vibration', held at Düsseldorf the same year, clearly indicates the primary importance they attached to light in their work. Mack covered his pictures of the time, painted black and white, with serried, undulating structures. During the same period, he assembled sheets of aluminium and marked them lightly, or cut them into blades, which were placed side by side to form his *Forests of Light*. In 1962, Mack. Piene and Uecker founded the Zero group, which worked as a team. One of their *Rooms of Light* was exhibited at the Kassel Documenta (1964) and one of their kinetic reliefs, called *Luminous Windmills*, at the Paris Biennial (1965). In 1963, Mack changed his structures with rectilinear coordinates for diagonal surfaces on which the outlines of figurative forms, like fish and arrows, occasionally appeared. In 1965, he began using coloured light in chromatic reliefs and for his *Merry-go-round of Light*, which he presented to the Stedlijk Museum of Amsterdam. Since his first exhibition at the Schmela Gallery at Düsseldorf (1957), he has held several others in the cities of Germany and Italy, Antwerp, London, Basel and New York. He was awarded the art prize of the town of Krefeld (1958) and the first prize of the Paris Biennial in 1965. H. W.

McWILLIAM F. E. Born 1909, Banbridge, Ireland. He trained at the Slade School, London (1928–1931) and in Paris (1931–1932). He held his first one-man exhibition in London in 1939. Since the end of the war, he has been represented on several occasions at the international, open-air exhibitions of sculpture (London, Antwerp-Middelheim, Sonsbeek). He took part in the

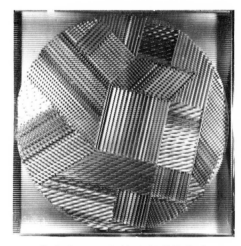

Mack. Dynamo of white light. 1964. Plastic.

São Paulo Biennial in 1957. His commissions include the *Princess Macha* (1957) for a hospital in Londonderry, Northern Ireland. McWilliam's versatility and facility are such that he has employed with equal skill stone, concrete, plaster, metal and wood, sometimes in combination, in every degree of realism and abstraction. In the greater part of his mature work, however, he has seldom strayed far from the human figure, though normally expressing it in highly stylised modes. He is a master of the adroit dissociation and reassembly of human anatomy and at times has taken advantage of the general move to open up the sculptural mass, to eliminate and imply parts of the body in a mildly Surrealist way. The smooth-contoured carvings of the immediately pre- and post-war periods (the influence of Moore was evident in the latter) at first gave way to more attenuated figures of metal construction. These figures were often depicted in violent action. McWilliam has also constructed a series of more static and hieratic groups and single figures, often on a

185

Maillol

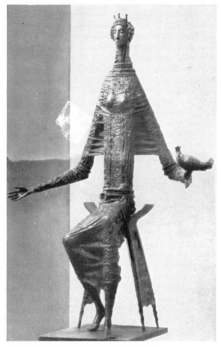

McWilliam. Princess Macha. 1957. Bronze.
N.W. Hospital, Londonderry.

discovered his real vocation. He was nearly forty, in fact, when he did his first sculptures, carved directly in wood without a preliminary clay model. Then he made terracottas that Vollard cast in bronze, which helped Maillol out of the poverty he knew only too well. In 1904, he moved to Marly-le-Roi, where he spent every summer afterwards and wintered in Banyuls.

There are two surprising aspects of his development as a sculptor: the rapidity with which he mastered his style and the slight amount of change that this style underwent afterwards. This is why the chronology of his works is difficult to establish and doubtless why the artist himself attached little importance to it. About 1900, Maillol was still influenced by the Nabis and Art Nouveau; line was hardly less important in his work than volume and it was long and sinuous. A short time afterwards, however, the imposing nude of a seated woman, which he called *The Mediterranean* (1902–1905), possessed the heavy volumes and architectural structure that were always to be the distinctive features of his style. About thirty years later, he did *The Mountain* (1937) which was another *Mediterranean*, with forms that were a little more refined, a little more firm and rather more clearly defined. While most of today's artists have acquired the increasingly rapid pace of city dwellers, Maillol went on with the slow, steady step of a countryman. He sought for strength and perfection rather than originality. His range of subject was limited and his style was nearly always the same: the body of a woman, a body that was generally mature and well built, with something earthy and timeless about it.

When he was asked about 1905 to do a monument to

considerable scale, the surface detail of which is coloured by recollections of Celtic ornament. Notable among these was *Princess Macha*. His most recent work of all is once more wholly non-figurative. McWilliam's gifts as a portraitist are exemplified by the simplified realism of his full-length bronze of the sculptress Elizabeth Frink (Harlow). M. M.

MAILLOL Aristide (Banyuls-sur-Mer, 1861 – Banyuls-sur-Mer, 1944). Maillol began as a painter. From 1882 to 1886, he trained at the École des Beaux-Arts in Paris under Cabanel, but his admiration for Puvis de Chavannes, Gauguin and Cézanne had more effect on his development than the official teaching. In 1893, he became associated with the Nabis, Bonnard, Vuillard, Roussel and Maurice Denis and, like them but without their talents, he tried to bring new life to painting. His interests turned soon afterwards to weaving and he opened a workshop at Banyuls, where he dyed the wools himself for the tapestries that were woven from his cartoons (*Swimmer*, about 1901). It was only when an eye disease prevented him from weaving that he

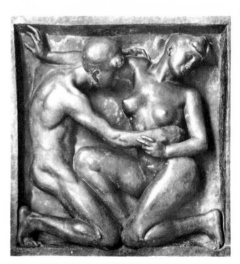

Maillol. Desire. 1903-1905. Relief in lead.
Musée National d'Art Moderne, Paris.

Louis-Auguste Blanqui, the Socialist, whose revolutionary activities had caused him to spend nearly half his life in prison, Maillol conceived *Chained Action*, a huge feminine nude, who, with her hands bound behind her back, turned round with a fierce and defiant movement. The same nude, but in calmer mood, became the bountiful *Pomona* (1910) a few years later. *The Night* (1902–1909) is a nude who is sitting on the ground. She is hiding her face in her arms, which are resting on her drawn up knees. When the torso leans back, while the legs and left arm are extended and the right arm rests on a support, covered with simple drapery, we have the figure for the *Monument to Cézanne* (1912–1920). All this is a long way from Rodin's ranging imagination. It is a long way, too, from any sort of literary art. There is no place in his work for what is generally called expression. His faces are quite empty, or rather, they express

Maillol. Ile-de-France. Detail. 1920-1925. Bronze.

Maillol. Chained action. Monument to Blanqui. About 1905. Bronze. Musée d'Art Moderne, Paris.

a very general feeling that is somewhere between a rather sullen seriousness and impassive serenity.

Nevertheless, however strictly sculptural were his aims, when he modelled a feminine nude, it was not without warmth. Even those that he covered with a clinging garment betray that he is a sensualist, who loves to feel the solidity of flesh and the gentle firmness of its curves. Fundamentally, he has much in common with Renoir. Like him, he can look at nudity without passion, and without sniggering either. Like him, he ignores sin, remorse, the anguish of the heart, the ills and decay of the body. Like him, he was a pagan. It can be said more truly of him than Renoir, that he belonged to the Greece of pre-classical times; he was not out of place in the twentieth century, but had been transplanted into an age that left no impression on him whatsoever. Was this because he came from the south of France and had deep

Maitec

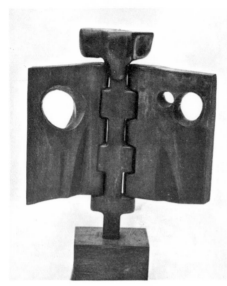

Maitec. Bird. Wood.

MAITEC Ovidiu. Born 1925, Arad, Romania. He trained at the Bucharest Art School and, in 1959, was awarded the prize of the Romanian Academy. His first works were realistic and expressive and showed a thorough knowledge of the human anatomy. Since then, his vision has changed and his art now draws its strength from the spiritual heritage of the medieval craftsmen and the peasant carpenters of folk art. His wood is worked and tooled in every way. The birds and butterflies, emerging from it, have strikingly decorative forms, in which the relations between voids and solid, even the way they are fitted together, and the potential movement they suggest, a slow, continuous movement, all belong to an imaginative, piquant art. The undeniable strength of Maitec's work lies in his ability to revive the intensity and meticulousness of past craftsmen and use them in the service of a modern conception, with its austerity and purity. R. I

MAKOVSKY Vincenc (Nové Mesto, Czechoslovakia, 1900 – Brno, 1966). His work was profoundly influenced by Jan Stursa, who trained him at the Prague Academy (1919–1926), and the logic and sensuousness of Stursa's sculptural forms often reappears in his student's work. After a study visit to France, he returned to Czechoslovakia in 1930, joined the Manes Society and sent work to various avant-garde exhibitions. He was a member of the Prague Surrealist group from 1934 to 1936. During these years, like other artists of his generation, including Emil Filla (1882–1953), his work followed in the direction that Otto Gutfreund had opened; he built up the human figure from elementary structures as, for example, in the Relief made of plaster, sheet-metal and wrought iron of 1929–1930, with its clearly defined, geometric volumes. By 1935, however, representational art proved a stronger force than any constructive style and it drew him towards an expressionist sculpture that was essentially concerned with social problems. Makovsky did a number of large-scale sculptures for public places, like the *Partisan* (1948) at Gottwaldov, *Victory* (1955) at Brno and the relief on the façade of a spa at Vitkov-Podhradi (1960–1964). R.-J. M.

MALAVAL Robert. Born 1937, Nice. Malaval is a painter as well as a sculptor and is self-taught. He exhibited for the first time at the Galerie Chave, Vence, in 1961. Since then, he has shown his work at the Galerie Yvon Lambert, Paris, in 1966 and 1967. He is also represented at the major international exhibitions. His first three-dimensional works, *White Aliments* (1961–1964), were made of wood and papier mâché, and were sometimes mobile. Superficially, they looked like objects, but they are enhanced by their significance, a sort of despair, which the artist infuses into them. Then he used modellings of pre-existent forms, especially nudes, which accentuated the iconoclastic nature of his art. The materials he used for them were polyester laminates and

roots in a Mediterranean region that had certain affinities with Greece? However this may be, the dream of the neo-classicists to recreate the grandeur and purity of Greece, a dream they thought they could make come true with the help of theories and formulas, Maillol realised in the most natural manner without straining himself in any way. His visit to Greece in 1908, which took him to the Acropolis, Delphi and Olympia, only gave further assurance to his art. Maillol preferred a body in which the bones and muscles were well covered with flesh because he loved volume in all its fullness, its firmness and assurance and solidity. He moulded clay, as Rodin did, to increase the surfaces that would catch the light and make an intensely exciting contrast with the greys and black of the shadows. Whether he modelled a form, or shaped it as a potter shapes a vase, or carved it directly from wood, stone or marble, he always merged one plane into another so that the light flows gently over the smooth surface of the volumes. There are certain sharp contrasts in his works, but there is nothing contorted or dramatic. There is hardly any movement either. 'A sculptor should synthesise,' Maillol used to say, like 'Negro sculptors who reduce forms to one.' While others around him let themselves be guided by Negro sculpture towards a new art, he only tried to reform it and purify the Greco-Roman tradition from realism. With his unusual, ingenuous character, he achieved this. He succeeded in reviving it in work which, while it marks an end rather than a beginning, is distinguished by its power, balance and vitality. J.-E. M.

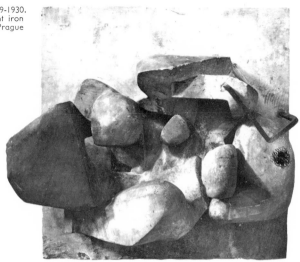

Makovsky. Relief. 1929-1930.
Plaster, sheet-metal and wrought iron
National Gallery, Prague

wax (*Sleeping Woman*, 1965). At the moment, his sculpture is built up of simple volumes that can be easily mass-produced. Malaval was one of the first artists, producing works in either two or three dimensions, who envisaged a 'multiple' edition of his work, in keeping with the social convictions he held. His materials at this time were metal and synthetic resins, which were

always coloured. Individualistic sensibility and aesthet-icism are equally repellent to him, because they sublimate art; he is a logician rather than a humorist. His inventions lie beyond any distinctions between representation and abstraction; the most extraordinary among them, in their technical perfection, their plastic style and their strict rationality, have the universal validity of a mathematical or logical demonstration. The driving force of Malaval's art is not so much fiction as anticipation, in other words, the reality of tomorrow. D. C.

MALFRAY Charles (Orléans, 1887 – Dijon, 1940). He came from a family of stone masons. He entered the École des Beaux-Arts at Orléans and supplemented his training in the studio of a local sculptor, called Lançon, for whom he always had the highest regard. Finally, he went to Paris in 1907, where he attended classes at the École des Beaux-Arts. In 1914, he was mobilised. After he had been gassed several times, he was released and returned to his training. For six years, he worked hard at his own sculpture and the completion of two grandiose works that he had been commissioned to do: the war memorials of Orléans 1924 and Pithiviers *(Fear)*. The Orléans memorial was an impressive bronze composition, over eighty-five feet high, weighing several tons, which earned him a ferocious attack from the press. Exhausted by his struggles and deeply hurt, he soon became very poor. He was forced to give up his sculpture and work as a studio assistant. In 1930, his friend, Maillol, got him a teaching post at the Académie Ranson, where he exercised a profound influence over all his pupils during his nine years there. He only once consented to break his

Malaval. Sculpture. 1968. Synthetic resin.

Malich

Malich. Blue corridor. 1967-1968.
Wood, brass, duraluminium, plastic.

silence and come out of his seciusion, when the Galerie Paquereau held an exhibition of his work in 1931. In 1947, the City of Paris paid homage to the sculptor and organised an impressive retrospective exhibition. There it was possible to appreciate the single-mindedness and range of Malfray's work from the rather hieratic forms of his early sculpture to the dynamic, spatial relationships of his final creations. D. C.

MALICH Karel. Born 1924, Holiche, Czechoslovakia. He trained at the Prague Academy (1950–1953), then joined the UB and Crossroads groups and took part in several exhibitions in his own country and abroad, notably Paris and New York (R. Solomon Guggenheim Museum, 1967). Malich is a painter and engraver as well as a sculptor, and, during the fifties, one of the leading exponents of lyrical abstraction of his generation. But in 1961, a new discipline began to appear in his painting and he incorporated linear mouldings and collages of corrugated cardboard into his paintings. The influence of a revised version of the Russian Constructivism of the twenties impelled Malich to made the radical change towards sculpture. The immediate products were reliefs in wood (1964–1965), which were generally monochrome. The raised forms were further emphasised by the shadow, cast by the light, which shifted and modified it with its changing strength and the angle of view. Soon the surface of these reliefs were perforated or hollowed and, while they grew into three dimensions, black and white paint was added to stress and differentiate the relationship of their planes. In 1966, this differentiation was ensured by the colour of the materials alone, polyester, plexiglas, chromium, duaraluminium. Malich's choice of these materials brought a further modification

to his sculpture, which now consisted of tubular structures combined with pierced, ellipsoidal forms. His sculpture rests on a strict definition of space and solid, which depends on the arrangement of sections of tubes, truncated volumes and surfaces, which are plane, convex or concave. The resulting dynamic and concrete interpenetration of contradictory space is a conception that his sculpture has in common with the experimental architecture of the future. J.-R. M.

Malich. Spatial sculpture.
1968. Nickelled brass.

MANÈS Pablo Curatella (La Plata, 1891 – Buenos Aires, 1963). After training at the Buenos Aires Academy, a scholarship enabled him to visit Europe, particularly Italy. In 1914, he settled in Paris and became Bourdelle's pupil. In 1925, he was represented at the International Exhibition of Decorative Arts, where he was awarded a silver medal. He joined the diplomatic service the following year, which did not prevent him from continuing his career as a sculptor. He has taken part, since the war, in several international exhibitions among which were the Venice Biennale (1952) and the São Paulo Biennial (1953). Before these he was awarded the first prize for sculpture at the National Salon in Buenos Aires in 1947. Although his early works, in their solid, strictly Cubist manner, showed the influence of Lipchitz *(Guitar Player, Nymph Leaning on her Elbow)*, they soon grew freer *(Acrobats* 1925) until the surrounding air and light became an integral part of their structure and they were rather like the exuberant shapes of tropical plants *(The Saint* 1932, *Fall of Icarus* 1933). They led one to believe that Manès had rejected figurative art and was going to turn to abstraction, but, as Léon Degand said, 'Manès has not taken up a definite position. His aerial sculpture has a tendency towards abstraction; his heavy sculpture a tendency towards figurative art, but it is an art treated as a means of showing, with every possible freedom, the potentialities of sculptural values.' In this freedom from the constraints of any particular style, he found his equilibrium and produced his best works, *Rugby* and *The Dance*.

MANNONI Gérard. Born 1928, Bastia. He joined the École des Métiers d'Art, in Paris, but was disappointed in the teaching there and, in 1948, attended the Académie Julian, under Marcel Gimond. Then the following year he went to the École des Beaux-Arts, while he attended Zadkine's classes at the Académie de la Grande-Chaumière as well. At that time he generally modelled clay and plaster. He went through a brief period of

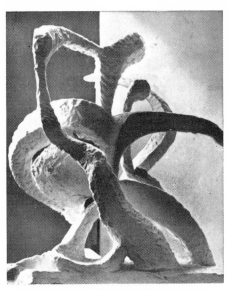

Manès. The dance. Plaster.

indecision and confusion, but his art soon grew more independent and gradually Mannoni rejected all inspiration that had the slightest connection with previously created forms. About 1954, he began to work on little plaster models, which he slowly transformed into increasingly simpler and larger sculpture and which were reproduced each time in a different material, concrete, stone or wood. These works were strictly abstract with a sculptural composition that was both flexible and severe. In 1956, Mannoni discovered the peculiar qualities of iron and considered it a material as malleable as clay or plaster, but with a weight that gave it a character

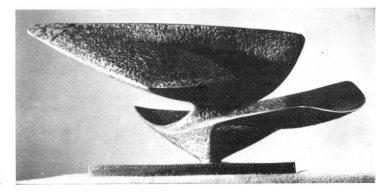

Mannoni. Horizontal development. 1959. Iron.

Mannucci

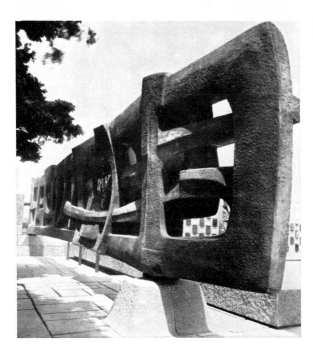

superior to bronze. At one time, he collaborated with the architects, Vago and Bourbonnais. He has taken part since 1957 in the exhibitions of the Espace group and, since 1955, in the principal Parisian Salons. His forms have now achieved an unusual power of expression; they are full, a little austere and are free from all attempt at facile appeal. Their surfaces always have a granulated texture, never a smooth, cold one, and the quality of the light suggests the vitality and sensitiveness of the artist. More recently, his idiom has been elaborated with a sort of dialectic of hollows and saliences and its space has developed a strangely monumental character. Even his small sculptures have an architectural quality, because of the exact relationships of planes and volumes. Mannoni has held several one-man shows: at the Colette Allendy (1958), Jacques Massol (1961) and Ranelagh (1965) galleries. He has sent work to the Biennials of Middelheim, Paris and Lausanne, as well as the Symposium of Quebec (1965). D. C.

MANNUCCI Edgardo. Born 1904, Fabriano, Italy. While he was quite young he went to live at Rome in the feverish atmosphere that Arturo Martini's revival had created, and turned, like all the Italian sculptors of the thirties towards a melancholy archaism, cut off from all outside influence. During the war years, a further change,

partly due to his association with painters like Cagli and Burri, gradually led Mannucci to evolve a modern idiom free from all external references. In 1949 he was awarded the sculpture prize at the first exhibition of the non-figurative Art Club. His completely abstract works date from 1950. His search for new materials and combinations of techniques sometimes led to sensational effects, which had a strange mixture of cruelty and gracefulness and even pathos, comparable with the effects Burri produced in his paintings. In 1957, he won a prize at the first exhibition at Carrara and, in 1958, the prize of the Albright Art Gallery of Buffalo was presented to him at the Carnegie Institute in Pittsburgh. He took part in various, important international exhibitions (Arnhem, Sonsbeek, Messina) and, in 1959, produced, in collaboration with the architect, Lambertucci, the monument to the International Red Cross, erected at Solferino. At the moment he is teaching in an art school in Rome. His work in which the fusion between the texture of the material and the skilful interplay of forms creates a style, is equally remarkable for the barbaric strength of its idiom, its elegance and even its preciousness. G. C.

MANOLO Manuel Martinez Hugué, called (Barcelona, 1872 – Briquetès, Catalonia, 1945). He wandered all over Spain during his youth and settled in Paris in

1900. There, he spent a good deal of time in the bohemian circles of Montmartre and Montparnasse. His career as a sculptor did not really begin until about 1910, at Céret, where he was invited by his friend, Déodat de Séverac, the French musician. A few years later, his Cubist friends, Picasso, Braque and Juan Gris, joined him and spent the summer of 1913 with him. He stayed there till 1928, when he returned finally to Spain. Manolo was amusing and capricious and not one of the race of great creative artists. He remained faithful to figurative sculpture and was strongly influenced by a certain kind of popular art. He produced a whole series of lively, comic little figures, of peasants, bull fighters and dancers, which were modelled in clay or carved in stone. Manolo also produced busts and nudes, which were fresh and zestful, like the *Catalonia* at Céret, in which Maillol's style, perfectly assimilated, is clearly recognisable. D. C.

MANZÙ Giacomo. Born 1908, Bergamo. He came from a poor family and had to earn his living as a boy but his parents, who had noticed his exceptional talent for drawing, sent him to an engraver and gilder, then to a stucco-worker, who taught design at an evening school in Bergamo.

While he was doing his military service at Verona, he attended the course in sculpture at the Cicognini Academy. At the end of his service, he went to Paris, where he discovered Impressionism, but lack of money forced him to return to his country. In 1930 he went to Milan, determined to become a sculptor. His admiration for the sculpture of the past dates from that time, Donatello and Francesco di Giorgio in particular, who, with Medardo Rosso, were 'the opposite terms of a stylistic equation on which his work was developed' (Brandi). His first one-man exhibition was held, in 1932, at the Galleria del Milione, Milan. The following year, he returned to Bergamo, where he did various busts (his wife, his mother, *Bruno Negri* 1934; *Camilla* 1936), which showed outstanding worth. In 1936 he went to Paris for the second time and discovered Rodin's work. In 1937, the Galleria Cometa in Rome held a large exhibition of his work. He refused to join in the controversies of the avant-garde circles, where he was known, and worked in solitude to give greater depth to the austere art he had created. Some of his most lyrical works were produced in this period, like the *David* of 1938, the admirable *Portrait of Sig.a Vitali* (1938–1939) and the little *Cardinal* of 1940.

In 1941, he was appointed to teach sculpture at the Albertina Academy in Turin and returned two years later to Milan, where he taught at the Brera Academy until he retired in 1954. During the war, he took refuge in the mountain valley of Clusone, where he worked without interruption (*Portrait of Françoise* 1942, the large *Pietà* 1943, *Depositions* and *Crucifixions* in which the executioners were represented as German soldiers). In 1948, the Venice Biennale awarded him the sculpture prize. In

1949, after a lively controversy in which critics and scholars joined, he was chosen out of a number of sculptors to execute the fifth door of St. Peter's, Rome, which was not put in place till 1964. It is called the *Door of Death* and is dedicated to the memory of Pope John XXIII.

Manzù's activity has always been very intense; he has exhibited ceaselessly all over the world and his reputation has grown steadily. In France, he is still not widely known and it was not till April 1969 that a full exhibition of his work was held at the Musée des Beaux-Arts in Bordeaux. From the *Self-portrait with a Model* (1943–1946) to the great *Cardinals* (1950–1954), the

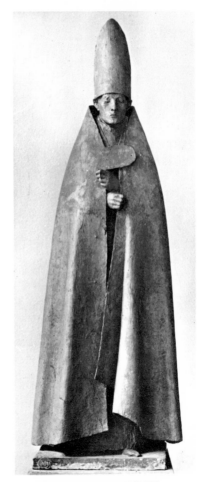

Manzù. Cardinal. 1949-1951.
Wallraf-Richartz Museum, Cologne.

Marcks

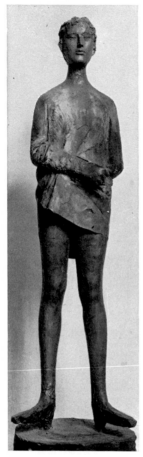

Manzù. Skater. 1957. Bronze.

Child sitting on a Chair (1949) to the series of Lovers (1968) his work has maintained the same intensity and an unwavering confidence of style, which has been typical of his work from the beginning. His originality does not lie in the relations of his forms, but in their subtle spirit, in the graceful rhythms and poses of each figure and by the tone of his sculptures, which can be sentimental, ironical, religious, sarcastic or sad. It is this humanism of Manzù that gives a faithful reflection of the anxiety of our times. G. C.

MARCKS Gerhard. Born 1889, Berlin. He taught at the Bauhaus from 1919 to 1925, then at the School of Arts and Technology at Halle until 1933, when he was dismissed by the Nazis. In 1937, his works were banned and he was forbidden to exhibit. After the Second World War, he was appointed to the Central Art School in Hamburg, where he taught for five years (1946–1950). Retrospective exhibitions of his works were held in honour of his sixtieth birthday in Hamburg, Stuttgart and Munich. Marcks is perhaps the only German sculptor to continue Barlach's manner, refined from its northern, peasant-like heaviness by his reflective feeling. Before he visited Greece in 1928, the draped figure was one of his favourite subjects. His young girls in long, flowing garments and with their modest gestures are like the descendants of figures in Gothic portals. His discovery of Greek art made him return to sculpting the nude, very often of young men or young girls. After the Second World War, Marcks once again set to work with all his characteristic energy. He was given some important commissions: six large figures for the church of St. Catherine at Lübeck, war memorials for Cologne, Hamburg and Mannheim and in 1959, a statue of *Orpheus* for the theatre at Lünen. His writings, however, reflect the resignation of a man who no longer feels himself quite at ease in the world of today. J. R.

MARI Enzo. Born 1932, Novara, Italy. He trained at the Brera Academy, Milan, from 1950 to 1955. He is a founder member of the international movement Nouvelle Tendance and lives in Milan, where he has held several one-man exhibitions, notably at the Galleria Danese. Besides his artistic activities, Mari is a well-known industrial designer. In 1952, he began a series of experiments that were variations on a single theme: the relations between colours and masses, cinematography and the use of techniques and industrial tools in the visual arts. His investigations led to the discovery of new possibilities with spatial values in three dimensions. According to Mari, the explorer in this sphere should experiment with methods of prefabricated programming, or modulars, in terms of the observer's faculties or perception, so that his investigations correspond to the new aesthetic requirements of architecture, industrial design and the plastic arts. The programming depends on the fact that the observer moves from one element to the next with a progressive view of the work. Mari applied this theory to a variety of 'plastic propositions', ranging from his alveolar structures in aluminium to 'self-propelled' objects and his *Programmed Transition-passages*, which was realised in association with Boriani, Chiggio, Colombo, Devecchi and Massironi for the exhibition 'Cinétisme, Spectacle, Environnement' at the Maison de la Culture of Grenoble, in 1968. In Mari's opinion, one of the most urgent tasks is the definition of the genuine aesthetic needs of man, the artist's function in society today, the means of communication that can be established with the help of new methods, in short, the definition of different levels of perception on which plastic ideas can be transmitted. F. P.

Mari. Structure in aluminium, black steel and rubber on a white background for the headquarters of the SNIA Viscosa at Torviscosa, Venetia. 1964.

MARIA MARTINS. Born 1900, Campanha, Brazil. She thought at one time of becoming a pianist, but in 1926 she took up sculpture. As the wife of a diplomat, Maria Martins is always travelling. When she lived in Tokyo from 1936 to 1939, she learnt pottery and did several sculptures in terracotta and, in 1939 in Brussels, she met the sculptor Oscar Jespers, who taught her the secrets of his art. At first her works were inspired by memories of the tangled plants in the forests of her country. Her sculpture is freer and more airy than it used to be. She stopped using wood and stone, which she found too hard to handle satisfactorily, and now she works directly in plaster for bronze casting, which is always done by the lost-wax process. Her first exhibition took place at the Corcoran Art Gallery, Washington in 1942. Several exhibitions since have been devoted to her work: Curt Valentin Gallery, New York (1942, 1943, 1944 and 1946); Galerie René Drouin, Paris (1947), etc. She was awarded the First Prize for Sculpture at the São Paulo Biennial in 1957 and was commissioned to do the sculpture for the Alvorada gardens in Brasilia, the new capital of Brazil. Maria Martins dislikes purely abstract art and thinks of sculpture as the best way of giving form to her dreams. There is something spell-binding about the luxuriant, baroque shapes of her work. It is like the fascination of the virgin forest for the spirit of man, that drives him into a sort of ecstasy in which sacred and profane love are joined. D. C.

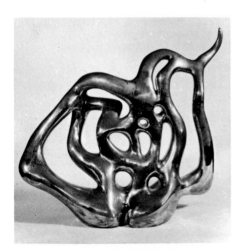

Maria Martins. Plant rhythm. Bronze.

MARINI Marino. Born 1901, Pistoia. He now lives in Milan. He was the son of a bank clerk and, while he was still young, he went to Florence, where he studied painting and sculpture at the Academy. He was eighteen when his first visited Paris and discovered the principal movements in modern art, which exercised a far more decisive influence over his development than the Impressionist style of Medardo Rosso, whom he had admired at first. From 1929 to 1940, he taught at the art school in the Villa Reale in Monza. It was during this period that he produced his first outstanding works. These roused some lively reactions in the established critics, who disapproved of the originality in his experiments. This negative attitude did not prevent him from continuing to work according to the strict discipline of his own style, as his early sculptures prove, such as the *Blind Man* (1928) and the *People* (1929) or later works like the *Pomona* of 1940, which challenged and rejected the tradition of handling volumes derived from Maillol. Marino Marini, however, learnt what was useful to his own innovatory art from Medardo Rosso and Arturo Martini, as well as

195

Marini

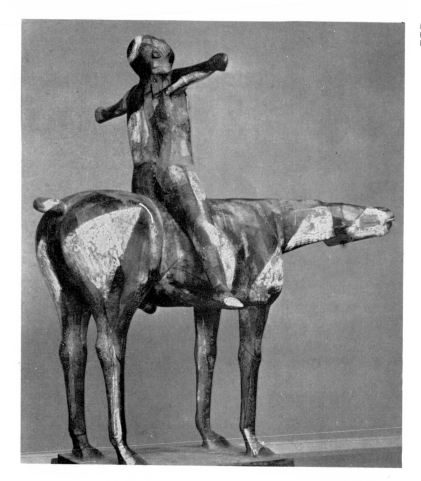

Marini.
Horseman. 1956.
Painted wood.

Maillol, from Egyptian and Etruscan sculpture, from the intense, vital realism of Roman portraits and the symbolism of Far Eastern art. This was not the most important thing about Marini: it was his unfailing ability to transpose nature into purely plastic terms. As he said himself in the introduction to his works in the catalogue of the II Quadriennale in Rome, in 1935, 'A work is only profoundly artistic when, after drawing its inspiration from nature, it can free itself and transcend it,' because, he added, 'art is perfect illusion.'

The II Quadriennale was a landmark in his career, because he was awarded the First Prize for sculpture. At the same time his reputation was spreading abroad and two years later he received a prize in Paris for his work as a whole. In 1940, he was appointed to teach at the Brera Academy, in Milan, where he is now still. He has travelled widely in Europe and the United States and his powerful personality has always been ready to accept and assimilate great art, especially if he found it particularly stimulating to his own.

The striking nobility of his figures and the quiet rhythm of their contours seem to be consciously derived from archaic sculpture, but it was transformed by the penetrating analysis of a modern mind. As early as 1941, Filippo de Pisis wrote of his *Horsemen* that they 'come to us in the pure dawn light of the Parthenon to become men and ride among men.' The importance of Marino Marini's horse and rider theme is well known and he has returned constantly to the same subject. Their compact masses and bare, decisive outlines have undergone every kind of variation with an increasingly dramatic expression until the tension is unbearable. At first the two figures of the

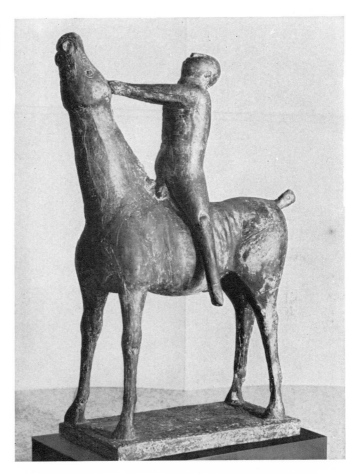

horse and man were distinct, but they soon tended to merge until they became part of the same block, involved in a single dramatic tension. The same development can be traced in his graphic work and painting (tempera and gouaches), which continued independently while he was making experiments in sculpture. The constant return to the same theme and the countless, rhythmic patterns that have sprung from it, has ended by creating a sort of 'plastic entity' which gives back strength and vitality to each of the works individually. These problems of structure, however, cannot be separated from those of surface modelling and its relations with the light and space surrounding it. All Marini's originality and daring are to be found in the answer he gave to these problems, either in the series of *Jugglers* or *Dancers* in which the effects he achieved were no less surprising. There is a

remarkable coherence in all his work, even in his portraits in which psychological analysis does not detract from plastic values, but strengthens them and provides a striking demonstration of Marini's style (*Campigli* 1940, *Carrà* 1946, *Stravinsky* 1951, *Henry Miller* 1961; *Arp, Chagall* and *Henry Moore*, 1962). The works of the past few years show an unmistakable development in style and in the nature of his experiments. This has not led to a further withdrawal from the representation of reality, because this is still his unique source of inspiration, but his art has become progressively more dramatic in conception. This reveals itself in an increasing distortion of his masses, which increases the spatial potentialities of the forms, and in the way he enlivens his surfaces with more distinctive roughening. The *Monument*, erected in The Hague (1957–1958), is particularly significant

Marisol

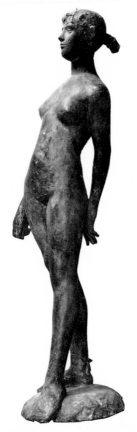

Marini.
Dancer. 1949.
Bronze.

from this point of view. In other works, this freedom of form is even more astonishing and is an added revelation of his vitality, varied expression and a deepening of artistic experience. In an earlier work, the *Miracle* 1953, Marini seemed to have reached the height of dramatic expression, but his last works (*The Cry*, 1960; *The Warrior*, 1960) have shown that he was far from exhausting his resources and has remained just as receptive of the vital, regenerative ideas in art today. He is one of the leading figures of contemporary sculpture and has produced some of its most stimulating ideas.

The great retrospective exhibitions of his work in 1962 at the Kunsthaus in Zürich and, in 1966, at the Palazzo Venezia, Rome, were an eloquent proof of this.

G. C.

MARISOL Escobar. Born 1930, Paris. Her parents were Venezuelan. She trained at the École des Beaux-Arts, Paris, then went to the United States, when she was twenty, and attended the Art Students' League in New York, where she made the acquaintance of Jasper Johns and Rauschenberg. She very soon showed a decided taste for sculpture in wood. In 1961, she exhibited a packing case containing two figures, called *From France*. Her works had a hieratic quality derived from the contradiction between the mass and the figurative image. The mass was crude, roughly hewn into simple volumes either parallelepiped or conical, on which sculpted or painted images were superimposed. Their features were mask-like and were stamped with a mould onto the face, while the limbs were merely indicated by a thin line. The introduction of extraneous elements, like bicycles (1962), accentuated their immobility and the petrified dignity of these figures. Yet, they came from the everyday life of humble people and from a mythology, which went far beyond South American traditions, sometimes

Marisol. Holiday.
1965-1966. Wood

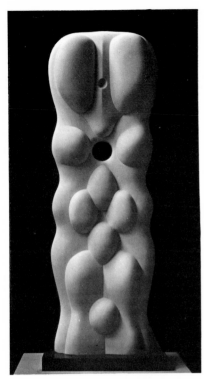

Martí. « Lao ». 1967-1968. Marble.

of the constructed object. In his relentless search for unusual combinations of forms, Martí has ended by developing a personal and very varied range of forms, which has won him a special place among the Spanish sculptors of today. J. E. C.

MARTIN Kenneth. Born 1905, Sheffield. He trained at the Royal College of Art, London (1929–1932). He worked direct from nature as a painter, in the tradition of English neo-Impressionism, exemplified by the Euston Road School, until 1946. Like that of Victor Pasmore, with whom he was associated, his work became increasingly abstract until the point of non-figuration was reached in 1949. Since 1951, he has been engaged almost exclusively on constructions of a mobile character. Among exhibitions abroad he was represented in the Salon des Réalités Nouvelles, Paris, and the São Paulo Biennial (1951). Martin's work is logical rather than fanciful, concrete rather than organic. His most characteristic constructions are of metal rods welded into mathematically conceived spirals and related figures. Hung vertically, these revolve to produce a *perpetuum mobile* of sinuous and flowing clarity. He is married to Mary Martin, the author of highly individual non-figurative

as far back as the Egyptian and Mayan cultures. A vigorous, basically sexual symbolism, often stresses this primitivism, which lacks neither humour nor refinement. Marisol has created a whole world, which, without her resorting to the pretences of narrative, belongs to a personal mythology in which man occupies a mysterious and rather arrogant place. G. G.-T.

MARTÍ Marcel. Born 1925, Alvear, Spain. Martí is a solitary, withdrawn artist, who has followed unwaveringly a path that has led him from the semi-figurative forms in marble of the fifties to his wholly abstract sculptures of today. Like all good Spanish sculptors, he used to work in wood, but now he uses copper, which he shapes into geometric masses. In between, there was a phase about 1960, when he made plaster and bronze sculptures covered with cloth and painted, which was a way of rejecting the emotive qualities of his early works by sublimating them. Since then, the dominant form has been strongly rhythmic and stressed by verticals, in which biomorphic images are combined with a very real sense

Kenneth Martin. Mobile construction, version I. 1955. Bronze and steel. Adrian Heath collection, England.

199

Martinez Richier
Sculpture. 1959.
Wood.

herself as an animal sculptor. Her favourite medium is bronze, cast with the lost-wax method. In this process, she takes great care to preserve in large measure the characteristics of the wax model, in other words, to modify the wax figure as little as possible; hence, the blemishes and streaks that liven the surface and give it an almost pictorial patina in contrast to the economy of the sculptural form is a contrast to this rather decorative surface. She tries to strike a balance between the simplification of abstraction and realistic representation. Her human figures have the same deliberate severity. Generally their bodies are contained by a triangle or rectangle, which is sufficient to give them an affinity with archaic art. However, some irregularities in the form fortunately break the severity of her art. J. R.

MARTINEZ RICHIER Luis. Born 1928, San Pedro de Macoris, Dominican Republic. When he had completed his training at the Art School at Ciudad Trujillo in 1945, followed by a spell at the Advanced School of Art in Buenos Aires in 1950, he went to Paris in 1952. In 1959, he was invited to send work to the first Paris Biennial, where he won one of the awards for foreign artists resident in France. The problem that Martinez Richier had to solve was the same facing nearly all young South American sculptors who have felt the attraction of primitive native art. They try to find, in terms of a secular art, a specifically sculptural idiom in which they can express the conceptions of modern times. Martinez Richier's wood carvings — wood is his favourite material — are directly inspired by the art of the ancient Tainos, a small tribe, who excelled in bone, jade and pottery work, which has been discovered in the Carribean Islands. These objects have a remarkable purity of form and it is these forms that he recreates and, though he does not imitate their archaic style, he tries to preserve the magic of their origin. The modern idiom of his work lies in its straight lines, geometric volumes, its freely

reliefs conceived within a serial discipline, likewise finding its origins in architectural and mathematical relationships. M. M.

MARTIN Priska von. Born 1912, Freiburg, Germany. She trained in Fernand Léger's studio in Paris and later went to the Munich Academy. She received considerable encouragement from the sculptor, Toni Stadler, whom she married in 1942. Priska von Martin made a name for

Priska von Martin.
Caribou. 1959. Bronze.

Martini. Woman swimming under water. 1941. Marble.

developed shapes and the conciseness and serenity of its style. M.-R. G.

MARTINI Arturo (Treviso, 1889 – Milan, 1947). He was apprenticed to a goldsmith at the age of twelve and then worked with a pottery-maker. About 1905, he began to sculpt and was a student first under Carlini at Treviso, then Nono at Venice in 1907 and finally under Hildebrand at Munich in 1909 (this visit to Germany has been questioned by some of his biographers). In 1911, he went to Paris with the painter Gino Rossi and both exhibited their work the following year at the Salon d'Automne. It has been pointed out that there is an obvious affinity between some works of this period, like the *Courtesan* (1909–1910) and his friend's paintings. Martini was mobilised between 1916 and 1919, and his first one-man exhibition, organised by Carlo Carrà in Milan at the gallery in the Via Dante, did not take place until November 1920. It marked the beginning of an eventful part of his life that his biographers find difficulty in following exactly. The important dates, anyway, are 1921, when he joined the Valori Plastici movement; 1924 when he completed his first monument, the war memorial at Vado Ligure; 1927–1928 when he worked in Rome on the imposing monument, dedicated to the *Italian Pioneers of America* (Worcester, Mass.). In 1929, he was appointed to a teaching post at Monza. In 1931, he won the sculpture prize at the I Quadriennale in Rome, which marked the beginning of the second period in his life, that of his public career, fame and official commissions. Two years before his death, he published a pamphlet called *Sculpture: a Dead Language*, a sad statement of his principles in which he condemned and dissociated himself from the sculpture of his time.

Martini's sculpture was a courageous departure in academic, conformist circles where every revolutionary venture seemed sacrilege. His early sculpture was stamped with a slight archaism, which became an accepted mannerism with so many other artists who were influenced by Martini, but in the end it showed the greatest freedom of expression. He pursued a solitary way in art as in life and, without borrowing anything from Cubism or Futurism, he created another conception of form and

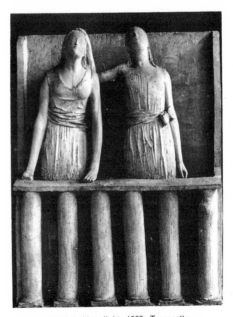

Martini. Moonlight. 1932. Terracotta. Middelheim Park Museum, Antwerp.

Mascherini

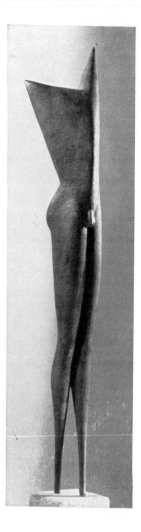

MASCHERINI Marcello. Born 1906, Udine, Italy. Apart from a brief stay in Abruzzi during the First World War, Mascherini has always lived in Trieste. He trained there at the Industrial Institute and exhibited his work for the first time, in 1925, at the Arts Circle. In 1933, his *Icarus,* exhibited at the Milan Triennale, earned him a well merited success. The first period of his development, which ended in 1943 with a sculpture called *The Earth*, was characterised by a faithful representation of reality and its plastic relations. With the end of the war, his works showed greater freedom and a new sense of rhythm, without losing the archaic flavour, which is one of its most typical features. He shared the First Prize for sculpture with Minguzzi at the XXV Venice Biennale in 1950 and is regularly represented at the main national and international exhibitions. An impressive retrospective exhibition was held in 1959 at the Galerie David et Garnier in Paris. 'An awareness of the breadth of art, civilisation and sculpture today makes me feel the need for a measure and order that cannot be established by individual acts of will alone. This is why, in a constant effort to maintain a figurative idiom, I consider my sculpture an entity that contains its own laws within itself and where form should be judged according to the equilibrium of masses and voids, light and shadow, in fact, as pure form, but a form that is nonetheless permeated with deep human feeling.' In these words from the retrospective exhibition catalogue, he has described better than anyone else could his principles and aims. The outstanding qualities of his art are an unusual and graceful line, a delicate sensuousness and a sharp sense of irony. G. C.

MASTROIANNI Umberto. Born 1910, Fontana Liri, near Rome. He produced his early work at Rome, where he lived till 1926. He then went to Turin, where he has remained. Mastroianni's figurative works earned some comment at the 1936 Venice Biennale. They were mostly heads and busts which reflected 'his endeavour to reconcile sculptural values with the characteristic features of the model; and a closed form with a sensitive movement over the surfaces' (Argan). In the beginning, his work had a certain affinity with Boccioni's sculpture, but his *Composition* of 1941 is his nearest approach to Futurist theories. In fact, it was only in the following years that he revealed the strength and integrity of his art. Although he continued to use the human figure as a subject, it was divested of any trace of reality and only remained as a suggestion or support to his experiments with forms. When Italian artistic circles were once again in touch with international ideas after the war, Mastroianni, with Spazzapan, became the moving spirit of this renewal in Turin. The prize of the city of Turin was awarded to him in 1947. In 1951, he gained his first great international success with an exhibition at the Galerie de France, in Paris. In 1957 he was appointed to teach sculpture at the Bologna Academy. A year later the XXIX Venice Biennale awarded him the First Prize in

an idiom that were a faithful reflection of his age. Every turn was always unexpected and each work seemed the result of complex experiences that had been restlessly questioned and transformed afresh every time. From a work that was full of new developments and includes about a hundred sculptures and thousands of drawings, one can mention pieces as varied as *Moonlight* of 1932, the *Pisan Woman* (1933), the astonishing group of *Thirst, Homage to Manet* of 1938, and the magnificent marble sculpture of *Woman Swimming under Water* (1941). Martini's work was so vitalising that it has been justly considered as a stimulation to all experimental sculpture in Italy after Futurism. G. C.

sculpture. Mastroianni's sculptures are memorable for their vitality, energy and their satisfying spatial relations. The strange rhythm of their forms gives them a monumental quality, which has something primitive and elemental about it. Works like *Memorial to the Partisan* in Turin or the *Large Sculpture* in the station hall at Rotterdam are good examples of the synthesis he has sought between a modern idea of sculpture and the ancient conception of monumental art. More recently, Mastroianni has moved towards a tenser and more dramatic vision. His mastery over material and space shows a new sureness in the placing of large, angular masses, which are powerfully articulated and rhythmised, and free from all external references (*Gypsies*, 1961; *Dancer*, 1964). G. C.

MATARÉ Ewald (Aix-la-Chapelle, 1887 – Cologne, 1965). He was a painter at first and only turned to sculpture in 1920. The Nazis dismissed him from his teaching post at the Düsseldorf Academy, but he was reinstated in 1945. In 1953, a large retrospective of his work was held at the Museum of Arts and Crafts in Hamburg. Mataré established his reputation as an animal sculptor. He loved to use fine woods like mahogany and kingwood in which the carved shapes of the animals followed the natural grain of the wood. His love of smooth, rounded masses, which were completely satisfying in shape and amplitude, limited him to a particular kind of subject, particularly cows standing up or lying down. Under the III Reich, Mataré had to turn to the

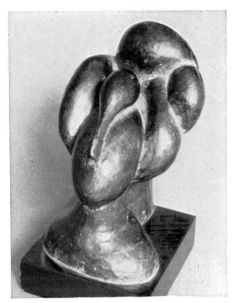

Matisse. Tiare. 1930. Bronze.

applied arts to earn his living and undertook commissions from the Church in particular. After the war, he was commissioned to do the bronze doors in the south portal of Cologne Cathedral (1948–1954) and three doors for the church in Hiroshima. Notable among his other works are the Stephan Lochner fountain for the Wallraf-Richartz Museum in Cologne and a huge statue of a *Sphinx*, which was placed in the waiting-hall of the Landtag in Düsseldorf. J. R.

MATISSE Henri (Le Cateau, Nord, 1869 – Cimiez, Nice, 1954). It seems paradoxical that this great master of colour who nearly always ignored volume in his paintings, should have excelled in a three-dimensional art. Like Degas, Gauguin, Renoir and other artists of his generation such as Derain, Picasso and Braque, Matisse felt the need to prove his gifts in a technique that was new to him and he brought to his sculpture the same freedom that he had shown in his painting. When he was running his own Academy in the Couvent des Oiseaux, about 1910, he gave his pupils a very clear explanation of his ideas on sculpture: 'The human body is an architecture of forms fitting into and supporting each other, rather like a building in which all the different parts contribute to the whole.' He applied this principle to his first sculptures: *Jaguar Eating a Hare* (1899) after a bronze of Barye, *The Horse* (1901), *The Slave* (1903). Certain facts that are significant for his subsequent

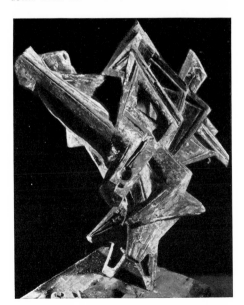

Mastroianni. Winged apparition. 1957. Bronze.

Meadows

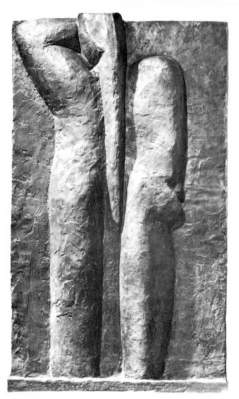

Matisse. Back IV. 1930. Bronze. Private collection.

in the more realistic gestures, movements and attitudes of the female statuettes, which he tossed off between a couple of paintings of Odalisques. Some of these little bronzes, however, show a more serious approach; for example, the *Small Torso* (1929), *Venus with a Shell* (1930) and especially *Tiaré* (1930), a head that Matisse did on his return from a visit to Tahiti, when he was still haunted by the memory of a tropical plant called 'tiaré'. Its rhythmic pattern and the unusual arrangement of the forms anticipate the boldest experiments of sculpture today. In spite of, or because of his successes, in 1932 Matisse gave up an art of which he thought he had personally exhausted the possibilities. This decision shows not only his intellectual honesty, but also his perception. Perhaps no artist had ever been so critical of his experiments and the means he employed. Matisse's sculpture, which includes sixty-eight known pieces, all in bronze, cannot compare either in number or importance with his painting, even though he could have been a sculptor and only that. His painting and sculpture, nevertheless, have one thing in common: a constant concern for balance, purity and clarity. F. E.

MEADOWS Bernard. Born 1915, Norwich. He studied at the Royal College of Art, London. He worked for a time as an assistant to Henry Moore. He has been represented at several international exhibitions, notably

development should be remembered. Matisse often lingered in the Ancient Egyptian and Oriental rooms in the Louvre. In 1906, he bought a Negro mask, which was the first of a whole collection. His nudes and heads of little girls, particularly two large *Negresses* of 1908, show an appreciation of elementary form and a roughness of manner that are common in archaic and primitive art. After *Serpentina* (1909), inspired, so we are told, by Florentine sculpture, but doubtless even more so by the funeral sculpture of the Aegean islands, Matisse's individual style was formed. In the series, *Heads of Jeannette* (1910–1913) the convexity of the contours is accentuated, the volumes thickened and are in strong contrast to each other. Nothing better illustrates the sculptor's development and his increasing severity and conciseness than the four bas-reliefs of the *Backs*, about six feet high. Matisse evolved a more daring conception of the human body in each one of them over the years of their production, 1909 to 1930, from the naturalism of the first to the abstract expression of the theme in the fourth nude, with its unified composition, stability and monumentality. His originality as a sculptor can be seen here rather than

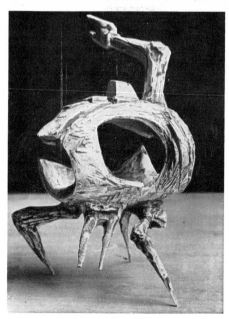

Meadows. Crab. Bronze.

the Venice Biennale of 1964, where he represented Britain. He also exhibited his work at the Middelheim Biennial, Antwerp, and the Kassel Documenta (1959). His commissions include a bronze for the Hertfordshire County Council (1954) and a large group for the new Trades Union Congress building, London (1958). Meadows has come to express his sculptural ideas through a very limited range of subjects. In particular, he has consistently made the cock and the crab his vehicles for a multitude of formal and Expressionist variations. At times these have been highly realistic; more frequently—and, it may be thought, more successfully—they have departed so far from the perceptual image that it has not always proved easy to tell the one from the other. Their vocabulary of horned forms speaks clearly of their period. Most typically, Meadows gives a florid, lively surface to a counterpoise of essentially simple shapes, balanced asymmetrically and with a certain straining sense of vertical or horizontal movement. In the works of 1955–1958, the 'bird' of his titles has often been prefixed with such adjectives as 'fallen', 'frightened' or 'shot'; the sculptures themselves have a less manmade look and sometimes suggest 'objets trouvés' — perhaps a fragment of ore or a fossilised tree trunk, which contrive to resemble the images of their titles. Since 1961, he has taken a greater interest in the human figure; the forms are more closed in, but they are no less disturbing than the Birds. Within his self-imposed limitations, Meadows continues to surprise by the range of his invention. M. M.

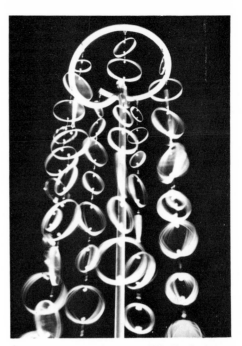

Megert. Fountain at Interlaken. 1965. Kinetic glass.

MEGERT Christian. Born 1936, Berne. He trained at the schools of applied arts in Berne, Paris, Stockholm and Berlin from 1952 to 1960. He has exhibited in Switzerland, Germany and Belgium. In 1968, he constructed an *Environment with Mirrors*, for the Kassel Documenta. The fundamental features of Megert's first style was a multiplication of sculptural elements and the vibration of black against white. In 1959, he made his first *Painting with Mirrors*, followed by a kinetic experiment with suspended mirrors, then with environments and 'infinite spaces', but this time with special mirrors. Since 1966, he has used colour. The first work of this kind was *Zoom* made of discs of reflecting material, set in motion by a motor, which provided extraordinary spatial sensations for the observer. Although mirrors and light are Megert's commonest mediums, his primary aim is the discovery of a new vision of space in which infinite extension is suggested. The observer can enter the work and so by his presence alone become the creator. Its space can also be modified and transformed as he wishes. F. P.

MEIER-DENNINGHOFF Brigitte. Born 1923, Berlin. Her training began in 1943 at the Berlin Art School. After the war, she continued her studies in

Munich, then, in 1948, she went to England where she was studio assistant to Henry Moore. The Solomon Guggenheim Foundation in New York gave her a grant to study in Paris and there she worked for two years (1949–1950) with Anton Pevsner. On her return to Germany, she was at first engaged on stage designing in Darmstadt (1953–1954), then she taught at the Kassel Academy (1957–1958). In 1959, she was awarded the Bourdelle Prize. She exhibited her work in Berlin, Munich and Düsseldorf and, in 1960, at the Musée Bourdelle in Paris. Meier-Denninghoff belongs to the young generation of German sculptors, who grew up under the III Reich and who made every effort to join in the international movements. After working in stone and wood, she used concrete and metal. Her early works were rather heavy and sometimes had a touch of grotesque humour. Gradually the compact masses melted into thin sticks, welded and bound together in sheaves, which gave a finely contoured movement to the surfaces, such as a few painters only have produced on canvas with sable and colour. For certain effects, she uses tin-solder, which forms a rough surface as it cools unevenly. The resulting patina has a pictorial charm that is sometimes reminiscent of the mineral deposits in caves hung with stalactites. Brigitte Meier-Denninghoff's interest in the inorganic world and her love for the slow growth of stone and

Melli

metal connects her with the new romanticism similar to the romanticism that appeared in abstract painting after 1950. On the other hand, everything impassioned or contorted is alien to her. Her most recent constructions consist of sheaves of finer and finer sticks, forming opaque, uneven fringed curtains that describe great, solemn curves as they swing to and fro. Evocative titles like *Pallas Athene, Angel* or *Planet* suggest their intellectual content. J. R.

MELLI Roberto (Ferrara, 1885 – Rome, 1958). He was not only a painter and sculptor but also an art critic and as such he made an effective contribution from 1911 to the artistic revival. His sculpture spread over a period between 1906 and 1914 after which he devoted himself to painting. Melli did not have any direct connection with Futurism, but his sculptures of 1913–1914 show the obvious influence of its revolutionary ideas and can easily be fitted into the context of the period. His first one-man exhibition of sculptures and drawings was held in the Secession Salon at Rome in 1914. Others followed: at Ferrara in 1920; Germany in 1921 with the Valori Plastici group; then, after an interval when he was banned by the Fascist government, at the Galleria Cometa, Rome, in 1947, and at the Palazzo Barberini in 1957. His early work was influenced by the plastic Impressionism of Medardo Rosso (*Relief with the Profile of a Girl*, 1911), then his sculpture was dominated by an extraordinary rhythm and a revolutionary conception of the relationship of masses and voids. From this point of view, his 1913 work (*Woman with a Black Hat* and *Portrait of Vincenzo Constantini*, National Gallery of Modern Art, Rome) are significant and show that Melli's contribution to the revival of contemporary Italian sculpture was limited, but effective. G. C.

MENDÈS DA COSTA Joseph (Amsterdam, 1863 – Amsterdam, 1939). He began to learn his craft in the workshop of his father, who was a stone mason. Then he attended the Amsterdam School of Decorative Arts (1882–1885). For some years, he worked with the sculptor Zijl. About 1898, he began modelling and firing figurines in stoneware, a process that he continued to use till 1910. His association, which began in 1901, with H. P. Berlage and other architects, gave him every opportunity to show his skill in large-scale sculpture. His style gradually became purer and more simplified. The keen intelligence he had inherited from his Jewish origins, his critical sense, and a perceptiveness that fortunately saved him from doctrinaire strictness, although in some of his later works, the bronze *Self-portrait*, for example, in the Kröller-Müller Museum, an almost exaggerated cult of form is noticeable. The monument to *Christiaan de Wet* (1917), the Boer general, which now stands in a stony, open place, not far from the Kröller-Müller Museum, is among his best known works. Mendès da Costa occupied the same place in Holland as Maillol in France and Minne in Belgium. His work was self-sufficient and one of its qualities was that it broke with the academicism of the day and at the same time his restrained, powerful idiom avoided the failings of impressionistic modelling. W. J. de G.

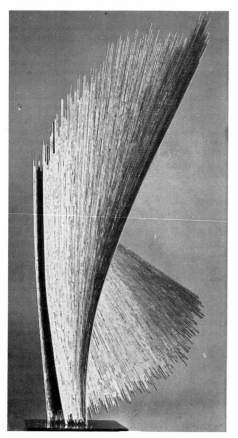

Meier-Denninghoff. Gust of wind. 1959.
Bronze. Private collection.

MERLIER Pierre. Born 1931, Toutry, Côte-d'Or. He went to Paris 1953, where he attended the studios in the Grande-Chaumière and learnt to admire Zadkine's work for its emotional quality and inventive spirit. Since 1954, he has been exhibiting in various Parisian Salons and has had a number of one-man shows at the Galerie Moura-dian-Vallotton (1963, 1966, 1967 and 1968). Merlier's style gradually changed from a formal abstraction to a

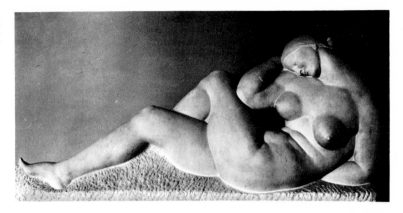

Mestrovic.
Reclining woman.
Mestrovic Museum,
Split.

sort of neo-classicism in which the austerity of Cubist construction blended with a vehement kind of expression. More recently, after a period when popular art inspired him, his sculpture has evolved with polychrome wood towards a caricatural expressionism, reminiscent of Daumier. He has also inserted miscellaneous elements like bits of mirror and pieces of metal into his material for purely realistic effect. Merlier has worked in terracotta and sandstone as well. D. C.

MESTROVIC Ivan (Vrpolje, Yugoslavia, 1883 – South Bend, United States). He was still a student at the Vienna Academy when he exhibited his work at the Wiener Sezession in 1902. Later on he lived in Paris, but most of his work was done in Zagreb, then in the United States, where he taught sculpture at the University of Syracuse. He became an American citizen in 1954. His early works reflected his attachment to the poetry and legends of his country, like the project for the *Temple of Vidovdan*, in memory of the heroes who fell at Kosovo in 1389 fighting against the Turks. Meštrović was one of the first Yugoslav sculptors to break away from Academic realism and his powerful work, with its simple, dignified volumes, contributed a great deal to the birth of a modern school of sculpture in Yugoslavia. His work includes a number of public monuments, including the Tomb of the Unknown Soldier on the hill of Avala, near Belgrade.

METCALF James. Born 1925, in New York. He studied sculpture at the Philadelphia Academy (1947–1948). He attended the Central School of Arts and Crafts in London from 1950 to 1952, where he learnt to work in iron and precious metals, bronze casting and the techniques of engraving and medal making. In his own country Metcalf had already learnt direct carving in stone, lead hammering and the cast-iron process. When he had finished his training at the Central School of Arts, he was appointed to teach there. His main interest was in the primitive techniques of metal work and he did research into the different processes once used in Mesopotamia, Egypt, Greece and barbarian Europe be-

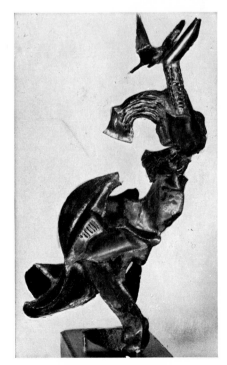

Metcalf. Phoenix-Mutation. 1959. Bronze.

Meunier

Meunier. The docker. 1905. Bronze.
Middelheim Park Museum, Antwerp.

MEUNIER Constantin (Brussels, 1831 — Brussels, 1905). Constantin Meunier devoted his art to portraying the life of the worker. He was a painter at first and it was not till he stayed in the Borinage with Camille Lemonnier in 1885 — he was fifty then — that he began to sculpt. He produced the *Puddler* the same year and exhibited it immediately at Antwerp, where it caused a sensation. Meunier had found his ideal means of expression, although he did not give up painting, which he practised at the same time. Its subjects were also taken from the world of labour, whose reflection in Meunier's art had both grandeur and a deep humanity. Some moving groups like *Fire-damp Explosion* (1887), inspired by a mining disaster, roused considerable comment and have since become famous. In 1896, he exhibited his work in Paris at Bing's, where it was much admired. For years he was absorbed in his *Monument to Labour*, a huge symbolic group, which was set up in the Place de Trooz, Brussels, in 1930. The house where he lived in Brussels from 1900 has been made into a museum. Meunier is represented in most of the museums of Europe. His name has become almost synonymous with the type of workman, especially the miner, whom he eternalized in bronze.

MEYLAN. Born 1920, Saint-Imier, Switzerland. After his first stay in Paris (1936–1941), where he trained as a painter, he returned to Switzerland and began modelling. When he went back to Paris in 1945, he worked in the independent academies, notably under Zadkine. His technique developed rapidly. At first he modelled figures in plaster on an armature, then he became interested in stone and learnt to carve. But stone did not really suit him and he soon returned to plaster. The various pieces he produced left him unsatisfied and he destroyed them. He then spent his time drawing, gathering notes and ideas for the future. Finally he went back to metal which afterwards remained his favourite medium. In fact, no other material could be more appropriate for the dry, stark arabesques he is so fond of. His recent works are certainly figurative, but reality is freely interpreted in them and Meylan has gone as far as abandoning all surfaces and planes. His sculptures are made of metal rods welded together. They contain no volumes, but are like the insistant repetition of a line in space, a line that he sometimes increases and sometimes lessens in thickness. This is really sculptural writing and each of his pieces is like a spatial calligraphy, a sort of moving, incisive poem in metal. A number of exhibitions of his work have been held in London by the Drian Gallery in 1958 and 1960, in Paris at the Iris Clert gallery (1967) and in Milan at the Cadario gallery (1964). About 1967, Meylan produced a series of works that could be set in motion, oscillating, balancing and pivoting, by the observer himself. Dali was moved to say of his art, which is created from the slenderest means and hardly imprints the air, 'It is the sculpture of void.' D. C.

fore the Roman occupation. In 1953, he won the Clark Foundation Prize, which enabled him to go to Spain to study ironwork and visit Italy and Greece as well. He held his first one-man exhibition at Barcelona in 1955. The same year, he settled definitely in Paris and decided to devote himself to sculpture and turn his attention to contemporary art. His favourite material, of course, was iron, which he could equally well forge or weld. His forms are intensely vital, partly because of their sculptural composition and partly because of the subjects he chooses. The abstract style of his works, in fact, is more apparent then real; they always retain some slight association with nature and a comparison, a memory or an underlying resemblance identifies them more or less exactly. There is a certain flavour of Surrealism in his works. In 1957, Metcalf received the William and Norma Copley Foundation Prize. Two years later, he held his second one-man exhibition at the Galerie Furstemberg, at Paris. He seems recently to have given up iron for brass, because it does not suffer from the effects of weather and particularly because of its possibilities in polychrome patinas. D. C.

Meylan.
Sculpture.
Iron.

followers from these efforts and the teaching he gave them generously took up the time he would otherwise have given to his own creative work.　M.-R. G.

MILANI Umberto (Milan, 1912 – Milan, 1969). Milani was still young and practically self-taught when he decided to become a painter. From 1928 to 1931, he attended evening classes at the Brera Academy in Milan. Then he worked with the well-known Milanese architects Baldassari, Zanuso and De Carli. His first one-man exhibition was held at the Galleria Como at Como in 1943; others followed in Milan at the Galleria Annunciata in 1944 and then the Galleria Il Milione. The Venice Biennale honoured him with one-man shows in 1958 and 1962. Milani's development was exceptionally consistent. At first he was influenced by Medardo Rosso, then, as a reaction against this impressionistic style, his volumes acquired solidity, which reflected his interest in ancient sculpture, especially Egyptian and Gothic. His work from 1945 to 1949 already depended on the interplay of masses and was reminiscent of Cubism. A more patently dramatic feeling replaced this manner, as in the *Pietà* of 1950. Milani's sculpture, now reduced to planes and simple walls, gradually lost all connection with reality; its impact was made by the mysterious harmony of hieroglyphics, extremely evocative markings, and vibrations, which was, in fact, the title of some of his bas-reliefs in the fifties. Painting was as intense an activity for him as sculpture and, in both mediums, he achieved a rare imaginative power.　G. C.

MICHELENA Bernabé. Born 1888, Durazno, Uruguay. He trained at Montevideo, under an Italian artist, Felipe Morelli. He went to Paris in 1927 on a grant, where a more extensive study of the works of Rodin, Bourdelle, Maillol and Despiau stimulated and enriched his own gifts. He exhibited his works at the Galerie Zak, during his stay. In 1930, he was represented in the important exhibition, organised to celebrate the centenary of Uruguay's independence and won the First Prize for sculpture. The Grand Prix was awarded to him at the National Salon of Fine Arts. There are several monuments at Montevideo, commissioned from him by the government: *The Schoolmistress*, *The Workman*, an equestrian group, erected to the Chilean hero, Bernardo O'Higgins, statues and bas-reliefs. Michelena only used traditional materials, whether he was modelling or using direct carving: clay, plaster, stone, marble and the red granite of the country. The individual quality of his work can be best appreciated in a series of portrait busts of Uruguayan artists, poets, writers, painters and sculptors whom he has known. Uruguayan sculpture owes much to him. In circles that were hostile to new ideas, he was the first to fight against academic traditions and stereotyped formulas, with his bold conception and his fluent, concise forms, which have escaped from the traditional canons of representation. His sculpture opened the door to modern art in Uruguay. But he gained less than his

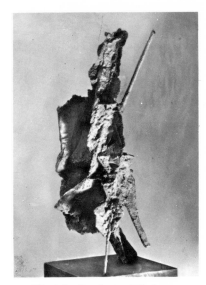

Milani. Small sculpture. 1962. Bronze.

Milles

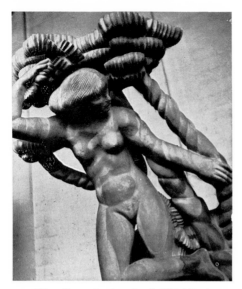

Milles. Man and nature. Detail. 1940. Wood.
Time and Life Building, Radio City, New York.

MILLES Carl (Lagga, near Uppsala, 1875 – Lidingö,
Stockholm, 1955). After three years' training at the
Tekniska Skolan of Stockholm, he decided in 1897 to
leave for Chile. He stopped on the way in Paris and
stayed for eight years. There he joined the Académie
Colarossi, earned his living with a variety of jobs and
made the acquaintance of Oscar Wilde and Rodin, whose
influence can be seen in Milles's early work. A visit to
Munich in 1904 left a lasting impression on his art.
When he returned to Sweden, his studio, which became
the Milles Museum (Millesgarden) at Lidingö in his
life-time, with its terrasses and lakes served as an ex-
perimental background for his monumental sculpture.
In 1913, a room was given over to his works at the Baltic
Exhibition in Malmö. His first exhibition at the Tate
Gallery, London, was held in 1920. In 1930, he settled
in Cranbrook, near Detroit, and obtained American
nationality in 1945. He executed several important monu-
ments, commissioned by towns in the United States. He
returned to Sweden to end his life there. Milles's early
sculpture was expressionist in character and gradually
changed to a sort of classicism with archaic tendencies,
in which the forms were boldly simplified into large,
smooth surfaces. Among his outstanding works are the
Singer of the Sun (1926), *Gustav Vasa*, which is a wood
carving twenty-three feet high (1927, Nordiska Museet,
Stockholm), the *Fountain of Orpheus* (1936) in Stock-
holm, the *Monument to Peace* (1936) in the City Hall of
St. Paul, Minnesota, *Man and Nature*, a wooden statue
for the Time and Life Building, Radio City, New York

(1940). A strong current of pantheism runs through
Milles's sculpture, which has strains of both sensuality
and austerity, anguish and serenity. Angles often take
the place of arabesques and a compact monumentality
replaces exuberance. It can be both restrained and full
of feeling and shows a sense of humour, which is
sometimes grotesque and is yet capable of creating men
and gods, legendary heroes, fabulous creatures and
symbols of implacable forces. Milles's creations with
their epic power and their divine and ambiguous animality
are like the dark myths of the Edda. P. V.

MINGUZZI Luciano. Born 1911, Bologna. He trained
at the Bologna Academy and, after 1931, the date of
his first exhibition in Florence, he took part in all the main
Italian art exhibitions. In 1950, he won the International
Sculpture Prize at the Venice Biennale and, in 1951, the
sculpture prize at the São Paulo Biennial. He is now
living in Milan, where he teaches at the Brera Academy.
He has gained an international reputation from several
exhibitions in Europe and America (Catherine Viviano
Gallery, New York). A large retrospective of his work
was held at Bassano del Grappa in 1964. There was a
certain impulsiveness in his early works which were
realistic and had a swift, economical idiom, deeply rooted
in his experience of life. His series of *Contortionists*, for
example, which he did about 1950, was a courageous
attack on the problem of the human figure and its
relations to the space surrounding it. He said himself,
'I need the absolute certainty, derived from feeling with
my hands and seeing with my eyes, that volumes, masses
and something, tangible in all its fullness, really exist.
This is a far more urgent necessity for my nature and

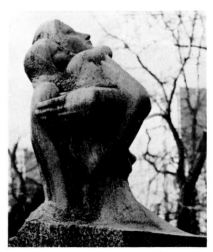

Minne. Mother and child. City Park, Antwerp.

210

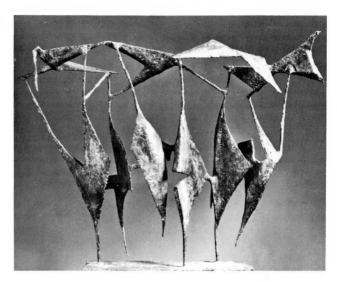

Minguzzi.
Study for six figures.
1958. Bronze.

temperament than the notion of space as an end in itself.' Although his recent works continue to illustrate this, Minguzzi treats his subjects now with even greater freedom and, in spite of certain strictly naturalistic features (*Shadow in a Wood* 1957, *Stag-beetles* 1958, *Wind in the Reeds* 1962) his productions no longer suggest anything in real life. His sculpture is more concerned, as Lionello Venturi has said, with 'realities of the imagination' made 'vital and delicate, slender and graceful as the forms of women.' In contrast to the overlapping of his rough, sharp surfaces he creates a whole tangled network, like lace in which to hold his dreams. His recent work includes fourteen bronze panels for the door of Milan Cathedral. Bronze, of all the materials Minguzzi has explored, including wood, stone and terracotta, has been his favourite medium from the full, compact structures of the fifties to his last expressive fantasies, in which there tends to be a greater interpenetration of space and form. G. C.

MINNE George (Ghent, 1866 – Laethem, Belgium, 1941). Minne's father, who was an architect, wanted his son to follow his profession, but at a very early age he was attracted to drawing and sculpture, the two arts he practised all his life independently of each other. His friends among the Symbolist poets, Verhaeren and especially Maeterlinck, with whom Minne felt a deep affinity, encouraged his artistic leanings. In 1892, he married and family life brought financial difficulties on him. It was, nevertheless, the period that produced the *Kneeling Figure* (1897), a hieratic, angular adolescent, which he later used for his *Fountain of Kneeling Figures*,

several copies of which exist, notably in marble at the Folkwang Museum at Essen. The Monument to the memory of the poet Georges Rodenbach for the city of Ghent is also in marble. In 1899, Minne joined the group of artists, who were living at Laethem-Saint-Martin, and became a leading figure among them. The subject of the *Mother and Child* appeared more and more often in his work and, during the First World when his son was at the front, he used it to express his agony of mind. Public recognition came to him at last in the twenties and a retrospective exhibition, held at the Galerie Giroux in Brussels in 1929, was a great success.

George Minne is a perfect example of the symbolist artist, if his work is considered as a whole, not because he followed a set of principles, but because he gave passionate expression to a moral message. He separated himself from the dominant tendencies of realism and impressionism and introduced into sculpture a feeling of quiet melancholy that had not appeared in it before. His influence seems to have been strongest in the Germanic countries.

MIRKO Basaldella Mirko, called. Born 1910, Udine, Italy. He attended with his brother, the painter, Afro, the Art Schools of Venice, Florence and Monza. From 1932 to 1934, he worked under Arturo Martini, in Milan. His first exhibition, held in Rome at the Galleria Cometa in 1935, drew the attention of the public to his works. These were figurative sculptures produced in circles that were deeply influenced by Martini. A visit to Paris in 1937 with his brother introduced him to the experimental work of the international art movements and, when he

Miró

Mirko. Figure. 1960. Bronze.

vivid, supple imagination has fused into them the images of barbaric and early Christian art from the common heritage of the West. Myth is one of the most important elements in his art, not because of any archaeological interests, but because it is a necessary element in the poetry of the unreal that is peculiarly his own. Although some of his works have affinities with idols and totems, they are free from any human association. As such they stand as symbolic of a modern vision of the world. G. C.

MIRÓ Joan. Born 1893, Barcelona. Soon after he arrived in Paris in 1919, he joined the Dada movement. Its strange, abandoned poetry released a strain of fantasy in him, infused with a love of the marvellous. Miró was very soon attracted by sculpture, which gives concrete form to the creations of the painter. In 1922, at Montroig, he made his first sculptures of natural elements, in an unrefined state. Ten years later, they were moulded with plaster in several of his ceramics. When Miró was influenced by the Surrealist spirit, he turned from the *Constructions* of 1930, in which ready made materials were given artistic treatment, to the Objects, which derived from the same method and which owed as much to the nature of the materials as to the fancy that used them in the service of its capricious inventiveness. He

exhibited his work again immediately after the war (sculptures at the Knoedler Gallery, New York in 1947; paintings at the Galleria Obelisco, Rome) it showed how much his art had gained from Cubism in Paris, which, in works like *Orpheus*, laid the foundation of his future development towards abstract art. This conscious, coherent evolution produced, between 1949 and 1951, a real masterpiece, the bronze portrait that he designed and cast for the 'Ardeatina Graves', in Rome, in memory of the victims of Nazi barbarism. In the power and drama of its conception, this work remains the most effective proof of the revival of Italian sculpture in the years after the war.

In other works, Mirko showed the same absorption in his subject and the same dramatic involvement when he had to solve in modern terms the problems of integrating sculpture in an architectural setting, as, for example, the war memorial at Mauthausen in Austria and the fountain with a mosaic in the Piazza Benedetto Brin in La Spezia. He was awarded the Grand Prix for sculpture at the São Paulo Biennial in 1955 and a whole room was set apart for him at the Venice Biennale in 1954. Since 1958, Mirko has been teaching at the Carpenter Center for Visual Art, Harvard University, where he is in charge of purely experimental work. A huge retrospective of his sculpture, 'Homage to Mirko', was held in 1965 at Aquileia. As well as an inexhaustible power for creating new forms, he has shown an equal mastery in the use of different techniques and the most varied materials. His

Miró. Ceramic. 1956. Galerie Maeght, Paris.

used the most varied materials: wood, cork, shells
(*Object-Sculpture* 1932), stone, pebbles, tiles, even eggs.
He also cast six bronzes, among which was *The Bird*
(1944–1946).

Pottery became his favourite medium. In 1944–1945,
his association with Artigas began and, in the course
of about twenty years, Miró produced a considerable
body of work, which culminated in the monumental
pieces that decorate the garden-labyrinth (1964–1965)
of the Fondation Maeght at St-Paul-de-Vence. He very
soon passed the stage of merely painting the work of the
potter and began creating with all the assured authority
of the born sculptor. Each piece, thrown according to
his instructions, was like the rock of his native Catalonia.
Long before his experiments with ceramics, he had tried
to paint on rock, like primitive people, and in these
ceramics it was almost as if he were endeavouring to
compete with nature and imitate the chance effects of the
elemental forces. He sometimes added bits of wood and
iron, a fragment of glass or earthenware or a bone to
the sandstone and fire-clay, like fantastic excrescences.
He encrusted them with enamels, china, ceramics, lead
glaze and metallic oxides. In these brilliant ceramics,
colour is no longer just a covering to the form: it is a
part of it; it is the form itself. The painter is never sub-
merged by the sculptor. Miró's passion for sculpture is
more in evidence in those masterpieces, the *Lunar Bird*
and the *Solar Bird* (1966). The savage, daringly primitive
forms of these huge sculptures in polished bronze possess
the secret and terrible magic of metamorphoses. P. V.

MIZUI Yasuo. Born 1925, Tokyo. He studied science
and art in Tokyo, then went to Paris to train at the École
des Beaux-Arts. He has taken part in the most important
Symposiums that have been held in recent years in

Miró. Lunar bird. 1966. Bronze.

Mizui.
Petrified fountain.
1968. Faculté de
Droit de Bordeaux.

Mlynarcik

Mlynarcik. The flirtation of Mlle Pogany. 1969. Multiples in plastic.

Yugoslavia, Austria, Israel, France (Grenoble), Japan and Czechoslovakia. He is at his ease in large-scale work and his sculpture is fundamentally monumental in character. Bronze and wood were his usual mediums at first, which he shaped into tormented, organic forms. Now his material is mainly stone, which attracts him because of its complexity. The eccentric vision of his early work has changed to complete abstraction with simple, architectural forms, which are much more restrained. D. C.

MLYNARČIK Alex. Born 1934, Zilina, Czechoslovakia. He trained from 1959 to 1965 in the art school of Bratislava, then at the Prague Academy. He has taken part in several exhibitions in his own country and abroad, especially in Italy and France. Mlynarcik's activities are directed on two planes, art and social criticism. His primary aim has been to tear down the deceptive veils from our modern world, with its fashions, infatuations, ephemeral idols and especially from the ambiguous mythology surrounding woman, as creator and saleable creature. From 1964 to 1966, he constructed all sorts of altarpieces, covered with obsessive writings, which were gilded, then patinated. On them were enthroned, by the wavering light of candles, the stereotyped images of the woman of today, modelled or moulded from fashion dummies. He went further in this direction in 1965, when he and Filko organised two group celebrations, called *happsoc*, at Bratislava. A 'happsoc' is a 'found society', a sort of live, urban ready-made, representing a sociological reality, which is strictly localised and limited to its duration. A variety of reaction to these encouraged him to offer his works on permanent exhibition to the public.

This happened in 1967, when he invited the public to cover nude, female dummies with graffiti. He then transferred the motifs of this sexualised space as photographic enlargements of strip-tease and stuck them onto panels that were articulated by a spiral labyrinth, which broke up as the visitors passed up and down. After *Mlle Pogany's Flirtation* (1968–1969), a tribute to Brancusi in the form of modelled eggs, he exhibited a *Donation to the VI Biennial of Paris* (1969), composed of characteristic materials sent from all over the world as protest-offerings of the reality of our age. R.-J. M.

MODIGLIANI Amedeo (Livorno, 1884 – Paris, 1920). His father's family came from Rome and his father was a Jewish banker. His mother, Eugénie Garsin, was born in Marseilles of Italian parents. His family faced a difficult time when his father's bank went bankrupt, and Amedeo had a rather unhappy childhood. His artistic career had a modest beginning. He travelled across Italy and studied the masterpieces of the Middle Ages and Renaissance in Rome, Naples, Florence (1902), then in Venice (1903). He left for Paris in 1906, when he experienced the exciting atmosphere of the Bateau Lavoir which soon made him realise what he really wanted to do. In 1909, he left Montmartre and moved into a studio in the Cité Falguière, where he made friends with the sculptor, Brancusi, who was his neighbour. There is a general opinion that it was under his influence that Modigliani began to sculpt. Some recent writers, however, disagree with this. Modigliani's daughter, in particular, insists, not without good reasons, that her father began to sculpt about 1906, before he met Brancusi. His wood carvings, which are now lost, belong to this period,

Moholy-Nagy

as well as the little plaster *Head of a Woman* (Private collection, Paris) in which it is impossible to trace any of the influence from Negro art that appears in his work between 1909 and 1913. It is nonetheless true that his discovery of Negro art and the sculpture of Picasso, Brancusi, Lipchitz and Metchaninoff was a turning point for him. Their example encouraged him, in fact, to continue his sculpture until his declining strength forced him to give it up and he had not the energy required for carving. During the summer of 1909, Modigliani went to Livorno, probably for the sake of his health, but also with the firm intention of going to Carrara to sculpt, in fact, the idea of direct carving in marble fascinated him. Besides, the difficulty of getting materials had always been a real misery to him; it has been said that he even went as far as taking sleepers and quarry-stones from Métro yards and building sites. In short, he was following Brancusi's precept: 'Direct carving is the real way to sculpture.' Alas! at the end of his stay, he was dissatisfied with his work and must have thrown all his sculptures into the canal. When he returned to Paris, he exhibited in 1911 in the studio of his Portuguese friend, Amadeo de Souza Cardoso, Rue du Colonel-Combes, a series of heads and gouaches of caryatids. This should perhaps be considered the private view of the group, called *Heads, a Decorative Collection*, which was exhibited in 1912 at the X Salon d'Automne. They are solid and compact sculptures that achieve a synthesis of pure Tuscan tradition and the austere principles of Cubism. They are archetypes cast in the crucible of contemporary culture and are at once the expression of a style and a personality. Far from being merely an interlude in his career as a painter, they should be considered, on the contrary, as an essential aspect of the artistic adventure that Modigliani lived with such passionate intensity.

G. C.

MOHOLY-NAGY Laszlo (Bacsbarsod, Hungary, 1895 – Chicago, 1946). His artistic career began with painting in 1917. He moved to Germany in 1920 and started painting abstract works after he had met Lissitzky. At the same time, he was engaged on a series of three-dimensional constructions in which the materials were built up on Constructivist principles. He used pieces of wood or pre-fabricated metal and combined steel, copper and aluminium, or contrasted varying transparencies and surfaces of polished nickel, as in the carefully calculated sculpture of 1923. An exhibition of his works, in 1922, at the Sturm Gallery in Berlin attracted the attention of Gropius, director of the Bauhaus at that time, who engaged him to teach there. He was put in charge of the metalwork studio as well as part of the preliminary course. He gave an account of his teaching in *Von Material zu Architektur*, which was published as one of the 'Bauhaus-Bücher' in 1929. Moholy-Nagy had meanwhile left the Bauhaus and moved to Berlin in 1928, where he widened his activities to include photography,

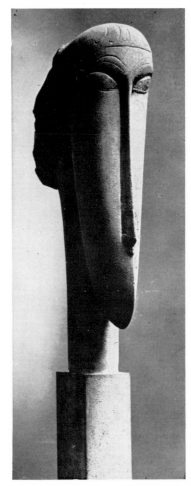

Modigliani. Head. About 1912.
Tate Gallery, London.

films, advertising and theatrical designs. After several visits to Paris, where from 1932 to 1936 he contributed to the exhibitions of the Abstraction-Création group, and a period in London from 1935 to 1937, he emigrated to the United States. He settled in Chicago and in 1937 founded the New Bauhaus there, which was followed two years later by the Institute of Design, which he directed till his death.

Ever since, his manifesto, *The System of Dynamo-Constructive Forces* (1922) in which he had enthusiastically defended a dynamic art of universal scope, which would supersede the static art of museums, Moholy-

Moholy-Nagy. Construction in opaque and transparent glass, wood and nickel. 1923.

Moholy-Nagy. Double ribbon. 1946. Plexiglas. Bayerische Staatsgemäldesammlungen, Munich.

Nagy had always been interested in the problem of movement in the work of art. He used light to create virtual, mobile volumes when, about 1930, he constructed a complex apparatus *(Lichtrequisit)* with transparent structures and 140 electric light bulbs, which projected images, shapes and changing colours onto the surrounding walls. It anticipated the *Space Modulators*, which he made in London after 1935. His last works were a sort of three-dimensional object-painting with completely abstract elements devoid of any representational association whatever; for example, one of these, made in 1936 and now in the Museum of Modern Art, New York, consists of a perforated and painted zinc plate, studded with interchangeable pins with coloured glass heads. In 1940, Moholy-Nagy began making sculptures of plexiglas with exceptionally flexible planes that circled round each other in concave-convex movements, while the interplay of forms was amplified by the light from lamps of varying intensity. The final effect seems produced from an immaterial work in which imagination dominated the strict Constructivism of his early years. H. W.

MOHR Dietrich. Born 1924, Düsseldorf. He trained at the Karlsruhe Art School, then went to Paris in 1951 and worked for some time at the Académie de la Grande-Chaumière. He has held three one-man shows in Paris and Nice. Since 1959, his usual medium has been sheets of brass, which he cuts out, shapes and solders. Mohr began with a very free interpretation of natural forms, but these have changed to entirely abstract, independent shapes, whose inner surfaces are hollowed into multiple compartments, rather like cells. Although, in his recent works, he has maintained this form of structure, manipulation of their spaces has eliminated the distinction between interior and exterior and, through a circular movement, has introduced a space that is mobile and profoundly varied. D. C.

MONASTERIO Luiz Ortiz. Born 1906, Mexico City. He trained at the San Carlos Academy, Mexico City, then left his country for California, where he lived for two periods (1925–1926 and 1928–1929). He finally settled in Mexico City, where he was offered a professorship in 1931 and the state commissioned some important sculptures from him (*Call to the Revolution* 1932, *The Slave* 1933). After 1940, he was represented in international exhibitions. His output is considerable. He has done statues and reliefs, in bronze and stone, at Chapultepec, Puebla and Jalapa, besides the decorations for several public buildings in Mexico City. This gifted, cultivated artist is also a consummate technician when working stone and clay and casting metals. Critics have recognised the clear vision that guided him to a personal style through the exuberant profusion of forms, invented in the course of the centuries by the popular genius of his country. In fact, he took his subjects from Mayan

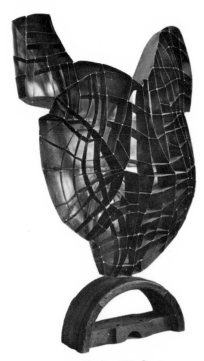

Mohr. Trophy. 1968. Brass.

of Art, London. He was commissioned as a war artist in 1940 and executed his well-known series of air-raid shelter drawings.

Since 1945, his most important exhibitions have been retrospectives at the Museum of Modern Art, New York (1946); Venice Biennale (1948), where he was awarded the International Sculpture prize; the Biennials of São Paulo (1953) and Tokyo (1959); and at the Tate Gallery, London (1968). He has been represented in all the major international sculpture exhibitions including those in London, Hamburg, Middelheim, Sonsbeek and Varese. His public commissions include the *Madonna and Child*, Northampton (1943); *Three Standing Figures*, London

mythology. He has sculpted his own conception of the Indian pantheon in stone and has tried to discover and re-interpret the archetypal forms of the native cultures and the ancient civilisations of Egypt and Greece. In other sculpture, Monasterio has stylised the human form and, in taking certain liberties with it, has been led to pure abstraction. After this, he became interested in the problem of the integration of the arts and completed a number of works in an attempt to do this, like the metal relief for the National Auditorium in Mexico City. M.-R. G.

MOORE Henry. Born 1898, Castleford, Yorkshire. He trained first as a teacher. He joined the army in 1917, was gassed at Cambrai and invalided back to England. After his demobilisation in 1919, he attended the Leeds School of Art for two years and then the Royal College of Art, London, until 1925. He travelled in France and Italy. He held his first one-man exhibition in London 1928 and received his first commission, for a relief on the headquarters of the London Underground Railway, in the same year. From 1926 to 1939, he taught first at the Royal College of Art and then at the Chelsea School

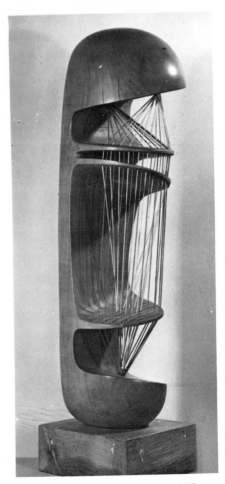

Moore. Figure in wood and string. 1937.

Moore

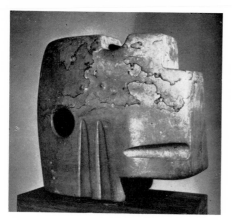

(1947); a *Family Group*, Stevenage New Town (1948); a non-figurative screen and a *Draped Reclining Figure* for the Time-Life building, London, 1952; the *King and Queen*, Middelheim (1953); a large relief in brick, for the Bouwcentrum, Rotterdam (1955); the *Reclining Figure* (1958) for the U.N.E.S.C.O. Headquarters in Paris; and a *Reclining Figure* (1962) for the Lincoln Art Center, New York. Moore's emergence in a nation almost without a sculptural tradition, may be taken as yet another instance of the British capacity to produce isolated figures of genius rather than movements and schools. At the same time, it may serve to emphasise the strength and consistency of his development within modern sculpture as a whole. The son of a miner, he spent his early days in the aftermath of the industrial revolution. That the dirt and confusion of this mining area, set within the wild grandeur of the Yorkshire moors, has some potent affinity with sculptural thought seems evident. Barbara Hepworth and Kenneth Armitage are among the several sculptors coming from the district.

During Moore's formative years, the chief sculptural doctrine in Britain, outside academic circles, was that of direct carving and 'truth to material' as exemplified by Gill, Epstein and Dobson. This undoubtedly coloured the executive side of Moore's development. The vision which directed it into its particular formal channels was shaped by work of the ancient past and primitive peoples. Pre-Columbian art, in particular, has affected Moore powerfully, as unsurpassed in its richness of form-invention. He has also been influenced in some measure by Masaccio and Michelangelo; by Brancusi—to whom he has paid particular tribute—Archipenko and Picasso; by Surrealism on the one hand and by limited aspects of Constructivism on the other. It is not easy to divide Moore's career neatly into periods, owing to his habit of returning at intervals to work out conceptions first stated many years earlier. At any given moment, furthermore, he is likely to be working simultaneously in figurative and non-figurative idioms. The main themes which preoccupy him had all appeared by the early thirties. From about 1931 to 1939 his essentially humanistic interests were diverted increasingly, but never wholly, into abstract forms, considered, for the greater part, organically rather than constructively. These works culminated in the wood and metal stringed and wired figures of 1938–1939, in which the voids are articulated by interpenetrating planes of threaded string or wire.

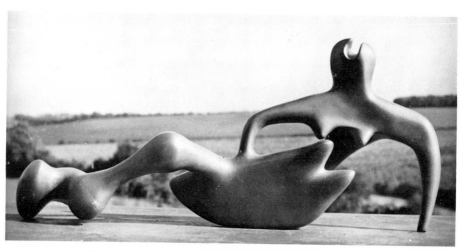

Moore. Reclining figure. 1938. Lead. Museum of Modern Art, New York.

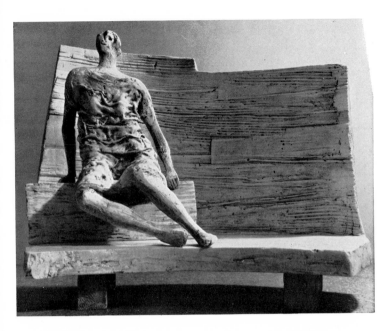

Moore. Draped seated
figure against curved
wall. 1956-1957. Plaster.

Throughout this period Moore's work gives a sense of being pushed and strained into its final form by its own internal forces. Throughout this period, too, with ever greater assurance, Moore developed his ability to penetrate and open up the sculptural mass, to bring solid and void into equal and organic balance. 'The first hole made through a piece of stone,' he has written, 'is a revelation.'

At regular intervals from 1930 onwards, however, Moore has returned also to that theme which he has

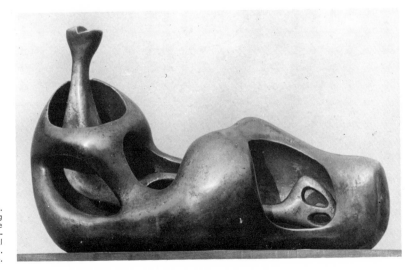

Moore.
Reclining
figure
(internal-
external
form).
1951. Bronze.

219

Mooy

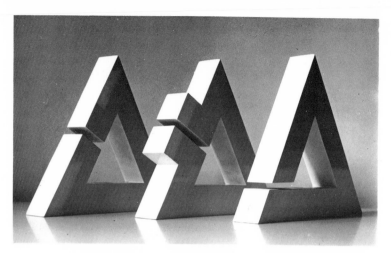

Mooy. Variations
on a triangle.
1968-1969.
Painted wood.

made particularly his own: the reclining figure. The many variations of this theme, from near realism to skeletal abstraction, in wood, stone and metal, have been developed with unflagging virtuosity. Many of these figures reveal with particular clarity their affinity with landscape forms. As human images they suggest severity, pathos, tragedy, the timeless aspirations of mankind; at the same time they are deeply imbued with reminiscences of and analogies with natural forms: hills and valleys, boulders and caves. 'The human figure,' Moore has written, 'is what interests me most deeply, but I have found principles of form and rhythm from the study of natural objects, such as pebbles, rocks, bones, trees, plants.' Arising naturally from the same source is Moore's view of the proper setting for his sculpture. 'I would rather have a piece of my sculpture put in a landscape, almost any landscape, than in, or on, the most beautiful building I know.'

Other themes to which Moore has returned with notable success have been those of the mother and child and the family group; the stricken warrior; the figure in relation to a setting—to a wall, a bench or a rocking chair; and the sculpture within a sculpture—the metal *Helmets* of 1951 and a very large carving in wood of 1955. He has never ceased, moreover, to interpose non-figurative works among his other pieces and, unless designed for some specific architectural setting, these have commonly tended towards the upward forms of the totem. M. M.

MOOY Jaap. Born 1915, Bergen, Holland. After he had sailed several times round the world as a deck hand, he entered the naval college, but discovered he had a vocation to be a painter before he had passed his examination for officer-engineer. His sculpture grew out

of the reliefs in wood and paper he was making in 1956. His first sculptures were in iron and their skilfully elaborated shapes suggested vague, spectral forms. Then his methods became more economical and more like the techniques of assemblage in the proud, vigorous, plant forms, which he created from the wreckage of car bodies. In 1965, he began painting, then constructing steel or wood compositions that were reduced to the greatest simplicity possible and were based on a few, essentially geometric forms. The sculptures had no

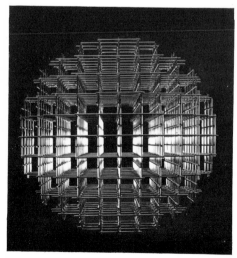

Morellet. Web-sphere. 1962. Chrome steel.

subjects and were entirely concerned with the almost limitless variations that could be derived from grouping these forms in twos and threes. D. W.

MORELLET François. Born 1926, Cholet, Maine-et-Loire. He was one of the founders of the Groupe de Recherche d'Art Visuel in Paris and joined in all its activities until it was disbanded in 1968. He is also one of the organisers of the international movement Nouvelle Tendance. He has had several one-man shows in Paris at the Galeries Creuze (1948 and 1950), Colette Allendy (1955) and Denise René (1967); and in Cologne at the Der Spiegel Gallery (1960). From the beginning of his experiments, Morellet has laid especial emphasis on the systematic elaboration of the rules governing his sculptural conceptions and on the elimination of all subjective elements. His webs were first constructed along a plane, then in space and, from 1955, they have consisted of a network of lines traced systematically according to an aleatory process. His *Web-spheres* follow these principles and are like mobiles made of aluminium tubes, sometimes nearly 4ft in diameter. They have also been mass-produced but in a smaller size. Since 1961, Morellet has been investigating the rhythmic possibilities of light. Electric light bulbs and neon tubes, superimposed and working in a predetermined order, are visually most effective in shocking the observer out of his habitual apathy. While his electric systems are strictly programmed, Morellet can increase and vary the rhythms of the lighting. He has created what can be described as luminous environments for the ambitious team projects of the Groupe de Recherche d'Art Visuel, notably for the exhibition 'Lumière et Mouvement' at the Musée d'Art Moderne de la Ville de Paris (1967). In some of his works, the observer can manipulate permutations of words, forms and rhythms, and arrange sequences of visual stimuli himself (Biennale de Paris, 1963; Kassel Documenta, 1968). Morellet's approach, based on the use of cellular micro-elements and raw, visual phenomena, may seem ascetic. It does, however, make a direct impact on the sensibility and conscience of the observer and modify his behaviour in consequence. F. P.

MORRIS Robert. Born 1931, Kansas City, Missouri. He trained at the Kansas City Art Institute, the California School of Fine Arts, and Hunter College, New York. Since his first one-man show at the Dilexi Gallery, San Francisco, in 1957, he has had others in New York at the Green Gallery (1963, 1964, 1965) and Leo Castelli Gallery (1967, 1968, 1969) and in Paris at the Galerie Ileana Sonnabend (1968). Morris has worked chiefly with simple, three-dimensional metal forms (beams, boxes, wire mesh). They differ as little as possible from each other and are of such a size that they are neither 'sculptures' nor 'monuments', since his purpose is to exclude all allusion for the sake for the sake of the

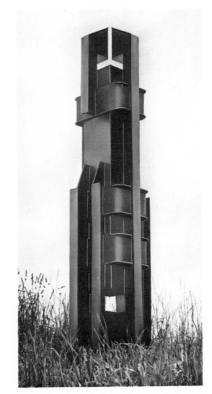

Moswitzer. Sculpture in iron. 1966.

'autonomous, literal nature of sculpture'. His intention is to create 'objects', which are not 'art' since they are a continuous part of the observer's everyday, physical space. Each work thus consists of a 'unitary form' which stresses shape, in an entirely literal, anti-illusionist manner. In contrast to past sculpture, emphasis is on the wholeness of form instead of its interior relations and on its true dimensions. More recently Morris, having become concerned with projecting his own 'process' of creation rather than its result, has made sculptures of felt strips whose formal distribution is deliberately inspirational, momentary and impermanent. R. G.

MOSWITZER Gerhard. Born 1940, Lankowitz, Austria. From 1955 to 1959, he trained as a painter only, then he attended the School of Applied Art at Graz to learn sculpture (1959–1961). He worked in wood and stone, and also made assemblages of wood and iron, but now he only uses iron. The little figures of his early phase, which looked like a craftsman's tools or semi-

Mousseau

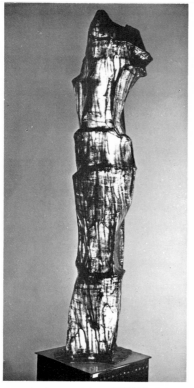

Mousseau. Luminous sculptures. 1960-1961. Polystyrene.

tures out of coloured polystyrene in forms like tree trunks. They were lighted from the inside by neon tubes of various colours, which could be regulated by the observer; in fact, the lighting was so arranged that he could modify endlessly the colour relationships and the sculptural values. G. V.

MÜLLER Robert. Born 1920, Zürich. He trained at Zürich in 1940 under Germaine Richier for modelling and Charles Baenninger for stone work. After 1944, he continued his work on his own, first at Morges on the Lake of Geneva, then at Genoa and Rome (1947–1950). In 1950, he went to live in Paris. Since 1953, he has been represented at the Salon de Mai and has exhibited his work regularly at the Galerie de France since 1955. The originality of his forms, the exactness of his craftmanship and especially the intense vitality of his sculpture have gained an international reputation for Robert Müller. The forms he most often uses to express his ideas are organic and elemental. Their dynamic life seems to be

industrial machines, have now been followed by monumental sculptures, bearing poetic titles, which spread their architectonic forms in several tiers. His major works, include an iron column (1964) for the Austrian Institute of Culture in Warsaw. J. L.

MOUSSEAU Jean-Paul. Born 1927, Montreal. He attended the painting classes at the College of Notre-Dame under the supervision of Brother Jérôme and, from 1944 to 1950, worked in the studio of the painter Borduas. He was one of the signatories of the manifesto that Borduas drew up, called *Global Refusal*. Since then, he has contributed to all the exhibitions of the Automatist movement. Mousseau is a painter, sculptor, theatre designer, interior decorator, graphic artist, illustrator, jeweller, teacher, and is always widening the field of his artistic activities. His ambition is to create not so much works of art, in the traditional sense of the word, as places where man can be really himself, sacred places, in a way'. In the early sixties, he made luminous sculp-

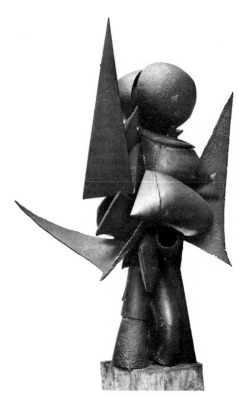

Müller. Spur. 1958. Assembled iron.

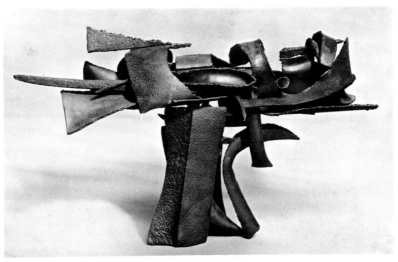

Müller. Gemini. 1958-1959. Assembled iron.

fed by some strange. hidden malignity rather than a harmless growth, and their world seems to be lighted by the moon rather than warmed by the sun.

Although Müller's art avoids all literary association and any morbid feelings, it possesses great poetic power. Like many of his contemporaries, the artist is not solely concerned with the purely aesthetic aspect of an interesting equilibrium, or a finicky shape: he is always preoccupied with the content and tries to intensify the enigmatic quality that emanates from the grotesque character of his forms and their daring, fantastic combinations. Robert Müller's first aim is to find what is puzzling, often baffling, to the onlooker, the kind of abstruse composition that cannot be grasped at a glance and that he can, nevertheless, articulate into a rhythmic movement with just a few simple devices. Generally he does not make a base, but creates shapes that serve the same purpose while forming a part of the work as a whole. In his opinion, a sculpture should rise directly from the ground to the eye-level of the observer. Müller has sometimes been classed with the Surrealists, but this is a mistake, because his first concern is to work out a basic idiom. The found object is not, for him, a shape wrapped in dreams that appears on a rubbish dump, but a form that appeals to him simply for its own sake. This is why he is always careful to remove from his material both its ready-made character and any traces of its origin in the scrap-heap of a large town. His determination to transform what he has picked up distinguishes him from many of his contemporaries, who do just the opposite. All this refuse, fragments of scythes, reaping-hooks, pipes and wire are transmuted by his sturdy peasant's temperament

and his sensitiveness as a craftsman. These various fragments acquire a new life and release fresh energies after they have been welded, forged, polished, cut up and scored. There is something dynamic in these works, in which distended volumes are contrasted with the hollow forms or dull, patinated surfaces with those that are brilliantly polished.

Sculptures like *Crayfish* (1955) or *Knot* (1956), with their pointed shapes, stretching in different directions, are technically interesting, but they are also emphatically aggressive. Later on, the artist preferred to gather together very rounded hollow volumes that encircled space more gently or that leaned more firmly against it. For some years, he has also been concerned with the horizontal development of tangled movements, as in works like *Larva* or *Saba* (1958) which, with their quiet composition and the play of light on their metallic carapaces, sometimes resemble medieval armour and sometimes elementary forms of life from the depth of the ocean. Other sculptures, on the contrary, standing like stelae, are built up of fabulous elements, derived from either animals or plants *(Stele for a Termite, Ex-voto 1957, Arrum, Rübezahl)*. There is a hieratic, ritualistic tone about all Robert Müller's works which their titles already suggest, although sometimes these can be full of humorous allusions. The artist said himself that his sculpture should be in a room rather than out in the open air, but, in 1954, he was able to execute a fountain for the Kügeliloo school in Zürich (1954) and harmonise it successfully with the architectural setting. He did another fountain for the Centre Vittel (1956) in Paris. He was awarded the sculpture prize at the São Paulo Biennial

Munari

in 1957 and the Jean Arp prize at the Bienne Quadriennale in 1966. Notable among his exhibitions have been those held at the Stedelijk Museum, Amsterdam (1964), the Kunsthalle, Berne (1965), and the Palais des Beaux-Arts, Brussels (1965). C. G.-W.

MUNARI Bruno. Born 1907, Milan. Munari can be justly considered a pioneer in a number of spheres, notably in kinetic and programmed art. In 1933, he constructed his *Useless Machines*, made of silk threads, which could be set in motion by the slightest breath. In 1938, he published his *Manifesto of Mechanisation* and made a 'machine for producing works of art'. In 1953, he realised his first projections of direct light and, a year later, his projections with polarised light. His

Continuous Structures appeared in 1960, a series of works that required the participation of the observer, who could dismantle or assemble them according to a predetermined code. Munari was probably the first artist to mass-produce a kinetic object, now known as 'multiples'. His experiments with movement and light eventually led to a programmed art, demanding a strictly controlled investigation, which was undertaken before the materials, forms and mathematical combinations of the movement had been determined. He also worked on a personal interpretation of Form (Gestalt) and especially a concept of 'pure and beautiful form'. Some of Bruno Munari's works consist of small screens on which he projects images of forms and changing colours *(Tetracono)*, accompanied by sound effects, which are also programmed. F. P.

Munari. Concave-convex. 1948. Wire.

n

NADELMAN Élie (Warsaw, 1882 – New York, 1946). He finished his various studies in art and other subjects before going to Paris at the beginning of the century. He also steeped himself in 5th-century Greek sculpture during a six months' stay in Munich and made a close study of the collection of wood and china dolls at the National Museum of Bavaria. Both were important to his later development. In Paris, he sketched for a short time from the model at the Atelier Colarossi. Then after 1905, he worked exclusively in his own studio, where he sought, as he said, to capture the essence of sculpture. In an attempt to achieve this, he did a series of drawings in which the human figure was reduced to almost abstract curves. Eventually he published these researches in his portfolio, called *Towards a Sculptural Unity* (1914). This work attracted both Leo and Gertrude Stein, which led to an exhibition at the Galerie Druet (1909). It has even been said that certain of these analyses anticipated Cubism. Nadelman left Europe for the United States in 1914. There, after a successful exhibition of his women and animal sculptures at the experimental gallery of Alfred Stieglitz, he gradually turned to the production of humorous mannikins, which were influenced, perhaps, by what he had seen at Munich. Living for years in virtual retirement before his death in 1946, he had assembled an notable collection of American folk art, long before most scholars had begun to notice it. A mannerist who polished material as if with the ideal of an enamelist, this complex man does deserve at least to be mentioned among the experimental sculptors of his period. J. M.

NAKIAN Reuben. Born 1897, College Point, New York. In 1916, he was apprenticed to Paul Manship in New York and was taught sculpture techniques by Manship and his assistant, Gaston Lachaise. After exhibitions at the Studios of America (1922) and the Whitney Studio Club (1923), he began his association with the Downtown Gallery in 1927. Since 1945, Nakian has been exhibiting with the Egan Gallery. He was represented at the Biennials of São Paulo (1961) and Venice (1961). There was a retrospective exhibition at the Museum of Modern Art in 1966. He has executed sculp-

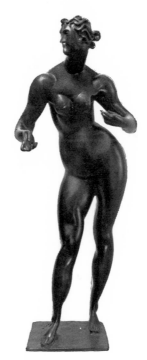

Nadelman. Standing woman. About 1909. Bronze. Museum of Modern Art, New York.

ture for the façade of the Student Center, New York University (1960), and the New York State Theater at the Lincoln Center (1965). After a series of highly expressive, realistic portraits in the early thirties, he did little sculpture for over a decade, but many drawings. In the late forties, these were continued in a series of free-flowing terracottas, some incised, some modelled, with the same graphic mastery. At this time, Nakian underwent a con-

Nando

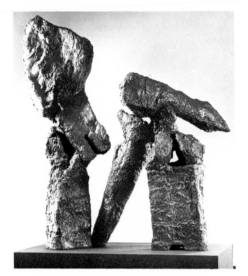

Nakian. The judgment of Paris. Detail.
1963-1964. Bronze.

version comparable to that of the painters of this period, and in his work of the fifties and sixties emerged as an abstract-expressionist sculptor. From the start he had been fascinated by allegorical nudes of the great tradition. These appeared in his terracottas. Now these subjects were embodied in large, openly composed, roughly surfaced figures and groups, whose stylised forms, nevertheless, recalled the humanity of their classical titles. With the exception of several works of 1955–1960, done in black sheet steel and rods, these sculptures are composed in plaster to be cast in bronze. Although he has frankly based his sculpture on works of the past, which he admires, Nakian consciously strives for and attains, through scale, theme and force of modelling, an heroic, humanist art of the present. R. G.

NANDO Pierluca Fernandino, called. Born 1912, Venice. He is a self-taught painter and sculptor, now living in Paris. His early work consisted of purely abstract, mobile mural reliefs, made of ropes and pieces of wood. They reflected his fundamentally architectural approach. For some years now, he has abandoned abstraction and has been exploring the possibilities of a figurative means of plastic expression, evolved from premises that were generally erotic. He used the same approach for his black and white drawings on canvas, accompanied by hand-written commentaries like a private diary. Painted terracotta and sometimes bronze were the media of his sculpture. It is often aggressive and provocative (court proceedings were brought against Nando in Italy be-

cause of them) and expresses a strictly personal and incisive view of reality. D. C.

NARVAEZ Francisco. Born 1908, Porlamar, Venezuela. When he was fourteen he joined the School of Plastic and Applied Arts at Caracas where he studied painting and sculpture. His first exhibition was held in Caracas in 1928. Then he went to Paris, where he stayed for three years, working at the Académie Julian. He held a second exhibition in 1932 when he returned to Venezuela. In 1936 he was appointed to teach sculpture at the School of Plastic Arts, where he had trained before. He taught there for twenty-one years, the last three years as director of the students' studies, which gave him an opportunity to reorganise the teaching and call on the services of young artists. He has executed several public commissions in Caracas: a fountain for the Carabobo park (1938), sculptures for the stadium of the University City (1950), a bronze for the university library (1954–1955) and a mural decoration in wood for the Botanical Gardens. He has often been chosen to represent his country and has exhibited his work in New York, Brussels, the São Paulo Biennial (1955) and the Venice Biennale (1956). Although his talents were obvious at a very early age, his introduction to the work of Rodin and Maillol was the turning-point in his career. After his return to his own country, he was influenced by the ancient American civilisations and the native mythologies, which supplied him with his main subjects. However, the new movements in art soon made an impression on

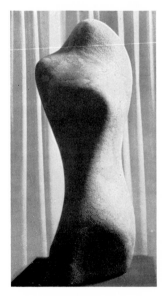

Narvaez.
Sculpture.
Direct carving.

Negret. Symbol for
an aquarium. 1954.
Polychrome iron.
Museum of Modern Art,
New York.

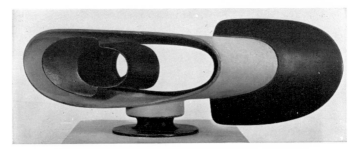

Negret. Symbol for an aquarium. 1954. Polychrome iron. Museum of Modern Art, New York.

him and led to the creation of forms of an increasing simplicity and bareness, which, in time revealed that the attraction he felt for non-figurative art was very real. Narvaez loves beautiful materials and most of his sculptures are carved either in woods, selected from the finest in the luxuriant tropical forests, or from the local stones abraded and eroded long ages by the sea, from which he can draw surprising effects. More important than Narvaez's skilful craftsmanship is his creation of lyrical forms that are satisfying and balanced. M.-R. G.

NEGRET Edgar. Born 1920, Popayan, Columbia. He trained at the Art School in Cali and exhibited his first works there. Just after he went to New York in 1950, he exhibited a selection of his works there. The following year, he exhibited his works in Paris at the Galerie Arnaud and the Salon des Réalités Nouvelles. In 1953 he exhibited them at the Museum of Modern Art in Madrid, when he took the opportunity to come to Europe and visit Spain. He spent two years in Majorca before returning to the United States, where he was appointed to teach at the New School of New York in 1959. Columbia certainly has interesting painters, but her sculptors are mediocre; Edgar Negret is an exception. When he was twenty-four he broke with the sacrosanct rules of representational art for a more subjective approach instead, but his innovations met with general condemnation. Yet there was nothing hermetic about his style. At that period there were touching reminiscences of the popular epics of his country in his work *(Young Girl at the Window)*. Suddenly, like so many other contemporary artists Negret revived the links that still held him to naturalism and began working in iron to express the religious themes that obsessed him. After 1954 his way was clear before him. He built geometric compositions of nuts, screws levers and wheels and brightly coloured constructions with austere lines. In his strange networks with metal rods and spiral blades there was an unusual blending of modern mechanism and the magic of a past age, of the present and the past. He succeeded in welding them into a coherent style as, for instance in the two groups of sculptures in coloured iron, *Masks* and *Magic Instruments*, which are like ritualistic objects that

have been recreated or, to put it another way, modern works of art, intoning the spells of ancient sorcerers.
 M.-R. G.

NEIZVESTNI Ernst. Born 1926, Ural Mts., U.S.S.R. He studied philosophy, then the fine arts at the Surikov Institute in Moscow. Although he has very seldom exhibited in his own country, his sculpture and drawings have been shown in France, Italy and England. He is a member of the Union of Artists in Moscow, but he very soon diverged from the official line, and his sculpture, like his other creative activities, follows a highly subjective interpretation of reality. His difficult, intense and contradictory work, monumental by nature and fraught with a sense of tragedy, is the expression of a powerful personality. His taut, eviscerated forms reappear in several cycles of drawings, like Dante's *Divine Comedy* (1966). The subject is illustrated in a firm, incisive style that penetrates to the heart of the matter. Neizvestni is obviously made for work with breadth and scale, like the vast relief he did for the Moscow crematorium, or the *Cosmonaut*, hurled up from the earth in a tremendous upthrust. A project for this monument has often been announced in Moscow, but so far it has come to nothing.
 R.-J. M.

NEPRAŠ Karel. Born 1932, Prague. When he had finished his training at the Prague Academy, he joined the UB group and was one of the founders of the Smidrové movement (1965), whose aesthetic is based on the artistic exploitation of strangeness. Besides exhibitions in Czechoslovakia, Nepraš has been represented in several international shows abroad, notably the Paris Biennial in 1965. His first sculptures were enigmatic (1959) and monstrous (1962) forms, tinged with irony, and made of pottery and plaster. Later on, he turned to abstraction. His concave relief structures in galvanised copper and nickel were assembled into stelae, called *Castles* (1963–1964), which were innervated by a network of internal tensions. This graphic armature was affected by his drawing and engraving and became more and more salient, then proliferated over the surface, while

Nevelson

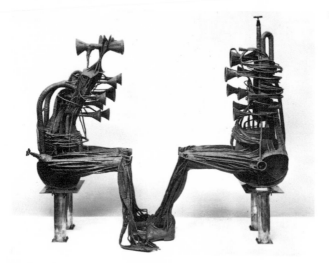

Nepras. The great dialogue.
1966. Iron, textile and laquer.

the body of the sculpture dilated and burst into human appearance. This terrifying, strange amalgam of wire, tissu and real objects, all coated with red lacquer, is the image of our obsessive fears and operates the horrible quickening of an organic system, whose menacing articulation of arteries and muscles have become congealed. From the *Face* of 1964 to the *Great Dialogue* of 1966, these flayed, aggressive creatures challenge and pursue us with their vehement, fantastic gestures.

R.-J. M.

NEVELSON Louise. Born Kiev, Russia, 1900. She went to the United States in 1905 with her family and lived in Rockland, Maine. She studied with Kenneth Hayes Miller at the Art Students' League, New York (1929–1930), then with Hans Hofmann in Munich (1931). Her first exhibition was held in 1940 at the Nierendorf Gallery, New York, and she has exhibited regularly since then. Her work is represented in several American museums and European collections.

Louise Nevelson is a sculptor in wood. For many years she worked with unfinished abstract shapes, rough-hewn blocks of cubic, curved or prismatic forms, associated in apparent haphazard fashion, sometimes fixed, sometimes movable. They were isolated, horizontal, meant to be seen below eye-level, semi-abstract, semi-Surrealist furniture-presences, demanding and suggesting space and aesthetic distance. Her recent work is almost the opposite of this in every respect. Vertical, crowded in itself and crowding in upon the spectator, it is composed of discarded architectural trimmings brought together according to a repetitive and cumulative method within framing boxes that, vertically and horizontally, can be

stacked without end. Though each section is composed in the Cubist tradition, their totality, brought together to make an impassable wall of a monotonous, even tone (black or white), produces the effect of a coalescence of Baroque funerary monuments from whose compulsive, claustrophobic environment there is no escape.

In the late fifties and early sixties, Nevelson also made free-standing pillar shapes, assembled in the same manner as the walls from separate parts, frequently painted gold or silver. More recent work has also been in metal and clear plastic, which is geometrical in character, or, when in wood, constructed of freshly manufactured elements. A certain decorative calculation seems to have replaced the compulsive intensity of the earlier, more intuitive assemblages.

R. G.

NIVOLA Costantino. Born 1911, Orani, Sardinia. He came from a family of masons, and did the same work himself until he was sixteen and went to the Art School at Monza. Since 1938 he has been living in the United States, in an old farm on the shore of Amagansett, Long Island. The rusticity of his forefathers and reminiscences of shapes and objects from Sardinian folklore cling to his sculptures, which are cast in cement from negative sand moulds. He has a most lively imagination that can turn from geometric and graphic experiments that are purely abstract to sculpture with a primitive flavour about it. 'My sculptures,' he once wrote, 'are made of ordinary materials: bricks, cement blocks, lime, stucco; and natural elements: sun, water and sand. It is the mason's technique. My strongest influences have been Sardinian... From Le Corbusier, I learnt that each part of a sculptural composition had a function and the relation that this

should have with architecture.' In fact, his works aim at an ideal fusion of painting, sculpture and architecture, whether they are sculptural blocks or memorials, like that to the Orani masons, which was inspired by the *nuraghi*, prehistoric monuments of Sardinia, or the memorial in Washington to the army chaplains, killed in action. He has collaborated with various architects, Bernard Rudolfsky among others, in the construction of open dwellings, which have grass or sand for their floor and the sky for their ceiling. Nivola not only used sculptural and architectural elements, properly so called, but also painted palisades that were like great abstract panels. Notable among a number of commissions are the decoration of the Olivetti Shop in New York (1956) and the mural panels that liven the façade of the Insurance Company at Hartford (1957). G. C.

NOGUCHI Isamu. Born 1904, Los Angeles. He is the son of Yone Noguchi, poet and English teacher at the University of Keio, and the novelist, Leonie Gilmore, an American of Scottish origins. From the age of two until he was fourteen, he lived in Japan. He was apprenticed to a cabinet-maker, when he returned to the United

Nivola. Commemorative monument to the Orani Masons. Maquette. 1954. Sand and cement.

Nevelson. Now. 1963. Wood. Hanover Gallery, London.

States in 1918. He made his first attempts at sculpture under Gutzon Borglum, who had engaged him as his son's tutor. He then began studying medicine at Columbia University, New York, in 1923. In 1924 he attended in turn the Leonardo da Vinci Art School and the East Side Art School. A Guggenheim scholarship enabled him to stay in Paris during 1927–1928. He was Brancusi's assistant for two years, when he made friends with Calder and Giacometti. He returned to New York in 1929 and went first to Pekin to study drawing, then to Japan, where he worked from 1929 to 1931 with a Kyoto potter. He was in London in 1933 and Mexico in 1936, where he made a relief in polychrome cement for the Rodriguez market in the capital. In 1938, he won a competition for a bas-relief for the Associated Press building, at the Rockefeller Center, and was commissioned the following year to design a fountain for the Ford pavilion, at the International Exhibition in New York. In 1941, he voluntarily entered an internment camp for Japanese civilians at Poston, Arizona. Since 1952 he has spent his time between Japan and the United States. Noguchi has held several one-man exhibitions: Eugene Schoen Gallery, New York (1929); Marie Sterner Gallery, New York, Arts Club, Chicago, Albright Gallery, Buffalo (1930); Demotte Galleries, New York (1932); Mellon Galleries, Philadelphia (1933); Sidney Burney Gallery, London (1934); Egan Gallery, New York (1949); Stable

Noguchi

Noguchi. Little fool. 1958. Marble. Roy S. Friedmann collection, U.S.A.

took place in Paris at the age of twenty-three, where he was influenced by Brancusi, Calder and Giacometti. These men left lasting impressions on his sculpture, as did the Surrealist-tinged work of Picasso and Miró of those days. In that atmosphere, Noguchi learnt his love of smoothly polished, slab-thin stone surfaces, his elongated shapes, sometimes bone-like, sometimes crescent or linear, his dual forms, his spatial platforms, hollowed and depressed, his cage housing for suspended symbols. In this language, to which he gave his own high finish, he worked with dedication for the long years of the thirties and the forties when it was most unpopular, and created work of undoubted elegance. He disdained fashion, and exhibited rarely, earning his living by interior design, and throughout this period was a figure of dedication to modernism. Following his important exhibition at the Egan Gallery in 1949 he again began to exhibit widely. His post-war visits to Japan aroused his enthusiasm for its early sculpture, Haniwa. He began to work in clay and created simplified human figures which were modern forms derived from a long native tradition. More recently he has returned to the use of marble, in forms whose calligraphic curves and contrasts of highly polished and naturally rough surfaces continue an oriental tradition.

Besides architectural sculpture, Noguchi has had several commissions for gardens, notably for the UNESCO. Building, Paris, 1956; the Beinicke Rare Book Library, Yale University (1964); Chase Manhattan Bank Plaza, New York, 1965; the Israeli Museum, Jerusalem, 1965. He approaches his gardens in a similar spirit;

Gallery, New York (1954, 1955 and 1959); Arts Club, Chicago (1955). In the sixties, he showed several times at the Ekstrom Gallery, New York. He was represented in the group exhibition '14 Americans', at the Museum of Modern Art, New York (1946); in 1968, he was given a large retrospective show at the Whitney Museum of American Art.

Noguchi is one of the most versatile of contemporary craftsmen. An intense student of modern and ancient styles, both East and West, a designer of lamps, furniture and gardens as well as a sculptor, Noguchi has nevertheless been dedicated to contemporary modes of expression. He began as a gifted worker in the traditional styles, and this flair, nurtured in the schools of the United States, he continued to cultivate in sensitive portraiture long after his conversion to the modern movement. This

Noguchi. Bird E - Square bird. 1958. Marble.

230

Nuñez del Prado

Noll. Cross. Sculpture in wood.

they become landscape sculpture, which combines the eastern past and the western present in a highly self-conscious formal vision. R. G.

NOLL Alexandre. Born 1890, Reims. He began carving wood in 1920. The applied arts were his main interest and he sent work regularly to the Salons of the Artistes-Décorateurs and became a member in 1939. His forms were inspired by Chinese and Negro art. Noll always works in wood and knows all the peculiarities of the various kinds: walnut, sycamore, ebony, pear, teak, mahogany. He carved out of undressed timber the shapes of bowls, jugs, lamp stands, etc., in solid, heavy volumes without any embellishments. Soon, he was not content with individual articles and made whole suites of furniture. The remarkable thing about most of his furniture was that it was not pegged together or glued, but carved out of the solid block, so that it was really sculpture. In 1943 he exhibited a collection of his works for the first time at the Compagnie des Arts Français. The following years saw the final stage of Noll's development towards pure sculpture. In 1946, he exhibited at the Salon des Réalités Nouvelles and the Galerie Colette Allendy some fine abstract sculptures in wood that were technically very advanced. His skilful use of voids in the interior of a compact mass created an internal and external space for the deployment of his polished surfaces. Since 1947,

when he exhibited his work at the Galerie La Pyramide and the Gentilhommière, he has held four subsequent exhibitions: at the Demeure in 1964, the Galerie de Messine in 1966 and 1968, and at the art gallery of Orly airport, also in 1968. Abstraction rises effortlessly to the level of symbolism through the austerity and concentration of his art. D. C.

NUÑEZ DEL PRADO Marina. Born 1912, La Paz, Bolivia. She trained at the La Paz Academy and returned there later to teach. When she was twenty-seven she gave up teaching and began a brilliantly successful career. A grant took her to the United States in 1940 where she stayed for eight years, was awarded sculpture prizes and honoured by exhibitions in several museums. When she returned to Bolivia, her reputation soon spread to the neighbouring countries. In 1952 at the Venice Biennale, she was on the committee of the Bolivian section in which her works alone were exhibited. In 1953 she exhibited her sculpture at the Petit-Palais in Paris and her *Native Madonna* was bought by the Musée National d'Art Moderne. When she was still young Marina Nuñez travelled all over Bolivia and lived with the Indians on the high plateaux to learn their secret

Nunez del Prado. The Virgin. 1957. Wood.
James Thyne Henderson collection, London.

Nusberg

lore and their immemorial poetry. Her early works were, in fact, inspired by the life of the Indians, their religious ceremonies and the representations of their old gods side by side with the images of Catholic saints. She abandoned the picturesque for social themes: the patience of the Indians, the maternal love of their women and the broader theme of the American people, seen as the product of the mixture of races. She gradually moved away from her early naturalism and tried to find a freer, barer idiom and for a time it seemed as if she were yielding to a facile stylisation. Fortunately, the non-figurative manner she evolved enabled her to express her feelings and ideas in an even more fluent and convincing manner with simple, harmonious forms. She uses marble, alabaster and basalt, but her favourite materials are also some of the most intractable: granite, onyx and guyacan wood. M.-R. G.

NUSBERG Lev. Born 1937, U.S.S.R. He is the founder and theorist of the Moscow kinetic group, called *Dvijenié* (Mouvement). In 1962, he gathered a group of young artists who had rebelled against the academic teaching of the official art. The avant-garde art of the twenties was their point of departure; elementary, geometric forms were taken as the basis of their art and, in this way, they continued the tradition of Suprematism and Constructivism. Their manifesto, published in 1966, was an apology for team work and the formation of creative groups: 'We are creating an art together that cannot be created alone… Kineticism is not only a new form of artistic creation… it is the expression of a new relationship between man and the world.' It was signed by Nusberg, Infante, Kuznetsov, Buturline, Koleichuk, Zanievska, Glinchikov, Orlova, Galkine, Bittova, Dubovska, Stiepanov and Muraviovova. Under Nusberg's leadership, the members of Dvijenié gradually gave up their individual work for a form of expression, combining light and movement, which they planned together on

an experimental and creative level. Until 1965, Dvijenié's activities were confined to various shows in the Komsomol clubs; three exhibitions took place: Moscow in 1964; Leningrad and Prague in 1965. Although Nusberg's group was not recognised by the Union of Artists, it received several commissions from official establishments, notably the decoration of the hall of the *Komsomolskaia Pravda* (1965). Then, in 1966, at the Cultural Centre of the Institute of Atomic Physics in Moscow, Nusberg presented a cycle of the *Metamorphoses* in which sound and smell enriched the complexities of light and movement. The painters and sculptors were joined by actors and mimers, musicians and architects, physicists and engineers, specialists in electronics and cybernetics, poets, mathematicians and choreographers. Word and movement entered into dialogue with science and technology, weaving their own counterpoint into the rhythmic web of concrete music, which was synchronised with projections of coloured light and the variations of kinetic structures. Next, Nusberg projected a *Labyrinth* onto mobile walls and ceilings, accompanied by variable temperatures and smells, which anticipated weightless cabins and offered the public the chance of modifying the arrangements. He also worked out a project for a kinetic theatre in Moscow, where the main theme would be the relations of man with machines (*Kiberteatr*, 1967). For the 50th anniversary celebrations of the October Revolution in Leningrad, Dvijenié arranged a grand kinetic spectacle, in honour of Soviet science, stretching for over a mile along the University Embankment. It was a vast audio-visual panorama, reflected in the Neva, which filled the city with the sound of its broadcast poetry and music. Giant, coloured screens, flame-sculptures, mobile and transparent architecture, with a symbolic structure, 40ft high, as the centre piece, provided the visual splendours, while, all around, publication stands completed the information broadcast by loud-speakers and explained by diagrams, plans and photographs. R.-J. M.

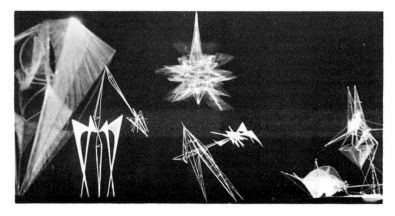

Nusberg and the Dvijenié Group. Kinetic projects for the "Kiberteatr", Moscow. 1967. Metal, plastic.

O

OBRIST Hermann (Kilchberg, near Zürich, 1863 – Munich, 1927). After studying natural history at Heidelberg, he joined the Karlsruhe School of Decorative Arts in 1888. He was disappointed by the teaching there and apprenticed himself to a simple potter of Thuringia, then went to Paris, where he was trained in sculpture in the strict sense of the word. In 1892, he founded a workshop of art embroidery, which he moved to Munich in 1894. He reached the peak of his career with the exhibition of the Cologne Werkbund in 1914. After the war, he seems to have lost touch with the times and, unlike the Bauhaus, he refused to associate industry and technology with the arts.

Hermann Obrist was one of the spokesmen of the Jugendstil. He published in 1903 *Neue Möglic*ʻ*keiten in der Bildenden Kunst (New Ventures in the Plastic Arts)*. As a reformer of interior decoration, he fought for the artistic revival of craftsmanship and a contemporary style, free from all influences from the past. But it is especially as a forerunner of abstract sculpture that he should be compared with the Spaniard Gaudi. Like him, Obrist lavished floral motifs over his work and decorated it profusely. In his designs for memorials and fountains, for instance, the forms of stone arabesques are purely imaginary and they have little importance in relation to the whole. The difference between these works and the abstract sculpture of a later date is their decorative character, which was more highly valued than anything else at that period. It was only after the Second World War, when there was a renewed interest in the Jugendstil, that Obrist was given due recognition as a precursor.

J. R.

OLDENBURG Claes. Born 1929, Stockholm. He is a graduate of Yale University and studied art at the Art Institute of Chicago. He has been living in New York since 1956. He was a painter and producer of happenings, but in 1962 he was attracted to the problem of the mass-produced article and made three-dimensional reproductions of them, like the dummies in the windows of food shops. But, when he produced his first models, Oldenburg made his attitude clear: 'I do not want to imitate, but to create an emotive situation. My work is the objec-

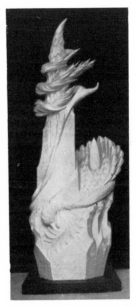

Obrist. Evolution.
1914. Plaster.

tivation of my relations with the world'. His approach was very methodical; it was associative, so that one object he created evoked another and one form effected certain changes in another (bidet-ear-oyster). At first, there was a subtle distinction between Oldenburg's dream and the world; his objects remained recognisable, but he introduced more obvious differences in their size, colour and, from 1966, in the material, as, for instance, in his series of sanitary, domestic and industrial equipment in plastic. Oldenburg is radically opposed to the principle, dear to the New Realists, of 'assembling found objects'. His stimulus is the iconography of the city and what he called 'commercial art'; he has drawn up an

Olivier-Descamps

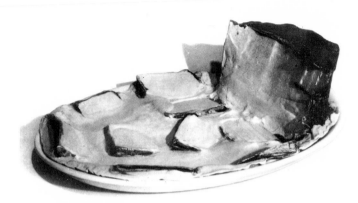

Oldenburg. Vitello Tomato II. 1964. Painted plaster, glue and casein. Michael Sonnabend collection, Paris.

inventory of industrial civilisation and the consummer society, but passes no judgment on them. His attitude is playful rather than derisive, but the derision is present when his works provoke a variety of reactions and different interpretations according to the setting and what was happening around them. Oldenburg has played an important part in the rise and growth of American Pop Art of which he is one of the best-known figures. G. G.-T.

OLIVIER-DESCAMPS. Born 1920, Tunis. He is a French sculptor and is self-taught. An exhibition in 1962 at the Toulon Museum introduced him to the public. The following year, he exhibited a selection of his work at the Galerie Creuze, Paris. He is happiest when he is working in metal in which he gives a piquant and very personal interpretation of reality, siezed in its most familiar and attaching aspects. At one time, he was also interested in the problem of the distortions caused by

speed: 'Speed', he said, 'demands an instantaneous vision. The eye imagines shape and selects the details. This may be the starting-point for a new realism.' He also conceived a series of sculptures representing figures in a situation, where they were completely surrounded by objects that seemed familiar at first sight, but, on closer inspection, proved to be imaginary. His association with architects in a variety of sculptures for buildings brought simplification to his forms and he even used concrete instead of soldered metal. His work gained strength in consequence. D. C.

ORLOFF Chana (Konstantinovka, Ukraine, 1888 – Tel Aviv, 1968). She left Russia for Palestine in 1904 and, after living in Jaffa, went to live in Paris in 1910. She attended classes at the École des Arts Décoratifs, while she learnt to sculpt at the Académie Russe, Avenue du Maine. In 1913, she began exhibiting her work at the Salon d'Automne. She was friendly with the Fauves and

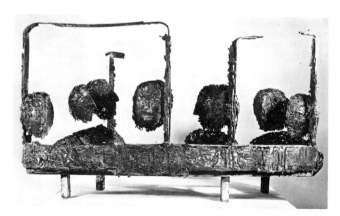

Olivier-Descamps. The bus. Soldered metal.

Otani

Orloff.
Bird.
Bronze.

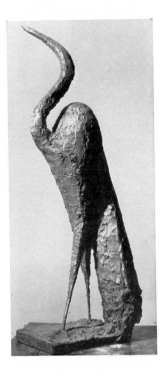

her works at the Galerie de France, in Paris, the Wildenstein Gallery in New York and the museum in Haïfa. Chana Orloff's last sculptures are an unusual synthesis of emotional and intellectual elements. While some are the reflection of her deep understanding of nature, others come from her acceptance of the principles of sculpture and architecture, different from each other, but equally demanding. In her sculpture, realism and invention, far from being incompatible, complement and heighten each other.
 D. C.

OTANI Fumio. Born 1929, Tokyo. He trained at the Art School in Tokyo and then went to live in Paris in 1959. He was awarded a prize at the Paris Biennial of 1963 and the Prix de la Jeune Sculpture in 1967. He attended the Quebec Symposium of 1966. He has held two one-man exhibitions at the Galerie Suzanne de Coninck, Paris (1960 and 1966). He experimented with cement and coloured glass in Japan, but began carving directly in wood in France. About 1963, he began working in metal, steel, and soldered aluminium. The free interpretation of nature in his early work has now turned to the creation of more independent forms. His forms are now charged with a sort of vital influx, which reflects an openness and sensitiveness to the deep workings of existence, which he tries to give a plastic equivalent. His most recent works are assemblages of mobile elements in wood, which lend themselves to a variety of combinations that completely change their appearance.
 D. C.

Cubists and knew Apollinaire, Picasso, Max Jacob, Modigliani and Soutine. Until 1919, she generally worked in wood and her stylisation had a slightly decorative flavour about it. Later on, she was attracted to Cubism (1919–1925), which was reflected in her forthrightly stylised figures in cement and marble, with their cylindrical bodies and spherical heads. Besides several portraits, the female nude predominated in her work. She obtained French nationality in 1925 and exhibited the same year at the Galerie Druet, Paris. In 1927, Léon Werth wrote a book on her in the Crès publications. From 1930 until the war, her art showed a considerable variety and she used a large range of materials, although a certain preference for marble was noticeable, a material that does not lend itself to complex pattern and superfluous detail. She took refuge in Switzerland during the war and returned to Paris in 1945. Since then, she has gradually given up working in stone and a change in her technique has made her turn to modelling, nearly always for casting in bronze. She shows a decided fondness for the bird as a subject, which she studies, develops and returns to without ever repeating herself. Between 1946 and 1949, she exhibited important selections of

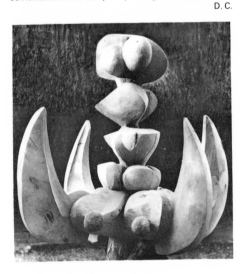

Otani. Petal. 1968-1969. Wood.

235

Marta Pan. Floating sculpture. 1961. Polyester.
Rijksmuseum Kröller-Müller, Otterlo

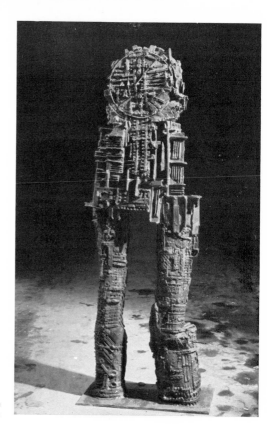

Paolozzi. Japanese
war god. 1958. Bronze.

p

PACIUREA Dimitrie (Craiova, Romania, 1875 — Bucharest, 1932). He began his training in Bucharest and completed it in Paris at the École des Beaux-Arts (1894–1901). When he returned to his own country, he produced his masterpiece, the *Giant*. The dramatic tension of the forms, the rising rhythm of the composition, the contrast between the rough stone and the vigorous modelling of the planes make it a fitting symbol of the awakening human conscience. In 1909, he was appointed to teach at the Bucharest Art School, where he remained till his death and exercised a considerable influence on the development of modern sculpture in Romania. Paciurea was a visionary and an innovator. At a time when Brancusi's art arrived at the same point, his series of *Chimaeras*, with their smooth, polished surfaces, shimmering strangely in the light, attained to pure, abstract form. The fantastic figures of *Chimaeras of Space* (1919), *of Water* and *of the Earth* are the issue of dreams and belong to a supernatural world, possessed by memories of folklore and the ancient myths. I. J.

PAN Marta. Born 1923, Budapest. She studied painting, sculpture and drawing in Budapest, and then went to Paris in 1947. She obtained French nationality in 1952. In the beginning, the subjects of Marta Pan's experimental sculpture were vegetables and shells in which she tried to trace the development of organic forms. Her purpose was not to copy the external appearances of real things, but to give concrete expression to her plastic ideas, an endeavour that soon led to abstraction. Her early sculptures had a very individual style, and consisted of two or more elements, each possessing an independent form, which did not acquire their real significance except in relationship to each other. These synthetic works were followed by others in which the relations between the component parts were modified by movement. The strong vitality of *Teck*, a wood carving, consisting of two powerful lower arms and a huge jaw, was followed by the more graceful and sensitive *Double Balance* with two indented discs, which created an endlessly varied, harmonious rhythm, when they were slowly rotated. The same sinuous modulation is repeated in *Equilibrium* of 1958, a shell shape that can be turned and bent on its metallic axis. Both *Equilibrium* and *Teck* were used for Maurice Béjart's ballets sets. *Double Balance* was the first example of large-scale sculpture in polyester. It was made especially for the Kröller-Müller Museum at Otterlo (1961), where it floats on the pond in the middle of the park, dominating and at the same time adapted to this natural setting. In recent years, Marta Pan has worked in association with her husband, the architect André Wogenscky, on works specially conceived for architecture, to which they add a vital and essential element. A sculpture, like a pivot, surrounded by four mobile elements, stands at the point of intersection of the architectural axes, at the Centre Hospitalier Universitaire of the hospital of Saint-Antoine. On the terrace of the Maison de la Culture at Grenoble, built by her husband in 1967, a powerful, concrete sculpture points metaphorically to the entrance and to the significance of the building. She has realised for the Parliament of Europe at Luxembourg a screen of slender bars, between which sculptural forms seem to climb like plants. Her interest in the lastest industrial materials produced sculptures in oxidised aluminium, which harmonise with the surroundings of modern living. She has also worked on models in plexiglas, made of imbricated and dismountable cubes and cylinders, their aspects multiplied by the transparent material. Marta Pan has contributed to the principal Parisian Salons and exhibited regularly at the Galerie Arnaud, Paris, from 1952 to 1968. One-man exhibitions of her work were held at the Stedelijk Museum, Amsterdam, in 1961 and the Palais des Beaux-Arts in Brussels.* H. W.

PAOLOZZI Eduardo. Born 1924, Edinburgh. His parents were Italian. He trained at the Slade School, London, and in Paris. His first exhibition was in London in 1947 and he was represented at the Venice Biennale in 1952. In 1953, he was commissioned by the Hamburg City Council to design a large fountain for a new park and in the same year received the British Critics' Prize.

Papa

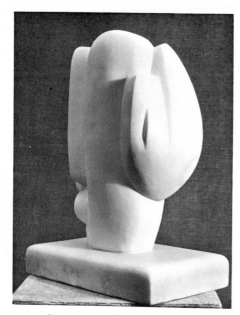

He has been represented at several of the great inter national exhibitions. He has undertaken collages, designs of fabrics and wallpapers. He has taught textile design at the Central School of Arts and Crafts, London (1949–1955), and sculpture at the St. Martin's School of Art, London (1949–1958).

Paolozzi is in some ways the most radical of his generation in Britain. Young enough to have escaped completely any influence from Moore, he represents the swing of the pendulum away from craftsmanship, simplicity and truth to material. With increasing confidence he has come to assume the lead in Britain of that antirational, nihilistic, movement of near-automatism that has its links with Dada and Picasso's sculptural improvisations in the past; with parallel tendencies in painting (art brut, action painting), music (musique concrète) and the theatre (Beckett, Ionescu) in the present; but which also relates at the same time to the innate romanticism of most British art. From his earliest days, Paolozzi has sought to find in sculpture a source of totemic signs, symbols and images; of intuitive echoes of pre-history; of intimations of archetypes in a technological world running amok. His earlier sculptures, mostly in cement, contained few implications of humanity; they rather suggested, through a haphazard scatter of seemingly marine and insect forms in relief upon some central mass or plane, ambiguous relics from an abstract world. Later, he did make figures, like patched-up robots making their

rickety way out of some atomic holocaust. Their archetypal status is emphasised by their titles: *Japanese War God, Monkeyman, Little King, Saint Sebastian*. Their surface derives from the multitudinous, mostly mechanical, components. These seem to corrode deeply into and through the vitals of these creatures while, conversely, their heterogeneous internal organs come tumbling out. Expressiveness and marvellousness beyond the rational — these are what Paolozzi has to set against the nihilism of an art that ignores all the traditional criteria. M. M.

PAPA Maria Baranowska, called Maria. Born 1923, Brno, near Warsaw. After training in architecture and painting at the Warsaw Academy and a period of several years in Paris on a UNESCO scholarship, she decided to settle permanently in Paris in 1956. The discovery of the art of ceramics and terracotta at Albisola in Italy made her decide about 1960 to give up painting for sculpture (bronzes and terracottas). A Copley Foundation grant in 1966 offered the opportunity of undertaking work on a larger scale at Henraut's, the large commercial marble works at Querceta, near Lucca. The archetypes from the art of the distant past were the starting point of her own experiments; she used them as a sort of sketch-plan for the forms she gave permanence and modernity. Her work, far from ending in a tribute to the values of the past, is charged with the significance of a living tradition borne in her mind and memory. Her images have an elemental quality reminiscent of the mysterious stones in the park at Nieborow. The formal simplification is not the result of any intellectual theorising of a purist kind, but a consequence of direct carving in the block of marble and a respect for the essential nature of the material. This approach is the measure of her moral commitment, which, for Maria Papa, is fundamental to her work and implies the gradual mastery of a technique adapted to the monumental character of forms. Besides a number of personal exhibitions in Paris (Galerie XXᵉ Siècle, 1962) and Milan (Galleria del Naviglio, 1960 and 1967), she has been represented at all the principal Parisian Salons since 1959 and at the Biennale of Carrara (1967 and 1969). G. M.

PAPARELLA Aldo. Born 1920, Italy. He has been living in Argentina since 1950, where he made a reputation for himself as a painter. He was awarded the Prix d'Honneur of the Salon of Mar del Plata in 1960. He has had sixteen one-man exhibitions and has been represented at several group shows, including the São Paulo Biennial (1963). His experiments in sculpture are based on a dual movement: the destruction of appearances, so that fresh forms arise from them; and the reconstruction of form in a synthesis combining the real world with the world of sculpture. This dual action is accompanied by Paparella's special interest in his materials, so that his idiom is adapted to its particular nature. His sculpture is

consequently the outcome of multiple antagonisms, which are resolved in each work in its own particular way.

J. A. G. M.

PASMORE Victor. Born 1908, Chelsham, Surrey. He studied painting by taking private lessons and going to evening classes, while he worked for the L.C.C., from 1927 to 1937. He was a member of the Euston Road group and taught at the Euston Road School from 1937 to 1939. After the war, his work became more abstract and continued in the same direction after 1948. Since 1951, he has spent more and more time on non-figurative relief and constructions. In this sphere, he has worked in close collaboration with architects and has been given several official commissions for mural decorations and various constructions. A retrospective exhibition of his work was organised by the Institute of Contemporary Arts in 1954. He was represented at the Kassel Documenta in 1959, the Venice Biennale in 1960 and various other exhibitions in Europe and the United States. Without abandoning his subtle realism, his art showed an in-

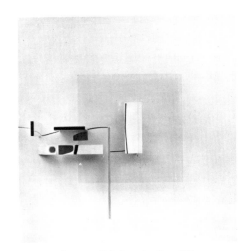

Pasmore. Relief construction. 1966.
Oil on wood and perspex.

creasingly marked taste for formal elements, until his search for pure form was no longer satisfied with two-dimensional substitues. 'In the sphere of pure form,' he wrote, 'painting is powerless to give a full realisation to organic, spatial relations... There is no doubt that in pure form sculpture is supreme.' The nature of a painter, subjected to a rather cerebral theorist, can be detected in Pasmore's abstract work. His relief and constructions are both painting and sculpture and their ambiguous nature clearly derives from the rationalism of a Mondrian and conceptions connected with modern technology. The reflected light and transparency of their materials, plastic, metal and wood, painted white, possess the delicate tones, worthy of Whistler, which once used to make his painting so vital. Pasmore might he considered as one more example of that thoroughly English talent for domesticating an international idiom in the setting of a local tradition, until the final result is a difference in kind rather than degree.

M. M.

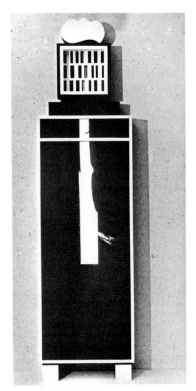

Paparella. Sculpture N° 29. 1967.

PATKAI Ervin. Born 1937, Bekescsaba, Hungary. He trained at the Budapest Art School, then in Paris. He was awarded a prize at the 1961 Paris Biennial and, five years later, the Prix de la Jeune Sculpture. In 1967, he was invited to the Symposium at Grenoble. Patkai modelled clay and plaster, then in 1965 began using plastic materials, followed the next year by reinforced concrete with polystyrene shuttering. His first small bronzes were made in 1968. But these materials and their techniques were only more or less appropriate tools for an increasingly exact expression of a particularly rich plastic thought. Patkai's works, which are cut out, pierced, and are almost labyrinthine in appearance because of the

Penalba

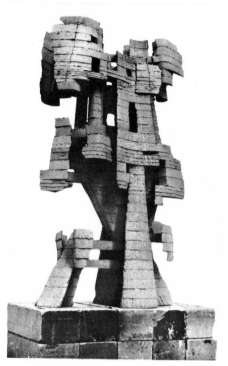

Patkai. Sculpture. 1967. Concrete.

close involvement of space and solid, possess an un-
deniable monumentality, accentuated by the extremely
studied sculpting of their various contours. Their struc-
tural complexity is not so much the symbol of some sort
of reality as a reflection, by making it tangible, of a partic-
ular process of thought with its infinite ramifications of
certainty, and doubts, regrets and scruples. D. C.

PENALBA Alicia. Born 1918, Buenos Aires. Penalba
studied painting and drawing at the Buenos Aires
Academy, won a prize and a government scholarship and
went to Paris in 1948, where she decided to take up
sculpture and trained in Zadkine's studio. Her personal
style developed very quickly and, in 1952, her first
important works appeared, *Totems*, like slender columns
that suggest petrified, exotic plants. The dual aspects of
plant and architecture have alternated and intersected
through her work. On the one hand, there were the
sculptures that opened out like flowers, spreading their
petals out in space; and, on the other, were the sculptures
with elements that rose in serried groups concealing
their germinating forms within. They were both composed
of homogeneous, leaf-like elements, which Penalba
subjected to her intellectual conceptions through her
composition and rhythm. Their equilibrium became more
and more daring with the bronzes of 1962–1963, where
the axes slope and spiral, and the branches sprout in
powerful, dynamic thrusts *(The Great Bird, Alada)*. Her
instinct to hollow and pierce the mass resulted in airy,
complicated forms, the strangest of which must be the
sculptures for a school playground, which are full of
grottoes and gorges, inviting the children to climb over

Penalba.
Great dialogue.
1964. Bronze.

240

them and nestle inside. The 1959 maquettes for fountains, where the function of the water was to stress the movement of the sculpture and increase the play of light and shadow, had a sequence in the sculptures she did for the Paris Floralies (horticultural show) in 1969.

Since 1959, Penalba has also made mural reliefs, composed of multiple elements, which are linked along the rhythmic curves, or gathered into repeated and extended clusters. In 1963, she designed for the School of Economic and Social Studies at St. Gallen, Switzerland, a group of large, concrete blocks, scattered on the lawn between the buildings, so that they formed the centre of gravity of the landscape as well as of the architecture. Her most recent works are made of large units of polyester, but the material she finds most congenial is still clay, which can be so easily shaped to give form to her creative ideas, with their strain of poetry and mystique. She was awarded the sculpture prize at the São Paulo Biennial in 1961 and has been represented at most of the great international exhibitions. Several one-man shows of her work have been held in Paris (Galeries du Dragon, 1957; Claude Bernard, 1960; Creuzevault, 1965), New York (Otto Gerson Gallery, 1960, and the Bonino Gallery, 1966) and in various museums (Rio de Janeiro, 1962; Otterlo, Eindhoven and Leverkusen, 1964). She was represented at the Salon de la Jeune Sculpture, Paris, in 1952 and 1957. H. W.

PEREZ Augusto. Born 1929, Messina. He is living now in Naples, where he teaches at the Academy. His first exhibition was held at Rome, in 1955, at the Galleria Il Pincio. The works in it were frankly realistic with a social significance *(Young Girl Cutting Bread, Peasant Woman with a Hen)* in the nineteenth-century tradition of the southern Italian schools, that was diametrically opposite to the tendencies of non-figurative sculpture. These works, however, revealed a deep sensitiveness in their handling of volumes, so much so that it was possible to perceive through the controversial intentions of the subject matter a potential development towards a sculpture of freer forms, which was realised four years later in the work exhibited at the Galleria Obelisco, Rome. The style of Perez had its beginnings in the Marino-Manzù controversy and seems to be an attempt at reconciliation between opposite tendencies, represented by the two artists whose influence was so decisive for Italian sculpture before the war: a sculpture of volumes or a sculpture of surfaces. He subsequently created a world of eroded, disturbing images that are rather like the mortified forms of Germaine Richier or Giacometti. The light vibrates so subtly on these monumental figures of *Kings* and *Queens, Survivors* and *Tyrannicides* that it almost dissolves their imperious presences into space. The dramatic intensity of such works is a desperate plea for figurative sculpture in a period when the human, if not the moral significance of the figure has lost all its power in art. From this point of view, they are a faithful

Perez. Masked man. 1960. Bronze.

reflection of our times. Perez is a prolific artist, as several one-man exhibitions since 1963 have proved. His development seems to have turned increasingly towards the myths of our industrial and technological age. G. C.

PERMEKE Constant (Antwerp, 1886 — Ostende, 1952). Permeke was the leading artist of Flemish Expressionism and was already a well-known painter when he began to sculpt. He made his first attempts in 1935. He had no experience whatever and he improvised a crude technique with the help of a peasant turned caster for the occasion. This lack of technical knowledge did not prevent him from producing some statues that possessed grandeur in spite of their initial, barbaric effect. The

Permeke. Marie-Lou. 1935-1936. Bronze.
Middelheim Park Museum, Antwerp.

PERRIN Fred. Born 1932, Neuchâtel, Switzerland. He trained as a sculptor at La Chaux-de-Fonds. His early work was influenced by Jean Arp and then acquired a sort of indeterminate baroque, but after 1965 a far more strict conception of form was noticeable. This change was made easier when he began to use epoxide resins in 1966, whose plasticity, resistance and fluidity enabled Perrin to vary his idiom. The characteristic breadth of his projecting volumes derive their power of expression as much from the voids they circumscribe as from their own compactness. These voids, which are a means of maintaining continuity as well as of communicating the notion of space, give a vitality and a spiritual dimension to his sculpture, which till then had been more organic.

D. C.

PEVSNER Antoine (Orel, Russia — Paris, 1962). He came from a family of engineers. He trained at the Kiev Art School (1902–1909), then spent a year at the St. Petersburg Academy. The Eiffel Tower was his introduction to sculpture in iron ('Eiffel,' he said as a joke, 'was the first Constructivist'). But Cubism disappointed him. After a few months in Russia, he returned to France. During his second visit, he made friends with Archipenko and Modigliani. He painted his first abstract painting, *Abstract Forms*, in 1913. From 1915 to 1917, he lived in Oslo, where his brother, Naum Gabo, joined him. While he continued to paint, he took an interest in Gabo's experimental sculpture, which helped to turn him towards sculpture himself. They laid the foundation of a new art together, which broke away from the traditional principles of compact masses and replaced them by the

work of the sculptor was related to that of the painter; the same rough, violent spirit found an expression in both. While Cantré and Jespers, who were also Expressionist sculptors, valued geometrisation for its eloquent qualities, Permeke's distortions of the human body were not the result of a rational approach but were entirely instinctive. Unlike the other Expressionist sculptors, Permeke hardly ever practised direct carving. He had little interest in the qualities or intrinsic beauty of materials; he was content with plaster and sometimes cement, notably for his huge *Niobe* in the Brussels Museum. During the war, from 1940 to 1945, Permeke was forced to stop sculpting and buried his works in the ground to save them. He then spent most of his time drawing. When he went back to sculpture, a quiet change had taken place. His style was more serene, and less Expressionist; his *Three Graces* could almost be described as academic. Permeke worked equally hard at his painting, sculpture and drawing until his death.

F.-C. L.

Perrin. Sculpture. 1967. Resin.

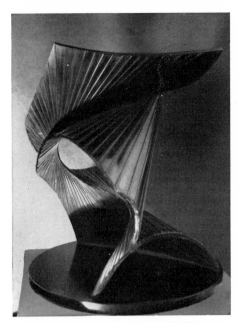

Pevsner. Projection in space. 1938-1939.
Oxidised bronze. Maya Sacher collection, Basel.

conception of voids and the significance of space as an integral part of sculpture. When he returned to Russia in March 1917, he was appointed to teach at the State Workshops in Moscow, where Kandinsky, Malevitch and Tatlin were also teaching. During 1919, Pevsner and Gabo worked out the *Realist Manifesto* together, which was printed on the government presses and posted all over Moscow in August 1920. An exhibition of works inspired by these reforming principles accompanied his declaration. It was held in the gardens of the Tverskoi Street and had far reaching repercussions. The intention announced by the signatories of the manifesto to 'construct' their works earned them the name of 'Constructivists'. Pevsner went to Paris in October 1923 and lived there till his death, having obtained French nationality in 1930. Pevsner did not finally decide to become a sculptor until 1923.

The *Realist Manifesto* contained the guiding principles of his art. These are summed up in a few statements. '1. If art is to be a reflection of real life, it should be based on two fundamental factors, space and time. 2. Volume is not the only means of expressing space. 3. Kinetic and dynamic elements are able to express actual time: static rhythms are not enough. 4. The volume of mass and that of space are not the same thing in sculpture, but two different materials that are actual, measurable entities. 5. Space is a malleable material that becomes an integral part of the work. 6. Art must cease

to be imitative and must invent new forms.' Pevsner created a poetry of the void from the new forms that he was demanding from art in 1920, a whole system of 'transformable spaces', a vision of the world defined by pure, abstract relations. His experiments in perspective, 'the annihilation of the plain surface' and the destruction of the inertia of mass at first led Pevsner to make transparent constructions of steel blades and plastic material, like the *Portrait of Marcel Duchamp* (1926, Yale University), which was a combination of open planes made of plates of zinc, copper and celluloid, cut out and contrasted with each other. He soon discarded these materials. Bronze wires arranged in parallel lines and welded seemed to him the only medium that could be shaped to his wish for an uncompromising severity and bareness (*Construction for an Airport* (1937), *Spiral Construction* (1943), *Dynamic Construction* (1947), *Kinetic Construction* (1953), *Developable Surfaces* (1936 and 1938), *Column of Peace* (1954), Cosmogonic Structures (*World*, 1947; *Germ*, 1949), and *Spectral Vision* (1959). All these creations of Pevsner are compositions with no beginning and no end within themselves. The material is reduced to a line, the straight, rigid metal rod and the abstract element. Each piece radiates from an axis of growth or involution and merges into the general form, whose continuity depends on uninterrupted alternations and reversals. A gliding movement is set up by the imperceptible modulations of the symmetrical, twisting shapes. Under the calculated effects of light, the virtual volumes flare out and hollow themselves into oblique and spiral lines, shells and volutes. The sculpture continues its progression beyond itself and transforms its swirling movement into a *perpetuum mobile*. Light fulfils the same function for the sculptor as colour for the painter. Each plane breaks or blocks it, spreads it out or disperses it, deepens the shadow or

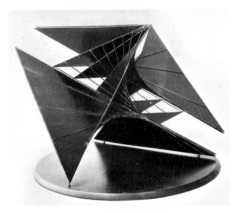

Pevsner. Construction for an airport. 1937.
Soldered copper. Stedelijk Museum, Amsterdam.

243

Pevsner

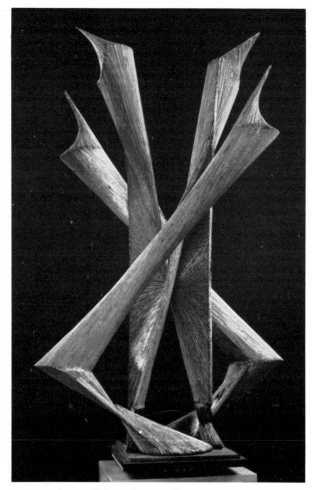

Pevsner. Column of peace. 1954. Oxidised bronze.

irradiates its reflections. Sometimes the surfaces receive, hold and absorb it: sometimes they divide it in a kind of cleavage of the impalpable, are permeated and coloured by it and then refract it, like filters in iridescent curtains. It is this incorporeal material, light and the field of its extension, that is the very substance of Pevsner's forms, their mobile density and fluent rhythms, shot through with complex tensions. Hollow is balanced with relief: salience contains the depth of void; light and dark fecundate each other, impregnate the texture of the work and create infinite variations. Antoine Pevsner was the creator of a new image of the world: he constructed

the first models on principles that were associated before with other ways of feeling and thinking.

Since the famous Constructivist Exhibition that he organised with his brother in Moscow in 1920, he has exhibited his work in several group and one-man exhibitions. Notable among these are the exhibitions he shared with his brother in 1924, at the Galerie Percier in Paris, then in 1948 at the Museum of Modern Art in New York. He belonged to the Abstraction-Création group before the war. In 1946 he founded with Gleizes, Herbin and some others the Réalités Nouvelles group, which held its first Salon in 1947. The same year, the

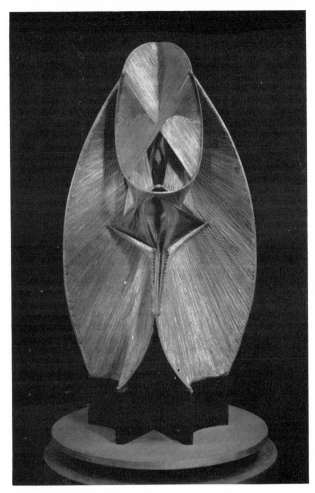

Pevsner. Spectral vision. 1959. Oxidised bronze.

Galerie René Drouin, then in the Place Vendôme, held his first large one-man show. An important retrospective exhibition of his work took place in 1956 at the Musée d'Art Moderne in Paris. Two years later, the Venice Biennale reserved a whole room for his work.　　　P. V.

PEYRISSAC Jean. Born 1895, Cahors. Settled in Algiers in 1920. Then he taught himself sculpture, using uncommon materials like iron, rope and pieces of already shaped wood. At the same time, he concentrated on drawing, trying to find the sources of rhythm through studying the human body. He painted large, abstract compositions as well. In 1927, the Galerie des Quatre-Chemins, in Paris, organised his first exhibition. The following year he went to Dessau where he visited the Bauhaus. The experiments of Kandinsky, Klee and Feininger, which he saw there, roused his curiosity. Then he returned to Algiers, where he lived for several years in complete seclusion. He gave up painting definitely to give all his attention to developing a non-traditional sculpture that was entirely based on spatial rhythms. Peyrissac was already concerned about dynamic organisation and thought that 'as soon as movement dominates

Philolaos

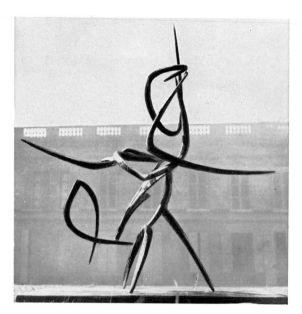

our constructions they become vital... and the laws of the cosmos are reflected in the little world we try to build.' In 1948, he exhibited at the Galerie Maeght a collection of works that he gave titles like *Plastic Machines* or even *Constructions in Space*. It was rather odd that his conceptions seemed to bring him closer to Calder, but such points of resemblance were only superficial and fortuitous. In 1957, he went to live in Paris, where he gave up the materials he had been using till

then and used metal for *Static Equilibriums*, which were perfect symbols of stability in spite of their lightness.

D. C.

PHILOLAOS Philolaos Tloupas, called. Born 1923, Larissa, Greece. He trained at the Athens Art School, then at the École des Beaux-Arts in Paris, where he settled in 1950. His first one-man exhibition took place

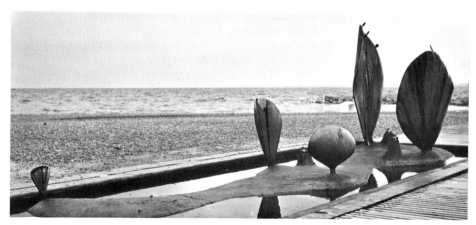

Philolaos. Fountain sculptures at Balaruc-les-Bains, Hérault. 1967. Stainless steel.

at the Galerie A, in Paris. He has been represented at the principal Parisian Salons and was invited to the Biennials of Middelheim, São Paulo and Athens. Philolaos worked in metal, either iron or lead, and from 1953 gradually drew away from forms derived from nature, but it was only after a long period of about seven years that his sculpture became completely abstract. Stainless steel was the medium he used in 1962 to realise his first object-sculptures. He has since continued to develop this particular side of his talents (screens, small furnishing or household objects, goblets, etc.). At the same time, he went on modelling terracotta figurines, which he called *Gogottes*, a kind of imaginary animal, and elaborated abstract forms on wood panels with a shredded grain, which played with the potentialities of the material. The ample volumes and strong, simple rhythms of his works in steel, commissioned for buildings, reflect his harmonious association with architects. They sometimes consist of movable elements, mounted on hinges, and show a keen sense of the marvels of contemporary technology. They are massive, almost monolithic, and their stream-lined surfaces, hammered diagonally, save them from dry formality. D. C.

PICASSO Pablo. Born 1881, Malaga, Spain. Admired the world over as painter and engraver, this prodigious creator of forms could not escape the appeal of sculpture. His first attempt goes back to 1899, when he was eighteen. However, it was not till 1905, the year when he painted his families of harlequins and acrobats, that he took up sculpture seriously. His bronze *Harlequin* is obviously influenced by Rodin's Impressionism, but the *Head* of 1906 is already stamped with Picasso's individual style and marks his final break with naturalistic illusion. The figures he carved so vigorously in wood and the bronze *Mask* of 1907 are remarkable for their preoccupation with formal synthesis and the primitive character he imparted to them, under Gauguin's influence without a doubt, and more obviously under that of African sculpture, although he denied that Negro art had any attraction for him before 1910. He was wholly preoccupied with the expression of volume during this period. It was, moreover, in his search for new relations between form and space that Picasso was led to 'cubism', the aesthetic movement that aimed at introducing the illusion of volume on a plane surface. From this point of view it is surprising that the bronze *Head* of 1910 and the *Portrait of Vollard*, painted the same year in the midst of the Cubist period, differ in method, but are based on the same principle: the analysis of form and the fragmentation of the mass into small volumes. After 1912, he preferred a more synthetic, architectural conception of painting and sculpture. While he was incorporating fragments of various materials into his painting, he made constructions of cardboard, wood and sheet metal, combined exactly like the 'papiers collés': *Guitar* (1912), *Violin* (1913), *Mandoline* (1914). The *Glass of Absinth* in painted bronze

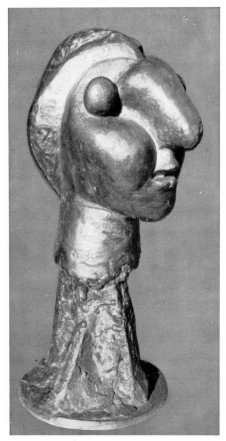

Picasso. Head of a woman. 1932. Bronze.

(1914) illustrated the parallel experiments he had been carrying out in painting and sculpture since 1907. For fifteen years, he concentrated his attention on painting, engraving and theatre design. After a series of very vivid works, lacking sculptural relief, he once again felt the need for full, vigorously modelled forms. After 1928, he created serene, majestic, monumental figures either in three dimensions or on the flat surface of a canvas. Then suddenly in one of his accustomed caprices, he abandoned solid, compact, static sculpture for an open sculpture, built up of thin metal sheets and iron wire, which gave plenty of scope to his irony and zest. He produced in this style a whole lively world of people, animals and plants, sometimes with the help of Gonzalez. At the time, he constructed geometric, openwork figures, which were like drawings traced in space with metal rods, a method that was to be common practice later on.

Picasso

 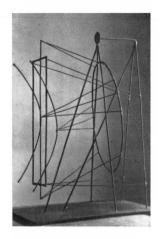 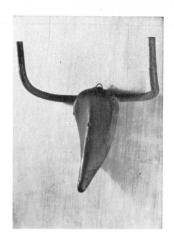

Instead of taking advantage of his discovery, he went on to explore and master other things, always capricious, always disconcerting and contemptuous of rules and conventions. In 1931, he liked to incorporate into his sculptures the first objects or utensils within reach: the horn of a bull, a feather-duster, a funnel or the drum of a coffee roaster. It was typical of his restless, inventive spirit that Picasso should combine the simple, everyday objects with the most fantastic imagination, that he should control the abstract by the concrete and bring together ordinary things in an incongruous association. It was in 1931, too, that he began a group of thread-like figurines, wire silhouettes, carved in wood before being cast in bronze, which inevitably suggested certain artifacts from Dogo or Changsha. 1932 and 1933 were particularly productive years. Picasso now had a huge studio at his disposal in his house at Boisgeloup near Gisors, where he could work on a large scale. He no longer produced open, hollow sculptures, reduced to their contours and a simplified linear composition, but, on the contrary, forms conceived in all their mass, volume and weight. Sometimes they were stripped, concentrated and simplified by a swift stroke of the imagination; sometimes they were a more or less faithful representation of reality, like the comical people and animals that were hardly freed from their material, sculptural

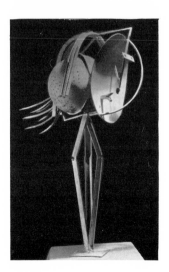 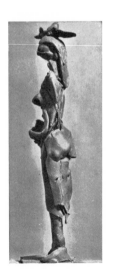

Picasso. Goat's head and bottle.
1951-1952. Painted bronze.
Museum of Modern Art, New York.

Picasso. Glass of
absinth. 1914.
Painted bronze.

Picasso. Wire
construction. 1930.

Picasso. Head of a bull
(Metamorphosis). 1943.
Bronze.

Picasso. Woman.
1931. Wrought iron.

Picasso. Woman.
1943. Bronze.

Picasso. Woman.
1943. Bronze.

Picasso. Goat's head and bottle.
1951-1952. Painted bronze.
Museum of Modern Art, New York.

sketches, which he never finished and which consequently still keep the spontaneity of his original, creative impulse. He produced at Boisgeloup, too, the great busts and heads of women, with elongated necks, bulging foreheads and noses, and fleshy, trembling lips, which are among his most forceful works. He produced, again at Boisgeloup, a wonderful *Cock* and *Head of a Bull* in bronze, fragments of anatomy in plaster and a huge cement statue, which was put in the Spanish pavilion at the 1937 Exhibition, and a variety of concretions in sand and natural substances.

Whether he drew his inspiration from the past or found he had a natural affinity with certain forms, created by archaic and primitive peoples, Picasso stamped them as unmistakably with his powerful personality as he did the bits of rubbish he picked up around him. During the war, in his studio in the Rue des Grands-Augustins, he sculptured with fresh enthusiasm: painted cardboard, statuettes in plaster or bronze, metal caps, paper masks and animals made of match-boxes. Everything was material for him, the meanest rubbish, the commonest scraps, everything could be used by him, anything was an excuse for invention. He brought together the most

incongruous and trivial objects: a scooter, fixed on a metal rod with a hen's feather, fashioned a wader. Two pieces of wire and a piece of wood, daubed with plaster, made a bird. A saddle and bicycle bars were transformed into the head of a bull (1943). Picasso succeeded in changing the strangest objects from the everyday world into the magic realm of art, without modifying them, just by a simple action, but one combining them in unexpected ways that were quite different from their original uses. Between two creations of astonishing boldness, he could go back to the well-tried tradition of modelling in which he produced terrifying human skulls and smooth feminine figures.

In 1944, he completed *Man with a Sheep*, nearly seven feet high, which was erected in 1950 on the Place du Marché, in Vallauris. This masterpiece was followed by others, notably the *Goat* and *Pregnant Woman* (1950) in which he took up the millennial theme of fertility with an almost unbearably virulent energy and realism. Others were *Woman with a Pram* (1950) and the admirable *She-monkey* (1952), which seems so true to life that one would never guess it was made from a child's ball, the handle of a frying-pan and two toy cars, bound

249

Pierluca

together to make the head. Colour in sculpture obsessed him to such a degree that he even painted his bronzes, like the *Crane* (1952), *Woman Reading* (1953) and the still-life with a goat's skull and a bottle of 1951–1952. He did the same a little later, when he was working on a series of sculptures of 1961–1962 made of sheet-metal, cut out and folded. He began with cardboard models and created for his amusement a whole world of droll, gay, little masks, clowns, harlequins, animals and meta-morphosed portraits, the originals of which still decorate his house at Mougins. Since 1946, Picasso has been working in the south of France, first at Vallauris, then at Cannes, the château of Vauvenargues, and now at Mougins, where he moved in 1961. It was at Vallauris that he was so captivated by the timeless gestures of Provençal potters, transforming a lump of clay into brightly coloured forms, that he became a potter himself. He soon learnt the old processes and gave new life to an art that was degenerating, a life all his own, which he spent without stint and with a feverishness that only increased with age.

Countless large exhibitions of his work have been held in France and abroad. The most important was the one organised to celebrate his 85th birthday. It opened in November 1966 at the Grand and the Petit Palais in Paris and contained more than 300 paintings, 200 drawings and almost all his sculptures (about 200). In all this immense, multiform body of work, it was possible to appreciate to what extent sculpture had been an essential factor in Picasso's experience. It was apparent, too, that while his painting was dominated by anxiety, sarcasm and a proud fury, his sculpture was generally a surrender to gaiety, tenderness, even sensuality. This may be because the hand that moulds, carves and models is in closer, more intimate touch with reality than the hand that holds the pencil or brush. Some people admire Picasso's sculpture more than his painting. In fact, one is as great as the other. If he had never painted, his sculpture would have been enough to ensure his fame. F. E.

PIERLUCA Degli Innocenti, called (Florence, 1926 – Spain, 1968). He began his training at the Florence Academy of Fine Arts in 1948 and the same year was awarded the Prize for Meritorious Work from the Ministry of Education. His first exhibition was held at the Galleria Numero, Florence, in 1953. From 1954 to 1958, he was in charge of the Workshop for Restoring Stained-glass. Working in metals then began to interest him; he decided to devote himself to sculpture and went to Paris in 1960. Three years later, he exhibited fifteen sculptures on the theme of *Laceration* at the Galerie XXᵉ Siècle in Paris. A second exhibition in 1965 at the Galerie Internationale, Paris, continued the same theme and included more recent work from a later series called *Communal Offence*. The Venice Biennale of 1964 invited him to exhibit and he contributed to the Kassel Documenta the same year.

Picasso. Goat. 1950. Bronze.

His premature death at the age of forty-two ended a work that was full of promise. Although the idea itself of *Lacerations* was derived from Burri's paintings, Pierluca showed an unquestionable independence and originality, especially in his 'combustions'. The integrity in the contrast between the perfectly modelled form and the laceration that rips open its depth is wholly convincing, because there is nothing to separate the conception from the act that embodies it. The idea of destruction was his starting-point ,and the intense working of the metal on the anvil created forms that were as beautiful as they were agonised, an expression of the pessimism of a whole, precarious civilisation threatened by its own power.

PILLHOFER Josef. Born 1921, Vienna. He attended the School of Arts and Crafts in Graz for a short time and then, in 1947, went to the Vienna Academy, where he was one of Wotruba's students. On a study visit to Paris in 1950–1951, he met Laurens, Brancusi and Giacometti. From 1951 to 1954 he continued his training under Wotruba. Since 1954, he has taught at the Academy, with only one break for a visit to Rome in 1957. He has exhibited his work in Paris (1951) and Vienna (1954, 1956, 1958) and was represented at the Venice Biennale (1954 and 1956), and Middelheim, Antwerp (1957), and exhibited work at Arnhem (1956). In 1959, the Santee Landweer Gallery in Amsterdam organised a retrospective exhibition of his work. Pillhofer's development was slow and it was some time before he found an individual style. He avoided an extreme modernism and steadily moved towards a soundly architectural manner, which was founded on a few simple, well-tried principles. His sculptures are never complacent; one feels they are the products of hard work and a genuine, creative power. It has no obviously striking effects, but is impressive simply by its very existence. J. L.

PINTO Marie-Thérèse. Born 1910, Santiago, Chile. After studying in Germany and Italy, she went to France, where she trained in sculpture under Brancusi, then Laurens. The war broke out when she was in Mexico. She stayed there several years, and almost any day during that time she could look at Toltec sculpture, the idols of Guerrero and the expressive figurines of the Tarascans. She wrote a book with Gilbert Médioni, which was a revelation of the art of ancient Mexico and was published in 1941 in New York. On her return to Paris, she continued her sculptor's career with a fresh enthusiasm for it. She was represented in several exhibitions notably the São Paulo Biennial (1951). Faithful to the lesson of her masters and all she learnt from ancient civilisations, she had rejected the conventions and methods of classical tradition. Although she is associated with avant-garde artistic and literary movements, Sur-

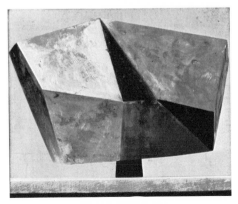

Pillhofer. Sculpture. 1958.

Pomodoro

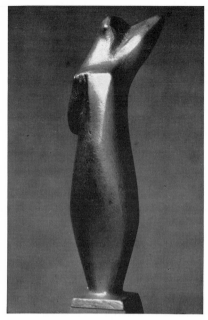

Pinto. Roof of the world. 1958. Bronze.

in the strict sense of the word, and carried on their own work independently of each other. Arnaldo's first sculptures in which there were still traces of influence from Wols and Burri, laid the foundations of an original idiom of abstract art and showed a genuine talent for sculptural invention. An invitation from the American government, enabled him to go to the U.S.A. in 1960 and familiarise himself with industrial materials and techniques, which gave fresh stimulus to his work. In 1961–1962, he organised exhibitions of the Continuity Group at Turin, Milan and Paris, which included work by his brother and avant-garde artists like Fontana and Dorazio. In 1963, he was awarded the First Prize of the São Paulo Biennial and the following year the National Prize for Sculpture at the Venice Biennale. A large exhibition of his work was held at the Marlborough Gallery in Rome in 1965.

His recent, forcefully articulated works have a strength of expression derived from his skilful modulation of bronze; they depend, in the words of the artist, 'on a dialectic process between infinite spatiality and organic structure'. The huge bas-relief in bronze and cement, made for the Volkshochschule in Cologne *(Homage to Technological Civilisation)* shows a greater concern for aesthetic values than experiment. The subtle alternation of 'interior-exterior' in Pomodoro's sculptures of disks, columns, cubes and spheres is unquestionably one of the most exciting art forms of the 'sign culture' that most contemporary artists share. G. C.

realism in particular, she has preserved her independence, and refused to sacrifice her artistic judgment to the dogmatism of artistic theories. Her works always show her concern for line, mass and weight, whether they are in bronze or stone. They also have a certain monumentality about them as, for example, in *Column-Women*. It is not only through the gracefulness and purity of its forms and the severity in its construction that her art is so impressive, but also by its underlying warmth and passion, by the inner movement of her most static creations, in short, by its integrity and all it draws from the dark vitality of an ancient world. F. E.

POMODORO Arnaldo. Born 1926. Morciano di Romagna, Italy. He trained as an architect, then went into partnership with his brother Gio Pomodoro and Giorgio Perfetti and together they founded Studio 3P. First at Pesaro, then at Milan, it was a centre for such varied activities as decoration and goldsmith's work. A wider public came to know them at the 1956 Venice Biennale, where they exhibited a collection of jewels, medallions and small sculptures. Marco Valsecchi wrote, with justification, in the preface to the catalogue, that these delicate ornaments might well contain 'the first ideas, the first signs of a revival of sculpture'. In fact, Arnaldo Pomodoro and his brother turned soon after to sculpture,

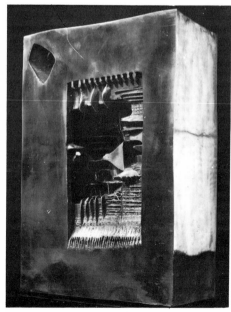

A. Pomodoro. The box. 1962. Bronze.

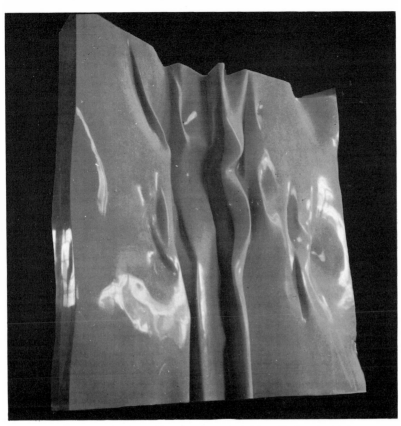

G. Pomodoro. Ghibelline. 1965-1966. Marble. Rockefeller collection, New York.

POMODORO Gio. Born 1930, Orciano di Pesaro, Italy. He was a painter and draughtsman at first, then he went to Florence, where he joined the group attached to the Galleria Numero. In 1954, he founded the 3P Studio with his brother Arnaldo and Giorgio Perfetti, which did a great deal to revive the art of goldsmithery. He began to sculpt at the same time as his brother and worked at first in the same free manner and in every kind of material, which was often coloured. Gio Pomodoro soon began to work independently and evolved an individual style that was quite different from his beginnings. The award of the first prize for sculpture at the Biennale des Jeunes Artistes at Paris in 1959 was a recognition of this originality. This was not all; he always tried to reconcile the idiom and attitude of the avant-garde with tradition. In his large, vital surfaces, there are, in fact, unmistakable reminiscences of classical bas-reliefs; but the modern flavour of the alternation, in a

sort of continuum, between the projections and breaks tends to make each of his works an independent entity, endowed with a remarkable life of its own, which it draws ceaselessly from the light and the reflections of the surroundings, which play over the polished surfaces of marble or bronze. G. C.

POMPON François (Saulieu, 1855 — Paris, 1933). When he had completed his training at the École des Beaux-Arts at Dijon, he went to Paris in 1874. He worked as an assistant to Mercié and Falguière, then Rodin with whom he stayed for more than fifteen years. He did not evolve a personal style till about 1908. Pompon replaced Rodin's poetry of form by a poetry of light, flowing over large, solid masses. His fresh, clear sculpture had an astonishing simplicity. Rodin encouraged him when Pompon showed him his experiments. He was not

Poncet

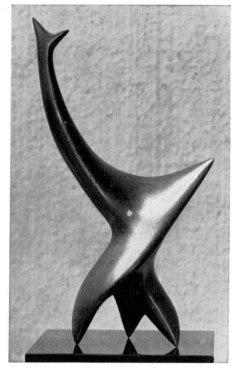

Poncet. Lunar bird. 1957. Bronze.

exhibited was considered revolutionary. A number of writers and essayists, Colette among them, published monographs on his work. However, Pompon was highly critical of his own art and continued his experiments without any sort of self-indulgence. Two years before his death, he withdrew a piece of sculpture from the Salon d'Automne and destroyed it, because he was dissatisfied with it. He died a few days before completing the Bull, which the City of Paris had commissioned. D. C.

PONCET Antoine. Born 1928, Paris. He is the son of the Swiss painter, Marcel Poncet, and, through his mother, the grandson of Maurice Denis. From 1942 to 1945, he attended the Lausanne Art School. When he returned to Paris in 1946, he worked in Zadkine's studio. However, his meeting with Jean Arp in 1952 was the event that had a decisive influence on the development of his art. He was his student at first, then assistant in the work of modelling, polishing and enlargement. After that he turned to abstraction. One day he turned one of his models upside down and discovered that plastic equilibrium was independent of visual habits and that perhaps this fact might lead to fresh ideas in art. Since 1952, Poncet has shown work at the principal Parisian Salons and various international exhibitions. In 1954, the Kunstmuseum of Winterthur organised a one-man exhibition of his work. He made the acquaintance of Stahly, Étienne-Martin and Delahaye, and worked with them on the sculpture and stained glass for the church at Baccarat. Although Poncet has freed his work from Arp's influence, he still has much in common with him through the lyrical spirit of his sculpture and his attitude to life. He used plaster, then cement and stone for a long time, but he prefers polished bronze now, which receives and reflects the outer world on its mirror-like surfaces. The ambivalence of his hollowed forms in marble and aluminium reconstitute the reality of space and light in plastic terms. Although outward appearances are still a starting

exclusively an animal sculptor, as so many art lovers think today, but also an outstanding portrait sculptor. The 1922 Salon d'Automne was a landmark in his career; the *White Bear* (Paris, Musée National d'Art Moderne) he

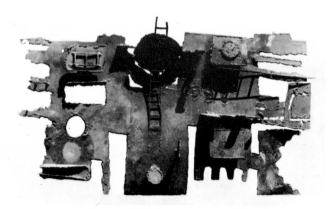

Popovici.
Obsession. 1967. Soldered and painted metal.

point for Poncet, his work has freed itself from any imitation or allusion to them. Public commissions include several sculptures for schools at Laon and Albi and a monument in Lausanne. He was invited to the Symposium in Tokyo in 1963 and contributed to the Biennials of Middelheim (1961 and 1965) and Paris. Since his one-man show at the Galerie Iris Clert, Paris, in 1958, he has held three other exhibitions of his work at the Galerie Roque (1960 and 1962) and at the Galerie Marbach (1965). D. C.

POPOVICI Ion Constantin. Born 1938, Iassy, Romania. His father, Ion Gr. Popovici (1907–1946), was a well-known sculptor and his mother was a painter. The year he completed his training at the Bucharest Art School, Ion Constantin exhibited a sculpture in stainless steel, *Electricity*, which attracted a great deal of attention. Since then, he has been regularly at group exhibitions in Romania. His sculpture was often shown abroad, notably at the Salon de la Jeune Sculpture, Paris (1967), and at the Milan Triennale (1968). A large one-man exhibition of his work was held in Bucharest in 1967. Popovici's usual materials are soldered metal, concrete and stone, which he seems to etherialise and suspend in space. This is the dominant impression left by the cycle of *Scarecrows* and *Obsessions*. His love of the fantastic, which is a reflection of his anxieties and a profound questioning of existence, explains the dramatic tension of his forms and especially the strange irregularity of his structures, honeycombed with space. He draws his symbolism and the vitality of his work as much from Romanian folklore as from the poetry of contemporary technology, sifted through a nostalgic spirit fighting between light and darkness. P. C.

PRANTL Karl. Born 1923, Pötsching, Austria. He trained as a painter from 1946 to 1952 at the Vienna Academy, but he taught himself sculpture. In 1959, he helped to found the Symposium at Santa Margarethen, in Burgenland, and did similar work in Western Germany, Yugoslavia, Israel, Japan, France, the U.S.S.R. and the United States. Prantl's sculptures in bronze and stone are essentially objects for meditation. They are abstract, but there is nothing dry in this abstraction; the structural and textural qualities of his materials are preserved in all their purity. Prantl has taken part in eleven Symposiums and was represented at the 1957 Middelheim Biennial and has held one-man shows of his work at Vienna (1960 and 1965), London (1962) and New York (Staempfli Gallery, 1967). J. L.

PRECLIK Vladimir. Born 1929, Hradec Kralové, Czechoslovakia. He trained from 1950 to 1955 at the School of Decorative Arts in Prague. He is a member of the Journey group, and has exhibited in his own country

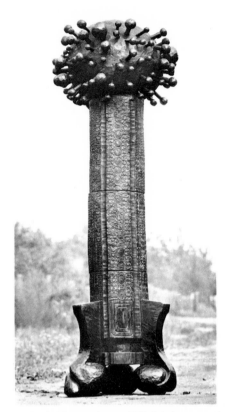

Preclik. Old Provençal town. 1966. Polychrome wood.

and abroad, notably in Yugoslavia, Germany, Italy, Sweden, Belgium and the United States. He has represented Czechoslovakia at the Biennials of Paris (1961), São Paulo (1967) and Venice (1968) and shared in various Symposiums. Preclik is mainly a sculptor in wood, which he used to carve directly as a cabinet-maker when he was only fourteen. After the compact, stylised and figurative sculptures of the years 1958 to 1961, he carved the *Treasures* (1962), huge, blocks, pierced like a display stand, in which colour took the place of precious stones. Several themes converged after 1963: *Thrones*, with their simple forms; elementary assemblages, which invite the hand to touch them and restore their forgotten functions as some sort of ploughshare; *Machines and Antimachines*, whose forms make no pretence of being able to produce or transform, but stand like a challenge to our industrial society, like wooden parodies of metal tools, used in all kinds of possible and impossible work, or the absurd arms invented by man to destroy himself. These plastic parabols were followed in 1964 by massive

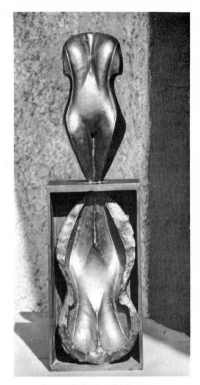

Presset. Reflection. 1966. Bronze.

bility. He was represented at the major Swiss exhibitions of sculpture, notably the Bienne Quadriennale, and was awarded the Premio del Fiorino at Florence in 1968. Like Germaine Richier and Giacometti, Presset was fascinated by the distance and communicability of reality. Man was the unique subject of his sculpture. His first torsos were made of industrial waste: rods, bolts and screws, soldered, filed and soldered again. Later on, he worked on reliefs and tried to establish new relations between the individual and his surroundings, the part and the whole. He made figures on different scales so as to increase the viewpoints. The discovery of the sculptural possibilities for him of the object in 1965 allowed him to return to a more complete expression of primordial form and simple volumes from which his feeling of incommunicability had deflected him. One day, a pair of shoes seemed to form into the image of a torso to him. After this, he was no longer concerned to embody an elusive reality in matter, but to imagine a new reality in an entirely new space. As a step towards this, he gave up using wrought iron for a time and turned to modelling, especially the technique of hollow mould-

constructions, incised with hieroglyphics and reminiscent of ancient musical instruments. From 1965 to 1967, after a visit to France, there followed the series of *Old Provençal Towns*, carved like column-statues in sturdy tree trunks. Their coloured, hieratic architecture is reminiscent of fortified bastions, clinging to impregnable sites. Since 1968, this new found restraint in his style, with its contained and disciplined tensions, was taken further in the purified idiom of constructions with a symbolism that confers a cosmic significance on them. The traditional contradiction between craftwork and mechanics has been mockingly neutralised by the application of brilliant, commercial paint. R.-J. M.

PRESSET Henri. Born 1928, Geneva. After he had completed his training at the Geneva Art School (1947–1952), he had to earn his living with a variety of jobs until 1961 and could only practise the plastic arts through architecture. It gave him a new sensitiveness towards materials and a sense of the monumental. When, in 1959, he discovered the immense potentialities of wrought iron, it proved to be ideally suited to his sensi-

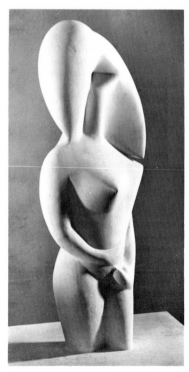

Prinner. Duck-woman. 1933-1934. Plaster.

ing. He produced some surprising effects from this by elaborating the relations of forms with the observer and also with the interior of the work itself. Presset belongs to the tradition of the great, twentieth-century figuratives. J.-L. D.

PRINNER Anton. Born 1902, Budapest. He trained as a painter at the Budapest Academy and went to Paris in 1928. He then gave up his art completely and spent all his time studying occult science and esoteric lore. He returned to painting in 1935. He worked on his own, almost completely unknown, and rarely exhibited his work. He only turned to sculpture in 1939. He gradually freed his work from the principles of abstraction, which no longer satisfied the exalted aims of his art. He wanted to establish through it a sort of communication with the occult forces of the universe and make each one of his sculptures the repository for an unknown, elemental divinity. Two one-man exhibitions over a few years showed the public the results of his experiments: one at the Galerie Jeanne Bucher in 1942, the other at the Galerie Pierre Loeb in 1945. From 1947 to 1949, he worked on the illustrations for the Egyptian *Book of the Dead*, which consisted of sixty-six plates of etchings and engravings. The series of bas-reliefs he made from them was exhibited at the Galerie Pierre in 1948. He has been living at Vallauris since 1950, where he learned to make pottery, and produced some monumental statues, between ten and thirteen feet high, which have an astonishing serenity about them. They are detached from this world and at the same time seem to be able to penetrate its secrets. Prinner has now returned to Paris, where he held a one-man show in 1965, which was like a retrospective. D. C.

PUVREZ Henri. Born 1893, Brussels. He only attended the Brussels Academy for about a year and is practically self-taught. He practises direct carving and has the skill to handle blue stone whose hardness and severity he appreciates. He disdains working from life and the construction of his forms is an intellectual activity. He

Puvrez. Maternity. Stone.
Musée des Beaux-Arts, Brussels.

reacted against academic convention from the beginning and, in trying to simplify the human figure and eliminate all details from it, by 1919 he found himself on the verge of abstraction. He did not stay there, however; his taste for the concrete was too strong for him. He was affected by the wave of Expressionism, which swept over Belgium in the years from 1925 to 1930, and his style drew closer to Zadkine and Jespers. He became interested in Negro art and his wood carving showed its influence, but soon returned to a more traditional manner. His rounded, solid, rather heavy volumes were well suited for display in the open air. In 1937, he sculpted a large *Naiad* for the garden of the Belgian pavilion at the International Exhibition at Paris, and a figure, twenty-seven feet high, for the Water Exhibition at Liège in 1939. From 1946 to 1957, Puvrez lived in Antwerp and taught at the Institute of Art. He is a member of the Royal Academy of Belgium. F.-C. L.

257

r

RAEDECKER Johan Anton, called John (Amsterdam, 1885 – Amsterdam, 1956). Raedecker's father was a decorator and his son was trained in the craft techniques of his workshop, but, as a sculptor, Raedecker was self-taught. A visit to Paris (1912–1914) brought him into contact with the Cubists and they influenced his work for a time. From 1914 till his death, he lived and worked in Holland, where his sculpture was appreciated. He differed from his predecessor, Mendès da Costa, and his contemporary, Krop, in the strain of poetry that runs through his art, which is bathed in an atmosphere of refined sensuality and diffused with a vague, nostalgic romanticism. The relations of sculpture and architecture do not seem to have interested him much. His memorial to Wassenaar in 1936 and the war memorial at Waalwijk (1947) differ very little from his other sculptures: portrait busts, masks, torsos, animal figures and female statuettes. One of the most famous of his works is the *Man with*

Ramseyer. Port. 1962. Musée d'Art Moderne, Paris.

Wings (1922) in cement, a sort of pensive dwarf, which is altogether a strange conception of flight. Raedecker was not concerned to innovate or fashion new forms and he seems to us less a sculptor than a poet carving his dreams from the raw material. The limitations of reality saved him from extravagance and, for the same reason, his portraits are the most appealing part of his work in their serenity and simplicity. W.-J. de G.

RAMSEYER André. Born 1914, Tramelan, Switzerland. He began his training at the Art School of La Chaux-de-Fonds, then went to Paris, where he completed it under Zadkine at the Académie Colarossi (1933–1936). Until 1954–1955, his style was fairly traditional. His first really abstract sculpture, *Eurythmy*, was produced in 1955. It consisted of a band of varying thickness and size, which developed with a continuous movement and an equilibrium of voids and solids, which set the light shimmering along its contours. Ramseyer's method of work was to make a number of preliminary, geometric diagrams and, during this preparatory work, organic forms emerged, which were embodied in his sculpture. *Birth* and *Germination* of 1957, for instance, are derived from plant forms, almost as though the corollas were opening out from the sap surging within. From 1962, the forms seem to sober down and develop along a single, frontal plane. Their concentric, imbricated elements *(Port of Call)* curled into spirals, which were accented by grooves and bends. During the last few years, his sculptures have all been cast in bronze and their style is even more restrained. Their simple ribbons, shaped into rings, opening at the top, or elongated ellipses, with notched, inner surfaces, have acquired a decidedly monumental character. They were intended to be displayed in the open air, or in architectural surroundings, and have found a fitting setting in several gardens and parks of Neuchâtel, Lausanne, Thun and colleges in Switzerland. Ramseyer has been represented at the exhibitions of sculpture at Bienne (since 1954), the Venice Biennale (1956), the exhibition of Swiss sculpture at the Musée Rodin, Paris (1963), and the Exposition Nationale Suisse at Lausanne (1964). An exhibition of his work was held in 1967 at the Galerie Numaga, at Auvernier. H. W.

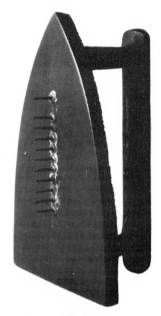

Man Ray. Present. 1921. Laundry iron and nails.

founded with his friend, Marcel Duchamp, and Katherine S. Dreier, he made a *Lampshade*, a simple sheet of metal, painted white and rolled into a spiral. This was one of the first mobiles, which Calder has made so fashionable today. He also exhibited a parcel, tied with string, which looked as if it contained a body, but, in fact, it was a sewing-machine. The package was called the *Enigma of Isidore Ducasse*, the real name of Lautréamont, whom the Surrealists considered one of their direct predecessors. When Man Ray arrived in France in 1921 he had trouble trying to explain to a customs officer the purpose of the objects he carried in his suitcase, like the jar filled with steel balls floating in oil. At the private view of his first Parisian exhibition, in December 1921, he bought an iron from a nearby shop, fixed a row of carpet tacks on it and called the work a *Present*. The *Object to be Destroyed* (1923) is just as famous; he attached a photograph of an eye to the blade of a metronome with a paper clip and the instructions invited the visitor to 'try to destroy it'. It was, in fact, destroyed like most of the objects he invented then. Man Ray has now reconstructed them or made copies. He continued to make others, like the *Memorial to an Unknown Painter* (1955) or the *Untamed Virgin* (1964). Man Ray's position in relation to Pop Artists today is just as vital as it was with the Surrealists in the past. H. W.

RAY Man. Born 1890, Philadelphia, United States. Art today owes a number of inventive ideas in the use of materials and the application of certain processes to Man Ray's creative imagination. Only his three-dimensional work will be mentioned here, the found objects and the assemblages, the first of which appeared in 1917 and were conceived before Dada. For the inaugural exhibition in 1920 of the Société Anonyme, which he

RAYNAUD Jean-Pierre. Born 1939, Courbevoie. His first one-man exhibition did not take place till 1966, at the Galerie Jean Larcade. Three years later, a retrospective of his work had already been organised and, after being exhibited in Amsterdam, Stockholm and Stuttgart, it was shown at the Centre National d'Art Contemporain in Paris. In 1963, his first *Psycho-objects*, made from a combination of real objects, embodied Raynaud's aim to express the poetry of our daily world. Apart from their new function, the colour he gave them and their modal-

Raynaud. Pot 815. 1968. Polyester.

Rehmann

naturally from figurative sculpture to abstraction through his innate sense of rhythm, until he reached a sort of absolute with his 'luminous sculptures' of 1955, which were conceived as 'spatial events', the degree zero of the material occupation of space. After this, he made constructions with soldered wire (1958–1959), which were so light and airy that they were like rays of light poised in equilibrium. Since then, Rehmann has returned progressively to a more earthy, more massive sculpture, which is built up from assemblages of bronze plates. His most recent works are like alveolar conglomerations, swept by a powerful, tragic rhythm and scarred over the surface, which seems to symbolise the grave, meditative soul of the artist impressing the discipline of the human order on the chaos of matter. J.-L. D.

REINHOUD Reinhoud d'Haese, called. Born 1928, Grammont, Belgium. He is the brother of the Belgian sculptor, Roel d'Haese. After his training at the School of Decorative Arts in Brussels (1947–1950), he took part in various group exhibitions and Salons, notably in the Exhibition of Experimental Art at Liège in 1951. He worked at first in plaster and clay, but soon changed to metal. His first one-man exhibition was held in 1956 at the Taptoe Gallery in Brussels. He received the Prize for

ities in the assemblage, he selected the forms for an efficacity that was entirely conceptual; white pebbles suggested sterility, an enormously enlarged flower-pot the negation of a function, sanitary equipment the notion of asepsis, road signs for a 'reality measured by the yard'. All these culminated in his most recent ventures with space and environments, which are made of the least romantic materials imaginable: polyester, enamel, sheet-metal painted in two colours, white and red, and panolac (panels of synthetic material). Raynaud said of them: 'Art and life are one and it is in the search for the poetry of everyday life in manufactured objects or existent structures that I can define my vision. I am in favour of the consumer society and punched cards. I do not feel that I am their victim.' D. C.

REHMANN Erwin. Born 1921, Laufenburg, Switzerland. He trained at the School of Arts and Technology in Zürich, before working in Paris at the Académie de la Grande-Chaumière. He also worked for a time with the sculptor Edouard Spörri. He is living now at Laufenburg. He has exhibited regularly at the Bienne Quadriennale and was represented at the Venice Biennale in 1956. A fair number of his large sculptures can be seen in public and private buildings in Switzerland. He developed

Renoir. The washerwoman.
1917. Bronze.
Private collection, Zürich.

Young Belgian Sculpture in 1957. He has been living in Paris since 1959. His most usual material now is of copper and brass, cut out and welded together. His style is baroque, but a rather rough baroque in which suggestions of figurative art remain. His volumes are round, solid, full and slightly heavy, which are sometimes comparable to Muller's, but they differ from him in their unusual sensuousness. His idiom now is unmistakably his own. The fantastic world he has invented of nightmare figures, monsters and cripples has a vitality and sometimes a harsh humour that are wholly imbued with the spirit of traditional Flemish expressionism. His creative curiosity has made him explore the possibilities of lead, wood and even bread-crumb. Among several one-man shows, Reinhoud has exhibited his work at the Galerie de France, Paris (1963, 1965, 1968), and in Brussels (1964, 1966, 1968). He has also contributed to the Biennials in Paris, Middelheim and São Paulo.
D. C

RENOIR Auguste (Limoges, 1841 — Cagnes, 1919) The case of Renoir, the sculptor. is exceptional in the history of contemporary art. It seems in fact, that sculpture, which he did not turn to until late in life. was a way of going beyond his achievement in painting, a means of giving relief and solidity to the voluptuous

forms he loved to paint. His paintings, particularly nudes of women, show all the signs that he was destined to become a sculptor, in a way, a promise of the future sculptor. They possess such an exceptional sense of volume that it seems almost possible to walk round his models, while the country where they are bathing is only a rather hazy indistinct background in which there is nothing to hold the eye. Such an interpretation should logically end in sculpture. Unfortunately, when Renoir wanted to explore this new medium he was crippled with rheumatism and did not have full use of his hands. Ambroise Vollard thought of a solution and suggested it to him; all that was required was a young artist, who would be skilful enough to interpret faithfully Renoir's ideas and modest enough to efface himself before them. The sculptor, Guino, accepted this difficult task and succeeded remarkably well. He showed such great humility that when, a few years later, he wanted to do his own private work, he did not try to exploit a style he knew so well, but developed his own means of expression and nothing in his work suggests Renoir's Bathers. Before collaborating with Guino, Renoir had already tried modelling on his own and had executed, in 1907, a bust and medallion of his son, Coco. These were the only two works made entirely by him. The partnership with Guino began in 1913 and lasted until the end of 1918. It was in this period that Renoir's most important sculptures were done *(Venus. The Washerwoman)*. He

Richier

,made a fresh attempt with Morel and the result was three bas-reliefs of women dancing and a pipeplayer, which are carefully modelled, but unfortunately lack the opulence of the former productions. It is obvious that the mature, serene beauty that derived from the great figures of the past had an immediate appeal for Maillol and all the artists of the movement that could be called neo-Classical. R. C.

RICHIER Germaine (Grans, near Arles, 1904 – Montpellier, 1959). Few artists could offer such complete coherence between creator and creation; each one of her sculptures came into existence as if they were living extensions of her own nature. In fact, in spite of what has sometimes been said, this daughter of Arles has fashioned sculpture that really belongs to the south of France. There, under the sun of Provence are found the cicadas and mantis that she knew from her childhood and that she transposed from nature to art, enlarged to human scale and tortured into hallucinating shapes. Something of her deep Provençal laughter went into her most fantastic, her strangest productions, even into those that are nearest to a sort of Expressionism, like the impressive arrangement of bone and plant forms in *The Mountain*. Something of the sturdy love of life that was revealed in her intense gaze went into her most morbid sculpture.

She had begun, like others, with a hard manual training in the Montpellier Art School. Her first master was Guigues, who had once been Rodin's studio assistant. In 1925, she went to Paris to train under Bourdelle, as a private student. In his studio in the Avenue du Maine, she did exercise after exercise on classical subjects which she exhibited for the first time in 1934 at the Galerie Max Kaganovitch: busts, torsos, figures of both sexes, executed in a powerful, individual style and an excellent technique. After 1940, she produced the first examples of her unusual tastes in nature. She was an eccentric animal sculptor and was more interested in the unattractive little creatures of the night than the conventional menagerie of Barye or the formalisations of Pompon. Bats, toads and insects appealed to her. *The Spider* (1946) with its web, a wonderful, sculpted network, was the first of a most unusual group. The threads of the polygonal lacework hang from the fragile extremities and seem, not only to bind the main points of the composition, but to project their vitality into the surrounding space; the sculpture already showed a timeless concern for the organising of void. She could have exploited this genre but she went on to take the elements for her subjects. *The Storm* of 1948 was the first of a whole group of large, allegorical figures that were her own, highly personal interpretations of natural forces: *The Hurricane* (1949) and in the same manner, *Ogre* (1951), *Hydra* and *Pentacle* (1954), etc. Her sculptures were no longer logically arranged analyses of the subject that were pleasant to the touch: she was creating a Baudelairian sculpture whose visceral, flayed appearance repelled sensitive minds from her work before the *Christ* of the church at Assy roused such violent controversies (1950). Her aversion to smooth, full shapes became more pronounced; the hollows became perforations so that nothing remained but the suggestion of a head in the shape of a mask (*The Eagle* 1954) and of the human body but its perpendicularity (*The Grain* 1955). At the same time, she roughened the surfaces and defaced them with markings; the bulging stomach of *The Leaf* (1948) is blotched with a plant motif and the back of the *Pentacle* is tatooed in its cavity with a curious spiral. In some of her works the surface is eaten through to the hollowed mass as in the figure of *Tauromachy* (1953), whose belly is bursting beneath our eyes.

Richier. Tauromachy. 1953. Bronze.

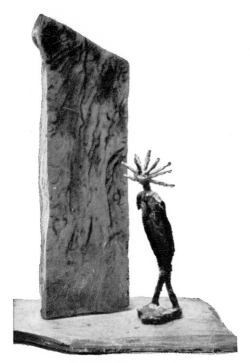

Richier. Thistle (Sun). 1956-1959.
Painted bronze against a slate background.

to the precious figurines in gilded bronze against a background of the same material or even against slate, which were raised in ribs or granulations or set with enamels she had prepared herself.

In 1952 she combined pieces of coloured glass with lead figures, bristling with strange excrescences, which she cast herself. After the painted backgrounds by abstract artists, there followed a second manifestation of her taste for colour, which was born, so she confessed, from a 'disgust with gilded bronze'. This time it produced the painted bronzes and large, coloured plaster sculptures, which were shown in her last exhibitions.

Powerful and contorted, violent and yet graceful, immensely intelligent too, Germaine Richier's sculpture moves us by the energy with which she returns for her inspiration to the immemorial rhythms of life and death. One of her most remarkable characteristics is the way she ignores the diversification of species. She seems to confuse deliberately the natural kingdoms and ignore

Since the exhibition in the Galerie Maeght in 1948, her work has been exhibited all over France and the rest of the world. The impressive one at the Musée de l'Art Moderne at the end of 1956, was an important event in her career. *Don Quixotte*, the *Horse with Seven Heads*, the *Shepherd from the Landes*, perched on his stilts — all these evil presences were close beside the visitor; instead of the usual pedestal, Germaine Richier preferred a thin slab that formed a part of the sculpture, like the base of lead soldiers. The fantasies of Bosch, the grotesque fancies of Ensor and the bird Surrealism of Max Ernst, all seemed to converge on these bronzes with their jagged surfaces, and in the tormented little figures of *Warriors*, *Cock-Women* and *Bird-Men* (1953–1955), as if they were covered with a petrified gangue of clay.

Others of her works are less strained particularly the 'lead sculpture against a painted background', which she began doing after 1951 *(The Town, The Top, Ladder)*. It was an unusual and ingenious collaboration between two arts. Elongated forms, about three feet high, were outlined against abstract paintings by Vieira da Silva, Hartung or Zao-Wou-Ki, which were placed like upright screens, a foot and a half from each figure. This idea led

Richier. Horse. 1957-1958.
Polychrome plaster.

Rickey. Column of triangles. 1968. Stainless steel.

the United States and Germany, he was twice represented at the Kassel Documenta. In 1967, he published *Constructivism, its Origins and Evolution*. Rickey is a kinetic sculptor and theorist. The subtle movements of his sculpture into space are the base of his work. His mobiles in stainless steel (he produced the first in 1945) are constructed of one or more elements, pivoting on ball bearings: *Six Horizontal Lines, Studies for Twenty-four Lines*. He has also made hanging mobiles *(Clouds)*. Their construction is strictly scientific and a prolonged period of experimenting precedes their final assemblage. He wrote: 'When one constructs an object, specifically with the idea of movement, one is always surprised by the movement itself; however carefully the design is calculated, the movement seems to come from elsewhere.' Rickey thinks that a great variety of movement is not necessary and is content to make his sculptures pitch and roll like boats. F. P.

RIVERA José de. Born 1904, Louisiana. He worked eight years in the machine tool industry, engaged on foundry and machine shop practice, construction and operation and experimental design. Then he studied drawing and painting in Chicago under the painter, John W. Norton. In 1932, he travelled in Europe and North Africa to study art. In 1936, he did an important sculpture in aluminium for the Newark airport, near New York. He taught successively at Brooklyn College, Yale University and the State College of North Carolina. He was represented at the '12 Americans' exhibition at the Museum

Rivera. Construction N⁰ 64. 1959. Stainless steel.

the frontiers between animal, vegetable and mineral; animal organs and roots are intermingled in *The Mountain; The Spring* begins as a woman and ends as a jar and the *Grasshopper* has a human head. A liking for the unusual suffix, which is noticeable in some of her titles, is paralleled by her refusal to complete a body except in farce or horror. Is this just Surrealism? or a desire to be a demiurge? Whatever the answer, we owe to this art of beyond the beginning, or beyond the end, one of the most enthralling attempts to sculpture the invisible.
 M. C. L.

RICKEY George. Born 1907, South Bend, United States. His family emigrated to England and he read history at Balliol College, Oxford, from 1926 to 1929. From 1929 to 1930, he attended the Académie André Lhote and the Académie Moderne in Paris. After the war, he completed his education at the Universities of New York and Iowa and the Institute of Design at Chicago. Besides a number of one-man exhibitions in

Roca Rey. Gateway
to the East. 1959.
Bronze and iron.

of Modern Art, New York, and the Salon de la Sculpture Abstraite at the Galerie Denise René, Paris, in 1956. Since 1952, he has exhibited regularly at the Grace Borgenicht Gallery, New York. In 1958, he showed at the Brussels World Fair, in 1960 in the Zürich 'concrete art' exhibition and, in 1963, at Battersea Park, London, and the Gallery of Modern Art, Washington. In 1961, he was given a retrospective show at the Whitney Museum of American Art. His numerous public and private commissions include two bas-reliefs for the New York World Fair (1939) and free-standing constructions for the Statler-Hilton Hotel in Dallas (1955), for 125 Maiden Lane, New York (1958), and a stainless steel sheet-metal construction, 8ft by 13ft, for the south terrace of the Smithsonian Institution, Washington (1964–1967). His work has been acquired by a number of American Museums.

José de Rivera is a purist; his entire concentration is on the immediate visual experience and he deliberately eschews iconographic reference and suggestion. In faithfulness to an objective aesthetic that incorporates a personal vision, he has adhered to a material, a method and a result. His material is highly polished non-tarnishing modern metal, usually forged chrome-nickel or stainless steel, in either rod or sheet form. His method consists in the bending of that single, unified material in gradual curves in space, curves that rest as lightly as possible upon a single point in a base and are made to turn slowly around a vertical axis. His result is a considered, subtle visualisation of the relations of curves in space; relations to each other and to the surrounding space; relations that change gradually as the work or the spectator moves and an accompanying study of light as it reflects in modulation from the sequence of these surfaces. 'The prime function of art is the total experience

of the production. Its social function is the communication of that experience. In the attempt to find plastic harmony in my work, I am always conscious of the necessity for a prime, visual, plastic experience. The content, beauty and source of excitement are inherent in the interdependence and relationships of the space, material and light.' Within the impersonal aesthetic of the purist tradition, de Rivera has achieved an idiom at once strong and delicate and altogether personal. R. G.

ROCA REY Joaquin. Born 1923, Lima, Peru. He was a student at the National Art School and was trained as a sculptor by the Spanish artist, Victorio Macho. His first one-man exhibition took place in Lima, in 1948. He took advantage of his visits to Spain, France, Belgium and Italy to exhibit his work during 1951 in Rome (Zodiac Gallery), Paris (Galerie Breteau), Florence (Numero Gallery) and Madrid (Biosca Gallery). When he returned to Lima, he exhibited his work there and was awarded the Baltasar Gavilan Prize. Later he undertook commissions for the city of Panama, the church of Saint Philip at Orrantia and Lima, where he has taught sculpture in the Art School since 1957. Roca Rey's art depends as much on his creative imagination as on his observation of reality. Victorio Macho taught him to ignore detail and unnecessary refinements and turn his attention to the construction and concentration of forms. Like many modern sculptors, however individual their approach, he uses apparently contradictory means, whether they reflect familiar aspects of reality, or whether these are reduced to patterns, linear rhythms and abstract planes. He has worked in stone, wood and clay and, at present, he has replaced these by materials, like steel, iron,

Rodin

laminated and soldered that modern technology offers the artist. He has no preconceptions and does not keep to a rigid plan. He is adaptable and is above all concerned to give his works the intensity of life itself. He is fond of slender forms that combine and develop into primitive figures, or into symbolic groupings, which are strongly bound together as if in an attempt to resist the powerful solvent of light and who knows? of time too perhaps.

M.-R. G.

RODIN Auguste (Paris, 1840 – Meudon, 1917) Rodin's work has such breadth and is so immense that it is impossible to describe it in precise terms or place it within the framework of a school. He dominates sculpture at the end of the nineteenth and beginning of the twentieth century and even here it is difficult to be exact, because his influence cannot be limited by dates any more than it can be confined to a particular country. He is a part of universal sculpture; he embodied a whole set of aspirations that found their most powerful expression in him. He was at once the passionate end and culmination of romanticism and the birth of modern art. He is more lyrical than Rude and more forceful than Carpeaux. He was as much a realist as Courbet, to such a point, in fact, that he was accused of moulding some of his works on the living model, but he is akin to the Impressionists in his ability to capture the most fleeting instants of life and to perpetuate their ephemerality in a work that lives beyond the momentary action it reflects. His distortions make every part of a sculpture significant and, like the Symbolists, he was more concerned with the meaning of a gesture than its realistic representation. Rodin very soon mastered the techniques of art but it was a long time before he was accepted. When, in 1854, he joined the École des Arts Décoratifs in the Rue de l'École-de-Médecine, Lecoq de Boisbaudran taught him and Carpeaux criticised his studies. Later on, he tried to enter the École des Beaux-Arts, but was refused three times. He worked for a contractor in masonry and

decoration to earn his living. Then he became an assistant of Carrier-Belleuse and had a chance to do work that required more skill and even shared in more important commissions for decorating buildings, like the house of the Marquise de Païva in the Champs-Élysées. The first work he sent to the Salon in 1864, *Man with a Broken Nose*, was rejected. He was called up during the 1870 war, invalided out of the army and, when the war ended, went back to his post with Carrier-Belleuse. Carrier-Belleuse had important contracts in Belgium. He entrusted some of them to Rodin, who went to Brussels and stayed there for five years (1871–1877). Rodin entered into partnership with the sculptor, Van Rasbourg, and this is how several monuments and buildings in Brussels came to be decorated with Rodin's work, notably the Palais des Académies and some of the houses in the Boulevard Anspach. In 1875, he visited Italy to acquire a knowledge that he considered indispensable, especially from Michelangelo, who helped, as he said himself, to free Rodin from academicism. The work he sent to the Salon in 1877, *The Age of Bronze*, roused a lively controversy and it was then that he was accused of moulding the figure on the living model. A committee of enquiry was elected and the artists argued violently for and against this work that possessed such astonishing power. Rodin protested, joined the battle himself and finally made them acknowledge his gifts. His realism and profound knowledge of the human body came from watching his models moving freely about his studio, unconsciously adopting the poses he wanted.

His supporters became more and more numerous until the Under Secretary at the Ministry of Fine Arts commissioned him, in 1880, to do the door for the Musée des Arts Décoratifs, which was planned to be built by the river on the site of the old Cour des Comptes. That was the origin of the *Gate of Hell*. He worked ceaselessly at this monumental task until just before he died, either gradually incorporating figures that had been free-standing sculptures (*Adam*, 1880; *The Thinker*, 1880), or by lifting out individual subjects *(Lust*, 1882; *The Prodigal Son)* and entire groups (*Fugit Amor*, before 1887; *The Kiss*, 1886), which were originally conceived for the project. It is an astonishing proof of Rodin's continuity of thought and a reflection of a stability that nothing could shake. Whatever he learned from others and whatever influences he received Rodin absorbed them all without his own art becoming shaped by them. Neither the years of hardship nor the years of success could lessen his urge to create, which was like an instinct. Neither a knowledge of the masterpieces of the art of the past, nor his admiration for Donatello and particularly Michelangelo, nor his enthusiasm for Gothic art (an enthusiasm that made him undertake a real 'tour of the cathedrals') succeeded in changing or leaving its mark on his personality. All through his life, in poverty and in triumph, Rodin was wholly absorbed in his sculpture and ceaselessly added to it. This probably explains why so many of his works are mentioned in all the memoirs

Rodin. Study for "Balzac". Final state. 1897. Plaster. Musée Rodin, Paris.

Roman. Sculpture. 1968-1969. Sheet metal.

About 1880, life became easier. The young painter, Maurice Haquette, who was in the art department of the Sèvres factory and was brother-in-law to the Under Secretary at the Ministry of Fine Arts, intervened on his behalf and a large studio in the Rue de l'Université at the government marble repository was placed at his disposal. This did not save many of his works for a long time from rousing violent controversies, particularly his *Victor Hugo* of 1896 and, especially, the famous *Balzac*, which the Société des Gens de Lettres had commissioned from him, and at the last moment, refused to honour their commitments. It did not occupy a position worthy of it until 1939, at the intersection of the Boulevard Raspail and the Boulevard Montparnasse. He had better luck with the *Burghers of Calais*, which the municipality of Calais commissioned from him, since the work was finally erected in 1895, and even that was six years after its completion. However, after 1900, when Rodin held an important retrospective exhibition of his work in the Place de l'Alma, he suddenly became famous and his genius was hardly even questioned. Now, because of his legacy to the country, a wonderfully complete collection of his work can be seen either in Paris, at the Rodin Museum in the Hôtel Biron, or at the Rodin

Museum at Meudon. They make one aware of the stature of this protean genius. Rodin's tormented, dramatic world was fiercely opposed to classicism and its static ideals and, because of that, he marked the beginning of the modern period and remains an inspiring example of the greatest of human values. R. C.

ROMAN Victor. Born 1937, Martinis, Romania. He began his training at the Bucharest, then completed it in London. He has already had several one-man exhibitions in his own country, as well as Rome, Lausanne and London. In 1967, a book on his work was published by the Méridiane publishing house of Bucharest. Roman soon discarded the canons of socialist realism and, by 1958, his sculpture was a revaluation of abstract motifs and a geometric stylisation of Romanian folk art. This evolution was accomplished under the sign of Brancusi, who was a major influence on him at one time. His favourite materials then were stone and bronze. Subsequently, his simplified forms, opening out to light and space, were a free interplay of the voids he had hollowed within them. His sculptures today, in synthetic resins, metal and jointed wood, have acquired through the reduction of the masses, a lightness and flexibility that make them look like signs, or antennae feeling into space. D. C.

ROMAN ROJAS Samuel. Born 1907, Rancagua, Chile. He came from a humble, peasant family and began to teach himself the art of sculpture when he was ten years old, modelling clay and carving wood. In 1924, he left the country for Santiago, where he attended sculpture classes at the Art School. Hardly a year had passed before he was awarded a medal at the national Salon. He was awarded the Humboldt scholarship in 1937 and went to Germany, where he lived for two years. In 1938, he took part in the International Exhibition of Applied Arts, at Berlin, where he was awarded a prize for his collection of ceramics. He already possessed an enviable reputation when he returned to Santiago, but poverty awaited him. He did not work any the less enthusiastically. After the war, he was appointed to teach pottery at the Art School and the state commissioned him to do various memorial statues for the parks in Santiago. The official recognition of his reputation with a retrospective did not come till 1950 in Santiago, where eighty-two of his sculptures were exhibited. Roman Rojas is one of the most winning personalities in the history of Latin American art. The Chilean people have found in him their most gallant representative. He was a seed sown in stony soil, a natural genius cultivated by art and an example of what the human will can do in its struggle against circumstances. He explored the secrets of his art at an early age and used every kind of material ranging from clay to the precious stones in which his country is so rich. He models clay with the skill and delicacy of

the great pre-Columbian potters. He is equally success-ful in carving granite, sculpting marble and forging iron, and endows his monumental works with impressive grandeur. His idiom is figurative, but he is as far from the imitative representation, taught by the art school, as he is from the excesses of modernism. He has tried to interpret the deep realities of his country and people with the most appropriate means at his disposal. His powerful lyricism has done the rest and communicated a keen proud poetry to his works. M.-R. G.

ROSSO Medardo (Turin, 1858 — Milan, 1928). He joined the Brera Academy, Milan, in 1882, but was expelled two years later for inciting his fellow-students to protest against the traditional methods of teaching. Several of Rosso's early works belong to this period *(Singer Walking, The Garibaldian),* which he exhibited at Milan in 1882, then at Rome the following year under the auspices of the Fine Arts Society. From 1884 to 1886, he lived in Paris and returned there in 1889 and enjoyed a gratifying success, particularly in avant-garde circles which included Rodin, Degas, the collector Rouart, whose portrait he modelled in 1890, and Émile Zola. Some of his best sculptures belong to this period: *Laughing Woman* (1890), which Rodin exchanged for one of his torsos, *Woman with a Veil* (1893), *Sick Child* (1893), *Yvette Guilbert* (1894), *Paris by Night* (1895).

Rosso. Ecce Puer. 1910. Bronze.
Musée National d'Art Moderne, Paris.

Rosso. Portrait of Yvette Guilbert. 1894.
Galleria Nazionale di Arte Moderna, Rome.

An argument with Rodin, after the latter had modelled his famous *Balzac* in 1898, about which of them was the first to introduce Impressionism into sculpture, strained relations between the two artists and began a fruitless controversy, which has been taken up by critics since, in spite of the impossibility of comparing two natures that were so different, although their aims were similar. Medardo Rosso lived most of the time in Milan until his death in 1928 at the age of seventy, enjoying a growing reputation in Italy and abroad. An important retrospective exhibition of his work was held at the Venice Biennale in 1950.

Although one part of his work was derived from genre sculpture, his mature work had no such associations and was surprisingly audacious for his time. Rosso's vision of reality was essentially pictorial; he turned naturally to delicate surface effects, which were the only means sufficiently subtle to render both the quivering life of forms and the sheath of light enveloping them. He used wax as the most appropriate material for his purposes, because it is such a malleable and fluid substance. In spite of its modernist qualities, Medardo Rosso's work today seems the consummation of the nineteenth-century, sculptural tradition, but this is probably largely owing to the melancholy, twilight feeling that permeates it. Rosso and Rodin 'constitute a decisive turning-point in nineteenth-century European sculpture, which achiev-ed in them its ambition to represent the physical reality of things, while at the same time it recognised its failure

to achieve it (Lavagnino). In fact, after Rosso and Rodin, it was impossible to take sculpture further along the same road and the work of both men stands at the dividing line of two periods, whose emotional and intellectual attitudes are separated by an incommensurable distance. G. C.

ROSZAK Theodore. Born 1907, Poznan, Poland. The future sculptor of the *Spectre of Kitty Hawk* was only two years old, when his parents, who were farmers, emigrated from Poland and settled in Chicago. He was twenty-four when he went to live in New York, after years spent as a student then teacher, in the art schools and institutes of Illinois, and he produced his first attempts at modelling. In 1946, there began to appear the spiky, metal sculptures with their tormented symbolism, which have made him famous. As a matter of fact, it was neither sculpture nor painting that interested him at first. Roszak was a draughtsman and lithographer before becoming a painter and a Constructivist before turning to other forms of sculpture. The problems of structure were for a long time far more absorbing to this adept of Moholy-Nagy's ideas than the problems of colour and surface. However, the experiments of his formative years, whether graphic, pictorial, neo-Plastic or simply concerned with craftsmanship and industrial technique, cannot be dissociated from his present work. 'Drawing, painting and the building of constructions are all directly connected with my love of metal,' he declared in 1949 in the course of an interview. 'It seems to me,' he added 'that one of the vital, essential qualities in creating sculpture is an attitude that integrates the widest sculptural experiments.' In spite of this conviction about the very real unity of techniques, Roszak's career can be divided into three different phases. Between 1930 and 1947, he painted various subjects which absorbed in

Roszak. Spectre of Kitty Hawk. 1945-1947. Steel, bronze and copper. Museum of Modern Art, New York.

turn, but always in the same precise, unified style, the vaguely romantic realism of Speicher and Kroll, who were his first masters, the fantastic perspective of Chirico and purist exercises in the manner of Ozenfant. At the same time, he was sculpting, or rather, building constructions. After his early attempts in clay and plaster (1931), he was engaged for seven years (1936–1943) on constructions based on the pure geometry of forms: wood and plastic relief and filiform, spatial structures, developed from the line and the core. Then after 1945 metal forms appeared that were much freer and more dramatic. They were the products of a consummate knowledge of welding and alloys and seemed to find again in them the romantic freedom of his early works. The artist has explained himself how, during the indispensable process of welding together large pieces of sculpture, he discovered its fascinating effects, eroded surfaces and variation in the texture of welded and hammered metal. An obsession with the nature of material could have led to preciousness in the treatment of the surfaces, but Roszak was aware of this risk. A sculptor can be so absorbed in technical development that he ends by being guided by the accidents of the material alone. In fact Roszak remarked that 'there is a constant inter-

Roszak. Iron gullet. 1959. Steel.

action between material and ideas and there is no denying that the work of the hand can itself inspire ideas. This incidental effect of the material is valid when it keeps a proper relation to the whole.' This compromise between the directing idea and the controlled exploitation of the nature of materials appears plainly in the whole of Roszak's work since the war, which is dominated by the luxuriant, dynamic, expansive style that has become synonymous with his name today. The compromise also exists in the relation of the sculpture with reality. In a collection of his works, as in the American pavilion at the Venice Biennale in 1960, there is a noticeable repetition in one work after another, of a few, favourite abstract motifs that are almost endowed with a life of their own, like the crescent in the famous *Spectre of Kitty Hawk* (1945–1947) or in *Cradle Song* (1956). Yet a remote figurative element remains in these works that suggest an atmosphere, an impression, even a narrative. *Thorn Blossom*, for instance, which represents the opening of a flower, is connected with an event in the sculptor's family life, the birth of his daughter that year. Recent memories of the war and its destruction appears in the upthrust of the delicate flower that has to throw a shield of thorns over itself for protection. Similarly, *The Whaler of Nantuckett* (1952–1953) combines the aggressive outline of an anvil, seen in the glow of the forge, and ideas of pursuit, suggested by reading *Moby Dick*. In *Sea Quarry* (1956) there are again certain suggestions of sea-weed and geodesic co-ordinates. Roszak draws his themes, then, from existentialist and literary sources. His drawings are even more romantic than his sculptures, graphic conflagrations that contain embryonic ideas and prefigurations of the sculpture. Such are Roszak's aims and endeavours, which make him one of soundest of contemporary sculptors. M.-C. L.

ROUILLER Albert. Born 1938, Geneva. He trained at the Art School in Geneva. His talents as a sculptor, backed up by an immense capacity for work and a strong artistic personality, were recognised early. In 1962, he was represented at the Bienne Quadriennale and other exhibitions of contemporary sculpture at the Musée Rodin in Paris and Vienna. He has fulfilled a number of commissions for public sculpture, notably at the Cité Universitaire, Geneva, and the Geneva School of Commerce. He handles any kind of material with ease, especially polyester and modelling in plaster for casting in aluminium. His sculpture is abstract, but as a preliminary stage, he makes organic forms, which can be easily connected with natural forms through their variety, dynamic rhythm and structure. Like the Japanese, he works on a form, controlling it carefully all the time, until it reaches a stage that is its final and natural mutation. His works became more refined and more contrasted with time, the transitions from one part to another were more unexpected, while the light penetrated them more and more deeply. Since 1968, a new dynamic manner

has appeared, half way between a mechanical articulation and the structure of a skeleton. His sculptures elongated and a strongly marked rhythm accentuated the form as well as the contrast between solid and void, creating a delicate equilibrium, which was far from traditional notions of axes and symmetry.　　J.-L. D.

ROULIN Félix. Born 1931, Dinant, Belgium. He was one of the founders of the Axe 59 group and, in 1961, was awarded the Belgian Prix de la Jeune Sculpture and the Prix Rodin. He has been represented at the principal international exhibitions, the Biennials of Venice, São Paulo and Paris, where he was awarded the Prix de la Critique in 1965. Roulin began as a furniture and jewellery designer, but he now devotes all his attention to sculpture. Large-scale work attracted him, which naturally brought him into association with architects and he sometimes designs his own architecture. His work is stamped with a sort of realism, compounded of expressionism and abstraction; it is the work of a poet, who has given concrete form to his dreams, and the work of a pure sculptor in the plastic strictness of his form. His 'architecture-sculptures' have grown out of the dialectic between container and contained. But this is only one part of his production. He often uses, for the rest of his work, mouldings or imprints of objects, fragments of reality, which were at first used to create abstract forms and, since 1957, as a means of recreating the subject. Roulin has been a skilled caster of lead and

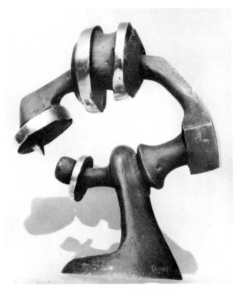

Rouiller. Sculpture. 1967. Cast aluminium.

271

Roussil

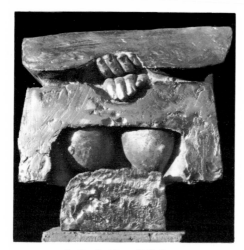

Roulin. Sculpture. 1966. Brass.

masses were generally rounded and sensuous; angles, sharp edges and straight lines were rare in them, just as in natural forms time has smoothed them away. Roussil has been living in the Alpes-Maritimes since 1957 and has held two other one-man shows in France: Nice (1961) and Cannes (1968). His work has been exhibited twice in Montreal (1962 and 1968) and a large retrospective was organised at the Museum of Contemporary Art. Roussil's materials are now varied with waste wood (old beams, telegraph poles and railway sleepers), which he assembles into sculpture, lead and concrete. After a series of large, static works, his recent constructions can be set in motion by the observer. At the same time, he has been experimenting with habitable sculptures. Roussil was invited to the Symposiums of Yugoslavia (1961), Montreal (1964), Quebec (1966) and Grenoble (1967). D. C.

tin, but recently has preferred using bronze and brass, which he casts with the cire perdue process. His last sculptures are metaphorical transpositions of nature; they combine actual imprints of real objects (the human body, for example) and strictly abstract forms. It establishes a sort of ambiguous interplay between literal significance and formal analogy. D. C.

ROUSSIL Robert. Born 1925, Montreal. He trained for two years at the Art Association of Montreal (1946–1948) and held his first exhibition during which one of his works had to be withdrawn because of the scandal it caused. The frankness and vitality, particularly of his nudes, have caused Roussil's art to be attacked for immorality, even obscenity. Scandal seems to pursue him inevitably; one of his sculptures was broken by indignant visitors to the exhibition, held in 1951 at the Agnes Lefort Gallery in Montreal. When he returned from his first visit to Paris in 1953, he even found that his studio had been locked by the municipal authorities. His style was realistic in the beginning, but soon became symbolic and allusive. In 1954, he executed wood sculpture, *Human Galaxy*, thirty-six feet high, for a public square in Toronto. The Galerie Creuze in Paris held an exhibition of his work in 1956. His works, at this time, still preserved the vestiges of outward appearances. The

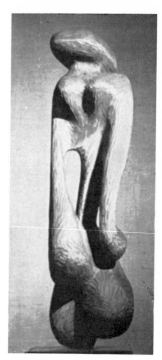

Roussil. Sculpture. 1958. Wood.

S

SAINT-MAUR. Born 1906, Bordeaux. He made his name at first as a painter and founded the Salon de l'Art Mural in 1935. He left for India in 1939 and was forced to stay in Indo-China for the duration of the war. There he learnt the technique of lacquering. When he returned to France in 1947, he exhibited at the Musée Cernuschi a huge collection of panels and sculptures in lacquered wood. After that his experiments were concerned with problems of form and colour and he gradually gave up painting to give all his time to sculpture. While continuing to direct the Salon de l'Art Mural, he has taken part, since 1954, in the Salon de la Jeune Sculpture and the Salon des Réalités Nouvelles and he also exhibits his work with the Espace group. Saint-Maur's reputation is closely connected with his use of a new material, polyester, which he was the first to experiment with. This extremely malleable material has a base of liquid synthetic resins and its great advantage is that the artist can colour it as he likes. It is very light, which is a useful quality for large-scale sculpture. In 1956, Saint-Maur held two exhibitions of collections of his work, at the Galerie Iris Clert in Paris, and at the Ex-Libris Gallery in Brussels. Saint-Maur's polyesters, whether they are translucent or opaque, dull or highly polished, are a most suitable medium for his ideas, which are entirely concerned with the potentialities of coloured light. He has sculptured portraits, made stained-glass windows, a baptistry, a fountain and vigorous abstract constructions in polyester, as if he wanted to show the innumerable purposes it can serve. The press called him 'the plastic man' and gradually his fellow-artists have been tempted by his results to try his material and processes. Saint-Maur's work is dramatic and violent and, as such, is a faithful expression of contemporary feeling. Recently, his very individual use of polyurethene foams has given his art a sort of gestural freedom with imaginative strength. From his earlier habitable sculptures to his present vehicles, which the observer can also enter, Saint-Maur has explored unendingly the exact relationship of form and colour in polychrome sculpture. His last one-man show in Paris was in 1961 at the Galerie Iris Clert, but he has since taken part in several group

Saint-Maur. Listening form. Blue polyester.

exhibition in France and abroad, notably at Cannes (1969) and at the University of Caracas (1969). D. C.

SAINT-PHALLE Niki de. Born 1930, Paris. She lived in New York from 1933 to 1951. She painted from 1952 till 1956, the year when she composed her first plaster reliefs and objects. From 1960 to 1961, she was engaged on shooting at plastic bags filled with paint. The really creative phase of her art began soon after with her 'blasphemous episodes' at the Galerie Jean Larcade, Paris, which were the raw expression of a particular state of love-hate. The Hearts, Married Women and Animals were acts of exorcism. The triptych of the *Married Woman*, which she exhibited at the exhibition of 'Mythologies Quotidiennes' in 1964, was a synthesis of her previous works and an expression of the threats and mockery that bear heavily on women. The idiom here placed the object in a new situation in which it wedded and modelled the form, with a consequent contradiction between two irreducible autonomies, the arranged components (toys, waste, bank notes and bits of cloth)

Saint-Phalle. Elizabeth. 1965. Plaster.

is more vulnerable than any other artist, not as she says, because she is a woman, but because her art is a public autobiography, the crucible of violent, contradictory forces, tearing and obsessing her, and the difficult projection of a femininity that tries to be a driving force.

G. G.-T.

SALVATORE Messina Salvatore, called. Born 1916, Palermo, Italy. He is the son of a sculptor and learnt to carve marble when he was a child. He trained at the Palermo Academy, went to Trieste and from there to Milan. His early work was figurative and influenced by Martini. His first exhibited work was a bas-relief, *The Family*, at the XXII Venice Biennale in 1940. He began to be interested in form for its own sake in 1945 and *Torso* of that year shows how he stripped his work of objective allusions. After 1948, his forms became purer and simpler from his study of Brancusi and Arp who made a deep impression on him. A fifteen months visit to the United States (1952–1953) during which he took part in several exhibitions, introduced him to fresh ideas. His works are remarkable for the consistency of their forms and his choice of subject, which in its recurrence reflects a type of form. A curved line, sweeping into space, is the basis of his sculptures, but the line is so sinuous and graceful that it has several points of view and requires the observer to walk round each work before he can appreciate its full significance. Since 1945, Salvatore has been represented in the major exhibitions in Italy and abroad. Two collections of his work, one

and the whole work. The pallid totems of the Married Women and the *Great White Lying-in* were the figureheads of painful, anecdotic definitions of the human condition.

These crazy, dishevelled, rather heteroclite works were succeeded by a Pantagruelian crowd of joyous ogresses, which were quite unambiguous. The most striking were large idols with anonymous faces and black women (1965). Admittedly, almost simultaneously, Niki de Saint-Phalle indulged in a decorative unreality, which consisted in covering her creatures with a sort of complicated tattoo of wool threads and meaningless magic figures, which conferred something of an eternal quality on the forms and eliminated the accidental. These Ubuesque presences, with their swollen bodies, are outside any spatial or temporal context, throw-backs to the mythical sculptures of remote ages or the sacred objects of a forgotten ritual. The enormous *Nanas* she made in 1966 for the Moderna Museet of Stockholm *(Hon)* and for the Roland Petit ballet, *In Praise of Folly*, belong to this period. Sophistication and instinct are the two creative impulses of this strange woman, who

Salvatore. Fecundation N° 2. 1964. Bronze.

Santa. Sexy goddess. 1968. Polished brass

(*Sexy Goddess*, 1968). Santa uses concrete and stainless steel in his sculptures commissioned for architecture, as these are more suitable than his usual materials. D. C.

SCHLEMMER Oskar (Stuttgart, 1888 – Baden-Baden, 1943). When he had completed his training under Adolf Hölzel at the Stuttgart Academy (1905–1909, 1912–1914), where he made the acquaintance of Willi Baumeister and Meyer-Amden, Gropius invited him to join the staff of the Bauhaus after the war. He taught sculpture and theatrical production there from 1920 to 1929. In 1929, he was appointed to the Breslau Academy, which he left three years later for a post at the Berlin School of Art. The Nazis dismissed him in 1933 and he retired to the south of Germany. Although Schlemmer was primarily a painter, his plastic work has a considerable importance; in many ways, they anticipated developments in sculpture that did not appear, at least in Germany, until after the Second World War. Only thirteen of his works, eleven of which are reliefs, survive from the period 1919–1923. His most important realisation, the decoration of the workshops building at the Weimar Bauhaus by a series of reliefs in coloured cement was destroyed in 1928 by the early vandalism of National Socialism. This decoration, which combined painting and sculpture into a single, ingenious unit, consisted of

at the Venice Biennale in 1956, the other at the Rome Quadriennale in 1960 established his reputation and confirmed the value of his experiments. A room was again reserved for him in 1964 at the Venice Biennale.
G. C.

SANTA Claude Santarelli, called. Born 1925, Paris. He trained at the École des Beaux-Arts in Paris. He was represented at the principal Parisian Salons and was invited to the Symposium of Montreal in 1965. His first abstract sculptures (about 1958) consisted mainly of accumulations of scrap metal, soldered into assemblages. Later, there came a constructivist phase in which the work was based on vertical and horizontal lines. Then he gave up using iron for thin sheets of brass, which he twisted, rumpled and folded, like paper, in a markedly eccentric style. The need for discipline has made him return in recent years to a more constructive approach. Using thicker sheets of brass this time, he made masses with smooth, polished surfaces, which contrasted with some forms made in folded brass as before. His latest works are strictly symmetrical and would be better described as anthropomorphic symbols than figures

Schlemmer. "Homo". 1931. Wire.
House of Dr Rabe, Zwenkau.

275

Schnabel. Vertical labyrinth. 1964.
Soldered duraluminium.

architectural elements that were basically figurative and a careful calculation of spatial values. Schlemmer, however, believed that his chief ambition, the realisation of 'man in space' could only be fulfilled in the mediums of painting or ballet. When a house, built in 1931, by Rading for Dr. Rabe in Zwenkau, was being decorated, Schlemmer had to construct a new relief which he reduced to pure sculptured design. Thus the first German 'construction in iron wire' was created and, at the same time, the last version he did of the subject 'Man'. It consisted of a formalised figure, made up of circles and identical curves, surmounted by a huge head, entirely constructed of blades of steel. A compass-dial, with its axis in the form of a cross, related the reliefs to each other. Schlemmer's contribution to mural sculpture was not fully appreciated until much later. J. R.

SCHNABEL Day. Born 1905, Vienna. After she had trained as a painter at the Vienna Art School, she went to Holland and, for three years, studied architecture and worked as a sculptor with Barend Jordaens. Then she went to Paris and worked in the studios of Gimond and

Malfray. During the war, she lived in the United States (she is now an American citizen) and continued her sculpture under the supervision of Zadkine. On her return to Europe in 1946, the abstract forms that she had been developing for some time acquired a new conviction and dominated her sculpture. The two strains of expressionist, slightly extreme forms and geometric constructions were of equal importance in her work and together reflected the whole personality of the artist. In 1953, she began working in metal and the problem of the interpenetration of sculptural forms with space became her primary interest. She soldered scrap iron, picked up in foundries and car dumps, and found in this direct contact with material some stimulating possibilities, which were imaginatively elaborated. The gradual simplification of her compositions culminated with the *Large Copper Sculpture* of 1964–1965, in hammered and soldered metal, built into a brilliant interplay of lines and curves. A more constructive attitude was apparent in the *Labyrinth,* which she made in 1964 from cutting out sheets of brass. They were the prelude to sculptures that were more like architectural maquettes, conceived on a human scale, like *Arc*, made of flexible elements, hinged together, and realised in a 30ft high model in the United States. Besides a personal exhibition at the Palais des Beaux-Arts in Brussels (1953), Day Schnabel has exhibited four times in New York at the Betty Parsons Gallery between 1946 and 1957 and also at the American Cultural Centre in Paris in 1968. H. W.

SCHÖFFER Nicolas. Born 1912, Kalocsa, Hungary. He trained at the Budapest Art School, then in Paris, where he went to live in 1936. He has since obtained French nationality. He began his career as a painter. After the war, he was attracted by Mondrian's neo-Plasticism and tried to apply its principles to three-dimensional work. He assembled mobile elements in such a way that they administered concentrated shocks to the senses of the observer. This was the first step towards the invention between 1948 and 1950 of what he called 'spatiodynamism' The first works of the kind bore an superficial resemblance to the constructions of Jean Gorin, the French follower of Mondrian. But Schöffer was more ambitious. In 1954, he associated with the composer Pierre Henry in making an architecture-sculpture, 192ft high, for the Salon des Travaux Publics, which emitted waves of sound. He then had the idea of using electronics to combine form, movement and sound in works that were made visually exciting with discs and blades of steel. An engineer helped him to make his first cybernetic sculpture, *Cysp. I*, which he exhibited on 28 May 1956 during the 'Nuit de la Poésie' at the Théâtre Sarah Bernhardt. The same year, *Cysp. I* was integrated into a ballet by Maurice Béjart, which was performed on the terrace of Le Corbusier's Unité d'Habitation (block of flats) in Marseilles. *Cysp. I*, responding to the electronic brain, hidden in the base,

Schöffer. Lux 4. 1957. Duraluminium.

Schöffer made some small-scale works, but he did not generally design for the bourgeois family and the private gallery. Conceptions that were increasingly architectural in character were the logical outcome of his ambitions. In one direction, it led to town-planning; he imagined a vertical city for work and business, higher than the Eiffel Tower, and a horizontal city for living and leisure that would be a permanent exhibition in itself (1962). The same year, he presented at the exhibition, 'L'Objet', in the Musée des Arts Décoratifs, Paris, a *Light-wall*, which offered a dazzling audio-visual show in itself. In 1967, he produced a grand project for Paris in the year 2000. This was a mobile tower for the Paris to Saint-Germain motor road, in stainless steel, nearly 1000ft high, which would emit brilliant, multi-coloured flashes of light, in a rhythm controlled by a computer. It would be equipped with 2250 projectors, 2085 electronic flash lights, 363

stirred its limbs and moved among the performing dancers. Schöffer's early training as a painter was perhaps responsible for the light he added to his spatiodynamic sculptures. In 1957 Schöffer conceived and constructed a mobile sculpture, consisting of shafts, discs and blades of steel on which beams of light were thrown by a projector across two sets of transparent blades, coloured red, yellow and blue. The two sets of blades involved are inside the projector itself, the other in front of it, like the shutter of a cinema projector. The light effects from this revolving sculpture were then thrown on to a plexiglas screen, where forms, colours and rhythms, all possessing the essential qualities of a work of art, were superimposed or juxtaposed, composed or decomposed in a planned and yet capricious order. Sounds, produced by percussion or electronically recorded, accompanied the visual, tactile and dynamic reactions roused by this ingenious creation. It is extraordinary that as the images follow each other perpetually but never monotonously on the screen, it is possible to forget the mechanism that produces them and surrender oneself to the endless aesthetic pleasure it stimulates.

Schöffer's ideas and means of expression had now fully matured and his work became more and more audacious. In 1960, he exhibited the *Musiscope*, a sort of piano or organ, which projected luminous images onto a plexiglas screen when the keys were played. In 1961, he built a pivotting, cybernetic tower, 170 ft high, in front of the Palais des Congrès, Liège. It was lit up and produced music. The sixty rotating mirrors in polished aluminium, equipped with electric motors and controlled by an electronic brain according to changes in the surroundings, reflected rays of light, while microphones, also electronically controlled, played music. The tower was as much an architectural as a sculptural creation.

Schöffer. Cybernetic light-tower. Project for The Rond-Point de la Défense, Paris. 1968.

rotating mirrors and 14 curved mirrors, fixed on the tower to reflect the beams of light, while 15 powerful projectors would guide the supersonic planes touching down at Roissy-en-France. It is a mistake to think that Schöffer is a megalomaniac or a dreamer. Large industrial companies have taken an interest in his experiments and contributed to them. Musicians, like Pierre Henry, Henry Pousseur, and Pierre Boulez have composed scores for his sculptures, and they have inspired cinema producers like Claude Lelouch. Schöffer is the first artist to have made use of the conquests of science and technology to create a new vision and a means of expression to the measure of our times. F. E.

SCHULTZE Klaus. Born 1927, Frankfurt-am-Main, Germany. He is really a ceramist, but his approach is that of a sculptor and has little in common with the craft of the potter. The powerful, massive character of his volumes is accentuated by brilliant colours obtained by heating enamels. After experiments with embossing, inlays of mouldings and folded surfaces, Schultze began a series of heads, followed later by busts, composed of elements fitted and imbricated rather like a three-dimensional puzzle. More recently, these heads have been combined plastically with slabs, which give them the appearance of grave stelae decorated with imaginary, inscriptions. They are strong, moving works, charged with a surprising imaginative power. Schultze has had more than twenty one-man exhibitions in Germany, Switzerland and France (Galeries Suzanne de Coninck, La Demeure, La Roue). D. C.

SCHWITTERS Kurt (Hanover, 1887 – Ambleside, England, 1948). He was one of the outstanding figures of German Dadaism. Painter and composer of innumer-

Scrive. Sculpture. 1968. Stone from Le Gard.

able collages made of waste materials (tram tickets, receipts, faded bits of paper), he used the same method for his assemblages and integrated all kinds of detritus in them: pieces of wood, rope, wire, rags, wire netting and other metal scrap. These 'object-paintings' have become the models for many an artist today. Schwitters's sculptures, in the strict sense of the word, are rare. The *Gibbet of Desire* is an example. It consists of a wheel fixed to a gibbet, and the loop of the rope, dangling from it, disappears behind a screen of cardboard. He called all his works, *Merz*, a syllable of a word cut out from a poster advertising a bank and in the end he applied it to all his artistic production. In 1920, Schwitters went on to works of a more architectural nature and built the first *Merzbau*, or Merz House, which was like a child's toy. It was the innocent precursor of the famous *Merzbau*, which was begun in 1923 and, after ten years work, spread through two storeys of his house in Hanover. This monster sculpture, which he also called the 'Cathedral of Erotic Poverty', was entirely built up of everyday waste. It contained recesses or 'grottoes', which were at first dedicated to friends, historical figures and imaginary characters of love and crime, but they were gradually filled with souvenirs and nondescript objects. The work was destroyed in 1943 during an air-raid. Meanwhile, Schwitters had taken refuge in Norway, at Lysaker, where the second *Merzbau* was set on fire by children. He

Schwitters. Broad Schnurchel. 1923. Wood
Hannah Höch collection, Berlin.

began the third in England, in a farmhouse near Amble-side, which was never finished. Such was the strange work of Schwitters. In some ways, it anticipated the Dadaist who dreamed of a universal art that would combine painting, sculpture, architecture and the theatre.

H. W.

SCRIVE Philippe. Born 1927, Ville-Marie, Quebec. He trained at the Quebec Art School, then in Paris, and was awarded the Viking Prize in 1952. His first one-man exhibition took place at the Galerie La Cimaise, Paris, in 1958. He was invited to the Symposium in Quebec in 1966. Scrive has been a stone and wood carver since 1946 and has continued to use these materials for all his personal sculpture. These are entirely abstract and carved out of the solid block. Every kind of form emerges without any preliminary conception, until the work is completed at the end of the slow process of disengagement from the material and the final form always seems the most obvious. A sort of logical and intuitive path lead him to an equilibrium of masses, endowed with an essentially organic vitality. In his large-scale sculptures, on the other hand, which are designed for buildings and generally made of concrete or metal, this organic character is replaced by a more deliberate and rational structure.

D. C.

SEGAL George. Born 1925, New York. He studied at the Pratt Institute of Design (1947), New York University (1949) and Rutgers University (1963). He is now living on a farm in North Brunswick. George Segal's 'presences' do not exactly belong to the world of sculpture; they are neither portraits, nor dummies, but individuals, without identity or history, fixed in everyday situations. Segal has said that he wanted to penetrate real space as a reaction against the academic recipes of pictorial representation. Gradually, his plaster 'sculptures' have occupied the space in which he lives and have forced him to react and define himself in relation to them. We find ourselves in rather the same position, when we are confronted by these creatures that seem to have risen up from some Pompeii, mummified in their last gestures. Segal has recreated a world that cannot be subjected to any commentary, which is not a realistic transcription of our own, but a sort of plastic paraphrase of man, stripped of all his personality and his external attributes, clothes, distinctive marks, and reduced to the most banal actions of life. It is this banality, by killing idiosyncrasy, aesthetics and sentimentality, that reflects an uncomfortably intimate image of ourselves, reduced to its common denominators, its vital functions, with its derisive gestures and necessary, daily rituals. The drama of a condition bound by solitude and waiting, automatism and legal restrictions, appears in these sculptures in spite of the coldness of Segal's approach and his deliberate remoteness from the subject.

G. G.-T.

SEKAL Zbynek. Born 1923, Prague. He was arrested in 1941 and deported to Mauthausen, so he did not begin his training at the Prague School of Decorative Arts till 1945, where he studied painting till 1950. His first sculptures appeared in 1948 after a visit to Paris in 1947 for the international exhibition of Surrealism at the Galerie Maeght. Sekal belongs to the Mai group and has contributed to several exhibitions in his own country and abroad, notably Germany. His early figurative sculpture was a blend of human and plant forms, but in 1958 it began to change towards harsh constructions, which seemed as if they had been cut out and pierced with an axe. An unbroken series of austere reliefs, begun in 1963, were divided into compartments according to the material and technique used. These assemblages were made of simple planks, either plain or worked over, and arranged like a palisade. Sekal soon decorated them with all kinds of waste material and drew extraordinary effects from its imaginative intensity, without ever sacrificing his constructive discipline. Sekal's reliefs are derived from collages, whether they are made of mosaic or laths, a marquetry of pieces of metal that are nailed, screwed and rivetted, or a labyrinthine design in copper

Segal. Seated girl, hands clasped. 1969. Wood and plaster.

Serrano

Sekal. Flea and Shell.
1962. Plaster and metal.

and iron wire. At the same time, the light accentuating hollows and solids, the roughness of the wood, the brilliance of the metal, the materials and colours show a pictorial conception of space in these reliefs. The emotive effect of each one, planned like the tragic heraldry of action and contemplation, emerges from the disciplined work to which it is subjected. R.-J. M.

SERRANO Pablo. Born 1916, Crivillén, Spain. Serrano returned to Spain after several years spent in Argentina, then Uruguay, where he taught at the University of Montevideo. Although most of his sculpture about 1950 was figurative and expressionist, he also experimented with purely abstract work in unusual techniques and forms; for instance, the basis of his first constructions was oxidised scrap iron. During a phase that covered the years 1955–1960, Serrano began working meticulously over the metal surfaces, but this was not so much in the tradition of the Russian Constructivists, whose approach had only a remote affinity with his own at the time, but the same romantic attitude to materials that some American sculptors, like Lassaw, had adopted. His dissatisfied, restless spirit abandoned this after a while and he began making structures of twisted and bent metal rods, imprisoning a log of wood. This was generally geometric in shape. He burnt a sort of interior void from the centre, whose regularity and neatness were a contrast to the relative formlessness of the exterior envelope. Serrano did not give up figurative expressionism while he was pursuing these ventures into abstraction; the recent memorial to Miguel de Unamuno at Salamanca is an example of his other style. J. E. C.

SIBELLINO Antonio (Buenos Aires, 1891 – Buenos Aires, 1962). His love of art was like a strong instinct and was apparent even in his childhood. When he was fourteen he began training in the studios of the sculptors

Tasso and Dresco, and at the same time at the National Academy. In 1909, a grant enabled him to go to Europe and attend the Royal Albertina Academy in Turin for two years. Then he went to Paris. What he saw there was so utterly different from all he had so far admired that he decided to settle in the capital. He began immediately to study Cubism, but three years had hardly passed before war broke out and, with no means of supporting himself, he had to leave Paris, broken-hearted. Back in Buenos Aires, be exhibited his early works, from 1916 to 1918, in the national salons which were still traditional in treatment. In 1923 he exhibited one of his sculptures in the new style, but it was considered too audacious and caused a scandal. He suffered great hardship and he had to wait till 1942 to be awarded the First National Prize for sculpture, then till 1945 before he was entrusted with a teaching post at the Manuel Belgrano Art School. This final advancement, which would have saved him from financial worries, unfortunately came too late and, with illness he had little time left for the great works of his dreams. He produced fewer and fewer sculptures; instead he drew and painted. In 1956 the National Grand Prix crowned a life that had been entirely devoted to art. Sibellino was the first Latin American sculptor to try to introduce the ideas of modern art into circles that were frankly hostile to them. He was the first, also, to go beyond figurative art to abstraction. He had been steeped in the vitalising ideas of French sculpture, but he escaped from all more or less direct influences and preserved his own powerful personality. After he returned to his country in 1915, he produced severely composed works that hardly concealed the disconcerting originality of their contents. His wish to explore further the potentialities of Cubism and strip his art from all traces of realism resulted in non-figurative sculptures like the *Composition of Forms* of 1926, which was the first abstract sculpture to be produced on the new continent. Without discarding anything he had gained from his experiments, he soon had to return to less daring forms

through which, at least, he could communicate with
others and which were, perhaps, his natural form of
expression. His rather slender output includes a series
of reliefs, which are miracles of composition, strength and
tenderness. He loved the craft of sculpture. Clay and
stone remained his favourite materials. M.-R. G.

SIGNORI Carlo Sergio. Born 1906, Milan. He trained
in Paris, where he went in 1924. After he had been
working for some years at his painting in André Lhote's
studio, he entered the Académie Ranson in 1935, where
Malfray taught him and Stahly and Étienne-Martin were
fellow-students. He won the competition for the Memorial
to the Rosselli brothers, near Bagnoles-de-l'Orne, in
1948, then soon afterwards, he discovered Carrara,
where he spends several months each year to rough out
his large marbles. In fact, with a few exceptions, all his
works, from the *Black Venus*, which won him the Prix
de Paris in 1950, to the most recent sculptures have been
carved from the stone of these wonderful quarries. It is

Signori. Sculpture in black Carrara marble. 1958.

Sibellino. Composition of forms. 1926. Plaster.

easy to appreciate the importance of the medium in
Signori's development if one compares his latest work
with his early, Cubist influenced sculpture; without the
Carrara marble, the late sculptures would be mere
objects, not real works of art. In contrast to most artists,
who torture and get their forms to let the vital effect of
light play inside them, Signori felt that marble required
much more than a flood of light; it had to be brought to
life like a crystal. A sculpture is only acceptable when
it is enclosed in its own precious and invisible aura. If
Signori's forms, including those that seem most remote
from nature diffuse a gentle human warmth, it is because
of the light he has patiently drawn from the marble
with his chisel and horny hands. Admittedly, he learnt
from Brancusi's example, but, while the Romanian
stripped the human figure to petrify it in absolute and
universal forms, the Italian seems to have reverently
gathered a few stones and restored humanity to them, in
the classical sense of human quality. While Brancusi
loved full, oval volumes, Signori prefers thin slabs of
marble and almost plane surfaces to set off the trans-
lucency of the stone. The economy of his means is just
as admirable and is only equalled by the variety of his
sculptural ideas. He was invited to the Venice Biennale
in 1958, which reserved a room for his work, and has
been awarded numerous prizes, including the inter-
national prize of the town of Carrara in 1962. A large
retrospective of his sculpture was held in Paris, in 1966,
at the Galerie Charpentier. S. L.

SINGER Gérard. Born 1929, Paris. He trained at the École des Beaux-Arts, Paris, where he learnt the techniques of fresco painting and direct carving. He began as a painter, then gradually gave up easel pictures for reliefs, which developed into free-standing sculpture. He won a prize at the Paris Biennial in 1961 and was represented at the Tokyo Exhibition of Young Artists in 1964. Throughout his development, experiments have steadily and logically led him towards a sort of total plasticity, a polychrome sculpture that would also be architecture. He was one of the first artists to imagine and realise an organisation of space to the measure of our bodies, which the visitor was invited to enter and move round. When this happened the sculpture appealed more to the sense of movement, equilibrium and even touch than to the eye. With this type of sculpture in view, Singer went far with his technical experiments in thermoset and thermoplastic materials. His major work, *Ambulomire*, in blue epoxide resin, made a striking impression when it was exhibited alone at the Galerie Jeanne Bucher, Paris, in 1968. D. C.

SJÖHOLM Adam. Born 1923, in Budapest from Swedish parents. From 1941 to 1946 he attended the Budapest Art School. He left Hungary finally in 1948 and spent two years in Sweden, where he failed to find a congenial atmosphere for his work. He went to Paris in 1950. His art very soon freed itself from any trace of a figurative manner. There are very few artists whose ideas have influenced this uprooted, retiring sculptor. He stopped working in stone, which he had preferred till then, and began to use metal, which was a more flexible medium for interpreting finer shades of feeling. With this new technique he created forms that suggested volume by their coiling and uncoiling planes like scrolls.

For this, he cuts out sheet-metal directly, which is difficult and delicate work that requires a strict control over the original idea and eliminates the accidental or even the possibility of having second thoughts. Material and space are, in fact, for him factors of one and the

Sjöholm. Sculpture. 1953. Cut out metal. Musée National d'Art Moderne, Paris.

same problem and he very soon succeeded in fashioning them into dialectic form. Besides sending work to various Parisian Salons, Sjöholm has exhibited in Paris at the Galerie Drouin (1955), in London at the Drian Gallery (1957) and in Munich at the Van Loo gallery (1960). He has remained faithful to the same material for twenty years and, after developing a sort of organic abstraction, Sjöholm now seems to be moving towards an elementary expression, which is also abstract but more linear and dynamic. D. C.

SKLAVOS Yerassimos (Sklavata, Greece, 1927 – Paris, 1967). He trained at the Athens Art School, then in Paris. He was invited to exhibit his work at the Biennials of Middelheim, São Paulo and Paris, where he was awarded in 1961 both the prize of the official jury and the critics' prize. A double retrospective of his work was held at the Musée Rodin and the Galerie des Cahiers d'Art in Paris. Sklavos's successive techniques were direct carving of wood and stone, then soldering metal and finally a personal technique for treating very hard stone (porphyry and granite), which consisted of disengaging the forms with a blow-pipe, a process ideally suited to his experiments on the communicability of interior and exterior spaces. In a few years, he had produced a considerable body of work, both individual and homogeneous in character. At the limit of abstraction, Sklavos's sculpture and the overall rhythms maintaining its cohesion, never lose contact with their source in nature. Behind their scale-shaped covering, which makes them look like cloisters filtering and modifying the light, behind the saliences and hollows that seem to project themselves over the surroundings, Sklavos's sculptures nearly always suggest the human profile and outline, fleeing like a spirit and merging with pieces of landscape and fragments of pure nature. His work slowly matured in the depths of his being until it contained its own commentary and spoke directly to the soul. D. C

SMITH David (Decatur, Indiana, 1906 – Bolton Landing, New York, 1965). When he had finished his studies at Ohio University in 1924, he worked as a riveter on an automobile frame assembly line at the Studebaker factory. In 1926, he was in New York where he went to evening classes at the Art Students' League. He studied painting under John Sloan and Jan Matulka. He earned his living as a taxi driver, ordinary seaman, carpenter and salesman. In 1930, he met the painters Stuart Davis and John Xceron, who turned him towards abstract art. The following year he produced his first sculpture in painted wood. In 1933 he used wrought iron for the first time. He was in Europe during 1935–1936, visiting London, Paris, Greece, Crete and Russia. When he returned to his own country he began a series of bronze sculptures which he called *Medals of Dishonour* (1937–1940). His first one-man exhibition was held at the East River

Sklavos. The idea. 1961. Porphyry.

Gallery in New York in 1938. The same year he was represented in the 'American Abstract Artists' exhibition. During the war he worked as a welder in a factory for tanks and locomotives. In 1940, he finally settled at Bolton Landing, in New York State, and built a studio for himself where he could work in comfort. He taught at the Sarah Lawrence College (1948–1950), then at Arkansas University (1953), and the University of Indiana (1954). He was one of the United States delegates to the first UNESCO International Congress of Plastic Arts at Venice in 1954.

From 1940 to 1956, Smith showed at the Willard Gallery in New York, then with other galleries. His work was exhibited in museums across the country, notably at the Museum of Modern Art, New York (1957), at the Institute of Contemporary Art, University of Pennsylvania, Philadelphia (1964), and the Los Angeles County Museum of Art (1965). In 1965, the Museum of Modern Art, New York, circulated a retrospective exhibition in Europe and, in 1969, the Guggenheim Museum, New York, put on a large show of Smith's work. Smith participated in many international exhibitions, notably the Venice Biennale (1954, 1958), the São Paulo Biennial (1959),

Smith

D. Smith. Twenty-four Ys. 1950. Welded and painted steel. Museum of Modern Art, New York.

Until about 1960, out of an interest in the social context he refused to allow his constructed compositions to become altogether abstract, thus preserving the balance of a purist composition and a narrative subject in a semi-representational style. Sometimes his work is linear, open and pictorial: iron drawing, horizontal in axis, especially in the period round 1950; sometimes it is constructed in three dimensions around a vertical axis (the series *Tank-totems* of the mid-fifties).

About 1960, until his death, Smith worked in a mode both considerably larger in scale and more geometrically abstract. In the *Zig* series, flat circular planes and the integration of colour and sculptural form were the dominant characteristics. The impressive *Cubi* series, of stainless steel, hollow rectangles, which looked like immense weights floating in space, contrasts the expectancy of mass with the actuality of lightness and reflecting surfaces. Of Smith's earlier style, they retain only a general frontality and the vision of space seen through open form.

Generally large in scale and forceful in technique, deliberately powerful and somewhat unsubtle in the effects envisaged, Smith's work at its best achieves a monumental quality. His aim was the creation of contemporary symbols: 'The metal itself possesses little art

the Kassel Documenta (1959, 1964) and the Festival of Two Worlds, Spoleto (1962).

David Smith is a pioneer of welded metal sculpture. From 1933, when he first experimented in this medium, he created a body of work impressive in its volume, variety, inventiveness and massive quality. Smith was a painter before he became a sculptor, but even earlier his experience on an automobile assembly line had given him an intimate acquaintance with metal working techniques. From 1931, through the stages of collages painted reliefs and relief constructions in wood, his painting thickened into sculpture. From the mid-thirties, although he continued to draw and paint, he was primarily a sculptor in metal, first with iron, then in the sixties with stainless steel.

Until the last five years of his life, Smith worked within an aesthetic that belonged to the thirties, evolved out of the late Cubist and Surrealist tendencies of that time. Among modern artists, Gonzalez and, through him, Picasso were Smith's main formative influences: Gonzalez especially in the work of the early forties; Picasso in the stylised symbols for representing the human figure that Smith made his own. His particular quality lay in his ability to fuse this common language of modern art with his own thematic references, related both to his individual history and to a wider American experience.

D. Smith. Cubi XVIII. 1964. Stainless steel. Stephen D. Paine collection, Boston.

T. Smith. Cigarette. 1966.
Steel. Bryant Park, New York.

history. What associations it possesses are those of this century: power, structure, movement, progress, suspension, destruction, brutality.' It is with this tone and accent that Smith put the language of the Cubists and Surrealists in a new American context and gave it new meaning. R. G.

SMITH Tony. Born 1912, South Orange, New Jersey, United States. He attended the Art Students' League in New York and the New Bauhaus, Chicago (1937–1938). Architecture had a great attraction for him and, from 1940 to 1960, he designed numerous residences and monuments, which were not executed. Smith has had one-man shows at the Wadsworth Atheneum, Hartford (1966), the Institute of Contemporary Art, University of Pennsylvania, Philadelphia (1967), and the Walker Art Center, Minneapolis (1967), the Galerie Ziegler, Zürich (1968), and the Fischbach Gallery, New York (1968). Smith's work has architectural scale and a geometric character. He is one of the leading representatives of Minimal Art, which could be described as a minimum of form on a maximum scale. Its sheet-metal surfaces, roughly finished and painted black, enclose volumes of regular or eccentric shape, ranging from single cubes to multiple units, which twist and sprawl along the ground. Smith does not think of these works as traditional, intimate sculpture, nor as monuments, but rather as objects whose rhythmically controlled forms unfold within a continuous flow of space that includes both object and spectator. Thus, despite their size they are not self-contained and symbolic, like older public sculpture, but man-sized spatial organisers and, although abstract, seem to push and pull within themselves as if possessing certain anthropological tensions. R. G.

SNOW Michael James A. Born 1929, Toronto. He qualified in 1953 at the Ontario College of Art and then went to Europe in 1954–1955. He has been living in New York since 1962. Snow is a painter, film producer and jazz musician as well as sculptor. One of his films, *Wavelength*, was awarded the first prize of the IV Festival International du Film Expérimental at Knokke-le-Zoute,

Snow. Walking woman. 1966-1967. Wood and aluminium. Art Gallery of Ontario, Toronto.

285

Sobrino

Sobrino. Indefinite spaces C. 1963. Transparent plexiglas. Galerie Denise René, Paris.

an invitation to the observer to intervene in the creation of the work of art. They stress to an even greater extent the constancy of Sobrino's theme, the theme of instability, which has also been investigated by other members of the Groupe de Recherche d'Art Visuel. With Sobrino, the illustration of the ephemeral and unstable is not only linked with structural modification, but also with the phenomena of light and colour; as, for example, in his *Reverse Rotations* (1966–1967), which are constructions in plexiglas and wood, or his major work, *In the Wind*, exhibited at the Paris Biennial of 1967, which laid emphasis on the transformation of the environment and the group participation of the public. F. P.

SOMAINI Francesco. Born 1926, Lomazzo, near Como, Italy. He began his regular artistic training at the age of eleven, which he continued later in Milan at the Brera Academy, while he was studying for a degree in law. He travelled abroad from 1944 to 1948 and this introduction to the art of other countries hastened his own artistic development. When he returned to Italy, he changed from his early figurative experiments to a style comparatively free from connections with reality, and produced his group of horses' skulls. It was only after 1950 that his sculpture become uncompromisingly abstract. His ambition to undertake works on a vast scale led him in 1954 to the invention of a new material, 'ferrous conglomerate'. A large sculpture, executed the same year for the park of the Milan Triennale, gives an idea of his inventive spirit and the freshness of his ideas. After various exhibitions in Florence (Galleria La Strozzina 1956) and Rome (Galleria La Salita 1957) he won the First Prize for the best foreign sculptor at the São Paulo

Belgium, in 1968. As a painter and sculptor, Snow has been exploring the subject of *Walking Woman* since 1961; which he has depicted in every way and in every sort of material as a truncated form. The most ambitious work of the series comprised eleven, over life-size sculptures, which he made for the Ontario Pavilion at the International Exhibition in Montreal (1967). Six of these were exhibited at the 'Canada, Art d'aujourd'hui' at the Musée d'Art Moderne, Paris, in 1968. Snow is fascinated by the most ordinary subjects and objects of everyday life, which he empties of their usual connotation and endows with calm and gravity through the intervention of the imponderable elements of space and time. G. V.

SOBRINO Francisco. Born 1923, Guadalajara, Spain. He trained at the Art School in Buenos Aires. He then went to live in Paris and, in 1960, helped to found the Groupe de Recherche d'Art Visuel and remained a member until its dissolution in 1968. He exhibited his work in Spain and Germany from 1966 to 1968 and at the Galerie Denise René, Paris, in 1968. Sobrino is a kinetic artist and the first to make interferential structures. These consist of a number of equal planes, juxtaposed or superimposed in tinted plexiglas or aluminium. As one walks round the work, its structure and forms are transformed and new, undetermined configurations take their place. The process is an attempt by the artist to abolish matter. His structures can sometimes be dismantled as

Somaini. Wound V. 1960. Lead and iron.

Soto. Mobile saturation. 1968. Plastic threads.

composition. In 1953, he introduced kinetic backgrounds and striped surfaces that tended to produce moiré effects. Then followed constructions of plastic elements superimposed on transparent surfaces, which were succeeded in 1955 by an 'optic synthesis', consisting of the superimposition at a distance of spirals traced on plexiglas. Soto then went on to suspending mobile elements, such as bars, curves, wires, against a striped background. They depended on a combination of several kinetic factors: mobile elements, the observer's shifting his position in front of the work and visual effects, such as the vibrating vision produced by movement, which is one of Soto's fundamental principles. According to Soto, the varied use of hanging elements illustrates first the transposition of matter, then the interception of light and finally the dematerialisation of the object. His *Light-traps* and, to a greater extent, his *Vibrating Walls* (exhibited at the Venice Biennale of 1966) are striking examples of the first phase of this development. Recently, Soto has made a series of very large-scale works, which are penetrable environments or forests of flexible, metallic rods or nylon threads, which the visitor is invited to walk through. F. P.

SOUCY François. Born 1929, Montreal. When he had completed his training at the Quebec Art School, Soucy lived in Florence for a while. He has had several exhibitions in Canada, Italy, Switzerland and the United

Biennial in 1959. In 1960, the Venice Biennale reserved a room for his work.

Somaini's forms have shown a steady development towards a bare, austere style. The whole structure of his solemn, monumental works rises up into space and the space seems quickened as it clings to the sheer, uneven surfaces of the forms. Somaini proves himself a consummate designer in this, but his severe composition of masses is far from suggesting a static vision of the universe. The fluency of his design, the gracefulness and harmonious development of his forms impart a vital fulness and dynamic warmth to his work. G. C.

SOTO Jesus Raphael. Born 1923, Ciudad Bolivar, Venezuela. When he had completed his training at the Art School in Caracas, he was appointed as director of the Maracaibo Art School in 1947. In 1950, he went to live in Paris. Several one-man exhibitions of his work have been held in Europe, the United States and South America, notably at the Galerie Denise René, Paris (1956 and 1967), the Museum of Fine Arts in Caracas (1961), the Kunsthalle in Berne, the Stedelijk Museum in Amsterdam (1968) and the Musée d'Art Moderne de la Ville de Paris (1969). In 1951, Soto began his experiments with vibrating surfaces by repeating the formal elements on them *(Optic Picture)*, which was cogent proof of how he had freed himself from traditional ideas on form and

Soucy. Three polychrome triangles. 1965.
Wood. Quebec Museum, Quebec.

Souply

Souply. Sculpture Nº 33. 1967. Oxidised steel.

States. Soucy considers that 'sculpture should always be associated with architecture' and 'always determined by its setting'. His approach is methodical and conscientious, his ideas clear, and in 1958 he decided to give up 'tree-sculpture' and construct with space, then soon after with movement. He may well be the first sculptor in Canada to investigate the problem of neo-Plasticism and kinetic art. His structures are very simple: empty, coloured triangles, which penetrate each other, or pivot, one inside another, at different speeds, which produces an endless mutation of relationships and forms, planes (real or virtual) and colours. They possess a dynamic equilibrium that defies the laws of weight and attains monumentality quite naturally. They almost demand to be set up on an immense scale in the middle of a park or along a motorway. G. V.

SOUPLY Émile. Born 1933, Charleroi, Belgium. He was a goldsmith by training and taught himself sculpture. He helped to found the Groupe Design in Brussels in 1962 and, four years later, the group Axe 66. Until 1960, Souply used cast silver for his works, which were generally small, because of its warm, stable colours. Their surfaces were either polished or roughened. From 1964, his vision widened and, while his sculpture remained abstract, it was no longer a precious object, but a work of art with breadth and weight. Oxidised, chrome or stainless steel were the materials he now used for his sculptures. Their lines were often lengthened and developed rhythms that were almost serial in character. Souply's concern for a thoroughly contemporary idiom in materials as well as form sometimes made him use convex glass, mirrors and plexiglas. The industrial world of today is the source of his inspiration and he often gives it a symbolic, slightly futuristic interpretation. D. C.

SPITERIS Jeanne. Born 1922, Smyrna. She was of Greek nationality and trained at the Athens Art School. She has contributed to all the exhibitions of the avant-garde movement Stathmi. Her first two personal exhibitions took place the same year in 1960 in Turin and Venice (Galleria Bevilacqua La Masa). She designed the masks and costumes for Aristophanes's comedy *The Clouds*, performed by the National Theatre at Athens in 1951 and then at the Comédie Française at Paris the following year. In 1965, she was invited to the Symposium at Montreal. Her frequent visits to France, Germany, Austria and Switzerland have kept her in touch with the finest examples of European sculpture. The lively, strongly contrasted rhythms, the superimposed masses with their sharp edges, the abrupt planes and the sudden articulations all give her work its dramatic character. An impetuous life sweeps over her *Divinities*. In recent years, an increasingly marked discipline has been noticeable in her sculpture, a return, perhaps, to memories of her childhood. Classicism and geometric composition have now controlled her previous tendency to extravagance. Even when she uses colour, Jeanne Spiteris can reconcile its richness with austere form. She gave cogent proof of this in the monumental work that was exhibited at the Salon de la Jeune Sculpture in 1968. F. E.

SPRONKEN Arthur. Born 1930, Beek, Holland. The subject of the horse remained an enduring attraction for Spronken from his studies under Marino Marini at the Brera Academy in Milan. Added to this was an admiration for classical sculpture. This dual strain

Spiteris. Sculpture Nº 6. 1959. Bronze.
Franchi collection, Italy.

Spronken. Centaur with solar disc. 1966. Plaster.

dominated all his work, beginning with a marked stylisation of the horse, with sinuous, ill-defined volumes, that eventually came to resemble the rocky excrescences of a landscape. Subsequently a more personal subject appeared in his work, the *Solar Bull*, whose originality lay in the contradictory tensions between the geometric element of the disc and an organic development of volumes, which alternately grew together or tended to diverge from each other. Spronken has elaborated innumerable variations on this basic network of relationships, which reflect the complexity of his artistic temperament. He was represented at the III Biennial of Paris in 1963. D. W.

STACKPOLE Ralph. Born 1885, Oregon, U.S.A. When he was sixteen he joined the Art School of California in San Francisco, then two years later he worked with the animal sculptor, Arthur Putnam. In Paris, from 1906 to 1907, he worked in Antoine Mercier's studio at the École des Beaux-Arts. Back in the United States, he studied painting under Robert Henri in 1911. Large-scale sculpture then attracted him and he became interested in its integration into architecture. After a further stay in Europe, notably in Paris (1922–1923), he returned to California, where he taught for nearly twenty years at the San Francisco Art School. Stackpole worked in stone and granite, which he valued for their strength and hardness and even their resistance. His early work was influenced by Rodin, then Gothic art after his various visits to Europe, but he found the real source of his inspiration in his own country in the monumental sculpture of the Aztecs and the totem carving of the Red Indians. In 1938–1939 he executed a huge statue, ninety-eight feet high, for the San Francisco Exhibition. Stack-

pole is a versatile artist and he can express himself in any form of art that lends itself to monumental style. He painted several frescoes for university buildings. In 1949, he returned to France and finally settled in the Puy-de-Dôme. His favourite materials have not changed;

Stackpole. Changing shadows. Volvic stone.

Stahly

they are still stone, but now he also uses wood, which is often painted or decorated with a variety of inlays. Whether his sculptures are massive or light, the evocative power of his volumes derives from their sculptural necessity and the strict logic of their concatenation. His powerful imagination infuses a primitive, almost barbaric life into them. Besides the principal Parisian Salons and international group exhibitions, Stackpole has twice shown his work in Paris at the American Cultural Centre in 1959 and the Galerie Paul Gay. D. C.

STAHLY François. Born 1911, Konstanz, Germany. He went to Paris in 1931 and attended the Académie Ranson, where he was taught by Malfray. In 1936, he helped to found the Témoignage group at Lyons. Étienne-Martin was also a member. Stahly very soon turned to abstraction. Stahly is an indefatigable seeker after new means of expression; he varies them constantly, invents new ones and reverts to old ones to adapt them to other purposes. His style has not developed in a straight line, but in a network of explorations to discover an answer to the same fundamental problems. His first sculptures in wood, which he carved during the occupation when he had taken refuge in Burgundy, were built up of airy curves, opening out and closing in on themselves with a sinuous movement that swept up and down, like the elusive silhouette of the *Angel*. His stone sculptures, formed of massive blocks with an enigmatic significance reminiscent of prehistoric magical art, were more monumental in character (*Tomb of a New-born Child*, 1947). Stahly, in fact, has always been attracted by the secret rites of Christian and pagan cults, like his friend Étienne-Martin. Although their works share this esoteric spirit, Stahly's show a more noticeable interest

in sculptural forms for their own sake as in the *Castle of Tears* (1952), a fascinating wood carving like a grotto, thick with stalactites like the outer defence of a hidden sanctuary. The secrets of nature and the phenomena of biological genesis enthralled him and were the origin of sculptures like *Birth* and *Bourgeoning* (1953) in which the sheath of plant forms conceal female organs. They were continued in the bronzes of 1961–1962: *Tree Mother* and *Mountain Mothers*. As he said himself, 'A unique solution has been replaced by multiple and changing meanings.'

A closer relationship with nature was noticeable in 1961, when Stahly began using stumps instead of tree trunks and imposed his own order on the wild tangle of roots. He produced at the same time a series of small bronzes, made of openwork grills, like trellises and branches intertwined in rhythms like those of the stained-glass reliefs that Stahly made in collaboration with Étienne-Martin for the church at Baccarat in 1956. The same year, he constructed his first fountain in which the water cascaded over the slope of rocky agglomerations. He designed several variations of this, the most interesting of which are probably the Fountain of the Four Seasons at the Golden Gateway Park of San Francisco (1964) and the fountain at the School of Economic Science at St. Gallen, Switzerland, which rises like a cluster of petrified trees. In 1960, he was invited to the University of California to supervise team work. He returned twice to the United States to teach at the Aspen School of Contemporary Art in Colorado, then at the Washington University at Seattle. His tall, wood sculptures, *Tree of Life* and *Forest of Tacoma*, were also made in the United States. The plant forms of these totem-like sculptures were now subjected to architectural transformations. Imagine a curtain-wall, composed of mobile

elements, carved from burnt mahogany into a variety of forms, leaves, branches, buds, etc., which can be assembled into porticoes, like the one at the Maison de l'O.R.T.F. in Paris (1962–1963). Besides wood, bronze and stone, Stahly also experimented in more contemporary materials: stainless steel for the *Signal* (1955), commissioned by the Sidérurgie Française and placed at the beginning of the motorway to Orly airport; aluminium for a large geometric sculpture for the 'Paris-Match' Pavilion at the Salon des Arts Ménagers of 1955. His partnership with young architects has led to a number of different projects including one for an open-air theatre. Then he designed a Labyrinth for the new Faculty of Science in Paris, which reflected his tendency to harmonise natural and architectural elements. He was awarded the gold medal of the Milan Triennale (1954) and, among other prizes, he won the first prize for sculpture at the Tokyo Biennial of 1965. Since his first exhibition at the Galerie Facchetti, Paris, in 1953, several others have been held in France and abroad. Two of the most important were at the Kunsthaus of Zürich and the Musée des Arts Décoratifs, Paris (1966). H. W.

Stankiewicz. Diving to the depths of the ocean. 1958. Steel. William Rubin collection, New York.

Stahly. Forest summer. 1966. Group of sculptures in oak. Nelson Rockefeller collection, Tarrytown.

STANKIEWICZ Richard. Born 1922, Philadelphia, U.S.A. He grew up in Detroit, Michigan. While he served in the navy during the Second World War he did some sculpture. He began as a naturalistic painter and studied painting at the Hans Hofmann School of Fine Arts, New York (1948–1949). He began to give more time to sculpture while at the Hofmann School. He went to Paris in 1950 and studied for a short time under Fernand Léger, then under Zadkine (1950–1951). He returned to New York in 1951, where he has lived since. At various times he has worked as a tool and die draughtsman, radio operator and technician, deck-hand, navigator, rigger, sailmaker, typist, housepainter, novelity and jewellery salesman, contractor's helper and patent draughtsman. In 1951, he helped found the Hansa Gallery where he had one-man shows in 1952, 1954, 1956, 1957 and 1958. In 1959 he had one-man exhibition at the Stable Gallery, New York. He was represented in the 'Young America 1957' exhibition at the Whitney Museum of American Art, New York; the XXIX Venice Biennale (1958); the 'Sixteen Americans' exhibition Museum of Modern Art, New York (1959), and in the same museum's 'Art of Assemblage' (1961). He exhibited in the 'Mobile Sculpture' exhibition of the Museum of

Stein

Stein. Propeller. 1967.
Polished steel.

Modern Art, Stockholm (1961), and at the São Paulo Biennial (1961). In 1963, the Walker Art Center, Minneapolis, gave him a retrospective show. His work is in several American museums.

Stankiewicz's sculpture begins with modern mechanical detritus. Where the Dadaists made use of the found object and only occasionally of the discarded object, he employs the worn-out fragments of a machine technology. In the morality of his materials, in the visual interest rediscovered among the refuse, in the recreation of usefulness for what ordinary thinking has classified as useless, he resembles Schwitters. But the scale of Stankiewicz's old boilers, steam fittings and bent pipes and the energy that goes into their sculptural reworking is humorous rather than witty, endowed not with the delicate irony of despair, but with force, and so eventually with optimism. The narrative, associative side of his reconstructions is matched by a formal vision that might well make use of any materials. In his earlier work the distance between the utilitarian worthlessness of his materials and the aesthetic value to which the artist had raised them was preserved and their convergence despite this distance was the work's commentary. More recently his objects are so treated that they become less discarded than found, *objets trouvés*, expressive with their own inherent form and patina which are combined into handsome, almost classic works of art. R. G.

STEIN Joël. Born 1926, Boulogne-sur-Mer. He trained at the École des Beaux-Arts in Paris. After contacts with the studio of Fernand Léger, he helped to found the Groupe de Recherche d'Art Visuel in 1960 and contributed to all its exhibitions until its dissolution in 1968. He worked at the same time with the Recherche Cinématographique of the O.R.T.F. In theory and practice he has broken down the barriers that separate the arts and surround the creative process with an aura of mystery; he was one of the first artists to invite the observer to take a real share in his work. The idea of 'play' was the principal means of achieving this. After a series of experiments with forms and colours in permutation and the correlation and superimposition of sculptural elements in relief, Stein achieved some most unusual effects with the movement of suspended objects and the manipulation of light reflected on polyhedrons and kaleidoscopes. With these additional fields of reflection, the object is no longer limited to its own form; it acquires a further visual dimension in a new space, which varies according to the form, the size and the direction of the reflector. Since 1963, Stein has made kaleidoscopes with aluminium mirrors and metallic prisms in truncated pyramids, which have often been integrated into the

Storel. Meteorite plant. 1968. Iron and copper.

amusement halls and labyrinths fitted up by the Groupe de Recherche d'Art Visuel for its different exhibitions. Chromatic polarisation has also interested him. His investigations produced the *Polascope*, which again requires the active participation of the observer to alter the shape of the structures, the virtual dilation of the forms and the metamorphosis of the colours. F. P.

STOREL Sergio. Born 1926, Cadore, Italy. He learnt the techniques of working metal at the Trevisa Art School before he completed his training at the École des Beaux-Arts in Paris. His first sculptures were made of sheets of lead, cut out and folded. Then about 1953, he began using cement, but he went back to metal, which seemed to him to have far greater possibilities of expression. However, he sometimes combined the two materials. During an early, purely abstract period, he made constructions composed entirely of iron struts, which, after a while, were formed of mechanical components. The overall result was the substitution of solid volume by open, freely arranged planes in space. In recent years, Storel has returned to a compact, closed sculpture in hammered and soldered sheet-copper. Natural forms have appeared in them, based on the classical principles of stability and comparative symmetry. D. C.

SUBIRACHS José. Born 1927, Barcelona. In 1945 he joined the Barcelona Art School and, three years later, held his first one-man exhibition at the Casa del Libro in Barcelona. In 1953 he was represented at the São Paulo Biennial. Then, while he was living in Bèlgium for a time, he exhibited his work at the Unicum Gallery in Bruges, at the Madeleine Baes Gallery at Knokke in 1954, and at the Giroux Galerie at Brussels in 1956. When he returned to his own country, he soon established his reputation as one of the leading sculptors of his generation and had an important commission for the public gardens in Barcelona. Subirachs is an abstract sculptor

Subira Puig. Skull. 1967. Wood.

and has an equal mastery over the media of iron, concrete and terracotta. Structural and functional problems fascinate him more than anything else, but this does not preclude a taste for unusual, refined textures and, recently, even for colour. His forms are not derivative, but spring from his own imagination. Their vitality makes an immediate appeal. They give dramatic expression to the conflict between light and shadow, sensuousness and grace, austerity and poetic feeling.

SUBIRA-PUIG José. Born 1926, Barcelona. He trained at the Barcelona Art School and held his first exhibition in Barcelona at the Syra Gallery in 1961. In 1967, he exhibited at the Galerie Les Cahiers d'Art, Paris. His early style was figurative but he gradually moved towards a very free interpretation of reality. Since 1962, his most usual material has been pieces of old wood from a variety of objects, like the staves of barrels, which he assembles into strictly architectural compositions.

Subirachs.
Sculpture. Terracotta.

Szabo

Szabo. Family. 1968
Limestone.

They are treated with an appropriate technique and the combination of rusticity and preciousness is most attractive. The special way in which he cuts them produces an articulated and strongly rhythmical view of space in effective contrast to the compact volumes created by the assemblage of the whole. D. C.

SZABO Laszlo. Born 1917, Debrecen, Hungary. He studied at the Debrecen University, then at Geneva and Lausanne and finally settled in Paris, where he taught himself sculpture. Since 1949, he has been represented at the principal Parisian Salons. In 1953, he had a one-man show at the Galerie Breteau. The following year, he founded the group, Quinze Sculpteurs, with abstract and Surrealist tendencies, which exhibited for several years at the Galerie Suzanne de Coninck. One-man shows of his work were held in 1968 in Budapest, Berlin and Copenhagen. His first works were bas-reliefs of symbolic animals, reminiscent of the archaic art of the Middle East. Soon, however, these figurative subjects gave way to more abstract ones, drawn from geological sources, like the *Disc of the Sun*, a kind of volcanic ground, hollowed in such a way that 'the shadows move with the sun in the very centre of the dial.' His sculpture, in the narrow sense of the term, similarly suggests a cavernous countryside with falls of rock, washed by water. Sometimes the broken elements take on an architectural appearance and, when scattered on the ground, evoke burial places, fallen in ruins. Other forms, which are imbricated in each other, remind one of labyrinths with multiple entrances shot with uncertain lights. *Dream Castle* (1955) is like this and is the prototype of the 'habitable sculptures' that have obsessed architects and sculptors ever since Étienne-Martin's *Dwellings*. Szabo himself undertook to transform his studio and the Académie du Feu, which he directed, into a romantic

habitation, composed of niches and grottoes without any straight lines. He loves to give mystic significances to his sculptures that weigh heavily on their dark recesses. Besides mythological animals *(Eagle, Fire-bird)*, the works of recent years are of related figures that form an inseparable *Family*. Szabo works in limestone, steel and black granite, but the material he finds most congenial is terracotta, with its fiery colours, which he also casts in bronze with dull surfaces. H. W.

SZAPOCZNIKOW Alina. Born 1930, Kalisz, Poland. When she had completed her training at the School of Arts and Technology in Warsaw, she went to the École des Beaux-Arts of Paris. Since 1952, she has been represented at most of the exhibitions of Polish sculpture abroad. She represented her country at the Venice Biennale of 1962 and has taken part in Symposiums in Austria, Yugoslavia and Czechoslovakia. In 1965, she was awarded the Copley Foundation Prize. She was only twenty-four when she made the memorial to Soviet-Polish friendship in Warsaw. The expressionist character of her sculpture developed rapidly soon afterwards. In 1962, the dramatic overtones of her figures were stressed by the incorporation of real weapons, then the débris of cars, into the cement. She tried to find significant microcosms of the violence of our world in the combination of modelled form and found object, as if she were trying to neutralise the terrible memories of her childhood in concentration camps. Shortly after 1965, this direct grasp of reality was tightened, when she used plastic materials, dyed flesh colour, for moulding parts of the body and composing bunches of mouths and swelling breasts, lit up by natural or artificial light, which irradiated the translucent opacity of the artificially sensuous flesh. These luminous and polychromed efflorescences were followed about 1968 by further experiments in other

materials chemically made by industrial processes. Polyurethane foam, which can be modelled at the point of expansion, was used as the container for fragments of the human body impressed in vinyl or polyester. These imprints of stomachs and chests with heavy breasts, standing prominently out, or casually scattered, seem to be rising out of a primordial mud, like stelae threatening cataclysms in which the human figure is petrified in a volcanic mass or atomic mud. Their counterparts are tragic visions bearing the names of Pompeii and Hiroshima. R.-J. M.

SZEKELY Pierre. Born 1923, Budapest. When he had completed his training as a sculptor in Hungary, he went to France in 1945. Until then, his vision of the world had been largely formed by craftsmanship and Hungarian folklore, but after that his outlook began to broaden. Between 1950 and 1954 wood and stone carving replaced the clay modelling he had been doing. After 1954 he exhibited his work with the Espace group and took part in the principal Parisian Salons. Each phase in his evolution until then had been marked by an exhibition of his work: at the Galerie Arts du Feu in 1950; the Galerie Maxime Old in 1952; the Galerie Mai in 1953, 1954, 1955.

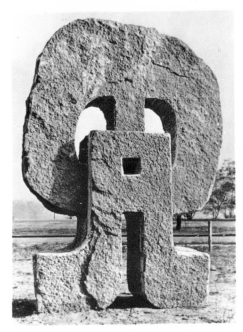

Székely. Contacı. 1963. Grey basalt.

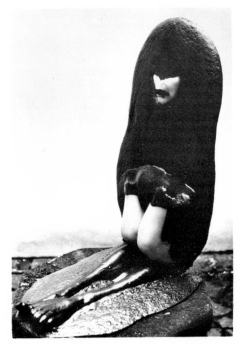

Szapocznıkow. Stele. 1968. Plastic moulds.

The exhibition at the Galerie Colette Allendy in 1955 seemed to suggest the influence of Surrealist ideas. The forms were contorted and showed the bizarre humour of a mind that was as imaginative as it was sculptural in attitude. Then Szekely became interested in the relationship of sculpture and architecture. The effect on his style was a greater simplicity and strength and an extremely severe conception of space. He did several sculptures for churches, educational institutions, playgrounds and groups of buildings. For a brief period he built constructions of different materials and did a few metal sculptures (1957–1959), but finally returned to stone which he handled in a fresh and varied manner. His primary concern since then has been to create a sort of synthesis of the plastic arts with their architectural and social surroundings. Szekely's art derives its power from its ability to renew its sculptural idiom from the deepest sources of life itself. For some years, he has also been working with concrete ejected from a gun without shuttering. Szekely has designed several memorials, alone or in association with architects, and drawn up plans for the chapel of the Carmelite convent of Valenciennes at Saint-Saulve (1965). Besides one-man exhibitions at The Hague (1964 and 1968), Paris (1967) and Padua (1969), he has contributed to the Symposiums in Austria (1960), Montreal (1964) and Grenoble (1967).
 D. C.

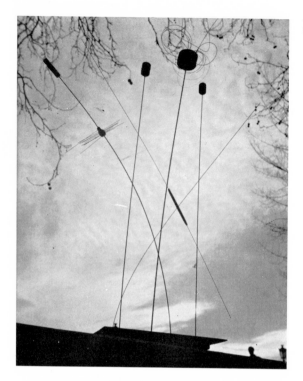

Takis. Signals. 1956-1957.
Steel and iron.

Tatlin. Counter-relief.
1915. Wood and iron.

t

TAJIRI Shinkichi. Born 1923, Los Angeles, United States, of Japanese parents. After the war, he went to Paris to work with Zadkine and Léger. He also attended the Académie de la Grande-Chaumière. He has been living in Holland since 1956. Although Tajiri grew up in American and purely European surroundings, his work often recalls the art of the Far East. Yet there is certainly no question of conscious imitation, because he tries to eliminate any specifically racial element from his work. His sculptures, in bronze or other metals, are grouped round a few themes such as aggression, germination or speed. They spread out in plant motifs that undergo unexpected metamorphoses and are sometimes tinged with a disturbing irony. Since 1966–1967, he has been attracted to steel, aluminium and polyester, which are sculpted into forms like robots, war machines or gigantic insects. On the other hand, the *Knots* in polyester, which seem to be derived from the complex machinery of racing cars, have a less formidable appearance and a more sensuous vitality. Tajiri was represented at the Kassel Documenta in 1959, 1964 and 1968. D. W.

TAKIS Vassilakis. Born 1925, Athens. He taught himself sculpture. When he was twenty-nine, he left for London and stayed there a year before settling in Paris. He held two one-man exhibitions, one at the Hanover Gallery, London (1955), the other at the Galerie Furstemberg, Paris (1956). Since then, exhibitions of his work have been held in the most important cities of Europe and New York. He has been represented in various Parisian Salons. Takis used clay at first, then for a long time he carved in wood, because he preferred it as a sculptural medium. The human figure was his only subject and it was through his handling of it that he developed from figurative to the beginnings of non-figurative art. Abstraction is inseparable for him from an objective view of the contemporary world. Since 1956, he has worked in iron, aluminium or bronze, as he prefers metal to any other material. Then he used wire for a series of linear constructions, which he called *Signals*. Its extreme pliability and lightness lend themselves to a kind of hieroglyphic language that is a suitable expression of

certain aspects of the industrial world, such as road signs, railway signals, antennae, etc. The year 1959 was an important date in the development of his work, when he exhibited at the Galerie Iris Clert, Paris, a collection of his tele-magnetic sculptures, in which the forms were immobilised in space by a network of magnets. After he had published an autobiographical account called *Estafilade* (1961), Takis developed his experiments further with the invisible energy that holds forms in suspension. He used plexiglas, piano strings, permanent magnets and electro-magnets, which were all ideal materials for his investigations, and elaborated a number of extraordinary objects, which he called 'electro-signals', 'indicators', or 'quivering mobiles', some of which were edited in several editions as 'multiples'. D. C.

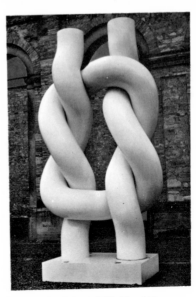

Tajiri. Knot. 1968. Fibreglass.

297

Tatlin

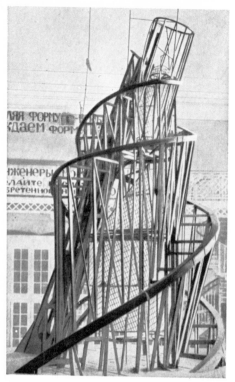

Tatlin. Project for a Monument
for the IIIrd International. 1919-1920. Iron.

TATLIN Vladimir Evgrafovich (Kharkov, 1885 – Novodevichi, 1953). He began by training as a painter at the Academy of Fine Arts in Moscow. His first paintings showed the influence of ancient icons and also Cézanne. The visit he paid in 1912 to Picasso's studio during a brief stay in Paris shattered his artistic notions. He was especially struck with a still-life, composed of different objects, which gave him the idea for the relief-pictures he began on his return to Russia. He used the most varied materials: wood, metal, cardboard, plaster, mastic, and tar. He coated the surfaces with glazes and sprinkled them with dust and broken glass. Admittedly, he was not the first to use these unusual means of expression. But, while Picasso used them to make 'musical instruments', Tatlin, by eliminating all figurative allusions from his works, endowed these materials with an elementary function and, because he restricted himself to simple, geometric forms, he produced an abstract art that eventually led to Constructivism. Tatlin showed these reliefs in his Moscow studio at first, during the winter of 1913–1914, then at St. Petersburg, in March 1915, at

the 'Tramway W' exhibition, organised by Pougny and his wife, Bogouslavska. One of these works ('a small plank of wood with two others, nailed on top of it') provoked some caustic comments. He continued his experiments and began his 'counter-reliefs' the same year, constructions without any pedestal or base, which had to be hung in the angles of walls, like aeroplanes with curved wings and with bridges placed over them. Although the 'art of the machine', initiated by Tatlin, reflected the admiration of the Constructivists for the work of engineers, it also expressed the anxiety that their inventions roused in human beings. This, and the way in which his works always preserved a sense of mystery, distinguished his sculpture from that of his successors. A whole room was reserved for his counter-reliefs at the '0.10' exhibition at St. Petersburg in December 1915. At the beginning of the Revolution, the government called on the services of artists and Tatlin was appointed to teach in the Studios for Training in the Liberal Arts and Techniques (Vkhutemas). Those who called themselves 'Productivists' and claimed, in opposition to Malevich, that art should be used for practical purposes, grouped themselves under Tatlin's leadership. Stirred by his political enthusiasm, Tatlin created in 1919 his model for a *Monument for the Third International*, which was one of the first buildings designed on completely abstract principles. It consisted of two cylinders and a glass pyramid, revolving at different speeds, around which an iron spiral wound and rose into space. Inside, rooms for meetings, concerts and exhibitions were planned. The model was over 80ft and the final building would have been 1,500ft high. However although after 1920, non-figurative art fell into disgrace, Tatlin left Moscow for Leningrad and, from 1922, taught at the Institute of Artistic Culture (Inkhuk), which specialised in the study of materials. He ended his life in the old monastery of Novodevichi, Moscow, which the government had requisitioned for housing needy artists. H. W.

TEANA Francesco Marino, called Marino di. Born 1920, Teana, south Italy. He went to Argentina in 1936, joined the Circulo de Bellas Artes of Buenos Aires and worked for the teaching diploma in drawing, while he earned his living. Then he trained at the School of Art and left it in 1950 with a certificate to teach to an advanced level. He obtained Argentinian nationality. Marino was producing excellent portrait sculpture at that time and its style reflected his admiration for Etruscan art. In 1952 he left Argentina and went first to Spain, where he collaborated for a year with the sculptor, Jorge de Oteiza, and then went on to Paris. There his art developed rapidly. He experimented with new materials, like steel and pieces of coloured glass, and evolved a strictly abstract idiom of open forms through which the light flowed freely. He then stopped signing his work with the name, Marino, and used Teana, the name of the village where he was born. Since 1955, he has sent work

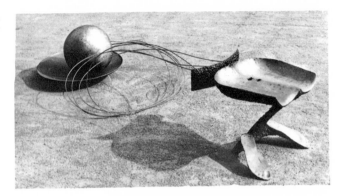

Theodoros. Specific seat with prohibited accessories. 1967. Metal.

to the principal Parisian Salons and several group exhibitions. His first one-man show was held in 1960 at the Galerie Denise René, Paris. After he settled in Paris, Teana's style became more confident and gained in power and depth. He began using metal, particularly wrought iron, instead of wood and stone. It was the ideal medium for the disintegration of the mass, which is the aim of all his experiments so that a vital space can be created in the interior of the sculpture. His work at this time was wholly dependent on the equilibrium of void and mass and their points of contact were the source of movement. As the centre of gravity can be shifted, each sculpture could be viewed from any direction and every plane could serve as a point of visual rest. His works are developed in an extremely individual manner from a dislocation, or to be more exact, a disintegration of a few simple volumes, such as the parallelepiped, the cube

and the cylinder. In doing this, Teana is trying to create a 'disintegrated' sculpture, as distinct from 'perforated' sculpture. The observer is expected to break away from his old habits of mind and let his eye travel from the interior to the exterior. This gives an idea of how space is one of the essential elements of his art. Teana took his sculpture as far as possible in this direction, then in the last few years, he has turned to making frankly architectural constructions in wood, stainless steel, concrete and glass. He is even interested in architecture itself and has designed countless maquettes of 'cities of the future', which are the urban equivalents of his experiments with space as a sculptor. On this plane, they are a measure of how much sculpture embraces every human activity for Teana and implies a complete reconstruction of reality.

D. C.

THEODOROS. Born 1931, Agrinion, Greece. He trained at the Athens Art School, then in Paris. He was awarded a Greek government scholarship and eventually settled in Paris. He won the Prix Rodin at the Paris Biennial (1965), exhibited at the Centre Culturel of Aix-en-Provence the same year, then at the Maison de la Culture in Amiens in 1966. Theodoros sculpted in marble until 1960, when he began using steel, whose qualities are better suited to the dynamic structures of his dreams. His strictly abstract works harmonise the culture of a long tradition and the demands of a modern idiom. Subtle references in his sculptures to a common fund of experience, shared by artist and public, are fundamental to each work as a privileged ground of communication.

D. C.

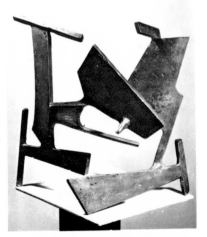

Teana. Uprising space. 1956-1957. Metal.

THIENEN Marcel Van. Born 1922, Paris. Thienen's studies not only included mechanics and electronics but also a course at the Conservatoire National de Musique. Since his first one-man show at the Galerie Iris Clert, Paris (1964), he has been represented at several group exhibitions in France and abroad. From

Thornton. Figure in a doorway.
1956. Bronze.

Sweden. His constructions of welded iron, steel and brass rods appear to exhibit the barbed and jagged angularity that is fashionable in an age of anxiety. His titles are by contrast, as often as not, everyday, even playful ones: *Figure in a Doorway, Figure Falling from a Chair, Children on Stilts*. The savagery of these spiky space-frames is more apparent than real. They may perhaps be regarded as a simplified notation for commonly observed events, scribbled in space with quick, straight jabs of metal. At times the meaningful content is explicit; at times it provides no more than a starting-point for an essay in abstract relationships. In his recent work, while still employing the same methods of construction, Thornton appears to be moving away from the space-frame towards more solid concepts. M. M.

TINGUELY Jean. Born 1925, Basel. From 1940 to 1944, he attended the Basel Art School to train as a painter, but as painting cannot render movement and ephemerality, it soon left him dissatisfied. Since a form can never be perfect, it should be perpetually and critically examined. No picture is satisfactorily finished, so the artist should overcome the finiteness of the single work.

Tinguely. Suzuki. 1963. Scrap iron.
Museum of Fine Arts, Houston.

1957 to 1963, he modelled his forms for casting in bronze. In 1964, he changed his medium to stainless steel for the sake of its purity and strength and because he considers it the characteristic material of the 20th century. His sculptures in steel wire have a remote suggestion of anthropometric shapes, but they are primarily mechanisms set in motion by motors; they are materialisations of the feeling of space and time. Their construction is extremely skilful and Thienen sees them as a transposition in living terms of the fundamental laws of our universe. His present experiments are mainly concentrated on the study of unstable equilibrium, developed according to unsynchronised relations. D. C.

THORNTON Leslie. Born 1925, Skipton, Yorkshire. He studied at the Leeds College of Art and the Royal College of Art, London. He held his first exhibition in 1957 and was represented at the São Paulo Biennial (1957) and exhibitions in Switzerland, Germany and

Tinguely. M-K III.
1964. Iron. Museum
of Fine Arts, Houston.

Tinguely. M-K III.
1964. Iron. Museum
of Fine Arts, Houston.

Surely the inescapable conclusion of this is that the ideal painting shifts ceaselessly beneath the appreciative eye and its memory. Since this is so, the artist should provide this mobility. This is the argument behind the best experiments of this exceptional sculptor, notably the animated reliefs that he made when he settled in Paris in 1953. These are pictures in process of endless transformation and are black and white, because colour is proscribed as an element of the static, with too ineluctable and definite a character. Against a square plate, hung on the wall like a canvas, elements of white, cut out in sharp curves, pivot on their own axes of different lengths and at different speeds, or it might be better to say, with a greater or less degree of slowness. These rotating shapes overlap each other like a silent crowding of contours in which form varies, not only in quality, but also in quantity as it alternately increases and recedes. The partial superimpositions cast shadows which add to the slow animation of the whole composition. After harnessing speed and movement in this fashion, Tinguely made use of them in a variety of ways. One of the most disconcerting consisted in parabolic surfaces in the shape of a plate, with a rod, punctuated at the end with a white spot, which revolved wildly in the hollow of the surfaces. Against the black background of the plate, the spot described erratic movements as it struck intermittently against a stop with a sharp ringing sound. Sound, in fact, plays an essential accompaniment in many of his creations, to such an extent in some of them that they have been called 'resonant sculptures'.

Irregularity in speed soon became a principle. It was already particularly irritating in the first group of 'meta-mechanical' works; by that he meant works that were on this side or beyond mechanical precision. It consisted of a gearing of iron wires, rigged with discs and crescents of sheet-metal, revolving in space like the big wheel in a fair or Denis Papin's crank-shafts. These slender machines in which the wheels slipped and jammed

against each other, were like a defiance to clockwork mechanism. They began a deliberate exploitation of the accidental and almost, in the words of its creator, of 'organised breakdown'. Their rotation was punctuated with grinding and stoppages. Then came the famous 'Painting Machines', which poured out massicot and scattered their drawings broadcast. One of them, exhibited at the Paris Biennial of 1959, *Metamatic no. 17*, was capable of producing 38,000 different paintings, while moving and changing its shape all the time. Disturbing and facetious though Tinguely's constructions may be, they are nonetheless astonishing as sculptures, even when stationary; it is enough to look at the bases, their cradles, tripods shooting straight from the seating, the bristling, black components and the steel aigrettes, barding their mechanisms and, when they are set in motion, scything the air beneath the nose of the onlooker and forcing a proper respect from him. M. C.-L.

A new phase began in Tinguely's art with the *Tribute to New York*, a sculpture made of heteroclite scrap iron, which he erected in the courtyard of the Museum of Modern Art in New York in May 1960. Its peculiarity was that it destroyed itself, bit by bit, as it moved. He continued along this line and organised 'spectacle-events' during which increasingly cumbersome machines proceeded to annihilate themselves in a sort of apocalypse *(Study for the End of the World)*. All these joyful and anarchical explosions could only lead to silence, until Tinguely consented to make the gigantic construction of *Eureka* for the Exposition Nationale Suisse at Lausanne (1964), which was a new departure. He made a complete break with the destructive delirium that was roused in him by anything connected with the notion of art and he started constructing well-oiled machines, painted all in black, but their regular, smooth functioning emphasised their utter uselessness all the more, like the series of *Copulations* of 1965–1966, which were condemned to make the same movement for ever. They are anarchical

Tombros

Tombros. Composition. 1968. Plaster.

and derisive witnesses, even in their faultless behaviour, of the first industrial age and offer us the spectacle of a ritual that is both despairing and magical, while their very absurdity prompts us to question the mechanics of our existence. R. M.

TOMBROS Michael. Born 1889, Athens. When he had completed his training at the Athens Art School, he went to Paris to finish it and attended the Académie Julian. By 1923, he was working in copper and producing forms that were a very free interpretation of reality. He often visited Paris and exhibited in the principal Salons

there. In 1934 and several times since, he has been represented at the Venice Biennale. Tombros has sculpted a number of public monuments in his country in a classical style, which is rather different from his personal sculpture, with its imaginative force. He was appointed to teach at the Athens Art School in 1938 and was made director nineteen years later. In 1968, after he had been awarded the Grand Prix of the Academy, he was elected one of its members. Tombros is journalist, lecturer, writer, and between the wars in Athens he edited the avant-garde *Vingtième Siècle* in association with Le Corbusier, Fernand Léger, Christian Zervos and others. Copper and marble carving have always been his media of expression. In both materials, Tombros's aesthetic ideal has been a geometric simplicity of forms, derived from the Aegean culture, which he has combined with influences from the École de Paris and a characteristically modern idiom. His influence in Greece on some of the best sculptors of the younger generation has been considerable. D. C.

TORIBIO Antonio. Born 1922, La Vega, Dominican Republic. When he had finished his training at the National School of Fine Arts he exhibited his works for the first time, in 1950, at the 'Estudios Ledesma' in Ciudad Trujillo. In 1954–1955, he was engaged on a commission for the Peace Fair at Ciudad Trujillo. For the next two years his experimental work was inspired by the primitive art of the Tainos people. He has been living in New York since 1959. He broke away early on in his career from pendantic disciplines and academic traditions and set out to master an idiom in keeping with the spirit of his own times, while endeavouring to preserve in new forms the permanent values of traditional art. Then, at a turning point in his career, he began to create shapes and rhythms that came from his feelings and imagination alone. They consisted of metal structures with sharp projections, iron sculptures, where hollow, open forms

Trsar. Large and small. 1960. Bronze.

Trudeau. Spatio-mobile. 1968. Painted steel.

circumscribed space, or dense, compact, massive volumes that were animated with the spirit of a young imagination.

M.-R. G.

TRŠAR Drago. Born 1927, Planina, Yugoslavia. He finished his training at the Ljubljana in 1951. Since his first exhibition, in 1953, he has taken part in several international exhibitions, notably the Biennial at Alexandria in 1955, where he was awarded a prize. He was also awarded a prize at the Yugoslav Biennial at Rijeka in 1959. Tršar's work from the very beginning has had a personal flavour both in his inspiration and his conception of form. He is fascinated by surging crowds of people, whether they are Protest Marchers, Spectators or City Dwellers going about their various occupations (these are the titles of his works) and the essence of his sculpture is an attempt to seize the inner effervescence of the human crowd and express it in generalised, plastic terms. His discriminating eye and unfaltering hand can take in the masses as a whole and the principal lines of force, and strip them of all narrative appeal. This unusual talent for generalisation has enabled him to develop a work that is figurative in nature but is strictly plastic in conception and owes nothing to traditional realism.

TRUDEAU Yves. Born 1930, Montreal. He began drawing when he was very young and, at the age of fourteen, was already haunting the studios of sculptors and potters. He was the first president of the Quebec Association of Sculptors, a scholarship winner of the

Canadian Council of Arts and has exhibited regularly in Canada and abroad since 1958. In 1964, he took part in the Symposium at Ravne, Yugoslavia, and, in 1965, in the Symposium at Quebec. One of his major works, *Lighthouse of the Cosmos*, a gigantic, mechanised robot, equipped with sound effects, was made for the Place de l'Univers at the International Exhibition, Montreal, in 1967. His recent works, 'spatio-mobiles' and 'open and closed walls' comprise spatial sculptures of two kinds. The first are assemblages of a variety of plane surfaces, which are irregularly segmented and broken by oblique and right angles, which penetrate the surface and project from it. The second are delicate structures with convex, curving surfaces. Both show imaginative freedom and, at the same time, a strict discipline.

G. V.

TUCKER William. Born 1935, Cairo. He read history at Oxford University (1955–1960), then trained at the Central School of Arts and Crafts and St. Martin's School of Art, London (1959–1960). His first one-man show was held in London in 1963. William Tucker's earliest sculpture was described as a sculpture of ideas. The titles of works were frequently metaphorical and Tucker set out to express particular conceptual notions, first in iron and plaster and later brightly painted aluminium and vinyl through three-dimensional exercises of balanced forms. An increasing airiness began to permeate

Tucker. Persephone. 1964. Aluminium and plastic.

303

Turnbull

Turnbull. Drum-Head. 1955. Bronze.

his work around 1962 when, though the construction of a piece appears intensely solid, its colour, curving forms and the suggestiveness of such titles as *Their name is light* (1962) give it a novel air of other-worldliness. As with the work of many of his contemporaries, Tucker's pieces became by 1965–1966 more monumental in conception and were given a more sculptural presence. *Memphis* (1965–1966) illustrates the far larger scale in which he began to work and colour began to play a more secondary role. Among the younger sculptors of his generation who have formed the avant-garde during the 1960s, Tucker has the most consistently extracted the essence from the myriad of new developments and converted them into a very strong and very personal style.

DA. F.

TURNBULL William. Born 1922, Dundee. He studied at the Slade School, London. He worked in Paris until 1950, in which year he held his first exhibition at the

Hanover Gallery, London. He was represented at the Biennials of Venice (1952) and São Paulo (1951). Turnbull was for some time associated in the public's mind with Paolozzi, whose admiration for Giacometti he shared. He himself has drawn upon several of Giacometti's inventions and idioms, notably the non-figurative 'landscape' of relief-forms and the extreme attenuation of the human figure. He has also joined forces with Paolozzi at the other extreme, in producing richly encrusted solids of mysterious significance. Of the two artists, however, Turnbull is the colder, the less inventive, the more controlled. His references to humanity have taken the form of hieratic and elongated images of minimal substance, executed with anti-formal freedom. He has perhaps been more sure of himself when using the language of non-figuration in his spatial drawings in frosted wire, in monolithic totems that are largely dependent for their sculptural interest on their surface texture, and most notably in his horizontal reliefs which are, in effect, playgrounds for the imagination. M. M.

Uhlmann. Constellation. 1956. Painted steel.

u v

UECKER Günther. Born 1930, Wendorf, Germany. He trained as a painter at the Berlin-Weissensee Academy, then, in 1953, went to the Düsseldorf Academy and decided to settle in the town. His first, really personal works date from 1957. These were trees with foliage composed of countless nails, soldered together in an inextricable tangle. Nails were to be his characteristic means of expression, whether bare or painted white. He creates the most surprising effects from them especially when they are driven in regular lines into discs, rotated by motors, and a flood of light is directed onto them. In 1962, Uecker, with Heinz Mack and the painter Piene founded the Zero group, which attracted attention at various exhibitions (Kassel Documenta, 1964). Then, about 1963, he began covering furniture, tables, chairs, television sets and even a piano with nails. But this was only a passing phase before he returned to his early experiments and arranged them on plain canvas mounted on wood. This time they were full of movement and were swept into spirals, or great waves uplifted by the wind. His last works, exhibited at the Galerie Denise René, Paris, in 1968, were again very orderly compositions. Only the length and size of the nails varied and they were hammered either straight into the panels, painted white, or at a calculated angle, and the whole was electrically driven. H. W.

UHLMANN Hans. Born 1900, Berlin. He was an engineer at first and trained at the Technische Hochschule in Berlin, where he taught later on until 1933. After 1925 he practised sculpture along with his engineering. He visited Paris in 1929 and Moscow in 1932. He held his first exhibition in 1930 at the Gurlitt Gallery in Berlin. Under the Nazis, he was persecuted for his political opinions and imprisoned from 1933 to 1935. It was not until 1945 that he could resume his activities fully. He was awarded the Arts Prize of the City of Berlin in 1950, the German Critics' Prize in 1954, and the Venice Biennale reserved a room for his work the same year. In 1955, the Museum of Modern Art in New York exhibited his works; the Kleeman Gallery in 1957; and the Staempfli Gallery in 1959, both in New York. Since then, he has been represented at all the major international exhibitions. Apart from Oscar Schlemmer, Uhlmann was the first German to practise sculpture in iron wire. He used for it thin metal plates, which he cut out and perforated, steel strips and cylindrical bars. He created his own form and was not influenced by a Pevsner or a Gabo. In his effort to escape from the three-dimensional, closed mass he began to superimpose pieces of cut out material on a surface and made something like a relief. The technique was similar to the Cubist 'cardboard cut-outs'. At the same time he produced his first constructions of metal, which looked rather like birds and insects. They radiated from an imaginery core and were like sketches

Uecker. Construction with nails. 1967-1968.

Ultvedt

Vaillancourt. Sculpture. 1967.
Black granite.

scribbled in space. After 1954, Uhlmann gave up this style. He now uses discs of metal, cut into rectangular sections, which he assembles into abrupt forms that are slashed and perforated. These diquieting constructions have an anonymous force that seem to overwhelm the onlooker. An impression of power emanates from their uncompromising technical character, which is the quality required for monumental sculpture like the *Amsterdamer Plastik* of 1965, in chrome and nickel steel, now at the Union Bode of Hanover. Other notable public commissions include the works that decorate the entrance to the Beethovenhalle in Bonn and the library of Freiburg University. Uhlmann also sculpted the Memorial to the Resistance under the Third Reich, which was erected at Leverkusen. J. R.

ULTVEDT Per Olof. Born 1927, Kemi, Finland. He studied painting and engraving at the Stockholm Art School, which he entered in 1945. In 1954, during a period of enforced idleness after an accident, he reflected on the problems of movement and began constructing his first machines. They were endowed with a harsh humour in keeping with their iron structure, like the *Iconoclast* (1956), a hand-turned apparatus for slashing canvases, which indicated Ultvedt's indifference to painting. The equivocal articulation of some machinery, bristling with household utensils, like the *Fly-swatter* (1962), was followed the same year by an inextricable labyrinth, made for the Stedelijk Museum, Amsterdam, of domestic furnishings, planks, bicycle wheels and mirrors, all connected by a complex arrangement of pulleys and ropes, which the public was free to manipulate. These experiments culminated in *Homage to Christopher Polhem*, an unlikely structure of planks, painted red and erected in 1965 in Amsterdam, which anyone was at liberty to destroy. Since 1966, Ultvedt has simplified his

idiom and given greater precision to his use of movement. This was never used for its own sake; it fulfilled a figurative function in relation to life, whence the profile figures cut out wood, which bore a certain resemblance to Javanese puppets, and the tools controlled and driven by electricity. The *Gran'daddies* (1967), which gesticulate and fondle themselves, and the anthropomorphic tools of 1968 are the work of a 'primitive' artist of the industrial age, whose artistic approach is based on a critical appropriation of the powers of the machine. R.-J. M.

UNDERWOOD Leon. Born 1890, London. Studied at the Regent Street Polytechnic, the Royal College of Art and the Slade; Prix de Rome 1920. Camouflage work in the forces during both World Wars. He travelled extensively in Russia, the Mediterranean, North and South America and West Africa. His half-dozen books include three on West African masks and sculpture. Underwood is a painter and etcher as well as a sculptor; his work is represented in the British Museum, the Victoria and Albert Museum and the Tate Gallery. An important retrospective exhibition of his work was seen in London in 1961, at the Kaplan Gallery.

Between the wars Underwood's independent radicalism was a potent leaven in English sculpture, still struggling to find its way back to the main stream. He opened his own school in 1921, and again, after a lapse, ten years later. Among the group then associated with him were the engravers Gertrude Hermes and Blair Hughes-Stanton. The cornerstone of Underwood's beliefs as an artist and a teacher was always that same 'truth to material' which Gill, Epstein, Moore and Hepworth, among others in England, were preaching as the prerequisite to sculptural honesty.

In his own work Underwood has always gone his own way. He has exhibited little in latter years and

has in consequence not shared fully in the public success of British post-war sculpture. His carvings of the early twenties were compact, chunky, influenced by African carving and, in their juxtaposition of convex and concave surfaces, the Cubist sculptors. After the mid thirties a flamelike rhythm has come increasingly to animate his work, at times reaching an almost mystical ecstasy. The smoothness of the earlier pieces has been replaced, in the bronzes of recent years, by a rougher floridity of surface and a wiry toughness of line. Such energetic works as *Lifesection* and the monument for the LCC's Hilgrove Estate, both of 1960, are among his finest. M. M.

VAILLANCOURT Armand. Born 1932, Blake Lake, Quebec. He trained at the Montreal Art School. Vaillancourt is a dynamic personality, bursting with activity, who organised the first 'happenings' in Canada. His intense curiosity for various techniques led him as a sculptor to experiment with nearly every kind of material and with the same devouring appetite for creation. He modelled in clay until 1954, then he turned to wood, carved directly or worked with controlled combustion, which produced sculptures of a surprising organic complexity. About the same period, he made abstract assemblages from scrap iron. Bone, concrete, stone, glass and synthetic resins were other materials he tried out. Vaillancourt has several large-scale sculptures to his credit, which he generally casts in solid metal. His immensely inventive art is a curious mixture of calculation and improvisation. A frenetic, almost excessive rhythm is a characteristic. The modernity of his techniques in recent works, such as machine-finishing, vacuum techniques and special tools, show a very different desire to introduce an unusual element of self-control and discipline into the elaboration of his conceptions. D. C.

VANTONGERLOO Georges (Antwerp, 1886 — Paris, 1965). He was a painter, sculptor, architect and writer on the theory of art. He studied sculpture and architecture at the Antwerp Academy. He was called up during the First World War, wounded and evacuated to Holland, where he was interned. There he got to know the artists of the De Stijl group in which he played a leading part in it. He based his ideas on mathematical theories and, with his first abstract sculptures of 1917, he became a pioneer of abstraction (*Construction in a Sphere* 1917, *The Interrelation of Masses* 1919). His works had a considerable influence on architecture. There is a striking resemblance between some modern architecture and one of his rectangular constructions. After a brief stay in Brussels he lived in Menton from 1919 to 1928 and then moved to Paris. He left the Stijl group in 1921. In 1924, he published a book called *Art and its Future*. His sculptures were sometimes in wood, nickel and iron and for a time he gave them titles like

Vantongerloo. Interrelation of masses. 1919. Stone.

Vantongerloo. Nucleus. 1946.
Chrome and silver-plated steel.

equations. Vantongerloo was very interested in town-planning; he did models for airports and investigated a project for a bridge over the River Scheldt. From 1931 to 1937 he was vice-president of the Abstraction-Création group in Paris. He had always built up his works on the

Vardanega. Asynchronous displacement of a circle to infinity. 1962. Plexiglas. Galerie Denise René, Paris.

to use traditional materials and began by producing extremely finished compositions with plexiglas bases, which he painted in various colours. A careful distribution of transparent elements, produced a colourful interplay of moving forms without disturbing the equilibrium or harmony of the work. His spatial compositions were dominated by the symbol of the spiral. He then began a series of spherical forms whose internal structure could be seen from any angle. The works he exhibited at the Maison des Beaux-Arts, Paris, marked a new phase; he had passed from the illusion of movement to movement itself and these 'automation sculptures' had a life of their own, which was largely modified by the play of lights. The exhibition he shared with Martha Boto at the Galerie Denise René in 1969, was a continuation in the same direction. He displayed on that occasion a world of geometric forms made of chrome steel and plexiglas, where the 'chromokinetic' variations were obtained this time with electronic circuits. The idiom of Vardanega's art is appropriate to its purely technological aspect; it is analytic, vigorous and abrupt, in keeping with the over-charged atmosphere of the modern city, which is reflected in the vibrant rhythms and syncopated lights of his sculptures.

M.-R. G.

straight line which was one of the principles of neo-Plasticism. He had observed this faithfully, but in 1937 he began to experiment with the curve, at first only in his graphic work. In 1945 it appeared in his sculpture as iron wires, spinning in space, sometimes enclosing a solid core. He also worked in white and coloured plexiglas. In his opinion, art tries to express the incommensurable, not through literary or representational forms, but by binding itself to the laws of infinity. A large retrospective of his work was organised by Max Bill in London in 1962.

F.-C. L.

VARDÁNEGA Gregorio. Born 1923, Possagno, Italy. His family emigrated to Argentina in 1926 and he trained at the Academy in Buenos Aires. He joined the Art Concret-Invention group in 1947 and was represented in its exhibitions. The following year he went to Europe and stayed in Paris. In 1950, he took part in a group exhibition at the Galerie Colette Allendy. When he returned to Buenos Aires, his work attracted attention in several exhibitions: the Arte Nuevo (1955), at the A.N.F.A. (1956) and at the Artistas no-Figurativos (1958). He sent work to the São Paulo Biennial (1957) and the International Exhibition at the Argentinian pavilion in Brussels (1958), where he was awarded a gold medal. He is now living in Paris. Vardanega refused

VASARELY Victor. Born 1908, Pécs, Hungary. He began his training at the Poldini-Volkmann Academy in 1927. This was followed by a spell at the Mühely, the Budapest Bauhaus, then he went to live in Paris in 1930. During this period of concentrated graphic work, he evolved his own conception of plastic form. In 1944, he helped to found the Galerie Denise René in Paris, where he still exhibits his work. In 1955, he contributed to the exhibition 'Movement' at the Galerie Denise René. He was awarded the first prize of the São Paulo Biennial in 1965 and countless one-man exhibitions of his work have been held in museums and galleries throughout the world. Vasarely's optic and kinetic ideas first materialised in black and white designs and the juxtaposition of colours on plane surfaces, then with the superimposition or separation of graphic designs on transparent materials. He is the inventor of two-dimensional kinetic art, a synthesis between the traditional techniques in two dimensions and the three-dimensional vision of the cinema screen.

By 1954, Vasarely conceived and planned certain developments related to kinetic structures (Deep Kinetic Works) and put forward the idea of 'multiples', or the mass-production of the single work of art. He has had several commissions for decorating buildings (University City of Caracas, Faculté des Lettres of Montpellier, Faculté des Sciences of Paris, Museum of Jerusalem, French Pavilion at the World Exhibition at Montreal in 1967, the skating rink at Grenoble). Plastic creation for Vasarely is indissociable from its final purpose: 'The kinetic, plastic work, which can be reproduced indefinitely, preserves... the perenniality of the object,

Vasarely. Caracas. 1954-1961.
Kinetic element. Duraluminium.

(Paris Biennial, 1965). He has made a large relief for the hall of the Prague airport. By 1960, Vesely was obstinately determined to define the *Stigmatic Object* that haunted him. At first it took the form of simple reliefs, modelled with textiles plasticised onto a circular armature of wood, plated with pieces of metal. This progressively developed into three dimensions, like the blazon of grief with gaping wounds, or a lunar landscape with extinct craters. In 1964, he began adding waste material to these burns and half healed wounds, until the assemblage was turned into vehement, cell-like emblems and menacing protuberances. Some of these *Enigmatic Objects*, driven onto stakes and bristling with sharp points, were exhibited with the *Usurping Chair* (1964), an object petrified in its fantastic mutations. Vesely's composite sculptures had grown from collages, dominated by the two, traditional forces of Czech art: baroque movement, which is transposed in his work as the frustrated rhythms of his heteroclite accumulations, and a Gothic theme running through its sharp, aggressive forms. R.-J. M.

VEYSSET Raymond (Vars, Corrèze, 1913 — Paris, 1967). After training at the École des Beaux-Arts in Paris, he worked under Malfray, Derain and Wlerick. The influence of the first two was particularly strong and

which is always young in its original form, while it unfolds the vast perspective of a statistical distribution of art that can become a treasure common to all. Vasarely would like this universal idiom to be present as an accepted factor in everyday life. This is the basis of his conception of a 'geometric, polychrome and solar' city where art would be 'kinetic, multi-dimensional and communal, certainly abstract and related to the sciences.'
 F. P.

VASILESCO Paul. Born 1936, Izvorul Dulce, Romania. He trained at the Bucharest Art School. His early sculpture was figurative, but in a decidedly modern idiom. Reality is only a point of departure for him, or at most a reference, from which he elaborates violently triturated forms as an expression of his intense mind and unquiet vision of world. The final result is a sort of romantic expressionism, which is most strikingly embodied in his portraits. Vasilesco has also made a large metallic structure for the airport of Otopeni. It is an impressive abstract sculpture and has an easy appeal.
 R. I.

VESELY Ales. Born 1935, Caslav, Czechoslovakia. He trained at the Prague Academy from 1952 to 1958, then took part in various exhibitions in his own country and abroad, notably Poland, Germany, Italy and France

Vesely. Usurping chair (1964), flanked by Enigmatic objects (1966). Wood and metal

Viani

Veysset. Propnetic wind. Stone.

Viani. Caryatid. 1952. Bronze.
E. Fischi collection, Milan.

turned him towards a sort of modified Expressionism. Later on, he was attracted by archaic Greek sculpture and the stone sculpture of the Middle Ages and his style became freer. His reflective approach and integrity made his development particularly slow and his artistic ideas did not change without prolonged experiment and thought; characteristically, he went through a period of uncertainty and experiment before he turned to abstraction. After 1949, he was represented in the Salon de la Jeune Sculpture and is on its committee. Since 1958, he has been exhibiting his work at the Salon des Réalités Nouvelles and is represented in all the major French art exhibitions. Instead of the stone of his early work, he now uses wood and materials that he can file down, carve, pierce and that will allow him to work rhythmically on the mass itself. However abstract his sculptures may be, their starting-point is always a feeling stirred by a real object: a bud, an everyday article or some object full of human associations. The unity of his style reveals the determination of a creative will, conceiving and fashioning a work as a whole and in its smallest detail. Veysset is the friend of the painter and art writer, Closon, and he himself has elaborated the sculptural ideas of what he calls 'Archi-Sculpture'. According to these, abstract sculpture should not become merely an object, but, by sharing something of the nature of both architecture and poetry, should be the absolute expression of everything that makes a man: his breathing, the proportions of his body, his movements and even the purpose of his existence. At one time, he experimented with the effect of colour and in the use of manufactured materials, which preferably had already been used and weathered by time such as tiles, railways sleepers and bricks. He also used concrete. All these experiments eventually ended in an extremely sensitive, abstract art. His most recent works are basically assemblages of unpolished elements chosen for their emotive power.

D. C.

VIANI Alberto. Born 1906, Quistello, Italy. He trained under Arturo Martini at the Venice Academy before becoming his assistant. In 1946, he joined the Fronte Nuovo delle Arte and the following year exhibited his work with this group at the Cairola Gallery in Milan, then in 1948 at the famous first Venice Biennale, which marked the revival of Italian art after the war. On this occasion, he was awarded the Prize for Young Sculptors. Two personal exhibitions of his work were shown later at the Venice Biennale in 1952 and 1958. In 1959, he was awarded the First Prize at the international open-air exhibition at Varese. His style was influenced by the last works of Arturo Martini, particularly by the astonishing freedom of composition that the master revealed to the younger generation in his *Woman Swimming under Water*. Alberto Viani differed from Martini, whose work was a synthesis of past styles, flavoured with archaism, in his endeavour to achieve a sort of classical ideal

Vieira. Equilibrium. 1952-1953. Silver.

through a search for an 'absolute form' in which the pure, vital contour of the image is like a line that leads back to the memory of the original. Here there is no separation between the pulsing inner life of the sculpture and its slow, reflective rhythm. This conception of his sculptures gives them a double significance: they constantly bring us back to the symbol of the masculine or feminine image; and their graceful, fugitive sensuousness suggests the human subject that inspired them. It is in this synthesis of the abstract and figurative that lies the main difference between the works of Viani and Arp, whatever the similarities in their idiom. If is it true, as Ragghianti declares, that Viani has found some of the conditions of his own freedom in abstract sculpture, it is just as true that he has not been lured by pure line or the magic of form for its own sake and his sculptures preserve the inner, meaningful life they possessed at the moment 'they resolved themselves into an object.' The serenity of his sculptures is inseparable from the form, which gives them integrity and makes them exceptionally satisfying.

G. C.

VIEIRA Mary. Born 1927, São Paulo, Brazil. An exhibition of Max Bill's work at São Paulo in 1951 came as a revelation to Mary Vieira and she decided to go to Zürich the next year and train under him. This encounter was decisive for her career and her art and today the marked individuality of her sculptures has found a place in the experimental work of Max Bill and his School, which is based on principles of a mathematical character. She paid a number of visits to Germany, France and Italy and then decided to settle in Basel, where she is living now. Her favourite materials are aluminium and polished steel. Whether her sculptures are purely linear or are constructions with plane surfaces cut out in geometric forms, they are designed for a natural setting with which they harmonise easily and where their virtual columns exist in limitless space. The purity of her mediums confers great nobility on the least of these constructions.

VIOLET Georges. Born 1900, Versailles. When he had finished training as a ceramist at the École Nationale de Sèvres, he decided to devote himself to sculpture in 1921. He was elected a member of the Salon d'Automne in 1929 and exhibits there regularly. The tenor of his sculpture through numerous portraits, figures and busts is a sort of psychology of form. His first non-figurative sculptures date from the years 1958–1959. The primary importance he gave to light was immediately noticeable; the masses were carefully composed so that they would look most effective when the light fell on them. With the use of synthetic resins, he gradually gave up making

Violet. The large door. 1968. Synthetic resin.

Viseux

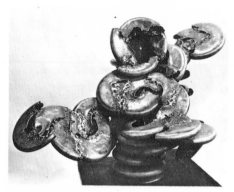

Viseux. Univalvia. 1964. Stainless steel.

Viseux specified the principles determining the assemblage of these families of *Cryptogams* and *Cryptophils*, mainly in the series of *Signals*, which are like rockets or interplanetary lighthouses. The composite nature of these sculptures avoids expressionistic modelling of form and finds its visual unity in the symmetrical arrangement of the selected pieces and the pre-eminence of a syntactical rhythm, which became progressively more refined as Viseux changed from stainless steel to plastic materials; the multicoloured *Homolids* (1969), made from a pile of buoys, beacons and other marine floating objects. Here, as in some of the *Signals*, colour introduces a second syntax that articulates plastic consonances and dissonances. More recently still, Viseux has widened his field of activity to the assembly lines of the Renault factory and has used a number of simple car components to

the sculpture-object for sculpture that would be appropriate for architecture, liven its surfaces and modulate the contours and space of buildings. D. C.

VISEUX Claude. Born 1927, Champagne-sur-Oise. He entered the École des Beaux-Arts, Paris, in 1946 to train as an architect. After working for a while with Jean Prouvé, he undertook several large-scale sculptures in ceramic and metal with other architects. Since the end of the fifties, he has taken part in most of the important international exhibitions in France and abroad. His first sculptures, a little after 1950, showed a desire to grapple directly with the raw material; *Concretudes*, for instance, were obtained by pouring molten metal onto the ground. But after 1958, he gave up painting, which he had been practising all the time, and the industrial scene became his unique theatre of activity. He worked and contorted his material in the fire itself and transfigured the waste of our metallurgical production with humour and vehemence to create his own interpretation of the animal, mineral and vegetable world, like the *Predator* (1966), which is a puddled sheaf of Boeing tubes. All Viseux's sculpture, in fact, grows out of the dialectic sum of two kinds of nature: the nature that exists independently of man and the nature that can only exist by him. It attacks these realities in their fundamental structures and in their historical contradictions and develops in a way that is essentially organic and generative of an unusual order. Since 1967, however, a new discipline has made itself felt in his work. He refuses to ensnare the accidental witnesses of our life and the basic elements of his sculpture are taken from mass-produced objects, which he diverts from their initial function and uses them unaltered in an assemblage. And so his work progresses by synchronous analogies and is elaborated from contrivances with cryptogamic structures, which fertilise each other and proliferate through successive grafts. In 1968,

Viseux. Isolated danger (family of the "Watchers"). 1968-1969. Polychrome stainless steel.

debunk the 'cultures' that dehumanise man and enslave him to the consumer system; an example is his *Mausoleum for the Car Culture* (1969), dedicated to the victims of the modern rituals of leisure. R.-J. M.

VISSER Carel Nicolaas. Born 1928, Papendrecht, near Rotterdam. After he had studied architecture, he went to the Academy at The Hague. Visser made his name with some attractive sculpture of birds in galvanised sheet-metal. He soon developed towards abstraction, but his forms were still distinguished by their extreme simplicity and the firmness of their expression. His spatial, largely asymmetrical sculptures, were made of beams and rectangles, superimposed in horizontal and vertical rhythms. One of the best of these, *Salami*, consisted of sections of identical, iron beams, which were brought together like the band of a caterpillar tractor. Although Visser's usual medium from the beginning has been iron, he sometimes uses reinforced concrete and wood. Besides his private work, he has fulfilled several commissions for large-scale sculpture, including one for the Waterworks at Leerdam and another for the airport in Amsterdam. He represented his country at the Venice Biennale in 1968. D. W.

VITULLO Sesostris (Buenos Aires, 1899 – Paris, 1953). He trained for a time at the Buenos Aires Art School and then went to Paris in 1925. There he visited sculptors' studios and made a special study of the work of Rodin and Bourdelle, who influenced him for a long time. By some strange phenomenon of intellectual and affective osmosis, he rediscovered, through his adopted country, his own country, the blinding light of Argentina, the terrible wind of the Pampas and the proud outlines of the Great Cordillera. 'I never fully understood its

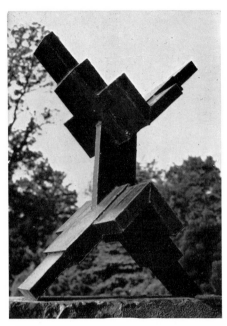

Visser. Joy. 1958. Galvanised iron.

violence,' he said, 'I did not know how to interpret it until I was enveloped by the gentleness of France. The light, the wind and the mountains of Argentina all went to my making. I lay my blocks on the ground or set them up like totems and I wanted them to be able to stand against the hardest light.' So he expressed himself in an

Vitullo. Sculpture. 1951. Granite.

Vlad

idiom that was neither European nor exotic, nor even cosmopolitan while his rough simplicity, his sensuous feeling and the innocence of his spirit saved him from the dangers inherent in all of them. For a quarter of a century, he worked unceasingly and produced a large number of powerful, monumental works and yet was hardly known. He only had a single one-man exhibition at the Galerie Jeanne Bucher in 1945, before Paris paid him the solemn tribute in 1952 of showing a collection of his works at the Musée d'Art Moderne, five months before his death. He worked in the most unyielding materials, granite, marble, boxwood, ebeny, and hewed out of them the vigorous forms and sculptured symbols of the gaucho, the sun and moon, legendary images that soothed his nostalgia. Although his *Memorial to Martin Fierro* (1940–1945) and *Lust* (1946) still show an untamed violence, the following works grew more restrained and severe. His work always vibrated with the harsh poetry of his myths, even when Vitullo suppressed the subject appeal of representational art for an abstract idiom of compact volumes and sharply cut planes. Whether his works are vertical like the block of rose granite of the *Condor* (1949), or horizontal like *The Bagual* (1951), or slender like the totem, *Liberation*, or massive like the *Monument to José de San Martin* (1952), their savage grandeur is a testimony to his faith and courage, his energy and the warm humanity of this unjustly neglected artist.　　　　　　　　F. E.

VLAD Ion. Born 1920, Fetesti, Romania. He trained at the Bucharest Art School and has won a number of prizes in his country, including the Simu Prize. In 1966, a monograph on Vlad was published by the Méridiane press of Bucharest. He exhibited at Venice in 1962 and at Athens in 1964. Vlad is now living in Paris. Like his lively, varied style, Vlad's technique explores the possibilities of the most diverse materials, stone, cement, wood, bronze and copper. His experiments have produced a sculpture that integrates space and form in a sort of contemporary baroque, which draws its vital spirit as much from life itself as from a free interpretation of the folk art of Romania. He prefers expressive power to perfection of plastic beauty and his works depend primarily on their inner tension, the energetic equilibrium of voids and solids, deep shadow and light.　　　D. C.

VOEGELI Walter. Born 1929, Winterthur, Switzerland. After an apprenticeship as a decorative painter, he trained at the Schools of Arts and Technology at Zürich, then at Lucerne. In 1952, he went to Paris to work there for a year. He has been living since at Berne and began to sculpt in 1954. His first works were in iron and tin. When he began to experiment with plastic in 1963, he at last discovered the material that would satisfy him as a sculptor and painter; he could now add an intense, pure colour to sculptural volume and achieve a brilliant

effect. He gained an international reputation as an optical artist and has exhibited in Munich, Amsterdam, Linz and Hamburg. He now assembles pieces of square and rectangular polyester, arranged according to horizontal and vertical modules. These are built up into walls within which he fixes convex and concave reliefs. They stress the progression of volume or the contrast between the different elements in the composition. The material of the walls is perfectly made, smooth and brilliant, rather like an embossed mirror shimmering with light, which creates a play of colours in combination with the reliefs and hollows. His sculptures have a monumental quality and create an impressive effect of spaciousness.　　　　　　　　　　　J.-L. D.

VOLTEN André. Born 1925, Andijk, Holland. Volten had already worked for some time as a painter before he began sculpting in 1953 and found his real vocation. He lives in the north of Amsterdam, where the factories and workshops are concentrated, and he soon learnt to forge, rivet and solder metals with the workers in the naval ship-yards. He considers that his own metal constructions are akin to the machines, cranes and bascule bridges, which are a part of everyday life. As an artist, he combines a great creative ebullience with the geometric strictness of De Stijl and is attracted to an almost puritanical economy of means. For Volten, the

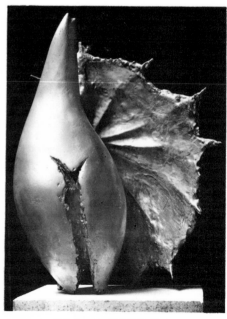

Vlad. Genesis. 1968-1969. Plaster.

314

Voegeli. Three-part composition, each part formed of four polymodulated elements. 1967. Blue-tinged polyester.

machine is the sign of our times, in every way comparable with the tools of the first men; it is a fundamental reality that should be used in the creative process. As he has never repeated himself, his art is very varied. Extremely simple constructions alternate with deliberately complicated ones. Although he has a marked preference for the straight line and the plane, he sometimes uses curved and inflected forms. His sculptures are not passively dominated by space, but seem to react violently against it by the angles and forms that shoot out into it. Several of his constructions can be found in the open air in the principal towns of Holland; one of them has been placed in the passenger terminal of the airport of Amsterdam. His work has been shown at several international exhibitions, notably the Venice Biennale in 1956 and the exhibition held in the gardens of the Musée Rodin, Paris, in 1961. W. J. de G.

VOLTI Volti Antoniucci, called. Born 1915, Albano, Italy. After studying for four years at the School of Decorative Arts in Nice, he went to Paris in 1932 and joined the École des Beaux-Arts. As he had become a naturalised Frenchman, he was called up in 1937 for a period which, with the war and his ensuing captivity, lasted for seven years. He was repatriated from Germany in 1943 and found his studio in Paris razed to the ground by bombing and all his works destroyed. This disaster and the long interruption to his work induced him to make a completely fresh start. He freed himself from all the influences that had affected him till then and, while his art remained figurative, he began to give a freer interpretation to reality. His first one-man exhibition was held at the Galerie Breteau in 1946. From 1949 to 1954, he exhibited every year at the Galerie Claude and the Galerie Chardin. Besides stone, which is particularly suitable for his rounded volumes, Volti often uses clay, either for bronze casting or firing. His sculpture is sensuous and vigorously designed. His favourite subject is the female nude, whose grace, elegance and purely animal qualities find a complete expression in his sculp-

ture. He goes his own way and his personal idiom owes nothing to the artistic theories of his contemporaries; it is inspired by a pagan love of life and a kind of frank hedonism. In 1957, a retrospective exhibition of his work was held at the Maison de la Pensée Française. Since then, his exhibitions include notably two at the Galerie Katia Granoff, Paris (1962 and 1964). Volti is now also working in white concrete and hammered

Volten. Arrangement. 1966. Aluminium.

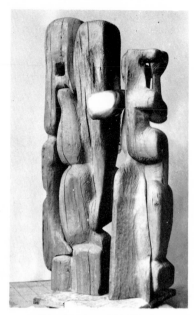

Vries. Sculpture. 1964. Wood.

VULAS Sime. Born 1932, Drvenik Veliki, Yugoslavia. He trained at the School of Applied Art in Split, then at the Art School in Zagreb. He has had several one-man shows in his own country and has been represented in group exhibitions in France, Poland, Switzerland, Belgium and the United States. The influence of Dalmatian Romanesque art on his sculpture soon disappeared before the influence of the École de Paris, Arp, Zadkine and Brancusi. Vulas carves wood as the medium most suited to his temperament. The source of his inspiration is a classical vision of the Mediterranean world, but he shears it of all but strictly plastic values. With the purity of their forms and visual perfection, his rigorously abstract forms communicate through the universal idiom of rhythm. They appeal, too, through a profound humanity, which emerges as a natural harmony with all that surrounds them. D. C.

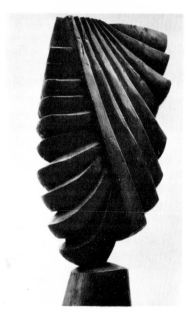

Vulas. Fragment. 1968. Wood.

copper. His style has become freer and he handles forms with greater liberty. D. C.

VRIES Léo de. Born 1932, Amsterdam. He trained at the Amsterdam Art School and was awarded a scholarship from the Maison Descartes. He has had two one-man shows, one at Enschede (Art Gallery), the other in Haarlem (Gallery T) in 1967. He is an abstract sculptor and worked at first in wood, carving sensuous, clustering masses, which evoke a living organism. Since polished metal became the material of his choice, his forms have become simple, geometric and generally complementary. These intimate, sensitive works depend on the greatest economy of means, which achieves its greatest effect with the precision of its articulation. D. C.

WALDBERG Isabelle. Born 1917, Ober-Stammheim, Switzerland. She did the first part of her training at Zürich from 1934 to 1936 under Hans Meyer. She stayed in Florence in 1937 and, until 1940, she gave up sculpture for a time and studied primitive civilisations and their arts at the Sorbonne. At New York in 1942, she experienced the first and only artistic shock of her life before one of Giacometti's sculptures, *The Palace at Four o'Clock in the Morning*. She became a Surrealist and through its ideas tried to give her works poetic intensity. Her first abstract sculptures were created in this way. In her endeavour to take away the opacity and weight from her medium, she used surprising and original materials: wood fibre, glass and string, which she stuck together in bundles and solidified. The technique she used for wood was entirely her own, which consisted in boiling it until it could be bent and stretched as she wanted it. The first exhibition devoted to her works was held at the Peggy Guggenheim Gallery at New York in 1943. When she returned to France in 1945, she took part in the International Exhibition of Surrealism at the Galerie Maeght (1947), then exhibited her work in the same year at the Galerie Jeanne Bucher and in 1951 at the Galerie Niepce. Although Isabelle Waldberg's sculpture returned to a degree of figuration for a time, it now seems finally to have changed to the elaboration of invented forms. They are often in bronze, sometimes in cork, and their sensitiveness and plastic imagination have earned her the Copley (1959), André Susse (1960) and Bourdelle (1961) prizes. Besides exhibiting at the principal Parisian Salons, she has recently held three exhibitions of her work in Paris at the Galerie du Dragon (1960 and 1962) and the Galerie Givaudan (1965). D. C.

WERCOLLIER Lucien. Born 1908, Luxembourg. He trained at art schools in Brussels and Paris and then tried to find his own idiom, first by studying Maillol's art, then Laurens's. About 1950, he began to turn away from naturalism and create figures in which the shape of a nude or a crouching woman might be discerned, but whose qualities were essentially sculptural. In 1952, his first abstract sculpture appeared and after this he had

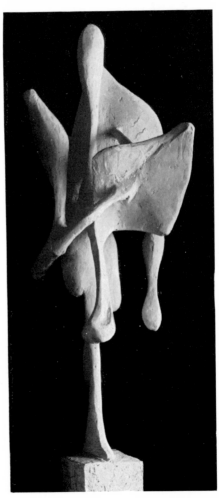

Waldberg. Flesh of a tree. 1957. Plaster.

Werthmann

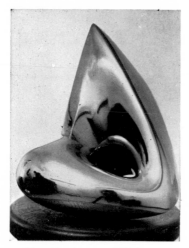

Wercollier. Sculpture. 1959. Bronze.

space. His mural reliefs, composed of rods and ribbons soldered into sheaves, or arranged in parallel lines, form wide, open curves, like the measures of a continuous rhythm siezed in flight. Another of his themes is the sphere, embodied with countless variations in his *Entelechies*. It attracts him because of its series of perpetual movements that trace the sphere, then swing back on themselves, carefully close together, or break and burst apart, as if torn by storms. About 1966, a fresh development appeared: staves and thin sheets of metal twined in each other to form compact knots and centres of centrifugal forces; animals bristling with aggressive spikes; and insects scything the air with their long tentacles. They were strange forms that metamorphosed the sober qualities of steel in the most astonishing manner. Werthmann has made several mural reliefs, porticoes and pierced walls, which are arranged so that the public can walk between them. He also realised a number of monuments based on the sphere, notably for the Goethe Institute in New Delhi. Besides exhibiting in private galleries in Düsseldorf, Wuppertal and Bonn, his work has been shown at the Kunstverein of Freiburg (1959), the Folkwang Museum in Essen (1968) and the Karl-Ernst-Osthaus Museum of Hagen (1969). H. W.

more in common with Arp and Brancusi than any other artists. He was commissioned to do the decorations for the Luxembourg pavilion at the International Exhibition in Brussels (1958) and, the same year, he exhibited his work at the Galerie Saint-Augustin in Paris. His works are anti-romantic and unspoilt by any sort of theatricality or overstatement. A sensuous line, purity of volume and a sensitive composition in which both develop and balance each other are the outstanding qualities of his works. Straight lines and angles are less important than the curves and their gentle movement. For some years, Wercollier has been polishing bronze and sometimes marble until the form is a reflection for the world outside. Added to this, he has broken with the convention of a definite base, so that none of the surfaces of his sculpture should be sacrificed to it. So the observer can not only walk round it, but he can also modify its aspect as he pleases. J.-E. M.

WERTHMANN Friederich. Born 1927, Wuppertal, Germany. He began carving wood and stone in 1948 without any previous training. By 1952, his work had become abstract. He tried using reinforced concrete for a year (*Diastructures*, 1956–1957), but gave it up for stainless steel, which has become his unique medium. He deprives it of its industrial character by hammering and soldering and reducing it, in a way, to its crude state, which is the only one suited to his creative purposes. Werthmann does not try to give form to definite subjects, but rather to bring about a deployment of forces and energies, sensations of effort and resistance, in fact. to create a whole interplay of movements in

WICHTERLOVA Hana. Born 1903, Prostejov, Czechoslovakia. She trained from 1919 to 1925 at the Prague Academy, mainly in the studio of Jan Stursa, where she became aware of the relationship of form and light. But shortly before the thirties, her sculpture turned uncompromisingly towards the Cubist style of Otto Gutfreund and Emil Filla. She was a member of the Manes Society, exhibited in her own country and abroad, notably in Paris. After disengaging her sculpture

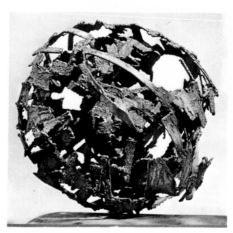

Werthmann. Entelechy III. 1961. Stainless steel.

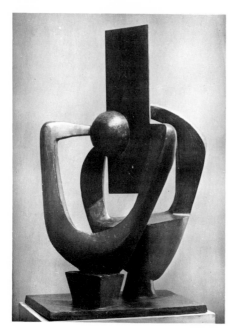

Wichterlova. Composition. 1929-1930. Bronze.
Regional Gallery of Liberec.

in the marble *Bud*, its sensuous lines and polished shapes, rising like a phallic symbol. After a long period of inactivity, she sculpted in the fifties, some extremely refined *Heads* and a series of idealised portraits. With the black marble *Kernel* of 1964, a compact, elementary form, she once again gave her sculpture a cosmic dimension that integrates it into the natural order.

R.-J. M.

WOTRUBA Fritz. Born 1907, Vienna. When he was fourteen, he began to learn engraving, but he later turned to sculpture and in 1925–1926, he was a student of Anton Hanak's. After 1929, he worked on his own. The architect Josef Hoffmann helped him and he was friendly with writers and musicians like Hermann Broch, Robert Musil and Alban Berg. In 1931, he held his first exhibitions in Essen and Zürich. In 1939, as a result of the Anschluss, he went to Switzerland, first to Zug, then to Basel in 1942 and Berne the following year. When he returned to Vienna in 1945, he was elected a member of the Academy. In 1950, he was represented at the Venice Biennale and afterwards at nearly all the important exhibitions in Austria and abroad. He was represented at the Kassel Documenta in 1959. Although he has produced several bronzes, Wotruba is above all a sculptor in stone. The style of his early works was strictly classical, but with something esoteric about it. The Torso of a man that he exhibited at Paris in 1929 made a great impression on Maillol. After going to Switzerland, the influence of archaic sculpture made his forms more severe and concentrated. Since 1945, however, Wotruba has gradually got rid of an archaism, which was essentially formal, and has sought in his experiments for the real, deep-seated origins of art which would provide a new, sound foundation on which sculpture could be built anew. 'Natural beauty', borrowed directly from the universe, was followed by aesthetic beauty', which gave way in its turn to a more

from figurative conventions, she elaborated a pure plastic idiom derived from organic nature and not from a simple geometric reduction of reality. The *Composition* of 1929–1930, with its pierced structure inscribing space shows this development clearly. However, in the *Torso* of the same period, she was already seeking for the unity and fullness of form that she achieved in 1932

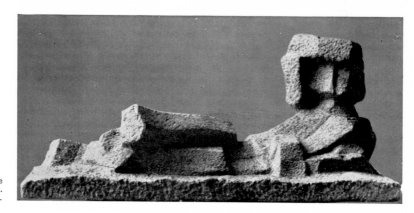

Wotruba. Large
reclining form.
1951. Stone.

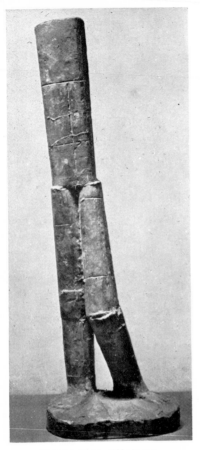

Wotruba. Torso. 1955. Bronze.

personal experience endowed them with a more genial attitude, which was just as inviolable in its independence. Oval heads appeared for the first time in his work in which the bronze seemed as thin as a shell. Curves, saliences, slight depressions appeared in his sculpture, while a delicate modulation of the surfaces now imparted to the bronze and stone a less obvious, but nonetheless rich vibrancy. 'The human body,'. said Wotruba, 'has never ceased to be the main source of my work; it was there at the beginning and will be there at the end.' The human figure, freed at last, from all individuality or idealism, is in no way 'abstract', but is recreated from its fundamental elements and so assumes a universal character.

J. L

WOUTERS Rik (Malines, 1882 — Amsterdam, 1916). Belgian painter and sculptor. He lived at Boisfort, a suburb of Brussels, and in 1907 became a full-time sculptor, having learnt the craft of wood-carving when he was very young. In 1909, he made the acquaintance of the French painter Simon Lévy, who helped him to complete his artistic education. The dealer Georges Giroux supported him and lost no time in concluding a contract. Wouters sculpted a full-length portrait of Mme Giroux, which is also called the *Coquette*, but it was his wife who generally served as his model. He liked to sculpt her as a draped figure, caught in one of the familiar, fleeting attitudes of everyday life *(In the Sun; Domestic Cares)*. Wouters was not, in fact, indifferent to the problems of integrating movement in sculpture and he gave a superb example of this in the *Mad Virgin* (1912), which was inspired by the dancer Isadora Duncan. He was called up, when war was declared, and interned with his unit at the camp of Zeist, Holland. He was striken with a serious cerebral disease and died blind at the age of thirty-four. Wouters's art had an impetuosity rare in sculpture, which is sometimes reminiscent of Bourdelle, but it was more exuberant. His nervous modelling made the surfaces alive to every modulation of light and his almost paradoxical search for the 'snapshot' pose is comparable to Degas, but Wouters's works were much more monumental.

F.-C. L.

structural and strictly constructive conception, where the human figure would have to be reinvented from roughly trimmed blocks in the Cyclopean style. It was no longer possible to take the art of the past as a guide, nor could the foundation of a work of art be found anywhere except in the creative act itself. Wotruba's new conception of art grew out of the crucial experiments he made all through 1945, 'zero year'. Yet, the powerful, life-size statues, made in bronze or stone during the years 1947–1952, seem to be the beginning of everything for Wotruba. Admittedly, since this period, and especially since 1958, his forms have become more refined and subtly differentiated, but the structure of the whole has remained unaltered. Instead of a stubborn, almost aggressive resistance to the outside world, his

WRIGHT Austin. Born 1911, Chester. He studied at Oxford, where he obtained a degree in languages. He held his first exhibition in York in 1950, and his second in London in 1956. He was represented at the São Paulo Biennial in 1957, where he was awarded the Ricardo Xavier Acquisition Prize. His commissions include sculpture for a Manchester school and tapestries for the cathedrals of Manchester, Derby and Wakefield. Austin Wright stands a little on the edge of the main stream of modern British sculpture, though his work pays tribute to developments there and elsewhere. Its accents of 'modernity' derive rather from Wright's hand-

ling of his materials—lead has proved particularly congenial—than from any very radical vision of life. Humanity about its daily existence provides his themes and his smaller and more closely observed pieces have generally proved more successful, because less forced, than very large compositions like the open group (10ft high) seen in Holland Park in 1957. M. M.

WYSS Josef. Born 1922, Obstalden, Glarus, Switzerland. He lives and works in Zürich. Since 1954, he has been represented regularly at the Bienne Quadriennale and, in 1966, was awarded the prize of the Pagani Foundation at Legnano. He has travelled in Europe and visited Israel in 1962. His art has an architectural dimension and he has executed large-scale sculptures for the Canton of Zürich (notably the Cultural Centre of Hemried), Israel and Grenoble. The love and understanding of stone is fundamental to Wyss's style. In spite of his contemporary idiom, the purity of his forms and techniques recall the classical sculptors. Nothing could be further removed from the literary than the constructions of this solitary man, who has expressed himself

Wright. Lovers. 1955. Lead.

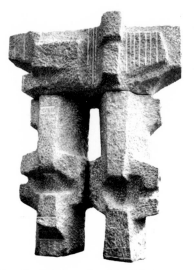

Wyss. Small pleasure. Grenoble, 1967. Limestone.

entirely in his art. His sculpture commands recognition by its presence alone, rising in a silence that defies time. Finely polished or marked by the chisel, his stones have a natural dignity. They are generally composed of several elements, related to each other, in the equilibrium of solids and voids, while the light slides smoothly over the transitions, or the harshness of the sharp edges. Just as the obelisks had an affinity with the lines of Egyptian architecture, Wyss's powerful signals harmonise with contemporary buildings and contain its essential spirit in their restraint and perilous equilibrium. J.-L. D.

y z

YENCESSE Hubert. Born 1900, Paris. His father was a talented medallist and Yencesse himself was the pupil of Pompon and Maillol from whom he discovered that sculpture could be a reflection of life and was not a way of arresting movement. His works were first exhibited at the Salon d'Automne in 1931 and were remarkable for his ability to make them vital, without excessive distortion or uncontrolled rhythms, and while preserving the purity of his line. These qualities placed him in a direct line with the sculptors of Versailles, who peopled the parks with elegantly French deities, which are never motionless and yet never gesticulate. He executed several monuments in France and contributed towards the decoration of the Assembly Hall of the League of Nations in Geneva. R. C.

YEPES Eduardo Diaz. Born 1910, Madrid. He is self-taught and was friendly from his adolescence with the most representative personalities of literary and artistic avant-garde circles in Madrid. He exhibited his works for the first time in 1930 at the Fine Arts Circle. The following year, he exhibited a new collection of his works at the Atheneum. They showed an extreme stylisation, with open forms in the manner of Archipenko and his followers. Yepes left Madrid, in 1934, with the Uruguayan painter, Torrès Garcia, whose daughter he married in 1936 at Montevideo. He returned to Spain in 1937 and exhibited his work in Madrid and at the Spanish pavilion in the International Exhibition in Paris. In 1939 he was imprisoned for thirteen months for his political opinions. Since 1948 he has been living and working in Montevideo. He has done an abstract sculpture for the façade of the Palace of Light (1952) and another in onyx, seven feet high, for the Uruguayan pavilion at the International Exhibition in São Paulo. This work has since been placed in the Ibirapuera Park. In 1956, he was granted Uruguayan citizenship. 'None of the potentialities of modern sculpture is beyond him,' the critic, J.-P. Argul, said of him. With Julio Gonzalez and Torrès Garcia, Yepes lived through the creative ferment of the 1930s, which saw the beginnings of so many artistic careers. His sculpture was shaped by his

Yvaral. Instability. 1964. Vinyl resin.

association with a few great artists and under the influence of new ideas. He has tried everything and explored everything: Cubism, Expressionism, religious art, returning from time to time to portraits of women in which he excels; sometimes his forms are solid and full: sometimes their hollowed shapes circumscribe space. His recent works have followed principles other than the traditional laws of representation; they are vital and their dynamism finds its justification and significance in the sculptures themselves. M.-R. G.

YVARAL Jean-Pierre. Born 1934, Paris. He studied graphic art at the École des Arts Appliqués de la Ville de Paris. He produced his first works in movement after a period of abstract constructivism. He was one of the

322

artists who founded the Groupe de Recherche d'Art Visuel in 1960 and contributed to its exhibitions until its dissolution in 1968. One-man shows of his work have been held in New York and several German cities. Yvaral is a kinetic artist, but tries to produce visual phenomena with a minumum of technicality. He uses a variety of materials (plexiglas, rubber, vinyl thread) and processes such as superimposition, displacement and acceleration and complex visual effects of structure, volume (cube) and transparency (moiré effects). These visual effects, like a game, inevitably encourage a more intimate participation on the part of the observer than merely looking. Yvaral is also interested in the phenomena of light and shadow (he exhibited his *Intermittent Projected Shadows* at the exhibition 'Lumière et Mouvement' in 1967 at the Musée d'Art Moderne de la Ville de Paris) and in their integration in an architectural space (Paris Biennial, 1967, and World Exhibition in Montreal, the same year). Yvaral is fundamentally a structuralist; he never neglects a thorough experimental investigation and his major interest is in the relations between scientific and artistic knowledge; he has, for instance, examined some of the fundamental problems of vision in so far as they are affected by certain, constant, natural factors. On the purely sculptural plane, he is primarily concerned with the scale and setting of his work. F. P.

ZADKINE Ossip (Smolensk, 1890 – Paris, 1967). When Zadkine arrived at a little English town at the age of sixteen to complete his education, his classes in sculpture and drawing meant more to him than anything else. He went to London shortly afterwards and, in 1909, to Paris. where he threw himself into the artistic

Zadkine. Female form. 1918. Bronze.

Zadkine. Homage to J.S. Bach. 1936. Wood. Stedelijk Museum, Amsterdam.

life of the time. Cubism had just been born and he joined the movement straightaway, but this was no more than a beginning for him and a means to artistic freedom. In spite of his success in this style (*Woman with a Fan*, 1914), he was temperamentally unsuited to such a rigid discipline. About 1920, the poet in him emerged and acted on the sculptor. He rejected any distortion that would only have served to create a plastic rhythm without at the same time expressing an idea or a feeling. His forms now were to be determined by his reactions to nature and, too, by the texture and the composition of the material. Great tree trunks were transformed into the bodies of women (*Demeter*, 1918) and closely embracing couples, who seem to have risen from the initial form of the wood or block of stone. This produced a great simplicity of outline and a stability that, all considered, was remote from Cubism and even seemed a return to a kind of classicism (*Torso of a Woman*, 1928, Antwerp Museum).

A further stage in Zadkine's development soon showed that this classicism was only apparent and left no doubt about the baroque nature of his inspiration. He had already shown in his Cubist period how tenderly he could fashion the human figure and did not shrink from

Zongolopoulos

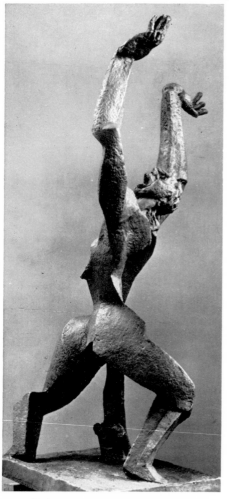

Zadkine. The destroyed city. Rotterdam,
1948-1951. Bronze.

materials that responded more sensitively to his inner vision. In this new phase, he had complete mastery over his medium and produced some of his best works (*Maenads*, 1934; *Homo Sapiens*, 1935).

A little before 1940, Zadkine tried to lighten his forms by opening up their masses, so that they lost their solidity and were perforated through and through. With extreme subtlety, the planes superimposed in depth created a multiplicity of viewpoints in one and the same work. After this, the form of his art evolved less than the ideas that gave it life. Till then, Zadkine had been the creator of a mythology and invented the gods of a supernatural world that contained a virtual reality. Then he seems to have adopted a different attitude; he conceived an idea and then gave it form. For example, the monument erected in Rotterdam (1948–1951) as a memorial to the destruction of the town by the Germans is not the image of a tortured city: it is a scream, a cry of suffering. His *Prisoner* (1943), made in the United States where he spent the war years, is not a woman, confined behind bars: it is an idea trying to escape and proclaim its existence outside. His *Orpheus*, one of the main themes in his work, became in the 1948 version, like the *Poet* of 1956, a melody that unfolds in space and suggests a conception of time. Zadkine proved in the last phase of his development how little he cared for artistic fashion, since his way of thinking was eventually diametrically opposed to it. At a moment when abstract art thought it had found complete independence in rejecting the image of reality, Zadkine, on the contrary, enclosed abstractions in a sculpture of which every element was taken from the real world. This was why, however far his imagination might carry his art, the public could always understand it, even the least initiated. For the same reason, he exercised a considerable influence on the countless students who came from all over the world to the Académie de la Grande-Chaumière or his studio to learn the secrets of their art from Zadkine. R. C.

ZONGOLOPOULOS George. Born 1903, Athens. After he had studied architecture and sculpture at the Athens Art School, he went to Paris and worked in Gimond's studio. He has executed some public monuments in Athens, Piraeus and Salonica, and has been awarded prizes for them. Since the war, he has been represented at the Biennials of Venice and São Paulo. Zongolopoulos is deeply interested in architecture and has contributed to the planning of school complexes. He also designed the fountains and the layout of the Omonia Square in Athens (1953). Three years later, when he gave up working in marble and modelling his figures for bronze casting, he turned to soldered iron as the medium for a more personal style of sculpture. He handled it with strength and skill; his sculptures are monumental, but with their clear, rational articulations, there is nothing static about them. In spite of their austerity, there is a magic

elegance of gesture or profile. Gradually this tenderness and emotional appeal became more prominent. He even tried to distil them from the most extreme distortions when, in an attempt to avoid facility, he replaced reliefs by hollows, curves by straight lines, shadows by light. Not content, as he had been formerly, with one or two motionless or entwined figures, he began to experiment with more complex groups, more involved and varied forms and compositions with greater breadth. He even went so far as to give up carving wood and stone and resorted to modelling and working in plaster with

in their commanding breadth of vision, as they are measured against the space of the new city planning.

D. C.

ZORACH William (Eurburg, Lithuania, 1887 – Bath, Maine, U.S.A., 1966). His family emigrated to the United States in 1891 and settled in Cleveland. In 1907, Zorach went to New York and attended the National Academy of Design for a year. He wanted to be a painter at that time. He went to Paris, where he worked with J. E. Blanche (1910–1911), and exhibited at the Salon d'Automne in 1911. On his return to the United States, he contributed to the Armory Show in 1913. His first sculpture dates back to 1917, but he did not give up painting until 1922; in other words, Zorach did not begin to sculpt till he was thirty-five. The change in medium also brought a change in his point of view. As a painter, he had been a Cubist, but it was the archaic art of Egypt and the Middle East that provided the aesthetic foundation for the sculptor's classical style.

Zongolopoulos. Steel sculpture. Salonica, 1966.

Zadkine. Brilliant silence. 1958. Copper.
Denver Museum, Colorado.

He was a devoted craftsman of direct carving in wood and stone and enjoyed the technical skill of contrasting carefully worked and polished surfaces with rough, coarse, textures. His favourite subjects were nudes, torsos, motherhood, children and animals. He also did some large-scale sculptures for public buildings, like the *Spirit of Dance* (1932) for Radio City Music Hall in New York. R. G.

ZUBER Antoine. Born 1933, Montbéliard. He trained at the École des Beaux-Arts in Paris and, in 1964, was awarded the Prix André Susse. He has been represented at the Biennials of Paris and Middelheim, Antwerp, and has had four one-man shows in Paris: at the Galerie Yves Michel (1962, 1963, 1964) and at the Mur Ouvert. His early sculptures were in plaster and fundamentally realistic, with a sensitive modelling that caught the light. Subsequently, problems of structure occupied his attention increasingly, especially when he was working on large-scale sculptures. His sculpture in metal and

325

Zuñiga. The hammock.
Stone. National Institute
of Fine Arts, Mexico.

some new materials is abstract, but the style is adapted to the purpose of the work; signal, mobile or aquatic sculpture. He has also made a whole series of little wooden objects, which were conceived, not as small-scale models, but as sculptures in their own right, and, as such, they are also landmarks in his development as an artist. D. C.

ZUÑIGA Francisco. Born 1913, San José, Costa Rica. He began his training in painting and sculpture in the studio of his father, who carved figures. He was only eighteen when he carved a large *Maternity* in stone, which preserved the monolithic appearance of the original block. He was fascinated by the primitive art of Mexico, whose ancestral roots were the same as his own race, and in 1936 he settled in Mexico. He studied drawing there under Rodriguez Lozano and worked in the studios of various sculptors, particularly Oliverio Martinez. By 1946, he was already closely associated with the artistic movement in Mexico and he won a competition for a group of statues for Valsequillo in Puebla. The following year, he became a Mexican citizen and was appointed as a state teacher. In this capacity, he made a considerable contribution to the rise of the young Mexican school and innumerable sculptors owe much of their development to Zuñiga (Alberto de la Vega, Fidencio Castillo, Augusto Escobedo, Jorge Dubon, Pedro Coronel, etc.). In 1958, the National Institute of Fine Arts awarded him their First Prize for Sculpture. Among his works, mention should be made of the *Monument to the Poet Ramon Lopez Velarde*, a group of figures and bas-reliefs in red stone for the town of Zapotecas; *Riches of the Sea* for the port of Veracruz, another imposing group, fifty-two feet by thirteen; the east façade of the Secretariat of Communications. No sculptor was more thoroughly Mexican than

this Costa Rican. His works are easily understood; their conception is simple and they are carved in compact masses. Their fascination and brute strength derives from the traditions of the great pre-Columbian civilisations. He has drawn on the immemorial, but forever fresh, sources of Indian culture, without yielding to facile, archaic stylisation or to the mysterious symbolism of the past. Zuñiga belongs to his own age. His style is characterised by a severe construction, sturdy forms and a rough, warm poetry. He is an impressive example of an artist, who has remained faithful, without any contradiction, to his own times, his ancestors and to himself. M.-R. G.

ZWOBADA Jacques (Neuilly-sur-Seine, 1900 – Fontenay-aux-Roses, 1967). Apart from a spell of six months at the École des Beaux-Arts, Paris, Zwobada pursued, alone and untrammelled, his apprenticeship in his art. The shock he experienced before Rodin's *Age of Bronze* and *Walking Man* made him decide to become a sculptor; the sharp, sensuous poetry of the master had found a warm response in the romantic temperament of the young man. His first works reflected this influence, the *Memorial to André Caplet* (1925) for the town of Le Havre and the *Memorial to Simon Bolivar* (1933) for Quito, the capital of Ecuador. Then in a moment of discouragement, he accepted a teaching post. For eight years, he almost gave up sculpture completely and spent his time drawing and teaching at the École Supérieure de l'Enseignement Technique, the Académie de la Grande-Chaumière and the Académie Julian. He even went to Venezuela in 1948, where the Art School of Caracas appointed him to teach a class of graphic composition. He gave up teaching after this until 1962, when he was appointed to the staff of the École des Beaux-Arts, Paris. An event in his personal life again

lighted the creative flame, when Zwobada met an exceptional woman, who dispelled all his inhibitions and doubts. He obeyed his instinct to treat sculpture as an art of synthesis, in its solid volumes, and an art of movement, in its hollows and openings. It suddenly set him free from the limitations of representation to create forms to which his imagination often communicated a dramatic tension. Indifferent to the tendencies of the day, he completed in a few years a body of sculpture that was not fully appreciated in its breadth and originality until the retrospective of his work at the Musée Rodin, Paris, in 1969. When the woman to whom he owed this miracle died prematurely in 1956, he devoted the last years of his life to raising a memorial to her around her grave at Montana, near Rome. All his present and future sculptures were to be put there; among these was the *Couple* of 1956, the extraordinary *Night Ride* (1963), and the monumental *Orpheus and Eurydice* of 1967. His last terracottas should also be mentioned: *Tellus, Gaia, Cybele* and the exuberant *Demeter*, which would not look out of place beside prehistoric mother-goddesses. Zwobada also fulfilled a number of public commissions including a high relief for the lycée at Pau (1959) and a marble sculpture for the engineering school at Caucriauville (1967). He executed some mosaics for the liner 'France' (1961) and for the façade of the Faculté des Lettres at Rennes (1968). Finally, he left an admirable collection of drawings. Whatever medium Zwobada chose as a means of expression, it reflected a life fraught with physical violence and insatiable love. Flesh is mortal and love ephemeral, but they are undying when a great romantic artist has fashioned them into the stuff of his art, which will survive him. F. E.

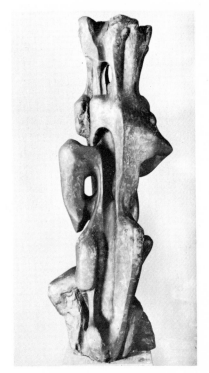

Zwobada. The couple. 1956. Bronze.

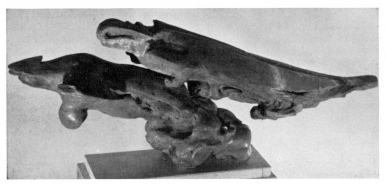

Zwobada. Night ride. 1963. Bronze.